The Comprehensive Guide for Selecting Interior Finishes

omp

for

Fini

Ph.D., NC

udies
eeley, Colorado

IIDA, IDEC,

n
sign

PEARSON

ous Indianapolis New York San Fra
Dubai London Madrid Milan
São Paulo Sydney Hong Kong Se

h

rtisch

nent: George

e Services, Pvt. Ld.
llville
ville

gration of many finish
errazzo flooring, carpet
plastic signage.

with permission, in this
ated, all artwork has been

E. Knowles, Ph. D., NCIDQ, IDEC,
ehr, IIDA, IDEC, registered architect,
erior design, Park University, Parkville,

3. Interior architecture—Materials.

2012044305

ISBN 10: 0-13-512191-4
ISBN 13: 978-0-13-512191-7

BRIEF CONTENTS

CONTENTS

CHAPTER 3

Wood 35

ix

Contents

The authors of this book considered finish materials in terms of the physical properties of the material based on its source. Rather than categorize materials by use, as many other books on interior finish materials do, the materials in this book are categorized by their origin. For example, linoleum is in the chapter on wood because it is made from the wood and resin of trees. Another difference in this book is that sustainability is carried throughout the book and discussed in terms of the material in each chapter. In discussing the history of materials use, interiors are considered any environment manipulated to create a desired space (Huppatz, 2012). This allows the history of interior materials to go all the way back to the use of a cave for shelter.

USE OF CASE STUDIES

Interior designers reading this book will most likely be visual learners, so the information discussed is accompanied by visual images. Although a photograph starts the visual image, an example through a case study presents a long-lasting visual image to help readers remember the properties of a material. Each chapter contains case studies describing how the material met certain requirements on a project. Some of the case study requirements will discuss meeting a client's desire, meeting standards such as sustainability requirements for Leadership in Energy and Environmental Design certification of a project, or how it reduced volatile organic compounds to meet indoor air quality standards. The examples will make these issues relevant to readers who are interested in interior design.

PURPOSE

The purpose of this book is to help interior designers organize their knowledge of finish materials. Knowledge of materials is necessary for interior designers to become certified by

Visually Harmonizing Materials that Create a Unified Design is the Goal of Interior Designers
Photo courtesy of Spanjer Homes.

the National Coucil of Interior Design Qualification. Each chapter discusses one material and its properties. Since all learning builds on prior knowledge, this book starts with the basic information regarding finish materials, including common uses and characteristics for each material. When the properties of a material are thoroughly understood, a designer may come up with unique uses and applications for it. Information on how the material is produced and where the raw material was found add to the understanding of information necessary for specifying installation of the material.

The order of materials was chosen so that information learned about one material carries over to the next material. Materials that are often used structurally, but become the finish are first: the structural materials of Metal and Wood. Materials that are mined with a small amount of refining are next: mined materials of Stone, Concrete, Gypsum and Plaster, and Brick. This is followed by the chapter about Ceramics, which builds on the clay material used for bricks, although ceramics are refined by shape and through firing at higher temperatures. Ceramics are further refined by adding a liquid coating that becomes glass. Thus, it follows that the next chapter is Glass, which goes into more detail on the production of pure glass. Materials that are more removed from their natural elements follow: the synthetic materials of Paint and Plastics, which rely on petroleum. Last is the chapter of finishes that incorporate different materials: Fibers and Textiles. Some fibers are made from plants (cotton, linen, and rayon), some come from animals (silk and wool), and many are made from petroleum products (nylon, polyester, acetate, and olefin). Fibers and textiles are included in this book because they are often used as finish materials in interiors. This chapter will not take the place of an entire course on textiles, but it discusses them in terms of their use as finish materials.

FORMAT OF CHAPTERS

Each chapter introduces an interior finish material and contains three parts. The foundation for learning about materials is a description of the material, its common uses, and its properties, including sustainability. The second level of learning about materials includes historical use, sources where a specific material may be found, and applications for the material. The third level of learning about the material adds code issues, specifying, installation methods, and maintenance. These sections help to organize the content into areas defined by the Council for Interior Design Accreditation.

Learning Objectives

Each chapter begins with a list of specific learning objectives for the chapter.

Part I: Awareness: An Overview

Although interior designers are not responsible for the form of the building itself, or for the design of the building envelope or interior load-bearing components, it is essential for interior designers to understand how buildings are designed and constructed. In addition to having an awareness of building construction systems, readers will learn about the roles different materials play in constructing a building as well as the role that those same materials can play on an interior. Readers are therefore introduced to the material with an overview, including a description of the material and its common uses, both in building construction and as an interior finish. Included in the overview of the material is a discussion of the *properties,* or characteristics, of each material and the environmental impact of the material. Each chapter includes a feature box listing the properties of the material, emphasizing the material's sustainable properties. An example of the material used in an interior is also included.

Part I will enable readers to identify common uses of the material in an interior and introduce them to the environmental impact of the material.

Part II: Understanding: In-Depth Information

For the readers to have an *understanding,* or more thorough comprehension of the material, the text provides a review of the historical development of the material followed by a description of how the material is produced, from raw materials to various methods of producing

the final product. This portion of each chapter includes detailed information on each variation of the material as well as methods used to change or improve the properties of the material. Alternate uses and composite forms of the material are discussed as well as options for applying a finish to the material.

Part II will enable readers to explain the history of the use of a material in an interior and to describe how the material is produced.

Part III: Application: Using Information Regarding Interior Finish Materials

To appropriately specify the material for use in an interior, students must be able to evaluate the material based on the specific needs of a design project. This requires knowledge of the environmental impact of the material as well as code requirements relating to the material, installation methods, life cycle analysis, and awareness of maintenance requirements. In Part III of the text, the application of the material to various interior surfaces and components of an interior is discussed. Specification requirements unique to each material are discussed in this part. A case study of the material used in an interior enhances the students' ability to apply the material.

Part III will enable readers to describe the code requirements that affect the use of the material in an interior, analyze the environmental impact of using the material, and evaluate how well the material will meet the specific needs of a design project.

Summary

The summary for each chapter concludes with a list of websites of organizations that readers may choose to investigate for further study. These lists are not intended to be comprehensive, as many other resources are available. There are review questions at the conclusion of each chapter intended for class discussions.

Glossary

Each chapter ends with a glossary of terms found in the chapter. The meaning given is in context to the use of the term with that material. Alternate meanings may exist but not be listed.

This textbook provides information about common materials used in building construction and interiors. It provides a history of the material and its use in interiors; discusses the application of the material, and provides information that will assist the interior designer in making finish material selections. However, the pace of product development is rapid. As new materials, products, and processes are developed, older materials and processes fall out of favor. Thus, this book should be used as a foundation for further research.

INSTRUCTOR'S RESOURCES

The instructor will have access to Pearson Education's Instructor Resource Center (IRC), which will provide an Instructor's Manual and a MyTest to accompany this content. The Instructor's Manual will include projects and activities that are applied to real-world applications.

Download the Instructor Resources from the Instructor Resource Center. To access supplementary materials online, instructors need to request an instructor access code. Go to www.pearsonhighered.com/irc to register for an instructor access code. Within 48 hours of registering, you will receive a confirming e-mail including an instructor access code. Once you have received your code, locate your text in the online catalog and click on the Instructor Resources button on the left side of the catalog product page. Select a supplement, and

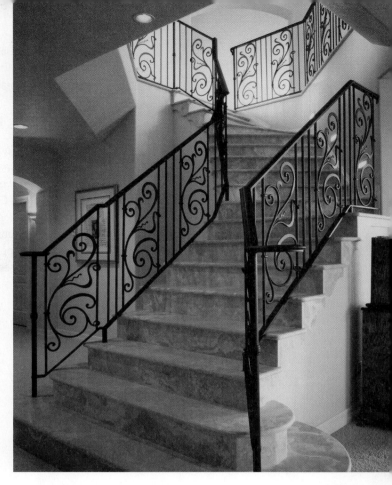

Finish Materials Can Be Combined to Form a Unified Theme Carried Throughout the Project. Photo courtesy of Spanjer Homes.

a login page will appear. Once you have logged in, you can access instructor material for all Prentice Hall textbooks. If you have any difficulties accessing the site or downloading a supplement, please contact Customer Service at http://247.prenhall.com.

STUDENT'S RESOURCES

eBooks. *The Comprehensive Guide for Selecting Interior Finishes* is available as a CourseSmart. *CourseSmart* is an exciting new choice for students looking to save money. As an alternative to purchasing the printed textbook, students may purchase an electronic version of the same content. With a *CourseSmart* eTextbook, students can search the text, make notes online, print out reading assignments that incorporate lecture notes, and bookmark important passages for later review. Students can also access their *CourseSmart* book on an iPad by downloading the CourseSmart App. For more information, or to purchase access to the *CourseSmart* eTextbook, visit www.coursesmart.com.

ACKNOWLEDGMENTS

We would like to give a special thank you to the reviewers of the manuscript for their input and valuable suggestions: Anthony Abbate from the Florida Atlantic University, David Butler from Florida State University, Ann Cotton from the College of DuPage, Donna Daley from the Art Institute of Philadelphia, Darlene Kness from the University of Central Oklahoma, Kimberly Morrison from the Art Institute of York Pennsylvania, and Alexander Schreyer from the University of Massachusetts.

Evelyn Everett Knowles earned both Bachelor of Science in Interior Design and Master of Architecture degrees from Kansas State University. An NCIDQ-certified interior designer since 1988, she worked in interior design and architecture firms for 10 years. She has taught interior design at Kansas State University, University of Illinois, University of Oklahoma, and Park University. Currently, Knowles is teaching Environmental Studies at the University of Northern Colorado.

Kay Miller Boehr earned a Master of Architecture with an emphasis in Interior Architecture from Kansas State University. After a 20-year career as an architect and interior designer, she now teaches interior design at Park University.

Introduction to Selecting Finish Materials

Materials and Finishes

The primary purpose of a building is to provide shelter. To do so, a building is made up of both an enclosing structural system and interior spaces. The components of a building include *structural elements* such as foundations, columns, floors, walls, and roofs, as well as *nonstructural elements* such as interior partitions or ceilings. A **thermal envelope** encloses and protects the interior of the building. The *building envelope* may be punctured by doors and windows. Within this enclosing shell are special construction elements such as vertical circulation (stairs, ramps, and elevators) and fireplaces. The plumbing and the mechanical and electrical systems provide the necessary comforts of heating, cooling, power, water supply, and sanitation.

The structural and nonstructural building **elements** are composed of *materials* such as wood, metal, concrete, stone, and brick. In some cases, the materials, such as a brick or stone wall, are left exposed. These exposed materials then become the *finish*, and may need

The primary purpose of a building is to provide shelter.
Lloyd Smith/Shutterstock

no further treatment, or they may require a protective coating. More often, the materials that make up the building element—for example, wood studs for walls, are encased in another material, such as gypsum board, which is covered with an applied finish. When a finish is applied to a surface, the surface to which the finish is applied is called a **substrate**. Thus, an interior finish can consist of a single material or an application of a finish product to the surface of a material.

Role of the Interior Designer

In the twenty-first century, we spend the majority of our time indoors, living and working within the shelter of a building. Interior designers not only plan and shape the spaces within the building shell but they also enrich the spaces with color, texture, and pattern, as well as design details and select finishes, furnishings, and accessories. All of this is done with the goal of designing a space that is a *unified whole*, or more than the sum of its parts. This goal for cohesiveness extends to the relationship between the interior and the building shell, requiring that the interior designer be aware of building construction systems. The designer must also understand that the building is the context within which the interior is designed. While working with architects, interior designers may also influence the shape and configuration of the building shell, helping to design buildings from the inside out, with the function of the interior spaces determining the form of the building.

The building shell meets the requirements for shelter, but it is the interior that provides comfort, convenience, safety, and security. As interior designers plan and shape interior spaces, they enhance the quality of life of the individuals who live and work in them. Thus, interior designers provide functional improvement, aesthetic enrichment, and psychological enhancement to the spaces they design.

Interior designers must also be aware not only that they are designing for the client who hires them, but that their work has a much broader impact—on all the users of the space, society as whole, and the environment. **Sustainable design** is a concept that influences every decision made by the socially responsible designer. A sustainable design considers the needs of the present users of a space, but does not compromise the needs of future generations. Thus, designing sustainably means that a designer considers the three intertwined issues of the economic, social, and environmental impact of any action, especially the design of a building interior.

Additionally, interior designers are responsible for selecting the materials that make up the nonstructural elements of the interior space and the finishes that are applied to these elements. According to the 2011 Standards of the Council for Interior Design Accreditation, or **CIDA**, the accrediting body for interior design programs at colleges and universities, students in interior design "have an awareness of a broad range of materials and products [and an awareness of] their typical fabrication and installation methods and maintenance requirements." According to CIDA, students should be "able to select and apply appropriate materials and products on the basis of their properties and performance criteria, including ergonomics, environmental attributes and life-cycle costs" (CIDA, Standard 11).

Because the work of interior designers affects the health, safety, and welfare of the public, many states regulate the practice of interior design. In 2012, 27 states, including the District of Columbia and Puerto Rico and eight Canadian provinces, have enacted some type of legislation that regulates either the use of the title "Interior Designer" or the practice of interior design. The National Council for Interior Design Qualification (**NCIDQ**) develops and administers the examination that certifies that an interior designer has the "knowledge and experience to create interior spaces that are not just aesthetically pleasing, but also functional and safe" (www.NCIDQ.org). After meeting the required combination of education and experience, one must pass the NCIDQ to be considered a professional interior designer by professional interior design organizations, employers, state regulators,

and the general public. The NCIDQ certification examination includes questions about finish materials. This textbook is designed to give interior designers information they need to successfully qualify as professionals. Questions that relate to materials and finishes are found in the NCIDQ test Sections 1 and 3, as shown here:

NCIDQ Section 1

Knowledge of and skill in the application of:

- Code requirements, laws, standards, and regulations, including accessibility guidelines
- Sustainable design practices

Knowledge of and skill in:

- Selection, specification, use, and care of furniture, fixtures, and equipment, including window treatments and textiles
- Selection, specification, use, and care of interior finishes and materials—for example, acoustics, life safety considerations, performance, and properties
- Procurement
- Cost estimating
- Sourcing and research as related to manufacturers' and vendors' information

What Designers Need to Know about Materials

- Be aware of the broad range of materials and finish products that are available.
- Select and apply appropriate materials and finish products on the basis of their **properties** or physical characteristics, which will determine how the product will perform.
- Know how the use of the materials will affect the acoustics of the space. Absorbent materials will help deaden the sound, making spaces less noisy. Reflective materials will add to the noise level of a space, which may be desirable in some instances. Some materials will help slow the passage of unwanted sound from one space to another.
- Consider the life cycle cost of selected materials, which include the required durability of all materials.
- Be aware of the environmental impact of the selected materials.
- Understand the typical fabrication and installation methods for materials and finish products.
- Know and understand maintenance requirements for finish products.
- Be aware of the resources that are available for obtaining information about products and materials.
- Evaluate materials for their function, aesthetics, and appropriateness for a given use.

Variety of Materials Used as Finishes in an Interior

The dining commons of this high school in Lawrence, Massachusetts, illustrates the variety of materials that are often used in an interior.

- *Plastics* include the quartz-based vinyl tile used to create a colorful pattern on the floor as well as a resilient vinyl base.
- *Concrete* walls are constructed of both split-faced and ground-faced concrete masonry units.
- To absorb some of the sound in the room, a fiberglass *textile* is wrapped around acoustical panels. Suspended

from the ceiling are custom fabric-wrapped acoustical tile "clouds."
- *Metal* used in the space includes exposed steel column, beams, and ductwork.
- *Gypsum board* surfaces as well as the exposed metals are *painted*.
- The abundant natural light is made possible by the use of *glass*.
- *Wood* is used for built-in cabinetry.

FIGURE 1.1 The Dining Commons at Lawrence High School in Lawrence, Massachusetts, designed by Flansburgh Architects, Boston, Massachusetts. Photograph courtesy of Heidi Jandris and A. Jandris & Sons, Inc.—New England CMU manufacturer

- Sustainable design practices
- Interior finishes and materials

Common Threads: An Overview of Topics in Each Chapter

Each material that is used by a designer must be evaluated for its environmental impact, the code requirements and other regulations to be considered in its selection, and the effect the material has on accessibility. Once a material is evaluated and selected for a project, the designer must be able to document that selection so the project can be properly built using the appropriate materials and finishes. Because each of these issues is a factor in selecting any material, the following overview will aid in the understanding of the discussion topics in each chapter.

ENVIRONMENTAL IMPACT

According to Edward Mazria, founder of Architecture 2030, an organization established to address the climate change crisis, buildings have a greater negative impact on the environment than does transportation or industry. Buildings are responsible for nearly half of the energy consumed in the United States and nearly half of the carbon emissions that contribute to global warming. Thus, designers of buildings have the greatest potential to solve the problems that are causing the rapid depletion of natural resources and global climate change.

A conscientious designer will analyze the environmental impact of the product he or she selects. Although most manufacturers claim that their products are "green," a careful evaluation of each product is necessary. Multiple factors must be considered in the decision-making process, and choices may be based on balancing the various options with the requirements for each project. Fortunately, several organizations and entities provide guidance and, in some cases, certification of specific products used in an interior. The mission of the *GREENGUARD Environmental Institute* is to "protect human health and quality of life by enhancing indoor air quality and reducing people's exposure to chemicals and other pollutants." A GREENGUARD-certified product meets stringent chemical emission standards. *FloorScore* was developed by the Resilient Floor Covering Institute (RFCI) in conjunction with *Scientific Certification Systems* (SCS) to test and certify hard-surface flooring and flooring-adhesive products for compliance with indoor air-quality emissions. *Greenseal* certifies a wide variety of products. A Greenseal certification considers the impact of the product on health and the environment. These certification agencies often refer to standards set by the *International Organization for Standardization (ISO)*, which sets standards for products based on criteria that have global relevance. In the United States, the *Environmental Protection Agency (EPA)* is the federal organization charged with protecting human health and the environment, and, as such, writes regulations related to environmental issues.

Each of the preceding agencies provides certification that will assist in designing a sustainable interior or building and achieving **LEED** certification. The United States Green Building Council (USGBC), a nonprofit organization established in 1998, created a rating system that assesses the sustainability of the "design, construction and operation of buildings and neighborhoods," known as LEED, or Leadership in Energy and Environmental Design. As of 2012, LEED has acknowledged the unique requirements for different types of buildings, and includes LEED for Homes, Existing Buildings, Commercial Interiors, New

- **Sustainable Sites** Included in this standard are such issues as determining where to build, the connection of the building to its surroundings, and the way the land is treated.
- **Water** This standard includes issues such as the source of water used in the building and where the water goes when it leaves the building. It can cover everything from runoff to the type of plumbing fixtures selected.
- **Energy and Atmosphere** Not only does this standard address the types of heating and cooling systems used but it also includes the power sources and the type of appliances selected.
- **Materials and Resources** Interior designers have the greatest opportunity to contribute to this standard due to their responsibility for selecting interior materials and finishes. Considerations include the origin of the material and the distance the material must be transported, as well as the quality of materials selected. Subtopics in this standard include:

> Source reduction and management
> Toxic material source reduction
> Construction waste management
> Optimized use of alternative materials
> Optimized use of indoor-air-quality–compliant products
> Sustainable cleaning products
> Occupant recycling
> Additional toxic material source reduction
> Recycled content

- **Indoor Air Quality** This standard not only addresses the issue of irritating or toxic gasses in an interior, usually caused by **volatile organic compounds**, but also addresses the quality of life of the occupants by considering access to daylight and views, thermal comfort, and the right to breathe clean air.
- **Innovation in the Design Process** "Extra credit" points are available for an innovative design that goes above and beyond requirements or solves a problem in a new way.

Construction, Core and Shell, and LEED for Schools, Health Care, and Retail. LEED for neighborhoods is in development. After passing an examination in a specific category, individuals can become LEED Accredited Professionals or Green Associates, and thus can assist design firms and building owners in the process of designing a building or interior that is in compliance with LEED. Buildings that are designed to comply with LEED standards may be awarded a certificate that reflects the level of compliance, from basic LEED compliance through LEED Silver, Gold, or Platinum based on the number of points received for meeting each standard. LEED is becoming a requirement for buildings that receive government funding from the local to the federal level. The organization is continually being evaluated and revised, but the six overarching categories of analysis remain consistent.

The environmental impact of a material used to construct and finish a building can be evaluated by referring to a measurement of its **embodied energy**, a complex system of determining how much nonrenewable energy is used throughout the life cycle of the material. *Indirect embodied energy* measures the energy used to produce the material, including processing, manufacturing, and related transportation. *Direct embodied energy* measures the energy used to transport materials to the site and the energy used during construction. *Recurring embodied energy* measures the energy used during the lifetime of the material, including the energy required to repair, restore, or replace the material. The numbers are expressed in megajoules (MJ) or gigajoules (GJ) per unit of weight or area. The numbers for individual materials vary based on the location of the project, and they may be used to compare the environmental impact of different materials.

CODE REQUIREMENTS

Interior designers must understand and apply government regulations that affect the way they design. These regulations include zoning ordinances, building codes, and the Americans with Disabilities Act. Some jurisdictions have incorporated environmental requirements into their local regulations. For instance, some publically funded buildings may be required to meet LEED standards.

Sustainable Design

MARIPOSA VET CLINIC

Approximately 600 locally harvested straw bales are used as a highly effective insulation infill between the post and beam structure of the Mariposa Veterinary clinic in Lenexa, Kansas. A 10-inch thick structural insulated panel (SIP) roof with 48-inch overhangs shelters the walls from the rain and shades interior spaces from the summer sun. Careful orientation on the site and strategically placed windows allow the building to take advantage of passive solar heating in the winter and natural day-lighting throughout the year. Native plantings conserve water, and a series of rain gardens planted with native sedges provide storm water detention and treatment. Interior finish materials visible in this photograph include a stained concrete floor that acts as a thermal mass, absorbing heat during the day and radiating it into the interior at night; plastered walls covering the straw bales; and the exposed structure of the ceiling, including the glulam (glued laminated timber) beams and the particle board of the structural insulated panel.

SLOCUM CENTER

The Slocum Center, the first LEED Gold orthopedic center in the United States, was designed by the Neenan Company in Fort Collins, Colorado. Design strategies that helped achieve LEED certification included:

- Sustainable site development
- Water-use reduction, including installing low flow and dual flush toilets
- Energy efficiency, including occupancy sensors and participation in a wind program
- Building exterior designed to reduce heat gain, taking into consideration the building orientation, sunshades, low-emissivity glazing, and strategies for natural lighting

Material selection played a large role in achieving the LEED certification. There was an overall goal of reducing plastic products made of PVC. Linoleum and carpet tile were used as well as eco-polymeric sheet flooring. Other materials used in construction and as finishes include:

- Local brick
- Certified woods (including particle board)
- Recycled steel
- White TPO (thermoplastic) single-ply roof, an alternative to PVC (polyvinyl chloride) roofing
- Low VOC (volatile organic compounds) paints, flooring, and walk-off mats

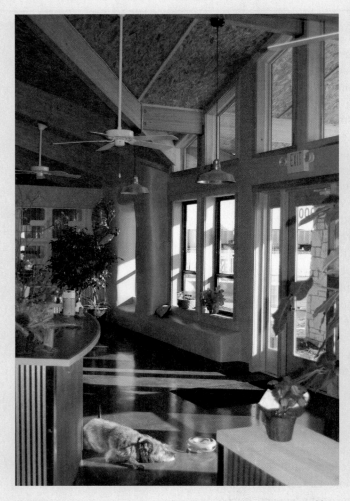

FIGURE 1.2 Mariposa Veterinary Clinic in Lenexa, Kansas, Designed by Rothers Design Build. Photograph courtesy of Rothers Design Build

FIGURE 1.3 Slocum Center for Orthopedic and Sports Medicine, LEED Gold, by Neenan Architects, Annie Lilyblade, Interior Designer and Medical Planner. Courtesy of The Neenan Company, LaCasse Photography

Zoning ordinances are locally created regulations that are used to control the type of development that may occur in a defined area or zone. They regulate land use and address such issues as the location of a building on the site, the allowed use of the building depending on its location, the height and size of a building, and the number of parking spaces required. Zoning ordinances are not based on life safety issues, but are planning tools that may control the character of a neighborhood, protect environmentally sensitive areas, and/ or conserve open space.

Building codes are regulations that help protect the health, safety, and welfare of the occupants by setting minimum standards for construction materials and methods, as well as setting standards for design and construction that protect the building occupants from hazardous conditions. The development of building codes was instigated by disasters, usually fires, that resulted in deaths to occupants. Each serious disaster led to a strengthening in codes, including the September 11, 2001, bombings of the World Trade Center in New York, which has led to more stringent construction and safety requirements for tall buildings. Architects and interior designers are professionally obligated to design buildings and interiors that meet code requirements.

The most commonly adopted building code in the United States is the International Building Code, or IBC. However, the interior designer must first check with the local jurisdiction to determine which code is being used. Not all jurisdictions have adopted the IBC, and/or there may be specific modifications to the code to reflect the conditions of the locality. For instance, NFPA 101 is a life safety code established by the National Fire Protection Association that may be adopted as a stand-alone code or in conjunction with another code. In addition, building codes are supported by specialty codes such as fire codes, residential codes, and electrical, mechanical, and plumbing codes. Environmental regulations, such as requirements for sustainable design, may be adopted by a specific jurisdiction and incorporated into a local building code. In some jurisdictions, publicly funded buildings must meet LEED standards.

The Americans with Disabilities Act (ADA) is a federal civil rights law ensuring that people with disabilities have equal access to places of employment, state and local government services, public transportation, public accommodations and commercial facilities, and communication services. The ADA is not a building code, but local jurisdictions have generally adopted ADAAG, the Americans with Disabilities Act Accessibility Guidelines, as part of their building codes. Although ADAAG is the most stringent accessibility code, other similar accessibility guidelines—such as the original accessibility standards, ANSI 117.1—may be adopted by individual jurisdictions. Federal buildings are covered under the Architectural Barriers Act (ABA), which has standards similar to the ADA. The Americans with Disabilities Act is concerned with allowing access to buildings, and interior finishes become an issue if they create a barrier to accessibility.

To design a space that meets building codes, the designer must know the occupant type, occupant load, and building construction type. The **occupant type** is a category based on the risk associated with the type of use of the building; it determines an allowable number of people (per square foot) that can safely occupy a building or the space within a building. For example, a restaurant may be categorized as "assembly without fixed seats" and has a higher occupant count (15 square feet per person) than a business occupancy, which allows 100 square feet per person. The **occupant load** is determined by dividing the size of the space in square feet by the number of occupants allowed per square foot. The **building construction type** is based on the level of combustibility of the materials used to construct the building, both exterior and interior, and is used to determine the allowable height and floor area of the building. The occupant type, occupant load, and construction type are used together to determine design criteria such as allowable use of construction materials on both the interior and exterior of a new building and on any interior construction in an existing building. This information is used to guide the selection of materials used for construction assemblies; the design of fire barriers; the selection and placement of finish materials, doors, and windows; and the selection and placement of furniture.

Agencies That Develop Standards

- **National Fire Protection Association (NFPA)** Established in 1897, the NFPA's stated mission is to "reduce the worldwide burden of fire and other hazards on the quality of life by providing and advocating consensus codes and standards, research, training and education." The NFPA establishes standards for life safety that are incorporated into all building codes, as well as developing its own stand-alone life safety code.

- **American National Standards Institute (ANSI)** This institute is a private not-for-profit organization established in 1918. It "promotes and facilitates voluntary consensus standards and conformity assessment systems." The American National Standards Institute approves and organizes the standards developed by other organizations, developing standards when an industry group or government agency commissions the organization to do so. The institute is the U.S. representative to the International Organization for Standardization.

- **American Society of Testing and Materials International (ASTM International)** The ASTM was founded in 1898 as an organization that writes standards, but does not test or certify products. It develops and delivers international voluntary consensus standards. Among the categories of standards written by ASTM International are newly developed sustainable design standards.

- **Underwriters' Laboratory (UL)** Underwriters' Laboratory is an agency that has tested and approved products since 1894. It tests hundreds of products in construction, building materials, systems, and assemblies to protect occupants from fire and life safety hazards.

Building codes base most of their requirements on an established set of *standards*, voluntary testing procedures that determine whether a product or material is compliant. Standards are not regulations, and testing is voluntary. However, when standards are incorporated into a building code, materials or products that are specified or assemblies that are designed must meet the pertinent standard.

INTERIOR FINISH MATERIALS AND FIRE

Building codes are not limited to regulations related to preventing the loss of life in fires, but it was disasters such as the Triangle Shirtwaist Factory fire in New York City in 1913 (145 young women died) and the Cocoanut Grove nightclub fire in Boston in 1942 in which 492 people died that led to stronger fire and life safety codes. The goal is to construct buildings using methods and materials that help prevent fires from starting. If a fire starts, the strategy is to ensure early detection (such as from fire alarms) and suppression (such as from extinguishers or sprinklers) and/or to contain the fire long enough for occupants to evacuate, as well as to allow firefighters enough time to bring in equipment and fight the fire. Many building materials and finish materials will burn, and some finishes, such as flammable coatings, can actually start fires. Once started, combustible materials can serve as fuel, feeding the fire and allowing the flame to spread. Smoke is often more dangerous to occupants than flames, obstructing vision in addition to causing injuries from smoke inhalation. In addition, some finish materials emit toxic fumes when they burn. Thus, the key is confining the fire to the location in which it starts, while providing a safe path of exit for the occupants. Finish materials must not contribute to the spread of fire or allow flashover from one burning material to another flammable material.

As determined by the use and construction type of a building, *means of egress* (exits, exit access corridors, and doors and windows as components of exitways) must be designed and built to provide barriers to smoke and flame. This involves designing floors, walls, and ceilings as *assemblies* of components that are rated based on the length of time they can resist fire. Ductwork and other penetrations must have fire stops and dampers. Finishes must pass tests to ensure that they resist flames and will not contribute to the development of smoke. The priority in a fire is to evacuate occupants before the building burns. Thus, corridor assemblies are rated by the time that they will withstand smoke and flame, usually one or two hours. Interior designers not only have to understand the methods required for the rated construction assemblies but also the flammability of finish materials applied to the surface of walls, floors, and ceilings, as well as window treatments, furniture, applied trim, and other potentially flammable objects in a space.

Testing Products for Flame Resistance

Testing agencies such as Underwriter's Laboratory will test the fire resistance of an assembly of components used to construct a wall, for instance. An **assembly** refers to the components of a structure, wall, or enclosure, combined and rated as a unit. A door assembly would include the door, frame, hardware, and window glass.

Interior finish materials are tested by a variety of smaller-scale flame tests. The finish material is usually tested on top of the substrate to which it will be applied. The results of the tests are used to rate the material—for instance, Class A, B, or C for wallcovering, or Class I

or II for flooring. The various standards organizations have written these tests into their standards, and they are thus incorporated into building codes.

SPECIFYING

In order to communicate the design of a space or building so the project can be priced, permitted, and built, the designer prepares a set of **contract documents** that include construction drawings and specifications. The codes officials working for the local jurisdiction review these documents for compliance with all applicable codes and regulations before issuing a *permit* to build the project. The documents also serve as the basis of a contract between the owner and the general contractor, as well as a guide for construction.

A **specification** is the written portion of the contract documents that describes the material or the product to be used, the quality of the product or material, and the installation or construction methods to be used. For some small projects, specification information may be incorporated into the set of drawings, but for larger projects, specifications are prepared as a separate written document or *Project Manual*. Interior designers may also write separate specifications for *furniture, fixtures, and equipment (FF&E)* to be issued, not to the general contractor, but to vendors who will supply the FF&E after the construction is complete. Interior designers and architects write standards into a specification, selecting and specifying products that have been tested for their compliance with codes and performance standards, and requiring evidence that the products used meet the standards.

Architectural specifications are formally structured documents, and have traditionally been based on CSI (Construction Specifications Institute) Masterformat, although other formats are similar. CSI Masterformat specifications are written so that the specifications writer can choose from options for each category of information. Information is included to guide the designer in the decision-making process. The CSI Masterformat specification package includes a *General Conditions* section that gives instructions to the bidder related to the entire project, such as definitions, responsibilities of each party involved, requirements for using the site, and processes for determining completion of work and receiving payment. The specification is then divided into divisions for each type of product or material. Interior designers are often given the responsibility for writing or gathering information for a specifications writer—specifically for the divisions related to interior finish materials and components of an interior, such as Division 9: Finishes. Specifications may require the submittal of evidence that products meet performance standards—for example, tear strength standards for vinyl, citing specific ASTM and ANSI standards or industry standards.

Tests Used to Test the Flame Resistance of Interior Finish Products

- **Steiner Tunnel Test** The *Steiner Tunnel Test* is used to test the flame spread and smoke development of finishes used on walls, columns, or ceilings. Using the manufacturer's recommended adhesive, a sample of the material to be tested is adhered to the type of substrate to which it will be applied when installed. This sample is mounted on the ceiling of a 25-foot-long tunnel-like apparatus called the *Steiner Tunnel*. A flame is applied at one end with a consistent draft blown through the tunnel. The distance the flame spreads before going out is measured and used to determine the *flame spread rating*. At the same time, a photo-electric cell at the opposite end of the tunnel measures the smoke that develops to determine the *smoke development rating*. The ratings are determined by comparing the measurements with two common materials: glass reinforced cement board, which is given a rating of zero, and red oak flooring, which is given a rating of 100. Materials that have lower flame spread ratings mean that the flame does not spread too quickly; therefore they allow people more time to evacuate and are given a higher rating. Materials that have higher ratings for smoke development will not allow enough visibility for occupants to get out. Both ratings must be acceptable for the product to earn a Class A, B, or C rating, with Class A being the best.

- **Radiant Panel Test** The *Radiant Panel Test* is used to evaluate flooring materials, including carpet, hardwood, and resilient flooring. Flooring is not generally a contributing factor in fires, but if the material is used in a means of egress it must be tested. A sample of the entire flooring assembly, including pad if it is to be used, is adhered to a substrate and placed on the bottom of the test chamber. The flooring is preheated with a radiant panel set at a 30-degree angle from the flooring, and then the flooring is exposed to a gas burner. If the flame ignites the flooring, the distance of the charred mark is measured when the flame goes out, and the radiant heat energy at the extent of the burned area is measured. The formula for determining the result is called *critical radiant flux*. Flooring materials are rated Class I, most flame resistant, and Class II, less flame resistant.

- **Methenamine Tablet Test** Since 1971, all carpets sold in the United States have had to pass the *Methenamine Tablet Test* or the "pill test." Carpet in a chamber is covered with a metal plate with an 8-inch circle cut out of the middle. The methenamine pill, replicating a slow-burning cigarette, is placed in the center of the circle, on the carpet. The pill ignites the carpet, and when it extinguishes itself, the distance from the burn to the edge of the metal is measured. If the burn extends to within an inch of the metal, the carpet fails. All carpets and large rugs that do not pass this test are labeled flammable.

- **Room Corner Test** Carpets or carpet-like looped textiles that are used on a wall as well as expanded vinyl wallcoverings are tested using a *Room Corner Test*. This test uses a full-sized room, with the wallcovering applied partially to two walls. A flame source is placed in the corner of the room that has wallcovering attached. The wall is exposed to flame at two different heat levels. If the wallcovering ignites, the height of the burn is measured. A duct outside the room collects and measures concentrations of gasses, as well as smoke velocity and temperature. The Room Corner Test measures the distance the flame travels, flashover potential, and smoke produced. Nontextile wallcoverings and ceiling material are tested in a similar fashion.

(continued)

- **Vertical Flame Test (NFPA 701)** Vertical treatments that are exposed to air on both sides include curtains, draperies, window shades, and wall hangings. There are two versions of the test: one used for single or multilayered, lighter-weight hangings and the other used for heavier fabrics that may have vinyl coatings, plastic films, awnings, or banners as well as large drapery with multiple folds and layers.

 The first test takes place in a chamber in which the fabric is hung from a rod and ignited by a gas burner placed at a lower edge. If any part of the fabric falls to the floor while burning, it must extinguish itself within two seconds. When the fabric no longer burns, it is weighed. The fabric fails the test if it loses more than 40 percent of its weight.

 The second test uses a larger chamber and allows some fabrics to be tested flat. The fabric must extinguish itself within two seconds, and then the char is measured to determine if the fabric passes.

Regardless of the format, the content of the specifications may be structured in different ways depending on the requirements of the owner and designer. *Proprietary specifications* are *closed specifications*. Proprietary specifications describe a specific product, listing the name of the manufacturer, the product name, number, color, and perhaps quantity. If there are several bidders who can provide a price for the same product, this method is the best way to ensure that the owner will get the desired product. If there are not enough bidders, an "or equal" clause will allow others to bid, but the burden often falls to the designer to determine if a product is indeed "equal." *Open specifications* are designed to allow more suppliers to submit bids to provide the product. A *performance specification* is a kind of open specification that does not list the manufacturer's name, but requires the bidder to submit proof that the product meets the performance criteria established by the designer. A *descriptive specification* is similar, but focuses on providing a very detailed description of the product. The bidder must provide a product that meets that description. The designer must determine if the submitted products do in fact meet the description. Often the desired manufacturer's specification information is used to write either the performance specification or the descriptive specification. A *reference specification* requires that the product meet certain testing standards (ANSI or ASTM). For example, a stained concrete floor is a type of construction that may be specified using this method because meeting the standards for materials and workmanship is more important than providing a specific product.

Content of a Typical Specification Section

PART I: GENERAL

Summary of this section

List of related documents

Requirement for submittals such as product data, shop drawings, samples, or mockups

Requirements for LEED submittals if applicable

Quality assurance: performance requirements, code requirements, qualifications of fabricators and/or installers

Conditions of the site

Delivery, storage, and handling requirements

Requirements for providing extra materials to the owner

Requirements for closeout documents such as *record drawings*, referred to as "as-built drawings," warranty manuals, and maintenance data

PART II: PRODUCTS

Detailed and complete description of products covered in this section

If not covered in Part I, this section may also include

Quality assurance: fabricator qualifications

Requirement for a pre-installation conference

Performance standards such as acoustical standards

Life safety standards such as fire performance data

PART III: EXECUTION

Examination of site conditions

Requirement for preparation to install a product: delivery, storage, and handling

Installation instructions

Requirements for protecting the site and keeping the site clean

summary

Interior designers select finishes for a space based on evaluation of function, aesthetics, and quality, with the goal of designing a space that is a *cohesive whole*. However, interior designers must also understand the context in which they design: the building itself and its construction. They must be socially responsible, which includes an awareness of the impact their actions have on the environment, and of the impact on the lives of people who will live and work in the spaces they design. Interior designers must also understand the legal responsibilities they have as professionals, to meet code requirements and to design buildings that meet the needs of all the occupants. Finally, interior designers must clearly communicate their design decisions to the client, codes officials, and the builder, using both drawings and specifications as tools.

How do you find out what you need to know? People are great resources. Manufacturers' representatives are available to provide product literature, assistance in writing specifications, and help if problems with the material or product arise. Staff working at showrooms and for distributors can be helpful as well. Manufacturers' literature is available, and most of the information found in printed literature can be found on websites. There are professional societies and organizations related to each type of material. These organizations have websites with technical information about the product as well as contact information for people who can answer questions. However, the interior designer must be aware that all these people have the goal of promoting or selling their product. Interior designers must always use their own filter of knowledge to analyze the information, especially if their resource is the Internet.

In addition to using this textbook as a resource, interior designers should read and keep other textbooks that focus in more detail on topics such as textiles, building construction, building codes, human factors, and sustainability. Effective interior designers will develop a library of reference materials, including copies of their local building codes. These references will serve designers throughout their professional lives.

To find out more about the topics discussed in this chapter, the following websites can be useful:

American National Standards Institute: www.ansi.org

American Society of Testing and Materials: www.astm.org/

Americans with Disabilities Act homepage: www.ada.gov/

Architecture 2030: http://architecture2030.org/

CIDA: www.acredit-id.org

CSI Masterspec: www.masterspec.com/

Floorscore: www.scscertified.com/gbc/floorscore.php

Greenguard: www.greenguard.org

Greenseal: www.greenseal.org

International Organization for Standardization: www.iso.org

National Fire Protection Association: www.nfpa.org

NCIDQ: www.ncidq.org

Underwriters' Laboratory: www.ul.com

United States Green Building Council: www.usgbc.org

The following books will also be useful:

Harmen, Susan Koomen, and Katherine E. Kennon. *The Codes Guidebook for Interiors.* New York: John Wiley and Sons, 2011.

McDonough, William, and Michael Braungart. *Cradle to Cradle: Remaking the Way We Make Things.* New York: North Point Press, 2002.

Mendler, Sandra, William Odell, and Mary Ann Lazzarus. *The HOK Guidebook for Sustainable Design.* New York: John Wiley and Sons, 2006.

GO GREEN Life Cycle Assessment: Evaluating the Material or Product

Selecting a material to be used in an interior is a complex process. Materials are selected for their aesthetic appeal and their contribution to a cohesive design, but they must also meet code requirements and sustainability requirements. The appropriateness of the product for the project may also be a factor of both initial and life cycle cost. The following list describes all the criteria that must be weighed when preparing a life cycle assessment of the product, with an emphasis on the environmental impact of the product. Use it as a checklist when evaluating materials and products.

Source of the Material or Product

- Is the material made from a resource that is easily renewed or replaced?

 Examples:
 Glass is made from sand, a plentiful resource. Wool fiber is obtained from sheep. The sheep's coat is sheared and the hair grows back.

- Where does the raw material come from?
- What is the impact of mining, or harvesting, the raw material on human health and the environment?
- Is the product recycled or made from recycled materials?

Environmental Impact of the Manufacturing Process

- Is air pollution a by-product of production?
- When the product is converted from its natural state to a usable finish material, how much energy is used?

 Example: Plastic production may use less energy and have less waste than the conversion of cotton fiber to a usable product.

- When the product is produced, how much energy and water is used to process, manufacture, and package the material or product?
- Are there toxic by-products from the manufacturing process?
- Does the production of the material or product waste large amounts of natural resources?

 Example: A large amount of water is used in the production of cotton.

- How much waste is produced?

Transportation or Distribution

- Is the product produced locally (with 100 miles) or regionally (within 500 miles)?
- What is the cost to transport the product?

Product Installation

- Does installing the product require additional products, such as adhesives, that have a negative environmental impact?

Product Performance and Useful Life

- Does the product function as intended?
- What is the long-term aesthetic durability of the product?
- Does it "ugly out" before wearing out?

- Is the product durable?
- Does it have a long useful life?
- How does the product affect the consumption of energy in the building?
- What is the effect of the product on indoor air quality?
- Does the product emit harmful gasses or fumes after installation?

Cleaning and Maintaining

- Is the product easy to maintain?
- Can the product be cleaned?
- What is the environmental impact of cleaning the product?
- What is the environmental impact of cleaning agents?

End of Useful Life

- When the product's useful life is over, can it **biodegrade**, going back to its natural state, or become compost?

 Example: Products made from materials such as wood fiber will eventually return to soil if allowed to degrade naturally.

Recycling

- After the product's useful life has ended, can it be recycled?
- Can it be remade into the same product?
- Is it made into a less valuable product?
- Can it be recycled again?

review questions

1. Explain the purpose of a thermal envelope.
2. Identify the organizations that assess sustainability and describe how they assess it.
3. Describe how codes protect the public.
4. Compare and contrast the different tests for flame resistance of interior finish products.

glossary

The Americans with Disabilities Act is a federal civil rights law ensuring that people with disabilities have equal access to places of employment, state and local government services, public transportation, public accommodations, and commercial facilities and communication services.

Assembly is a term relating to construction that refers to the components of a structure, wall, or enclosure, combined and rated as a unit for code purposes.

Building codes are regulations that help protect the health, safety, and welfare of the occupants by setting minimum standards for construction materials and methods, as well as setting standards for design and construction that protect the building occupants from hazardous conditions.

Building construction type is based on the level of combustibility of the materials used to construct the building, both exterior and interior, and is used to determine the allowable height and floor area of the building as well as the type of materials that can be used to construct interior components of the building.

CIDA refers to Council for Interior Design Accreditation, the body that ensures the quality of college- and university-level interior design programs by accreditation.

Contract documents include construction drawings and specifications, which are legal documents that communicate the design of a space or building so the project can be priced, permitted, and built.

Element in this text refers to the structural and nonstructural components that make up a building. These structural and nonstructural building elements are composed of *materials* such as wood, metal, concrete, stone and brick. The *finish* is the final layer of material, usually applied to the surface of a construction material.

Embodied energy is a system of measuring the amount of non-renewable energy used throughout the life cycle of a material. The embodied energy of a material measures indirect, direct, and recurring energy used.

LEED is the acronym for Leadership in Energy and Environmental Design. The United States Green Building Council (USGBC) has established LEED standards to certify the sustainability of buildings, interiors, and neighborhoods.

NCIDQ is the abbreviation for National Council for Interior Design Qualification. The NCIDQ issues professional certificates to interior designers who have proven their competency by passing the organization's qualifying examination.

Occupant load is determined by dividing the size of the space in square feet by the number of occupants allowed per square foot. Building codes use the occupant load to determine requirements for design, including the number of exits, width of exitways, exit access corridor construction, and number of plumbing fixtures.

Occupant type is based on the risk associated with a specific type of use that is used by building codes to determine an allowable number of people that can safely occupy a building or space within a building.

Properties of a material refer to the physical characteristics of the material. These characteristics will determine how the material will perform in a given application.

Specifications are the written portion of the contract documents that describe the material or the product to be used, the quality of the product or material, and the installation or construction methods to be used.

Substrate is the material that supports another material or finish.

Sustainable design means designing to meet the social, economic, and environmental needs of present users without compromising the ability of future generations to meet their own needs.

Thermal envelope is used to describe the enclosing system that protects the interior of a building

Volatile organic compounds are chemicals present in some materials that emit irritating or toxic gasses in an interior.

Zoning ordinances are locally created regulations that are used to control the type of development that may occur in a defined area or zone.

Metals

learning objectives

When you complete this chapter, you should be able to:

1. Recognize terms used when discussing metals.
2. Identify common uses of metal in an interior.
3. Summarize the history of metal use in interiors.
4. Describe how metals are produced.
5. Describe how metals meet code requirements for interior use.
6. Describe and analyze the physical characteristics and properties of metal for a specific interior use.
7. Analyze the environmental impact of using metal.
8. Evaluate how well metal products will meet the specific needs of a design project.

Awareness: An Overview

DESCRIPTION AND COMMON USES

Manufactured to the precise standards made possible by modern industry, products made of metal are ubiquitous in twenty-first-century building construction. Metals are appreciated for their smoothness, shine, and perfection. However, metal products are made of natural materials that weather as they age and are exposed to atmospheric conditions. Thus, metals are also valued for the patina that can occur over time.

Three-fourths of all known chemical elements are metals, which are mostly found in mineral-bearing substances or **ores**. Ores containing iron produce **ferrous** metals: cast iron, wrought iron, steel, and stainless steel. Nonferrous metals used in architecture include aluminum, copper, chromium, zinc, nickel, tin, and lead. When two or more metals are combined in their molten state or another material is added to molten metal to change or improve the properties of that metal, an **alloy** is formed. Metals primarily used as alloys include tin, magnesium, and manganese. Some common metals are actually alloys: **Bronze** is an alloy of copper and tin, and **brass** is an alloy of copper and zinc.

Every system that makes up a building uses metal for components of its construction. The structural system may be composed of structural steel beams, girders, and columns or lighter-weight steel joists and studs. The building envelope is protected with metal flashing, metal scuppers, gutters and downspouts, and often metal roofing materials. Equipment for the mechanical, electrical, and plumbing systems is constructed using metal. Ductwork, plumbing pipes, electrical wiring, and conduit are made of metals. The interface between

The Central Light Court of the Rookery Building in Chicago, Illinois, with cast and wrought iron in structural elements and staircase. Designed by architects Burnham and Root in 1888; modified by Frank Lloyd Wright in 1905.
© Keith Levit / Alamy

the hidden components of the mechanical, electrical, and plumbing systems and the visible interior components such as grilles and diffusers, faucets, and electrical outlets is made of metal. Light fixtures are constructed partially or wholly out of metal. Doors, door frames, and window frames can also be made of metal, as well as door hardware. The examples of metal components used in construction are almost endless. Stairs, elevators, and fireplaces can be made of metal or be surfaced with metal. Kitchen and bathroom appliances, fixtures, cabinets, and countertops can be made of metal or have metal applied to their surfaces. Interior walls can have metal applied in sheet or tile form. Ceilings may consist of metal ceiling grids with metal ceiling tiles. Interior accessory items made of metal include signage, bathroom accessories, and cabinet hardware, and a myriad of specialty and feature items. Even interior and exterior furnishings are often made of metal.

CHARACTERISTICS

All metals share two main characteristics: ductility and malleability. Both are evident in different degrees depending on the metal. **Ductility** means the metal can be permanently drawn out into a long thin wire or thread without breaking. **Malleability** means the metal can be hammered into a shape or form or formed by pressure from rollers. Metals are good conductors of electricity and tend to be thermally conductive as well. They heat quickly, but also cool quickly, and are usually cool to the touch. Metals can be shiny or matte, depending on the type of metal and the surface treatment, but in general they tend to reflect light, giving them their characteristic luster. Metals also reflect sound, and can contribute to the acoustical liveliness of a space. Most metals have a protective layer of oxide, but will corrode or rust when exposed to atmospheric moisture or slowly develop a **patina**, the greenish film that develops over time on the surface of metals such as bronze and copper. Corrosion can be consistent across the surface or it may be localized, which results in pitting. Because it is a natural material, metal will move or undergo dimensional changes when subject to variations in temperature.

ENVIRONMENTAL IMPACT

The mining and production of metal consumes energy, creates waste materials, and emits greenhouse gases. Ore deposits take many thousands of years to develop, so for all practical purposes, ore is a nonrenewable natural resource. Mining ore can be destructive to the environment, disturbing the land and disrupting biodiversity. The human cost of mining is high, not only when mining accidents occur but also in incidences of illnesses suffered by miners from exposure to fumes and other conditions in a mine. As with mining, the production methods that turn metal ore into a usable product can have harmful effects on workers. The process of producing metal uses a large quantity of fossil fuels, releasing contaminants into the atmosphere. For example, waste products from copper include arsenic and lead.

The metal production industry is aware of its negative environmental impact, and steps are being taken to mitigate it. Mining companies strive to balance the financial need to mine the maximum amount of ore with the practical need to mine lower grades of ore, getting the most out of a mine so that less area needs to be mined. Better ventilation in mines is one of the improvements that has nearly eradicated black lung disease in workers.

A positive aspect of metal production is recyclability. **Slag** and **cinders**, by-products of iron ore production, are now reused as an aggregate for concrete and in asphalt and cement products. Steel, aluminum, and copper are easily recycled;

Properties of Metal

(sustainable properties are denoted in green)

- Metals have high electrical and thermal conductivity.
- Metals are acoustically reflective.
- Metals have a high light reflectance.
- Metals are malleable (capable of being formed or transformed).
- Metals are ductile (capable of being permanently drawn out without breaking).
- Metals are hard.
- Metals are opaque.
- Metals have the ability to resist repeated stressing.
- Most metals are recyclable.
- By-products of metal production are used to make concrete.

copper and aluminum are 100 percent recyclable without any loss in quality. Because metal products are very durable, they have a long life. Finished metal products do not affect indoor air quality.

The combined total of the energy required to extract, manufacture, ship, and dispose of aluminum over its lifetime results in the highest **embodied energy** of common building products. Alcoa, a major producer of aluminum, acknowledges the environmental impact of its product. To improve the sustainability of aluminum, Alcoa is locating refineries close to mines, incorporating sustainable mining practices, managing water use to preserve and maintain biodiversity connected to water sources, implementing progressive land rehabilitation, reusing waste products such as bauxite residues and **spent pot linings** (the residue that is left when smelting pots reach the end of their useful life), and taking steps to ensure that no valuable aluminum will find its way to landfills. Aluminum can have a positive environmental impact, such as supplying essential nutrients, improving fuel efficiency when vehicles use lightweight aluminum components, and aiding in the increased sustainability of furniture by making components fully recyclable.

When designing a project that is anticipating LEED certification, credits may be achieved in the following categories:

1. *Indoor Air Quality* Metal projects do not contribute negatively to indoor air quality, but plating and finishing processes often use products that release volatile organic compounds. Specify products that are finished by physical methods such as grinding and polishing rather than solvent-based coatings.
2. *Using Recycled Materials* Some aluminum has recycled content or may be entirely recycled. Steel often has a high recycled content. Mixed metal products are often not recyclable.

Perforated Metal as an Interior Screening Device

Metal can be used as a shading device or to cast dramatic shadow patterns. At Johnson County Community College in Overland Park, Kansas, a glass atrium connects the new Nerman Museum of Contemporary Art with the existing Regnier Conference Center. To shade the atrium space, a screen of perforated and corrugated aluminum was used to cover the ceiling and upper walls.

FIGURE 2.1 Atrium Connecting Nerman Museum of Contemporary Art (Kyu Sung Woo, architect) to Regnier Center, Johnson County Community College, Overland Park, Kansas. Photograph courtesy of Timothy Hursley

FIGURE 2.2 Detail of the Sun-Shade in the Regnier Center Atrium. Photograph courtesy of by Roger Reed

Understanding: In-Depth Information

HISTORY OF METALS

Phases of early human development are categorized by the materials used to make weapons and tools: the Stone Age, the Copper Age, the Bronze Age, and the Iron Age. Gold, silver, and copper are easily obtained in their natural state. Gold nuggets, for instance, are found in sand and gravel of river beds. These metals have been put to ornamental and utilitarian use since the Stone Age 6,500 years ago. The Stone Age transformed into the first of the metal ages when humans learned that copper could be made into tools, such as axe heads used in the Balkans in 4000 B.C.E. Eventually, copper was melted and cast into molds and later separated from the chunks of rock that encased the metal using heat, which led to a primitive form of **smelting**, the refining process that separates copper (or other metals) from surrounding ores or minerals. The Copper Age became the Bronze Age when it was discovered that copper mixed with arsenic (and later tin) was superior to cast and wrought copper. True bronze, an arsenic-free copper/tin alloy, was manufactured in the Tigris-Euphrates Delta around 3000 B.C.E. The Bronze Age developments occurred simultaneously in various parts of the world and were also spread throughout the world via trade and migration of people from the Midde East. As the exposed copper ore deposits were depleted, the ores underneath the surface were mined and smelted. A by-product of copper smelting was the realization that iron, then used as a **flux**, was a better material to make tools and weapons than bronze. Thus, the Bronze Age gradually gave way to the Iron Age (1200–1000 B.C.E.). Iron at that time was worked by repeated heating and hot hammering, which separated usable iron from slag (waste material) in a process called **blooming**. The resulting wrought iron, along with other metals, was used for weapons, tools, agricultural implements, coins, and ornaments. The functional use of metal in construction may have first occurred in 100 B.C.E., when the Romans used sheets of lead to form pipes for water systems.

Precious metals such as gold, silver, and copper represented wealth and status and have long been used as ornamentation in architecture and on furnishings. Metals such as copper were applied to doors by the Egyptians who also applied gold and silver to furniture. Islamic cultures made furniture and objects for the interior out of metal. The Baroque period saw metal used as ornamentation and embellishment on furniture and interior surfaces—for example, **ormolu** gilding was done on Louis XIV furniture.

From the sixth century until the Industrial Revolution of the nineteenth century, the developments in **metallurgy** mostly centered on iron: mining improvements, the blast furnace that increased the production capacity for iron (invented by Abraham Darby, 1709), smelting processes, and improvements in fuels. Great Britain was the greatest iron producer in the world. In 1740, the British developed the **crucible** process in 1740, producing low-carbon, ductile steel products by placing bar iron and added materials in clay crucibles heated by **coke** (from coal) fires. The British also developed the **puddling** process that converted high-carbon pig iron from blast furnace into balls that could be shaped or *wrought*.

The Industrial Revolution of the nineteenth century occurred partly because of the technological developments related to iron. Machinery and equipment, factories, trains and other modes of transportation—all required for producing and delivering goods—used iron in their construction. Iron became a major structural material for the framework of train sheds and columns in factories. It was also used

FIGURE 2.3 Ormolu Gilding on Furniture. Photograph courtesy of Hamilton Havers

for bridge building and for market halls and other utilitarian buildings. Nineteenth-century commercial buildings used cast-iron columns and beams protected from burning by masonry. Such columns and beams also allowed larger expanses of glass for storefronts. Pressed tin was often used on the interior, mostly for ceilings, but also on the walls. The pressed tin was a "modern" alternative to decorative plaster, chosen for its durability, ease of maintenance, and cost. Today, these metal elements are preserved in place, salvaged, or reproduced for historic buildings. Significant developments in cast-iron architecture include Joseph Paxton's Crystal Palace (London, 1851) and the world's tallest building at the time, the Eiffel Tower (Paris, 1889).

In 1855 and 1856, Henry Bessemer of the United States developed a process that used a pear-shaped vessel called a *converter*, which later became known as the **Bessemer converter**. It enabled the refining of metal at a lower melting point while keeping the carbon content low. The Bessemer process and other innovations allowed inexpensive production of steel, which rapidly replaced iron. The availability of steel for structural components was a significant factor in the development of tall buildings by the turn of the twentieth century. Examples of early use of steel in architecture include Louis Sullivan's steel-framed, masonry-clad structures in Chicago and Otto Wagner's Austrian Postal Office Savings Bank (1904–1906) with a roof of metal and glass and columns of steel with exposed rivet heads.

Throughout the twentieth century and into the twenty-first century, tall buildings have relied on a structural grid of steel columns, girders, and beams. Steel is cut and drilled in a factory, delivered to the site, and connected with bolts, rivets, and welds. Steel trusses may be used to support roofs. Light-weight steel is made into open web steel joists; indeed, steel studs and joists have become the standard for smaller commercial buildings. Residential construction, although primarily constructed with wood, often incorporates steel as a main floor beam and/or as columns in basements to support the main floor beam.

Bauhaus furniture designers turned to steel for its modern, industrial aesthetic. Tubular and flat steel bars were exposed as the framework for furniture by Bauhaus and international-style architects and designers. Mies van der Rohe and Le Corbusier are among the twentieth-century designers of steel-framed furniture that set a design standard continuing until the present.

Aluminum is as important as steel in buildings and interiors. Because it does not occur naturally on its own, the extraction process of aluminum from ore was initially so expensive that aluminum was more precious than gold or silver. Economical extraction methods have made aluminum available commercially for about 100 years.

FIGURE 2.4 Metal Used in an Interior: Metal Cladding on Columns, Bartle Hall Convention Center, Kansas City, Missouri. Photograph courtesy of Kay Miller Boehr

PRODUCTION: HOW METAL PRODUCTS ARE MADE

Metals begin as ore, which is a concentration of the desired raw metal encased in *host rock* and other materials. Ore is removed from the earth either by surface or underground mining and then converted to raw materials. These raw metals may be combined with other metals before they are formed into usable products.

Mined ore is *smelted*, a process of separating the desired metal from the surrounding host rock, using the heat of a blast furnace and a source of carbon such as coke from coal. This process removes the oxygen from the ore, leaving metal. The coke introduces a small amount of carbon into steel. **Pig iron** is a direct product of the blast furnace, which then either is refined to produce steel, wrought iron, or **ingot iron**, or is melted again into special shapes.

Metal ingots must be shaped to create finished products by **working**. Working brings metal to its desired shape but also changes its properties, refining its crystalline structure. Worked metal can be either wrought or cast. *Wrought* metals begin with the solid molded shape of an ingot that is formed into its final shape by either hot or cold working. *Hot working* simply means that metals are heated to a temperature that is above the melting point of metal before being worked. *Cold working* methods keep the metal just below the melting point. Wrought, or *worked,* metals can be rolled, pressed, forged, stamped, drawn, or extruded.

Enough softening occurs with hot-working methods for metals to recrystallize. The mechanical process of working metal deforms it in such a way that the coarse crystallinity of its ingot-cast state becomes progressively fragmented and rearranged so the crystalline structure is refined, creating a smooth, dense product. Hot-working methods include pressing into shape between forging dies, or **rolling**, passing the metal through pairs of flat or grooved heavy rollers. Bars, shapes, plates, sheets, and strips are formed by hot rolling.

Cold working occurs at such temperatures and rates that no recrystallization occurs, but the working increases **tensile strength**, the amount of pulling force an object can take before it breaks and decreases ductility. Cold working processes include drawing, extruding, pressing, and stamping. In the **extrusion** process, used most often for aluminum, semi-molten metal is forced through a *die*, which is a mold or shape. This can create continuous shapes, such as window frames. **Cold drawing** is used to make wire or tubing, *drawing* the metal through a series of dies to reduce its cross-sectional area until the final shape is obtained.

In the **casting** process, the final form of the metal is created in a foundry with a mold of the desired shape. Molten metal is poured into the mold and allowed to solidify. The metal shape can then be machined, etched, or carved for design variety. *Sand molds* are prepared from a mixture of moistened sand and clay, packed over a wood or metal mold. Objects cast in sand molds can be solid or hollow. Although sand casting is the traditional casting method, others include plastic mold casting for nonferrous metals, composite mold casting for alloyed aluminum, and investment (lost wax) casting, creating permanent reusable molds. *Die casting* is used for lower-melting-point, nonferrous metals that are forced into the molds under pressure.

Expanded metal is open mesh formed by slitting metal sheets. **Metal mesh fabric** is made by weaving or welding strips or wires of metal into a sheet that ranges from rigid to flexible. **Perforated metal sheets** have holes in various shapes and sizes that are stamped out of the sheet of metal. **Industrial steel plates** have pressed or stamped raised patterns.

GALVANIC ACTION

Galvanic **corrosion** occurs when an electrical current flows through a liquid between two dissimilar metals. One metal will be corroded and the other will become plated. Metals are ranked from the most *noble* (unlikely to be affected by **galvanic action**) to less noble. Noble metals include gold, platinum, stainless steel, and silver, which will not corrode. The less noble metals, such as iron, steel, and zinc, will corrode when they come in contact with more noble metals. To avoid galvanic corrosion, a nonabsorbent material must be placed between the two metals at the point of contact. Fasteners must be carefully chosen to avoid

FIGURE 2.5 **Expanded Metal.** Zlatko Guzmic /Shutterstock

FIGURE 2.6 **Metal Mesh.** Serg64/Shutterstock

FIGURE 2.7 **Perforated Metal.** Yuri Samsonov/Shutterstock

FIGURE 2.8 **Industrial Steel Plates Used for Stairs.** Reinhold Leitner/Shutterstock

contact between dissimilar metals. In addition to galvanic corrosion caused by metal-to-metal contact, nonferrous metals such as zinc, aluminum, and lead may corrode when they are either embedded or in surface contact with concrete due to the presence of moisture and the alkalinity of fresh concrete or mortar.

METAL SHAPES USED IN CONSTRUCTION

When used for components of building structure, steel is produced in several standard **metal shapes**. I-beams are designed to place the material where most of the strength is needed, with flanges at the top and bottom, and a thin connecting element, thus the standard "I"

shape. A "W" shape refers to a wide flange. Other shapes used in construction include C-shapes, angles, T-shapes, solid bars, and hollow tubes. Bars and tubes can be square, rectangular, or round. Steel studs, used as structural components of walls as well as to construct interior partition walls, are C-shaped or U-shaped.

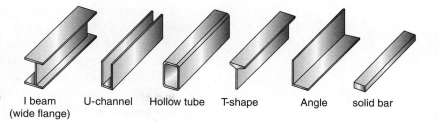

I beam (wide flange) U-channel Hollow tube T-shape Angle solid bar

FIGURE 2.9 Metal Shapes.

Sheets of steel may be thicker *plates,* either flat or with raised diamond or cross patterns. Thin **sheet metal** (steel or other metals) is used when flexibility is important, such as for flashing or applied to surfaces as roofing material or walls. Metal floor and roof decking is made from sheet steel bent or corrugated to add strength. Thinner sheets of expensive or more precious metals may be laminated to a substrate with adhesives.

Slotted and expanded sheet metal is used for lath with plaster, and for grilles and other objects. Expanded metal is formed by slitting the metal sheet with the resulting diamond-shaped openings. Perforated metal has openings punched in the steel plate.

Metal can be made into *welded wire fabric*, with a variety of sizes and uses, including reinforcement for concrete or for fences. Smaller mesh *hardware cloth* has utility uses, including window screens. Heavy rope can be made of twisted strands of metal around a core.

Metal pieces are connected by **welding**, which combines two metals by melting pieces at high temperatures, then adding a filler. The *weld puddle* hardens to form the joint. **Brazing** uses heat to join brass or bronze, and **soldering** seals joints at a lower temperature. *Sweating* is the term used for soldering copper pipes. **Mechanical fasteners** include bolts and rivets.

TYPES OF METAL: FERROUS METALS

Iron

Iron (ferrous oxide), relatively inexpensive and naturally silver-white in color, is soft, malleable, ductile, and magnetic. When exposed to acids, it corrodes. All iron has some degree of carbon, introduced in the smelting process, which increases its strength and hardness, but reduces its ductility and ability to be welded. The two types of iron are cast iron and wrought iron, both briefly discussed earlier in the chapter.

Cast iron is an alloy of iron with 2 to 4.5 percent carbon and 1 to 4 percent silicon. The molten iron is cast into a mold, and then machined to make building products. Cast iron is hard and long wearing but brittle. It has low tensile strength and is not malleable. The development of cast iron in architecture was essential to the success of the Industrial Revolution. The epitome of cast-iron construction occurred when it was already being replaced by steel and concrete: the Eiffel Tower. Modern uses of cast iron include hardware, stairs, ornamental railings, and decorative garden furniture. Cast iron may also be used for plumbing waste pipes.

Wrought iron contains less than 4.3 percent of carbon, but usually 1 or 2 percent, along with 1 to 2 percent slag. Wrought iron is made directly from ore using the puddling method, in which pig iron is subjected to heat while being frequently stirred in a reverberating furnace in the presence of oxidizing substances. Wrought iron is tough but malleable, and relatively soft. Because wrought iron is easily forged and welded, it is used for cabinet and decorative hardware, gates, outdoor furnishings, railings, fences, screens, and ornamental work, including light fixtures and curtain rods.

Steel

Steel has less carbon than cast iron and more carbon than wrought iron. Steel is strong, hard, and elastic, and is relatively inexpensive. Carbon steel is unalloyed, containing limited amounts of residual carbon from the smelting process. It can be categorized as mild (soft), medium, and hard. The hardest steel is spring steel. Alloys of steel with other metals have been developed for specific performance requirements. An example of a steel alloy is tungsten steel, with

10 to 20 percent tungsten added to increase hardness and heat resistance. Steel is the most common material used for framing of high-rise construction; it is the primary method of reinforcing concrete. Steel is also used for fasteners, welded fabrications, wall grilles, and ceiling suspension systems. Steel must be coated or painted to avoid corrosion or rust. Weathering steel, with the trade name *Cor-ten*, was developed using a surface alloy that allowed intentional rusting. Once the metal is completely coated with rust, it is protected from further rust. This eliminates the need for painting. Generally used on an exterior, pre-weathered steel must be used carefully to avoid rust damaging other surfaces, although newer weathered steel products are less likely to stain.

Stainless Steel

Stainless steel is very strong and resistant to rusting. It is an alloy of steel and chromium. The chromium forms a transparent film on the surface, protecting it from oxidation and rust. Stainless steel is the preferred material for use in damp locations, having a high resistance to corrosion. In addition, stainless steel does not stain adjacent surfaces and does not react with mortar or concrete. Although stainless steel is expensive (five times the cost of carbon steel), it is durable. It may be polished or unpolished or have a brushed surface that gives it a satin finish. Stainless steel has long been the standard for commercial kitchen furniture because it provides a hygienic surface, and it has become a popular material to face appliances in residential applications. Stainless steel sheets are used as countertops, column covers, and wall panels. It is also used for hardware, fasteners and anchors, railings, furniture and accessories, and light fixtures. Additionally, stainless steel is used for commercial and residential bathroom accessories. High-luster stainless steel shows fingerprints and must be carefully cleaned.

TYPES OF METAL: NONFERROUS METALS

Aluminum

Aluminum is abundant in rocks, gemstones, and soil, but it does not occur in nature in its metallic form. Rather, aluminum is derived from the ore *bauxite*. Aluminum is an excellent thermal and electrical conductor. It is lightweight and strong, but also ductile, malleable, soft, and flexible. This makes aluminum easy to fabricate, although it is not easily welded or heat treated.

Aluminum develops a thin oxide coating or corrosive layer that does not provide adequate protection, so it must be treated or painted. A common option for treating aluminum is anodizing, an electrostatic process that thickens the coating. Anodized aluminum may be clear, maintaining its natural silvery white color, or it can be dyed as series of colors ranging from bronze to black. Aluminum may also be painted, usually with a factory-applied electrostatic or powder coat, or it may be painted on site. Aluminum is easily recyclable and resists rusting, but it should not come in contact with concrete and masonry. Aluminum alloys can be hard, light, and stronger than structural steel. It may be alloyed with copper to create aluminum bronze.

Most aluminum used in architecture is *extruded*, squeezed through a die to create continuous shapes or sections, or used in sheet form. Extruded aluminum sections are used for door and window frames, as well as framing for exterior glazing systems (storefronts), light fixtures, and exterior cladding. It may also be die cast into large shapes, mold cast, or sand cast. Aluminum composite panels can be used for exterior cladding, and curtain walls or sheet aluminum may be used for siding. The metal is used for flashing, and can be used for electrical wiring. Aluminum has many uses in an interior, including furniture, light fixtures, signage, and the horizontal louvers in blinds. Pressure cast aluminum is used as a substitute for cast iron for interior and exterior products, including lighting, handrails, brackets, and hooks. The metal will most likely be painted for these functions.

Copper

Because *copper* is found in nature in a free metallic form, it was easy to retrieve and work with in the Copper Age. The word *copper* is from the Latin word meaning "metal from

Cyprus," *cuprum*, shortened from "cyprium." Copper is easily fabricated and has high ductility and malleability. Its high thermal and electrical conductivity make it ideal for electrical wiring. It is also commonly used for water supply pipes. Copper resists alkaline chemicals, so it can be used in contact with masonry. On the exterior of a building, copper is used for roofing, gutters, and downspouts. On an exterior, copper should be used with copper or brass fittings. On an interior, in addition to its use for water pipes and electrical wiring, copper is used for hardware, range or fireplace hoods, bar or kitchen counters, sinks, and decorative accessories. Copper is generally corrosion resistant, but it weathers from brown to green unless treated. The final stage of weathering is a *verdigris* patina that will continue to protect the metal indefinitely. The original color can be restored by polishing or it can be preserved at any desired stage by applying a transparent coating. For interior finishes, copper can be treated in several ways:

- Polish copper regularly to maintain shine.
- Allow copper to develop its patina naturally.
- Artificially age copper to the desired stage; maintain the stage with a lacquer finish.

Lead

Lead rarely occurs by itself in nature; rather, it must be extracted from copper, zinc, or silver ore, or the mineral galena, which is 87 percent lead. Lead is soft, heavy, and dense, and is corrosion resistant. Its bluish white color tarnishes to a dull gray. Lead, which is a poor conductor of heat and electricity, is easily worked, has low strength, low elasticity, and a low melting point. In building construction, lead is used in sheets for roofing and flashing, as well as for waterproofing. Lead sheets are also used for sound and vibration isolation and radiation shields. From the time of the ancient Romans until the 1970s, lead was used in plumbing pipes. Lead is part of the alloy that makes pewter. Until the 1970s, lead was an ingredient in paint, but because lead is toxic and can accumulate in the human body, it is no longer used.

Nickel

Nickel is a hard silver-white metal that is also malleable, ductile, and corrosion resistant. It is used as a base for chromium and for plating other metals. Hardware, lighting, and interior accessories made of nickel are good choices for uses in areas that are exposed to humidity and heat. When used to plate solid brass items, nickel protects them from corrosive pitting caused by humidity. Nickel can have a polished or brushed finish.

Titanium

Titanium is light, strong, lustrous, and corrosion resistant. It develops a thin, conductive oxide surface film at high temperature and it resists tarnishing. The process of producing titanium is expensive because it generates a lot of waste. The material is expensive to recycle as well. Titanium is most often used to make personal objects, but has been used as a building cladding.

TYPES OF METAL: ALLOYS

Brass

Brass is an alloy of copper and zinc, and occasionally aluminum is added for strength and corrosion resistance. Brass has a relatively low melting point, so casting is a good method for making brass objects. This metal is valued for its yellow-gold glow, and thus is used for decorative details: trim, hardware, light fixtures, and railings. Untreated brass will lose its shine and develop a brownish hue. The oils from skin will leave prints. There are three choices when finishing interior products made of brass:

- Allow brass to naturally age.
- Regularly polish brass.
- Apply a lacquer coating.

Bronze

Bronze is an alloy of copper plus tin, although other metals or elements can be added. Bronze, like brass, is used for decorative detail. It is strong and weather resistant, hence its use in outdoor sculpture. The pinkish brown cast of this alloy will weather into a deeper brown or greenish brown patina. To heighten the effect of the patina of untreated bronze, specify an oil-rubbed finish, which requires a series of applications of linseed oil, lemon oil, or paraffin. The protective coating of oil-rubbed bronze builds up over time. Bronze may also be lacquered.

Pewter

Pewter was originally an alloy of tin and lead, historically used to make eating utensils before glass became widely available. Due to the health concerns about lead coming in contact with food, most pewter is now lead-free. Pewter is primarily tin (93 to 98 percent) alloyed with a small amount of copper (1 to 2 percent), and the metals antimony and bismuth for added strength. Pewter has a low melting point, and products made of pewter are generally cast into molds. In an interior, pewter is used for cabinet hardware. Builder's hardware, light fixtures, and interior accessory items may have a pewter finish, a dull-gray color, sometimes with black undertones.

TYPES OF METAL: USED PRIMARILY FOR PLATING OR COATING OTHER METALS

Chromium

Chromium is a component of stainless steel; it is a hard metal and usually has a highly polished finished appearance. Chromium also has a high melting point. It is used as a pigment in paint, as chromium salts for tanning leather, and, because it is shiny and protective, it is also used for decorative purposes. In interiors, however, chromium is most often used as plating for other metals. When chromium is used for industrial purposes, this plating is hard, not shiny. All the waste products of industrial chromium are considered toxic carcinogens and are regulated as hazardous materials, but decorative chromium is not toxic and not regulated. The chrome-plating process uses nickel as a base layer.

Tin

Tin is ductile, malleable, and soft. When it is alloyed with copper, it makes bronze. Tin doesn't corrode, so it is used to plate other metals. Tin-coated steel, or *terne plate,* is used for roofing. Pewter is composed primarily of tin.

Zinc

Zinc is a ductile but brittle metal. Because it resists corrosion in both air and water, it is used as a coating for steel or aluminum. *Galvanized* or zinc-coated steel or aluminum has the strength of the base metal with the rust resistance of zinc. Galvanized steel can be welded. Ductwork is made from galvanized steel. Zinc in sheets is used for roofing, flashing, and nails. This metal can also be sand cast or die cast into forms and used for faucets and bathroom hardware. Zinc can be bright or dull, and will weather to a dull patina. Zinc scraps are usually recycled.

ALTERNATE FORMS OF METALS

Powdered metal, especially lead, can be dried, then **sintered** or heated enough that the particles stick together. This sintered metal can be molded to form inexpensive metal products.

TREATMENTS TO IMPROVE THE PROPERTIES OF METALS

Heating and cooling iron in a controlled manner can improve its strength, hardness, and other properties. When iron is *annealed*, it is heated to temperatures just below that which will cause it to recrystallize, making the product more shock resistant. Cast, then annealed, iron can be bent without breaking. This resistance to breaking makes annealed cast iron a good product for the construction of door pulls and closer arms (which are metal attachments that

bring a door back to its closed position). Other treatments include *quenching*, immersing the hot metal in water for quick cooling that increases its hardness, and *tempering*, the reheating of metal at a lower temperature than annealing, then slowly cooling. *Case hardening* is used for steel; *carburization* introduces carbon under conditions of high heat, hardening the outside surface while the inside is still tough but softer.

TREATING AND FINISHING METAL PRODUCTS

Anodizing

Anodizing is primarily used for aluminum, but the process can be used on other nonferrous metals such as titanium. Anodizing is not a coating but an actual thickening of the existing oxide skin on the surface of the metal. The metal to be anodized is immersed in a sulfuric acid solution and an electrical current is passed across the material. Anodizing maintains the ability to be recycled without the need to remove a painted finish. The anodized finish can be clear or have color added through pre-treatment options and dyes. Standard architectural anodized finishes range from clear through a series of bronze tones to black.

Plating

There are several methods of *plating*, a process of adhering a thin layer of decorative or durable metal over a more utilitarian base layer. Common metals applied as plated surfaces include chrome, zinc, and tin, all used to improve the properties of the base metal, such as corrosion resistance, hardness, and durability. Some metals are plated to other metals or surfaces for aesthetic reasons. If gold is plated to metal or glass for decorative purposes, it is called *gilding*. A thin sheet of metal may be applied to another surface using heat and pressure to fuse the two. *Electroplating* is a method of applying a metal coating to an object or surface by negatively charging the object and immersing it into a metal salt solution that contains positively charged metal ions. This electrolytic process is used for brass-, bronze-, or nickel-plated hardware.

Powder coating

Powder coating is a relatively new process (developed in Australia in 1967) of applying dry (powdered) paint to an object. Powder coatings are applied to the object, and then the object is heated so the powder particles melt and form a continuous film. The powder may be electrostatically charged and sprayed onto the object or the object may be immersed in a bed of fluid powder coating. Powder-coated finishes are relatively hard and abrasion resistant. Objects used on the interior will not crack, chip, or peel, as is possible with conventional paint. Powder coating can be solvent free and the overspray can be reclaimed and reused.

Electrostatic coating

For painting metals onsite without overspray, *electrostatic coating* uses a magnetically charged surface to apply paint, wrapping around items such as railings. The coating is polyurethane enamel mixed with a catalyst given a positive charge. The metal object is grounded (given a negative charge). Coatings applied with this method give off strong odors. Electrostatic coating cannot be applied while the space is occupied.

Painting

Metals may be factory painted using one of the previously mentioned techniques or may be field painted. Hollow metal (steel) doors and frames are generally factory primed for site painting.

Lacquering

To avoid the need to constantly polish metal, but to maintain a desired level of shine, metal may be coated with *lacquer*. The coating process begins with buffing or polishing the metal to a *mirror finish* for a product with high gloss. If the product is to have a *satin finish*, the product may be dry-brushed and scoured to dull the surface. The final coating is lacquer, which can be easily maintained under nonhumid conditions.

Application: Using Information Regarding Interior Finish Materials

CODE ISSUES

Steel is the metal generally used to construct buildings, either as structural steel or lightweight steel. Steel is considered a noncombustible material. It will not burn, but under extreme conditions of heat, it will soften and ultimately fail. Thus, for fire-resistant structures, steel columns

Case STUDY *of Metal Used in an Interior*

Stainless Steel

Interior designer Kathy Kaleko chose stainless steel for her kitchen countertops and island, which complement the stainless steel appliances and sink. Stainless steel can withstand the abuses of a family kitchen and can be welded and ground smooth for a seamless installation.

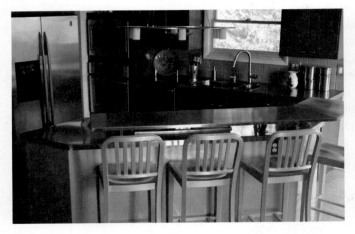

FIGURE 2.10 Extensive Use of Stainless Steel in the Kaleko Residence Kitchen. Photograph courtesy of George Lu

FIGURE 2.11 Stainless Steel Kitchen Island in Kaleko Residence. Photograph courtesy of George Lu

FIGURE 2.12 Stainless Steel Countertop Blends with Stainless Steel Sink and Appliances. Photograph courtesy of George Lu

and beams must be protected—either by covering with concrete or masonry, encasing in layers of ⅝-inch Type X (fire-resistant) gypsum wallboard, or by coating exposed steel with a minimum thickness sprayed on fire- proofing material. Steel reinforcing must have a concrete covering.

Fire-rated walls (partitions that are used as exit corridors, or as separation between dwelling units and guest rooms, or for separation of tenants) may be constructed as an assembly of steel studs and fire-resistant gypsum wallboard for the required rating that allows time for occupants to leave the building. Openings in fire-rated walls must be constructed of time-rated assemblies. Hollow metal is often used for rated doors and will have a permanent label affixed by the manufacturer. Hollow metal is used for fire-resistant door frame assemblies.

SPECIFYING

When specifying a metal product, interior designers must be aware of the changes that will occur in various metals when they are exposed to atmospheric conditions, moisture, and other agents. Some interior spaces, such as kitchens and bathrooms, have high humidity or conditions of heat and moisture that affect the surface of the metal. For example, lacquered brass light fixtures will retain their shine under nonhumid conditions, but will eventually "pit" when used in high-humidity locations. In this case, a metal that resists corrosion—such as polished nickel, stainless steel, or polished chrome—may be a better choice than lacquered brass.

The United States Department of Commerce's National Bureau of Standards developed product standards for metal finishes, expressed as "US" numbers; for instance, US26D refers to Satin Chromium, plated. Recently the standards have been revised by the Builder's Hardware Manufacturers Association. The new numbering systems use numbers in the 600 range, so US26D is now "626." Finishes are organized by the base metal (aluminum, brass, bronze, stainless steel, and steel) and the surface finish. Interior designers can use the standard numbers to specify coordinated finishes for hardware and accessories.

The following CSI Masterformat divisions have sections that assist in specifying metal products.

Division 05: Metals

Basic Metal Materials and Methods

Structural Metal Framing

Metal Joists

Metal Deck

Cold-Formed Metal Framing

Metal Fabrications

Ornamental Metal

Expansion Control

Metal Restoration and Cleaning

Division 08: Doors and Windows

Metal Doors and Frames

Specialty Doors

Entrances and Storefronts

Windows

Skylights

Hardware

Division 09: Finishes

Metal Support Assemblies

Metals Used in an Interior

Floors
Industrial diamond steel plates on stair landings or catwalks

Walls
Metal studs: used to construct interior partitions
Metals as a finish material applied to walls
 Sheet steel
Column covers
Metal panels, sheets, or tiles for decorative and durable wall
 surfaces
Perforated metal, expanded metal, or metal mesh to allow the
 filtering and/or manipulation of light and shadow patterns
 through the metal

Ceilings
Exposed structure, pipes, and ductwork
Grid for lay-in ceiling tiles
Ceiling tiles and panels

Special Construction
Stairs and their components
 Steel pan stairs
 Spiral stairs
Handrails and guardrails
Elevators: stainless steel applied to doors and walls for durability

Doors and Windows
Steel and aluminum window frames
Hollow metal steel doors
Hollow metal door frames
Metal cladding on sliding doors
Overhead rolling doors or security grilles

Kitchen and Bath
Cabinets
Countertops and backsplashes
Appliances
Sinks and faucets
Range hoods
Cabinet hardware and accessories
Plumbing fixtures
Lavatories and tubs
Faucets
Bathroom accessories:
 Towel bars, grab bars, toilet roll holders, as well as commercial
 products such as paper towel and soap dispensers

Hardware and Accessories
Builders' hardware
Cabinet hardware
Functional and decorative items such as hooks, shelf brackets,
 and drapery rods
Metal fasteners
 Rivets, screws, nuts, and bolts

Signage

Light Fixtures
Egg crate grid for 2 x 4 or 2 x 2 fluorescent fixtures
Light fixture housing

Mechanical, Electrical, and Plumbing Materials
Plumbing pipes
Ductwork
 Exposed ductwork
 Spiral ducts
 Painted or unpainted

(continued)

MAINTENANCE

Metal finishes can be delicate and must be treated carefully. Strong cleaners may damage the finish, so a cleaner should be tested in an inconspicuous place before applying to the entire surface. Always use a clean cloth or sponge and apply cleaner to the cloth, not the surface.

In addition to atmospheric conditions causing metals to change, metals used on an interior are subject to discoloration caused by contact with skin and other contaminants. It is important to properly clean metals to avoid damaging the surface or protective coatings.

Stainless steel surfaces can be pre-cleaned to remove initial spots such as grease and fingerprints. An acetone or alcohol solvent can remove spots. The entire surface should be cleaned with a damp (not dripping) cloth dipped in soapy water, wiped in a swirl pattern and changed often. After thorough rinsing and drying, a stainless steel cleaner (sprayed on the cloth, not the surface) will protect the surface. The surface can then be maintained with a vinegar-based window cleaner or citrus-based biodegradable cleaner.

When caring for copper, use polishes with care. If the copper patina is developing unevenly, sponge-clean with phosphoric and nitric acid in water. Use a sponge soaked in sodium bicarbonate to remove the staining. Use ammonium oxalate as a second neutralizer. Follow up with mineral spirits on a clean cloth using parallel strokes. Apply carnauba wax as a coating; it will wear off, but it will allow the patina to spread uniformly.

LIFE CYCLE COSTS

The choice of metal for a given product may be limited by the manufacturer's available selections. Cost may be a factor in choosing metal products. For instance, aluminum that is die cast into large shapes is often less expensive than cast iron or other metals. Smaller shapes of aluminum may be more expensive than other metals. Steel is less expensive than cast iron for builders' hardware. Although the cost of metals is subject to fluctuation, a 2011 comparison of metals of similar thicknesses without specialty finishes indicated that the most expensive metal was copper, followed by stainless steel, zinc, aluminum, and galvanized steel. When used for builders' hardware, steel is stronger than iron at a lower cost. Cast aluminum hardware is a less expensive alternative for cast iron.

All metals are durable, but metals made of cast or wrought iron with appropriate finishes, as well as objects made of solid materials such as brass with chrome plating, will have the longest life.

APPLYING METALS IN AN INTERIOR

Since metal is used throughout an interior space, the interior designer must make a series of interrelated decisions when choosing metal products for a project. Good attention to detail means coordinating the appearance of all metal products and

components of an interior, so selecting metals for their consistent appearance (aesthetics) as well as their functional performance should guide decision making.

Metal sheathing and conduit for electrical wiring
Visible interface between mechanical and electrical supply and the interior:
 Grilles and diffusers
 Convectors
 Metal junction boxes and cover plates
 Switches and outlets
 Louvers

Floors

The need for slip resistance makes metal floors impractical in most situations; therefore, metal is rarely used as a flooring material. Industrial diamond pattern steel sheets are sometimes found in floors of industrial buildings and may be reused in designing new spaces within older industrial buildings. Metal grating used for industrial stair treads may also be used on landings and adjacent surfaces.

Some manufacturing facilities or scientific research laboratories require environments that control contaminants as much as possible. These controlled environments are called *cleanrooms* and sometimes they require seamless metal floors, which is an expensive solution due to the skilled labor involved in installation.

Walls

Walls may be clad in metal for protective durability, or to take advantage of the magnetic properties of metal. Decorative metal panels may be used as a feature wall. Metal panels used on the exterior of a building are often continued into the lobby or other interior spaces to create a cohesive transition from the exterior to the interior. Types of metal panels that may be used on both the interior and the exterior include a composite material that sandwiches a layer of polyethylene plastic or nonaluminum core between two sheets of aluminum, or between various sheet metals. Panels generally used for ceilings, such as pressed tin or linear ceiling tiles, can also be applied to walls. Also, light shelves or interior shading devices of metal may be attached to walls to either reflect light further into the interior space or to screen and control the amount of light and heat entering the space.

Galvanized metal panels may be applied in conference areas and used as magnet boards. Perforated metal backed with fabric-covered tackable material allows attaching through the perforations or attaching items with magnets.

Ceilings

The "pressed tin" ceiling tiles of the nineteenth century are still made and used today by the W. F. Norman Company in Nevada, Missouri. The tiles are panels made of pressed sheet steel that can be painted or plated with other metals. The company also makes moldings, cornices, siding, and roofing of galvanized steel and copper.

The most common ceilings used in commercial applications are suspended ceilings. Various types of ceiling tiles are supported by a grid of painted steel channels hung with wires from the structure above. This metal grid supports a variety of types of ceiling tiles. Among the options for ceiling tiles are those made of metal. Metal ceiling tiles are used in areas that require soil resistance and the need to clean by washing and scrubbing. Another reason to use metal ceiling panels is the high sound absorption achieved when perforated metal is backed with an acoustical batting material. The panels may also be decorative, designed to mimic nineteenth-century pressed tin; they may have a three-dimensional coffered form, or they may be made of open mesh. Other metal panels made of steel and mounted in suspension systems include linear planks of powder-coated steel. *Integrated ceiling tiles* allow the designer to incorporate lighting, air vents, and other utilities into a suspended metal-tiled ceiling.

Another form of metal ceiling is *exposed steel structure*: open web steel joists and corrugated metal decking. Metal ductwork may be exposed as well. Exposed structure and ductwork may be left in its existing metal state or painted. Exposed structure does not have the acoustical properties of a suspended acoustical tile ceiling. Therefore, the companies that make metal ceiling grids have developed options for the designer that use their suspension systems for *clouds*, *islands*, or *canopies*, including curved, rectangular, or square forms. The systems are suspended in the grid to form floating areas of acoustic absorption. Light fixtures and

HVAC grilles can be incorporated into the system. Specialty items include three-dimensional serpentine or wavy forms that are suspended using metal cables and use either metal panels or panels of other material. These elements can be used as a design element to "define space, accentuate an area, provide focus or create ceiling artwork" (Armstrong Ceilings).

Kitchens and Baths

Residential kitchen cabinets used in the mid-twentieth century were made of metal, with a factory-applied paint finish. Metal kitchen cabinets are still manufactured by high-end European companies such as the German company, Poggenpohl. Metal cabinets may be made of stainless steel, aluminum, and steel with a paint finish. Some cabinets have metal interiors with wood veneer door and drawer fronts.

Stainless steel is used for countertops and work tables in commercial kitchens for hygienic purposes. It may also be used for counters in residential kitchens or in corporate coffee rooms. Stainless steel shows fingerprint smudges and must be carefully cleaned with stainless steel cleaners. Alternate metals that can be used for countertops include zinc and copper, both of which are appreciated for the patina that develops when exposed to moisture and fingerprints.

Kitchen sinks may also be stainless steel. When specifying stainless steel sinks, be sure they are undercoated to absorb sound. Specify a lower gauge number for thicker steel. Copper is used for specialty sinks. Faucets are made of chrome-plated steel, brass, or copper.

Appliances can be porcelain enamel-coated metal, stainless steel, or chrome plated. Range hoods made of metal are often custom-designed and fabricated out of metals such as copper or stainless steel.

Polished nickel was the traditional choice at the end of the nineteenth century for kitchens and bathrooms. Nickel plating of solid brass fixtures makes them less susceptible to humidity pitting. Polished chrome is a modern finish for faucets and accessories that also resists moisture.

Hardware, Light Fixtures and Accessories

Builders' hardware includes all hardware for doors and windows such as hinges, locksets including knobs and lever handles, push plates, panic bars, and items such as doorstops. **Cabinet hardware** includes a variety of types of hinges and knobs and numerous other

FIGURE 2.13 Metal at Los Angeles Police Memorial. Metal sheets have punched-out lettering. Lit from the front, the images cast shadows on the wall behind. Photograph courtesy of Roger Reed

FIGURE 2.14 Perforated Metal on the Exterior Wall of Kauffman Stadium, Kansas City, Missouri. Photograph courtesy of Roger Reed

elements that are used for furniture and cabinetry. Builders' hardware and cabinet hardware items are heavily used and must be durable, thus they are constructed of metal. Metal can be formed to the required precise shapes.

Light fixture housings are generally made of metal. Finish options for hardware and for light fixture components are similar. The metals most often used for hardware and light fixtures are solid brass, bronze, steel, iron, stainless steel, aluminum, and zinc. Metal may also be used as switch plate and electrical outlet covers.

Signage is often made of metal, especially signage to be used on an exterior surface. The surface can have the text engraved or cut out, and the surface can be sandblasted or etched. The metal can have the same range of clear or painted finishes as metals used for other surfaces.

Decorative Uses of Metal

Metal may be used as a custom element on feature items. Perforated metal may be used for its intrinsic decorative characteristics as well as the design opportunities using light and pattern. It is often used as a decorative and functional screening device. Metal mesh, made of expanded metal or woven metal, available in a range of forms from rigid to flexible, is used to filter or reflect light or used with light to cast shadows on a surface. Metal mesh, perforated metal, and expanded metal also allow air transmission; thus, they are often used to screen light fixtures as well as in air diffusers. Chains of metal beads are used as a curtain-like divider. Metal sheets can be etched with decorative patterns.

summary

The ores from which metals are made are the source of tools and weapons that defined the advancement of human civilization. As humans advanced, the mining and production of products made of metal became more sophisticated. The Industrial Revolution was partially a result of the ability to use metal to construct factories and to build a system for transporting goods. Metals are now a major component of building construction, and are used in the hybrid construction material called *reinforced concrete*. Metals are used

to construct interior partitions and for the hidden and well as visible components of mechanical, electrical, and plumbing systems.

Because of their smooth, reflective aesthetic appearance, and their comparative rarity, precious metals have also been a symbol of wealth and have been used since ancient times to make decorative objects and objects of personal adornment. Metals today add a level of perfection to interior products because of the precision of industrial production, but they are also appreciated for their natural characteristics, including the patina that occurs over time.

There are many types of metals, and each one has specific qualities that make it useful for interior construction and finishes. Steel, aluminum, copper, and nickel can be both decorative and functional. Metals are used to construct furniture and accessories as well as to clad interior surfaces. Metals are durable, but they must be carefully cleaned to maintain their appearance.

The designer must be aware that metals, although resistant to fire and a component of fire-resistant construction, will eventually soften when exposed to extreme heat. Thus, metal construction must be protected by fire-resistive material.

Although the extraction and refining of metal has a negative environmental impact, metal products are durable and long-lasting. When their useful life is over, metal products can be recycled. To find out more about metals, the following websites and publications of professional organizations in the metal industry can be useful:

Alcoa Aluminum Website: www.alcoa.com/sustainability/

The Aluminum Association: www.aluminum.org/

Home page of the metals finishing industry: www.finishing.com

Specialty Steel Industry of North America: www.ssina.com/index2.html

review questions

1. Describe the difference between steel and stainless steel.
2. Explain why and how the Bronze Age gave way to the Iron Age.
3. Compare and contrast the alloys of bronze and brass, explaining their strengths and differences.
4. Analyze your options for making a space fire resistant when it has exposed steel beams and columns.
5. Evaluate the benefits of three metals—aluminum, wrought iron, and steel—used for a courtyard gate. Give an example of where each metal would be the appropriate choice.

glossary

Alloy is the combination of two or more metals or other material added to metals in their molten state to change or improve the properties of the final product.

Aluminum is a metal derived from the ore bauxite. Aluminum is lightweight, strong, and easy to fabricate.

Anodizing is a method of protecting metal by thickening the oxide skin on the surface. Anodized metal can be recycled. Anodizing is an electrostatic process, immersing the metal in a sulfuric acid solution and passing an electrical current through the material.

Bessemer converter is a pear-shaped vessel invented by the American Henry Bessemer that enabled the refining of steel at a lower melting point while keeping carbon content low.

Blooming is a process of separating iron from slag by repeated heating and hot hammering.

Brass is an alloy of copper and zinc with a yellow-gold glow. The low melting point means brass objects are often cast.

Brazing is a method of using heat to join brass or bronze.

Bronze is an alloy of copper and tin. Its pinkish brown cast weathers to a deeper brown patina. Because brass is strong and weather resistant, it is often used for outdoor sculpture.

Builders' hardware includes all hardware used for doors and windows such as hinges, locksets, knobs and handles, push plates, panic bars, and doorstops.

Cabinet hardware includes hinges, knobs, and other elements used for furniture and cabinetry.

Casting is a process of forming molten metal into shapes using a mold. *Sand molds* are the most common. *Die casting* is used for lower melting point metals.

Chromium is a hard metal used to plate other metals. Its appearance is usually polished and shiny.

Cinders are by-products of iron ore production and can be used to make concrete and cementitious products.

Coke is a fuel derived from coal used to heat metal-producing furnaces.

Copper is found in nature in a free metallic state. Because it is easy to mine, it was the metal used in the Copper Age. Copper is known for its tendency to weather to a desirable green color referred to as *Verdigris.*

Cold drawing is a method of making wire or tubing by drawing metal through a series of dies as the cross-section gets progressively thinner.

Corrosion is the rusting that occurs on some metals when they are exposed to atmospheric conditions.

Crucible is a clay container used in a process developed by the British in 1740 to hold bar iron and other materials while heating, which resulted in low-carbon steel.

Ductile refers to the ability to permanently draw out a metal into a long thin wire or thread without breaking.

Electroplating applies a metal coat to an object or surface by negatively charging the object and immersing it into a metal salt solution that contains positively charged metal ions.

Electrostatic coating is a method of painting metals onsite using a combination of positively charged paint and negatively charging the metal to be coated.

Embodied energy is the combined total of energy used to extract, manufacture, ship, and dispose of a product over its lifetime.

Expanded metal is open mesh formed by slitting metal sheets.

Extruding is a process of forcing semi-molten metal through a die, making continuous shapes.

Ferrous refers to metal containing iron.

Flux is an element used in production of a product such as metal or glass to lower the melting point and increase the fluidity of the product.

Galvanic action is the corrosion that occurs when an electrical current flows through a liquid between two dissimilar metals. Metals are ranked in a continuum from most noble to least noble, with *noble metals,* such as gold, platinum, stainless steel, and silver, being the least likely to corrode.

Industrial steel plates are sheets of metal that have raised or stamped patterns.

Ingot iron is a pure iron, with little carbon, cast into a convenient shape for transportation or storage to be processed into the final product.

Iron is referred to as ferrous oxide, an inexpensive, soft, malleable and ductile metal. The strength of iron is increased by the addition of carbon in the smelting process. Iron is either wrought or cast.

Lead does not occur by itself in nature, but must be extracted from other metals, most commonly Galena. Lead is soft, heavy, dense, and corrosion resistant. It is toxic, and can accumulate in the human body.

Malleable refers to the ability to hammer metal into a shape or to form it by pressure from rollers.

Mechanical fastening joins two pieces of metal using bolts or rivets.

Metallurgy is the study of the process of extracting, refining, and processing metals.

Metal mesh fabric is made by weaving or welding strips or wires of metal into a sheet that ranges from rigid to flexible.

Metal shapes usually of steel, are used as components of building structure and include I-shapes, W-shapes, C-shapes, T-shapes, angles, solid bars, and hollow tubes.

Metal mesh fabric is made by weaving or welding strips or wires of metal into a sheet that ranges from rigid to flexible.

Nickel is a hard, silver white metal used as a base for chromium and to plate other metals. Nickel is corrosion resistant.

Ore is the mineral-bearing substance that is the raw material for metal. It includes the desired metal and the surrounding *host rock.*

Ormolu refers to a type of *gilding,* applying thin gold sheets to furniture and objects as decorative trim or ornament.

Patina refers to the brown or green film that develops on some metals over time and as they are exposed to atmospheric conditions.

Perforated metal is sheet metal with stamped holes of various sizes and shapes.

Pewter was traditionally an alloy of tin and lead and was historically used for eating and drinking vessels. Pewter is now made of tin and other metals. It is soft and easily molded, and in interiors is used for cabinet hardware.

Pig iron is a the direct product of the blast furnace, which can be further refined to create steel, wrought iron, or ingot iron.

Plating is the process of adhering a thin layer of decorative or durable metal over a more utilitarian base layer. Gold plating on metal or glass is called *gilding.*

Powder coating is a process of applying dry powdered paint to an object and then heating the object so the powder melts and forms a film.

Puddling is a process developed by the British that converted high-carbon pig iron into balls that could be shaped or *wrought.*

Rolling is a form of hot working, passing metal through pairs of flat or grooved heavy rollers. Bars, plates, sheets, and strips are formed by hot rolling.

Sheet metal may be thick (plates) or thin, and are used when flexibility is important such as to be applied to other surfaces.

Sintered refers to powdered metal formed into shapes in a mold.

Slag is a waste product of metal smelting process.

Smelting is the refining process that separates metal from the surrounding ore or other material.

Soldering is a method of joining metals using heat, but a lower temperature than welding. *Sweating* is the term for soldering copper pipes.

Spent pot linings are a waste product of the aluminum smelting process that remain when a smelting pot reaches the end of its useful life. Once disposed of in landfills, where they are considered hazardous materials, spent pot linings are now being treated and reused as fuel source in cement kilns.

Stainless steel is an alloy of steel and chromium, which forms a transparent film on the surface, protecting the metal from dampness and rust.

Tensile strength is the amount of pulling force an object can take.

Tin is ductile, malleable, and soft. Because it is corrosion resistant, it is used to coat other metals. Tin is the main component of pewter.

Titanium is strong, lustrous, corrosion resistant, and very expensive. Titanium is primarily used for objects and has been used as building cladding.

Welding is a method of connecting two pieces of metal by melting pieces at high temperature and adding a filler. The joint is formed when the *weld puddle* hardens.

Working is the process of shaping ingot iron into finished products. Metals are either *hot worked* at melting point temperatures or *cold worked* at temperatures just below the melting point. *Wrought iron* is formed by either hot or cold working.

Zinc is a ductile but brittle metal used as a coating to produce galvanized steel. It is corrosion resistant.

Wood

Awareness: An Overview

DESCRIPTION AND COMMON USES

Wood is probably the most versatile material for use in interiors. It has been used for almost all surfaces of interiors from the beginning of time. Throughout history, wood has been used for structures wherever it was available. Because wood was abundant in many areas, it was used for practically every surface in a structure. Wood has been used for substance surfaces, as in flooring, and for structural elements, as in load-bearing beams.

Wood is available for use as a covering of veneer paneling on walls. It can be made into cabinets or used for accent and trim around openings. Wood can also be processed into paper and applied to walls as a decoration, or walls could be made of paper, as is common in Japan.

The properties of different species of wood have made them desirable for various purposes. Woods with smooth graining and medium hardness, such as walnut and cherry, are desirable for furniture and cabinets. Harder woods, such as oak and hickory, are good for flooring. Closed grain woods, such as maple, are used for butcher blocks. Cedar is often used to line closets because it repels moths and other cloth-eating insects. Faster-growing woods, such as pine, are used for building structures and furniture because they are plentiful and

learning objectives

When you complete this chapter, you should be able to:

1. Recognize terms used when discussing wood and wood products.
2. Identify common uses of wood in an interior.
3. Explain the history of wood use in interiors.
4. Describe how wood is produced from trees.
5. Describe code requirements that affect the use of wood products for interior use.
6. Analyze the physical characteristics and properties of wood products for a specific interior use.
7. Analyze the environmental impact of using wood.
8. Evaluate how well wood products will meet the specific needs of a design project.

WoodWorks Radial Custom Ceiling System in Custom Maple Quartered by Armstrong Ceilings in San Diego National Bank, Encinitas, California
Armstrong Ceilings

35

FIGURE 3.1 **Japanese Paper Walls.**
Nan Standish Blake

FIGURE 3.2 **Wood Used on Interior Walls and Ceiling Gives a Warm and Cozy Appearance.** The pine paneling, showing its characteristic knots and natural color, yields a relaxed mood reminiscent of early American log cabins, although the large enclosed space and wide windows create a contemporary feeling. Courtesy of Dura-Groove.com and mapleislandloghomes.com

quickly resupplied, but their grain and softness are not as desirable for fine-finished wood furniture. Pine is used for rustic or casual looking interiors and furniture.

Wood is defined as the hard fibrous substance that makes up the greater part of the stems and branches of trees or shrubs beneath the bark. For the purpose of this book, this chapter on wood will include all the materials that come from trees or shrubs. There are various types of wood from various types of trees.

CHARACTERISTICS

Wood is a fibrous material composed of **cellulose**, lignin, hemicelluloses, and minor amounts of extraneous materials contained in a cellular structure. Variations in the characteristics and proportions of these components and the differences in cellular structure make woods heavy or light, stiff or flexible, and hard or soft. Wood is also **hygroscopic**, meaning that it expands when it absorbs moisture and shrinks when it loses moisture.

A tree trunk is composed of various materials in concentric circles. The outside of the tree is the outer bark. It provides protection to the softer inner bark and helps limit evaporative water loss. The inner bark is tissue through which sugars produced by photosynthesis are transferred from the leaves to the roots of the tree. Each year new layers of wood cells develop in the **cambium** layer under the outer bark. This produces an annual ring consisting of a light-colored layer and a darker layer. The **sapwood** is the band inside the bark. Sapwood is the living wood that conducts the water or sap from the roots up to the leaves. The **heartwood** is nonconductive, darker-colored wood in the middle of most trees. The pith at the center of the trunk is the remnant of the early growth of the trunk, before wood was formed.

As a tree grows, some of its limbs die, leaving a **knot** where the limb was. The tree trunk will continue to grow thicker, covering the knots with a new layer of growth. When the trunk is sawn into **lumber**, any knots that appear will affect the grade assigned to the lumber. Knots are considered defects in the structural integrity of wood, but

they can be considered desirable in the appearance. A mass of knots results in a **burl**, which is a tightly swirled grain pattern desirable for furniture.

Properties

Wood is known for both its desirable properties and its undesirable properties. Among its good properties are strength, in both tensile (parallel to grain) and compression (perpendicular to grain) directions. *Strength* refers to a material's ability to withstand an applied load without failure. Wood's strength normally comes into consideration for structural members rather than finishes. However, at times structural wood is seen, such as exposed beams or flooring materials, so the structural material is also the finish material. For decades, the wood industry has been developing engineered wood products to increase wood's natural strength. When layers of wood are *laminated* (glued together), they become stronger. One form of lamination is called **glulam**, which is made into load-bearing beams. A newer product is called **cross-laminated timber (CLT)**, which is comprised of boards stacked together at right angles and glued over their entire surface.

The undesirable properties of wood include deterioration, discoloration, and tensile strength in one direction. Wood is weak in tension perpendicular to the grain, which would allow the fibers to be pulled apart under heavy loading. Deterioration of wood most often comes from fungi that develop when wood is exposed to wet conditions without a preservative treatment. Wood that is kept dry (below 20 percent moisture content) will not develop decay. The term **dry rot** is used to mean deterioration. If the wood had been kept in dry conditions at all times, however, the rot would not have been able to develop. Another cause of deterioration is insect infestation. Examples of insect deterioration in forest trees would be Pine Beetle Kill in pine forests. A common example of insect deterioration in homes is from termites where wood touches the ground. For interior finishes, insect deterioration is less common. Discoloration in wood happens when sap seeps out of a knot hole. Discoloration can be prevented by applying a sealer to the wood.

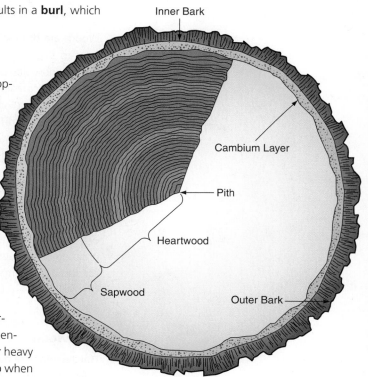

FIGURE 3.3 This Tree Trunk Cross-Section Shows the Layers of a Tree from the Outer Bark, Cambium Layer, Inner Bark, Sapwood, Heartwood, and Pith.

FIGURE 3.4 Laminated Wood Used for the Structure and Finish Material of the Dining Space in the University Center at the University of Northern Colorado.

WOOD SPECIES

Woods are divided into two broad classes: hardwoods and softwoods. The category names refer to their cellular structure, not their actual hardness. *Hardwoods* are trees with broad leaves, known as **deciduous**, and generally they lose their leaves in winter. Hardwoods are porous and contain vessel elements. Their cells form a continuous vessel that serves as a conduit for transporting water or sap in the tree. *Softwoods* are trees with needle-like leaves, and are known as **coniferous**, because they produce cones. These trees are nonporous, meaning their cellular structure does not contain vessels.

Wood species can be identified by the appearance of their **grain**. The pattern of the grain, the tightness of the lines of the grain, the uniformity, and the color of the grain distinguish one species of wood from another. Grain is classified as open or closed, which affects how it absorbs a stain. Open grain woods easily absorb water, stains, and oils, whereas closed grain woods do not absorb oil or particles well. Maple is an example of a closed grain wood that is desirable as a cutting board surface because the closed grain prevents bacteria from growing in the board. Some wood grains are highly desirable for the appearance of their grain. These woods are used for furniture or large surfaces that will be seen. Usually these woods are hard with a tight grain pattern, such as walnut and cherry.

Hardwoods

Hardwoods are mainly grown in the eastern United States, with a few species on the West Coast. The broad leaves of hardwood trees require water to survive and in turn give oxygen back to the surrounding air. Climates that receive more rain usually have trees with larger leaves. Hardwoods have qualities of strength and straight grain that make them desirable for use in construction. Hardwoods that have a uniform and beautiful grain—such as ash, cherry, maple, mahogany, oak, and walnut—have been used for centuries for finishes such as flooring, trim woodwork, cabinets, furniture, and paneling. Ash and oak have a very similar look and feel. The grain in ash is more likely to be straight, whereas oak can have a wider pattern. Ash will be white; common species of oak are red oak, white oak, and brown oak. There are many other species of oak not as commonly used.

FIGURE 3.5 Knotty Cherry Has Knots for a Slightly Rustic Look Added to the Subtle Grain Pattern of Cherry Wood.

Cherry, mahogany, and walnut are considered luxury woods. They have been used for fine-quality furniture because they have a soothing grain pattern and a natural reddish color that is usually enhanced with stains. These luxury woods also have a mellow look and softness to the touch due to their open grain. Maple, a closed grain wood, has been a prized wood for cabinetry because it is dense and hard, which produces a lustrous finish. Some maple has a grain with small round patterns known as *bird's eye* maple. This characteristic was so popular that it is now almost impossible to find. Beech, a strong wood with a straight grain pattern, has been used extensively for furniture because it is suitable for steam-bending processes.

More recently, alder, birch, and hickory have been added to the list of woods used for cabinetry. Hickory is very hard and brittle, which makes it more difficult to work with, but it has a random, almost wild grain with a contrast of light background to dark grain, which gives a rustic appearance to interiors. Birch is a light-colored wood with an unobtrusive pattern. It is commonly used as a veneer for wood doors in commercial interiors. Birch has an appearance much like maple, but it lacks the hardness that makes maple more valuable. Alder is from the West Coast and is used for cabinets and interior trim because it has low shrinkage. It is a light-colored, lightweight wood, but when it is stained it looks similar to cherry. Eucalyptus and bamboo have been used recently for cabinets and interiors because they are quickly regrown and considered sustainable.

Aspen, cottonwood, and poplar are similar woods that are lightweight and have little grain pattern, which looks good when painted. They are not considered desirable trees for lawns because they have a short life span and their limbs break off easily. However, these trees have a use environmentally. They grow quickly, spreading their roots to create more trees, causing them to be good for erosion control in open spaces. Aspens are used for replanting forests lost to fires. Cottonwoods provide erosion control along rivers and streams. For more information on wood species descriptions, refer to the Forest Products Laboratory's *Wood Handbook*, available online.

Softwoods

Softwoods are often called *evergreens* because they do not drop their leaves in cold weather. The small surface of their leaves does not require them to need much water to survive. They grow well in harsh climates where there is wind, cold, and little rain. Softwoods are grown across the United States. They are more prevalent in mountainous areas than in the Great Plains. Softwood lumber is usually lighter weight and not as strong as hardwood. It grows faster and as a result is not as dense. The grain is not as close, and it does not take a stain as evenly as hardwoods. Softwood lumber is normally used for rough elements such as framing lumber and plywood. Species of softwoods include cedar, cypress, fir, hemlock, pine, redwood, and spruce.

Bamboo

Bamboo is used in many of the same ways that wood is used. The difference is that wood is available in pieces up to 12 inches wide, whereas bamboo is a grass that grows in narrow stalks, only a few inches in diameter. It is used in strands, and many strands are pieced together to make a usable surface material. Because long narrow strips are pieced together, the finished piece is stable in humidity. The strips and nodes are accepted as a part of bamboo's character. Large panels, 4 feet x 8 feet and larger, millwork strips, and flooring planks are produced in bamboo. Most commonly, bamboo is seen with its grain running horizontally or vertically. It could also appear as strands or end grain. The natural color is very light. Bamboo's grain is enhanced through a steaming and drying process that gives it the light yellow color. An additional process darkens it to the amber color. Due to its cellular structure, bamboo takes a stain differently than wood does. The ends will take on more stain color, which is why we normally see it in its natural color. Bamboo is harder than most wood used for flooring. As a result, bamboo will take impacts and show fewer dents than wood flooring.

FIGURE 3.6 Typical Leaves from Deciduous Trees Have Flat Surface; Typical Leaves from Coniferous Trees Are Needle-Like.

Eucalyptus

Eucalyptus is a species of shrub that is native to Australia, although some varieties of Eucalyptus grow to be tall trees. Eucalyptus wood is grown in the western United States and other countries. Although its main use is production of pulp for paper, currently Eucalyptus is being used for cabinetry, flooring, and interior finishes. It has become popular due to its fast growth and low cost. A Eucalyptus tree can be mature enough for lumber production in 14 years. The wood from Eucalyptus is harder than oak and is durable.

Palm

Palm wood is a newer product on the market. There are approximately 150 palm species. The palm wood commercially available is considered renewable because it comes from coconut trees that have finished bearing coconuts. Palm wood comes from plantations where the trees have grown for centuries, and no new space is allocated for trees. This feature makes it greener than bamboo, and meets Forest Stewardship Council approval. Palm wood can be produced formaldehyde-free. It is usually medium to dark red mahogany in color and shows a small dark speckle. Sardar (2009) described it as "flecks of thread floating in resin, [which] gives coconut palm wood a beautiful quality seen more often in more expensive endangered hardwoods."

Palm wood boards that are untreated have a tendency to twist. Drying in natural air results in less strength and color for the palm wood. Therefore, it is dried in a kiln and sliced before being laminated to a core material. The cell structure is most dense at the perimeter of the tree, causing the outside to be harder and darker, and the center to be softer and lighter. This is the opposite of most trees. The coconut palm tree grows only to 12 inches in diameter, but may be 100 feet tall.

Palm wood is not available in large planks. The lengths range between 2 feet and 6 feet. When it needs to be longer, pieces are spliced together. It is produced for flooring, paneling, and as a veneer over a core material. Flooring is available in ⅝-inch tongue and groove. The palm veneer is ³⁄₁₆ inch thick, which allows it to be sanded and refinished. Paneling is available in thicknesses ranging from ¼ inch to 3 inches thick. The downside of palm wood is the cost. Coconut trees decay from ants as they age, making the raw material less available than bamboo.

ENVIRONMENTAL IMPACT

Embodied Energy

Wood has a fairly low level of **embodied energy** relative to many other materials used in construction, such as metal or plastic. The energy needed to produce wood is low because the sun and rain provide most of the growing needs. Some forest operations use fertilizer and pesticides, which add some production cost. Energy is used for powering harvesting equipment and transporting logs to the lumber mill where the logs are sawn and dried. Kiln drying is the most energy-consumptive process of lumber manufacture; however, **bioenergy** from a mill's waste wood is often used to heat the kilns. Bioenergy for fuel is considered to be carbon neutral.

Solid wood has a level of embodied energy at 10.4 **MJ/kg**. **Plywood**, which requires more processing steps and the addition of **glue**, has an embodied energy of 15 MJ/kg. The more processing involved in the manufacture of wood products, such as flaking, veneer cutting, added heat for pressing, gluing, and kiln drying, the more impact it has on energy use, solid water production, pollution production, and carbon release into the atmosphere.

Recycle and Reuse

Wood that is left over from product manufacturing is easily recycled. The U.S. Forest Products Laboratory estimates that 94 percent of wood-product manufacturers capture their waste. Leftover wood from construction projects is approximately 75 percent salvaged. Only about

34 percent of wood from demolition projects is currently recovered. This amount could be increased if buildings were dismantled carefully when they are demolished.

Sustainability

Wood plays a significant role in carbon in the atmosphere. Forests are considered a means of offsetting climate change because trees absorb carbon dioxide from the atmosphere. However, when trees or wood products burn, they emit carbon into the atmosphere. When trees are growing, they are absorbing and storing carbon. Also, when wood is being used as building materials, it is storing carbon. According to Lippke and colleagues' article in *GreenSource* (2011), trees have a limited capacity to store carbon as they grow older. This is part of the principle of responsibly harvesting forests. It is better to cut the older trees rather than risk having a forest fire that would release their carbon dioxide back into the atmosphere.

Wood is a product of a forest. When major amounts of trees are cut from a forest, deforestation is the result. Replanting of trees is called *reforestation*. However, if the trees in a forest are properly managed, the flow of wood products can be maintained indefinitely.

Certified forests

When forests have managed harvesting and diversity, they can be certified. More than 50 different forest certification systems in the world are involved with producing and marketing certified forest products. In North America, 5 major certification systems are used: Forest Stewardship Council, Sustainable Forestry Initiative, American Tree Farm System, Canadian Standards Association, and Programme for the Endorsement of Forest Certification.

The Forest Stewardship Council is most widely recognized in the United States. This organization sets standards for accreditation, but does not actually issue certification. Within the Forest Stewardship Council (FSC) there are divisions of certification. *Forest Management Certification* is awarded to forest managers or owners whose management practices meet the requirements of the FSC Principles and Criteria. *Chain of Custody Certification* applies to manufacturers, processors, and traders of FSC-certified forest products. It verifies FSC-certified material and products along the production chain. *Controlled Wood* is designed to allow organizations to avoid the categories of wood considered unacceptable. FSC-Controlled Wood can be mixed only with FSC-certified wood in labeled FSC Mix products. For more information on the FSC certification types, the international website is www.fsc.org.

Bamboo sustainability

Bamboo is a strong and durable plant and has been used for centuries. It is considered to be similar to wood because it is used in the same manner, although it is not a tree. Bamboo is a plant family with hundreds of species that grow very quickly, some reaching 100 feet in only a few months. Quick growth makes it renewable, which is a trait of sustainability. The type of bamboo used in commercial products is harvested every three to five years with no damage to the ecological system of renewal. Bamboo's cellular structure has thin, parallel filaments that are extremely strong. Like wood, bamboo stores carbon while it is growing, allowing more oxygen to clean the air of pollution. Almost every part of the bamboo plant can be used, producing no waste in production of bamboo items. Bamboo is a renewable choice for interior materials because it can be grown much quicker than trees. Bamboo is available from certified forests, in no added urea formaldehyde, and low-VOC options.

Eucalyptus sustainability

Eucalyptus is considered a renewable resource. It grows much faster than hardwoods or softwoods, but not as fast as bamboo. Eucalyptus trees can be harvested within 14 to 16 years of planting. Those that have burned or been cut easily regenerate and grow quickly. One company that is certified in Brazil is marketing Eucalyptus under the Lyptus brand name.

Fibria's mills use virtually every portion of the log, converting it to lumber and other usable by-products, including bioenergy for the kiln-drying operations. Fibria's Lyptus forests produce 30 times the volume of lumber per hectare per year when compared to an unmanaged temperate forest.

The drawback to Eucalyptus is that forests actually can cause fires due to the flammable Eucalyptus oil in the trees. Eucalyptus trees are also notable for using water, although this trait can be put to good use in swampy climates. Eucalyptus trees were brought from Australia to other parts of the world after the James Cook expedition of 1770. In areas where they are replacing hardwoods, such as oak trees, they have an impact on the wildlife inhabitants of the forests.

Engineered wood sustainability

Normally when you hear the term **engineered wood**, you think it is the antithesis of sustainability. It conjures up images of sawdust glued together giving off tons of VOCs. New products are focusing on sustainability and wood particles. One such product is Echo Wood's FSC-certified engineered veneer. It is produced as a veneer with a visually tight stripe effect that mimics rare species of wood, such as ebony, wenge, macasser, zebrawood, walnut, mahogany, teak, and rift white oak. The veneers are applied over 100-percent recycled wood **particleboard** or MDF. Echo wood uses all thermo-fused vinyl and **adhesives** that are green certified, or are low VOC with no added formaldehyde. The tree species used for these products are Ayous from Cameroon and Basswood from northern China. Echo wood uses sustainable forestry practices.

Indoor Air Quality

Trees and plants contribute to our air quality. The process of photosynthesis occurs when plants take in water, sunlight, and carbon dioxide to produce glucose and oxygen. The glucose is used for the plants' energy to grow and the oxygen replenishes the earth's supply of breathable air. Trees take in sunlight and carbon dioxide only during the daytime. They release oxygen during the day and release carbon dioxide at night. This is a process that is absolutely necessary for life on earth and the main reason people are concerned with preserving forests. A variation in carbon dioxide level, either increased or decreased, could harm the environment.

When wood burns, it emits smoke with toxic chemicals into the air. The most significant problem with wood smoke is the release of hydrocarbon particles that are harmful to

FIGURE 3.7 Engineered Wood Made to Look Like Zebra Wood Used for a Kitchen Cabinet.

breathe. The Environmental Protection Agency (EPA) reported 50 different chemicals in wood smoke, some of which are known carcinogens. Particles that are smaller than 10 micrometers in diameter can get deep into lungs and even the bloodstream. The particles can cause breathing difficulty, irritation of the airways, decreased lung function, aggravated asthma, bronchitis, irregular heartbeat, heart attacks, and premature death in people with heart or lung disease. Wood smoke can also cause environmental damage. Particles can be carried over long distances by wind and then settle on ground or water, changing the nutrient balance of ecosystems.

Social Health

People respond emotionally to wood. Psychologist Erich Fromm created a term, **biophilia**, to refer to the instinctive bond that exists between humans and other living systems. Lippke and colleagues (2011) explain how biophilia between humans and wood contributes to a socially positive experience: "They are attracted to its visual variety and natural expressiveness." The researchers also cited a study that found "the visual presence of wood in a room lowers sympathetic nervous system activation in occupants, further establishing the positive link between wood and human health."

Properties of Wood

(sustainable properties are highlighted in green)

Wood absorbs impacts well.
Wood is a good sound insulator.
Wood can be reproduced by growing trees.
Damaged wood can be easily repaired.
Wood can be easily shaped with tools.
Wood has good insulating properties against heat.
Wood resists corrosion from oxidation, acid, and saltwater.
Wood uses a small amount of energy to be produced into lumber.
Some wood species hold up well in moisture.
Wood can be easily fastened with adhesives, nails, screws, bolts, and dowels.
Wood has a high ratio of strength to weight.
Wood insulates against electricity.
Wood absorbs and dissipates vibrations.
Wood grains can be aesthetically pleasing.
Wood is susceptible to fire.
Wood is susceptible to decay.
Wood emits toxic chemicals when burned.
Solid wood reacts to humidity in the environment (shrinking, swelling, warping, etc.)

Understanding: In-Depth Information

HISTORY OF WOOD USE FOR INTERIORS

Through most of history, wood has been used for building structures for ordinary use. Where trees are available, they can be used for quickly building a shelter—either by wrapping bunches of tree branches together, or by cutting the trunk of the tree into strips of wood and piecing them together. Wood was probably the first material used for building and the most common.

Wood structures have not been durable enough to last through the centuries, so there are very few ancient wood structures remaining. Ancient Chinese buildings were preserved better than most because they were painted. They were constructed with large wood horizontal elements that extended beyond the roof and highly decorated with paint. In ancient Egypt, wood was used for carved vertical columns. The wood columns were painted and the dry climate in Egypt also served to preserve wood better than a damp climate. Ceilings had wood **beams** closely spaced with reeds and twigs laid perpendicular on top of the wood beams. When the structural look was concealed, small poles were laid against the underside of the beams and fastened to them. The beams and poles were covered with plaster and painted.

During the Middle Ages in Europe, twelfth to sixteenth centuries, wood planks were used for floors in upstairs rooms. Rooms were large and multipurpose with interior walls made of wood and plaster. Wood screens were used to separate spaces and keep drafts of cold air out. The lower part of a wall, the *wainscot,* consisted of wood boards held vertically between upright planks. By the sixteenth century, wall paneling was framed by vertical wood pieces called *stiles* and horizontal wood pieces called *rails.* The panel had thinned edges that fit into a cutout in the frame pieces.

During the Italian Renaissance, ceilings took on many forms, and wood was used in the well-built rooms in the mid-fifteenth century. For flat ceilings, the simplest design had small

FIGURE 3.8 Coffered Ceiling Barrel Vaults in St. Peter's Basilica in Rome. grafelex/ Shutterstock

FIGURE 3.9 Wood Parquet Flooring is Shown in a French-Theme Room. arsdigital/Fotolia

beams spaced closely together across the room in one direction, resting on larger beams that were widely spaced running the other direction. The large beams rested on **corbels** protruding from masonry walls. The arrangement of beams could create a variety of shapes known as *coffered* ceilings. These coffers were usually rectangular shaped, made of carved wood, and were highly decorative around the middle of the fifteenth century. Later, plaster was used for ceilings.

In the French Renaissance, mid-fifteenth and sixteenth centuries, interiors were influenced by Italian designers who brought with them the idea of having a unified theme. Wood flooring laid in a **parquet** herringbone pattern was used in the gallery at Fontainebleau built in the 1530s. The wainscot walls were walnut panels of various sizes with **inlaid designs** of different materials. The French Baroque period, seventeenth century, continued to see exposed wood beam ceilings. Wood also continued to be used for geometric parquet floors. Occasionally, **marquetry** designs were used, or the geometric and representational designs were mixed.

The Baroque period in England, late seventeenth century, saw the use of elaborate wood carvings applied to paneling, door frames, chimney pieces, balustrades, cornices, and wall panels. Carving was done with fruit woods and applied to panels of other woods. The French concept of a unified theme carried throughout was prevalent, meaning that all the details worked together to support the interior architectural theme. Wall paneling covering the entire room was common and the wood panels became larger. The principal woods used were oak and pine, with walnut and fir as secondary. Oak was left untreated or waxed to keep its natural color. Pine was usually painted, but a treatment imported from Sweden was to rub pine with cold water and slaked lime to produce a smooth white surface. Oak planks with wax were used for flooring on upper floors, keeping it away from the ground where it would deteriorate easily. The first parquet wood floor used in England was installed in 1660. In the late eighteenth century, parquet designs were still used in England, made of unvarnished fir or pine and sometimes oak.

During the nineteenth century, the more desirable woods were walnut and cherry, but oak and pine were used for most wood paneling

and trim in U.S. homes. By the early twentieth century, the Craftsman style was fashionable, using dark stained oak or pine for floors, stairs, handrails, baseboard, door and window jambs, and crown moldings.

PRODUCTION: MILLING WOOD

Trees cut from forests are called *logs*. Logs are shipped to a **sawmill** where they are sawn into lumber. The first step in the milling process is peeling the bark from the log. With the bark removed, the shape and knots of each log are revealed. The first cutting rips the log into rough boards. The next cutting rips the boards into the desired widths. Most hardwood lumber produced at sawmills is known as *dimension stock* and is used for furniture, flooring, cabinetry, and paneling. Rough lumber is seasoned or kiln dried and processed into dimension stock. Before lumber is dried, it is known as **green lumber**. **Seasoning** is done to take moisture out of the wood and reduce its tendency to warp, shrink, or host fungi.

After seasoning, lumber is planed to take the roughness off, called **surfacing**. As lumber is planed down to become smooth, the piece of wood becomes smaller. For example, if you started with a piece of wood that was rough cut to 2 inches thick and 6 inches wide, the **planing** process would take about ½ inch off of each original dimension. The result would be a piece of wood that is smooth, but only 1½ inches thick and 5½ inches wide. This is a general rule in the lumber industry. If the original size was less than 2 inches, then it will only be reduced by ¼ inch. For example, a 1-inch piece of lumber is planed down to ¾-inch dimensional lumber. If the original size of the lumber was over 6 inches, then surfacing will reduce it by ¾ inch; a nominal 8-inch wide board will measure 7¼ inches. The name used to describe a piece of lumber is the **nominal** size, such as a 2 by 6. The dressed (finished) size of the same piece of lumber actually measures 1½ inches by 5½ inches. Timbers are thicker lumber, usually 5 inches or more in thickness. Their dressed thickness and width will be smaller by an additional half inch.

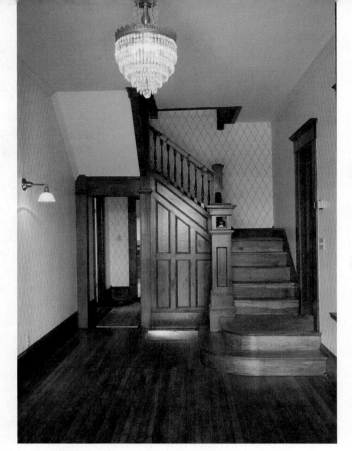

FIGURE 3.10 A Combination of Oak and Pine Were Used for the Wall Paneling and Staircase in this Early Twentieth-Century Interior.
Nan Standish Blake

Nominal Size	Dressed Thickness	Dressed Width
1 x 2	¾ inch	1¼ inches
2 x 4	1½ inches	3½ inches
4 x 6	3½ inches	5½ inches
6 x 8	5½ inches	7¼ inches
7 x 10	6¼ inches	9¼ inches
8 x 12	7¼ inches	11¼ inches

The direction the lumber was cut from the log determines its grain pattern. The two main cutting directions are plain sawn and quarter sawn. For *plain sawn lumber,* a wood log is sliced perpendicular to the growth rings. For *quarter-sawn lumber,* a wood log is cut into quarters and then sliced.

Characteristics of plain sawn wood are that it is less expensive to produce because less labor is used and less waste is created, figure patterns are attractive, knots are round or oval in shape, and there is less shrinking and swelling in the thickness of the wood. Characteristics of *quarter sawn wood* are that the grain pattern is more uniform (making it wear more evenly), knots appear more pronounced, it shrinks and swells less in width, it twists and **cups** less, and it works smoother for long pieces of trim profiles.

FIGURE 3.11 The Two Most Common Ways a Log is Cut are Plain Sawn, Which Slices the Log, and Quarter Sawn, Where the Log is Cut into Quarters and then Sliced.

Hardwood lumber is classified according to quality, based on the number of undesirable growth characteristics. The quality classifications are common or select. *Common grades* are suitable for general construction purposes. *Select grades* provide a surface suitable for finishes. The American Hardwood Export Council publishes size and grading rules for sawn hardwood lumber. Grading rules set by the Architectural Woodwork Institute in their Architectural Woodwork Standards can be used to control hardwood lumber produced for interior use.

TYPES OF WOOD MATERIALS USED IN INTERIORS

Wood Flooring

Standard wood flooring is made from strips of solid wood ¾ inch thick, varying from approximately 2 to 10 inches wide. When the wood is wider than 3 inches, it is called a *plank* instead of a *strip*. Normally, a hardwood such as oak or cherry is used for flooring. Occasionally, a softwood such as pine is used, which shows wear much more than hardwoods do. Wear shows by compaction where objects hit the wood, as in dents from small heels or dog feet, and sunken path areas where people have walked for years. The most common wood floors are oak strips, ¾ inch thick, 2¼ inches wide, 8 feet long. Each strip has a tongue protruding out along one side and a groove recess along the other side so that strips will be locked to each other when pounded together.

Wood flooring strips are available as either unfinished wood that will be stained and finished after they are installed, or pre-finished wood. The pre-finished wood strips cost more, but the installation time is much quicker—about one day compared to several days for sanding, staining, and finishing drying time. Another advantage of selecting pre-finished wood strips or planks is that you see exactly what the finished floor will be. Unfinished wood flooring is less expensive; however, the finished look is in the hands of the installer. In a case where new flooring will be added to existing flooring, the existing wood needs to be sanded until it is completely raw and the new wood should match the raw wood. Then they are both finished in the same manner. An advantage of using solid wood strips or planks is that they can be refinished after years of wear. Solid wood floors are ¾ inch thick and can be refinished four times before the tongue and groove joint becomes loose. The disadvantage of solid wood is that it is susceptible to humidity changes that can cause shrinking, swelling, or warping. Pre-finished wood strips are usually a ¼-inch to ⅛-inch veneer of wood over a core material, thus making them less durable for sanding and refinishing.

FIGURE 3.12 Red Oak Unfinished Flooring Strips Showing the Tongue and Groove Method of Attaching Strips to Each Other.

Salvaged or reclaimed wood can be used for flooring. It may take more time to refit the wood for a current installation, but the distressed effect may be worth it. Reclaimed wood may not have a tongue and groove or a backing that allows for uneven subflooring. Sometimes the planks are remilled, other times alternate methods are used to install the wood as flooring.

Wood flooring is also available in parquet, small pieces (billets) cut to form a pattern. Parquet designs are often used for formal rooms because the historical reference is the French Palace of Versailles. Parquet designs are available in block, usually square, with wood billets running in diagonal directions. The wood may be solid ¾ inch thick, or a veneer applied to a substrate of wood product for stability. The main disadvantage of parquet is humidity-related shrinkage. The block will act as a unit and all the shrinkage may be transferred to one large gap.

Wood cabinetry

Solid wood paneling is only found in old buildings, or where a person has his or her own trees cut to make the wood paneling. Older pieces of wood furniture, called *case goods,* or *cabinets,* used solid wood in the past, but it is rare to find them made since 1970. The only time you will find new production of solid wood other than flooring is for cabinet doors. The remainder of the cabinet is usually a different wood product, either plywood or medium-density fiberboard.

Cabinet doors are seldom one solid piece of wood, but when they are, it is called a *slab.* Most cabinet doors consist of five pieces, using a rail and stile construction. The horizontal rails (top and bottom) and vertical stiles (sides) are approximately 2¼ inches wide (assembled) surrounding a center panel, with a notch cut for the center panel to fit into. This construction allows for humidity changes without causing cracks in the wood. The center panel is free to move as the wood shrinks or swells. The center panel is usuall ¼ inch thick, which is one-third the thickness of the door. If the center panel is thicker in the center, it is called a *raised panel door.*

Some cabinets have a face frame that the doors shut against. Doors of a traditional overlay show some of the face frame around each door. Doors of a full overlay cover the face frame completely. The advantages of the frame style cabinets are that they are stronger and less expensive to build.

FIGURE 3.13 Cabinet Doors Are Usually Solid Wood, Whereas the Remainder of the Cabinet Is a Quarter-Inch Wood Veneer over Plywood.

FIGURE 3.14 Solid Alder Wood Door in Rail and Stile Construction. This beautiful grain will look attractive when showing through a light or dark stain.

FIGURE 3.15 Cabinet Door Construction Showing MDF Panel Insert Surrounded by Alder Rail and Stile. The combination of types of woods requires a painted finish.

Another style of cabinetry does not have a face frame. It is called *frameless,* or *European style* cabinetry. These cabinets have doors that fit flush with the cabinet, there is no overlay. The advantage of frameless construction is that it allows wider access to the inside of the cabinet. However, the cabinets cost more to build.

Cabinets are classified as kitchen wall, kitchen base, and tall cabinets. *Kitchen wall cabinets* are normally 12 inches deep and either 12, 24, 30, 36, or 42 inches high. They are mounted at 18 inches above a kitchen counter, or 54 inches above finished floor (AFF). A 42-inch-high cabinet placed at 54 inches AFF results in a height of 96 inches, or 8 feet, which is the standard height for a residential kitchen. When the kitchen is taller than 8 feet, wall cabinets can be stacked to achieve a taller cabinet. For 9-foot ceilings, a 12-inch-high wall cabinet is often stacked above a 36-inch-high cabinet, leaving 6 inches for wide crown molding at the ceiling. Wall cabinets generally have doors. If they are manufactured boxes, they will be available from 9 inches wide to 48 inches wide in increments of 3 to 6 inches, such as 9, 12, 15, 18, 21, 24, 27, 30, 33, 36, 39, 42, 45, 48, 54, and 60 inches. If they are custom made by a cabinet company, they can be made any size to fit the space available.

FIGURE 3.16 A Frameless Cabinet Will Have the Cabinet Box Covered When the Door Is Closed.

FIGURE 3.17 A Face Frame Cabinet Will Have Some of the Frame Covered by the Door When the Door Is Closed.

Drawer cabinets are usually in the lower part, the *kitchen base cabinets.* Drawer glides come in different qualities to take various weights, or have a quiet closing feature. Some drawers are called *pull-outs.* These cabinets pull all the drawers out with a single pull. They can be wide and used for baking dishes, or narrow and used for spice jars.

Kitchen base cabinets are generally 24 inches deep and 34½ inches high. This allows for a countertop to be placed on top to bring the counter up to 36 inches above finished floor. Base cabinet depth can be altered for design purposes. Base cabinets can be either door cabinets or drawer cabinets. Most companies offer different qualities of hinges and drawer glides for light use or heavy use. The base cabinets normally have a recess 4 inches deep by 4 inches high at the floor level known as a *toe kick,* to allow more comfortable standing while working at the counter.

Architectural Millwork

Wood pieces that trim around architectural openings are called **millwork** or *architectural trim.* When millwork is applied, the opening is called a *cased opening,* referring to the millwork as casing. Millwork not only adds a protection to the wall edge but it is also a nice design feature. Throughout history, millwork has been used, resulting in certain motifs or shapes being appropriate for re-creating a specific design period. Baseboards, crown moldings, door and window jambs, thresholds, and window sills are typical pieces of millwork. These pieces are available in standard shapes, sizes, and species of wood. Commonly they are available in pine or oak at home improvement stores; however, they are also made in other woods and medium-density fiberboard that is available through specialty lumber yards. When a project uses a specialty wood throughout, then the millwork will

FIGURE 3.18 This Pull-Out Drawer Is Located Next to the Stove Top for Convenient Location of Cooking Ingredient Containers.

need to be created out of that same wood. The designer will need to select the shape, or **profile**, for the trim.

Millwork is produced in long strips, usually from 8 feet up to 16 feet, and shaped into a profile. The long strip of wood is fed into a machine called a *shaper* that cuts the desired shape to create the profile a designer selects. Designers can select the look they want from a catalog of profiles, sometimes combining two or more profiles for spaces that need larger proportions. Different or unusual shapes can be made by custom order. The website at www.mouldingandmillwork.com/buildups.php shows how to use moldings to create a wall trim or mantel.

Example of Kitchen Cabinets Made to Fit an Existing Space

One wall in this kitchen wall was 132 inches long. The existing 36-inch refrigerator needed to go at one end of the wall, taking up 38 inches. The other end of the wall needed to have a corner base, taking up 36 inches on the base wall and 12 inches on the upper wall. The remaining base wall space required a 30-inch wide stove and a stack of base drawers. The remaining upper wall needed to have a vent hood and door cabinets. The owner wanted the vent hood to be wider than 30 inches so the stove area would not feel crowded. If box cabinets were used, there would be either wasted space or uneven placement of cabinets because of the 3-inch increment size restriction. By using custom-made cabinets, the usable space was maximized and the vent hood was centered between equal-sized upper wall door cabinets. The solution for the base cabinets was to use a 6-inch pull-out with a 1½-inch spacer between the corner cabinet and the stove, with a stack of drawers 19¼ inches wide between the stove and refrigerator. The solution for the upper wall was to use a 36-inch-wide vent hood cover with short cabinets above, and a pair of 16¼-inch-wide door cabinets on each side.

FIGURE 3.19 Cabinet Shop Drawing of Kitchen Cabinet Dimensions.

FIGURE 3.19 Continued

FIGURE 3.19 *Continued*

Cherry Woodwork

Wood can also be custom made for architectural distinction. In this project, American cherry was chosen for the wood because of its beautiful grain and warm color. All of the wood trim was made from solid cherry wood stock. Instead of using molding profiles, pieces of lumber were used in this project. The mantel was made from a ¾-inch cherry veneer plywood panel, with solid wood cherry strips added. The edges were **eased** with a router and sander to produce the rounded edges. The sides of the arch were made from ¾-inch cherry veneer plywood, cut into the arch shape. The bottom of the arch was made from ¼-inch cherry veneer plywood, which was flexible enough to bend into the arch. The edges of the plywood were mitered to look like a solid piece of wood. The wall paneling is made from solid stock 1 x 3 cherry for the top rail, and ¼-inch cherry veneer plywood for the flat panels.

The floor is made of Brazilian cherry planks. American cherry is known for its color becoming darker with exposure to light. Brazilian cherry is a darker red color, and has a different, more pronounced, grain pattern. Both varieties of cherry wood were purchased from Frank Paxton Lumber. Unusual and exotic woods such as American cherry are not available in most lumber yards.

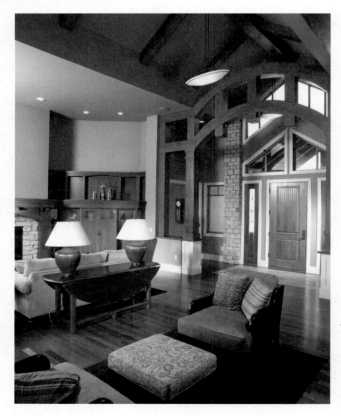

FIGURE 3.20 Cherry Wood Used to Create a Custom Wood Interior.
Spanjer Homes

FIGURE 3.21 Ceiling Beams of Wood Are Painted and Supported by Columns in a Late Nineteenth-Century Style. 2009fotofriends / Shutterstock

Wood Ceilings

Wood ceilings are a specialty feature for high-end design projects. Common ceilings are constructed of gypsum board or acoustic panels. Using wood for a ceiling is much more expensive and very dramatic. Notice the photograph at the opening of this chapter where wood is used to create a dramatic ceiling and then carried into the practical use of the bank-tellers' counter. The use of maple wood gives a light and contemporary feeling to the interior. When wood is used in a large expanse, as a ceiling, the grain is highly visible because nothing is blocking the view. A wood ceiling is used when you want the emphasis on the visual aspects of the wood and you desire the acoustical properties of wood. Many concert performance halls use wood for ceilings and wall paneling. Wood ceilings could be constructed of solid (¾-inch) wood, but most often veneers are used to decrease the weight and the cost of the ceiling.

Many times wood is used for a focal point on the ceiling without covering the entire ceiling. A veneered wood panel can be suspended from a higher ceiling to bring emphasis to a certain area or to add acoustical properties to the area. Another way wood is used is reminiscent of the days when wood beams supported a structure. It looks like wood beams, but the beams are not part of the construction. They are a decorative addition made in the shape of a beam by wood forming a square shape when placed against the ceiling. Several wood beams may run one direction the width of the room, or a few wood beams may run both directions and intersect with each other. These are called **boxed beams** and they are hollow inside.

Wood Veneers

Wood veneers are made of a thin layer of wood laminated to another material called a *substrate.* The wood on the outside is the veneer. It is the wood chosen for its appearance. The veneer can vary in thickness, usually from ⅟₃₂ to ¾ inch. It has been considered a technological achievement to produce thinner layers for veneers. This allows a manufacturer to slice a desirable (expensive) wood into many thin layers of veneer, making more profit. Thinner veneers do not allow sanding and refinishing that thicker veneers would accommodate. The substrate material is not seen because it is covered by the veneer. The purpose of the substrate is to reduce the amount of expensive wood in the product, while adding stability to the product. Laminating layers of wood together makes it more stable, reducing the wood's tendency for shrinking, swelling, or warping.

FIGURE 3.22 Methods of Cutting Wood Veneer From a Log.

Basic Matching Effects

Book Match

Random Match

Slip Match

Vertical Butt

FIGURE 3.23 Veneers May Be Laid Out to Create Different Patterns.

Veneers are cut in different methods and each method results in a different appearance. After a log's bark is removed, the log is placed in a lathe that turns it. A knife edge saw is placed against the turning log to peel the wood off the log in a long roll. This is a *rotary* cut and it can produce extremely thin wood veneer. If the veneer is intended to be thicker, it will be cut by slicing the log rather than peeling the log. The grain pattern will appear different from a rotary cut than from slicing.

Usually a veneer will be laminated at a factory and produced as a piece of plywood. Plywood is comprised of thin layers of wood glued together. Each layer is placed at a right angle to the next layer, resulting in the grains running both directions. Sometimes the core will be a thicker piece of lumber or strand board. The interior plies will consist of woods that are inexpensive because they grow quickly and do not have desirable appearance, usually poplar or sweet gum. The layers are bonded by using a water-resistant glue and high pressure. Plywood always has an uneven number of layers or it will warp. Construction plywood will have a soft wood such as pine on the outside layers. One side is usually graded a higher quality than the other. Decorative plywood will have a hardwood veneer on at least one side. This is the decorative side that will be seen after installation. Plywood is normally produced in sheets 4 feet wide by 8 feet long. The thickness may vary, but standard thicknesses are ⅛ inch to ¾ inch. When a designer specifies wood veneer panels, the method of matching the panels should also be specified. If you have a large area that will be covered in wood veneer panels, the grain patterns and placement may have a dramatic effect on the look of the room. Pattern matching is best shown visually.

Wood Fiberboards

Particleboard is made of wood flakes or chips formed into layers and held together by resin. It is glued and heated under pressure. Because wood chips or flakes are used, it does not have a smooth surface and it does not have much strength. Particleboard is used as a substrate where strength is not required. It has a rough surface that soaks up paint or water, meaning that it should not be used around wet areas, such as a countertop around a sink. A form of particleboard developed more recently is referred to as **OSB**, or **oriented strand board**. Most of the strands of wood are oriented in the long direction of the panel, with a few layers of strands in the opposite direction. This configuration is used to give more strength to OSB than the previous particleboard had. Particleboard or OSB is produced in sheets 4 feet wide by 8 feet long.

FIGURE 3.24 Pine Mantel. This mantel is made of shaped solid pine wood at the top and bottom with MDF for the flat vertical surface between. This is a common construction method for architectural trim that will be painted.

Chapter 3

Medium-density fiberboard is made of small wood particles or fibers combined with resin under pressure and heated to produce a hard and smooth surface. It has many advantages over particleboard. The most important difference between MDF and particleboard OSB is that MDF is denser and has a very smooth surface. Medium-density fiberboard is made of very small wood fibers that produce a smooth surface that is very good for painting. It does not have a grain direction, so it can be cut into any shape, drilled, or even dowelled with traditional woodwork joints. Medium-density fiberboard is a stable product that does not absorb moisture, warp, shrink, or expand, thus making it better than real wood for any application where wood will be painted. The major disadvantage of MDF is in cutting it. When it is cut, MDF releases particles of formaldehyde into the air. Formaldehyde comes from the resins used to bind the small fibers together. Formaldehyde can cause irritation to lungs and eyes, so a facemask should be worn when cutting or sanding MFD. Another disadvantage of MDF is that traditional nails will not hold as well as in wood, causing alternate fasteners to be used.

ALTERNATE USES OF WOOD PRODUCTS

Cork

Cork is a product from the bark of the Cork Oak tree that grows in Portugal, Spain, and northwest Africa. It has been part of the culture of the Mediterranean region for centuries, where there are large Cork Oak forests producing mature cork. Cork cannot be harvested until the tree is more than 25 years old with a 24-inch circumference. Immature bark would be brittle, show a darker color, and lack the thermal and acoustic values that cork is known for. Bark is removed from the trees every 9 years, with no damage to trees. This allows the tree to continue growing and producing bark again, making cork harvesting a sustainable practice, since Cork Oak trees can live up to 250 years. In harvesting cork, chemicals are not normally used, making cork a green product. A Cork Oak tree that has its bark removed every 9 years will absorb three to five times as much carbon dioxide than a similar tree with bark intact. Storing carbon is a sustainable quality.

Cork consists of microscopic pockets of air encapsulated by the cork fiber lignin. This cellular structure gives cork tremendous thermal and acoustic properties. Cork is often used for interior surface covering for its sound absorbing quality and thermal insulation value. The sound-deadening qualities work for both absorbing impact sound and preventing sound transmission between rooms. Cork also has natural fire resistance qualities.

FIGURE 3.25 Cork Flooring Provides a Look of Natural Materials and a Soft Feel in a Commercial Workroom.

Additionally, cork can be used for flooring in either tiles or planks. Cork tiles used in the 1940s and 1950s were made from shredded cork that was compressed into a block, then sliced into tiles. Tiles of compressed cork looked granular and bland. There was no distinction in color or pattern, which resulted in a homogeneous appearance. Today, tiles are made of cork veneer that can have various colors and patterns designed into it. The veneer is mounted onto a conglomerate cork backing, and the tiles remain 100 percent cork. Tiles are soft and thin, so when they are glued to the floor, they show any texture or unevenness below them.

Tile planks have cork on the top and bottom, with MDF sandwiched between. This construction makes them thicker and they are attached to each other instead of the floor. This eliminates the possibility of a texture showing through the cork, but it adds the risk of water damage. The MDF core is susceptible to moisture and will not return to its original shape if it absorbs moisture or water. Cork planks made in Portugal are considered low VOC. Planks from other countries might use a high VOC for the MDF core. A downside of using cork for flooring is that cork is soft and impressions are retained in its surface temporarily. However, cork consists of microscopic air pockets, allowing it to return to its shape. This is known as **impact memory**.

Cork floor installation

Cork tiles are installed by the glue-down method. The tiles are soft and thin, making an absolutely smooth surface imperative. Contact cement is used to make a good contact with the subfloor and to prevent edges from curling up. The tiles need to have weight applied with a roller to ensure there are no air pockets under the tiles.

Installation of cork planks is done by using the floating method. The planks are attached to each other, not the floor, with a slight gap at the perimeter of the room. The plank floor becomes a unit that can shrink and swell with humidity changes, and needs ½-inch space to expand. It is important to keep water away from the cork planks due to their MDF core that is susceptible to water damage.

Linoleum

Linoleum was developed in 1860 and widely used until the 1950s as a floor covering. The backing was fabric, either cotton canvas or jute, and the top was printed with a colored design. It withstood foot traffic well and was used in places that needed a durable surface, such as corridors. The design printed on the top wore off due to lots of foot traffic. A process of making a pattern with colors going all the way through the material was developed, called **inlaid design**. To make the inlaid pattern, a metal stencil of the pattern was laid on the backing and colored granules of linoleum were placed in between the metal outlines. As the sheets of linoleum were heated, the color granules fused to the backing. The advantage of inlaid color is that the pattern does not wear off. Linoleum was used on the decks of battleships until the attack on Pearl Harbor revealed how flammable it was. Linoleum was known for use in kitchens because it was easy to clean with water. Although linoleum has mainly been replaced by the use of PVC (polyvinyl chloride) flooring, it is still used in places that need nonallergenic finishes and sanitary conditions. Currently, linoleum is produced under the trademarked name of Marmoleum by Forbo and the trademark name of Harmonium by Johnsonite.

Linoleum is a renewable product, made of organic products, mostly wood products. It is considered renewable because the natural raw materials are available in abundance. These are linseed oil, pine rosin, ground cork dust, wood flour, and mineral fillers. Linseed oil comes from the seeds of the flax plant. Rosin from pine trees is the binding agent in linoleum. Oxidized linseed oil and rosin are combined to form linoleum granules and give strength and flexibility. **Wood flour**, sawdust from hardwood trees, is used to bind mineral color pigments to the linoleum.

For several reasons, linoleum is used in health-care facilities. Linoleum contains no toxic materials. It is naturally antistatic and resists indentations. It also meets ASTM and NFPA criteria for smoke development and critical radiant flux with a Class I rating. Linoleum is not affected by blood or other body fluids and can be cleaned with most chemicals, although

some chemicals, such as ammonia and sodium hydroxide, will cause linoleum to soften.

Linoleum is available in tiles or very wide rolls, approximately 80 inches wide. This allows it to be easily installed in commercial spaces. Seams, if any, can be heat welded, yielding a homogenous flooring finish, which is necessary in places that cannot have bacterial growth. The backing may be jute and the installation can be done with low VOC adhesives.

The life span for linoleum is about 25 to 40 years. When the life of a linoleum floor covering is over, it can be burned in an energy-recycling incineration plant or safely added to landfill refuse sites to decompose. Recommended maintenance is to sweep and vacuum dust and dirt. Water and chemicals can be used when necessary.

Wallpaper

Wallpaper is made from wood pulp mixed with chlorine dioxide and oxygen, which separates the lignin from the rest of the wood pulp and bleaches the pulp. Wallpaper made for commercial use is different from wallpaper made for residential use. The differences are in weight of the paper, serviceability, size of the paper, and quality standards. Residential-use wallpapers are lightweight and come in narrow rolls, usually 20 to 28 inches wide and 15 yards long. Residential wallpaper is priced by the single roll or bolt, but sold in double or triple rolls or bolts. Residential-use wallpaper includes grasscloth. *Grasscloth* is made from strands of grass laid horizontally with very fine strings of fiber vertically holding the grasses in place. The grasses give a unique natural quality to the wallpaper and the appearance of being handmade.

Commercial wallpapers are packaged in wider rolls, normally 54 inches wide, and 30 yards or 60 yards long. They are sold by the linear yard, which is 36 inches length of the paper, regardless of the width. Commercial wallpapers have an acrylic or vinyl coating to meet or surpass minimum physical and performance characteristics. The Chemical Fabric and Film Association produces guidelines for quality standards of commercial wallcoverings. The requirements are for minimum coating weight, tensile strength, tear strength, abrasion resistance, flame spread, and smoke development. Commercial wallpaper is used in hospitals, hotels, nursing homes, and office buildings. It is used on walls because it holds up to abrasion better than painted walls and adds subtle decoration.

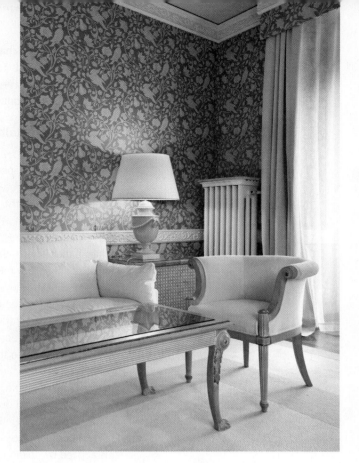

FIGURE 3.26 Wallpaper Adds Pattern to a Room and Gives It an Additional Texture. photobank.ch/shutterstock

History of wallpaper use

The earliest known use of wallpaper was in China where rice paper was mounted to walls as early as 200 B.C.E. In Europe, religious images were painted on paper and pasted to interior walls in the early thirteenth century.

Wallpaper did not become an important decoration until the late seventeenth century in England. It gained in popularity and was widely used in the eighteenth century. Early European wallpapers were printed by hand with block-printing. Wallpaper was made in sheets that were 3 feet by 2 feet. One technique embossed wallpaper by adhering a powder of wool particles to the paper with oils. Another technique simulated stucco. Wallpaper was not applied directly to the wall. It was applied to a canvas that had been stretched over a wood frame. The frame was fastened to the wall. Interestingly, wallpaper was not used in dining rooms due to the fact that the canvas and wool dust would retain food odors. By the eighteenth century, American interiors walls were covered with wallpapers from Europe. These early wallpapers had a backing of cotton.

Due to the Industrial Revolution in the late nineteen century, the paper industry was able to produce paper in long rolls, and wood pulp became the backing for wallpaper. The

printing method changed to a cylinder printing technique instead of block-printing. Each color was applied separately, but the labor was much less intensive with the long strip of paper rolling between two cylinders. By 1885, it was cheaper to cover the walls of a house with wallpaper from wood pulp than to paint them.

Wallpaper installation

Wallpaper should be specified with its dye lot number to make sure all rolls are of the same dye lot. All wallpapers except textures and murals have a pattern repeat. The *repeat* is the vertical distance between a point in the design and the place where that point in the design appears again. If the wallpaper design needs to match from one strip to the next, then each strip needs to start at the same point in the design, causing waste between strips of wallpaper.

Wallpaper needs to be applied to a smooth surface. If the wall surface is lightly textured, liner paper is recommended to smooth the surface. For a more pronounced texture, a skim coat of sheet rock mud can be applied to make it smooth. Sizing must be applied to the walls before applying the wallpaper. Sizing seals the surface against alkali and provides a texture for the wallpaper to grip. The sizing and the type of adhesive must be compatible. The wallpaper manufacturer will specify which type of adhesive to use.

If there is a repeat in the pattern that needs to match, then there will be some wasted wallpaper between the cut strips. Wallpaper needs to be unrolled and cut to the height of the wall plus a few inches. The next strip of wallpaper needs to be matched to the first strip, and cut the same length, in the same place on the pattern. Rolling the paper the opposite direction takes the curl out, to help it lie flat. The adhesive is applied to the back of the wallpaper with a wide brush. The lower part of the strip of wallpaper is loosely folded up, adhesive sides together. This allows the backing to absorb moisture and controls shrinking. The paper is applied by holding the top edge up to the top of the wall. When the top edge is pressed in place, the lower strip is unfolded, but not pressed to the wall until the strip above is smoothed, starting at the top and working down. Each strip is applied until the area is covered. Last, a razor edge is used to trim the excess paper at the base molding and a side edge or molding.

Maintaining wallpaper consists of removing dust on the surface. Paper and grass cloth should be vacuumed to remove dust. If more cleaning is needed, use a wallpaper eraser, or for removing something that is water soluble, pat lightly with a slightly damp sponge. If paper becomes wet, it will not return to the same texture and appearance it had before.

Application: Using Information Regarding Interior Finish Materials

CODE ISSUES

Fire resistance for wood is very good. According to Woodworks.org, wood outperforms non-combustible materials in direct comparison fire tests. Because of wood's unique charring properties that protect it from fire, a 2 by 4 wood timber maintained more of its original strength under higher temperatures and for a longer period than did aluminum alloy or unprotected steel.

Smoke density testing of wood products normally stays under 450, a limiting value determined by a complex calculation commonly used in building code regulations. Smoke is important for fire safety because most fire fatalities are caused by inhaling smoke.

Flame spread requirements for interior finish materials are typically mandated by building codes. These will vary according to the building occupancy, location of material, and presence of sprinklers. Flame spread ratings are determined by ASTM E84, the standard test method for surface-burning characteristics of building materials. The test uses a small (12 inches high by 17.75 inches wide) 25-foot-long chamber with gas burners at one end. The material sample is placed in the chamber and the burners are lit. The distance the flame travels under a controlled air flow during 10 minutes determines the classification of the

material. Most tested wood products have a flame spread index less than 200, making them acceptable under current building codes for a wide range of interior finish uses, according to the American Wood Council.

Class of Material	Flame Spread Index	Acceptable use for material
Class I or A	0–25 feet	Enclosed vertical exits
Class II or B	26–75 feet	Exit access corridors
Class III or C	76–200 feet	Interior rooms and areas

SPECIFYING

Wood will be listed under different CSI divisions according to the form it is in when it will be installed in a building. The general division for Wood, Plastics, and Composites is Division 6. Architectural woodwork is in Section 06.40.00 and finish carpentry is in Section 06.20.00. When wood is used for a door or window, it will be in Division 8, Openings. Many wood products will be in Division 9, Finishes. Here, you will find ceilings in 09.50.00, flooring in 09.60.00, and wall finishes in 09.70.00. If wood is used for cabinetry, it may be in Division 12, Furnishings. Casework is in Section 12.30.00.

When specifying wood, the species of wood and grade of wood should also be called out. Wood is graded according to how many defects show on the surface of the board. There are different standards for softwoods and hardwoods. Softwoods are allowed more defects in the higher grades than hardwoods may show. Please refer to the resources at the end of the chapter for descriptions of grading in hardwoods and softwoods. To specify a quantity of lumber, the measure is a *board foot.*

Lumber is priced by the board foot. A **board foot** is the amount of lumber in a piece with nominal dimensions of 1 inch thick, 1 foot wide, and 1 foot long. (The actual dimensions of this board are ¾ inch thick, 11¼ inches wide, and 12 inches long.) To calculate the board feet in a piece of lumber, multiply the thickness in inches, by the width in feet, by the length in feet.

LIFE CYCLE COSTS

Solid wood has a low life cycle cost because it can be recycled, resurfaced, renewed, and reused for hundreds of years. Wood is a sustainable product that can be reproduced by growing trees that take anywhere from 30 to 90 years to mature. The faster a species of tree grows and the easier it is to harvest, the less it will cost to regenerate. When considering wood as a raw material, we consider efficiency in production and natural resource conservation as well as efficient, profitable use of solid wood, its residues, and its by-products. Waste from sawmills is used to make some products combined with toxic adhesives. Although these products have a long use life, their decomposition is a problem.

INSTALLATION METHODS

Wood flooring can be installed in straight strips or in patterns. Patterns take more time to figure out the cuts of wood and careful placement to create the pattern, but they add

Wood Used in an Interior

Floors
Wood strips or planks
Bamboo planks
Plywood subflooring

Walls and Dividers
Solid wood wall panels
Wood paneling wallcovering
MDF substrate for other finishes

Ceilings
Wood ceiling planks
Wood ceiling tiles
Wood ceiling beams

Kitchen and Bath
Butcher block countertop
Cabinets
Kitchen accessories

Architectural Trim
Wood trim around wall base or openings
Fireplace mantel and trim
Stair treads, balusters and handrails

Signage
Wood plaque signage

Hardware
Cabinet hardware

Light Fixtures
Housings and grilles

Furniture
Tables and desks
Chairs
Cabinetry

Window Treatments
Wood blinds
Paper window shades

Doors and windows
Solid wood doors
Hollow core wood doors
Wood framed windows

Alternate Uses of Wood
Substrates for other materials

sophistication and interest to the floor. Start a pattern by choosing a focal point, such as a fireplace, and working the pattern out from there. There are three methods for installing wood flooring:

- **Floating:** Floating is a very stable installation method because it's not attached to the subfloor. It floats above it, allowing for the natural expansion and contraction of the hardwood.

- **Gluing:** This method is primarily used when installing engineered wood strips or planks over a concrete subfloor. Glue-down installations can be very stable if properly installed. This method is recommended for those who have experience working with subfloor preparations, as it is critical that the subfloor be level.

- **Nailing:** Nailed-down installations are used when installing solid and engineered wood flooring. Solid wood flooring expands and contracts more than engineered and laminate flooring, so take care to **acclimate** the wood to your interior before starting the installation. Nails should go through the face of the boards and should be long enough to penetrate the subfloor by at least 1 inch. This method of hardwood flooring installation is not recommended as a do-it-yourself project.

Cabinet Installation

Cabinet installation is started by checking to see that all pieces on the drawing are at the site. Upper wall cabinets are hung first, starting with the corner, before base cabinets are in the way. A level line is drawn on the wall at 54 inches AFF. If a crown molding is to be installed, consider its placement for the molding at this time. Cabinet boxes are attached with 2½-inch finish screws to the wall studs without doors or drawers for easier installation. All cabinets should be checked for levelness as they are attached to the wall. The upper cabinets are clamped and screwed to each other as they are mounted to the wall. If cabinets do not meet due to the walls not being square, fill in with shims to keep the cabinets level.

After the upper wall cabinets are installed, put the base cabinets in position. If they are not being placed on the finished floor, take the finished floor height into account so appliances will be level with the base cabinets. Make sure they are level, or shim them to be level before attaching them to the wall. Also, make sure the fronts of the cabinets are in a straight line and shim to the back wall where necessary. Where plumbing or electrical access is needed, cut the back of the cabinet to line up closely with the fixture. Start attaching the cabinets to the wall at the corner, then other cabinets with critical placements. Use shims or fillers where it is necessary to make the cabinets level. Clamp and screw the cabinets to each other. Attach fillers, trim, and toe kick with indiscreet finish nails. Install the doors and check that they are square with the cabinet. Insert the drawers into the drawer cabinets, making sure they glide easily.

Mark drill holes for drawer pulls to be placed in the center of the drawer front. Cabinet door knobs should be in the corner opposite the hinge and closest to the countertop for ease in opening the doors. If crown molding is used, it attaches to the top of the cabinets and requires the use of a **miter** saw to cut the corners. If a light rail is used, it attaches to the bottom of the upper wall cabinets and requires the use of a miter saw for the corners. Both can be nailed to the face frame of the upper wall cabinets with brads or finish nails.

MAINTENANCE

Wood needs to be protected from drying out. To keep wood's moisture intact, a finish of oil or a protective coating must be applied. Most wood will have a protective coating of lacquer, varnish, stain, or paint on it. For these finishes, the wood surfaces need to be cleaned of dust and debris in the air. To remove dust, use a feather duster or soft cotton cloth prior to cleaning. Wood should not be wet, but cleaning can be done with a slightly damp cloth. Murphy's Oil Soap or other wood cleaner that does not contain waxes or silicone oils can be used when diluted with ten parts water. Do not use soaps, cleaners, solvents, waxes, ammonia, glass cleaner, or other household chemicals containing alkaline. If the finish on the wood is oil, the same type of oil should be applied after the wood is cleaned. Oil finishes need to be reapplied often to keep moisture in the wood.

Case STUDY *of Wood and Wood Products*

Interior Application

A client having a new house built wanted to create an "elegant and impressive library." The designer was also the builder in this project. Steve Spanjer of Spanjer Homes in Fort Collins, Colorado, has over 30 years' experience building custom homes for clients. To create an impressive look, the ceiling was raised from a normal residential level of 8 feet, to an impressive height of 14 feet. The library shelves, fireplace surround, and mantel were constructed of wood and wood products. Since different materials were used for construction, paint was applied to give the consistent appearance. In choosing the wood to be under the paint, care was taken to be sure the wood would not have a grain showing through. Poplar was chosen for some trim pieces because it shows little graining, is inexpensive, and is soft, which makes it easy to shape.

Maple was chosen for the cabinet doors because it is stable (stable in the sense that it does not react to humidity, which would keep the paint from cracking). Also, maple is a dense hard wood with little graining, it holds screws better than MDF, and paint looks extremely smooth on it, adding an elegant feeling to the room. Intricate pattern trim was made from resin castings, but the long strips of molding trim were made of poplar wood. Medium-density fiberboard was used for structural pieces, such as the vertical sides of the fireplace opening, the mantel top, and the ceiling beams. The edge trim applied to these structures was poplar millwork. This one room was so intricate that it took three master carpenters one month to finish building. After that, it required a great amount of sanding to get every surface smooth enough for paint. The painting took another month.

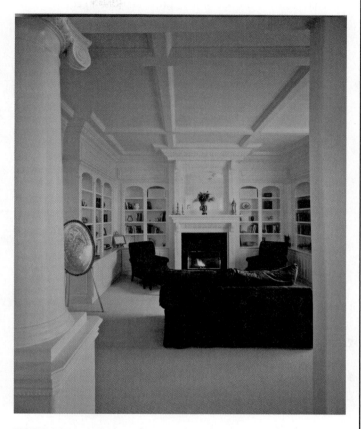

FIGURE 3.27 To Create an Elegant and Impressive Library, Wood and Wood Products Were Chosen. Spanjer Homes

summary

Wood is used in many forms in interiors. You will see pieces of solid wood used for ceiling beams, doors, stair railings, architectural millwork, cabinet doors, and flooring. Wood veneers are used for wall paneling, cabinetry, flooring, and specialty ceilings. Wood chips are made into particle board or medium-density fiberboard for substrates in constructing floors, cabinets, and countertops. Wood is ground into a pulp to make paper that is used to cover interior walls or cover frames to become interior wall screens.

Wood has been used for interior surfaces in buildings as long as structures have been built. It is a natural resource from trees, which grow wherever they can get water. Trees are important to

the earth's atmosphere; they clean the air and absorb carbon dioxide. Therefore, it is important to harvest trees selectively, allowing for trees to be replanted and the forests to be regrown. Wood's main disadvantage is that it will burn. When wood burns, it emits carbon dioxide and toxic chemicals into the environment.

New products from different types of plants are available that have many similar properties to wood. The newer products are from rapidly growing trees, which allows more products to be produced in a few years. The fast growth allows them to be considered renewable. As a result, they are more sustainable than hardwoods, which require many years to reach maturity.

To find out more about wood, the following websites and publications of professional organizations in the wood industry can be useful:

American Wood Council: http://awc.org/publications

Architectural Millwork Drafting: http://amdrafting.com/organization.aspx

Architectural Millwork profiles: www.archmillwork.com/archmillwork_stock_catalog.pdf

Architectural Woodworks Standards: www.awinet.org/store/publications.cfm

Ferche Millwork and Moulding catalogs: www.ferche.com/catalogs/

Forest Products Laboratory. *Wood Handbook: Wood as an Engineering Material*. Madison, WI: United States Department of Agriculture Forest Service, 2010. This contains excellent descriptions of species of wood with line drawings in Chapter 2. www.fpl.fs.fed.us

Forest Stewardship Council: www.fscus.org/

Greenspec rates embodied energy of materials: www.greenspec.co.uk/embodied-energy.php

Harwood species (to see different species of wood, select species guide): www.hardwoodinfo.com/articles/view/pro/24/267

Illustrated Guide to American Hardwood Lumber Grades: www.ahec.org/hardwoods/pdfs/IllustratedGradingGuide.pdf

This site shows how to use moldings to create a wall trim or mantel: www.mouldingandmillwork.com/buildups.php

National Hardwood Lumber Association: www.nhla.com/

WoodWorks: www.woodworks.org

review questions

1. Explain what causes knots in lumber and discuss their desirability.
2. Describe how hardwoods differ from softwoods in leaves, weight or strength, absorption of stains, and grain pattern.
3. Describe the difference between rotary cutting wood for veneer and plain sawn lumber.
4. Analyze the properties of cottonwood and describe why it is not used for flooring, cabinetry, or furniture.
5. Evaluate the environmental impact of specifying cork flooring for a project as opposed to oak flooring.

glossary

Acclimate is to adjust to the climate, including temperature and humidity.

Adhesive is a substance capable of holding materials together by surface attachment.

Beam is a horizontal structural member supporting a load applied transversely to it.

Bioenergy is energy derived from biological fuel, such as farm animal or grain waste.

Biophilia is a term created by German psychologist Erich Fromm that relates to the instinctive bond that exists between humans and other living systems.

Boxed beam is wood built into a box shape running across the ceiling; it is not supporting beams.

Burl is a woody outgrowth on a tree, rounded in form, showing in lumber as a severe distortion of grain, usually resulting from overgrowth of dead branch stubs.

Cambium is the layer of active cell growth in a tree just below the outer bark.

Cellulose is the fibrous substances that make up the cell walls of plants.

Coniferous is a type of tree that has needle-shaped leaves and retains most of them each year.

Corbel is an "L"-shaped bracket attached to a vertical surface to support a horizontal surface.

Cross-laminated timber (CLT) is comprised of boards stacked together at right angles and glued over their entire surface.

Cupping is a term describing wood boards where the long sides pull toward each other and create a convex side, resulting in a concave side on the other side of the board.

Deciduous defines a type of tree that has broad leaves and drops its leaves each year except in tropical climates.

Dry rot is a name for decay caused by fungi in wood that appears to be dry.

Eased is a term used for slightly rounding the edges of a square-cut board, either by sanding the sharp edge or using a router bit to take the sharpness off the corner edges.

Embodied energy is the quantity of energy required to harvest, mine, manufacture, and transport to the point of use a material or project.

Engineered wood is made of wood particles or cellulose fibers combined with adhesive to produce a product manufactured to meet engineered specifications for strength and tested by national standards.

Glue is originally a hard gelatin obtained from tendons, cartilage, and bones of animals, prepared with water and heat. The term is now synonymous with the term *adhesive*.

Glulam is a type of load-bearing beam made of layers of wood laminated (glued together).

Grain is the direction, size, arrangement, appearance, or quality of the fibers in wood or lumber. Its appearance is different according to the angle from which the wood log was cut.

Green lumber is freshly cut trees that have a high moisture content known as green wood.

Hardwoods are wood from deciduous trees.

Heartwood is the dark colored wood in a tree where the cells are no longer active in transporting sap.

Hygroscopic is something that expands when it absorbs moisture and shrinks when it dries or loses moisture.

Impact memory is when a material can recover from the indentation caused by a weighted impact such as an impact from furniture legs or small heels on shoes.

Inlaid design is when color for the design becomes part of the material through heat fusion. The color goes through the material, from the top surface to the backing.

Knot is a limb embedded in a tree that has been cut through during the milling process.

Lumber is wood cut from a log that was a tree.

Marquetry is made of small pieces of wood cut into intricate patterns that are not geometric.

MDF (Medium-density fiberboard) is an engineered wood panel with a smooth finish for painting.

Millwork is long lengths of lumber that have been shaped into a profile, used for trim around architectural openings.

Miter is used to cut wood on a 45-degree angle. This results in one seam on the corner where the two pieces join.

MJ/kg signifies megajoules per kilogram as a measurement of nonrenewable energy per unit of building material.

Nominal is the name given to a piece of lumber, not the actual size.

OSB (Oriented strand board) uses long strands of wood in opposing directions to give strength to particleboard.

Parquet originally meant a raised platform area for royalty. Later, it referred to small pieces of wood cut into geometric designs and laid to have a level surface floor.

Particleboard is made of wood chips or flakes glued and processed into 4-foot by 8-foot sheets.

Planing is a process used to shave off the rough edges and make the board smooth.

Plywood is a panel made up of thin layers of wood placed at right angles to each other and glued.

Profile is a term that describes the shape of a piece of millwork when viewed from the side.

Sapwood is the light colored part of a tree where cells are active in carrying sap from the roots up to the leaves.

Sawmill is a facility where tree logs are cut into lumber or boards.

Seasoning is the process of reducing the moisture content of wood. When a tree is freshly cut, the wood has a high moisture content. It must be dried either by evaporation into the natural air for a season, or by dry air from a kiln.

Softwoods are wood from trees that produce cones and have needle-like leaves.

Surfacing is using a planer to shave off the rough edges of a wood board.

Wood flour is fine particles of dust from hardwood trees used as fillers in products.

Stone

learning objectives

When you complete this chapter, you should be able to:

1. Recognize terms used when discussing stone.
2. Identify common uses of stone in an interior.
3. Summarize the history of stone use in interiors.
4. Describe how stones are produced.
5. Describe how stone meets code requirements for interior use.
6. Describe and analyze the physical characteristics and properties of stone products for a specific interior use.
7. Analyze the environmental impact of using stone.
8. Evaluate how well stone will meet the specific needs of a design project.

Awareness: An Overview

DESCRIPTION AND COMMON USES

Natural stone is one of the oldest and most durable building materials. Stone is used in almost its natural state, with less processing than most other materials. When we see ruins of a civilization, stone is usually what is left of an ancient culture. Because buildings of stone are still standing, or partially standing, we have learned to equate stone with stability and permanence.

Stone has been used for the most important community structures, such as religious and government buildings.

Interior of a Ancient Stone Interior. Stone is the finish for the interior of this Cathedral in Lisbon, Portugal.
Horvath Botond/Fotolia

There are pre-historic remnants of temples made from sandstone in Egypt and limestone in Greece and India. Granite was used at **Machu Picchu** in Peru. The pre-historic cultures used post and lintel construction, with the earliest stone arches appearing over 5,000 years ago in northern Mesopotamia (Iraq). Romans used limestone in arch construction for buildings and bridges more than 2,000 years ago. Because of the association with permanence, stone is often the preferred building material of people who can afford it. The labor is the most costly part of stone construction due to the fact that it requires skilled workers.

A great many public and religious buildings in the United States are made from limestone because Limestone is abundant in the midwestern United States. The supply in Indiana alone is expected to be available for at least another 600 years, possibly more than 1,000 years. Limestone has been used for all types of building, from rustic cabins to capitol buildings. In the mid-1800s, machinery advances increased the production of limestone so that it

FIGURE 4.2 The New American Home, 2009. The photo features travertine in honed Durango on a 16-by-16 patio floor. Image used with permission of Dal-Tile Distribution, Inc.

could be supplied to more building projects than before. Building projects were plentiful in the United States in the late 1800s due to rebuilding after the Civil War and the Great Fire of Chicago in 1871. Limestone, marble, and granite were used for many of the neo-classical buildings—especially government buildings and banks—built before and after the turn of the twentieth century.

Stone is used in many interior applications, both as a finished surface and as a structural component. Until the twentieth century, stone was used in large solid blocks. When you saw stone on the outside of a wall, the stone would be approximately 12 to 18 inches thick and visible on the inside of the wall. Today, stone is used in much thinner slabs, allowing it to more easily be used for interior surfaces. Stone used for a floor may be 3 to 4 inches thick, whereas stone used on the face of a wall may be less than 2 inches thick.

CHARACTERISTICS

Stone is a natural material extracted from the earth. It does not burn and it is fire resistant. Stone absorbs heat and retains heat well, and because of this, it is cool to the touch. It is normally dense, creating heavy weight. Architects and engineers must make sure a building structure can support the weight of the stone, which is expressed in weight per unit of volume.

Also, stone is **porous**; it absorbs water and other liquids that can create stains. Water absorption is a measure of porosity of a stone, and it can be an indicator of susceptibility to damage in freezing conditions. The maximum allowable water absorption for stone ranges from 0.20 percent for marble to 12 percent for limestone.

Compressive strength is a measure of the resistance to crushing loads. The compressive strength is the maximum load per unit area that the stone can bear without crushing. Values range from 1,800 **pounds per square inch (psi)** for marble, to 19,000 for granite—granite being the strongest under compression.

Abrasion resistance is also known as resistance to wear; it determines whether a stone is suitable for use as a flooring surface. The abrasion test has a result of an index number, generally scaled to range between 0 and 100. Softer stones such as sandstone and slate will have an index of approximately 8, marble and limestone will have an index of approximately 10, and granite, the hardest, will have an index of at least 25. Resistance to abrasion is highly correlated to **Knoop micro hardness**. The Knoop micro hardness test represents the relationship between a load acting on a diamond penetrator and the area of the impression achieved on the stone.

Fissures occur naturally in many stone types. A fissure is defined by the American Geological Institute as "an extensive crack, break, or fracture in the rock, which may contain mineral-bearing material." The term *fissure* is used commercially in the stone industry to describe a visible separation along intercrystalline boundaries. This separation may start and stop within the field of the stone or extend through to the edge. A fissure differs from a crack in that it is a naturally occurring feature in the stone (Marble Institute of America, 2007).

ENVIRONMENTAL IMPACT

The environmental impact of stone is positive with very low **embodied energy**, meaning that processing stone uses little energy. Stone also has **thermal mass**, allowing it to hold heat and release it slowly back into the air. Stone is usually available within 500 miles of a building project, which meets LEED criteria for local resources. After stone is removed from a **quarry**, the quarry can be filled in and covered with soil and grass for cattle grazing land, as it was before the stone was extracted.

Properties of Natural Stone

(sustainable characteristics are denoted with green color)

- Stone does not burn.
- Stone is available locally in most areas.
- Stone has a low embodied energy-production cost.
- Stone has thermal mass-retention of heat.
- Stone is inert—it does not give off toxic fumes.
- Stone is available in abundant quantities.
- Stone can be salvaged and reused.
- Stone is strong under compression.
- Stone is low in sound absorption and provides good acoustical reverberation.

Stone is often used in kitchens or bathrooms to create an earthy feeling of natural simplicity and provide a durable surface that will not need much maintenance, considering the water or humidity that will be present. The photograph is of a residential bathroom where tumbled marble tiles were used for the wall above the sink to provide a feeling of nature incorporated with the function of washing. The color and simplicity of the sink in a stone composite by Swanstone Corporation blends with the natural color and feel of the tumbled marble tiles. The stone composite sink is seamless for easy cleaning and prevention of mold growth.

FIGURE 4.3 Composite Stone Sink. This Swanstone composite stone sink provides an easily cleanable surface to blend with the tumbled marble tile wall in a residential bathroom.

Indoor Air Quality

Due to its **inert** quality of not giving off any gases, stone has little direct impact on indoor air quality. Most stone is smooth and does not harbor bacteria; however, some stone used indoors will have a rough texture and hold dust or bacteria. In the case of lava rock or travertine, there are holes through the stone where organisms such as mold could live. Sealing or deep cleaning could solve these potential air-quality problems. When stone is set without the use of mortar, it is environmentally friendly. The use of mortar reduces the sustainability due to the absorption of carbon dioxide when the mortar is drying. Lime mortar is more sustainable than other mortars because it absorbs less carbon dioxide.

Understanding: In-Depth Information

HISTORY OF STONE USE IN INTERIORS

The earliest surviving human dwellings were stone caves. Drawings have been found on the stone walls of caves from France and Spain dating to 14,000 B.C.E. Other pre-historic locations show that stones were moved to construct structures. Because of the weight of

stone, it required many people to move it; thus, only religious or monumental structures were built of stone. Early civilizations such as those in Mesopotamia (3200 B.C.E.), China (2800 B.C.E.), and Egypt (2600 B.C.E.) used stone for construction of their important buildings. Even where stone was not present, such as in some of the flat land of Egypt and Iran, it was important enough that large stones were moved over distances of hundreds of miles to the construction site.

Before the time of recorded history (500 B.C.E.), stone was used for building in the **post and lintel** construction style, where vertical posts held up a horizontal lintel. This was a common building technique in Egypt, Greece, and Mesopotamia. Stone was good for the vertical posts or columns because of its high compressive strength. However, stone is low in **tensile strength**, which is needed for spanning distances. Column spacing was limited to the length of a stone, dictating that the vertical elements needed to be placed close together. Hand-carved stone columns replaced posts in more decorative architectural construction, becoming very important cultural icons.

Marble was plentiful in Greece and on the Aegean Islands close to Greece. The Minoans and later the Greeks used marble blocks held together by metal clamps (instead of mortar) for building. Classical Greek (500 B.C.E.) structures used marble and limestone for floors and fluted columns in temples. As stone working tools changed from bronze to iron, stone building techniques developed, allowing larger enclosed spaces to be constructed. Trusses were used extensively in ancient Greece. The **truss**, being a triangular shape, can span a long distance. This allowed the interior spaces to be more open, not requiring the closely spaced columns previously used.

Romans gave more attention to interior spaces and used more materials than the Greeks did. Alabaster, lava, and travertine were used in addition to marble and limestone. Both Greeks and Romans used mosaics for decorating floors. Mosaics were made of **tesserae**, extremely tiny pieces of stone or glass set in mortar to form a design. Because of the weight of stone, it was used for ground floors over earth, but not used for upper floors.

By the fourth century B.C.E., Romans were using **arches** to transfer the horizontal load, which allowed columns to be spaced farther apart. An example of the use of arches is the Colosseum in Rome, built in the first century C.E. The exterior of the Colosseum consisted of 80 travertine arches. The basis of stone arch construction was to first construct a wood frame in the shape of an arch. The stone work was built up around the frame starting at the bottom of the arch with wedge-shaped stones. At the apex, a **keystone** in a wedge shape was set in to hold the other stones in position. Each wedge-shaped stone would **thrust** downward. Arches continued to be used into the early Christian era (313 to 476 C.E.) in Rome. Roman building technology was also used in Constantinople in the Byzantine era (482 to 1453 C.E.), including mosaics in tesserae and arches.

FIGURE 4.4 Brick and Stone Voussoir. Interior of the Great Mosque in Cordoba, Spain.
PHB.cz/Fotolia

Byzantine decoration became more elaborate and changed the shape of arches. In arches, stone was often alternated with brick, giving a red and white striped effect called **voussoir**, referring to the wedge-shape pieces forming the arch. Mesopotamia adopted the Islamic religion after 622 C.E., and Islamic people carried the striped arch motif across northern Africa through Morocco into Spain. Islamic arches added ogival, scalloped, multilobed, or a curve inward at the bottom, forming a horseshoe shape. This motif was seen in Spain from 785 C.E., when the Great Mosque at Cordoba was started, through construction of The Alhambra (1338–1390).

While Europe was in the Dark Ages (476 to 1000 C.E.), having lost most of the ancient Roman building technology, eastern regions under Byzantine and later Islamic rulers were thriving. From 1095 to 1291 C.E. European Crusaders traveled south to Jerusalem to fight Islamic forces for control of the Holy Land. The Islamic forces kept control, but Crusaders returned to Europe with the concept of a strongly fortified stone castle. Stone was used for the structural walls and ground floor covering in buildings that were considered important. Interior stone walls were kept refreshed by a whitewash containing lime to cover the soot deposited from fires.

Through the Gothic period (1150 to 1550 C.E.), stone could be found in interiors of churches and castles. When the castle walls were stone several feel thick, small spiral staircases were often carved in the stone walls. Gothic churches, found in France, Germany, northern Spain, and England, used stone walls and pointed arches to achieve higher interior spaces. The lower walls were fortified with stone **buttresses** (reducing the need for load-bearing walls) and ribbed vaults, diminishing the number of columns necessary. Higher parts of the walls had large window openings with stone **tracery** in the window. Gothic roofs were steep and often covered with slate stone tiles.

The Renaissance (1400 to 1600 C.E.) first appeared in Italy, striving to emulate Classical Roman and Greek forms. Stone, used for structural arches and columns, was a primary building material. In southern Europe, marble or limestone was used for floors and walls. For important rooms, the floor would be stone **parquet**, in patterns of circles or squares. The most important rooms had marble laid in checkerboard patterns. Stone or marble could also cover the lower part of the wall, the **dado**. Renaissance design moved to Spain, France, and England around 1500. Interior walls were generally covered in materials that gave a softer sound and warmer finish than stone would provide, but stone was used for trim around fireplaces, doors, and windows.

European construction techniques were brought to America from the 1500s to the 1800s. Most buildings were less palatial in America, using local materials, including limestone and granite that were abundant in northern and midwestern areas of the country. When stone was available, it was often used for fireplaces. Stone was often used for the end walls of colonial houses known as *Stone Enders*. In places where trees were not available, stone was used for walls. Fireplaces were the focal point of early American houses. These rustic construction materials were used across North America as the land was settled in the 1700s and 1800s. The American use of stone bestowed a rustic aura to interiors and has remained a common design theme. Stone is often used for elements such as a fireplace or column cladding to achieve a rustic and natural atmosphere in an interior.

FIGURE 4.5 Carved Stone Interior of the Alhambra in Granada, Spain. KateD/Fotolia

FIGURE 4.6 Stone Tracery. Stone tracery is shown in this Gothic arch window. cosma/Fotolia

TYPES OF STONE

Stone is categorized according to how it was formed in the earth: igneous, sedimentary, or metamorphic.

Quartz is found in all three types of rock. Quartz, known as rock crystal, is composed of silicon dioxide and is the most common mineral on earth. Some forms of quartz are semi-precious stones, and some forms are utilitarian. It can be transparent, translucent, or opaque. Colors of quartz are clear, white, purple, pink, brown, or gray.

Igneous rock

Igneous rock was formed by lava, molten magma, that went through cooling and crystallizing. Igneous rocks are generally the hardest, strongest, and most resistant to chemicals. Following are types of igneous rock.

- **Granite:** This igneous rock has crystals or grains of visible size, consisting of quartz and feldspar. Granite is normally specified as polished (mirror gloss) or **honed** (dull sheen). It is harder than marble and less susceptible to etching, making it difficult to scratch. It is often used for floors because it holds up well to foot traffic. It is also used for countertops because it can take heat up to 500 degrees Fahrenheit. Granite is found in Italy, Brazil, Peru, India, and in the northeastern and western mountains of the United States.

- **Serpentine:** Erroneously called "green marble," this igneous rock's color ranges from yellow-green to golden-brown, or black. Serpentine consists of magnesium iron silicate hydroxide. In a fibrous form it is asbestos. Normally, serpentine is used in interiors rather than exteriors because it does not stand up well to water.

- **Malachite:** This igneous rock varies in color from light to dark green. It is usually highly polished and used for accents such as fireplace trim. Malachite comes from Africa, Russia, Australia, and the United States.

- **Onyx:** Known for its warm, waxy luster and translucent stripes, this igneous rock is often used for lighting fixtures and decorative inlays in stairs, floors, and walls.

Sedimentary rock

Sedimentary rock was formed under oceans where sand, shells, and minerals sank to the bottom. The shells were crushed and redeposited by water currents, transforming them into calcium carbonate. They were compacted into layers by the weight of the

FIGURE 4.7 Different Finishes on Granite. Granite can be used for both a floor surface and a vertical surface as seen in this photograph of a performing arts center. The floor surface is a honed finish so that it will not be slick, while the columns have a polished finish. Both are made from the same color of granite.

FIGURE 4.8 White Marble. Stacks of marble blocks after being extracted from the Polycore Quarry in Marble, Colorado.

water. Many times you will be able to see the layers in sedimentary rock. Sedimentary rock is lighter weight than igneous rock and is porous.

- **Limestone:** Commonly used for exteriors of buildings, limestone may also be used for interiors to give a rustic look. It is too soft to take a polish. Acid rain will etch the surface. The largest deposits of this sedimentary rock in the United States are found throughout the midwest. There are especially large limestone quarries in Indiana. Colors of limestone are white, light gray, buff, blue, green, brown, and black. The stone is characterized by tiny sea shells visible in the face of cut stone.

- **Sandstone:** This sedimentary rock is commonly used for exteriors of buildings, but it can be used for interior flooring and countertops. It is highly resistant to acids, alkalis, and thermal impact (drastic change in temperature). Colors range from red, as in Colorado Red Rocks, to green, yellow, gray, white, blue, buff, brown, and black. Sandstone consists of sand, silica, clay, and calcium carbonate. It is characterized by the appearance of granules of sand.

- **Travertine** is derived from limestone. It is porous with visible holes, but a designer may specify filling the holes with cement. It is found in the Tuscany region of Italy, and not widely exported. The colors are usually white to light brown. Travertine is used for floors and walls, but water can be retained in the holes, making it a possible place for mold to grow.

Metamorphic rock

Metamorphic rock was formed by extreme pressure and high temperature, making it harder than it was before. Either igneous rock or sedimentary rock can be changed by extreme pressure and high temperature. During the metamorphic process the crystals in the rock change size, known as *recrystallization*. For example, small calcite crystals in limestone become larger when they transform into marble.

- **Marble:** Marble has always been considered a highly desirable material for its translucent look and soft colors. It is derived from limestone and is commonly used for floors, furniture tops, and countertops. Marble's main drawbacks are that it can be etched by acidic foods, and it is porous (absorbs oil, water, and stains). Marble usually has colored veins running through it; the different colors come from different minerals. Red-yellow comes from iron oxides, blacks and blue-grays from bitumens, and green from silicate chlorite and mica. Used for floors, walls, furniture tops, and exteriors, marble is usually highly polished to show off the colors, but it will also show scratches. Marble is thought of as a product of Italy, but there are large amounts in the United States. There are quarries of marble in Georgia producing several colors of marble. Also, there is a large quarry of white marble in western Colorado that supplied the marble for the Lincoln Monument and Arlington Cemetery. Currently, the quarry in Marble, Colorado, produces white marble shipped to Italy for the European market because it produces larger pieces of marble than Italian quarries.

- **Quartzite:** Quartzite is recrystallized sandstone. It is usually white or gray, but may have pink or orange colors when iron is present. Quartzite is a very hard stone used for road construction.

- **Slate:** This is a dense, fine-grained rock formed by compression of sedimentary rock shale. Common colors are gray to black, but some green, brown, and red are available. Slate is found in Great Britain, western Europe, eastern United States, Brazil, India, and China. Its natural finish has textural variations known as *cleft face*. Slate can be finished as either honed for a dull finish or rubbed to produce a smoother finish. Slate is commonly used for walkways today, but in the past, slate was used as roofing shingles.

- **Soapstone:** This metamorphic rock is very soft, so it does not take a polish, but it is dense and durable. It contains talc and other minerals. Soapstone is available in slabs up to 5 feet long. It does not react to heat, making it safe for countertops, fireplace hearths, and steps. It is nonporous, which is good for water and resisting staining. Soapstone starts as a light bluish-gray and is usually treated with oil weekly, which gives it a darker appearance over time.

FABRICATION OF STONE

Stone is extracted from the earth where a large amount of rock is found. In its natural setting, it is a rock, but after it is extracted from the quarry, it is called *stone.* The area where the rock is found becomes the *quarry,* and the stone extracted is named for the location of the quarry. What we consider stone color and pattern names are really the name of the location where that stone was quarried. For example, Carrara marble was quarried in Carrara, Italy. Similarly, Cottonwood limestone was originally found in Cottonwood Falls, Kansas, and is quarried in that general area.

Stone is extracted by drilling long, narrow, close-together holes into the stone. These long vertical holes perforate the stone so that it breaks along the line of holes. After a large piece is removed from the quarry, it is cut with a diamond-studded saw into manageable blocks or slabs. The slabs are numbered with spray paint as they are removed to a stacking area.

A water-jet cutting machine cuts the stone into the desired size pieces. The machine can cut angles less than one degree, which are for intricate inlay patterns. Designers must consider more than the appearance of color, texture, and grain size (petrographical) when selecting a block of stone to be cut. The cut direction affects the strength of the stone. Stone can be cut from the side of a block, the top of the block, or the end of a block.

Advances in technology have allowed for thinner slabs to be produced. Currently, technology can produce slabs as thin as 4 millimeters. These thin slabs are very fragile and need to have backing added for strength. Types of backing are aluminum honeycomb and fiberglass and epoxy resin.

Finishing

When a stone slab is moved to a fabrication mill its finish is decided. Polishing has been a traditionally desirable finish because polishing brings the variety of colors in the stone structure to light. Polished stone does not show saw or grinding marks. It is the easiest finish to clean, but it is also the slickest—a drawback for floors.

A flamed finish can be used on stones containing quartz. *Flaming* creates a rough texture with overlapping shadow lines that is nonslip but also hard to clean. The heat from flaming causes color changes.

FIGURE 4.9 Slabs of Granite, Marble, and Other Stones on Display in the Las Vegas Warehouse for Designers to Select for Projects. Image used with permission of Dal-Tile Distribution, Inc.

Here is a list of different types of finishes used for stone.

- Quarry-face or sawn-face shows marks of removal from the quarry.
- Hand finishes can be chiseled to produce a texture.
- Machine finishes can be *polished,* which is often described as mirror finish or high gloss; *honed,* which is a dull sheen; or *flamed*, which is a rougher finish.
- Sandblasting uses an abrasive to give a coarsely or finely stippled finish.
- **Tumbled** finish is the result of placing small pieces or tiles of stone into a barrel with abrasive grit and water. The barrel slowly rotates to texture the stone.

Resin coatings are used to protect stone, especially the polished finishes. These are used often in residential kitchen and bath design where the stone will have water used on it daily.

ALTERNATE USES OF STONE

Composite stone is a general term for a combination of crushed stones, called *aggregate,* that are added to a mixture of resin or cement to provide some of the characteristics of stone in an easier-to-use form. They can be poured for a floor covering or made into slabs. Three common types of composite stones are discussed next.

Terrazzo

Terrazzo was invented by Venetian construction workers as a low-cost flooring material using marble chips from larger marble flooring jobs. The original terrazzo was made from marble chips, clay, and goats' milk, but today's terrazzo is a composite of marble, quartz, and granite, for a minimum of 70 percent stone added to a cement binder, such as Portland cement, polyacrylic modified cement, or epoxy. Terrazzo is used mainly for floors. When it is poured to create a floor, usually the cove base is also poured, integrated into the flooring. Terrazzo is very practical for heavy-duty seamless surfaces for commercial and industrial applications. It is often used for commercial applications that will get a lot of traffic, such as schools, convention centers, medical facilities, airport terminals, and government buildings.

Terrazzo floors with cement can be up to three layers thick. The first layer is a poured concrete base 3 to 4 inches thick. When forms are removed, a layer of 1 inch of sandy concrete is added. Divider strips of brass or zinc are laid in the second layer. The third layer is a mixture of chips and cement poured between the strips with some additional chips laid on top. When the terrazzo is thoroughly dried, it is ground with a terrazzo grinder and polished. Terrazzo with a cement base is porous and requires a penetrating sealer for protection. This weighs about 5 to 7 pounds per square foot.

Terrazzo made with epoxy or resin is more durable and nonporous. It is thinner (¼- to ⅜-inch thickness) and does not require metal strips, although they are often used

FIGURE 4.10 Limestone Wall and Floor. Dal-Tile limestone in Jerusalem Antiqued Gold is laid in a hopscotch pattern on the floor. Image used with permission of Dal-Tile Distribution, Inc.

FIGURE 4.11 Terrazzo Flooring. Terrazzo creates a spectacular floor design in the Shands Cancer Hospital at the University of Florida. Harvey Namm, Artistic Surfaces

for decorative purposes. This weighs about 3 to 4 pounds per square foot and makes for a faster installation. When the terrazzo is cured, it is ground with a terrazzo grinder and then polished.

Engineered quartz

Known as quartz stone by the brand names of Caesarstone, Cambria, Silestone, Swanstone, and Zodiaq, engineered quartz has been available in the United States since 1997 for countertops. Engineered quartz stone is made of a resin binder and 93 percent pulverized quartz. The resulting product is one of the most durable manufactured countertop materials on the market. Engineering stone makes it uniform, resulting in more strength than natural stone and less porousness. The fact that it is nonporous means that it does not absorb oils or stains and is unlikely to harbor bacteria. It is fabricated with the same tools as natural stone. Engineered quartz does not emit any pollutants or toxic chemicals. It is harder than granite, making it scratch resistant. It is also stronger than granite, requiring fewer support corbels than the same size countertop in granite would require.

The downside of engineered quartz is the polyester resin. Over time, the resin loses its flexibility, and the resin is not UV stable, thus it should not be used outdoors. Also, the inclusion of resins renders engineered quartz less heat resistant than natural stone. Although engineered quartz is less porous than natural granite, sealed granite is equal in porosity. Quartz stone is available in a wide variety of colors, patterns, and textures. Engineered quartz is used for kitchen countertops, desktops, stairs, flooring, and fireplace mantles.

Manufactured stone veneer

This product is made from a lightweight concrete mix consisting of Portland cement, lightweight aggregate, admixtures, and mineral oxide colors. Manufactured stone veneers come in various sizes and colors. They are pre-cast in molds made from actual stone to achieve the look of real stone. Veneers are used where the look of natural stone is desired but is prohibitive due to weight limitations. A natural stone wall would be much heavier than veneers and require a substantial footing to hold the weight. Another reason stone veneers may be used is for keeping the cost of installing the product down. Manufactured stone veneers generally are one-third or one-half the price of natural stone. These veneers are efficient to use, producing only 2 percent waste. They can incorporate fly ash, reclaimed water, and post-consumer recycled materials, making them energy efficient.

FIGURE 4.12 Engineered Quartz Countertop.
This residential kitchen island top was made from Cambria, an engineered quartz product.

Application: Using Information Regarding Interior Finish Materials

CODE ISSUES

Stone is inherently flameproof and fire resistant, which makes it an ideal surface for commercial spaces where codes will require surfaces to be fire resistant. A code issue could arise for stone in a vertical installation. If not properly adhered to its substrate, stone could fall off a vertical surface, causing harm to people as it falls. Local building codes should be checked to see if they are more stringent than the manufacturer's recommendations.

SPECIFYING

Stone specifications are in the Construction Specification Institute Division 04 Masonry. However, when stone is used as an interior finish, it will be listed in CSI Division 09 Finishes. Many interior stone veneer uses—such as wall facings, stair treads, thresholds, window stools, countertops, and lavatory—will be listed in CSI Division 09-450. Flooring use will be listed in CSI Division 09-700. Partitions will be in CSI Division 10-180.

More information may be found in the individual trade organizations for each type of stone with its own recommendations for specifications. For example, granite specifications are found at the National Building Granite Quarries Association website, www.nbgqa.com. Granite shall comply with ASTM C 615 for material characteristics, physical requirements, and sampling for selection of granite. Manufactured stone is represented by the Cast Stone Institute. The standard specifications for cast stone is CSI section 047200-04, available at www.caststone.org/specifications.htm. Here are notes you may want to include with specifications:

- Natural stones are absorbent, making them susceptible to stains and mold. Some applications may be sealed, in which case they will need to be resealed every 3 to 5 years.

- When using natural stone, it is very important that you choose the actual piece(s) of stone you want, especially for slabs. Looking at just a small sample of material will not give you the entire look of the stone. Not only will color, tone, and amount of veining vary from piece to piece, but there are many other qualities of natural stone that will vary.

- Edge profiles shall be consistent throughout the installed piece, and smooth along the entire length. Edges are to be finished to the same type and quality of surface as the top.

- Stone materials are to be crated or otherwise protected for transport to the project site.

LIFE CYCLE COSTS

Stone has a low life cycle cost based on the fact that it is durable and requires practically no maintenance. Occasionally a stone will break under stress and need to be replaced. Labor would be the main cost of replacing a broken stone.

The color of stone is permanent, and it is relatively soundproof. Stone has good thermal properties that insulate from losing or gaining heat, and passive solar heat retention, contributing to lower utility costs for heating and cooling. The fact that stone is fire resistant allows a building to have lower insurance costs.

Stone Used in an Interior

Floors
Stone tile floor covering
Solid flagstone or cobblestone set in mortar
Thick stones set directly on earth

Walls and Dividers
Thin stone veneer with metal supports
Stone surface over concrete wall
Thick solid stone walls (historical use)

Kitchen and Bath
Countertops and backsplashes
Sinks and lavatories
Bathtubs and shower surrounds

Accessories and Trim
Trim at wall base or openings
Fireplace hearth and surround
Stair treads and nosings
Stair handrails and balusters
Kitchen and bath accessories

Signage
Stone plaque with engraved letters and numbers

Hardware
Cabinet hardware

Light Fixtures
Light shade (translucent stone)

Furniture
Benches
Tables

Cost Estimating

Stone is priced by the square foot. The price will depend on the facing specified. Floors normally use stone tiles, which are less expensive than slabs used for countertops. Installed slab countertops are priced by the square foot, and vary depending on the type of stone and the edge profile selected. Manufactured stone may cost half as much as natural stone because the material is easier to produce and weighs less, thus making installation quicker.

INSTALLATION METHODS

Each application of stone will have different installation methods associated with it.

Case STUDY *of Stone in a Hospital Application*

Construction

When the 600,000 square-foot Medical Center of the Rockies in Loveland, Colorado, was designed, sandstone was a first-choice material, along with a locally manufactured exterior face brick and a metal panel system for sophisticated highlighting. Project designer/planner, Mark Johnson of Heery International, explained that the architectural concept was to have the hospital feel comfortable and put patients and families at ease. To accomplish the comfortable feel, natural materials native to Colorado were specified. Buff-colored sandstone was used extensively on the exterior and filtered into the interior public spaces, inpatient bed floors, and some clinical areas. This provided a sense of "exterior to interior" continuity and thoroughness that enhanced intuitive ways for visitors to navigate the building and a sense of organization to the physical space within a soothing aesthetic. Margie Snow, principal of Gallun Snow Associates, reinforced this intent by specifying stacked sandstone for key design information elements. These information elements included the main entry control points, the emergency reception desk, and the main nurses' stations on each bed floor. Key elevator points were also clarified with stone appliqué.

The owner and design team had decided to pursue a LEED-certified building from the outset. Important for LEED certification was the use of local material and labor, with reduced transportation costs. The stone used for the project came from Masonville, Colorado, approximately 20 miles to the west of the construction site.

The 4-inch sandstone used for interior applications for the medical center was mounted to 16-gauge, 16-inch steel studs at 16 inches on center by wire ties through a ⅝-inch layer of cement backer-board. A matte finish sealer was applied to most interior stone locations for infection control and cleanability purposes.

The owner and design team's mission was to create a sustainable, hospitality-like environment for the hospital. The well-lit, four-story atrium, with its stacked stone fireplaces and winding grand staircase, feels like the lobby of an exclusive hotel. An exterior stunning sky terrace above the atrium, with its panoramic view of the Rocky Mountains and Longs Peak, also contributes to the nature-inspired healing ambience. The Medical Center of the Rockies achieved LEED Gold certification for New Construction in 2009. (Design team: Heery International/Architecture of Denver, Colorado, and Gallun Snow Associates/Interior Design of Denver, Colorado)

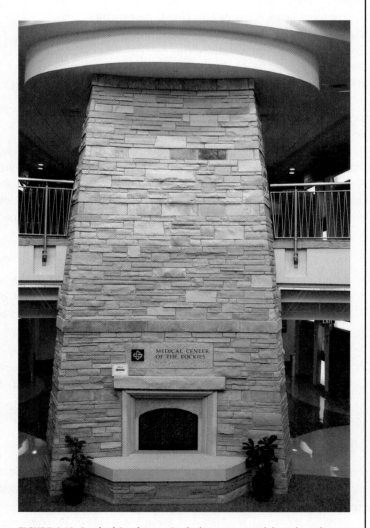

FIGURE 4.13 Stacked Sandstone. Stacked stone was used throughout the Medical Center of the Rockies as a Key Design Element.

FIGURE 4.14 Stone Pavers. This stone pavement is considered flagstone because of the irregular shape of the stones.

Floor installations

Stone that is laid on a floor is called a *paver*. Pavers can be laid in a variety of patterns; most common are flagstones, which are irregular shapes, and cobblestones, which are rounded shapes. Flagstone can come from fine grained sandstone, bluestone, quartzite, or slate. It is necessary that they contain a high silica content necessary for durability and holding up to the weight a flooring might endure. For outdoor use, pavers may be thick, but when they are used for interiors, they are thin enough to set into mortar.

Most stone flooring installations will be stone cut into tiles, approximately the thickness of ¼ to ⅜ inch. Stone is heavy in weight and must have a foundation that can support it. Also, it needs to have a properly installed substrate below it. A concrete floor can serve as a substrate, as can a wood floor with a cementitious backer unit for support and a moisture barrier. The layout of the stone should start with finding the exact center of the room. From the center, the layout needs to be marked with a chalk line at 90 degrees. The stone pieces are cut to fit the layout and have any cut edges filed smooth. Thin-set mortar is applied to the floor surface with a notched trowel. Stone pieces are typically installed very close together with few to no grout joints. The installer will need to check periodically to make sure the floor is level. Any unevenness in the floor could cause a person to stumble. Grout can be applied after the mortar has dried for 24 hours. There should be no heavy traffic on the floor for 72 hours. Sealer may be applied to keep the stone or grout from absorbing dirt.

Wall installations

Stone used for walls is usually laid up in courses with mortar between courses. When the stone is rectangular in shape, it is known as **ashlar**. Ashlar masonry consists of stones that have been **dressed**, or cut to rectangular shapes. Variations of ashlar are ledge stone and stacked stone. *Ledge stone* consists of narrow rectangular shapes of stone where very little mortar is visible. *Stacked stone,* also called *dry stone,* does not have mortar holding it together. This look is appropriate for indoor use because in outdoor use, wind could force water into the wall.

Rubble masonry consists of stones that are not in rectangular shapes. Variations of rubble masonry are fieldstone and river rock. **Fieldstone** will have not uniform shapes and sizes. The stone appears to have been picked up from a field. River rock is rounded as if it has been eroded by water running over it for thousands of years.

Natural stone veneers used to cost much more than manufactured veneers because of their thickness and weight. Traditional full-depth veneers were 4 to 6 inches deep. A ledge

FIGURE 4.15 Ashlar Cut Stone. In this example rectangular cut sandstone was used to form an ashlar stone wall.

or shelf was necessary to support the weight of the stone, and a professional mason was required for the installation to chisel and dress the stones. Thin natural stone veneers that are ⅝ inch to 1½ inches thick have reduced the cost and time of the installation. Thin stone veneer can be applied with clips instead of a structural ledge. Either natural stone or manufactured stone veneers must weigh less than 15 pounds per square foot to meet building codes.

Stone veneer can be applied to any structurally sound surface. It can be installed over existing concrete, stone, concrete block, brick, or stucco surfaces without additional surface

FIGURE 4.16 Slate Mosaic Backsplash. Slate squares are held together with a mesh backing for keeping the grout lines straight.

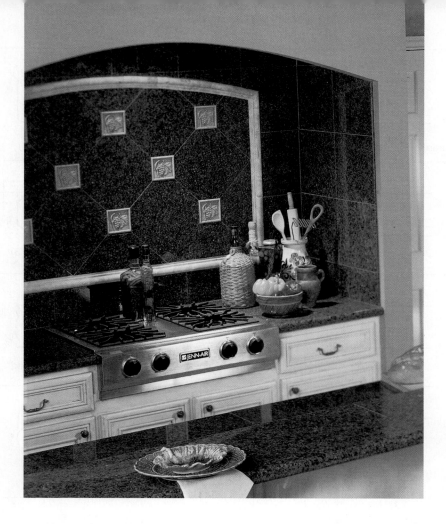

FIGURE 4.17 Granite and Stone Backsplash.
Dal-Tile Tropical Brown Granite is used for the countertop slab and backsplash. The trim on the backsplash is made of sand-tumbled stone chair rail and Ravello fashion accents. Image used with permission of Dal-Tile Distribution, Inc.

preparation using mortar with thin set. If the wall is wood, a metal lath with a mortar scratch coat may be necessary. Stone can be made into a mosaic pattern and applied to a wall. A mosaic pattern is usually constructed face down and a material is applied to the back of the tiles to hold them in the pattern.

Countertop installations

Recently, stone used for countertops has become in vogue for home design. The popularity is due to advances in stone extraction and cutting techniques that have lowered costs and made stone comparable in cost to synthetic materials. To install a stone such as granite for a countertop, the designer will go to the distributor of stone and select a slab large enough to minimize seams with a desirable graining pattern. The installers will go to the site of the installation and make a template from thin strips of wood. The template should follow the wall and any protrusions to guarantee an exact fit.

The normal thickness of a countertop is either 1¼-inch or ¾-inch stone over ¾-inch plywood substrate. If 1¼-inch stone is used, it is installed directly over the cabinets. When ¾-inch stone is used, construction adhesive or silicone sealant is used to adhere the stone to the ¾-inch plywood substrate. Where seams are necessary, the seams are glued together with polyester resin. In countertops that are cantilevered beyond the supports, the cantilever is usually limited to 10 inches for 1¼-inch countertops. Some joints, particularly those between narrow stone pieces, are often splined together with a steel key or rod for reinforcement. Sealant is often applied to a stone countertop as a protective finish, although it is not necessary.

Countertop edges are normally 1½ to 2 inches thick. The edge may be shaped from a single piece of thick countertop or from a countertop with extra thickness applied at the edge to create a deeper edge trim. The edge profile should be shaped on any edge of the counter that will be seen after installation—normally the front and exposed sides of a countertop. Common edge designs are shown in the figure chart.

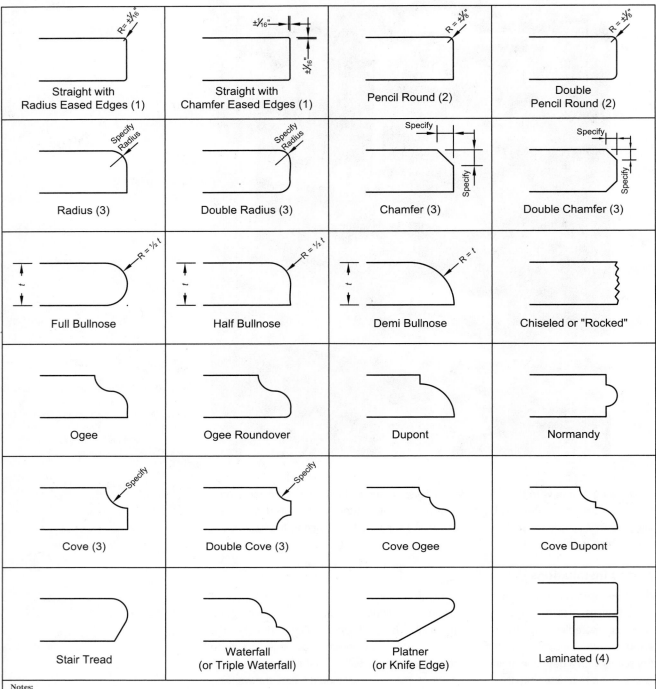

Straight with Radius Eased Edges (1)	Straight with Chamfer Eased Edges (1)	Pencil Round (2)	Double Pencil Round (2)
Radius (3)	Double Radius (3)	Chamfer (3)	Double Chamfer (3)
Full Bullnose	Half Bullnose	Demi Bullnose	Chiseled or "Rocked"
Ogee	Ogee Roundover	Dupont	Normandy
Cove (3)	Double Cove (3)	Cove Ogee	Cove Dupont
Stair Tread	Waterfall (or Triple Waterfall)	Platner (or Knife Edge)	Laminated (4)

Notes:

1. The term "Eased Edge" more commonly refers to a slightly radiused profile than a slightly chamfered profile, although the use of the term varies regionally and/or with specific fabricators. In either case, the edge treatment is slight, and normally does not exceed ⅟₁₆" (1.5 mm).
2. "Pencil Round" generally refers to a radius near that of a standard pencil, approximately ⅛" to ⁵⁄₃₂" (3 to 4 mm).
3. Radius, Chamfer, or Cove edge profile can be any dimension. The actual dimension should be specified at the time of sale. Chamfers are most commonly 45°, although not necessarily so.
4. Many of the profiles shown on this drawing can be done with laminated edge details.

MARBLE INSTITUTE of AMERICA
28901 Clemens Road - Suite 100
Cleveland, OH 44145
Tel: (440) 250-9222
Fax: (440) 250-9223
www.marble-institute.com

MARBLE INSTITUTE of America

REV	DATE
0	Jan 2005
1	Jun 2006
2	Oct 2006

EDGE PROFILE NOMENCLATURE

MIA DIMENSION STONE DESIGN MANUAL VII

DRWG NO: 17-D-16

SCALE: N.T.S.

17-D-16

FIGURE 4.18 Chart of Edge Profiles for Stone Countertops. Marble Institute of America

summary

Stone is the oldest material used for interior spaces since it formed the walls of caves. It has been used continually throughout history because it is strong, durable, and abundant in the earth. Stone is also heavy, which meant it took a community project to build large structures of stone. Religious and civil structures were built of stone so that they would last for centuries.

Practical aspects of stone allowed it to be used as a flooring material in ancient times. It was not susceptible to decay as some other materials were. It could be used in its natural form without requiring heat or drying time; however, stone does require the use of sharp tools and skilled masons to cut it into usable forms. Stone is a sustainable material because of its abundance and the low amount of energy required to extract and fabricate it. Stone is inherently fire resistant and has good sound-reflecting qualities.

To find out more about stone, the following websites and publications of professional organizations in the stone industry can be useful:

Building Stone Institute: www.buildingstoneinstitute.org/

Granite and Sandstone Supplier Trade Association: /www.granite-sandstone.com/trade-associations.html

Indiana Limestone Institute of America: www.iliai.com/

Marble Institute of America: www.marble-institute.com/

National Stone Council: www.naturalstonecouncil.org/

National Stone, Sand, and Gravel Association: www.nssga.org/

Rocky Mountain Stone Association: www.rmstoneassn.org/

review questions

1. Explain what a fissure in stone is.
2. Describe the difference in characteristics of igneous rock, sedimentary rock, and metamorphic rock.
3. Describe what terrazzo is and how its use originated.
4. Analyze how indoor air quality may be affected by the use of travertine for an interior surface.
5. Evaluate how the porosity of different types of stone (marble, granite, limestone, quartz, and soapstone) will affect its use for an interior horizontal surface, flooring, or countertop.

glossary

Arch is a method of spanning space by changing vertical pressure into horizontal thrust.

Ashlar is a stone-laying pattern where the stones are cut to rectangular shapes and fitted closely together.

Buttress is a structural reinforcement for stability and support.

Compressive strength is a term meaning strong under a load of heavy weight.

Dado is the name for the lower part of an interior wall when it is finished differently from the remainder of the wall.

Dressed is the term for cutting stone to desired shapes.

Embodied energy is the energy used to produce or manufacture a product.

Fieldstone is a stone-laying pattern where the stone is not cut but used as it comes from the field.

Fissures are naturally occurring cracks or fractures in a rock along intercrystalline boundaries.

Flagstone is a term for thin flat slabs of stone used for paving walkways.

Honed means a dull sheen finish on stone.

Igneous rock was formed by lava or molten magna, through cooling and crystallizing.

Inert means not active; an inert material does not react with another substance

Keystone is a wedge-shaped stone at the top of an arch that makes the arch self-supporting.

Knoop micro hardness is a test for the relationship between a load and the area of impression it made on a stone.

Machu Picchu is a prehistoric building site in the high Andes Mountains of Peru.

Mesopotamia is the land that is now known as Iraq and Iran.

Metamorphic rock was formed by extreme pressure and high temperature.

Parquet is small pieces of stone laid in geometric patterns.

Porous signifies that water and other liquids can pass through.

Post and lintel is a building method where vertical posts or walls support a horizontal lintel, the first device used to span space.

PSI means pounds per square inch.

Quarry is a location where the material is extracted from the earth.

Rubble is a stone-laying pattern where the stone may be cut but not to rectangular shapes. It is laid in a random pattern with mortar between the stones.

Sedimentary rock was formed by seashells settling to the bottom of an ocean, forming layers of calcium carbonate.

Stone is rock that has been extracted from the earth.

Tensile strength means strong when pulled.

Terrazzo is a composite of small stone chips added to a cement or epoxy binder, poured to create a flooring surface.

Tesserae is a term for tiny pieces of stone or glass used to form a mosaic.

Thermal impact refers to the ability of a material to change temperature readily.

Thermal mass is the ability of a material to absorb and retain heat.

Thrust is the sideways pressure of one part of an arch against another.

Tracery is decorative stonework in Gothic structures used to hold small glass in windows.

Truss is a triangular form that can span very long distances.

Tumbled is a finish achieved by tumbling small pieces of stone in a barrel with abrasive grit and water.

Voussoir is the wedge-shaped pieces making up an arch, often done in two different materials, such as brick and stone to produce a red and white stripe effect.

Wainscot (same as *dado*) is the lower part (usually 3 feet at the lowest) of a wall when treated differently from the remainder of the wall

Window stool is a vertical piece of trim below a window opening.

Concrete

Awareness: An Overview

DESCRIPTION AND COMMON USES

Concrete is a **cementitious** (cement-based) product that has been used in construction since ancient times. Concrete—made of a mixture of cement, aggregate, and water—can be poured into formwork or molds onsite or prefabricated offsite in a factory. The shape and texture of the object, surface, or building made of concrete is almost unlimited. Considering the constraints of weight and structural design, concrete can be formed into any shape or form that can be created by a mold.

learning objectives

When you complete this chapter, you should be able to:

1. Recognize terms used when discussing concrete.
2. Identify common uses of concrete in an interior.
3. Summarize the history of concrete use in interiors.
4. Describe how concrete is produced.
5. Describe how concrete meets code requirements for interior use.
6. Describe and analyze the physical characteristics and properties of concrete for a specific interior use.
7. Analyze the environmental impact of using concrete.
8. Evaluate how well concrete products will meet the specific needs of a design project.

Béton Brut refers to concrete that is left exposed, with the textures created by patterns of formwork and the design of form tie locations as decorative elements. Corbis

Concrete is strong in compression but weak in tension; therefore, structural concrete is reinforced with steel. In building construction, steel-reinforced concrete is used to form foundation walls and footings, columns, walls, floors, ceilings, and roofs. Concrete is used in landscaping for retaining walls and as a paving material, both as individual paving stones and as poured slabs. In interiors, concrete floors, walls, and/or ceilings may be exposed as a finish material, or concrete may serve as a **substrate**, a surface to be covered with a finish material. Components of an interior such as fireplaces and stairs may be constructed of concrete. Lightweight concrete may be used to construct furniture, tubs, sinks, and countertops; or it may serve as a topping to prepare and level floors for application of finishes. **Cement**, one of the components of concrete, is also used for mortar and grout as well as for cementitious products such as tile backer boards or panels used for exterior siding.

CHARACTERISTICS

Concrete, a relatively inexpensive material, relies on its mass for strength, which resists crushing or **compressive** forces. Structural concrete is reinforced with steel to improve its **tensile strength**, resisting forces that pull or stretch an object. The mixture of cement, aggregate, and water begins as a semi-liquid that can be poured into a mold. This **plasticity** is another significant characteristic of concrete since it can be formed into almost any shape and can have a variety of textures and finishes. As the concrete hardens, it goes through the process of **curing** and becomes stronger. The concrete continues to strengthen over time and is extremely durable, but it is also very heavy. Concrete also shrinks as it hardens and will almost certainly crack. It breathes and will allow the passage of moisture vapor. Concrete's hardness means it will tend to amplify rather than absorb sound, adding to the acoustical liveliness of a space. However, properly designed concrete walls will prevent the passage of sound. Concrete resists burning, and thus is used when fire resistance is necessary.

ENVIRONMENTAL IMPACT

The raw materials used to make concrete are abundant, and are generally available within 100 miles of where they will be used. However, it takes a great deal of energy, usually from fossil fuels, to produce one of the main ingredients—cement. Cement kilns are generally coal-fired, although waste fuels, such as used motor oil, inks, and cleaning fluids, can be used. Burning fossil fuels results in carbon dioxide emissions, but they can be lowered by improvements to cement kilns. In addition, a large amount of water is needed to clean **aggregate**, the second main ingredient in concrete. However, concrete has a relatively low embodied energy rating.

Uncured concrete is caustic. Workers must wear protection and avoid contact in order to prevent chemical burns. When left in place, concrete does not affect indoor air quality, but concrete dust created during demolition and after a natural disaster can be harmful.

Supplementary cementitious materials added to the concrete mix can improve its environmental impact. The greatest benefit is from using **fly ash**, a by-product of coal-fired electrical generating plants that is a pollutant if released into the atmosphere. If fly ash is trapped and used in the concrete mix, less water can be used and the strength of concrete is improved. Concrete can also be made from recycled materials, including concrete that has been ground up and used for 30 to 40 percent of the aggregate in a mix. Concrete, once cured, is inert, so it does not affect indoor air quality. Concrete is also extremely durable, but when it is no longer needed, it is too often ground up and burned or taken to a landfill.

Properties of Concrete

(sustainable properties are denoted with green color)

- Concrete is strong in compression but weak in tension.
- Concrete is plastic or malleable when first mixed; it can be formed into shapes and have a variety of textures and finishes.
- Concrete gains strength as it cures or hardens.
- Concrete is fire resistant.
- Concrete breathes, and water vapor will be able to pass through concrete.
- Concrete is extremely durable.
- Concrete can act as a thermal mass.
- Concrete is heavy.
- Concrete can be recycled.
- Concrete is manufactured from abundant natural materials.
- The raw materials for concrete may be sourced locally or regionally.
- Concrete can be made with materials recycled from the waste of other manufactured products.

The use of concrete can help increase the sustainability of a building project in a number of ways, some of which may qualify for LEED credits:

- Using concrete for paving and roof tops can help avoid the heat island effect because its light color reflects light and heat. Thus, concrete pavement is an improvement over darker asphalt pavement. It is even better to substitute an open grid system of concrete pavers for at least 50 percent of sidewalks, parking lots, driveways, and impervious surfaces. Another option is to use **pervious** concrete for paving surfaces. Pervious concrete allows water to percolate into a gravel bed below.

- Concrete's mass makes it ideal for thermal storage in a passive solar application. Even though the building may not be a passive solar design, the thermal mass can help moderate daily temperature swings and reduce peak heating and cooling loads. In this case, adding a dark colorant to concrete can improve its thermal absorption.

- Recycled content can be added to concrete either by using ground-up concrete for part of the aggregate or incorporating admixtures including fly ash, a coal production by-product; **silica fume**, a by-product of silicon; and ground granular **slag**, a waste product from blast furnaces that produce steel.

- Most concrete is made from materials that are available regionally, with aggregates generally sourced from within a 100-mile radius and cement from within a 500-mile radius.

- Concrete is durable, but when the structure built of concrete is no longer useful, there are options to avoid sending the material to a landfill. Buildings can be stripped to their concrete structure and new exterior surface materials can be applied. Concrete that is demolished can be recycled as aggregate, for such uses as road bases.

Example of Concrete Used in an Interior

The architect Dan Rockhill chose concrete as the primary material for this house for functional reasons such as its economy and durability, as well as for the heating and cooling advantage of the thermal mass. He also chose the material for its plasticity, which meant it could be used in any form and for any function. Concrete is used for countertops, shower panels, and for all major surfaces in this bathroom, including the bathtub shown in this image.

FIGURE 5.1 Concrete Bathtub in a Private Residence in Lawrence, Kansas.
Photograph courtesy of William R. "Rusty" Owings III

- If **precast** concrete panels are used to construct a building, the panels can potentially be reused when the building's useful life has ended.
- Insulating concrete forms are made of Styrofoam insulation. They are designed to be left in place, as they provide increased thermal protection, save labor, and reduce waste.

Understanding: In-Depth Information

HISTORY OF CONCRETE

Evidence of naturally occurring cement, a mixture of limestone and oil shale, has been found in ancient Israel. Although Serbians made cement that was used for floors in 5600 B.C.E., most ancient cultures used cement as a binding agent. Egyptians used it to bind the rocks used to construct the pyramids. The Chinese used cementitious products on the Great Wall. Mayan roof structures were built with crossed wood beams, filled in with sticks, and covered with lime cement. The beams were removed when the cement hardened. The Romans used a type of cement referred to as **Pozzolana Cement** for roads and buildings. Made from volcanic ash and sand found in the Bay of Naples, Pozzolana Cement had a pinkish color. Roman structures were built with a stiff mixture of cement and a small amount of water that was tightly packed into the space between two **wythes** of brick. Aggregate was pounded into the cement by hand as the wall was built up in layers. This material was very strong, but it was not reinforced. However, bronze bars were used as reinforcement for the dome of the Pantheon in Rome in 125 C.E. The differing expansion rates of bronze and concrete resulted in **spalling**, and reinforced concrete was not used again until the nineteenth century. In fact, concrete was not used for several centuries.

Modern concrete is a result of the development of **Portland Cement** and the practice of reinforcing concrete with steel. Throughout the seventeenth and early eighteenth centuries, inventors experimented with various forms of hydraulic cement. In 1756, John Smeaton, a British engineer, used hydraulic lime with pebbles and powdered brick as aggregate. In 1824, a British stonemason, Joseph Aspdin, heated finely ground limestone and clay on his kitchen stove, and then ground it into a powder. This became known as Portland Cement because of its similarity in color to stone found on the British coastal island, Isle of Portland. Portland Cement has become the dominant cementing agent in concrete production today.

In 1849, Joseph Monier, a Parisian gardener, began making garden tubs of concrete reinforced with iron mesh. He received his patent in time for the 1867 Paris Exhibition, where reinforced concrete products—including railway ties, pipes, floors, arches, and bridges— were exhibited. At about the same time, Jean-Louis Lambot was reinforcing small concrete boats with iron bars and wire mesh. Credit for the first reinforced concrete building is given to William B. Wilkinson, a plasterer from Newcastle, England, who built several two-story servants' cottages of concrete reinforced with iron bars and wire rope with the goal of building fireproof dwellings. In the United States, the first significant building of reinforced concrete was the 1875 William Ward home, designed to resemble masonry and to reassure Mr. Ward's wife, who was afraid of fire. The Ward house is still standing today.

Early skyscrapers were able to take advantage of the new technology of using reinforced concrete. The first was the 1904 Ingalls building in Cincinnati, Ohio, at 16 stories tall. In 1919, Mies Van der Rohe wrote of the idea of building high-rise buildings with a concrete core and cantilevered floors. Frank Lloyd Wright applied the cantilever concept when he designed Falling Water for the Kaufman family in 1936, and implemented Van der Rohe's core and cantilever ideas when designing the Johnson Wax Tower in 1947. Bertrand Goldberg's Marina City Towers in Chicago sparked the development of the concrete skyscraper. Chicago architects used concrete for its high strength, constructing tall buildings made of concrete throughout the late twentieth century.

Early twentieth-century architects were intrigued by the possibilities allowed by the plasticity of concrete, such as the ability to design fluid structures or to develop thin shell structures. Several significant structures were designed to take advantage of the sculptural properties of concrete. Early to mid-twentieth-century architects who used concrete as a sculptural element included August Perret, designing buildings in and around Paris. Le Corbusier was a master of using concrete in expressive ways, exemplified by the slab construction of Villa Savoye and Notre Dame de Haut (Ronchamp Cathedral). Frank Lloyd Wright's last work, the Guggenheim Museum in New York City, is an expression of the fluidity of concrete. Thin shell concrete structures such as Eduardo Torroja's Madrid Hippodrome of 1935 and Pier Luigi Nervi's Sports Palace in Rome of 1960 were often designed by engineers. Architect Felix Candela developed thin-shell parabolic structures in Mexico City in the 1950s and 1960s. Eero Saarinen's TWA terminal at John F. Kennedy Airport in New York is another example of the sculptural use of concrete.

Before concrete was accepted as a material with its own aesthetic value, it was often formed to imitate other materials, such as stone. Concrete blocks used in late nineteenth-century homes were rusticated to look like stone. Frank Lloyd Wright also explored the decorative possibilities of concrete block, designing four houses in southern California in the 1920s that used custom-designed **textile blocks**.

Béton Brut refers to concrete that is left exposed, with the textures created by patterns of formwork and the design of form tie locations as decorative elements. In the 1960s and 1970s, this style became known at **Brutalism**. Examples include Boston City Hall and the Sydney Opera House. Many Brutalist buildings have interiors with exposed concrete walls.

In the late twentieth and early twenty-first century, an appreciation of nineteenth- and early twentieth-century industrial buildings and the prevalence of the "loft" aesthetic resulted in the celebration of the structure of a building by exposing it. In renovated older buildings as well as in new construction, concrete beams, columns, and ceilings are often exposed. Concrete floors, once a surface to be covered, are now considered an appropriate finished surface and may be polished, sealed, stained, or colored. Concrete furniture, tubs, sinks, and countertops are designed for interiors that embrace the inherent aesthetic value of the material.

PRODUCTION: HOW CONCRETE IS MADE

Three components make up concrete: cement, aggregate, and water. *Cement* in concrete acts as a binding agent. Mixed with water, the resulting paste coats and fills the spaces between the aggregate of gravel, rocks, or sand. The term **hydraulic cement** refers to the chemical change that takes place when cement is mixed with water. The hardening or curing process results in a hard, dense material. However, pure cement is fairly useless except as a binding agent due to its excessive shrinking and cracking. Portland Cement is the most common type of cement used in mixing concrete today. A mixture of clay and limestone is burned in a kiln until it fuses into a lump called *clinker,* which is ground into a fine powder. There are several types of Portland Cement, each of which imparts particular desired qualities based on anticipated weather, need for extra strength, need to counteract excessive heat buildup, or where resistance to sulfates is necessary. *Pozzolans,* including fly ash, silica fume, and slag from steel production, have the qualities of Roman volcanic ash. They can be added to the cement mix in powder form. Pozzolans improve the performance of concrete, all while incorporating recycled products. *Metakaolin* may be added to impart an aesthetically desirable white color.

Water is mixed with cement to create a paste-like substance. Water used to make concrete must be **potable** (drinkable), and impurities such as chlorides, sulfates, alkalis, and solids must be limited. Impurities can affect the setting time or strength of the concrete. They can also cause staining, corrosion of reinforcement, volume instability, and reduced durability. There is an art and science to getting the ratio of cement to water just right. The cement must be fluid enough to pour and allow the concrete to be spread. However, too much water will cause excessive shrinkage and cracking. Less water results in stronger

FIGURE 5.2 Slump Test. How a slump test works: (1) Place a sample of wet concrete in a cone; (2) Tamp concrete in a prescribed manner; (3) Lift the cone; and (4) Measure the "slump" (vertical settling).

12"

Cone Wet concrete

concrete, but the mixture must have enough water to allow it to coat each piece of aggregate with cement paste and to fill the voids among the pieces of aggregate. If the mix is too stiff, it may not be workable and the concrete may be porous and rough. A **slump test** is used to test mixed concrete for moisture content; the mix is tamped into a cone and then turned onto a flat surface. The amount of vertical settling is measured to determine if an acceptable standard is met.

Aggregate refers to sand, gravel, or crushed stone. The cement/water/paste binds the aggregate to form a solid mass. Aggregates are categorized as *fine* (sand-sized up to ¼-inch in diameter) to *coarse* (usually ¼ to 1½ inches in diameter. Aggregate up to 6 inches in diameter may be used for large concrete projects such as dams. Aggregate must be clean and free from contaminants to avoid chemical reactions that can affect the strength of the concrete. The shape of the aggregate affects the concrete as well. Round aggregates require less water and air and result in better consolidation. Aggregates can be exposed, adding color, texture, and pattern to the surface. Lightweight concrete may have a shale or slate aggregate. **Perlite**, a spherical volcanic glass with insulative properties can be used to improve the insulation value of concrete.

A typical concrete mixture may be made up of 10 to 15 percent cement, 60 to 75 percent aggregate, and 15 to 20 percent water. The performance of concrete is enhanced by the addition of admixtures that are chosen for a specific desired outcome. The term *admixture* refers to something added to a mix. In the case of concrete, admixtures improve or change the performance of the final product. From 5 to 8 percent of the concrete mix may be composed of admixtures. A common admixture is **entrained air**, an intentional use of air pockets for improved performance during freeze/thaw cycles. Some chemical admixtures are used to accelerate the curing process, whereas other admixtures are *retarders* that slow the process in order to allow more time to place and work the mix. *Plasticizers* and *super-plasticizers* are admixtures that reduce the need for water, which can result in increased strength. Pigments may be added as *coloring agents* for aesthetic purposes.

As concrete is poured, it must be compacted to ensure that there are no unwanted air pockets, that the form is completely filled, and that there are no **honeycombing** voids that occur when cement does not completely fill the spaces between the particles of aggregate. When an exterior slab is poured, a flat board or an aluminum tool called a *screed* is used to cut off excess concrete, smoothing and leveling the surface. A wood or metal **bull float** is used to further smooth the surface, leaving it relatively even but slightly rough. At this point, water will appear on the surface, giving the concrete a glossy appearance. No further finishing is done until the sheen evaporates. A **broom finish** leaves a slip-resistant surface on exterior surfaces. On an interior, a **hard trowel** finish provides a smooth surface.

Hydration is the chemical process that occurs as concrete hardens and cures, becoming progressively stiffer, harder, and stronger. Curing begins when the *bleed,* or moisture sheen, has disappeared from the surface and the exposed surface begins to harden. The stiffening, hardening, and strengthening development is progressive. In about 28 days, concrete has reached most of its strength, but it continues to gain strength for years. Concrete should not cure too rapidly, so measures are taken to slow the process by keeping it moist, such as sprinkling with water fog, covering with a moisture-retaining fabric, or sealing with plastic or special sprays.

The mass of plain concrete makes it extremely strong in compression, but it cannot withstand wind, earthquakes, vibrations, or bending or stretching (tension) stresses. Steel is strong in tension, and the hybrid that results from combining the two is referred to as reinforced concrete or **Ferroconcrete** (*ferro* from "ferrous," meaning iron), strong in both tension and compression. When concrete is poured into the molds or formwork that will determine the final shape, steel is placed where the greatest stress is anticipated. The steel must also be located where it will be adequately covered by concrete for protection from corrosion and fire. Steel reinforcement may be in the form of rods or bars with ribs for better bonding or in the form of welded wire fabric, a grid of steel wires. Vertical and horizontal sections of concrete are tied together by steel. Steel reinforcement also helps to minimize shrinking and cracking and helps control thermal expansion and contraction.

FIGURE 5.3 Illustration of Concrete Reinforced with Welded Wire Mesh.

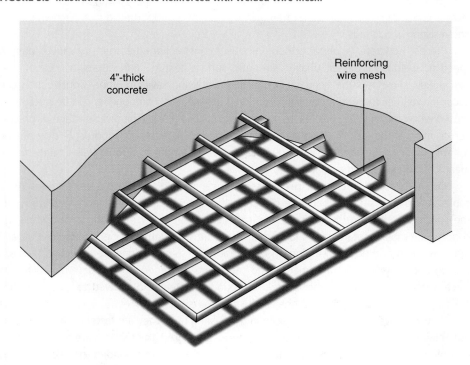

TYPES OF CONCRETE

Site-Formed Concrete

When concrete is **site formed**, or *poured in place*, the size and shape of the building or object can be unique. Most concrete is delivered to the site in a concrete truck with a revolving drum. This "ready mix" concrete may be mixed at a plant, mixed while in transit in the revolving drum of the concrete truck, and/or remixed on site. **Formwork** holds the concrete in place until it is cured. Forms for concrete walls may be prefabricated and reusable. Wood formwork can be designed to leave an imprint such as board patterns of wood on the concrete. Square or rectangular columns also use wood forms, but round columns are usually formed with a compressed resin-impregnated paper tube that is disposable. Forms are held in place by a framework of vertical wood studs and horizontal reinforcement boards known as *walers*. Bracing and shoring may be necessary. Spreaders and form ties keep the forms separated as they are filled with concrete. Formwork must be treated with a parting compound, such as oil, wax, or plastic, for easy removal. When concrete is to remain exposed, the designer can carefully place the form ties to create a pattern or design on the finished concrete surface. When concrete cures, the forms are removed. The resulting surface may be left exposed or used as a substrate for other materials. As an alternate to using shoring, floor slabs can be cast on the ground and lifted into place using a crane. Similarly, wall slabs can be cast on the ground and tilted into place.

Precast Concrete

Precast concrete is poured, reinforced, and cured offsite. Furniture, concrete masonry units, and industrial objects such as culverts are all precast products. Building construction components of precast concrete are poured, reinforced, steam-cured in a factory, and then shipped to the site and set in place using a crane. Precast concrete used for building construction includes wall panels, columns, beams, floor, and roof panels. An entire building can be built of precast concrete; connections then become more important. Floor panels and similar roof panels can be cast with hollow channels or cast as single or double tees acting as small beams. When floor and roof panels are used, a lightweight reinforced concrete topping bonds the panels and provides a smooth surface for finish flooring. Interior designers may note that the topping can be eliminated if carpet with pad is used as a finish material. Walls must have window and door locations pre-planned. **Corbels** may be cast in to support floor slabs. Precast panels may also be used for **curtain walls**, which are supported by or literally "hung" from a concrete or steel structural frame of the building, supporting only their own weight and resisting wind loads.

Precast concrete is prefabricated, modular construction that has the advantage of speed as well as consistent quality, strength, surface texture, and durability. Use of precast panels eliminates the need for onsite formwork and saves in labor. Construction can occur in weather that would prevent pouring concrete. The components can be potentially reused when the building has reached the end of its useful life. The disadvantage of precast construction is the lack of flexibility in building design. In addition, modularity may not be suitable for irregular-shaped buildings. The size of individual components is limited by the means of transportation available.

Often, precast concrete is **prestressed**, meaning high-strength steel tendons (wire cables, bundled strands or bars) are placed in the concrete and tightened or stressed until the concrete forms an upward *camber,* or arched curve. This curve flattens out when the concrete member is set in place and loaded. There are two methods of prestressing concrete: pre-tensioning and post-tensioning. In *pre-tensioning,* steel tendons are stretched across a *casting bed* between two abutments. The cables are tightened to a predetermined tensile force. Concrete is cast into the formwork around the steel and allowed to cure. Tendons are then cut, producing the camber. In the *post-tensioning* process, cables are coated or sheathed to prevent bonding and placed in the casting bed. They are fastened to abutments but allowed to drape. After the concrete is poured and cured, the tendons are pulled tight by clamping on one end and jacking on the other. The cables may be bonded to the concrete by injecting the open space with grout.

CEMENTITIOUS PRODUCTS FOR INTERIORS

Mortar and Grout

Cement-based products include **mortar**, which is used to set ceramic tile and for masonry construction, and **grout**, which fills the spaces between the tiles. The two products are similar, but mortar is relatively stiff and higher in strength. Mortar helps adhere tiles to the substrate and helps bind masonry units to each other. Grout may be more liquid and is more water resistant, filling the spaces between tiles without leaving air gaps. Thus, the units are bonded to form a solid unit. Designers must select mortar and grout colors, as they have an impact on the appearance of the surface.

Backer Boards

Several manufacturers make cement-based backer boards for tiles, floors and countertops. These products include Portland Cement and sand. Some are glass-fiber–reinforced. Backer boards are installed in a manner similar to gypsum board. They are non-combustible and some types have a natural resistance to the growth of mold, which makes them good choices for wet areas.

Lightweight Concrete Topping

Several types of lightweight concrete mixtures may be used to cover floors. Some types are used to fill the spaces in corrugated steel decking. Others are used over existing floors to create a smooth, level surface to use as an underlayment for an applied floor finish. These toppings can also assist with limiting sound transmission from floor to floor and can add a noncombustible fire-resistant layer. Lightweight concrete toppings are used to pour over hot water tubes or electric heating cables in radiant-heated flooring applications. Some toppings have nylon fiber reinforcement and can be used as a wear layer. Designers can specify colored additives or the application of stain or paint as a finished floor.

ALTERNATE USES OF CONCRETE

Concrete Masonry Units

Often erroneously called "cement blocks," **concrete masonry units (CMUs)** are a form of precast concrete. Concrete is formed into molds, creating hollow blocks that conserve material and are lightweight. Concrete masonry units are relatively inexpensive and are used to construct walls using techniques similar to other types of masonry construction. Like concrete, the blocks are strong in compression but weak in tension. Thus, CMU walls are constructed with both horizontal and vertical reinforcement and the hollow spaces are filled with grout. The walls must be constructed so that the mass of the combined units acts as one entity. The main characteristic of concrete masonry units is their modularity. The standard CMU size is a nominal $8 \times 8 \times 16$ inches but other sizes and shapes are available. Lintels, required to span openings in walls, correspond with modular dimensions of the CMU.

Concrete masonry units are used to construct low-rise buildings and for interior walls that require fire separation, such as to enclose stairs, elevators, or mechanical rooms. Plain concrete masonry units are also used to provide a backup surface to attach brick or stone veneer walls on an interior or exterior. When exposed on an interior, plain CMU walls may be painted, or they may have furring strips and sheet rock applied. Alternatively, decorative CMUs can be used as an exposed surface, and may be colored and textured or ground smooth for a finished appearance.

Types of Concrete Masonry Units

In addition to the utilitarian plain gray concrete blocks, smooth-faced concrete blocks can have color added to the mix. The appearance of concrete masonry units is improved by adding color to the cement and exposing the aggregate, which can also be selected for a desired color. These more decorative CMUs are used to construct the exterior walls as well as interior walls of a building. *Split-faced* concrete masonry units have a textured appearance

FIGURE 5.4 Both Split-Faced and Ground-Faced Concrete Masonry Units in an Interior: Lawrence High School Commons, Lawrence, Massachusetts. Photograph courtesy of Heidi Jandris

that imitates natural stone. The stone-like texture is achieved by splitting the block so that broken aggregate is exposed. The surface also has a rough texture. *Ground-faced* concrete masonry units are made by grinding and polishing the surface of split-faced CMU, exposing the aggregate and giving the appearance of a polished stone or terrazzo. Both split-faced and ground-faced CMUs come in a wide variety of colors, depending on the color in the cement, the aggregate additives, and the pigment. They can be scored for a square appearance rather than the standard rectangle. Concrete masonry units can also be glazed, with an appearance similar to ceramic tile.

FIGURE 5.5 Screen Blocks.

Empress Screen Block

Del Mar Screen Block

HISTORIC USES OF CONCRETE BLOCKS

Screen Blocks

Popular in the mid-twentieth century, **screen blocks** had open areas that allowed light and air to be transmitted. Screen blocks were used both on the exterior and interior as divider screens.

Textile Blocks: Frank Lloyd Wright

In an effort to create something decorative out of concrete block, Frank Lloyd Wright developed the *textile block*, a square concrete block that he called "permanent, noble and beautiful." The hollow blocks were textured on the outside. Steel-reinforcing rods tied the blocks together. The walls were built two wythes wide with a cavity air space for insulation. Frank Lloyd Wright designed four textile block houses in California in the 1920s, the Millard House in Pasadena, California (1923), the Storer House and the Freeman House (1923), and the Ennis House (1924) in Los Angeles. Each of the four houses had textile blocks with a different pattern.

FIGURE 5.6 Textile Blocks by Frank Lloyd Wright.

Rusticated Concrete Block

In the early twentieth century, from about 1905 until 1930, a popular style of concrete masonry units called **rusticated concrete block**, or **rock-faced block**, was formed in molds with a texture that mimicked stone. Portland Cement had become reliable, and Harmon S. Palmer had invented a hollow concrete block manufacturing machine that was sold through the Sears & Roebuck catalogue. The blocks could be made onsite with nonskilled labor. Rusticated concrete blocks were popular because they were less expensive than brick and stone, yet were fire-resistant. Rusticated blocks are still available for historic restoration and new construction.

Cinder Blocks

The popularity of **cinder blocks** began in the 1930s. The aggregate in concrete blocks was replaced with lighter cinders, which made the surfaces smooth.

Application: Using Information Regarding Interior Finish Materials

CODE ISSUES

Concrete is a noncombustible material that can be used for the structural components of fire-resistant construction. However, steel used as reinforcement for concrete must be covered with prescribed thicknesses of concrete. For interior fire walls, fire barriers, and elevator and stair shaft enclosures, concrete or concrete masonry units are used to meet the required fire-resistance rating.

Case STUDY *of Concrete Used in an Interior*

Concrete Floors, Tables, and Reception Desks

Craig Shaw chose concrete to complement the industrial aesthetic of the former automotive repair building that is now the office of the architecture and design firm, Shaw Hofstra + Associates. Concrete topping on the floor was scored to create a pattern, with different stain colors in each area. The reception countertop is made of poured white concrete in a steel frame with insets of glass tiles. Work tables throughout the space have concrete tops enhanced by glass tile insets.

FIGURE 5.7 Stained Concrete Floor. Photographs courtesy Kay Miller Boehr

FIGURE 5.8 Concrete Transaction Top on Reception Desk. Photographs courtesy Kay Miller Boehr

FIGURE 5.9 Detail of Concrete Transaction Top on Reception Desk. Photographs courtesy Kay Miller Boehr

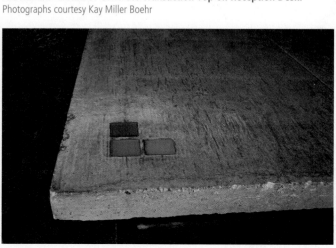

FIGURE 5.10 Concrete Work Table. Photographs courtesy Kay Miller Boehr

FIGURE 5.11 Detail of Concrete Work Table. Photographs courtesy Kay Miller Boehr

SPECIFYING

When specifying concrete, an interior designer should be aware that concrete is a natural product and as such will allow the passage of moisture. For this reason, a vapor barrier is used between a concrete slab and the ground below it. Prior to selecting or installing a flooring material below grade over concrete, determine that a vapor barrier is present and specify moisture testing according to the finish flooring manufacturer's instructions. In addition, when concrete is used for an interior surface, especially in kitchens and bathrooms, the porous nature of concrete requires sealing. Concrete may not be appropriate as a surface in installations that have special hygienic requirements.

Concrete will shrink as it cures and will continue to move over time. Thus, cracks must be anticipated. When concrete slabs and other large areas of concrete are poured, several types of joints are used. *Isolation joints* separate the concrete slab and adjoining walls and columns, allowing differential movements. *Construction joints* are the places where a concrete pour has stopped to be continued later. These joints may be doweled and serve a dual purpose as control joints. *Control joints* are placed at pre-planned locations. The purpose of control joints is to create an area of weakness so when the concrete cracks, it will crack at the joint line.

Many interior uses of concrete are specialty items. When specifying specialty concrete, interior designers should keep the following in mind:

- Make sure the contractor is qualified to do specialty work.
- Specify a standard concrete mix. A "six sack mix" at 94 pounds of cement per sack is considered an adequate strength.
- Require a mock-up.
- Plan a pre-construction conference to ensure communication.
- If concrete is to be given a bright color, a white concrete should be specified.

The following CSI Masterformat divisions have sections that assist in specifying concrete:

Division 03 Concrete

Basic Concrete Materials and Methods

Concrete Forms and Accessories

Concrete Reinforcement

Cast-in-Place Concrete

Precast Concrete

Cementitious Decks and Underlayment

Grouts

Mass Concrete

Concrete Restoration and Cleaning

Division 04 Masonry

Concrete Masonry Units

MAINTENANCE

Concrete is easy to maintain. Concrete floors, for example, can be damp mopped with a synthetic detergent. Avoid soap, which reacts with lime. Applying a sealer to the surface of a concrete countertop makes it easier to maintain.

LIFE CYCLE COSTS

Concrete is relatively inexpensive and, as a durable, easily maintained surface, its life cycle costs make it a good value. Labor costs can make specialty concrete more expensive than standard concrete. The designer should also be aware that white concrete, although

Concrete Used in an Interior

Floors
 Exposed:
 Sealed
 Stained
 Painted
 Stamped

Walls
 Exposed:
 Textured
 Plain
 Painted
 Covered with a finish material
 Cementitious Panels
 Backer board for tile
 Mold-resistant surfaces

Ceilings
 Exposed
 Slabs with integrally poured beams tied to columns or load-
 bearing walls
 Flat slabs with thickened capitals at columns
 Waffle slabs, one-way joist slabs, flat slabs with thickened con-
 crete column capital
 Raw (unfinished) state or painted

Kitchen and Bath
 Countertops
 Tubs
 Sinks

Furniture
 Made of lightweight, precast concrete

Construction Specialties
 Stairs
 Fireplaces

Alternative and Crossover Uses
 Cement as matrix for terrazzo
 Cement grout for tile

necessary as a base if bright colorants are to be added, is four times more expensive than gray concrete.

APPLYING CONCRETE IN AN INTERIOR

Floors

Homes without basements and smaller commercial structures are built with concrete slab on grade floors. Basements have concrete slab floors. Multistory commercial structures may have concrete slab floors or steel decking with poured concrete topping.

Traditionally, concrete floors are covered with another finish material such as tile or carpet. When installing flooring material over a concrete slab below grade, the issue of moisture must be considered. Some materials are not recommended for use below grade for this reason. Prior to installing a finish floor over concrete below grade, the floor must be tested for moisture content. Some finish materials such as thin resilient flooring or lightweight carpet installed without pad may telegraph imperfections, meaning the imperfections of the substrate are visible through the finished flooring material. For these finish applications, the existing concrete floor can be smoothed and leveled with a lightweight topping.

Concrete can be left exposed as the finished flooring. Existing concrete floors may require a topping that can serve as a wear layer. There are many options for treating exposed concrete that can result in floors ranging from utilitarian gray concrete to a highly finished decorative floor. Options for finishing exposed concrete floors are as follows:

- Plain gray concrete can be sealed with a clear acrylic sealer or other type of sealer.
- Color can be added to the concrete mix or sprinkled into wet concrete.
- Concrete can be stained. Existing concrete floors should be washed with muriatic acid before applying stain.
- A pattern can be stamped into concrete before it cures.
- Joints can be designed to create larger areas of pattern that can be stained different colors.
- Aggregate can be exposed by washing the surface, or stone can be pressed or rolled onto the surface while the concrete is still plastic.
- Concrete can be polished using a grinder with diamond pads.
- Concrete can be painted with epoxy paints, although this finish will need regular re-application.

Walls

Commercial buildings from the 1960s and 1970s were often constructed in the Brutalist style with exposed concrete walls. If this is the case, the walls may be left exposed as an interior finish. Concrete walls designed to be exposed may have intentional patterns from the formwork, such as plywood sandblasted so the grain is more pronounced, board pattern, or board and batten pattern. Special form liners can add textures such as ribbed patterns. After the

concrete is cured, it can be acid etched, sandblasted, or bush hammered to add texture and expose the aggregate, or it may be ground smooth. Often the holes left by carefully placed form ties create a grid pattern on the surface.

Decorative concrete masonry units that are most often used on the exterior of the building may be carried into the interior. These units are meant to be exposed. The designer should work with the architect to select a color to coordinate with the interior finishes. The mortar color can have significant visual impact and must be carefully selected by the designer.

A building may be constructed with concrete walls or CMU walls that are not meant to be exposed and may be treated in several ways, including:

- A stud wall can be constructed with 2 × 4s adjacent to the concrete, allowing space to run plumbing, mechanical, and electrical system components as well as insulation and vapor retarder before applying gypsum wallboard. The wallboard may then be finished as desired.

- On interior walls that do not require insulation, ¾-inch wood furring strips or ⅞-inch metal furring channels may be applied to the wall and then covered with gypsum wallboard, allowing the application of desired finishes.

- Concrete or concrete masonry unit walls can be plastered and painted or, in primarily utilitarian spaces, simply painted. If painting CMUs, the specification should state that mortar should be allowed to dry, and then chipped off the surface of the block. The block will be painted with a long nap roller formulated for painting concrete masonry units.

- Concrete masonry units can be covered with a liner cloth that can be painted or used as base for application of a decorative wall covering.

Ceilings

The concrete structure of a building may be left exposed. Some concrete slabs are flat with thickened column capitals. Others are waffle slabs or concrete tee slabs that express a distinctive pattern. When exposed, the concrete structure may be left in its raw state or painted.

Kitchens and Baths

Concrete has been used in recent years for specialty items such as bathtubs, sinks, and lavatories, and especially as countertops. Concrete countertops have become "do-it-yourself" projects for homeowners. When constructed by professionals, the concrete surfaces can have a highly crafted appearance. The appearance of a concrete countertop can range from a raw Brutalist aesthetic to a highly finished surface, polished to resemble stone. Glass and other exposed aggregates give the product a terrazzo look. Concrete countertops are porous and must be sealed.

Furniture

Concrete's fluidity means that it can be formed into almost any shape that can be made from a mold. Concrete has long been used for exterior furniture such as garden benches, urns, and other objects. Interior furniture made of concrete is less common, but includes Maya Lin's seating for Knoll, called "Stones." Furnishings made of concrete are lightweight and precast in a factory.

FIGURE 5.12 "Stones" Concrete Furniture by Maya Lin for Knoll Studio.
Photograph courtesy of Knoll, Inc.

Concrete Countertops

When Damon and Kari Heybrock renovated their circa-1900 stone farmhouse, they chose concrete countertops. Damon had constructed concrete countertops before, so he decided to do it himself, with the help of his design-build contractor, Jarad Foster of Studio Build. After the wood base cabinets were installed, forms were built onsite using melamine-faced particle board. The forms were moved to Studio Build's shop where the concrete was mixed and poured using black colorant and black marble chips. Colored glass rods were glued to the surface of the side panel form before the concrete was poured.

FIGURE 5.13 Concrete Countertops in Heybrock Kitchen. Photographs courtesy of Kay Miller Boehr

FIGURE 5.14 Detail: Side of Kitchen Island Showing Glass Tubes. Photographs courtesy of Kay Miller Boehr

FIGURE 5.15 Detail: Kitchen Island. Photographs courtesy of Kay Miller Boehr

summary

Concrete is an ancient material made from cement, aggregate, and water. The components of concrete have been improved throughout its history, most significantly with the development of Portland Cement in the nineteenth century. Because concrete is strong in compression but weak in tension, steel is used to reinforce concrete, creating a hybrid product that has allowed concrete to become a common and relatively inexpensive material for building construction. Concrete is also used because it is durable, fire resistant, and made from renewable natural materials that can be recycled. In interior construction, concrete and concrete masonry unit walls are used in locations that require high fire-resistance ratings, such as to enclose stairwells and mechanical rooms. In an interior, concrete and similar products such as concrete masonry units are common substrates to which other finish materials are applied. However, some concrete is intended to be exposed, such as concrete in structures designed in the Brutalist style. This concrete may be textured or have exposed aggregate that adds to its decorative quality. Ground-faced concrete masonry units are designed with intrinsic color and exposed aggregates, requiring no additional finish.

Concrete's plasticity or ability to be molded into almost any shape means that concrete can be formed to mimic other materials such as stone, or formed to have decorative surfaces resulting from the shape and texture of the mold or the texture and color of exposed aggregate. Concrete can be made into a variety of products, including furniture and components of interior construction such as stairs, fireplaces, countertops, bathtubs, and sinks.

The interior designer must not only understand the characteristics of concrete as a building material but must also understand methods of treating concrete surfaces, either as a substrate or a finished surface. Concrete as an exposed finish material may be sealed, stained, or painted. The surface of exposed concrete can be stamped and treated for a range of textures from rough to polished.

To find out more about concrete, the following websites and publications of professional organizations in the concrete industry can be useful:

Portland Cement Association: www.cement.org

American Concrete Institute: www.concrete.org/

review questions

1. Explain what a slump test is for concrete.
2. Analyze the reasons why concrete often cracks.
3. Describe why the production of concrete is not environmentally friendly and how it can be made more sustainable.
4. Evaluate and select the type of concrete that would be used in an atrium to create each of the following: a concrete floor, concrete benches, and concrete walls that will be a substrate for a tile mural.

glossary

Admixture is a term that means something is added to a mixture. In concrete, admixtures are products added to the concrete mix to achieve a desired result. Admixtures include *retarders* to slow curing, *plasticizers* and *super-plasticizers* that reduce the need for water and add strength, and *coloring agents,* such as *Metakaolin* for white concrete.

Aggregate refers to the sand, gravel, or rock that is one of the three main components of concrete.

***Béton Brut*/Brutalisim** refers to concrete that is intentionally exposed and appreciated for the decorative qualities of its surface texture.

Broom finish is a description of the slip-resistant finish used on exterior concrete.

Bull float is used to smooth concrete on a horizontal surface after it is poured.

Cement is the binding agent in the concrete mix made of finely ground limestone and clay.

Cementitious refers to cement-based products.

Cinders/Cinder blocks Burned slag cinders, a by-product of steel production, are sometimes used as aggregate in concrete. Concrete masonry units made with cinders were popular in the 1930s and referred to as cinder blocks.

Compression/Compressive forces are crushing forces. Concrete relies on its mass to resist them.

Concrete masonry units (CMUs) also referred to as concrete blocks, are modular precast concrete units that can be cast with a variety of surface treatments, including *split-faced* (rough) or *ground-faced* (smooth).

Corbel is an "L"-shaped bracket attached to a vertical surface to support a horizontal surface.

Curing is the process of hardening and strengthening concrete.

Curtain wall is an exterior panel that supports only its own weight and is hung like a curtain from the structural framework of a building.

Entrained air is an admixture to concrete. Adding intentional air pockets improves performance during freeze/thaw cycles.

Ferroconcrete (*ferro* meaning iron) refers to concrete reinforced with steel.

Fly Ash, silica fume, and slag are referred to as *Pozzolans* because of their similarity in function to the volcanic ash used in Roman Pozzolana cement. Fly Ash is a by-product of the coal industry, silica fume is a by-product of silicon production, and slag is a by-product of ore production.

Formwork holds concrete in place until it is cured.

Grout is a cementitious product that fills the joints in ceramic tile and fills hollow spaces in concrete masonry units. One difference between grout and mortar is that grout resists water.

Hard trowel is the method used to provide a smooth surface on interior concrete.

Honeycombing can occur when concrete is not properly compacted and cement does not fill the voids in the aggregate.

Hydraulic cement refers to the chemical change that takes place when cement mixed with water cures; also known as *hydration.*

Mortar is a cementitious product that is used as a setting bed for ceramic tile and for masonry construction. Mortar helps construct a solid mass wall of masonry. Mortar holds tile in place and helps masonry units stick together.

Perlite is a spherical volcanic glass with insulative properties that can be used to improve the insulation value of concrete.

Pervious concrete allows water to soak through to a gravel bed below rather than run off the surface

Plasticity or plastic is a description of the ability of concrete to be molded into almost any shape.

Portland Cement is the most common type of cement used in modern concrete. It is made of fired limestone and clay *clinkers* that have been pulverized to a powder and mixed with water.

Potable is water that is pure enough to drink; it is necessary to make the cement paste that binds the aggregate and forms concrete.

Pozzolana Cement refers to pink-colored cement developed by the Romans using volcanic ash and sand from the Bay of Naples. Today, the term *Pozzolans* refers to Fly Ash, silica fume, and slag from steel that all have the characteristics of volcanic ash.

Precast concrete is formed, reinforced, and steam-cured in a factory, then transported to the construction site.

Prestressed concrete has steel reinforcement inserted and pulled tight, or *tensioned,* during the forming process. The steel reinforcement is either *pre-tensioned* (tightened before the concrete is poured) or *post-tensioned* (tightened after the concrete is poured). Prestressed concrete components have a camber, or slight arch, that will flatten when loaded.

Rusticated or Rock-faced concrete masonry units were molded to look like stone and used for construction of homes in the late nineteenth and early twentieth centuries.

Screen block is a decorative concrete masonry unit used the mid-20th century to divide, yet see through space.

Site-formed concrete is poured in place.

Slump test is used to test mixed concrete for moisture content; the mix is tamped into a cone and then turned onto a flat surface. The amount of vertical settling is measured to determine if an acceptable standard is met.

Spalling occurs when moisture and or salt enters brick, concrete, or natural stone and forces its way to the surface. Small pieces of the concrete or other material then break off in fragments referred to as *spalls.*

Substrate is a supporting element or surface on which a finished surface is applied. A concrete masonry unit wall may serve as a substrate for brick veneer.

Tension/tensile strength refer to forces that pull or stretch an object.

Textile blocks were developed by Frank Lloyd Wright in the 1920s as a way to create a decorative building material out of the lowly concrete block.

Wythe refers to one column of brick stacked vertically.

Gypsum and Plaster

Awareness: An Overview

Gypsum and plaster are often considered utilitarian materials. They lack the glamour of inherent natural graining and color variations that stone and wood offer. Their value lies in what the designer decides to do with them. Plaster can be made into any shape, texture, or color—either smooth, flowing curved lines, or intricate detail sculptures. The work can be done in a factory and shipped to the installation site, or may be done at the job site by local artisans (under direction).

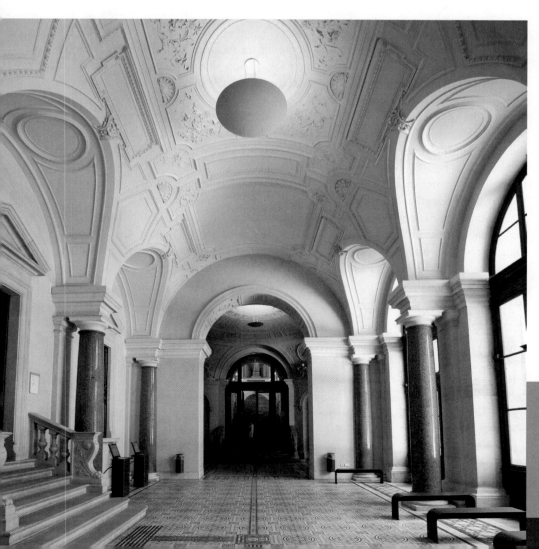

learning objectives

When you complete this chapter, you should be able to:

1. Recognize terms used when discussing gypsum and plaster.
2. Identify common uses of gypsum in an interior.
3. Summarize the history of plaster and gypsum use in interiors.
4. Describe how plaster and gypsum board are produced.
5. Describe how gypsum products meet code requirements for interior use.
6. Describe and analyze the physical characteristics and properties of gypsum products for a specific interior use.
7. Analyze the environmental impact of using gypsum.
8. Evaluate how well gypsum products will meet the specific needs of a design project.

Plaster Ceiling. Plaster was used to create a decorative Baroque ceiling. GlobetrotterJ/Shutterstock

FIGURE 6.1 Gypsum Board Surfaces. Gypsum board can be used to create forms and become the substrate for color or texture. Here, gypsum board was used to form a smooth ceiling and walls of contrasting color and arched opening that define the room. Spanjer Homes

DESCRIPTION AND COMMON USES

Plaster is a centuries-old material that can be used for forming intricate details or smooth surfaces. It is mixed in a liquid form, making it easy to pour into molds or apply on surfaces. However, the fact that it is a liquid requires that the person who applies the plaster be a skilled artisan to create a pleasing finished surface.

The desire for smooth walls in interiors became more feasible and economical when a form of prefinished plaster known as plaster board or **gypsum board** became available in the mid-twentieth century. Today, gypsum board is commonly used as the surface of walls and ceilings in houses and apartments. It provides a smooth background that people have become accustomed to and it provides a warm comfortable feeling. In commercial applications, gypsum board is used only for a formal effect.

Beyond the basic smooth walls and smooth ceilings, plaster has been used to form intricate and elaborate shapes, especially where the ceiling and walls meet. One way these intricate *ceiling-to-wall transitions* are being constructed is with pieces of gypsum board cut into concentric shapes to fit a room perimeter. This form, called a *stepped ceiling*, or *tray ceiling*, is currently the trend to upgrade new residential building.

CHARACTERISTICS

Gypsum plaster is a smooth, hard material when it is dry. It is formed while it is wet, which allows it to be applied to various forms and be finished in many various textures. Plaster provides an ideal surface for paint applications. The composition of plaster can be varied to produce different qualities such as sound absorption or abrasion resistance. Plaster can be formulated to be sound absorbing by mixing chemicals with gypsum to form small air bubbles in the plaster.

Plaster has rarely been used in homes since the invention of gypsum board. The warm comfortable feeling from gypsum board is due to its low level of thermal conductivity. It feels warm to the touch and does not add humidity to the air as plaster does when it is new. Gypsum board is also much quicker to install and uses less skilled labor than plaster.

Gypsum board has some sound-attenuating properties, but the way it is installed determines its acoustic value. Typically, gypsum board is attached to both sides of a stud wall. When sound waves hit the gypsum board on one side, it vibrates. Because the gypsum board is attached firmly to the studs, the sound waves carry through the wall to the other side. Sound waves also reverberate through duct work in the walls. If a material is added to the wall construction that keeps the gypsum board from being rigid, it will aid in reducing sound transmission.

Commonly, gypsum plaster is formed into sheets 4 feet wide by a length of 8 feet, 10 feet, 12 feet, or 16 feet. The thickness of the gypsum board ranges from ¼ inch to

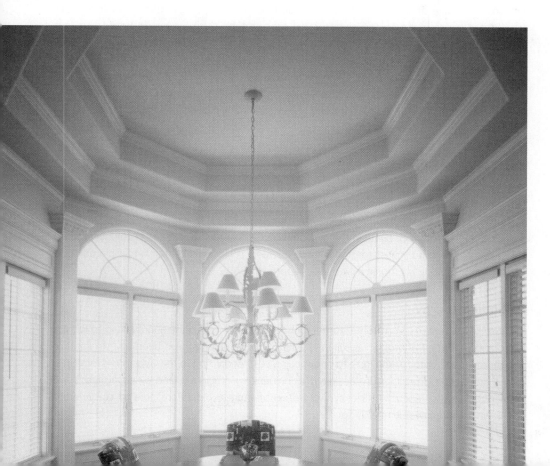

FIGURE 6.3 Creating Drama. This stepped ceiling in concentric circles was constructed from gypsum board to create drama in a residential dining room. Spanjer Homes

⅝ inch. The thinner sheets can be used for creating curved walls. Regular wall construction uses ½-inch thick sheets; fire-resistant walls require more thickness. In commercial construction, it is common to use two layers of ½-inch thick gypsum board for a fire wall. Gypsum board has the advantage of being fire resistant, but it has the disadvantage of being moisture attracting. Moisture will cause gypsum board to lose strength and decompose. There are various types of gypsum boards produced for differing applications.

- Type X gypsum board has increased fire resistance due to fiberglass reinforcement.
- Abuse-resistant gypsum board has a covering more durable than the standard paper.
- Green board is moisture resistant. It can be used in areas that will be around water. It is not recommended for an area that will receive a lot of water, such as a shower.
- Moisture proof gypsum board has an aluminum foil or plastic backing to prevent water vapor from passing through a wall.
- Blue board is used as a substrate for plaster veneer.
- Ceiling board is ½ inch thick, which reduces its weight, making it resistant to sagging.

ENVIRONMENTAL IMPACT

Synthetic Gypsum

Much of the **gypsum** used now is *synthetic gypsum,* also called *by-product gypsum*. Instead of mining the gypsum, it is recovered from waste. Synthetic gypsum comes from a process used to remove sulfur dioxide from emissions at coal-fired power plants. The by-product comes from removing impurities and taking the stack emissions through a limestone **slurry** to remove sulfur dioxide. The remaining chemical is calcium sulfate, which is gypsum rock. Natural and synthetic gypsum have the same general chemical composition.

Indoor Air Quality

After gypsum or plaster is installed, there is no problem with indoor air quality. The product does not give off any volatile organic compounds when it is undisturbed. Indoor air quality is a concern during the construction process when using gypsum board. It is cut with a saw and sanded during the construction process. Both sanding and sawing produce dust, which should be contained; it must not be allowed into the ventilation system. The installers will wear masks when they are working with it. Gypsum dust contains silica, vermiculite, perlite, and lime, which are irritants to the skin, eyes, and lungs. After construction is completed, the containment system can be removed and there should be no further risk of gypsum dust.

Chinese Drywall

From 2001 to 2008, gypsum board made in China was imported to the United States. This gypsum board was used to supply the large need for **drywall** in regions that had been destroyed by hurricanes. Gypsum board imported from China was found to cause environmental problems. The high content of pyrite in the gypsum board, mixed with heat and humidity, emitted sulfur gases. The sulfur gases formed a black powdery surface on copper metal plumbing in the houses. Respiratory problems were also reported.

Embodied Energy

Because plaster and gypsum come from a rock found in the earth, the energy used to extract them and produce the product is minimal. Manufacturing plants have been able to capture the energy used in production instead of disposing of it. According to the Gypsum Association, new manufacturing facilities are designed to use energy efficiently, and older facilities have been upgraded for energy efficiency. Some manufacturing plants are able to co-generate power and use renewable energy sources.

Gypsum board is a heavy material. Because of its weight, transportation costs could be an issue. However, gypsum panels require minimal packaging, making the transportation costs lower than if they needed packaging. Manufacturing plants are located throughout the United States so that the shipping distance is not far. When shipped by railroad and the distance is less than 500 miles, gypsum board may help a project gain LEED credits.

Recycled Gypsum

Gypsum board is wrapped in paper. The face paper and liner paper can be made of post-consumer recyclable content. Gypsum-based materials and gypsum board can be recycled as clean construction waste. Recycled gypsum can be introduced back into the production stream in limited amounts or used as a soil amendment or soil conditioner. In large projects, gypsum scrap can be recycled onsite and the ground-up gypsum can be spread over the top layer of soil. If a high percentage of construction waste is recycled, gypsum board may help a project gain LEED credits.

Properties of Gypsum and Plaster

(sustainable properties in green)

- Gypsum products are inherently fire resistant.
- Gypsum products can be recycled.
- Gypsum products can be produced from waste of other industry.
- Gypsum board has a low level of thermal conductivity, making it a natural insulator.
- Gypsum board is susceptible to moisture damage.
- Gypsum board is strong in compression—the thicker it is, the stronger it becomes.
- Gypsum board is weak in tensile strength—it does not span distance well, as in ceiling applications.
- Plaster is hard, but it may crack due to structural shifting or vibration.
- Plaster can be applied to any rough porous surface.

Understanding: In-Depth Information

HISTORY OF GYPSUM AND PLASTER

As far back as ancient Egyptian times, prior to 300 B.C.E., gypsum was used for making plaster. Deposits of alluvial soil in the Nile Valley provided the gypsum. Plaster was used as a wall covering over clay, and became the foundation for mural painting. The Egyptians painted wet plaster, using a coating of wax to protect the painting. They also mixed a gypsum concrete slurry for a poured smooth floor surface.

Ancient Greeks used plaster for walls in homes of wealthy citizens although, most of their emphasis was placed on exteriors rather than interiors. Ancient Roman (200 B.C.E. to 100 C.E.) interiors were full of ornaments using architectural orders. The ancient Romans used **pilasters** and broken pediments made from plaster in interiors. Their plaster consisted of lime, **calcinated** calcium carbonate processed from limestone, mixed with sand and marble or alabaster dust. Plaster reliefs were made by using damp plaster and either pressing a molded plaster piece into it, or creating the design elements by hand. Plaster was also important for creating smooth surfaces over concrete or stone walls as a base for fresco painting. The interiors were smooth continuous plaster walls without windows. Outdoor scenes were a common theme for painting on interior walls. Roman ceilings were made of several materials: wood frames, concrete, and stucco plaster. Geometric patterns were stamped into damp plaster covering the entire ceiling. The division between the ceiling and wall was emphasized by a cornice molding.

Plaster continued to be used for wall surfaces throughout medieval times and the Renaissance. A new development using plaster came about in England during the reign of Elizabeth I. The suspended ceiling came into use at the beginning of the sixteenth century. Ceiling beams were covered with plaster and designs were carved into the damp plaster. All the structural members were concealed in decorative plasterwork called **pargework**. From 1500 C.E. through the 1600s, plaster was used widely. Plaster was applied to a base wall of brick, stone, or lath, and then whitewashed. Plaster was used for decorative **friezes** on the walls in manor houses. Plaster was also used to fill in between wood vertical studs. Often, the plaster was painted to look like textiles or wood.

The Italian Baroque period (1600 to 1700) used frescos for walls and ceilings. Ceilings, made of plaster and painted masterfully, were the focal point in rooms of homes owned by the wealthy. The paintings used superior Italian perspective techniques that created the feeling of extended vertical space.

When the Baroque style reached England (1660 to 1715) it took on elaborate details in plaster. This was the height of English plasterwork. The plaster at that time consisted of lime, sand, water, and animal hair to hold the ingredients together. Plaster was used to form ceilings, cornices, coves, and soffits. When the plaster detail was elaborate and unique, it was formed and created in place over a wire or wood form. Repetitious forms, such as those for moldings around a room, were created by pouring plaster into molds. Ceilings were very elaborate with carvings of plants or flowers in a circular or oval form. The high-relief carvings continued into a cove shape that joined the ceiling to the walls. Other motifs carved in plaster consisted of shells, fruit, animals, and busts of Roman emperors.

The early Georgian period in England (1715 to 1760) moved from Baroque style, through Palladian style, to Rococo style. Rich decoration of interiors became popular with an emphasis on decorative painting on walls. Plaster was used on walls and ceilings as the base material for the painting. It was not feasible to use fresco painting on wet plaster in England because of the damp climate. Instead, the plaster walls were sized with a thin coat of paint. Oil paint was used for the pictorial scenes to protect the plaster from moisture. Painting imitating marble was also popular at this time. *Scagliola*, an imitation marble, was developed and perfected during this time. It consisted of calcined gypsum mixed with sand and isinglass. Scagliola was used for fireplace surrounds and chimney pieces.

In the French Rococo period (1700 to 1760), plaster was commonly used for ceilings and the cove joining the ceiling to the wall. The difference from English Baroque is that French Rococo detailing used low-relief details in a delicate flowing design. White and soft colors were used with gilt.

The early English Neoclassic period (1770 to 1810) was a reaction to the heavy decoration of the Baroque and excessive decoration of the Rococo styles. Plaster continued to be used for walls and ceilings. Robert Adam was the leading interior designer of the time. Adam composed much fine detail work in plaster using classical motifs, applied to ceilings, cornices, friezes, and frames for paintings. Gypsum-based Scagliola continued to be used as an imitation marble.

The late French Neoclassic period (1789 to 1820) experienced a change in design. The cornice dividing the ceiling from the wall was more restrained than previously done. The ceilings were still decorated with plaster work in geometric shapes and coffered ceiling used medallions. Ceilings were either flat or barrel vaulted.

FIGURE 6.4 Delicate Details in Plaster were Used for Wall Decoration in the Late 1700s.

The late English Neoclassic period (1810 to 1830 in England) experienced another simplification of plaster ornamentation. A central medallion became the focal point of the ceiling and there was an emphasis toward simplicity. The moldings at the edge of the ceiling changed to classical Greek moldings. Many ceilings were flat, although there were some shallow domes in ceilings.

The Victorian period (1830 to 1901) was a time of industrialization. In 1856, a process was patented that combined canvas and plaster. The canvas-reinforced plaster made casting of plaster forms possible. The cast forms were used for central medallions in ceilings and cornices. Ceiling decorations included pargework, where plaster covered timbers in the ceiling. Relief plaster details on walls, including festoons and flowers, were created by plasterers.

Large deposits of almost pure calcined gypsum were found underneath the city of Paris and mined around the turn of the century. This pure white plaster became known as *Plaster of Paris*. The early 1900s saw a gradual simplification of ceiling and wall design. In the 1920s and 1930s, Art Deco designs were popular in public spaces. Theaters especially were ornate with Art Deco designs.

By the 1940s, International Style architecture was capturing popularity with its emphasis on no decoration, only simple planes for walls and ceilings. The 1950s' residential compromise between traditional plaster decoration and the simplified International Style was a large cove molding at the ceiling-to-wall transition, leaving the ceiling and walls plain.

PRODUCTION

Gypsum is a rock mined in many parts of the United States. It is usually found with other rocks or clay. When a large deposit of pure gypsum is found, it is white. Gypsum rock is crushed until it is the size of ½-inch diameter gravel. From this point it is put through a rotary calciner to grind it into a powder. As the gypsum rock is ground, it is heated to 350 degrees Fahrenheit to evaporate the water in the rock. This results in a fine dry powder of gypsum. It can be returned to its original form by adding water, known as **crystallizing**. Other materials are added to gypsum to help it have the needed consistency. Gypsum is the binding material in gypsum products. The materials added to gypsum may be rock aggregates, organic fibers, lime, or chemical retardants; each has a different purpose. **Aggregates** are added to give bulk, increase stability, or increase hardness. Organic fibers may come from wood or other plants. They are used to control the working quality and help plaster hang on to a **lath**. Lime is added as a putty to finish coat plaster to increase bulk and improve workability.

Aggregates used with gypsum are sand, vermiculite, and perlite. The sand used in gypsum plaster must conform to the contents and particle size established by the American Society of Testing and Materials. The contents will be mostly quartz and silica, with rough angular particles producing stronger plaster. Vermiculite ore consisting of silica, magnesium oxide, and aluminum oxide is composed of layers that expand when heated. The ore is processed through crushing and heating over 1,600 degrees Fahrenheit to produce the expansion. The expanded material is soft and silvery in color. The most lightweight vermiculite, Type II, is used in plaster products. Perlite comes from volcanic ore, consisting mainly of silica and alumina. The processing is similar to that of vermiculite; it is crushed and heated until it expands. Because Perlite consists of silica and alumina, it forms glassy bubbles when it expands.

Lime used in gypsum plaster comes from limestone. The limestone used for plaster is **dolomitic**, meaning it has more magnesium carbonate than calcium carbonate. When

FIGURE 6.5 Barrel Vault Ceiling. Neoclassical design in plaster is shown in this barrel vault ceiling in the Basilica Del Santo in San Marino, Italy.
Fulcanelli / Shutterstock

FIGURE 6.6 **Cove Ceiling Molding.** Deep coves created with plaster at the transition between walls and ceiling were a fashionable feature in the 1950s.

dolomitic limestone is heated, magnesium oxides result. The oxides from magnesium produce putty with better working properties than if it were made with calcium carbonate. **Quicklime** is formed as the heating process turns the carbonate to oxide. At this point, the quicklime must be combined with water and soaked for weeks to hydrate its oxides and make a lime putty usable in plaster. The process is called **slaking**, which initiates a chemical reaction that transforms oxide to hydroxide, a more stable form. Since the process takes time, most lime is partially slaked and sold as **hydrated lime**. To be usable for a finish coat in plaster, lime must have less than 8 percent unhydrated oxide. Higher rates of unhydrated oxides could hydrate on the job site and cause cracking of the plaster.

BASECOAT PLASTER

The **basecoat** is the first coat applied to the substrate and any additional coats below the finish coat. There are different types. The first type is called **neat plaster**. The word *neat* implies that the plaster is smooth. It does not contain aggregates. It is used when matching an existing plaster and the texture needs to be added on the job site to get an exact match.

The second type of basecoat plaster is **wood-fibered plaster**. Organic fibers from wood and cellulose plants are generally mixed with gypsum to provide bulk and greater coverage. This is used to produce high-strength basecoats for use in ceilings where high fire resistance is needed.

A common type of basecoat plaster is ready-mixed plaster, a mixture of calcined gypsum and an aggregate that requires the addition of water at the job site. Ready-mixed has the proportion of aggregates listed on the package, making it easier to keep the mixture consistent. A less often used type is bond plaster, which contains gypsum and up to 5 percent lime and chemical additives to improve its bond with surfaces such as concrete. Instead of this formulation, bonding agents are used today.

FINISH COAT PLASTERS

Finish coat refers to the final application coat of plaster. It usually consists of calcined gypsum, lime, and some type of aggregate. The types of finish coat plasters are gauging plaster, Keene's plaster, prepared plaster, veneer plaster, molding plaster, and acoustical plaster. If the finish coat is mixed with lime putty, it is called *gauging plaster*. Lime putty does not set by

itself; it needs the gauging plaster to control the setting time. For Keene's plaster, a kiln is used to dry the gypsum instead of a calciner, which removes more water, producing *dead-burned gypsum*. The resulting material is denser and has greater resistance to impact and moisture than other gypsums. Prepared plaster is a ready-mixed plaster that is ready to be mixed with water at the job site. It can be purchased in various colors and textures.

Veneer plaster is for a very thin application where high strength is needed. Since veneer plaster is 1/8 inch or less in thickness, it dries quickly and speeds up the job. Molding plaster uses a finely ground smooth gypsum. It is used for casting in molds and creating ornamental plaster work. Acoustical plaster is made with chemicals to induce small air bubbles. The bubbles are meant to increase the surface area, thus absorbing sound and reducing reverberations.

GYPSUM BOARD

Naturally mined gypsum and calcium sulfate from coal-fired power plant emission scrubbing are used for the ingredients in gypsum board. The board is wrapped in paper produced from recycled paper with additives to provide strength, moisture resistance, and mold resistance. Crushed and calcined gypsum is mixed with water to create a *slurry*. The slurry is placed on a sheet of paper and sent down a production line. Another sheet of paper is added on top to surround the gypsum. A chemical reaction causes the slurry to harden as it travels down the line. It is cut into finished lengths before going into a dryer. In the drying process, water evaporates, forming crystals of gypsum that migrate into the paper, making a tight bond. Gypsum board is packaged by placing two sheets face side to face side, protecting the inside surfaces. It can be shipped within a few hours of production.

Application: Using Information Regarding Interior Finish Materials

CODE ISSUES

Gypsum board is normally used for walls and ceilings, so its use will be covered by building codes. For commercial spaces, codes will require walls be fire resistant. Areas of egress may need to meet a 2-hour fire resistance, whereas walls in other spaces may need to meet a 1-hour fire resistance. The requirement will be based on construction type of the building and type of occupancy for the building.

Gypsum is a rock that is naturally fire resistant. The amount of resistance to fire it provides to a wall assembly is mostly dependent on the thickness of the gypsum board. The wall assembly may have wood or metal studs behind the gypsum board. For commercial spaces, a typical 1-hour fire wall can be constructed of 5/8 inch gypsum board over metal studs. Two layers of 1/2-inch gypsum board over metal studs may be used to provide a 2-hour fire wall. Other configurations of layers and thicknesses of gypsum board can be used to meet specific code requirements. Fire-rated gypsum board is available, known as type X. Type X gypsum board 1/2 inch thick may provide a 1-hour fire-resistant assembly.

SPECIFYING

The Construction Specifications Institute category for gypsum products is Section 09-200. Lath is in section 09-205, gypsum plaster is in 09-210, and gypsum board is in section 09-250. Specification for gypsum board assemblies is in section 09-260. Of major importance is the temperature and humidity at the job site. Interior finishes should be installed only when the temperature onsite is maintained between 55 and 70 degrees Fahrenheit. Ventilation should be provided to eliminate excessive humidity. Gypsum board should be delivered to the job site, not stored elsewhere, and laid flat.

Gypsum Board Used in an Interior

Walls and Dividers
Wall surfaces
Fire rated type X wall surfaces
Durable abuse resistant wall surfaces
Blue board as a base for plaster

Ceilings
Ceiling surfaces

Kitchen and Bath
Moisture resistant green board around sinks and lavatories
Coated moisture proof around tubs and showers

Gypsum Plaster Used in an Interior

Walls and Dividers
Wall surfaces over lath
Wall surfaces over gypsum board
Wall decoration in relief or texture

Ceilings
Ceiling surfaces
Ceiling decoration in relief or texture

Plaster fabrication is in CSI section 09-230 and plaster restoration is in section 09-280. The standard for basecoat and finish coat plasters is ASTM C 28. Basecoat plasters are formulated for hand-trowel or machine applications.

Not every location needs to have the gypsum board completely finished.

- **Level 1:** Taping of joints is customary even for unfinished attics and spaces above plenums in commercial construction.

- **Level 2:** One layer of joint compound is applied in areas that do not need to be completely finished but need moisture resistance, such as garages and warehouses.

- **Level 3:** Commercial areas that will be receiving a textured heavy vinyl wallcovering only need to have two coats of joint compound applied and sanded smooth.

- **Level 4:** Normal residential construction and painted commercial spaces will have taped joints with three coats of joint compound and a sprayed texture finish.

- **Level 5:** An extra high level of finish that includes a skim coat of joint compound and a primer can be specified for areas that will show any imperfection in the finish, such as a museum that may have spotlighting or enamel gloss paint.

LIFE CYCLE COST

Gypsum products do well in a life cycle cost analysis. Their cost of installation and construction is low and their life span is long. Gypsum products have an expected service life well in excess of 50 years. Building systems finished with gypsum-based products typically require minimal routine maintenance and are easily repaired.

Estimating the amount of gypsum board to be used on a job is done by measuring the length and height of each wall to determine square footage. Amounts for large openings such as doors and windows can be subtracted from the square footage. The total square footage is adjusted to the size of panel to determine the number of panels. For example, 600 square feet of space could be covered with 19 panels that are 4 feet × 8 feet, or 15 panels that are 4 feet × 10 feet, or 13 panels that are 4 feet × 12 feet. The websites listed in the resources section provide calculators for gypsum board panels, fasteners, joint compound, and tape.

To estimate the cost of installing gypsum board, calculate the amount of material needed and find its cost. Add 100 percent of the cost for hanging the drywall, and another 100 percent for finishing the drywall. For example, if the cost of material is $980, add another $980 for hanging it and another $980 for finishing it.

INSTALLATION METHODS

Gypsum Plaster on Lath

Lath is a perforated surface that serves as a base for plaster coats on walls. In older buildings it consisted of narrow wood strips, about 2 inches wide, nailed horizontally to wood studs or furring strips. After 1940, lath was made of wire mesh, galvanized to withstand the moisture in the plaster. Another type of lath is called plaster board, which is gypsum board perforated and attached to the studs in horizontal strips.

Gypsum plaster is normally applied as a three-coat process, with each coat setting until partially dry.

FIGURE 6.7 Typical Plaster Application on Lath Showing the Three-Coat Process: Wire Mesh (a) with Scratch Coat (b), Brown Coat (c), and Finish Coat (d)

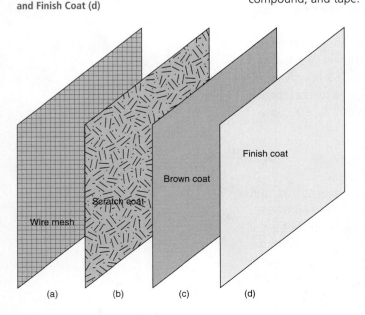

Finish coat

Brown coat

Scratch coat

Wire mesh

(a) (b) (c) (d)

1. The base coat is called the **scratch coat** for installation because it must be cross-raked while wet. The raking or scratching is done to form grooves to help the next coat to bond with it. When applied to metal lath, the base coat will have fibers in it to help it hang on to the metal and not be squeezed through the lath. For smoother types of lath (clay tile, concrete masonry, or gypsum), fiber is not needed in the base coat.
2. The next coat is called the **brown coat**. The brown coat is used to level the surface and prepare it for the finish coat. It may take several applications to achieve a level surface.
3. The finish coat is a smoother texture and is the last coat of plaster applied.

If gypsum plaster is applied as a two-coat process, the brown coat becomes the base coat. The second coat is the finish coat. Veneer plaster can be applied over gypsum board, usually blue board, on conventionally framed walls.

Gypsum Board over Framing

Gypsum board is installed on the ceiling before walls. Screws are used to attach drywall to the ceiling because nails could slip out with gravity. The wall gypsum board should fit tightly against the ceiling board. It can be applied to either wood or metal wall studs, either horizontally or vertically, starting at a corner. When applied horizontally, the panels are started at the top of the wall. Panel seams are staggered and not placed directly above or under a window. Drywall can be attached with either nails or screws. Whereas nails could back out and loosen the drywall, screws will stay in place. The most common method in residential construction is to attach one layer of ½-inch drywall to each side of a wood stud wall.

When screws are used, the drywall is attached with 1¼-inch bugle head screws, long enough to go through the gypsum board

FIGURE 6.8 Residential Construction. In residential construction half-inch gypsum board is attached to each side of a 2 × 4 wood stud.

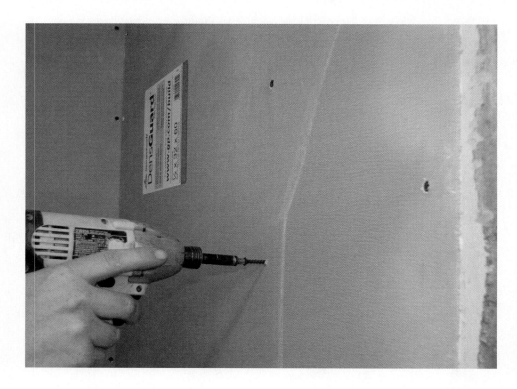

FIGURE 6.9 Attaching Gypsum Board. Gypsum board is attached to structural studs by screws with pronounced threads.

FIGURE 6.10 Cut-Outs. Joints of the gypsum board have been taped and bedded with joint compound. The rectangular cut-outs are for electrical outlets above a kitchen counter.

and into the wood studs (type W screws), or 1½-inch long screws for metal studs (type S screws). Panels should overlap at corners. Metal corner bead will be nailed into the studs to reinforce corner joints.

There are regional differences in the finishing of gypsum board walls. In the Northeast and Southeast, a smooth plaster finish is normal. It is achieved by applying thin skim coats of plaster over the entire gypsum board wall. The plaster finish is extremely smooth, and it is labor intensive, making it costly, but it does not need to dry between coats, making it a quick procedure.

In the Midwest and West, a taped and bedded finish is normal. This involves applying paper tape to joints and joint compound over the tape. First, all panel joints are covered with a coat of thinned joint compound using a 5-inch wide finishing knife. Paper tape is pressed into the wet joint compound, and more joint compound is applied over the tape. Joint compound is also applied to cover screw heads. The first coat is allowed to dry overnight.

FIGURE 6.11 Orange Peel. A common texture for finish coat joint compound over gypsum board is a splatter pattern called *orange peel*. It is created by spraying the finish on the wall and leaving the small splatter pattern that resembles an orange.

FIGURE 6.12 Knock Down. A common texture for finish coat joint compound over gypsum board is called *knock down*. It is created by spraying the finish on the wall and scraping the top with a trowel, thus knocking the top down.

The second coat starts with scraping off lumps of dried joint compound. Wet joint compound is applied to the taped joints and screw heads with an 8-inch wide knife. The joint compound is spread a few inches past the tape to **feather** or gradually level it into the gypsum board. The second coat is allowed to dry overnight.

The third coat starts with scraping off lumps of dried joint compound and lightly sanding it to a smooth surface. The third coat is applied with a 10-inch wide knife. This will be feathered 2 inches beyond the second coat. When the third coat is dry, minimal imperfections in the surface can be smoothed with a damp sponge. This type of preparation does not cover the gypsum board completely and is not perfectly smooth. It is intended for a sprayed-on texture to be applied on top, giving a three-dimensional quality. The texture can be sprayed in various patterns.

FIGURE 6.13 Stipple. A common texture for commercial projects is stipple. The texture is applied as a spray over gypsum board. It is more uniform than orange peel or knock down.

The design of this space called for arches because the company occupying the space produced pasta and they wanted an Italian look. Gypsum board was used to cover curved shapes, such as arches. The wall framing was done as usual, and then the gypsum board was cut to the arch shape and screwed to the studs, taped, and mudded. In this case, metal studs were used for framing because it was in a commercial office building. Like most commercial ceilings, this space used lay-in ceiling tiles, lightweight panels of mineral fiber, laid on a suspended metal grid, with access to lighting and ventilation above the ceiling in the plenum space. Around the perimeter, gypsum board smooth ceiling is apparent.

FIGURE 6.14 Gypsum Board Cut to an Arched Shape. The metal grid of the suspended ceiling is ready for lay-in tiles with the ventilation ductwork hanging down from the ceiling.

MAINTENANCE AND REPAIR

The most important aspect of maintaining gypsum board and plaster is to keep it away from water or moisture. The other aspect for maintenance is breaking. Plaster can break easily on impact. Care needs to be taken in the design to make sure the gypsum plaster product is not used where hard objects will come into contact with it.

Repairing plaster can be done in different ways. The quick fix is to apply thin gypsum board over the damaged area and veneer plaster. Skilled plaster restorers can do a type of repair to the actual plaster. They would open the damaged plaster area, clean it out, and fill it with new wet plaster in small amounts, allowing curing time, until the surface is level.

This stove vent hood has a plaster finish to look like an Old World design. It is a custom creation made out of medium-density fiberboard (MDF) surrounding the metal vent pipe. The covering is plaster in a hand-applied finish.

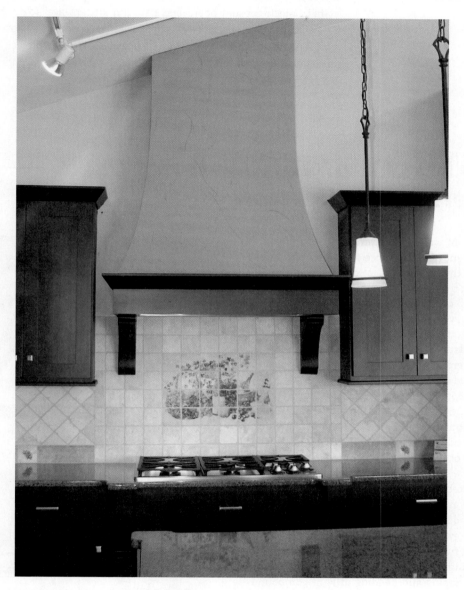

FIGURE 6.15 Stove Vent Hood. This stove vent hood was created to look like Old World plaster with a hand-troweled finish..

Repairing gypsum board is a common procedure. Moving furniture or other activities can cause a hole to be punched in gypsum board that will need to be repaired. For face paper tears, joint compound can be applied and feathered to a smooth finish, then lightly sanded. For a dent, it is simply a matter of filling it with finishing joint compound and letting it dry. If it shrinks, a second coat can be added. After it is hard, it is sanded and textured to match surrounding wall.

For small to medium holes, apply joint compound around the edges and joint tape over the opening, with more joint compound on top. Allow the first coat to dry. Apply a second coat of joint compound, allow it to dry, then sand it. For large holes, cut the damaged gypsum board out carefully, to avoid electrical wires. Put drywall repair clips on the edge of the damaged wall. Cut new drywall to fit the cut-out section and insert into the repair clip. Screws are placed on each side of the clip to hold the new piece in place. The tabs of the clips on the face side are torn off and joint compound is applied in three coats as it was originally.

Thin ¼-inch gypsum board and patching kits are available for small repairs. The kits consist of joint compound, fiberglass drywall tape, sandpaper, a plastic spreader, and drywall screws. If one knows that impacts will be unavoidable in the project, then an abuse-resistant gypsum board product should be specified.

Case STUDY of This Material Used in an Interior Application

For this project, the client wanted a symmetrical entry feature that would be reminiscent of Renaissance formality. The architect drew up a sketch of the arch feature to convey the idea to the builder, but it was up to the builder to engineer the construction of the feature. The main consideration for the construction was to execute symmetry in every aspect of the arches and surrounding architectural trim. In the 1500s, the entire design would have been constructed of plaster, and taken months to complete. In 2012, other materials were used to replicate the plaster look and the project took weeks to complete.

Steve Spanjer of Spanjer Homes explained that gypsum board alone could not be used to create the arches, since narrow strips of gypsum board would snap if bent. His solution was to use Masonite to build the curves on the underside of the arches. Multiple layers of ¼-inch Masonite board were cut into the width and length needed. The parts of the arches that are vertical did not need to bend; they could be cut into the arch shape. Gypsum board was used for the vertical surfaces, cut into the shape needed. Wood studs were used for the arch framing, with the Masonite and gypsum board attached to it. This complex design took about two weeks to complete; the arch framing took two days, cutting and attaching the gypsum board took another two days, the taping and bedding of joint compound took another few days, and painting took another two days. The crown molding is painted wood, the columns are fiberglass, and the pedestal base for the columns is wood framing covered with gypsum board. The ceiling and arch are painted with flat latex paint. The trim, columns, and pedestal bases are painted with industrial enamel to prevent any brush strokes from showing.

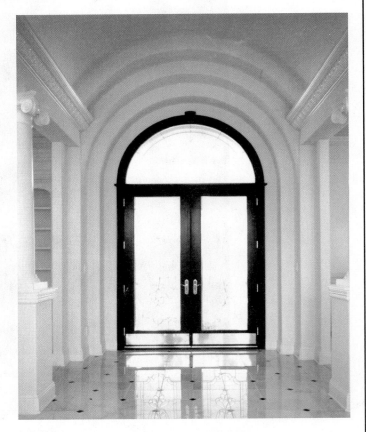

FIGURE 6.16 Gysum Board Arches Formed to Create a Formal Entrance Reminiscent of Renaissance Designs. Spanjer Homes

summary

Gypsum board has been in use only since the mid-1900s. Before that time, the smooth surfaces of walls and ceilings were made from plaster. Plaster made from gypsum has been used throughout history. Plaster is easily formed into shapes when wet and it can be carved easily when dry, so it was used both to cover surfaces smoothly and to create intricately detailed sculptures and architectural moldings. The greatest benefits of gypsum are: it is fire resistant, it is a material easily mined from the earth and needs little processing, it can be recycled, and it can be molded into any shape desirable. It is also an excellent background for painting or texturing.

Gypsum board has become ubiquitous in design projects; it is used to create most of the surfaces we use in every design project, whether residential or commercial. The designer selects the shape of the wall and how the surface will be finished: smooth or textured with paint, or wallcovering applied. New types of gypsum board are continuously being developed to meet the needs of construction projects. The website below give more information on gypsum board products:

American Gypsum is a manufacturer of gypsum products http://www.americangypsum.com/

CertainTeed is a manufacturer of gypsum products using the ProRoc brand name: www.certainteed.com/products/gypsum

Georgia-Pacific is a manufacturer of gypsum board products using the ToughRock brand name: www.gp.com/build/index.aspx

National Gypsum is a manufacturer of gypsum products using the Gold Bond brand name: www.nationalgypsum.com

U.S. Gypsum Corporation is a manufacturer of gypsum products using the Sheetrock, Fiberock, and Durarock brand names: www.usg.com

review questions

1. Explain the term *calcinated* and tell how it is important in processing gypsum.
2. Analyze and discuss different ways gypsum board can be used in interiors.
3. Describe the process of fabricating gypsum board.
4. Evaluate the environmental impact of using gypsum board on a project.
5. If your client wants a smooth finish on the walls of her house, describe which process and finishing you would specify for the project.

glossary

Aggregate is a combination of small rocks, like gravel. In gypsum products they are sand, vermiculite, and perlite.

Basecoat is any coat of plaster applied to a substrate before the finish coat, including scratch coat and brown coat.

Brown coat is the intermediate coat of plaster in a three-coat process.

Calcinated is the state of gypsum after it is intensely heated, loses water, and becomes a fine powder

Crystallizing is when water is added to gypsum and it returns chemically to its original rock-like state by forming interlocking crystals.

Dolomitic is limestone consisting of magnesium carbonate used for the lime in gypsum plaster.

Drywall is a generic name for gypsum board.

Feather is a term meaning to blend materials to a uniform level.

Finish coat is the top coat of plaster.

Frieze is a term for a panel below the ceiling cornice of an interior wall.

Gypsum is a rock found in the earth, calcium sulfate.

Gypsum board is a sheet of gypsum material, wrapped with paper. It comes in sheets 4 feet wide with a thickness of ¼ inch to ⅝ inch, and lengths from 8 feet to 16 feet. It is abbreviated as either *gyp bd* or *GWB* (gypsum wallboard).

Hydrated lime is partially slaked quicklime. It is added to water to make lime putty.

Lath is a substrate that is perforated to hold plaster.

Neat plaster is a gypsum basecoat plaster that does not contain aggregates.

Pargework is a term for elaborate decorative plaster covering structural components of a ceiling.

Pilaster is a column shape that blends into a wall.

Plaster of Paris is a relatively pure calcinated gypsum that was mined in Paris.

Quicklime was used as the binder in lime plasters before the introduction of controlled setting gypsum plaster.

Scratch coat is the first layer of plaster in a three-coat process.

Slaking is the process of transforming oxide to hydroxide in quicklime by soaking it in water.

Slurry is a thick liquid mixture.

Veneer plaster is a thin coat of plaster, 1/8 inch or less, applied over gypsum board.

Wood-fibered plaster is a mixture of calcined gypsum and coarse cellulose fibers to produce high-strength basecoats for use in highly fire-resistant ceiling assemblies.

Brick

Awareness: An Overview

DESCRIPTION AND COMMON USES

Brick is one of the oldest, most traditional building materials; it has been used for buildings since ancient times. Brick is usually thought of being used for a structural wall or an exterior face of a structural wall; however, brick elicits an earthy, warm feeling, and as such is used often for an interior wall or floor finish material. Brick is used often in homes for the fireplace to provide a sense of stability and warmth. In commercial spaces it is used for walls in eating areas, giving a sense of casualness and warmth, or on the floor for a rustic, primitive feeling. Brick may be selected by a designer for its aesthetics, but it brings many beneficial properties with it. Bricks are available in a variety of standard sizes and a standard range of colors. However, for an order of a large quantity, they could be produced in a different color and possibly in a different size.

CHARACTERISTICS

Brick is one of the most durable materials used for construction. Examples of brick buildings centuries old are still standing and in use. Old bricks can be salvaged from demolished brick structures and reused for nonstructural surfaces. Bricks can also be made using recycled

learning objectives

When you complete this chapter, you should be able to:

1. Recognize terms used when discussing brick.
2. Identify common uses of brick in an interior.
3. Summarize the history of brick use in interiors.
4. Describe how bricks are produced.
5. Describe how brick meets code requirements for interior use.
6. Describe and analyze the physical characteristics and properties of brick for a specific interior use.
7. Analyze the environmental impact of using brick.
8. Evaluate how well brick will meet the specific needs of a design project.

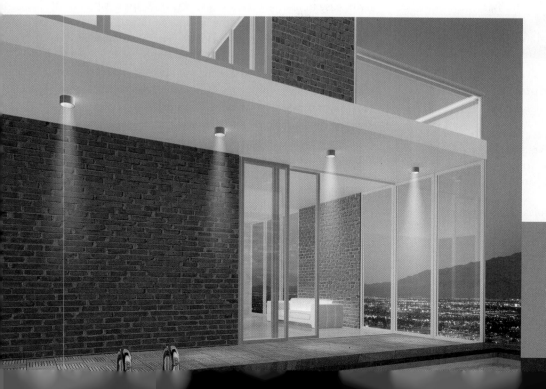

Brick is the featured material used inside and outside this house to give continuity.
helix/Fotolia

119

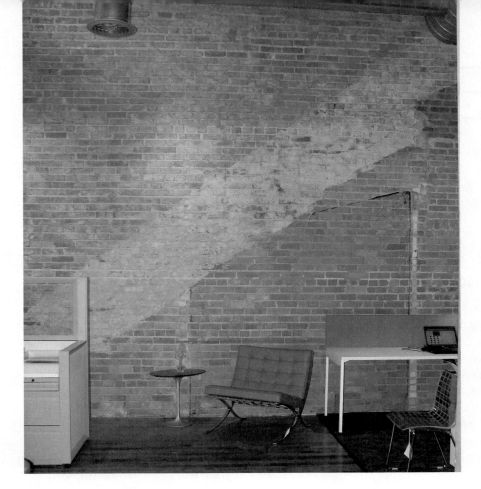

FIGURE 7.1 Old Brick Walls. Showing the original brick walls in old buildings adds a sense of heritage to a contemporary office.

products, such as glass, added in production. Bricks need very little maintenance, adding to their durable characteristics. Brick is also noted as one of the best materials for sound resistance. Brick prevents sound from being transmitted through a wall and reflects the sound back into the room, creating desirable acoustics for a lively space.

Brick is made from natural earth materials, clay and **shale**, therefore it does not burn, making it fire resistant. Also, being a natural earth material, it is **inert**; it does not give off any toxic fumes in an installation. Clay is plentiful in the soil of the earth, easy to find, and easy to extract. Thus, brick is produced in most countries, and 38 of the 50 United States (Brick Industry Association) making it available locally. Bricks are made in various colors of yellow, orange, red, gray, and brown.

Brick inherently possesses energy-efficient qualities. It has high thermal mass which conserves heating and cooling energy. The **thermal mass** allows brick floors or walls to absorb heat from the sun and release the heat back into the air slowly, keeping the area warm longer. For this reason, brick is great for use in places where it gets direct sunlight during the day and the heat is needed at night to keep air temperature from getting cold. Bricks have low embodied energy, meaning it does not take much energy to produce bricks. They are produced in small units, usually 4 × 2 × 8 inches. Because of their small size, there is little waste in the production or installation process.

ENVIRONMENTAL IMPACT

The environmental impact of brick is positive. The amount of energy used to produce bricks is the main concern. Extraction from the earth takes minimal energy, shaping bricks takes a

Properties of Brick

(sustainable properties are denoted with green color)

- Brick does not burn; it is fire resistant.
- Brick is produced locally in most areas.
- Little energy is needed to produce brick.
- Bricks are durable and do not need maintenance.
- Bricks can be salvaged and reused.
- Brick provides good sound-transmission resistance.
- Brick is inert; it does not give off toxic fumes.
- Brick conserves energy—both heat and cold.
- Nonhazardous waste from other industries can be reused in bricks.
- Clay depletion is not an environmental concern.
- Clay quarries can be reclaimed and covered with topsoil.

Brick is often used on the interior walls of restaurants to create a warm and casual atmosphere. The concept came from historically using brick for ovens. It has been used for ovens because it can withstand the heat in cooking and retain the heat to keep foods warm. Brick, as it was used on the interior walls of this restaurant in Ouray, Colorado, encompasses the focal point of the restaurant area, the oven, and the cooking area. The atmosphere created by the use of orange brick is casual, warm, and comfortable. This atmosphere is desirable in a mountain town that has many visitors during ski season.

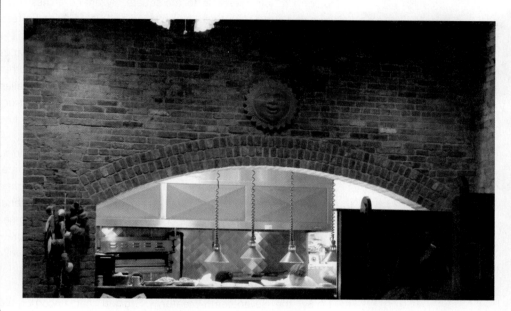

FIGURE 7.2 Brick Used in a Restaurant. Brick adds a feeling of comfortable casualness and warmth.

moderate amount of energy, and the **kiln** firing process takes considerable energy for heat. After bricks are fired, packaging is minimal. Bricks weigh less than stone or ceramics for transportation costs. Removing clay from the earth is minimally invasive. Using brick often qualifies for LEED credits in several categories. Bricks are produced in 48 states, making them a local material, clay is an abundant natural resource and the extraction process does not harm the environment. When a **quarry** is no longer used, it can be filled in and covered with little impact to the land. Brick has little effect on indoor air quality. The material is inert; however, there may be air pockets that could harbor dust or bacteria.

Understanding: In-Depth Information

HISTORY OF BRICK USED FOR BUILDINGS

Thousands of years ago brick was used in many parts of the world for building walls and covering ground floors. In ancient Egypt, **sun-dried mud brick** was primarily used for palaces and dwellings, with a plaster and whitewash finish on the interior walls. In ancient Greece, many houses were made of mud brick, with an interior wall finish of plaster and paint. Most ancient bricks were made from sun-dried clay, which was not very durable.

During the Roman era, bricks were fired at high temperatures in kilns rather than baked in the sun. Once kilns were used to bake the clay to a high temperature, bricks were stronger

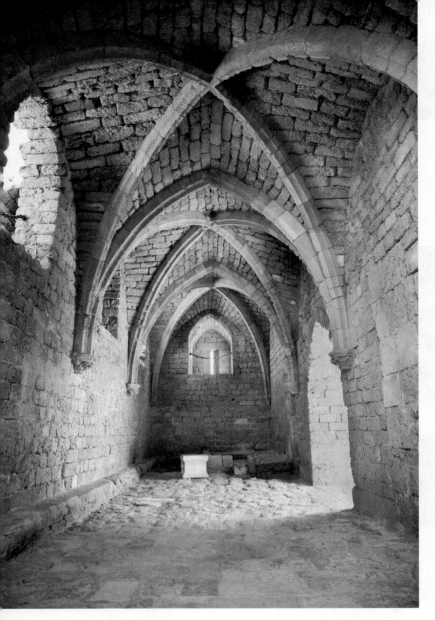

FIGURE 7.3 Ancient Brick Pendentive Arches in Caesarea, Israel. Aleksandar Todorovic/Fotolia

and more durable. Romans used bricks for constructing walls, arches, and **barrel vaults**, or cross vaults, and as a façade over concrete walls. In the Early Byzantine era, Roman designs were adopted, incorporating brick and arches. A barrel vault required walls several feet thick for support. The brick arch design concept continued through the Middle Byzantine period and Romanesque period, with patterned brickwork on walls for Romanesque interiors while gold mosaics covered the brick on the Byzantine interiors.

In the Gothic and Late Byzantine periods of the twelfth century, a new form of arch was used, the pendentive arch. A **pendentive arch** is a circular dome over a square space, using a triangular curving form to join the circle to the square. Byzantine arches often alternated stone with brick, giving a red and white striped affect. Since brick was lighter weight than stone, brick was used for the upper walls and domes. It was also used to create curved shapes with iron tie-rods to reinforce arches and vaults. This and other engineering breakthroughs allowed walls to be thinner and taller. Gothic churches in northern Europe let the brickwork and structural elements show, whereas the Italian Gothic and Byzantine churches usually covered brick with stucco, marble, or mosaics.

During the Renaissance, fifteenth to seventeenth centuries, European builders tried to copy the designs of ancient Rome, although there were no examples of ancient Roman interiors available at that time. Brick was an important building material for the Renaissance due to the construction of arches and domes in ancient Roman design. Humble dwellings commonly used brick for their interior finishes. While interior brick walls were usually plastered and painted, brick used for flooring was not. Instead it was laid in a pattern, often a **herringbone pattern**.

By the seventeenth century, England had incorporated Renaissance style into the Gothic style, giving special attention to brick patterns, known as bonds, used on exterior walls. A **bond** is the arrangement of bricks rows, called *courses*. There were many different arrangements of bricks, sometimes taking the name of the place where they were developed and used. Bonds combined bricks in different placements, which affected not only the visible pattern but also the strength of a vertical wall. Bonds that combine the **header** and **stretcher** faces of bricks, such as the Common Bond, English Bond, and Flemish Bond, are stronger than those without combination.

English building styles using brick bond patterns were brought to the American English Colonies in the seventeenth century. The southern colonies used more brick due to having more suitable clay in the South and many of the southern colonists were bricklayers from England. Even as late as the nineteenth century, bricks were used for floor covering in large homes throughout the United States. Brick was especially used for kitchens because of its resistance to heat or fires from ovens. One problem associated with brick floors in kitchens is that rodents were attracted to the food and could easily get in between bricks. A common scene in those kitchens was the rat trap that needed to be emptied every morning.

PRODUCTION OF BRICKS

Bricks are made from clay composed of decomposed igneous and metamorphic rocks containing feldspar, kaolinite and hydrous aluminous minerals found in the earth. The clay is dug up from a quarry in large chunks that need to be pulverized into a fine-grain consistency. After the consistency is fine-grain, the pulverized clay is sent to the **pug mill** where water is added and mixed into the clay to make the mixture moldable. Clay color varies according to where it

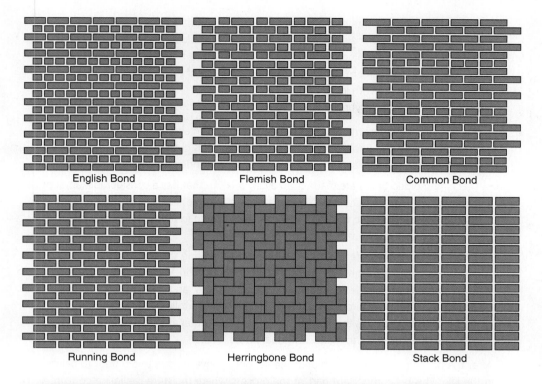

English Bond Flemish Bond Common Bond

Running Bond Herringbone Bond Stack Bond

FIGURE 7.4 Commonly Used Patterns of Brick Bonds.

Brick Faces

Because of the small unit size of bricks, it is possible to lay bricks in various patterns. Different patterns have been used by many cultures throughout history, so each pattern has a specific name, as shown in Figure 7.5. Bricks are also named according to which face of the brick is seen.

Bricks placed vertically with the 8-inch high by 2-inch wide edge showing are in a *soldier* position. Bricks placed vertically with the 8-inch high by 4-inch wide side showing are in a *sailor* position, and bricks placed vertically with the 4-inch high by 2-inch wide end showing are in the **rowlock** position. The rowlock position is commonly used under windows on exterior brick walls. Most times the rowlock bricks under windows slant slightly downward to help direct water away from the window.

Similarly, horizontally placed bricks are in the *rowlock stretcher* position when the 8-inch wide by 4-inch high sides are showing, the *stretcher* position when the 8-inch wide by 2-inch high edge is showing, and in the *header* position when the 4-inch wide by 2-inch high ends are showing.

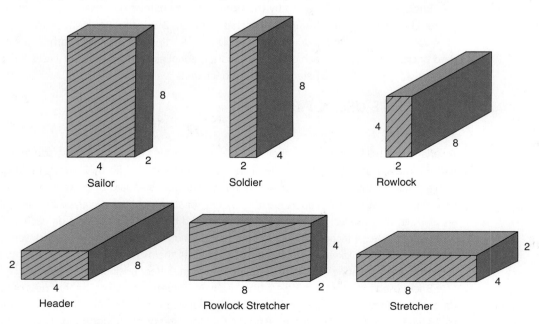

Sailor Soldier Rowlock

Header Rowlock Stretcher Stretcher

FIGURE 7.5 Names of Various Brick Faces.

was found and it can be altered by oxides of iron, magnesium, and calcium. Small amounts of other nonhazardous materials can added to the clay to produce different colors and textures of bricks. In all of the forming methods, excess clay mixture that doesn't go into the mold is placed back in the mixture, resulting in practically no waste of clay. When a quarry is no longer used, it can be covered with loose unused clay and topsoil.

According to Glengerybrick.com, there are three methods of forming bricks:

- Handmade, the oldest method of forming bricks, is to make the clay mixture soft enough to press into molds by hand. The clay mixture is cut into slugs that are individually picked up, rolled in sand, and thrown into a pre-sanded wooden mold by a worker.
- Machine-molded bricks are made from a clay mixture that has a considerable amount of water added. The mixture is placed in a machine that presses the wet mix into **sanded molds**. The sand is used to keep the brick from sticking in the molds and to affect different textures and colors of the final product.
- **Extruded** brick is a stiffer mixture with less water, making the mixture denser. The mixture is forced through a die having the shape of the brick with holes in the center. The core holes are needed to reduce the mass for firing, and the weight for future handling. Textures are produced by scratching, scraping, rolling, or sanding the surface of the column as it exits the die. The column of clay material that is produced by the extruder is cut by wires to make individual bricks.

After the brick unit is formed, the units are set onto conveyor cars to dry prior to being fired in the kiln. This is an important part of the process where moisture is eliminated to prevent scumming and certain mechanical defects from occurring when the brick is subjected to the intense heat of the kiln. Bricks are considered green until they are fired in a kiln.

Bricks are fired in a kiln by passing through it on a conveyor belt. The continuous tunnel kiln employs a combination of vertical and horizontal drafts. The preheating, burning, and cooling is done in zones varying in temperatures up to 2,000 degrees Fahrenheit. In this type of kiln, closer temperature control is possible and less handling of the **green bricks** results in better quality products. The temperature of the kiln regulates the color of the finished bricks. If a **flashed** look is desired, the dampers are regulated at the end of the burn to cut off the air and subject the brick to a **reducing fire**, thus bringing out the blacks, blues, and browns that make up a flashed range.

After exiting the kiln, the bricks are allowed to cool prior to handling. Defective bricks are discarded and the finished product is packaged and banded into cubes of approximately 500 bricks, inventoried by lots, and distributed to customers.

Bricks are usually referred to by the **nominal dimensions** (not exact). Standard bricks in the United States are nominally 4 inches wide by 2½ inches thick, by 8 inches long (4 × 2½ × 8). The actual size is a bit less, allowing for the **mortar** joint width. Three standard bricks laid on top of each other, with mortar, equal eight inches in height (2½ × 3 plus mortar). ASTM C216 covers standard facing brick units.

ALTERNATE USES OF BRICK

Thin Bricks

A variation of brick for interior veneered walls is thin brick, which is the same size in length and thickness, but only ½ inch to 3/8 inch wide. The 8-inch length by 2½-inch thickness is visible. Walls of thin brick **veneer** are lighter weight than standard brick walls, so they can be used where structural support is not sufficient for standard brick weight. Also, since they are thinner, they use less interior space than standard bricks, 3½ inches less on each of four walls would save 14 inches of interior room space. Another advantage of thin brick veneer is that highly skilled bricklayers are not needed to install them. Thin bricks are adhered to the substrate wall with adhesive. ASTM C1088 covers Thin Veneer Brick units made from clay.

Bricks used for floor covering are usually pavers. **Pavers** are half of the thickness of standard bricks. They are 4 inches wide and 8 inches long, but only 1¼ inches thick. The 4-inch by 8-inch face is visible. These can be used either for exterior or interior floors. Pavers can be

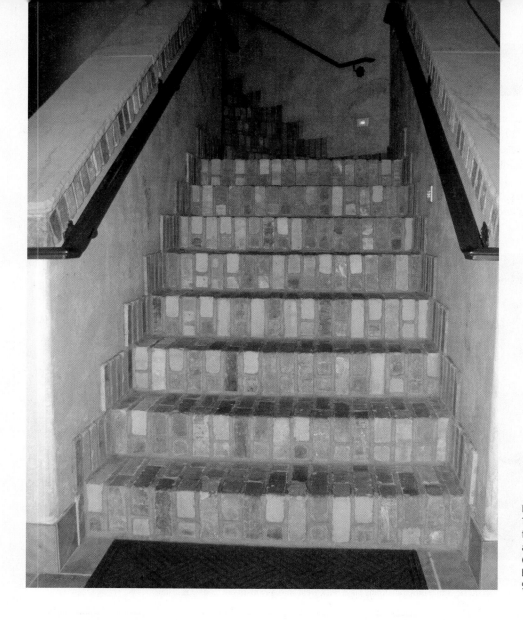

FIGURE 7.6 Thin Bricks Used for Stair Treads.
Thin bricks (½ inch thick) can also be used for a
floor covering. They were used for all interior trim
at Della Terra Mountain Chateau in Estes Park,
Colorado. The stair treads appear to be a solid
brick because the thin brick is shaped to show a
90-degree angle.

**FIGURE 7.7 Brick Pavers in a Herringbone
Pattern.** Christian Delbert/Fotolia

Brick can be formed into different shapes to create alternatives to the flat brick face and to transform a utilitarian material into an art sculpture. **Mise-en-Scene** is a mural of 32 brick relief sculptures surrounding the entrances to Yardley Hall and Polsky Theatre in the Carlsen Center for the Performing Arts in Overland Park, Kansas. Artist Donna L. Dobberfuhl of San Antonio, Texas, created the brick mural panels in a storage building at a brick manufacturing plant.

She made the relief in brick by stacking the unfired bricks, tracing the figures into the cold wet clay, and sculpting the figures using small hand tools. Afterward, the bricks were dried and fired in the manufacturing plant. Dobberfuhl's sculptures "set the stage" and give a powerful performance of their own. In the faces, gestures, and postures of the medieval actors, one can sense the primeval emotions of theater, dance, and musical presentation.

FIGURE 7.8 Mise-en-Scene. Mise-en-Scene is a mural consisting of larger-than-life brick sculptures representing the history of theater, dance, and music. The mural transforms plain brick walls into a work of art. Bret Gustafson

laid without mortar close together, or laid over mortar with joints showing. Bricks are strong and stand up to light traffic, but joints of cement between bricks crack easily. Latex additives can be put in the mortar to allow it to move without cracking.

Glazed brick is a variation on standard size brick in color and texture. Bricks can be glazed to produce a smooth feeling, colored surface. A ceramic glaze is applied before firing the brick in the kiln, so that the glaze is baked into the surface of the brick. The glaze provides a surface that is impervious to both liquids and gases. Usually glazed bricks are a custom production for a specific job. ASTM C1405 covers glazed bricks.

Application: Using Information Regarding Interior Finish Materials

CODE ISSUES

Because brick is made of clay, an inert material, and fired in a kiln, it will not burn and it will not give off toxic fumes. This makes it an ideal surface for meeting code requirements for egress. Corridors and stairwells used for exits in a building can have a surface of brick to

provide a safe exit in case of fire. Brick walls can withstand a fire burning on one side for several hours, depending on the construction of the wall. A brick-enclosed stairwell can keep fire and smoke contained, away from the exit corridor, keeping occupants safe during an evacuation.

SPECIFYING

The American Society for Testing and Materials (ASTM) specification for brick assigns a grade of severe, moderate, or negligible weathering to accommodate varying climates and applications of brick. Most bricks currently produced have strengths ranging from 3,000 pounds per square inch (psi) to over 20,000 psi. Thin brick veneer is covered by ASTM C 1088, and facing brick is covered by ASTM C 216. Brick is found in CSI Division 04-210. For brick specification guidelines, contact the Brick Industry Association at www.brickinfo.org.

LIFE CYCLE COST

Brick has an extremely low life cycle cost based on the fact that it is durable and requires practically no maintenance. Brick resists moisture, pests, fire, and damage. The color of brick is permanent, and it is relatively soundproof. Brick has good insulating capabilities and passive solar heat retention, contributing to lower utility costs for heating and cooling. The fact that brick is fire resistant allows buildings to have lower insurance costs.

Cost Estimating

A designer will be able to determine the amount of brick needed for the design, but the bricklayer will need to determine the amount to order to account for overage needed. There are normally 6.85 bricks per square foot with 3/8-inch mortar joints. Each style of brick may have a different cost due to processes and ingredients to produce a specific color or texture brick. Brick production usually shuts down during the winter months for maintenance of the kilns and changes to designs.

To determine cost, the designer will need to work with the brick supplier who will have information on availability and delivery charges for shipping brick to the construction site. If there are a lot of corners in the wall, more labor and brick will be used. The advantage of using thin brick is that it would allow the project to be completed in about 30 percent less time, even though thin bricks cost slightly more than full size bricks and may not be as readily available.

INSTALLATION METHODS

Brick may be used for interior walls, either as load-bearing structural walls or as a veneer over another wall structure. Load-bearing brick walls are limited in height and length, so most brick walls presently are full-size brick veneered over a structure of reinforced steel, concrete block, or wood studs.

Mortar

Brick walls use mortar to hold the bricks together and bond reinforcing steel anchors into the wall. The joints in a wall installation are normally 3/8-inch thick, which compensates for any dimensional variations in the brick units. Mortar consists of a mixture of Portland Cement, hydrated lime, and sand. Colored mortars can be produced through the use of colored aggregates, such as white sand, ground granite, marble, or stone, or by adding pigments. The joints between bricks are either troweled or tooled. **Troweled joints** have the excess mortar scraped off with a trowel. **Tooled joints** are finished with a metal tool to compress and shape the mortar in the joint. The joint is tooled when it is hard enough to show a thumbprint, just before it looses its plasticity. A concave joint, or a V joint, is the most resistant to water entering the mortar because the tool compresses the mortar in the joint

Brick Used in an Interior

Floors
Brick pavers

Walls and Dividers
Brick wall surface
Thin brick wall surface

Accessories and Trim
Trim around floor or openings
Brick stair treads
Brick columns

FIGURE 7.9 Brick Wall Installation Showing Mortar between Bricks. photoclicks/Fotolia

and the shape of the joint directs water away from the mortar. Joints that allow mortar to extend beyond the face of the brick are most receptive to water entering the mortar. Mortar for brick units is covered by ASTM C270-02, and ASTM C979 covers pigments for integrally colored concrete mortar.

Mastic

For the installation of thin brick on an interior wall, there are three basic steps. If the area is a floor or wet area, bricks are set into mortar. If the area will be above the floor and dry, such as around restaurant booths, the tile is applied with **mastic** over concrete board. First, the height

FIGURE 7.10 Chalk Line. A chalk line is applied to the substrate concrete board to mark the guide line for the next courses of brick veneer to be applied.

of the brick course is measured at both ends of the wall and a chalk line is snapped between the two marks to give a straight guide line for applying the bricks. The coursing starts at the most noticeable height—in this case, it is below the wood trim cap of the half wall.

Second, mastic is applied to the wall in horizontal bands above the chalk line. A metal notched trowel is used to apply the mastic. Third, the thin bricks are removed from their package and applied to the mastic. In order to get the best contact between the brick and the mastic, the back side of the brick is scraped to knock any burrs off the brick and make it as flat as possible. The bricks on this wall are in the **running bond** pattern where each row's grout line is centered under the brick above. This is the most commonly used pattern for installing bricks.

MAINTENANCE

Regular maintenance for brick interiors would be brushing and vacuuming the brick. A coating or sealer can be applied to bricks to prevent penetration of grease or smoke.

Case **STUDY** of Brick Used in a Commercial Interior Application

Brick is used for the interior wall surface in a chain of casual restaurants, 54th Street Grill and Bar, designed by Shaw Hofstra + Associates Inc. of Kansas City, Missouri. They specify brick for interior walls in the booth seating area because of the durability and easy maintenance of brick. The restaurant's practice is to give crayons to children while they are waiting for their food. Children use the crayons to draw or write on the tabletops, but sometimes they color on the walls also. Since the walls are brick, the crayon does not show from a distance and can be scrubbed off without damage to the brick surface.

The restaurant owner normally likes the use of full-size bricks on the interior to match the bricks used on the exterior.

The project architect, Lois Walkenhorst, described two cases where thin brick was used for interior walls instead of full-size bricks. In one restaurant, she specified thin brick from Glen Gery Brick because the brick surface was applied to a tall wall, approximately 14 feet high. The weight of the brick was reduced greatly by using thin brick. In another restaurant, she specified thin brick from Glen Gery because she was remodeling an existing space. To use the existing concrete floor slabs 4 inch thickness, thin brick was selected. If the architect had been designing a new structure, the floor slabs would have been increased to 8 inches to accommodate full-size bricks.

summary

Bricks have been made since ancient times and used for constructing buildings. At times bricks were covered on the interior walls with plaster to provide a surface for decoration. Now, bricks are appreciated for their earthy look and acoustical qualities in interiors. Brick interiors provide a warm and casual atmosphere to spaces through their texture and color, whether they are used on a floor or a wall.

Bricks are made of clay, yielding a lighter weight than stone and not requiring as much skilled labor. They are inherently fire resistant, making them safer to use than wood. Bricks are sustainable because clay is abundant and available in most parts of the earth. New technological development is allowing brick to be produced thinner and to cover larger expanses of walls.

To find out more about brick, the following websites and publication of professional organization in the brick industry can be useful:

The Brick Industry Association: www.gobrick.org

The Brick Industry Association, Heartland Region: www.heartlandbrick.org

International Masonry Institute: www.imiweb.org

review questions

1. Describe how the dark color of "flashed" bricks is achieved.
2. Explain why brick has been used in many cultures throughout the world.
3. Describe the purpose of drying bricks before they are fired in a kiln.
4. Analyze the environmental impact of using reused bricks compared to new bricks for both a 5,000 square foot space and a 20,000 square foot space.
5. Evaluate the impact of specifying full-size bricks versus veneer bricks for an interior wall incorporating a fireplace.

glossary

Barrel vault forms a half-circle ceiling, continuing the half-circle like a tunnel.

Bond is an arrangement of brick rows to form a pattern.

Extruded refers to the material pushed out of a specially shaped opening.

Flashed is a dark color that appears over the normal color of the brick.

Green bricks is the term that describes bricks that have not been fired in the kiln.

Header is bricks placed to show their face of 2 inches tall and 4 inches wide.

Herringbone pattern is a pattern made of adjacent rows that are perpendicular to each other.

Inert means inactive; does not affect other substances.

Kiln is an enclosed furnace for heating materials to a certain temperature and maintaining that temperature for a specified length of time.

Mastic is an adhesive used to secure tiles to a wall; a composition of mineral matter bound by a resinous medium in a volatile solvent.

Mise-en-Scene is French for "set the stage."

Mortar is a mixture of Portland Cement, lime or gypsum, sand, and water that will become hard when dry.

Nominal dimensions is the name used to express the size, not the actual dimension.

Pavers are used to cover the ground and make a flat surface.

Pendentive arch is a circular dome over a square space joined by triangular curving forms.

Pug mill is a machine consisting of a shaft armed with blades revolving in a drum used for mixing a substance into a desired consistency.

Quarry is the place where a material is extracted from the earth.

Reducing fire is when the air is cut off in a kiln at the end of a firing to produce a desired blackened effect.

Rowlock is bricks placed to show their face of 4 inches high and 2 inches wide.

Running bond is bricks placed in alternating rows so that the grout joint of one row is in the center of the bricks in the row below.

Sanded molds are molds sanded to keep the brick from sticking to the mold and to produce a texture.

Shale is a dark, fine-grained sedimentary rock in layers formed from compressed layers of clay.

Stretcher is a brick showing its face as 8 inches wide and 2 inches high.

Sun-dried or mud brick are bricks made from clay that were not fired in a kiln.

Thermal mass refers to a material that retains heat well.

Thin brick is a brick that is 8 inches by 2 inches on the face, and only 3/8-inch thick.

Tooled joint is formed by a metal tool used to create a concave shape in the grout between bricks.

Trowel is a flat metal blade with a handle used to spread or scrape excess liquids off a surface.

Veneer is a material applied to a surface, not the structural material.

Ceramics

learning objectives

When you complete this chapter, you should be able to:

1. Recognize terms used when discussing ceramics.
2. Identify common uses of ceramics in an interior.
3. Summarize the history of ceramic use in interiors.
4. Describe how ceramics are produced.
5. Describe how ceramics meet code requirements for interior use.
6. Describe and analyze the physical characteristics and properties of ceramic products for a specific interior use.
7. Analyze the environmental impact of using ceramics.
8. Evaluate how well ceramic products will meet the specific needs of a design project.

Awareness: An Overview

DESCRIPTION AND COMMON USES

There are regions of the world where buildings have all of their surfaces, exterior and interior, covered with intricate patterns of colorful ceramic tile. The tradition of covering building surfaces with ceramic tiles was established by ancient cultures using blue and white glazes in the areas that are now Turkey, Iraq, and Iran. **Persia** (Iran) became the center of ceramic tile production centuries ago and continued the tradition under Islamic culture. The Islamic culture embraced ceramic tile decoration and carried it throughout their regions, spreading east to India and west across northern Africa to Spain. Colorful Spanish tiles were shipped to Italy where they became popular.

Italy became the major tile producer during the Renaissance, until their craftsmen took the technology to Holland. Holland came under the influence of ceramic tiles and decorated all their surfaces in tiles, but the bright colors were discarded and blue and white tiles became the tradition in the Netherlands, going back full circle to the original blue and white porcelains from Asia.

Today, ceramic tiles with their rich heritage of design and technological developments are available for many uses. Designers can choose to create beautifully decorative surfaces with bright colors and exotic patterns, or select an unobtrusive durable surface purely for its functional qualities. Ceramics have been used for thousands of years by almost all civilizations in one way or another. Currently, in the United States ceramics are being used in a way that is reminiscent of the ancient American tradition of earth tones and functional uses.

Elaborate and colorful tile decoration on the walls and ceiling exemplify the Islamic culture.
Artur Bogacki/Fotolia

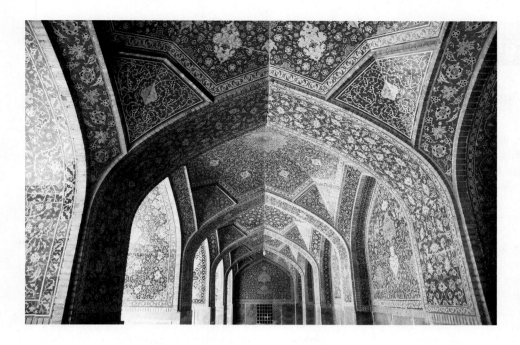

The definition of **ceramics** is objects made from clay that have been fired and glazed. We will include tiles that are not glazed in this chapter also. For interior finishes, ceramics are tiles that are applied to a floor or wall surface. Although ceramic tiles may be selected for use because of their durability, they can add color and decoration to an interior. Ceramic tiles are often selected for installation in places where water will be present, such as bathrooms, showers, kitchens, swimming pools, and courtyards. Ceramic products made for bathrooms, such as water closets and lavatories, will be labeled *vitreous china* or *vitreous porcelain,* meaning they have been fired at a high enough temperature to make them nonporous, or waterproof.

CHARACTERISTICS

Ceramics start out as clay pottery. The existence of **pottery** depends on two important natural properties of clay: the property of plasticity and the property of being converted when fired into a hard, almost indestructible building material. When a **glaze** is added to a fired clay

FIGURE 8.2 Ceramic Tiles Are a Good Choice for Walls and Floors in an Area Where Water Is Present. Kletr/Fotolia

Ceramics **133**

Properties of Ceramic Tiles

(sustainable qualities are highlighted in green)

- Ceramic tiles do not burn.
- Glazed ceramic tiles do not absorb liquids or stains and will be slick when wet.
- Ceramics are durable; they have lasted for centuries.
- Ceramics absorb heat and release heat slowly back into the air.
- Ceramics are strong in compressive strength, which makes them good for floors.
- Ceramic tiles are dense and heavy, leading to high transportation costs.
- Ceramics do not absorb dirt and are easy to clean.
- Ceramics are color permanent; the tile color will not fade from chemical or sunlight.
- Ceramics are chemically inert, giving off no emissions.
- Clay used to make ceramics is abundant in the earth.

form, it becomes a ceramic. Ceramics are hard, rigid materials known for their durability. They make good flooring materials because they have high compressive strength. However, they can break if not installed properly for a floor covering, or in the case of impact, where something such as a car runs into a tile wall. Ceramic tiles will not burn, which makes them ideal for hot areas such as stoves and fireplaces. They retain heat for a long time and slowly release heat back into the surrounding materials or air, making them ideal for floor covering in climates that get hot during the day and cold at night.

ENVIRONMENTAL IMPACT

Ceramic tiles used in a building project can help the project acquire points toward LEED certification. The use of ceramic tile can help attain credits in the category of Materials and Resources, and Indoor Environmental Quality.

Clay is an abundant resource in the earth. It is easy to find and extraction from the ground takes little energy or special equipment. The energy used to produce ceramics is during the kiln firing, which takes several days of heat in an enclosed kiln, thus the firing process requires high embodied energy. Ceramic tile can be a local resource if the designer specifies a U.S.-made tile. If ceramic tile is not local, transportation is costly because ceramic tiles are heavy and transportation uses great amounts of energy in fuel cost.

Ceramic tiles are inert and do not emit any volatile organic compounds. They are also nonabsorbent, meaning that odors, smoke, liquids, chemicals, bacteria, and viruses remain on the surface until they are cleaned off. Ceramic tiles continue to be inert in a landfill.

Ceramic tiles also have good thermal properties. When sunlight falls on ceramic tiles during the day, the tiles store the heat and release it back in the surrounding air during the night. In warm climates, ceramic tiles store cold temperature, making it an effective material to cool warm air and surfaces. This thermal property reduces energy consumption and helps maintain indoor temperatures.

Tiles are made in small sizes and sold in boxes of small quantities, resulting in very little waste product on a construction site. Ceramic tile waste can be reused for road beds and other paving.

Ceramic tiles can be made from post-consumer and post-industrial recyclable content. This is not always done, so ceramic tile is not well known for containing recycled content. Tiles can be recycled by being ground up and added to fresh clay as **grog**. Tiles made from recycled content, as much as 30 to 100 percent recycled solid waste, produce very durable flooring. Post-consumer recycled materials going into the production of ceramic tiles can include granite dust as well as glass from windows, bottles, and windshields. Post-industrial contributions include plate glass and grinding paste from the computer industry.

Indoor Air Quality Issues

Ceramic tiles are made from natural, nontoxic ingredients. They do not emit any toxic particles into the air since the firing process has left them inert. The composition of ceramic tile does not provide a food source for fungi and mold. If mold is present in an environment, it will not destroy ceramics and can be cleaned off. Ceramics do not hold dust, mold, allergens, or other air impurities. However, when the grout used between tiles is porous, the grout can hold air impurities. To relieve that possibility, grout can be sealed with a liquid sealer that dries to an impervious coating, or epoxy grout can be used.

For a ceramic tile installation to be sustainable, the installation materials such as substrate (supporting materials under tile) adhesives, grout, mortars, and sealants should be zero or low-VOC without petroleum or plastic substances.

In the Hispanic culture, ceramic tiles on the interior walls and floors are very important. They are so important that a Spanish term for poor is "having a house without tiles." People in the United States have come to associate Mexican culture with brightly colored ceramic tiles; indeed, they are one of the most used materials to give a Mexican atmosphere to a business or restaurant. When the Rodriquez family created their restaurant, Cazadores Mexican Grill and Cantina, they chose Talavera tiles imported from Puebla, Mexico, for wall decoration. Talavera handcrafted tile is a vital expression of Mexican culture, and combines influences of Spanish, Moorish, Chinese, and Mediterranean cultures. Ceramic wall tiles are used in a single row just above the table height around the restaurant seating area and for the wainscot and lavatory counter in the restrooms. The sinks are also made of Talavera ceramics. **Terra-cotta** tiles from Saltillo, Mexico, are used for floor covering in the bar area.

FIGURE 8.3 Painted Tiles. The wall tiles, counter tiles, and sink are Talavera tiles from Mexico used to give a definite Mexican theme.

FIGURE 8.4 Floor Tiles. The terra-cotta floor tiles from Saltillo, Mexico, provide a Mexican mood.

Understanding: In-Depth Information

HISTORY OF CERAMIC USE IN INTERIORS

The precursor of ceramic tile was glazed clay bricks. Ceramics were developed in **Mesopotamia** by the Sumerians as early as 4000 B.C.E. with blue and white striped decoration. Later, the Assyrians used glazed bricks in the Palace of Nimrud in 1000 B.C.E. Around 600 B.C.E., glazed bricks were used for the Ishtar Gate in Babylon where lions, bulls, and dragons were depicted in primary colors against the glazed deep-blue background.

Egyptians used glazed clay bricks and tiles as early as 2780 B.C.E. with blue copper glazes. The Egyptians' method of decoration was to inlay clays of different colors on the surface of the tile or brick. Glass production was very important in Egypt, resulting in glass technology being applied to ceramics in later centuries. The application of glaze in layers resulted in a more transparent glazed ceramic. Consequently, Egyptians developed a design method of

FIGURE 8.5 Ishtar Gate in Babylon.
Bogacki/Fotolia

scratching a pattern into the clay before glazing, giving a deeper color effect. This was first developed in Egypt around 1300 B.C.E. and was later adopted by the Byzantines and Romans. Ancient Greek and Roman civilizations used terra-cotta for building materials such as floor tiles, roof tiles, and wall tile medallions, but they were not known for the use of glazed ceramics. The ceramic firing process was not well controlled in ancient times and the potters were lucky to get a few good ceramic pieces when placing dozens in a kiln.

The Chinese, as early as 1700 B.C.E., produced their first ceramics for pottery found in Shang Dynasty tombs. Later, they used a fine, white **stoneware** with glaze around 1400 B.C.E. Stoneware is fired at a higher temperature than **earthenware**, but the clay body was not the thin translucent quality of porcelain. Chinese potters acquired a mastery of high-temperature kiln-firing methods to make **vitrified** stoneware. Over the next centuries, the T'ang Dynasty (618 to 908 C.E.) of China developed porcelain ceramics that were the envy of

FIGURE 8.6 Chinese Wall Tile. Shi Yali / Shutterstock

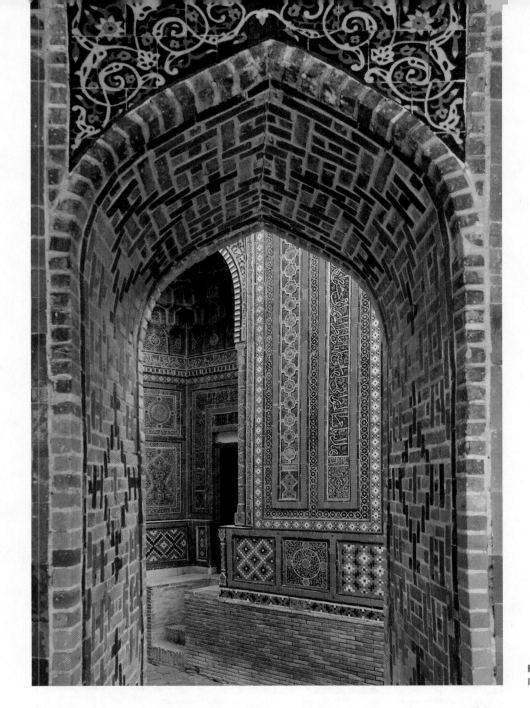

FIGURE 8.7 Blue and Turquoise Tiles in an Islamic Design. javarman/Shutterstock

the world. China's greatest contribution to the advancement of ceramics was the invention of white translucent **porcelain** during the Sung Dynasty (960 to 1279 C.E.). Chinese porcelains were admired for their translucency, thinness, and fine quality, which made them the standard for imitation.

Islamic architecture concentrated its decoration on interior spaces, with courtyards, gardens, and fountains. Tile work was a favorite means of decorating architecture throughout Islamic lands. Islam was founded in 622 C.E. and overtook the empires that were in Syria, Egypt, and Persia. In 762 C.E., Islam established its capital at Baghdad in Mesopotamia. By this time, Chinese porcelains of the T'ang Dynasty were brought to Mesopotamia and had a great influence on ceramics produced in Persia, although Persians still used earthenware for their ceramics, which was much thicker than porcelain. Islamic influence spread through northern Africa into Spain. Construction of the Great Mosque at Cordoba in 785 C.E. marked the beginning of Islamic architecture in Spain and northern Africa.

By 1100 C.E., Islamic tile makers in Persia had developed a good imitation of Chinese porcelains from the Song Dynasty. The imitation was stone-paste, or fritware, made of

FIGURE 8.8 Turkish Tiles in Floral Designs of Cobalt Blue. snowflakedesign/Fotolia

ground quartz mixed with glaze **frit** and fine white clay. The white clay, *kaolin*, was not locally available in Persia. Ceramic tiles in blue and black were used to decorate the exterior of domes on mosques. By the 1200s, tiles were also used to decorate the prayer-niche or *mihrab*, inside the mosque. White Ting porcelains of the Sung Dynasty in China inspired Islamic production techniques of ceramics in Persia, especially in the city of Kashan. By the 1200s, Kashan's ceramic industry was the main producer of tiles in many shapes for the insides and outsides of buildings all over Persia. Decorations for the Islamic tiles included swirling arabesques, scrolling plants, dots, palmettes, flowers, leaves, birds, animals, and

FIGURE 8.9 Detail of Spanish Wall Tiles.
Pabkov/Fotolia

human figures with inscriptions from the Koran. Persian potters fled to western Turkey to escape the Mongol invasions of the 1220s.

In western Anatolia, tiles of the highest quality were produced throughout the 1500s due to the patronage of the Ottoman court. By the 1500s, tile designs had become more influenced by plants and flowers rather than human figures or inscriptions. Between 1555 and 1700, vast quantities of wall tiles were made for the embellishment of mosques and palaces in Iznik, Anatolia. The time-consuming technique of cut tile mosaic was developed and used for magnificent effects. The most stunning examples are in the interiors of religious buildings and palaces.

Lusterwares were developed in Spain around 1100. During the next centuries, the Islamic and Gothic Christian designs mixed and were known as mudejar. The Hispanic culture used ceramic tiles, *azulejos*, on walls as a wainscot and trim around walls, doors and windows, instead of covering the entire surface. By 1450 the lusterwares gained popularity in Italy. They were imported to Italy from Valencia, Spain, through the island of Majorca. Because they passed through Majorca, they were known as *majolica* ceramics. The production of majolica tiles was taken over in Faenza, Italy, in the late 1400s. Majolica tile designs were mainly objects of everyday life surrounded by borders in a combination of Renaissance motifs and Islamic decoration in square and hexagon shapes. In Italy, ceramic tiles were blue with bright colors used for walls, ceilings, and church floors. The Italian majolica craftsmen took their techniques to Europe—mainly France, Belgium, and the Netherlands—in the 1500s. The European ceramics at this time were still made of earthenware that was glazed.

By the 1600s, Holland in the Netherlands was the main producer of ceramic tiles. They used tiles to cover the walls of all types of utilitarian rooms, including kitchens and dairies. Decorated tiles were used in a single row around the floor of stone-floored rooms. In the Netherlands, the use of bright colors was discontinued and ceramic tiles became increasingly more blue and white. **Delft** designs used everyday scenes and added a small motif in all four corners of square tiles that formed a pattern when combined on a wall. A finish of **kwaart** was applied to the tiles to give a shinier surface.

Delft designs were very popular and were copied in England and Germany. During the 1700s and the 1800s, ceramic production was refined and expanded by English and German pottery factories. There were many ceramic makers, and new developments included **bone china**, considered to be the epitome for teacups and dinnerware. The ceramic industry was brought to the United States by the early settlers from England and Germany (known as *Pennsylvania Dutch*).

FIGURE 8.10 Delft Design. Dutch Delft blue tiles show the characteristic blue color with everyday scenes and corner motif on white tiles.
R. Martens / Shutterstock

FIGURE 8.11 Quarry Textures in Red Flash. Image provided by Dal-Tile Distribution, Inc.

Renaissance building design was brought to the Americas by Spanish conquistadors in the 1500s and 1600s, mostly using terra-cotta tile for floors instead of brick. The Spanish tradition of producing ceramics was continued in Mexico, with similar designs and colors. The tiles of Talavera de la Reina, Spain, with their vivid colors of green, yellow, and orange, are a form of majolica. They have been reproduced in Mexico since the 1500s and continue to be produced in the city of Puebla in Mexico for Spanish Revival Architecture.

Terra-cotta maintained popularity in the 1800s while the United States was searching for a fireproof building material. Quarry tiles were developed during the late 1800s Industrial Age as a mass-produced alternative to handmade terra-cotta tiles. Made by extruding an unrefined clay and shale mixture into a mold before the material is pressed and heated, quarry tiles look very similar to terra-cotta but they are more durable and water resistant. Quarry tiles built on the tradition of pottery from ancient inhabitants of the American Southwest, Mexico, and Central America down to Peru. Ancient Americans did not use glaze on their pottery. From early times they used a firing method with an oxidizing flame for red, brown, and orange wares, and a reducing flame for firing black and gray colors. This technique is often seen on quarry tiles used for nonslick durable flooring in commercial installations.

Glazing

Glaze is very important to ceramics because it seals the clay body in glass and makes it impervious to moisture or water. A glaze is applied to a clay tile after it has been fired to a **bisque** finish. The tile is fired again with the glaze at a different temperature to fuse the glaze to the tile. In the early Islamic period (622 to 750 C.E.) the principal glaze used lead oxide for flux.

FIGURE 8.12 Ancient Tiles Showing Opaque Turquoise Glaze. Araspixel/Fotolia

FIGURE 8.13 Tiles Using Different Color Glazes Were Produced Using the *Cuerda Seca* Method. © Oleksii Sergieiev/Fotolia

Lead glaze created a problem by causing the colors painted under it to run. In the 900s C.E. Mesopotamian potters mixed their pigments with slip (liquid clay). The early Islamic potters in Mesopotamia (900s C.E.) developed a thick opaque white glaze, and painted designs over the glaze. Anything used to opaque the glaze is called a **tin glaze**. *Faience* is another term for a tin glaze. By the 1100s, Islamic potters developed an alkaline glaze, and pigments painted under it did not run. The alkaline glaze was used for Kashan ceramics when they were at their height. Alkaline glazes gave a greater clarity and brilliance. A popular color glaze was opaque turquoise, produced through a combination of the alkaline glaze, tin, and copper.

Spanish potters were known for using a type of glazing developed in Iznik, Anatolia, called **cuerda seca** (dry cord) around the mid-1400s. This technique involved drawing an outline with grease and manganese on a tile to keep the colored glazes separated. In the late 1400s, a technique called **Cuenca** was used where the tile design was pressed into the clay by a mold. This left raised lines for a border and the depressions were filled with colored glazes.

Glazes are used to add decoration and color to ceramic bodies. One decorative pattern is called **crackle**. This is where

Ceramic Colors

Antimoniate of lead produces an opaque yellow.
Antimony and cobalt produce green.
Chromium produces maroon or green.
Cobalt oxide produces vivid blue.
Copper in an alkaline glaze produces turquoise blue.
Copper when reduced produces red.
Gold (Purple of Cassius) produces pink.
Impure ore of manganese produces dark purplish brown.
Iridium produces grey or black.
Iron produces reddish brown or dark reddish brown.
Iron in **feldspathic glazes** produces soft grayish tones to celadon, opalescent blue, brown, and black.
Lead added to manganese produces a velvet-like glow to rich brown.
Manganese oxide produces soft purple or purplish brown.
Manganese with iron produces black.
Manganese in an alkaline glaze produces violet.
Titanium produces grey or black.

the glaze appears to have uniform fine lines covering the surface. The lines can be induced purposely by alternating heat and cold. The final product is known as *crackleware*. If the fine lines are not uniform or occur only in small areas on the ceramic, they are called **crazing**.

The colors in glazes come from pigments of inorganic materials such as minerals. Ceramic colors require the action of fire for their transmutation. These are divided into two categories: high-temperature colors and muffle-kiln colors. The high-temperature colors are iron-browns, iron-reds, manganese and cobalt, copper, and antimony.

PRODUCTION OF CERAMICS

Clay for ceramics is a stiff, viscous earth found in many variations throughout the world. It consists mainly of hydrated aluminum silicates and is derived mostly from the decomposition of **feldspathic** rocks. Most clays contain iron, giving them their red color, but in varying amounts. Clays also differ in plasticity. Red-burning clays that contain iron are generally more plastic than the white-burning pipe clays. Clays may be fusible from the presence of an alkaline **flux** such as lime or some other kind of material such as iron, which acts in the same manner. Clays can be made less fusible by increasing silica, such as sand, flint, or quartz. Clay compositions containing more water are more likely to shrink and become deformed in the kiln. This tendency is lessened by adding grog, pulverized fragments of pottery or fired clay from which the water has already been removed. Kaolin, the white clay used in porcelain, comes from a decomposition substance of the feldspar of granite (Boger, 1971).

A potter selects the clays and combines them through wedging or walking the clay to remove air bubbles. This process is similar to kneading dough for bread and gives the clay a better uniformity and consistency. For tiles, clay is pressed into molds and left to dry. When dry, they are fired in the kiln to produce the bisque tile. Glazes are applied to the bisque tile to create designs. Afterward, the tile is fired again in the kiln. The temperature and time of firing vary according to the type of clay used.

Types of Ceramics

Porcelain tiles are made with kaolin clay and china stone. These two silicates of aluminum (fusible and nonfusible) are fired at a temperature that exceeds 2,200 degrees F, resulting in a very dense, white, translucent material. During the cooling stage, the materials fuse together and solidify again to increase in strength and hardness. Because porcelain tiles are dense, they have a low absorption rate. They are vitrified, translucent, and emit a musical note when struck.

Stoneware refers to clay pottery having a body fired to a state of vitrification that is nonporous. Stoneware is always fired in a high-temperature kiln, but it does not use kaolin. The colors of clay for stoneware are normally grey or red, and occasionally brown.

Earthenware is low-fired clay that is usually red, orange, or brown color. Earthenware was used for many of the ceramics made in the world. They often have glazes on top and require two firings.

Quarry tiles are strong, utilitarian tiles made from graded shale and fine clays with the color throughout the body. Normally they are not glazed and retain their clay color of brownish orange or reddish brown. They are the same colors as bricks, but they are much denser with a smoother surface.

Terra-cotta, sometimes called *Saltillo,* is formed from clay, but fired at a much lower temperature than quarry tiles. The firing process leaves tiny air pockets in the clay, resulting in a porous surface. The porousness helps the tiles retain heat, but also allows them to absorb moisture. Terra-cotta tiles come in a range of earth colors, from brick-red to soft pink, and include fiery oranges, yellows, and dusky browns. Terra-cotta tiles are handmade, which means they will vary slightly in thickness.

Mosaic tiles are fired clay already glazed and cut into small shapes. If they were cut before firing, they would not fit together due to the shrinkage from the firing.

Application: Using Information Regarding Interior Finish Materials

CODE ISSUES

Ceramic tiles are fire resistant because they have been produced by high temperatures. They will not burn, do not contribute to combustion, and do not release toxins fumes in a fire. Ceramic tile can provide protection for underlying substrates and structures.

Case STUDY of Ceramic Tiles Used at Discovery Cove

The task for the designers of Discovery Cove in Orlando, Florida, was to create a sense of water flowing through the interior building of the park and make it look like it might have been created by island craftsmen. To accomplish this goal, four designers at Suzanne Sessions, Inc., of St. Louis, Missouri, in cooperation with PGAV architects, worked out a design using ceramic tiles, reminiscent of tiles used around swimming pools. The tiles provide a fluid pattern by incorporating broken tiles with square tiles swirling around the vertical surfaces, walls, counters, columns, and spilling onto the floor.

The designers started their task by sketching every surface on paper, including the restrooms and food serving area.

Signage was also incorporated into the tile design to make the experience as thematic and subtle as possible. The tiles varied in size from 1 inch square up to 12 inches square. After the design was drawn by hand, it was time to check for feasibility in creating the design in tiles. Colors were selected from available tile colors. The design was transferred to the computer and detail drawings were produced. The work required several tile layers, one tile artist, and several craftsmen. Dal-Tile's Ecobody Ceramics were used for the project. The client, Sea World Parks and Entertainment, was so pleased with the project that they decided to use the same theme and design team for their expansion.

FIGURE 8.14 A Broken Mosaic Mural Using Natural Hues of Smooth and Abrasive Glazed Tiles, Discovery Cove in Orlando, Florida. Architect: Peckham, Guyton, Albers and Viets, Inc. Designer: Suzanne Sessions, Inc.
Image provided by Dal-Tile Distribution, Inc.

Slip resistance is dependent on the surface treatment of the tile. Neither the American Society for Testing and Materials (ASTM) nor the American National Standards Institute (ANSI) has established an industry standard identifying a minimum coefficient of friction (COF) value whereby ceramic tile may be labeled "slip resistant." Tiles are produced with varying amounts of surface texture from smooth to rough. Although unglazed tiles such as quarry tiles are used for many flooring installations, there are some installations where grit will be added to the surface of quarry tiles, especially for areas with grease and water such as commercial kitchens.

Abrasion resistance is measured subjectively by observing the visible surface abrasion of the tile when subjected to the ASTM C 1027-99 testing procedure.

- **Class 0:** Not recommended for use on floors.
- **Class 1 Light traffic:** Residential bathrooms; primarily wall tiles or floors where soft soled shoes are worn, such as a bathroom.
- **Class 2 Medium to light traffic:** Residential use except for kitchens and entrance areas where scratching may occur.
- **Class 3 Medium-heavy traffic:** Suitable for all residential installations with normal foot traffic and light commercial areas with no direct access to the outside.
- **Class 4 Heavy traffic:** Heavy traffic residential and commercial floor coverings subjected to considerable traffic and scratching dirt.
- **Class 5 Heavy traffic:** Heavy commercial traffic areas and exterior use such as airports, hotel lobbies, public walkways, and shopping centers.

SPECIFYING

American National Standards Institute A137.1 presents voluntary standard specifications for ceramic tile. It lists and defines various types, sizes, physical properties, and grading procedures for ceramic tile, including mosaic tile, quarry tile, pressed floor tile, glazed wall tile, porcelain tile, trim units, and specialty tile. It is intended for reference or inclusion in the ceramic tile section of project specifications and contracts. It is available at www.tileuse.com.

Slip resistance is important for tiles used as flooring. Slip resistance is determined by ASTM C1028-06, the standard test method for determining the static coefficient of friction of ceramic tile. Static coefficient of friction is measured in this procedure by the use of a calibrated dynamometer, a specified neolite heel assembly, a standard reference tile surface, and a 50-pound weight. This procedure measures the maximum force required to initiate motion in the testing assembly in four perpendicular directions. The values are recorded and an averaging calculation is performed that determines the static COF.

Water absorption is measured using ASTM C 373-88. Individual tiles are weighed, saturated with water, then weighed again. The percent difference between the two conditions is referred to as the *water absorption value*. Tiles are classified according to water absorption percentages as follows:

- **Impervious:** 0.5 percent or less absorption
- **Vitreous:** 0.5 percent or more, but less than 3.0 percent
- **Semi-vitreous:** 3.0 percent or more, but less than 7.0 percent
- **Nonvitreous:** More than 7.0 percent absorption

Scratch hardness is measured on the Moh's Scale of mineral hardness. The relative hardness of glazed tile is an important issue for selecting tile. The test is performed by scratching the surface of the tile with different minerals and subjectively assigning a number to the glaze. The softest mineral used is talc, with a 1 rating; the hardest is diamond, with a 10 rating. Other minerals of varying hardness provide Moh's ratings for the other values. Scale hardness values of 5 to 7 are suitable for most residential floor applications. A value of 7 or greater is normally recommended for commercial applications.

Breaking strength of ceramic tiles is determined by ASTM C 648-04. In this test, a force is applied to an unsupported portion of the tile specimen until breakage occurs. The ultimate breaking strength is recorded in pounds. Final selection of the tile should be based on the breaking strength and the appropriate installation methods.

Tile Classifications

Tiles are classified by their hardness using the Porcelain Enamel Institute rating system. Tiles with a 5 rating are intended for heavy commercial use. Tiles with a rating of 4 are intended for commercial interiors. A rating of 3 is appropriate for residential and light commercial applications. A rating of 1 or 2 on tiles means they are suitable for light traffic, as in residential use. A material rated 0 should not be used for flooring.

Ceramic tiles are also classified by their density, which is a critical characteristic of sustainable interiors. Tiles with the highest densities have the fewest air pockets, which results in a more durable product. Density also determines whether the tile can be used only indoors. Tiles classified as nonvitreous absorb the greatest amount of water and can be used only indoors. Semi-vitreous is denser, but it, too, can be used only indoors. Vitreous ceramics absorb practically no water, and are therefore used around water, such as in bathroom fixtures. Impervious tiles do not absorb any water; as such, they are frost resistant and can be used in an outdoor application.

LIFE CYCLE COSTS

Ceramic tiles are a choice that benefit from life cycle cost analysis because they are durable and last for centuries. Higher-quality, denser tiles such as porcelains will cost more than less dense ceramic tiles. The cost of the ceramic tiles is usually low compared to other materials. However, the cost of labor to install ceramic tiles will be higher than that for some other materials, due to the hours of labor required to prepare the surface, lay the tiles carefully to keep them straight, apply grout between the tiles, and clean the excess grout from the tiles.

In addition, the cost of transportation of ceramic tiles is high because of their weight. Transportation may also be affected by worker strikes and other delays. It is possible that the quantity of ceramic tiles needed for a job may not be in stock in a local warehouse, so transportation and availability become an issue in selecting a specific tile for an installation. It is essential to check on quantity and reserve the amount needed for a job when you begin to select materials.

INSTALLATION METHODS

Installation of ceramic tile is covered by American National Standards Institute. These are voluntary standards for the installation of ceramic tile. ANSI A108 defines the installation of ceramic tile. A118 and A136 define the test methods and physical properties for ceramic tile installation materials. These are available at www.tileuse.com.

Floor Tile Installation

An option available for ceramic floor installations is under-floor heating. Electrical radiant heating can be installed under ceramic floor tiles. This type of heating is often used in dry climates. In a damp or humid area, condensation may occur under the floor from the combination of heat and humidity. If under-floor radiant heat is to be used, it will be laid into the mortar bed and wired to an electrical switch in the wall. Ceramic tiles will be installed over the mesh of electrical wires.

Ceramics Used in an Interior

Floors
Ceramic tile floor covering

Walls and Dividers
Ceramic tile wall covering

Kitchen and Bath
Countertops
Backsplashes around sinks and lavatories
Bathtubs and shower surrounds

Accessories and Trim
Tile trim around wall base or openings
Kitchen and bath accessories

Signage
Ceramic plaque signage

Hardware
Cabinet and door knobs or handles

Light Fixtures
Housings and sockets

Furniture
Tables
Benches
Planters

FIGURE 8.15 Setting Floor Tiles. Floor tiles are set on a minimal amount of mortar with small plastic spacers to keep the lines even.
csimagemakers/Fotolia

Make sure the tile layer is aware of this application before he or she plans the tile installation.

Interior installation with a mortar bed is covered in Construction Specification Institute number 09-32-13 for ceramic tiles and 09-32-16 for quarry tiles. CSI Thin Set installation is covered in 09-31-13 for ceramic tiles and 09-31-16 for quarry tiles.

When installing ceramic tile on a floor, the floor must be structurally sound and the substrate material must be rigid. The substrate must be level and clean prior to installation of the tiles.

Porcelain tiles have a low absorption rate that requires additives to promote bonding be added to mortars and grouts. Latex modified thin-set mortar is recommended for all **through-body** color porcelain tiles.

To achieve optimal results of a product with random shading, tiles should be selected from multiple cartons. The shading arrangement should then be planned prior to installation.

Use grout spacers between tiles for uniform thickness grout lines. Let the mortar dry for at least 24 hours.

To grout, remove the spacers. Use unsanded grout for grout lines tighter than ⅛ inch, adding a waterproofing agent. Using a rubber float, apply the grout at a 45-degree angle to the grout lines. Press firmly to get the grout all the way to the bottom. Work in small sections (about 3 square feet) to be sure you get uniform coverage of all grout lines. Wipe off any excess grout with a wet sponge and clear water. After the grout has dried for about 30 minutes, buff away any grout haze.

Sealer can be applied to grout joints two weeks after the installation of the tiles. Sealer is recommended to keep the grout color from becoming dirty and maintaining a water-resistant installation.

Wall Tile Installation

Interior installation is found in Construction Specification Institute number 09-30-13 for ceramic tile and 09-30-16 for quarry tile.

Earthenware ceramic tiles can be installed directly on drywall or plaster in dry areas. If they are in moist areas, cement backer board is recommended, but green-backed drywall, formulated to resist moisture, is acceptable. Find the center of the wall and use a carpenter's level to mark the horizontal line. Use a plumb line to mark vertical lines. Dry fit the first row of tiles starting at the center and working out to the ends, so that the pattern is even. Then follow these instructions:

1. Apply a thin layer of mastic on the surface to be tiled with the smooth side of a trowel, then go back over it with the notched side to make ridges in the mastic.
2. Place a small amount of mastic in the middle of the back of the tile.
3. Set the tile in place using a twisting motion to make optimum contact.
4. Use grout spacers on all sides to make sure the grout lines are consistent. Do not use spacers for handmade tiles that are not **rectified**.
5. To cut straight lines in tile, use a wet tile saw. For irregular shapes, use tile nippers to nip a piece at a time until the shape is cut. Allow tiles to dry overnight before applying grout.
6. Use sanded grout for grout lines over ⅛ inch wide. Apply with smooth strokes in one direction.
7. Allow 20 to 30 minutes for the grout to set. A haze will begin to appear.
8. Use clean water and a clean sponge to gently wipe away excess grout.
9. Allow a drying period of 24 hours and clean grout haze again.
10. If the tile is in a kitchen or bathroom, use mildew-resistant silicone caulk to seal the edges where the ceramic tile meets the counter or tub.
11. After two weeks, sealer can be applied to the grout to keep the horizontal surface's grout from discoloring.

FIGURE 8.16 Cutting Tile. Ceramic tiles are cut by using a circular saw with a tray and water, known as a *wet saw*.

Pre-grout sealer or grout-release products may be recommended when installing porous tiles or tiles with heavy texture to prevent them from retaining grout after the grouting process.

MAINTENANCE

Ceramic tiles should be swept of dust to keep them free of sand and grit on the surface. They may be washed with water. If bleach or other chemicals are used, the grout color may be affected. **Epoxy grout** will hold up to bleach, whereas unsealed grout may lose its color.

FIGURE 8.17 Application of Colored Grout on Top of Ceramic Tiles. littlny/Fotolia

summary

Ceramics have been used in interior spaces for many centuries in almost every culture because they are made from a natural resource, clay, which is easy to dig out of the earth in most regions. Ceramics were originally dried in the sun, making them easy to produce, with a surface hard enough to withstand compression and wear. As ceramics developed, they became stronger and harder through the addition of different types of clay and drying in a kiln at high temperatures. Ceramics were painted with glaze mixtures to produce decorative tiles, making them specific to the culture in which they were produced.

Ceramic products are sustainable products because the natural resource is abundant and uses little energy in production. They are produced in many locations, making them a local regional material for LEED projects. Ceramic tiles are versatile; they can be a practical solution for covering a surface and will project an earthy feeling, or they can be highly decorated artistic accents in an interior. Ceramics inherently meet fire codes; they are not flammable and do not produce smoke. Ceramics are extremely durable and require little maintenance; therefore, they are a good value for their cost.

To find out more about ceramics, the following websites and publications of professional organizations in the ceramic industry can be useful:

The Ceramic Tile Distributors Association provides educational and networking opportunities for distributors of ceramic tile and their suppliers to further the consumption of ceramic tile: www.ctdahome.org/.

The Ceramic Tile Institute promotes greater consumption of tile through education, public relations, and liaison with all facets of the construction industry as well as the general public: www.ctioa.org

Ceramic tile industry information and resource center for the ceramic tile industry: www.ceramic-tile.com/.

The Tile Council of North America, Inc., is an international trade association. www.tileusa.com/

Information on ceramic tile producers is available at these websites:

Dal-Tile is one of the largest producers and importers of ceramic tiles: www.daltile.com

Florida Tile is a large producer of ceramic tile: www.floridatile.com

Interceramic, Inc., has a digital visualizer on its website: www.interceramic.com/site/USA.xhtml

Italian Tile Manufacturers' website: www.italytile.com

Marazzi Tile has a layout guide on its website: www.marazzitile.com/patterns

review questions

1. Describe the difference between porcelain and earthenware.
2. Explain the purposes for using a glaze on pottery.
3. Describe what constitutes a tin glaze and where it is used.
4. Analyze the effects of using through-body porcelain tiles on a floor with lots of windows on the south.
5. Evaluate which type of tile (terra-cotta, through-body porcelain, rectified glazed tiles, or quarry tiles) would be best to use in a commercial kitchen where bacteria growth must be prevented.

glossary

Azulejos is the term for a decorative wall tile in Spain and Portugal.

Bisque (or biscuit) is the first firing of a clay form without a glaze.

Bone china is softer than porcelain and incorporates the ash of calcinated bones, used to give it pure whiteness and translucence.

Ceramic tiles are made from clay and glazed.

Crackle is a network of fine lines in a glaze caused by the difference in the expansion and contraction of the body and the glaze under heat and cold.

Crazing is the accidental splits in a glaze consisting of a mesh of fine cracks.

Cuenca is a method of keeping glaze colors separated by raised borders pressed in the clay tile.

Cuerda seca is a method of keeping glaze colors separated by a grease line painted on the tile before the glaze colors are applied.

Delft is tin-glazed earthenware tile from Holland in the Netherlands.

Earthenware is made from nonvitrified (low-fired) reddish clay and is slightly porous. It is the most common type of ceramics and can be unglazed or glazed.

Epoxy grout is a waterproof cement mixture with epoxy used between tiles.

Faience is earthenware ceramic with a tin glaze.

Feldspar is a variety of crystalline rocks from which clays were formed by decomposition.

Feldspathic glaze is a powdered feldspathic rock mixed with lime, sand, potash, or quartz, requiring a high temperature to fuse them.

Flux is the substance that lowers the melting or fusion point of a glaze.

Frit is made of pounded quartz and calcinated soda plant, heated until it melts into clear glass.

Glaze is a top coating of silica and fluxes; when fired, they fuse and result in a glassy surface.

Grog is ground-up fired clay.

Grout is a porous Portland Cement used between tiles.

Kwaart is a thin transparent lead glaze for sheen.

Lusterware is a tin-glazed ceramic with sliver or copper oxide painted over it, then fired again at a low temperature.

Majolica is a tile with a luster glaze originally imported to Italy from Spain through Majorca.

Mesopotamia is the area that is now Iraq and Iran.

Mudejar is the mingling of Moorish and Gothic Christian design motifs in Spanish designs.

Persia is presently known as Iran.

Pottery is a term that describes all objects fashioned from clay and then hardened by fire, but commonly used to mean earthenware.

Porcelain is made of kaolin clay, feldspar, and quartz. It is translucent, nonporous, and sonorous (emits a musical note when struck).

Rectified tiles are also called *true-edge*. They are square on all sides, which allows them to be placed close together for smaller grout joint or no grout.

Stoneware is pottery fired at a high temperature that does not use kaolin.

Terra-cotta is an Italian term that originally meant *burnt earth*. It is earthenware clay of a brownish red color, low-temperature fired. Normally the term *terra-cotta* is applied to architectural features and sculpture.

Through-body refers to porcelain tiles without a glaze where the color is consistent throughout the tile.

Tin glaze is a glaze with an opaquing agent.

Vitrified is a term for firing ceramics at a high temperature to make them nonporous; heat and fusion close the crystallization to make the ceramics like glass.

Glass

learning objectives

When you complete this chapter, you should be able to:

1. Recognize terms used when discussing glass.
2. Identify common uses of glass in an interior.
3. Summarize the history of glass use in interiors.
4. Explain how glass is produced.
5. Describe how glass meets code requirements for interior use.
6. Describe and analyze the physical characteristics and properties of glass for a specific interior use.
7. Analyze the environmental impact of using glass.
8. Evaluate how well glass products will meet the specific needs of a design project.

Awareness: An Overview

DESCRIPTION AND COMMON USES

People in buildings thrive when they have access to daylight and views. Workers are more productive, students are better learners, and people are generally happier when they are able to see nature and are exposed to sunlight. Openings in buildings are **glazed** (fitted with glass) to provide protection from exterior elements while allowing natural light to penetrate interior spaces.

Glass is used to glaze exterior windows, doors, and skylights, and for storefronts and **curtain walls**, non–load-bearing exterior sheathing, "hung" from the structural frame of a building. Glass is used in an interior to enclose and separate interior spaces, providing acoustical separation while permitting light to pass from one space to another, and either allowing or obscuring vision. Interior glass used for this function includes glass in interior windows and doors, vision lites in doors, side lites, divider screens, privacy panels, feature walls, and shower and bathtub doors and surroundings. The ability to control the quality of light passing through clear or colored glass, or textured or patterned glass, appeals to designers and artists who design using glass for both functional and nonfunctional decorative objects. Decorative glass in an interior may be used for furniture, light fixtures, signage, tabletops, countertops, transaction tops, and backsplashes; in tile or sheets on walls; and as mirrors. Glass can also be used for stairs, ceiling panels, and floors.

Glass Bridge over a Field of Poppies at the Entry to the National World War I Museum, Kansas City, Missouri.
Photograph courtesy Kay Miller Boehr

CHARACTERISTICS

The most significant characteristic of glass is its transparency, but glass can be modified to be translucent or opaque, thus allowing a range in the amount and quality of light that passes from the exterior to the interior of a building or between interior spaces. Glass also allows a range of visual access between interior spaces or between the exterior and interior of a building.

Heat and cold can easily pass through glass. A building designer must carefully determine the placement and size of windows in order to balance the need to conserve energy with the need for daylight as well as the need to balance the desire for views with the desire for privacy. The size, location, and placement of glazed openings must be carefully designed to avoid the impact of unwanted brightness or **glare**. Glass will reflect sound, and glass walls can limit the sound transmission from room to room.

ENVIRONMENTAL IMPACT

Glass is made from sand, which is a plentiful, nonpolluting natural material. The production of glass requires high heat; a variety of fossil fuels—including fuel oil, natural gas, and liquid petroleum gas—are used to heat the furnaces, supplemented by electric heat. The fuel combustion can result in harmful emissions. Glass has an embodied energy rating between those of concrete and metals.

Glass is continuously recyclable. Waste from producing glass is reused as **cullet**, a component of new glass that makes up 10 to 20 percent of the material to make flat glass and up to 50 percent of the material used to make blown or pressed glass. Using cullet as an ingredient in glass also means that the melting point is reached sooner, thus requiring less energy to produce the glass. Strategic Materials Recycling, the largest glass recycler in the United States, collects post-industrial and post-consumer scrap glass, processes it into cullet, and sells two million tons per year back to the glass product manufacturers to use as a raw material in making glass. Glass from all sources can be recycled. Recycled glass is used to produce glass tiles, the aggregate in terrazzo, and glass fiber insulation.

When windows are properly sized and located, glass can be an essential component of a passive solar energy system. For example, in the Northern Hemisphere, windows located on the south-facing wall of a building allow winter sun, which is low on the horizon, to enter the building. The glass allows the sun to warm the interior of the building, and combined with a thermal mass (such as stone or concrete) the heat can be absorbed and released to warm the building in the evening. In the summer, the sun is higher in the sky and does not shine directly into south-facing windows. The sun's rays can be screened with deciduous plantings (trees or vines), exterior screening devices, or interior window shading. Fewer windows should be used on the eastern and western faces of a building because summer sun is more difficult to control on these faces. North-facing walls should have minimal openings to protect from winter winds.

In spite of its advantage as a source of solar heat gain, glass is a poor insulator and has a very low *R-value*. R-value refers to the measure of thermal resistance of a material. Materials with high R-values resist heat and cold and are better insulators. Windows and doors with glass allow the transmission of heat and cold and must be sealed to prevent heat loss or gain. Various types of glass have been developed to prevent heat gain/loss, including double glazing, low-e glass, reflective glass, and tinted glass. Double-paned insulating glass with a low-emissivity coating can improve the insulative quality of glass while allowing daylight and

Properties of Glass

(sustainable properties are denoted with green color)

- Glass is hard but brittle. It is easily fractured on impact or by a sudden change in temperature and may shatter or break into shards.
- Glass transmits heat and cold easily. It may be considered to have high thermal conductivity because of the ease of heat transfer. However, because it is transparent, glass can also absorb and radiate heat.
- Glass is chemically stable. It is only slightly affected by ordinary solvents, but can be etched by hydrofluoric acid.
- Glass transmits light. Because glass is technically a liquid in a semi-solid state, it is transparent.
- Heat can melt glass and return it to its molten state.
- Glass, especially when double glazed, has good sound-insulating properties.
- Glass is durable, and glass products can have long, useful lives.
- Glass is made from abundant natural materials.
- Glass is continuously recyclable.
- Glass production can incorporate recycled glass.

views. In addition, it is important to minimize heat loss or gain through gaps in windows and doors, so proper installation and sealing is essential.

Sustainable design principles include designing buildings that are healthy places for the occupants. LEED points can be gained by designing a building that allows interior access to daylight for 75 percent of the regularly occupied spaces and for achieving a direct line of sight to the outdoors for 90 percent of the occupants of the building.

The use of glass may also qualify for LEED points for using materials with recycled content and, depending on the location of the project, for using regional materials. Glass can help save energy if windows allow natural light to replace electricity for part of the day, allowing the building to gain LEED points for energy use.

Indoor Air Quality

Glass is a natural product, so there is no off-gassing in a glass installation. However, indoor air quality is not simply preventing the negative effects of the fumes given off by interior finish products; rather, it implies a concern about the health and welfare of building occupants. Thus, *Daylight* and *Views* are included in the LEED Indoor Air Quality section. Using glass in exterior walls is the key to allowing light and views to enter interior spaces. Interior designers

An Example of Glass Used in an Interior

Architect: Jason Tippie of HMN Architects; **Glass:** Arch Glass; **Installation:** Carter Glass

The waiting areas on each floor at Shawnee Mission Medical Center are divided from the elevators by a wall of glass. These walls represent the collaborative effort of many individuals, including a committee of Medical Center representatives who chose the text; the graphic designer who developed the text layout; the architect who designed the installation; the glass manufacturer who submitted seven 1-foot-square mockups for approval of color and shading; and the glass installer. Each panel of glass is three layers thick with informational and inspirational text printed on film sandwiched between the layers. There are four panels for each lobby wall, installed in channels set in the floor and ceiling. Panels are butt-jointed and held in place with clear silicone. The wall is lit from above with T-9 fluorescent wall washers.

FIGURE 9.1 Glass Walls. Glass walls divide the elevator lobby from the intensive care unit waiting area at Shawnee Mission Medical Center.
Photograph courtesy Kay Miller Boehr

FIGURE 9.2 Glass Walls. Glass walls divide the elevator lobby from the comprehensive care unit waiting area at Shawnee Mission Medical Center. Ils
Photograph courtesy Kay Miller Boehr

can ensure that occupants of the space will have access to daylight and views by using the following planning guidelines:

- Locate open office workstations along the perimeter of the building.
- Use low panels to divide office workstations.
- Locate private offices and conference rooms in the interior of the building. Use glass in doors, side lites, and transoms to allow light and views to enter these offices. If closed offices must be located on the perimeter of the building, use glass walls, windows, doors, and transoms to allow light to pass to the interior of the building.
- Design interior glazing and glass walls to allow light and views to penetrate a space.
- Use skylights to allow light to reach spaces that are not close to the perimeter of the building.
- Design interior light shelves to bounce light deeper into the building.

Understanding: In-Depth Information

HISTORY OF GLASS

The Egyptians used glass beads as early as 2500 B.C.E. and later produced cast glass vessels. Ancient Romans sliced *canes* of different colors of glass crosswise and used the pieces for mosaics. The Romans also pressed or blew glass into molds to create shapes.

As early as 100 C.E. in Alexandria, Egypt (part of the Roman Empire), manganese oxide was added to the materials used to make glass, and the resulting clear, cast glass was used for windows in Roman baths and villas.

The Syrians developed glass-blowing techniques in the first century B.C.E. Sheets of glass produced through the glass-blowing process were used throughout the Middle Ages as stained glass for windows in cathedrals. Glass for window panes was blown using the cylinder method, blowing a cylinder shape, and then cutting it so it would lie flat. The resulting pieces, the largest being 10 inches by 12 inches, were cut into shapes and assembled using grooved strips of lead canes. Stained glass was colored by metallic oxides while in the molten state or painted after cooling with powdered vitreous enamel that was then fused to the glass. The rich dark colors and variable thickness of the glass evolved throughout the Middle Ages to the use of lighter colors and thinner, more uniform glass.

The creative possibilities of using colored or clear glass in conjunction with light has long appealed to artists, designers, and architects. Art glass has been used in windows and for lamps and decorative objects from its early origins, but was a significant feature of late nineteenth and early twentieth-century Art Nouveau decorative objects, windows, and light fixtures, used by artists such as Emile Galle in France and Louis Comfort Tiffany in the United States. Similarly, stained-glass windows continue to be used in both religious and secular buildings. Examples of twentieth-century designs in stained glass include Le Corbusier's Ronchamp Cathedral, Charles Rennie Mackintosh's tea rooms in Glasgow, Scotland, and numerous residences designed by Frank Lloyd Wright.

FIGURE 9.3 Stained-Glass Window in Cathedral in Chartres, France.

FIGURE 9.4 Stained Glass by Charles Rennie Mackintosh.
© scottish view / Alamy

The Industrial Revolution resulted in glass and iron buildings such as Joseph Paxton's Crystal Palace, erected for London's Great Exhibition of 1851. Modern skyscrapers built in the twentieth century often use glass as a curtain wall, creating glass-clad towers. Glass buildings in the twenty-first century take advantage of new technologies such as the channel glass lit from the interior used in Stephen Holl's addition to the Nelson-Atkins Museum of Art in Kansas City, Missouri.

PRODUCTION: HOW GLASS IS MADE

The main ingredient in glass, an inorganic material, is sand (silica) heated to such a high temperature that it becomes a liquid. It then passes through a viscous or molten stage before it is rapidly cooled so that it becomes solid without forming visible crystals. Glass can be formed from sand alone, but this would require unreasonably high temperatures, so a **flux** (sodium carbonate or soda) is added to reduce the melting point. Glass made from silica and soda alone would be water soluble, so lime is added to the mixture. Other materials are added to change the properties of glass, most commonly minerals that affect the color of glass or modify the properties of glass for specific uses.

TYPES OF GLASS: FLAT GLASS

Glass used for vertical and horizontal applications such as doors, windows, and divider walls is referred to as **flat glass**. Methods for producing flat glass have changed and improved, but older methods are still used for specific purposes.

Sheet Glass

Sheet glass is also known as **drawn glass** from the practice of *drawing* molten glass from a furnace, or as **cylinder glass** from the practice of forming molten glass into a cylinder, cutting it lengthwise, and flattening it. The

FIGURE 9.5 Channel Glass: Interior of the Bloch Building at the Nelson-Atkins Museum of Art, Kansas City, Missouri, Steven Holl Architects. photograph courtesy of Jason Ayers

resulting fire-polished surfaces are not perfectly parallel, so there is some distortion of vision. Early medieval churches used sheet glass produced by this method, which added to the visual quality of the light as it passed through thick and thin glass.

Plate Glass

Plate glass is made by pouring molten glass onto a large metal table with a raised edge. Heavy rollers force the glass into a uniform thickness determined by the table edges. The glass is ground and polished after cooling. The result is glass with perfectly clear, undistorted vision.

Rolled Glass

Hot sheets of molten gas are passed as continuous ribbons between two rollers set at a desired thickness apart. Linear or geometric patterns may be embossed on one or both sides of the glass by the rollers. This method is used to make **wired glass**—where two softened sheets of glass are rolled over a wire mesh between the two layers.

Float Glass

Modern flat glass used to glaze openings is *float glass*. The materials used to make glass, referred to as **frit**, are mixed and combined with cullet. Heated molten glass is poured onto a surface of molten tin, which has a different melting point than the glass. Ribbons of glass are stretched by top rollers as they are moved along conveyer rollers from the tin bath through the **annealing lehr** where controlled cooling and strengthening take place. The resulting surfaces are flat and parallel with minimal distortion. Edges marked by the top rollers are trimmed and reused as cullet. There is no need for grinding and polishing.

TYPES OF GLASS: DECORATIVE AND ART GLASS

Glass has aesthetic as well as functional properties. The quality of light as it passes through glass can enhance the beauty of a space or object. This beauty may be found in functional glass used to glaze window openings or divide space. The aesthetics of glass are especially effective, however, when designed in conjunction with light, such as diffusers for light fixtures, or when colored, such as stained-glass windows, or with a textured or patterned surface. In addition to using flat glass to enhance the aesthetics of a space, many decorative objects are made of glass, both colored and clear.

Blown Glass

Glass blowing is the practice of shaping a mass (referred to as a *gathering*) of molten (heat-softened) glass by blowing air into it through a tube. The molten glass can be blown into a mold or shaped by blowing. The bubble at the end of the pipe can be formed into a vessel by blowing, swinging, and rolling on a smooth stone or iron surface called a *marver*. *Crown glass* is a type of **blown glass**, made by cutting a bubble of glass while it is still on the rod. The centrifugal force of the continued spinning on the rod results in a disk with a thick center where

FIGURE 9.6 Glass Bridge in Tacoma, Washington, with Art Glass by Dale Chihouly.
© Zach Holmes / Alamy

FIGURE 9.7 Glass Rondels in Stained-Glass Window Panels.
© BUILT Images / Alamy

FIGURE 9.8 Orange Stained Glass Used in Ceiling Light.
© BUILT Images / Alamy

the rod was attached. The relatively flat edges were cut to use in early medieval leaded paned windows. The first nearly flat glass was blown using the *cylinder method*. Blown glass continues to be used for glassware, vases, and decorative objects as well as light fixtures and works of art. Modern blown-glass **rondels** are used for windows, light fixtures, and decorative objects.

Cast Glass

Cast glass is produced by pouring molten glass into a mold to obtain the desired shape or surface texture. Decorative objects are made by pouring molten glass into a variety of heat-resistant molds. For larger objects or thicker, textured panels used in interior architectural installations, the heat-resistant mold is placed in a kiln. Nuggets of solid glass are heated until the glass turns to a liquid and is allowed to settle into the mold.

Channel Glass

Channel glass is a translucent linear glass system, consisting of U-shaped cast glass panels installed either horizontally or vertically in a metal perimeter frame. The resulting self-supporting wall system can be used on an exterior or an interior. Individual panels range

FIGURE 9.9 Diagram Showing Standard Glazing Details and Sketch of Channel Glass.

from approximately 9 to 19 inches wide, with flanges from 1.57 to 2.36 inches, and in lengths up to 23 feet when used vertically or 13 feet when used horizontally. When used on an exterior, two layers of channel glass create a double-glazed system that can be filled with insulation and/or be manufactured with a low-emissivity coating. Channel glass is manufactured in several colors and levels of translucency. It can be made more obscure by sandblasting the interior. Channel glass can be tempered or have an applied safety film. Double-paned channel glass is an effective acoustical barrier.

ALTERNATE USES OF GLASS

Glass Fiber

Molten glass can be extruded to create *glass fibers*, which are extremely strong in tension and compression. Glass fiber can be used to make textiles or spun glass wool for acoustical and thermal insulation. When glass fibers are embedded in plastic resin, the result is **fiberglass**, a strong but thin material used for furniture and building products. Similarly, foamed or cellular glass is used for rigid insulation.

Glass Block

Glass block is used to construct non–load-bearing walls or to fill window openings for security. Glass blocks are constructed by fusing two halves of pressed glass together with a hollow center, thereby creating a partial vacuum. The air space gives glass block good insulating qualities. The two glass halves can range from clear (transparent) to obscure, depending on the pattern used. Thus, glass block can also be used to allow light transmittance while maintaining varying levels of privacy.

Mirrors

Mirrors are made of flat glass with a reflective coating applied to the back in a process called **silvering**. The first step is *tinning*, which helps the second layer, silver, to adhere. For the third layer, metallic copper is applied to the silver to help prevent oxidation. The final layer is a protective paint layer. The mirror with its layers of backing is cured in an oven before being cut, polished, and possibly beveled.

Glass Tile

Glass tile can be made from recycled glass (bottles, jars, and window glass), powdered glass, or cullet. Four methods of producing glass tile are *smalti, fused, sintered,* and *cast.* **Smalti** is a traditional Italian method of making small colorful mosaic tiles from a glass paste fired at high temperatures, then rolled into a slab, and, when cool, hand cut into small pieces of tile. **Fused** tile begins with clear flat glass that is cut into tile shapes, then fired, with color added on top or under the glass. The result is a translucent tile with a layer of visible color. Fused tiles can range in size from mosaics to larger format tiles. **Sintered** tile is made by pressing glass powder into a die and heating until the powder particles are fused. Sintered tiles are usually 1 inch square up to 3 inches square. Since color can be added to the powder, the tiles have a uniform

FIGURE 9.10 Glass Tile Backsplash in a Private Residence. Photograph courtesy Kay Miller Boehr

appearance. **Cast** tile is made from cullet placed in a mold and heated in a kiln. Melting cullet in a mold results in a layered look.

Glass tiles made from recycled glass are usually cast using recycled glass as cullet. Recycled glass must be sorted by source and color. This is because the original manufacturing methods result in different coefficients of expansion, which can affect the resulting tile. Small recycled glass mosaics can be made by pouring the molten recycled glass mixed with color onto a metal surface and using a cookie cutter-like method to make the tiles by hand. The color is more easily controlled and, unlike larger tiles, the small mosaics do not have to be annealed.

Glass Terrazzo

Glass terrazzo is traditionally made by embedding marble chips in a concrete or epoxy matrix. Terrazzo becomes a sustainable product when the marble is replaced with chips from recycled glass bottles, windows, or mirrors. The various sizes and colors of the glass chips make this an attractive product for floors and countertops. Glass terrazzo can be made into tile form as well.

MODIFICATIONS TO IMPROVE THE PROPERTIES OF GLASS

Property: Tendency to shatter upon impact or when exposed to heat

Annealed

Annealed glass is cooled slowly to relieve internal stresses.

Heat Strengthened

Glass is annealed as well as partially *tempered* by reheating and sudden cooling. *Heat-strengthened* glass has twice the strength of annealed glass.

Tempered

Tempered glass is reheated to just below its softening point, then rapidly cooled. It is three to five times more resistant to thermal stresses and impact than is annealed glass. Most important, when tempered glass is fractured, it breaks into relatively harmless pebble-sized

particles. Tempered glass cannot be altered after fabrication. Since tempered glass will not break into shards, it is used for furniture, horizontal surfaces, light fixture diffusers, doors, and windows.

Safety Glass

Safety glass consists of two or more layers, or *plies,* of flat glass bonded under heat and pressure to layers of resin between the layers. If the glass is broken, the resin holds the shards in place.

Security Glass

Laminated glass with exceptional tensile and impact strength is used for installations that require security in addition to the need to protect users from harm due to broken or shattered glass.

Wired Glass

Wired glass can be flat or patterned glass. A square or diamond mesh is embedded between two layers of glass. Wired glass resists shattering under impact or when exposed to excessive heat. It is used in fire-rated openings as well as for security.

Property: glass as a poor insulator

Insulating Glass

Air is a good insulator when trapped between two surfaces. Two panes of glass *(double paned)* or three panes of glass *(triple paned)* separated by a hermetically sealed air space help improve the insulative property of glass. *Insulating glass* also includes a *desiccant* that restricts condensation and may be glass-edged units (3/16-inch air space) or metal-edged units (1/4-inch or 1/2-inch air space).

Tinted Glass

Chemicals added to glass in production help absorb some of the radiant heat as well as visible light that strikes glass used on an exterior surface. These chemicals tint the glass: iron oxide added to the molten glass results in a pale blue green, cobalt oxide and nickel add a grayish tint, and selenium creates bronze *tinted glass*.

Reflective Glass

A thin, translucent metal coating is added to one surface of a single pane of glass, between plies of laminated glass, or on the interior or exterior surface of insulating glass. This coating reflects a portion of the light/heat that strikes the surface of the glass, and thus produces *reflective glass*.

Low-Emissivity Glass

Low-e or *low-emissivity glass* transmits visible light while selectively reflecting the longer wavelengths of radiant heat. Low-emissivity glass is created by coating either the glass itself or a transparent plastic film suspended in the sealed air space of insulating glass.

Property: Transparency

The transparency of glass is a unique and desirable property. However, some applications require the control of visual access for functional and/or aesthetic reasons. Thus, the level of transparency can be modified using color, texture, or pattern.

Colored Glass

Adding metals to molten glass can change the color of glass and affect the quality of light passing through. Iron gives glass its characteristic green tint, and since traces of iron are found in the purest sand, minerals are often added to counteract the iron. *White* or *decolorized*

glass is made with the addition of selenium or cobalt oxide plus arsenic trioxide and sodium nitrate. Colored glass has been used in stained-glass windows from the early Middle Ages through modern times. Examples of metallic oxides added to the mixture and the resulting glass colors include:

Cobalt = purple-blue glass

Chromium = chrome yellow or green glass

Uranium = canary-yellow glass

Manganese = violet glass

Textured Glass

It is often desirable to restrict vision while still allowing the transmission of light. Textured or patterned glass may be used to restrict vision or simply for its aesthetic qualities. Glass may be textured during the casting process or produced by rolling or in molds. One unusual way of texturing glass produces a decorative glass made from slabs of glass that have been stacked and then fused together for a deep texture.

Obscure Glass

To make it more difficult to see through glass (more opaque or *obscure*), one or more surfaces of a sheet of glass may be sandblasted or acid etched. Another method of obscuring vision is a *ceramic frit*, ceramic granules that are fused to the surface of the glass. Sandblasting may weaken the glass and leave a rough surface that shows fingerprints and is difficult to clean. Aluminum oxide etching provides a smoother surface and does not weaken the glass. In addition, etched glass can be sealed to prevent fingerprints, making the glass easier to clean.

Spandrel Glass

Spandrel glass is colored opaque glass used in an exterior curtain wall to mask mechanical, electrical, or structural elements of a building. The opacity may be created by fusing a ceramic frit to the inside surface of the glass. Spandrel glass is either heat strengthened or tempered.

Patterned Glass

In the process of making glass, rollers can be used to form linear or geometric patterns on the glass. Patterned glass may be used in wired glass, glass block, or sheet glass. Another type of patterned glass uses digital printing methods on glass. Joel Berman Studios has developed a ceramic frit ink that is used to print photographic images and designs on glass, and then is fused to the surface of the glass.

"Smart Glass"

Smart glass refers to glass that can change from transparent to opaque by flipping a switch, used for interior partitions when variable privacy is desired. **Liquid crystal glass** is a laminated glass product made from liquid crystals dissolved in a polymer film inserted between two layers of glass. When the liquid crystals are random, the glass appears clear. When the liquid crystals are aligned, the glass appears translucent. **Suspended particle glass** is similar, but the interlayer material is made of rod-like particles suspended in fluid between the two layers of glass. When the suspended particles are aligned, the glass appears clear, and when the particles are not aligned, the glass blocks light and appears opaque. Both types of glass are controlled by an electric switch. **Electro-chromatic glass** is made with a very thin conductive layer of material, also controlled by electricity. These types of glass are also referred to as *fogged glass* and *variable tint glass*.

Property: Improving resistance to heat

Clear Ceramics

Since glass made from sand, soda, and lime is not heat resistant, additives such as borosilicate have been used to increase heat resistance. Production techniques are used that change the

chemical structure of glass so that it is more like ceramic, while maintaining the transparency of glass. *Clear ceramic* is heat resistant and can be fire rated from 20 minutes up to 90 minutes. Fire-resistant glass can be clear or obscure and may be lightly sandblasted on one side only.

Application: Using Information Regarding Finish Materials

CODE ISSUES

The tendency of glass to shatter when subjected to impact or heat means that measures must be taken to protect the public in situations where either may occur and cause harm.

Case STUDY *of Decorative Glass used in Interior Design*

Dierk Van Keppel is the owner of Rock Cottage Glassworks in Merriam, Kansas. Dierk uses traditional glass-blowing techniques to create works of art, light fixtures, and decorative screens and objects. His work may be seen in restaurants, office buildings, and private residences. *Rondels*, similar to medieval crown glass, are used in multiples to create chandeliers or fused to create panels. Individual rondels are installed with lead canes as modern stained-glass windows. Glass can also be blown or poured into molds to create slabs of decorative glass used to diffuse light in wall sconces and other light fixtures. Examples shown include slabs of glass as diffusers for a chandelier and fused rondels to create a screen within a glass wall.

Dierk uses a kiln or furnace to melt clear glass nuggets. The *gathering* on the blowing rod is initially clear, but colors are added by dipping the bubble into a smaller kiln with colored glass, then spinning in the opposite direction. Dierk continues layering clear and colored glass to develop variety and rich depth of color. He works on a traditional gaffer's bench, sometimes using an assistant to blow the glass into a bubble. When the sphere of glass is the desired size and mix of colors, it is transferred from the blowing rod to a *punty* rod, and then twirled on the rod to form the rondel while inside a 2,250-degree Fahrenheit furnace, called a *glory hole* by glassmakers. The final step is to cure the glass in an annealing furnace.

FIGURE 9.11 Fused Rondels Used as Part of Divider Wall Panel for Capital One Office, Overland Park, Kansas. Photograph courtesy of Rock Cottage Glass Works

FIGURE 9.12 Art Glass Diffusers for Chandeliers at Fogo de Chao Restaurant, Kansas City, Missouri. Photograph courtesy of Rock Cottage Glass Works

FIGURE 9.13 Glass Blower at Work on the Gaffer's Bench, Forming a Glass Sphere from a *Gathering* of Molten Glass on a Blowing Rod.
Michal Durinik/Shutterstock

FIGURE 9.14 Spinning the Rod to Form a Rondel While the Glass Is Inside the Glory Hole. itakefotos4u/Shutterstock

Fire Safety

A fire-rated wall must resist the spread of flame for a period of time long enough for occupants to leave the building. The components that make up the construction of the wall are referred to as *fire-rated assemblies*, and they are rated for a specific length of time. Openings in a fire-rated wall (room partition, rated corridor, or smoke barrier) are called *opening protectives*, and they may be rated to resist fire for less time than the wall surrounding them. For instance, a wall that is 2-hour rated may have openings that must resist fire for 1½ hours. Doors with glazing or separate windows are considered *assemblies*, meaning all components (frame, glazing materials, and hardware) must meet rating requirements, with the entire unit considered as a whole. A rated door or window assembly must have a permanent label placed by the manufacturer indicating that it has been tested to withstand fire for the appropriate length of time. Glass must stay in place in case of fire, resist thermal shock in a hose stream test, maintain strength against human contact, and resist heat transfer from one side to another. The following are options for glass in a rated opening:

- *Wired glass* may be used as glazing with size limitations. It is generally rated for up to 45 minutes with a size limit of 9 square feet (1,296 square inches) or up to 90 minutes in fire doors with a restriction of 100 square inches in size. The low impact resistance of wired glass limits the allowable locations in which it can be used.

- Depending on the local code, some *glass block* may be rated, usually for 45 minutes. If glass block is used as a view panel in a rated wall, it may need to be set in steel channels.

- Fire-rated glass is actually a *clear ceramic* product highly resistant to heat and thermal shock. Although expensive, fire-rated glass has replaced wired glass in most fire-rated assemblies because it can be transparent or translucent, panes can be larger than wired glass panes (up to 24 square feet per lite), and can have ratings from 20 minutes to 3 hours, depending on the type of fire glass.

- Fire-rated glass can be laminated to serve as safety glass as well as fire-rated glass. This increases the length of time that the glass will withstand smoke and flames.

- Special multilayered assemblies of clear ceramic fire-rated glass can be used as a fire-rated transparent wall unit, rated for up to 2 hours, resistant to heat transfer, and bulletproof.

Safety Glass

Safety glazing is required for glass panels in areas where people might walk into them or where a window might be mistaken for a door. Tempered glass and laminated glass qualify as safety glazing, although the size of tempered glass is limited because the entire pane breaks. Wired glass can be used as safety glazing only when it is also being used as fire-resistive glass. Safety glazing is required in skylights and sloped glazing unless a screen is located under the skylight to catch glass shards in case of breakage.

Installations that require safety glazing include swinging doors, fixed and sliding panels of sliding doors, bi-fold closet doors with mirrors, storm doors, and doors for hot tubs, saunas, showers, and bathtubs as well as compartment glazing that is less than 60 inches above the floor of the enclosure.

- Any window more than 9 square feet and within 24 inches of a doorway or less than 60 inches above the floor must have safety glazing.
- Guardrail panels or railings must have safety glazing.

SPECIFYING

CSI Masterformat Division 08 Doors and Windows includes sections that assist in specifying glass:

> Entrances and Storefronts
>
> Windows
>
> Skylights
>
> Glazing
>
> Glazed Curtain Walls

When specifying glass, reference the following standards:

- ASTM E 2010 Standard test for positive pressure tests of window assemblies.
- NFPA 257 Standard for Fire Tests of Window and Glass Block.
- ANSI Z97.1 for Safety Glazing: Glazing Materials Used in Building Safety Performance Specifications. This test determines resistance to impact.
- Hose Stream Test: All glass rated for 45 minutes or more must undergo a fire hose stream test to determine that the glass can withstand the shock of both heat from a fire and water from sprinklers or a fire hose.

Include the following requirements in a glass specification:

- Windows in fire-rated openings and walls must have a permanent label applied by the manufacturer guaranteeing its fire rating.
- All glass shall bear a manufacturer's label on each pane designating the thickness and type of glass or glazing material.

Glass that will be used in a structural application, such as stairs or floors, must be carefully designed. A structural engineer should perform load calculations and assist with designing supports and determining glass thickness for stair treads and glass floors. Tempered glass is generally specified, but engineered and tested systems for stair treads and floorings are available that use glass block and laminated glass. Slip resistance is also a consideration, and can be achieved by etching or embossing the surface or applying a ceramic frit.

When designing glass shelves, the designer must determine the weight of the objects to be placed on the shelves, per square foot of shelf space. She or he must then determine the thickness of the glass to be used and refer to glass manufacturer's charts to obtain the distance between supports. The following chart is based on one published by Nova Display, Inc., which is calculated using annealed glass. If the manufacturer uses tempered glass, the shelves will be four times as strong.

Permissible Loads for Glass Shelves

Glass Thickness (nominal)	Distance between supports in feet				
	1	2	3	4	5
	Approximate permissible load in pounds per sq. foot				
3/16"	49	10	3	1	
1/4"	73	16	5	2	
3/8"	196	45	17	8	3
1/2"	345	81	33	15	7
5/8"	556	133	54	27	14
3/4"	817	197	82	42	23
1"	1489	362	153	81	48

MAINTENANCE

Regular cleaning of glass should be part of a building maintenance plan. Glass used in an interior is subject to fingerprints or (in showers and tubs) soap residue. It can be easily wiped clean using ammonia or vinegar-based cleaning solutions. Etched glass can be coated for easier cleaning. Exterior glass must be cleaned of environmental dirt to maintain its transparent and visual properties, using soft rags and a squeegee to remove excess water.

LIFE CYCLE COSTS

The interior designer must be aware of cost differences in types of glass and choose the appropriate product for the project. Thicker glass is more expensive. Textured and other decorative glasses are also more expensive than clear glass. Fire-rated clear ceramic glass is more expensive than wired glass.

Consider life cycle costs when budgeting for glass. Glass is a long-term investment, rarely needing replacement unless it is damaged by scratches or cracks, which can weaken it. Glass that is more energy efficient has a higher initial cost, but will result in savings in energy costs.

INSTALLATION METHODS

The interior designer must be familiar with the components of windows, doors, and similar elements and understand how glass is installed within the assembly. A pane of glass in a frame, generally a window or door, is called *glazing*. When selecting a manufactured window or door, the designer can refer to the manufacturer's details of unit sections and profiles.

All glass used vertically or horizontally must be supported in a frame of wood or metal (aluminum or steel) or in a frameless installation. **Frameless glass** is usually supported at the head and sill with metal frames that are either visible or set into recesses in the floor and ceiling. The jambs of frameless glass panes are often joined to adjacent panes, called **butt joint framing** with a silicone sealant, referred to as *butt joint glazing*. The sealant is applied with a caulking gun and is flexible enough to allow movement, but will hold the glass in place. In some frameless installations, glazing may be butt joined on all four sides. Frameless installations may also be **point glazed** with a mechanical attachment rather than silicone. A hole is drilled in each corner of the glass, which is fastened to a steel or aluminum frame behind the glass, allowing the glass to appear to float.

The perimeter frame supports the glass, but the glass must be allowed to float in its opening and be cushioned with a resilient glazing material. Glass may be set in a bed of glazing compound or held in place by glazing tape, liquid sealant, or a compression gasket. A *glazing bead* or *glazing stop* is a wood or metal strip that is set in front of a glass pane to hold it in place.

Mirrors are often attached to a wall using adhesive. The designer should specify a sealer to be applied to the wall before installing the mirror to avoid future adhesive failure.

It is important for the interior designer to be aware of the size limitations that may be set by the interior location of the glass. If the glass is to be installed above a building's first floor, the elevator must be large enough to transport the glass.

APPLYING GLASS IN AN INTERIOR

Floors and Ceilings

Glass floors and glass ceilings can be used to create special effects, such as the glass bridge at the National World War I Museum in Kansas City, Missouri. Visitors are able to view a field of poppies below the bridge. Considerations when designing glass floors include structural calculations, attachment and support devices, preserving modesty if there are occupants below the floor, and slip resistance. Glass ceilings may actually be glass roofs such as those in conservatories or an array of skylights allowing light to enter occupied space from above.

Glass and Window Treatments

Often, an interior designer has the responsibility to design window treatments. Window treatments that are operable and insulating can be an important component of a passive solar system, preventing heat gain through glass in the summer or preventing heat escape during winter evenings. By working with the building architect, windows can

Glass Used in an Interior

Floors
Glass in floors for visual access to space below

Walls and Vertical Surfaces
Glass walls for translucency or transparency
Glass in interior windows
Glass in interior doors, side lites, and transoms
Glass block walls and windows
Glass in sheets or tiles as wall surfaces or backsplashes

Ceilings
Glass ceilings
Glass skylights

Trim and Accessories
Decorative panels
Mirrors
Signage

Lighting
Lamp enclosures
Shades
Diffusers

Kitchen and Bath
Glass lavatories
Glass tile
Glass backsplash
Countertops
Shower doors
Tub and shower surrounds

Furniture
Glass furniture, especially table tops
Glass transaction tops and countertops

Special Construction
Stair treads and handrail or guardrail panels

FIGURE 9.15A Panes of Glass in Wall Next to Stairwell Are Connected with Decorative Mechanical Fasteners, Referred to as Point Glazing. Photograph courtesy of Kay Miller Boehr

FIGURE 9.15B Detail of Point Glazing Connecting Glass Panels, Shawnee Mission Medical Center. Photograph courtesy of Kay Miller Boehr

FIGURE 9.16 Glass Stair Treads. This example shows glass stair treads in a stairwell in the lobby of the Medical Center of the Rockies in Loveland, Colorado. Photograph courtesy Evelyn Knowles

be designed to allow stack spaces at the sides and/or mounting space above the windows so that the window treatments, when open, do not obscure views.

Window treatments may reflect heat back onto the glass, increasing the temperature of the glass. To allow heat to escape, the designer must allow for ventilation between the window treatment and the glass.

summary
summary

Glass is a natural product made from renewable and recyclable materials. Glass as glazing in wall and door openings is valued for its transparency, allowing natural light and views to enter a space. However, glass can be modified with color, pattern, and texture so that it can range from nearly opaque, to translucent, to transparent, allowing the designer to control the amount of light in a space or visual access to a space. The color, texture, and pattern possibilities of glass give the material aesthetic qualities that have been appreciated by artists and craftspeople for centuries, from its use in medieval stained-glass windows to current uses of glass to construct windows, interior partitions, light fixtures, furniture, and decorative objects.

Skillful designers control the type and location of glass in buildings to take advantage of its property of allowing sunlight and views to enter a building while controlling the heat gain or loss.

Interior designers can help control heat gain and loss by designing interior shading devices and window treatment.

Interior designers must be aware of the code implications of using glass, which can break or shatter under impact or when exposed to heat and flame. Interior designers must be familiar with the requirements for safety glass and for fire-rated openings as well as the options for flame-resistant glass products.

To find out more about glass, the following websites and publications of professional organizations in the plastics industry can be useful:

Glass Association of North America: www.glasswebsite.com

Corning Glass Museum: http://www.cmog.org

National Glass Association: http://www.glass.org/

Strategic Materials: www.strategicmaterials.com

review questions

1. Describe the process of heat-strengthening glass.
2. Describe what "Smart glass" is and why it is "smart."
3. Explain why glass is not made from silica alone.
4. Analyze and describe why you would use tempered glass for a glass door.
5. Evaluate the differences between low-e glass and reflective glass by giving an example of where each type would be used.

glossary

Annealing is a process of cooling molten glass slowly to relieve stresses.

Blown glass is an early method of producing glass that is still used to make art glass. A *gathering* of molten glass is shaped by blowing air into it through a tube. *Crown glass, Rondels,* and *Cylinder glass* are all types of glass used in an interior that are made by the glass-blowing process.

Butt Joint Framing is the installation of glass panels installed adjacent to each other without frames and sealed with silicone.

Cast glass is produced by pouring molten glass into a mold.

Channel glass is a translucent system of U-shaped cast glass panels installed either horizontally or vertically in a metal perimeter frame

Clear ceramics have borosilicate added for increased heat resistance while still remaining transparent. Clear ceramics glass may be fire resistant.

Cullet, one of the ingredients in glass, is a chunk of broken or recycled glass that allows new glass to be made with a lower melting point.

Curtain walls are non–load-bearing exterior panels of glass or other material that are hung (like a curtain) from the structural framework of a building.

Cylinder glass is blown as a cylinder, and then cut so it lies flat. This was the earliest method of producing flat glass, which was used for medieval stained-glass windows, held together with lead *canes.*

Drawn glass is another term for *sheet glass,* which reflects the practice of drawing molten glass from a furnace.

Flat Glass is used for vertical and horizontal applications. Types of flat glass include drawn or sheet glass, cylinder glass, plate glass, rolled glass, and float glass.

Flux means flowing or flow. In the glass-manufacturing process, a flux lowers the melting point of sand, facilitating the change from the solid to liquid stage of glass production.

Frameless glass is usually set into a metal track installed in the floor and/or ceiling. Horizontal panes are butt-joined using silicone.

Frit refers to the materials used to make glass. It also refers to granules of glass or ceramics that are fused to the surface of flat glass to give additional color, texture, or opacity.

Fused glass tiles begin as clear flat glass cut into shapes then having color added to the top or bottom of the glass.

Glare refers to unwanted brightness, usually when there is too much contrast between a light surface and a darker surface.

Glass block is created by fusing two halves of pressed glass to make modular units that can be used to construct walls or fill openings.

Glass fiber is extruded molten glass used to make textiles or spun glass insulation.

Glass terrazzo uses chips of recycled glass as the aggregate in a concrete or epoxy matrix.

Glass tile is made from recycled glass, powdered glass, or cullet.

Glazing or glazed means "fitted with glass."

Heat strengthening is a process that includes annealing as well as partial tempering by heating and sudden cooling.

Insulating glass consists of two or three layers of glass with airspace between the layers.

Liquid crystal glass or suspended particle glass changes from clear to opaque by switching from aligned particles to unaligned particles.

Lites are the pieces of glass that are cut, prepared, and used to create windows and doors.

Low-emissivity glass (low-e glass) transmits visible light while selectively reflecting longer wavelengths of radiant heat.

Point glazing is a method of attaching glass panels to one another using a mechanical device rather than silicone.

Reflective glass has a coating that reflects a portion of the light and heat that hits its surface.

Rondels are disks of glass created in the glass-blowing process.

Safety glass consists of two or more layers or plies of glass bonded with resin between the layers.

Silvering and tinning are two steps in making mirror, in which thin layers of tin, silver, and copper, followed by a layer of paint, are applied to be back of flat glass.

Sintering is a method of producing glass tiles by pressing powder into a die and heating until the powder particles are fused.

Smalti refers to an Italian method of making glass mosaics from a glass paste fired at high temperatures, rolled into a slab, and cut into small tiles.

Spandrel glass is colored opaque glass used as part of a curtain wall system to mask elements of a building from view.

Tempered glass is reheated to just below its softening point, then rapidly cooled. Tempered glass is strong and when broken does not shatter. It cannot be cut or altered after fabrication.

Tinted glass absorbs some radiant heat and visible light. The tint is achieved by adding chemicals to molten glass.

Wired glass has a square or diamond mesh embedded between two layers of glass

Paint and Coatings

Awareness: An Overview

One's first reaction to a space will probably be to the colors in the space. Color has a great impact on our emotional reaction and the information we receive. Certain colors are considered dignified, such as a silver, beige, and black scheme that might be used in an upscale shopping area. Other colors are considered warm and cozy, such as browns and reds that might be used in an underground bar to create a feeling of warmth. A spa might use aqua blue and peach to give the feeling of being on a vacation in the Caribbean. A real estate

learning objectives

When you complete this chapter, you should be able to:

1. Use appropriate terms when discussing paint and coatings.
2. Identify common uses of paints and coatings in an interior.
3. Summarize the history of paint use in interiors.
4. Describe the ingredients used to produce paints.
5. Describe how paint and coatings meet code requirements for interior use.
6. Describe and analyze the physical characteristics and properties of paint and coating products for a specific interior use.
7. Analyze the environmental impact of using paint and coatings.
8. Evaluate how well paint products will meet the specific needs of a design project.

The reception area at V3 Consultants uses bold colors to convey their image to clients.
Linda Hanselman Photography

FIGURE 10.1 Painted Walls Can Change the Effect on a Room. Corbisrffancy/Fotolio

developer may choose off-white surfaces, so a prospective client can imagine her or his own furniture in the spaces. The easiest and least expensive method of producing the color is through paint on the largest surfaces that people look at directly: the walls.

Most people notice that certain colors are "in fashion" for a time, but then new colors are suddenly fashionable and the previous colors become "dated," or linked to a certain year. This occurs because of color forecasting firms that issue projections defining palettes of colors that can be expected to gain popularity in coming seasons. The design industries develop their new lines with these projections in mind. On the whole, color trends change more slowly for interior design than other fashions because changes in furnishings and carpet entail a more serious financial investment. Paint companies keep up with the latest color forecasts and change the colors in their paint decks accordingly. Some color forecasting companies are listed in the Resources section at the end of this chapter.

The interior designer will specify the use of paint at some time, even if the project was started with other materials. The designer needs to know what paint can do for a space and how to make it function in the best possible way. He or she could choose to keep the colors intrinsic to the materials being used, or the opposite, apply colors that are not inherent to the materials. An example of this would be deciding whether to leave metal panels in a school gray (inherent), or paint them bright colors (noninherent). One decision in which designers need to guide their clients will be regarding the color of the walls in a space. Should the walls match the colors in the furnishings, or should the walls be a subdued color to let the furnishings stand out?

DESCRIPTION AND COMMON USES

Paint is a liquid coating applied to a surface. Paint, either water-based or solvent-based, consists of four parts. The part that gives the color is the **pigment**. Generally, better-quality pigments result in better-covering quality paints. The liquid part that allows the paint to spread on a surface is the solvent. The **solvent** is water in a latex paint and a chemical in a solvent

FIGURE 10.2 Paint a Room Online with Personal Color Viewer by Benjamin Moore & Co. This technique allows the decorator to view rooms with different paint colors on surfaces.

paint. The third part is the **binder**, with the purpose of helping the paint adhere to a surface. For **latex**, or water-based paint, the binder is acrylic or vinyl. For **alkyd**, or solvent-based paint, the binder is a chemical solvent, either hydrocarbon or oxygenated. The fourth part consists of *additives for special performance.* Paint formulated for indoor use differs from paint formulated for exterior use, due to the fact that exterior paints must allow moisture to escape and resist sun damage.

Paint is used to change the color or protect the surface to which it is applied. For interiors, the surface most often painted is a wall because that is the surface most noticed. Architectural trim, commonly called *woodwork,* is usually painted or stained. Wood floors are often stained in interiors, but they are not often painted due to the fact that floors get a lot of abrasion and paint can be scratched off of a floor easily, resulting in a permanent scratch mark. Ceilings are usually painted in residential buildings, but they are not often designed to be noticed. An exception of course is the painted ceilings of churches depicting scenes or figures from the Bible. For exterior use, paint is used to protect wood or siding from weather, including humidity and expansion and contraction from temperature fluctuations.

Color Visualizer

There are web-based paint programs designed to help the designer visualize the room with different colors. One of these is from Benjamin Moore & Co., Personal Paint Viewer.

Paint and Coatings **171**

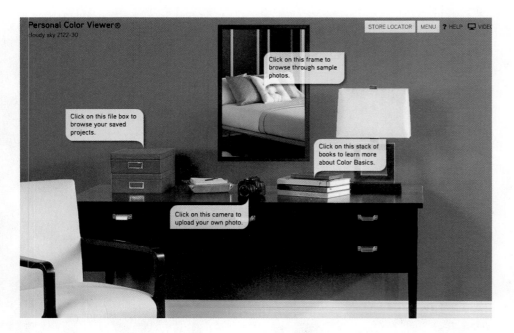

FIGURE 10.3 Color Viewer. To access this tool go to www.benjaminmoore.com/en-us. This tool may be used online or downloaded. Courtesy of Benjamin Moore & Company

CHARACTERISTICS

Properties

Paint is applied in a liquid form. It dries to become a solid finish adhered to the surface of the substrate. For latex paint, the dried material forms a flexible film. Solvent-based paint dries to a hard film that is not flexible. The paint film makes the substrate impervious to water or moisture. Paint is available in five sheens. The sheen is varied by the amount of pigment volume concentration (PVC). The amount of PVC affects the amount of light reflected from the painted surface.

The lowest sheen is *flat* or *matte*. The surface of flat paint appears smooth and velvety because the surface does not reflect much light. If you were to look at the surface under a microscope, you would see a rough texture with evenly spaced high and low spots. The high and low rough texture diffuses the light so that you do not see reflectance. However, if you were to wash the wall to get marks off of it, the high spots in the texture would be worn down easily and eventually leave a shinier place where it was washed. Flat finish paint gives a quiet, relaxed atmosphere to a space. It is used in areas where you do not want shiny walls and you do not expect to need to clean them often. It is often used for a master bedroom or private office.

The next to the lowest sheens are *eggshell* and *satin*. These are not as rough in texture as flat, so they reflect some light. Because the texture of eggshell or satin is less rough than flat, it can be cleaned without the problem of creating a shiny spot. Satin finish paint gives a more formal atmosphere to a room than flat finish. Satin finish is normally used in an area where you expect lots of people moving through. Hallways are commonly painted with satin finish paint.

The medium sheen is *semi-gloss*. Semi-gloss is shinier than satin and holds up to repeated cleanings better than satin finish. Semi-gloss paint is used in areas where people put their hands. Places that are touched often need to be cleaned often, such as doors and windows, and trim around windows. Places where either water or soap is splattered also need to be cleaned often, such as kitchens and bathrooms. Usually a paint labeled "Kitchen and bath" is a semi-gloss paint. *Note:* When you specify a paint color, you also need to specify the sheen.

The highest sheen is *gloss*. It has the lowest concentration of pigment but provides a very shiny surface. The drawback of a very shiny surface is that due to light reflection, it shows every imperfection. The reason for using gloss is that it is harder and can be cleaned without removing the paint. Gloss is normally used in areas that will need to be cleaned often, such as wood trim around doorways or handrails.

The term **enamel** once meant high-gloss, hard-surface paint. Enamel now means high-quality paint with greater durability and a smoother finish. It can be in a flat, low-gloss, or high-gloss sheen.

FIGURE 10.4 Red and Black in a Restaurant.
A restaurant used industrial enamel for the red color to make it tough and shiny, whereas the black is flat interior latex for a matte finish.
Mike Starling

The level of gloss is determined by the ratio of the pigment to binder. Generally, higher levels of pigment result in lower gloss, or a flat finish. The type and particle size of pigments can affect gloss; small pigment particles result in higher gloss.

ENVIRONMENTAL IMPACT

Sustainability features

Paint seals whatever material it is applied over. It becomes a barrier between the surface it covers and the outside environment. Paint cannot be scraped off and reused once it is dry. Dried paint must be disposed of properly.

Until 1978, high-quality interior paint contained lead, which was known to be poisonous. Lead was a required component of paint specified by the federal and state governments for its superior quality and durability. In the 1970s the Consumer Protection Agency discovered that many children had elevated levels of lead in their blood. The source of the lead was found to be lead paint in the home. As the paint chipped off of window sills and walls, children would pick it up and eat it.

Indoor air quality issues

During the drying process, chemicals from the paint escape into the air. These chemicals can contain volatile organic compounds which pollute the air. When the chemical consistency of paint is altered so that volatile organic compounds are not present, this is called Low VOC paint. To comply with the VOC emissions laws, more **solids** are added, making paint heavier and slower to dry.

Properties of Paint and Coatings

(sustainable properties highlighted in green)

- Paint is available in almost any color.
- Paint can be used to create two-dimensional designs.
- Painted surfaces can be repaired easily.
- Paint and coatings applied before 1978 may contain lead.
- Paint and coatings emit VOCs while they are liquid.
- Paints can be formulated to not contain VOCs.
- Paint provides a Class A wall surface.
- Paint does not burn.
- Paint can be formulated to be flame retardant and protect a substrate.
- Paint forms a film of protective coating over any material.
- Paint protects a surface from water and moisture.
- Stains provide only some protection from moisture.
- Varnishes vary in the amount of protection from moisture.
- Shellac does not provide protection from moisture.
- Lacquer provides a water-resistant finish.

Understanding: In-Depth Information

HISTORY OF USE IN INTERIORS

The earliest painted walls—cave dwellings at Pont d'Arc, France—used colors that came from minerals, clays, and charred wood. Painted interior walls and ceilings were used in ancient Egypt more than 20,000 years ago. Egyptian painters made paints by using colors from earthen pigments, ocher, and umber, mixed with beeswax. Ancient painting was often done by the encaustic method where pigments were dissolved in a binder of molten beeswax. The beeswax is both the binder and the vehicle because it is fluid. Encaustic painting was applied to stone walls, and the heat of the sun fused the pigments to the stone. Egyptian painters made a Blue Frit color from finely ground glass about 3000 B.C.E.

Ancient Minoan artists (2500 B.C.E.) used the fresco method, coating walls with lime and painting them before they were dry. By 1500 B.C.E., paint making was developed in the Mediterranean cultures of Greece and Crete. Most interior walls were whitewashed. A major development around 1000 B.C.E. was the use of gum from the Acacia tree for paint. Between 600 B.C.E. and 400 C.E., Greek and Roman cultures developed varnishes also using gum. Colors were still very limited with white lead, iron red, and whatever could be found from soil, minerals, and plants. Artists at the time worked with *tempera* paints made with egg yolk as the binder, powdered pigments, and water. Their pigments came from earth soil, sands, and plants. Ancient Romans in Pompeii used paint in the **trompe l'oeil** technique to trick

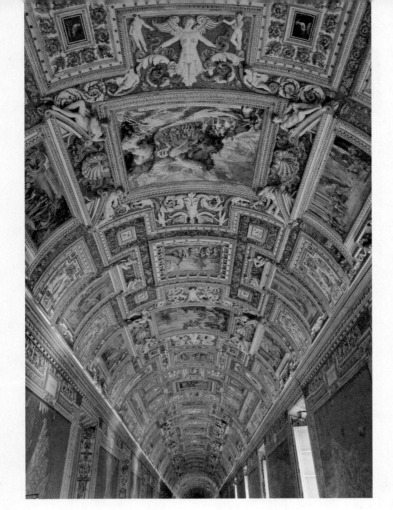

FIGURE 10.5 Painting on the Ceiling of the Sistine Chapel by Michelangelo.
© esinel_888/Fotolia

the eye. They used perspective well to create the illusion of larger spaces that looked like garden scenes.

In the late Byzantine era, walls were decorated with **frescos**. Fresco walls were covered with several coats of plaster, and the last coat of plaster had mixed pigment colors with the wet lime plaster. Frescos were used in Italy during the Renaissance. A well-known example of a fresco is the Sistine Chapel in Rome painted by Michelangelo Buonarroti from 1508 to 1512.

Oil paint had been used since the first century C.E. for decorative purposes. By the 1600s, decorative painting was popular in England, where oil paint was applied to plaster walls. In this century Flemish painters developed paint made with linseed oil pressed from the seeds of the flax plant. During the 1700s and 1800s, the paint industry evolved into a large industry. Pigments were ground by hand until the 1700s. The grinding process exposed many painters to lead powder, a source of lead poisoning. In 1718, a machine for grinding pigment colors was invented.

By the early 1800s, an alternative to lead was invented in Europe, a nontoxic zinc oxide. The process for nontoxic zinc oxide did not come to the United States until 1855. Linseed oil was used as an inexpensive binder in paint, but it was also a superior protector of surfaces. Paint had reached the point of becoming the protector of surfaces, rather than just decoration. The Sherwin-Williams Company in Cleveland, Ohio, worked on perfecting the formula where fine paint particles would stay suspended in linseed oil. In 1873, Sherwin-Williams released ready-to-use linseed oil paint. A few years later, they produced paint in tin cans that could be resealed. By 1880, their formula far exceeded the quality of all paints available at the time. Another paint company, Benjamin Moore, started in 1883, hired a chemist for a research department in 1907.

The mid-1900s saw another major development in paint production. During World War II, linseed oil became scarce. Chemists developed a different formula using alcohols and acids to make alkyds. Alkyd paints were cheap to make and durable. Alkyd soon replaced oil as a paint base. The first **acrylic paint** was developed by 1949. It was a mineral spirit-based paint called Magna. Water-based acrylic paints were available in the 1950s, sold with the name "latex" house paint. The paints used acrylic dispersion, and did not use latex, which comes from a rubber tree. Interior "latex" paints use either vinyl or acrylic vinyl as a binder.

The late 1900s saw more developments in paint. First, the formulas had to be changed. Since 1978, lead has been illegal in paint used in a residence. The white lead was replaced with **titanium dioxide**. Next, there was an explosion of color. Benjamin Moore introduced its computerized color-matching system in 1982. All paint companies benefited from the color technology and multitudes of colors became available to consumers. Technology improved water-based paints for exterior use and latex paints became the majority of paints sold.

COMPONENTS OF PAINT

Pigments give paints their color. There are two types of pigments: prime pigments and extender pigments. *Prime pigments* provide color and *opacity,* the ability to hide whatever the paint covers. *Extender pigments* provide bulk and other qualities for the paint.

Pigments come from organic and inorganic sources. An *inorganic pigment* found in many paints is titanium dioxide, which provides white color and opacity. Black color is also available from inorganic sources. *Organic pigments* cost more and are synthetically processed

in a controlled environment. Copper phthalocyanine provides blue and green colors, naphthol provides reds, hansa provides yellows, and quinacridone provides violets.

Extender pigments can impact qualities such as gloss, washability, hiding ability, durability, and flow of the liquid. Clay from aluminum silicate is used to hide whatever it covers and is used as a flattening agent. Silica is used for exterior paints to provide dirt and stain resistance. Calcium carbonate is used to control gloss and mold. Talc as magnesium silicate is used to improve adhesion.

Binders are the adhesives that act like glue to hold the pigment particles together. They are the film-forming materials that are responsible for the adhesive qualities of paint. Binders, sometimes referred to as the **vehicle**, are different for latex and alkyd paints. Latex, or water-based binders, are synthetic solid polymers, such as acrylic or vinyl acrylic dissolved in water with soap. Solvent-based binders are synthetic polymers, such as alkyd, vegetable oil, or petroleum oil, dissolved in a chemical solvent. Chemical solvents are either hydrocarbons or oxygenated.

Solvents (meaning liquid) such as water or a chemical solvent, make the paint fluid enough to spread on a surface. Solvents help the coating to penetrate a surface and control the rate of drying. Solvents provide the desired **viscosity** for applying the pigment and binder to a surface. They evaporate as the paint dries.

Additives are for special performance functions. For example, a preservative may be added as a mildewcide, to reduce mildew problems for high-moisture areas. A biocide may be added to prevent bacterial growth in the can. A defoaming agent may be added to prevent foaming. Thickeners are used to reduce the drying time for application in hot weather. To comply with the VOC emissions laws, more solids are added, making paint heavier and slower to dry.

TYPES OF PAINT AND COATINGS

Alkyd or oil-based paint is produced using a chemical as the solvent. Chemical solvents are either hydrocarbons or oxygenated. *Hydrocarbon solvents* include naphtha, mineral spirits, toluene, and xylene. *Oxygenated solvents* include ketones and alcohols. The solvent makes the mixture of binder and pigments fluid enough to spread over a surface. As the solvent evaporates, the mixture cures by **oxidation**, making it extra hard. Solvent-based paints take a long time to dry, possibly 24 to 48 hours. The more oil or alkyd the formula contains, the longer it will take to dry. However, the result will be better elasticity, which makes it less likely that the paint will crack as it ages. A film is formed in alkyds by the evaporation of the solvent, followed by a chemical reaction with oxygen in the air to harden the film. Alkyd paints provide a hard glossy surface that is good for windows that need to slide easily, as well as cabinets and furniture.

Latex paints use water as the solvent. Water-based paints are made with either acrylic or vinyl acrylic for their binder. When water-based paint is applied to a surface, the water evaporates and individual resin particles become closely packed together. The resins unite to bind the pigment particles into a continuous, flexible film. Water-based paint usually dries within 4 hours, depending on the humidity in the air. Acrylic paints can be diluted with water, but become water-resistant when dry. Because water-based paints dry quickly, brush strokes show in the dried paint. Normally pure acrylic is used for exterior due to its adhesion quality, and vinyl acrylic is used for interior because it has better washability.

Surfactants are a necessary component of water-based exterior paints. *Surfactants* are soap compounds that impart color and stability to paint. They contain water-soluble solid matter that migrates out of the paint film and deposits itself on the surface of the paint. The migration occurs over a period of weeks after the paint has been applied. The deposits are not visible, but they are distributed uniformly over the entire surface. In climates where condensation forms on exterior surfaces, the moisture from the condensation extracts surfactants from fresh paint film. As the condensation dries, the surfactants are visible as spots or streaks on the paint. Dark colors contain more surfactant and are more prone to surfactant leaching. The streaks or spots can be washed off easily if done within a week. If they are allowed to dry, they will be difficult to scrub off.

Epoxy paints are used in conditions that require high performance. They can come in two types. One type is available ready-mixed in a can. The other type, catalyzed epoxy, comes in two containers that need to be mixed to start a chemical reaction making it extremely hard, almost like a ceramic glaze. **Epoxy** is chemically cured; the chemical reaction combines small molecules to create larger molecules. Epoxy paints are used on surfaces such as industrial floors, around water (such as swimming pools and showers), and where cleaning with harsh chemicals is required (such as in food service preparation areas).

Primers and Sealers

Paint is expected to cover and hide anything to which it is applied. If you can see anything that was previously visible on the wall, then the paint did not cover it adequately. **Primers** must be used in many cases to achieve the desired effect. The first coat applied to an unfinished surface is to prepare it for subsequent coats of paint. Different materials require primers with different characteristics.

Sometimes primers are necessary to seal a porous material, such as wood or gypsum board. If the surface is not sealed, paint will soak into the material and the result will not look like the paint sample. Also, a lot of paint will be wasted in the absorption by the porous material. A primer works by holding the binders in the surface, preventing them from soaking into the surface. A water-based primer works best for gypsum wallboard because it will not raise the fibers as a solvent-based primer would and it is alkali resistant.

Dark colors pose a challenge in painting, usually requiring more coats of paint. When selecting a dark color it is best to use a gray primer rather than white. A representative from Sherwin-Williams, Brook Niestedt, explained this concept by pointing out that automobiles are primed in gray. In the Sherwin-Williams paint deck about 20 percent of the colors have a code of P1 to P6 on the back of the color chip to indicate which shade of gray is recommended.

Alkyd sealers are necessary for surfaces such as unfinished wood that contain resin or natural dyes. A water-based paint primer would raise the grain on unfinished wood, so a sealer with a solvent base is necessary to prevent that from happening. Water stains or graffiti also need to be blocked by a sealer to keep them from bleeding through paint. In that case, the sealer would need to contain a stain killer, such as white pigment. Alkyd primers are used where resistance to bleeding, mold, and moisture is desired and penetration of the paint needs to be controlled.

Metal has traditionally been primed with red lead oil. The oil binder wets the surface well and protects cracks in the metal. Zinc oxide is often used under alkyd paints on metal. Wash primers containing phosphoric acid are used to clean and prime a metal surface. They promote adhesion of subsequent coats of paints and frequently are used to protect freshly sandblasted surfaces from further corrosion.

Protective Finishes

Lacquer has traditionally come from tree resin mixed with a solvent (lacquer thinner). In the mid-1900s, nitrocellulose resin was discovered by the auto industry and added to lacquer. The unique property of adding nitrocellulose resin to lacquer is that each coat dries into the next coat, resulting in a very hard finish that is flexible enough to not crack. The drawback is that it deteriorates in ultraviolet light. Lacquer is used in commercial finishing of wood furniture. It is very fast drying, but also very flammable. It is applied with a spray in a spray booth designed to keep dust particles out. Lacquer is applied in many thin coats with extremely fine sanding between coats. Lacquer provides a durable and water-resistant finish.

Polyurethane (which is a plastic) can be classified as a varnish or a lacquer, although it is neither. Polyurethane varnishes are resistant to water, alcohol, and fingerprints. They cannot be used over shellac or paste wood fillers. They can be either clear or pigmented, matte or gloss, but they will eventually lose their gloss. Urethanes provide better abrasion resistance than varnishes or lacquers do.

FIGURE 10.6 Dark Stain Is Being Applied on Oak Flooring. Taiga/Fotolia

Shellac is a natural resin secreted by the lac bug. The resin is harvested from tree branches, processed, and dissolved in denatured alcohol. It is available in clear, orange, and pigmented white. Orange shellac is used for restoring antique furniture and floors. White shellac is sometimes used as a stain killer on raw wood. Shellac is an old and natural finish with low toxicity. On furniture, shellac turns white when water stands on it; therefore, coasters are necessary to protect the wood.

Stains are used when one wants to change the color of the natural wood but still wants the wood grain to show. Stains penetrate the surface of wood, adding oils to help preserve the wood. A stain can be either semi-transparent, adding color while allowing the texture of the wood grain to show through, or solid color, adding color and covering most of the grain pattern. Stains do not keep moisture out completely as paints would. For indoor use, a varnish or lacquer is often applied over a stain on wood to protect it.

Varnish is a mixture of resin, oil, dryer, and solvent. Older formulas for varnish used oleoresinous varnishes that tended to yellow over time. Varnishes for interior use usually include alkyd resins. Alkyd varnishes have good initial color retention, but may crack and peel over time. *Spar varnish* is a varnish with additives that give the material a resistance to salt water, for use near the ocean. Varnishes that contain ultraviolet-screening agents exhibit less discoloration and generally greater durability. Flat and satin varnishes have an agent such as silica added. They do not have the reflective quality associated with gloss varnish, and they are less abrasion resistant.

DECORATIVE FINISHES

Faux finishes are created with paint to look like another material, such as stone, marble, or wood. Faux finishes can be achieved by using sponges, textured rollers, rags, or brushes. Kits are available in paint stores to achieve certain effects. These can be applied to either flat surfaces or shapes such as columns.

Glaze is sometimes applied over a painted surface to add luminance and depth. A glaze is a thin, transparent film of color. To

FIGURE 10.7 These Cabinets Had a Seven-Step Finish. They were sanded, sealed, sanded again, and primed before the first coat of finish color paint was applied. The finish coats consisted of paint, catalytic lacquer, glazing, burnishing, and a final coat of catalytic lacquer. Cabinets by Tharp Cabinet Corporation.

Poudre River Public Library District built a small community library in a commercial area, LEED Silver Certified, Front Range Village Development. The goal was to design the Council Tree Library to be certified under LEED for Commercial Interiors 2.0. The library was completed in March 2009 and received LEED CI Platinum Certification. Architect Chris Freeland, with the architecture firm of Aller+Lingle+Massey, acknowledged that low-VOC paint is more expensive than regular-VOC paint, but he said that "within the grand scheme of low-VOC finishes, it isn't that much." The project earned 4 LEED credits in the Indoor Environmental Quality category for the finishes being low-VOC. Only 1 point was for the paint. The other 3 points were for the low-VOC composition wood, carpet tiles, and air filters. Low-VOC paint is not as robust due to the fact that it has less solvent in it. As a result, it is not as durable as regular VOC paint. The project used paints from Diamond Vogel. Paint was used on many surfaces and for signage in the Council Tree Library.

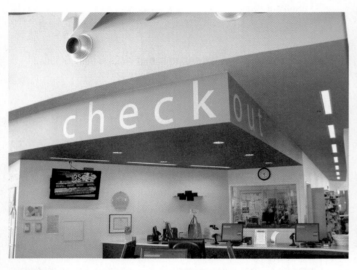

FIGURE 10.8 Interior of Council Tree Library Checkout Desk Shows How Paint was Used for the Signage.

FIGURE 10.9 Signage in Paint on Wall. Wall décor and signage in the Council Tree Library used paint rather than plastic signage to keep the finishes within the limits for the LEED platinum certification.

produce glazes, oil colors selected for their transparency are diluted with a mixture of oil and varnish. Glazes give depth to a painted surface by allowing light to pass through and reflect from lower paint layers.

Burnishing is a process for creating an old, worn appearance, usually on cabinetry. A dark color paint is applied and wiped off to look like old coats of wax have dried in the corners.

Application: Using Information Regarding Interior Finish Materials

CODE ISSUES

The codes affecting painted finishes are the National Fire Protection Association NFPA 101 Life Safety Code, and ASTM E84, Standard Test Methods for Surface Burning Characteristics of Building Materials. Most conventional paint systems when applied at a normal film thickness will develop a Class A (0-25) flame-spread rating with 0 smoke development when tested over a noncombustible, previously uncoated substrate, such as cement board.

Normal paint will do nothing to prevent a substrate from burning. Special fire-retardant, or **intumescent**, coatings can be applied to combustible substrates such as wood to reduce the overall flame spread rating of the system. Flame-retardant paints are specified for public

buildings. Intumescent coatings retard flame spread through their intumescent-sublimative-ablative and synergistic flame-suppressing action. On contact with flame or excessive heat, intumescent fire-retardant coatings decompose and puff up, forming a dense foam layer that stops flame spread.

Disposal of paint is governed by law. Latex-based paint will dry up into a solid piece if left open in the air. A hardener can be added to thicken paint. Paint can be spread out to dry on trash paper; when hard, it can be disposed of with other trash. Solvent-based paints must be disposed of according to local or state environmental control agencies' guidelines.

SPECIFYING

Descriptions for specifying paint are found in CSI division 09-900.

It is your responsibility to specify the best type of paint and gloss level for the location of the painted surface. An interior space may need to have a scrubbable surface in an entryway or a washable surface in a kitchen. "Scrubbability" is tested with an erosion method. The surface is scrubbed with a stiff brush. A paint may show a burnish mark and still pass a scrubbability test. "Washability" is a test of repelling of releasing stains. It is a nonabrasive test. The American National Standards Institute classifies paints according to properties that include chemical composition, corrosion resistance, hazard potential, and reflectivity. It provides standard test methods and certification to ensure products are manufactured according to specifications.

The paint color selected by the designer and client may have been from a paint sample supplied by the paint company on paper. It is a good practice to purchase a small amount of paint and apply the paint to a sample of the substrate with the primer that will be used in the application. The sample should be at least 8 inches by 10 inches—larger if possible. Take the paint sample to a place where the lighting will be the same as in the finished installation to check the color. If natural light will be used, the sample will need to be checked under varying daylight conditions.

Make sure excess paint is controlled in your specification. *Splatter* is the tendency of a roller to throw off droplets of paint during application. *Overspray* comes from a paint sprayer. For either case, areas adjacent to the surface to be painted should be protected from splatter and overspray. The painting contractor should be made responsible for cleanup of paint on glass surfaces, paint masking tape, and disposal of unused paint. Paint to be used should be stored in an interior location with a temperature of approximately 77 degrees Fahrenheit. Every paint manufacturer produces a paint specification. It would be best to use the specification prepared by the manufacturer for selecting the primer, the thickness of the paint, and the drying time between applications.

LIFE CYCLE COSTS

With paints, the lowest material costs will not result in the best cost for the life cycle of the paint. Selecting a long-lasting paint can cut costs of material and labor. According to Thomas Westerkamp at facilities.net, "Careful attention to detail during preparation phase pays off in longer performance life and a lower life-cycle cost. Application labor is the work done to apply a paint or coating and often is only a small fraction of preparation labor, if workers do the job right."

Cost Estimating

The spreading rate per gallon will enable a designer to calculate approximately how many gallons are needed for a job. It is normally stated on a can or in paint specifications. Viscosity and **volume solids** are a part of the calculation that determines spreading rate per gallon. However, the spread rate is

Paint or Coatings Used in an Interior

Floors
Stain over wood or concrete flooring
Paint over flooring surface
Varnish over wood flooring

Walls and Dividers
Paint over wall surface
Stain over wood surface
Varnish over wall surface

Ceilings
Paint over ceiling surface

Commercial Kitchen and Shower
Epoxy paint

Signage
Paint over gypsum board or other surface

Furniture
Paint
Lacquer

extremely dependent on the texture and preparation of the substrate surface. Painting materials consist of paint, brushes, rollers, sprayers, disposable paint tarps, and masking tape. Of these, paint is the largest material cost. To reduce ozone depletion, the U.S. Environmental Protection Agency closely regulates solvents that contain VOCs. Paints that are more environmentally responsible and contain few or no VOCs can cost 50 percent more than paints with higher levels of VOCs.

INSTALLATION METHODS

Surface Preparation

Before applying paint, the surface must be clean, dry, and dull. *Clean* means there should be no dirt, dust, oil, loose surface, peeling paint, mildew, or other contaminants on the surface. *Dry* means the moisture content for the substrate should be less than 8 percent for wood, less than 12 percent for plaster, and less than 15 percent for masonry. *Dull* means the surface should have tooth, from sanding or applying deglosser. Composition hardboard must be cleaned thoroughly with a solvent prior to painting. Plaster must be allowed to dry thoroughly in a warm room for at least 30 days before painting.

Previously coated surfaces require special attention. If a surface has been previously painted, the old paint may have been applied before 1978, in which case care will need to be taken when sanding due to a possibility of lead in the sanding dust. Usually, a dust containment system will be required around the work area. All surface contamination such as oil, grease, loose paint, dirt, foreign matter, rust, mold, mildew, mortar, efflorescence, and sealers must be removed to assure sound bonding of a new coating to the existing coating. Glossy surfaces of old paint must be clean and dull before repainting. Any bare areas need to be primed before painting.

The Painting and Decorating Contractors of America publish a document titled *Levels of Surface Preparation for Repainting and Maintenance Projects Receiving Architectural Coatings*, PDCA P14-06.

FIGURE 10.10 A Painter on Scaffolding Is Painting a Room Where Holes in the Wall Have Been Prepared for Painting. Studio DER/Fotolia

Application of Paint

Paint can be applied with a sprayer, a roller, or a brush. Paint application is measured in mils: 1 mil is 1/1,000 inch. The thickness of the paint should be approximately 3 to 4 mils per wet coat. The coverage will depend on the texture of the surface, the preparation of the surface, and the method of application. For estimation purposes, many architectural paints are applied at 300 to 450 square feet per gallon of paint.

For the majority of interior applications, paint will be applied to a gypsum board wall or ceiling. The surface will be ½-inch thick gypsum board, nailed to wood or metal vertical studs. Make sure the surface is uniformly smooth, all nails set, nail holes filled, joints taped, joint compound applied, and sanded smooth. Dust from sanding must be removed prior to painting. Gypsum board must be primed prior to applying the finish color paint. Flat or satin paint is normally applied to gypsum board.

The second most common application will be on wood trim. Nail holes need to be filled before painting. If the wood is unfinished, it will need to be sealed with a primer or sealer. For staining wood trim, wood putty is used to fill nail holes so it will take the color of the stain. A protective finish of varnish is applied over the stain. For painting wood trim, wood sealer or primer may be used under paint, and nail holes may be filled with spackle or putty. Paint for wood trim is often applied with a brush of bristles or sponge. A heavy application is desirable on wood trim, so spray application is not normally used. Normally, semi-gloss or gloss paint is used.

When applying paint to other surfaces, such as concrete, brick, or metal, it is best to follow the directions from the paint manufacturer. Specific products are formulated for use on those materials.

Paint should not be scrubbed, unless it is scrubbable paint. Most painted surfaces can be dusted lightly to remove dust and brighten the color. They can also be washed with water and a mild soap. Paints should not be cleaned with chemicals unless they are specifically formulated for chemical cleaning, such as epoxy paints.

Case STUDY of Paint Used in an Interior Application

A new house has been painted with the finishes specified by the designer. The entry hall has satin finish paint because the designer expected it to have lots of traffic moving through it and satin would be easier to clean than flat, yet still have a somewhat subdued reflectance of light. As the furniture is being moved into the house, one of the movers stumbles and the leg of the sofa makes a vertical brown stain where it scraped the entry hall. The homeowner finds the buckets of paint left by the painters and tries to cover the brown stain. After the paint dries, the brush strokes of the fresh paint are very obvious. Thinking that the brush is the problem, the home owner paints it again, this time with a sponge instead of a brush. Again the fresh paint shows and does not blend in with the original paint. The painter is called in to give advice on the paint in the entry hall. The painter explains that satin paint has a slight sheen. Because of the sheen, any touch-up will show as long as there is light on it. The only way to fix the touch-up is to paint the entire expanse of that wall, from corner to corner, without getting any paint on the adjacent walls. If any paint touches the adjacent walls, then they too will need to be painted or the newly painted spot will show.

Case STUDY Regarding Specification of Paint

Gypsum board is available in sheets 4 feet wide by 8 or 10 feet long. Due to the size constraints, a wall will consist of several pieces of gypsum board with joints of paper tape joining the pieces together. Since the gypsum board is a light gray color, the designer thinks a primer is not necessary. The wall is painted with one coat of the latex paint, in the specified color and finish type. The designer and the client notice that something is wrong with the paint, because they can clearly see the joints that are not supposed to show. The painter shows them the latex paint he used. The designer calls the paint company's architectural representative, who explains to her that new walls that have never been painted need to be sealed to keep the white tape joints from showing through against the light gray gypsum board. In this case, the product was improperly specified because a primer was necessary. For a new surface that has never been painted, a primer is needed to hide color differences and seal the surface of the gypsum board before the finish paint is applied.

summary

Paint has been used throughout history on interior surfaces. Sometimes the purpose is to protect the structural material, other times the purpose is for artistic endeavors. Originally, paint was made from organic materials, minerals from the earth for color, and oils or eggs for binders. White was the most common paint because very few colors were available and paint colors were mixed by hand. The Industrial Revolution of the mid-1800s changed the conception of paint. It became available in ready-mixed cans, more colors were available, and new formulations were made. In the mid-1900s, synthetic products, vinyl and acrylic, were added to paint, as well as more colors, and painting became a do-it-yourself process. No longer were the long drying times and careful clean-up of oil paints required.

Paint is used somewhere in almost every interior, from being the focal point of the interior to being used for trim and barely noticeable. Although knowledge of color interaction is a large part of selecting paint, understanding the characteristics of different

types of paints, stains, and finishes is crucial to designing an interior that will perform in the manner intended.

To find out more about paint and coatings, the following websites can be useful:

Benjamin Moore: www.benjaminmoore.com/en-us/ for-architects-and-designers (will send representatives to call on designers)

Color Marketing Group: www.colormarketing.org/ (forecasts color trends)

Painting and Decorating Contractors of America: www.pcda.org

Pantone: www.pantone.com/pages/pantone/index.aspx (fashion color report)

Pratt and Lambert: www.prattandlambert.com/color-and-inspiration/ (offers color trend information and a Style and Design Guild for professionals)

Sherwin-Williams: www.sherwin-williams.com/architects-specifiers-designers (offers education and paint samples to interior designers and students)

review questions

1. Describe at what point in the painting process paint releases volatile organic compounds (VOCs) into the atmosphere and what you can do to prevent this from happening in your next paint project.

2. Describe the purpose of a solvent in paint.

3. Explain how paint can be used to make a surface fire resistant.

4. Analyze why a painted wall could show different sheens (light reflectance) when all the paint came from the same can and is all the same gloss level.

glossary

Acrylic paint is a fast-drying paint containing pigment suspended in acrylic polymer emulsion.

Alkyd is a modified or synthetic oil used in paint as a binder.

Binder is the adhesive that holds the pigment particles to each other and the surface.

Enamel originally meant a high-gloss finish; today it means a high-quality, smoother-finish paint.

Epoxy is a chemically cured coating applied in a liquid form like paint.

Extender pigments provide qualities other than color for the paint.

Faux finish refers to when a surface is painted to appear to be a different material.

Fresco is when paint is mixed with the top coat of plaster forming a design on a wall finish.

Glaze is a thin transparent film that adds luminescence.

Intumescent refers to a fire-retardant in coatings that slows the progress of a fire by forming a protective foam.

Latex is a misnomer for water-based paints because latex is a product of the rubber tree and not present in latex paint.

Paint is a pigmented liquid applied to a surface in a thin layer which dries to a film.

Pigment is the ingredient in paint that provides color and opacity.

Primer is the first coat applied to a substrate to prepare it for paint.

Oxidation occurs when a solvent-based binder reacts with oxygen in air to cure and harden paint.

Shellac is a natural resin from the lac bug used for sealing and finishing furniture and floors.

Solids are the part of paint that remains on the surface after the paint dries.

Solvent has a dual meaning in the paint industry. Solvents can be any liquid used to dissolve a binder in paint. The term also refers to a chemical, either hydrocarbon or oxygenated, used for making oil or alkyd paint.

Stain is a semi-transparent coating with color designed to penetrate into the surface yet allowing the surface texture to show through.

Titanium dioxide is a nonlead white pigment used to cover and hide other colors or stains.

Trompe l'oeil is a visual painting technique meaning to trick the eye, or create an illusion.

Varnish is a transparent finish applied to wood to make it impervious to water.

Vehicle is the same as the binder that holds the pigment to the surface and later evaporates.

Viscosity refers to a liquid's consistency.

Volume solids refer to the percent of solid ingredients in a can of paint that remains on a painted surface after it dries.

Plastics

Awareness: An Overview

DESCRIPTION AND COMMON USES

In the 1967 film, *The Graduate,* career advice to the young college graduate was summed up in this famous line: "One word: Plastics." Indeed, in the 1960s, plastic had become the dominant material for constructing just about anything, and the future of plastic as *the* material for the Space Age was promising. In the twenty-first century, the dominance of plastic is complete, with plastic used to construct everything from clothing, to decorative and functional household items, to materials used in the construction of buildings and industrial products.

The word *plastic* comes from the Greek word *plastikos,* which describes something that is pliant, malleable, or easily changed. As used today, the noun *plastic* refers to products manufactured from polymer resins by heating, shaping using various types of molds, and then cooling. Plastics are **synthetics**, a term that refers to the combination of two or more substances to make a product that does not occur naturally. Thus, a synthetic product is human-made from substances created in a laboratory.

The development of plastics began in the nineteenth century as scientists and inventors worked to improve the performance of natural materials, often discovering substitutes for those materials. Many natural materials, including concrete, plaster, glass, and clay, go through a pliable or moldable state at some point, but when cured or hardened they may be brittle and breakable. One reason for the development of plastic was to create flexible, pliant, nonbreakable products.

learning objectives

When you complete this chapter, you should be able to:

1. Recognize terms used when discussing plastics.
2. Identify common uses of plastic in an interior.
3. Summarize the history of plastic use in interiors.
4. Describe how plastics are produced.
5. Describe how plastics meet code requirements for interior use.
6. Describe and analyze the physical characteristics and properties of plastic for a specific interior use.
7. Analyze the environmental impact of using plastic.
8. Evaluate how well plastic products will meet the specific needs of a design project.

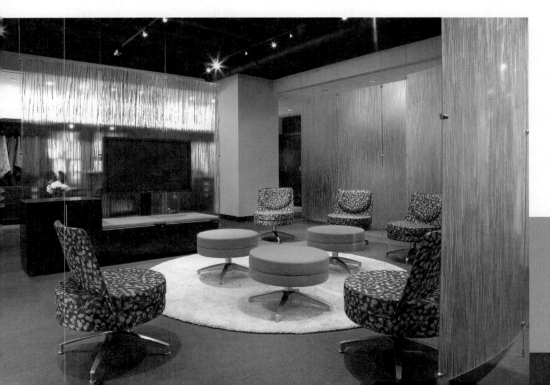

Fusion Panels Divide Space in the DesignTex Showroom.
Photograph courtesy of DesignTex

Products made from plastic are generally less expensive than the natural materials they replace and often have features that are improvements to those products. Many different types of plastic are manufactured because each has been developed to meet specific performance criteria and for specific end-uses. Even early plastic products that were manufactured from natural substances, such as cellulose, in order to improve or substitute for such natural products as rubber or resins, now have completely synthetic plastic counterparts.

Plastics are made from **polymer** (*poly* meaning "many") resins, which are created by combining two or more **monomers** or single molecules into long repeating chains that create one large molecule. **Polymer resins** are the raw materials from which plastic products are made. The term *resin* is often used synonymously with the term *plastic,* especially when the resin can be molded into a finished product without the addition of a **plasticizer**, or made into varnishes, coatings, and adhesives. *Synthetic fibers* are not technically plastics, but are made from polymers that are chemically the same as those used for plastic products.

Plastic products are divided into two types: *thermoplastic* and *thermosetting plastics.* **Thermoplastic** products will soften when heated and harden again when cooled. They can be reheated and remolded without damaging the original composition. Products made from thermoplastics are easily shaped and tend to be flexible and pliant, often because plasticizers have been added to maintain those qualities. *Thermoset* or **thermosetting plastic** products are hardened by chemical curing or heat; when cured, a chemical change occurs that prevents them from being softened again. Thermosets are more rigid, hard, and brittle but are also durable. They may decompose, but they will not soften.

Plastics are used extensively in building construction and interiors. In building construction, plastics are used as insulation, sealants, roofing materials, vapor retarders, and siding, as well as for exterior decking. Plumbing pipes are made from plastic, and electrical wires are coated with plastic insulation. Plastics are used as adhesives in the construction of wood fiber products. In a building interior, plastic in the form of **vinyl** is used in floor tiles and sheet flooring, as wallcovering, and to protect ceiling tiles from moisture. Synthetic rubber is also used for flooring. Vinyl and synthetic rubber are used for stair treads and nosings, resilient wall base, and carpet edging. Plastic laminate is used for countertops, furniture, wall panels, and flooring. **Solid-surfacing** products, most often used for countertops, are made of plastic. Plastics are used as components of light fixtures and to construct signs. Plastics are also used for hardware, accessories, and the visible components of an electrical system such as receptacles and cover plates. Interior windows, doors, and wall panels can be made of plastic products. Wall panels for areas that require extra durability and the ability to be cleaned are made of **fiber-reinforced plastic (FRP)**. Both indoor and outdoor furniture can have plastic components or be constructed entirely of plastic. Synthetic fibers are made from extruded plastics, and yarns made from these fibers are used to construct carpet, woven wallcovering, and fabrics for interior uses such as upholstery, window treatments, and household textiles. Interior finish materials are applied to their substrate using adhesives made of polymer resins. Polymer resins are also used to manufacture paints and coatings.

CHARACTERISTICS

Because plastics are created in a laboratory, and because they are so easy to form into almost any shape, many types of plastic have been developed to meet specific performance criteria. Almost every type of plastic has variations based on the level of rigidity or flexibility desired. Some plastic products may help absorb sound.

Thermoplastic products tend to be flexible and malleable. Seams or joints can be bonded by heat welding or chemical bonding, so they are good for environments with high hygienic requirements or for the aesthetic appearance possible with a continuous surface. Thermoplastics can resist impact better than thermosetting plastics, and they maintain flexibility with the addition of *plasticizers*. When exposed to fire, thermoplastics will usually decompose rather than burn, but in the process they will emit toxic gasses.

Thermosetting plastics resist higher temperatures and are more dimensionally stable. They are permanently hardened, and may be glossy or shiny. When exposed to fire, thermosetting plastics will melt.

ENVIRONMENTAL IMPACT

Although the durability of plastic products is one of their advantages, this strength causes the greatest problem associated with the use of plastics: Plastic products last for centuries and may never completely decay. Although plastics enable many products to be made less expensively, the proliferation of plastic products has a negative environmental impact. Even if plastic is recycled, it is often recycled into products that, when their useful life is over, must be sent to a landfill. If all plastic products were either recycled or sent to a landfill, the quantity of plastics in the environment would still pose a problem. However, many plastics never make it to either a recycling center or a landfill. The result is, at a minimum impact, an increase in litter, and at the worst, situations such as the floating garbage island that continues to grow in the Pacific Ocean.

The embodied energy of plastic products is higher than glass, but less than metals. Plastics are primarily made from petroleum by-products. The process of procuring and refining petroleum has a negative impact on the environment. As petroleum becomes more scarce and expensive, it is now feasible to use other sources of the carbon-containing substances as the basis of plastics. Coal tar and coal oils can be used to produce plastic, but coal also has a negative environmental impact, so using coal is not a sustainable solution. Current research is underway to develop plastics made from natural cellulosic materials rather than coal tar or petroleum. **Bio-plastics** are made from renewable bio-mass sources such as vegetable fats and oils, corn starch, and pea starch, or from genetically engineered corn. Using food sources to make plastic rather than to feed people has serious moral implications, but researchers are experimenting with alternatives: living or recently living sources that are renewable. The goal of creating bio-plastics is sustainability, and some, but not all, are also biodegradable. Although some **biodegradable plastics** require industrial composting, there are encouraging developments, such as plastic bottles that degrade when exposed to oxygen to the point where micro-organisms can complete the work. This takes months rather than centuries.

Plastic recycling is more difficult than recycling other products because products made from plastics are often a combination of several different materials that must be separated before they can be recycled, which is a labor-intensive process that is not yet economically feasible. Thermosetting plastics, used in plastic laminates, cannot be recycled. To make a product from recycled plastic, the plastics that are used must be the same or nearly the same composition; otherwise, the product made from the recycled plastic will have weaknesses caused by the tendency of the two different plastics to separate. The codes found on plastic products indicate the type of plastic used to make the object and serve as a guide for separating into different categories for recycling. The recycling process requires that dyes, fillers, and other additives be removed, which is a difficult process. For the most part, plastic products are **downcycled** into less

Properties of Plastics

(sustainable properties are denoted with green color)

The numerous types of plastic were each developed to have specific characteristics. However, all plastics share general characteristics:

- Plastics are by definition pliable and easily shaped.
- The polymer resins from which plastic products are made have no intrinsic color. Thus, plastic products can be more transparent than glass.
- Plastics can be molded, pressed, extruded, or cast to create objects, films, and fibers, and thus can be made into almost any form.
- Colorants can be easily added to polymer resin; thus, a wide variety and clarity of colors are associated with plastic products.
- Plastics are tough, strong, and durable. This durability translates into a sustainable feature since plastic products have a long useful life.
- Plastic products generally have additives that slow (but don't completely stop) degradation by heat and light, and plastics do not completely disintegrate. Thus, plastic products do not wear out, but may "ugly out" or lose their aesthetic appearance over time.
- Products made of plastic are lightweight. This characteristic helps increase the fuel efficiency of vehicles made of plastic components.
- Plastics are corrosion and moisture resistant.
- Plastics are chemically inert; thus most substances, including alcohol and gasoline, will not cause them to dissolve.
- Components of some plastics are potential carcinogens. If the plastic is heated, the carcinogen may leach into food or water. If the plastic is burned, the carcinogen is released into the atmosphere.
- Adhesives used in some plastics release volatile organic compounds that, if not allowed to dissipate before the space is occupied, can cause inhabitants of a space to develop respiratory problems.
- Products made of some plastics can be recycled either by making them into different products or, as in the case of carpet, recycling used carpet into new carpet.

functional or less durable products that generally cannot be recycled again. Thus, the inevitable trip to the landfill is only delayed. Bags and beverage containers, having fewer additives, are more easily recycled.

Fortunately, the interior products and building construction industry has been able to make use of recycled plastics in several ways:

- Soft drink bottles can be recycled into outdoor furnishings, decking timbers, and trash containers.
- Plastic containers can be recycled into fabric. The PET polyester used to make plastic bottles can be used in fabrics for interior uses or for carpet fibers.
- Carpet fibers, especially those made from Nylon 6, can be recycled into carpet fibers again. This is **closed-loop recycling** as the nylon can continuously be used to make new nylon.
- Manufacturers, aware of the need to provide products that help projects achieve LEED certification, are providing plastic products with 40 percent or more recycled content.

Some types of plastic may contribute to LEED credits in the following categories:

- **Low-Emitting Materials:** Look for Greenguard and Floorscore certification, which address indoor air quality.
- **Recycled Content:** Many manufacturers, as a result of LEED requirements, include at least one product in their lines that contains at least 40 percent recycled content.
- **Regional Production:** The location of the plant that produces the plastic product may be within the range considered regional and thus qualify for LEED credits.
- **Rapidly Renewing Materials:** Some products are made from bio-plastics, using renewable plant materials instead of petroleum as a polymer.

Plastics and Health

Pure plastics have not been found to be harmful to humans, but the additives in plastics have been shown to cause health problems. The list of harmful products referred to as **persistent bio-accumulative toxins (PBTS)** continues to grow. For instance, *phthalates,* used as plasticizers in the production of polyvinyl chloride, have a tendency to separate from the polymer as some products age. Phthalates can be released into the atmosphere in the form of dust, which can cause asthma and allergic reactions. They can also be released when plastic products deteriorate in landfills. Phthalates are known as **xenoestrogens**, or *endocrine disruptors*, mimicking estrogen, causing a change in hormone levels and possibly causing cancer. Another xenoestrogen, *bisphenol A (BPA),* a monomer used in the production of polycarbonate plastic and epoxy resin, may leach into food. Bisphenol A has been banned in Canada and is no longer used in plastic baby bottles in the United States. *Benzene*, used in several plastics including synthetic rubber, is another cancer-causing volatile organic compound. Burning plastics releases toxins, such as *dioxin* from polyvinyl chloride, and *antimony*, a catalyst in polyester fabrics and bottles. *Styrene*, the type of plastic used to make Styrofoam cups, is also used in insulation and carpet backing. Styrene is toxic when heated and can also emit toxic fumes. *Melamine*, the hard surface layer in plastic laminate, is dangerous in its powder form. If melamine particles are ingested, they can cause a range of illnesses, such as reproductive damage, kidney stones, and bladder cancer. Manufacturers, aware of the environmental concerns, are offering products in their lines that are PBTS-free. They are also researching and adding products to their lines that are made of non-PVC polymers or made of bio-plastics.

Indoor Air Quality

Plastics in the form of formaldehyde resins or epoxy resin are used to make adhesives. These adhesives are used in the construction of plywood, particle board, and medium-density fiberboard, the product that emits the highest level of formaldehyde. Plastic products such as vinyl flooring and plastic laminate are adhered to their substrates using these adhesives. Formaldehyde dust and fumes released into the air can cause respiratory illnesses such as

- PETE or PET plastics: Include soft drink and water bottles and bottles that contain cooking oil and peanut butter. PET plastics are the most widely recycled. Polyester fabrics are made from PET plastics.
- HDPE (high-density polyethylene): Jugs that contain milk, water, detergent, fabric softener, and bleach.
- V (polyvinyl chloride): Bottles that contain salad dressing, vegetable oil, and mouthwash.
- LDPE (low-density polyetheylene): Flexible plastic products such as bread, produce, and trash bags; dry-cleaning bags; and shrink wrap. When recycled, LDPE is used to make grocery bags.
- PP (polypropylene): Drinking straws, battery cases, some dairy tubs, labels and bottle caps, and rope.
- PS (polystyrene and expanded polystyrene): Includes packaging for peanuts, plastic utensils, meat, and egg trays.
- Other: Plastic products made of multiple resins or layers of different types of plastics. Included are items such as microwave packages, snack bags, and industrial plastics.

The familiar number inside a triangle made of **chasing arrows** found on plastic products indicates the type of plastic that was used to make the product. The reason for the numbering system is to make sorting plastics easier, since different types of plastic must be recycled separately. The plastic recycling process includes:

- Sorting by type and/or color
- Shredding or chopping into small pieces
- Cleaning and eliminating impurities such as labels
- Melting to make polyester resins
- Extruding into pellets
- Extruding the pellets to make fibers, caps, labels, or plastic carpet cores

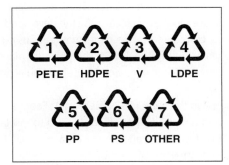

FIGURE 11.1 Illustration of Plastic Recycling Symbols.

FIGURE 11.2 Plastic in Bales to Be Recycled. fffranz/Fotolia

asthma and can exacerbate allergies. Phenolic resins, which are used in the construction of plastic laminates, can emit toxic fumes during the manufacturing process. When initially installed, PVC flooring, plastic laminate, and vinyl wallcovering release chemical gasses into the air. If the fumes from new plastic products or adhesives are not allowed to dissipate after a building is finished, the effect on occupants is referred to as **sick building syndrome**.

Understanding: In-Depth Information

HISTORY OF PLASTICS

Before the development of synthetic polymers at the end of the nineteenth century, popular natural materials had characteristics we now associate with plastic products. Tortoiseshell, horn, and ivory have long been worked to create objects of function and beauty. Resinous materials from tree sap and insect secretions have been used for functional products such

Acrylic is used to make solid surfacing that is ideal for kitchen countertops. Not only is the product attractive but also the nonporous surface and fused seams result in a surface that will not support the growth of mold or bacteria. The material is fire resistant and is not harmed by chemicals.

FIGURE 11.3 Solid Surfacing for Kitchen Countertop "Cloudy" by Hanex. Photograph courtesy of Hanwha Surfaces

as rubber and shellac. In addition to their aesthetic properties, these materials had characteristics that made them potentially useful for inventions of the modern era, such as tires for automobiles and insulation for electrical wiring. Much of the research that led to the development of early plastic was centered on efforts to find flexible heat- and water-resistant materials for everything from coating wiring to making rainwear.

The first inventors of plastics combined natural materials. In 1839, Charles Goodyear, in a process he called **vulcanization**, added sulfur to crude rubber in an effort to make it more resilient and durable. At the 1862 International Exhibition in London, English chemist Alexander Parks presented a product he called *Parkesine*, which combined softened nitrocellulose with vegetable oil and camphor. Parkesine was used as a waterproof coating for rainwear. Efforts to keep Parkesine inexpensive resulted in low product quality. Nearly bankrupt, the company was sold to Daniel Spill, who released the product under the name *Xylonite*. The product is no longer used today. In the United States in 1869, John W. Hyatt, searching for an inexpensive substitute for ivory for billiard balls, invented the machinery to develop the products made from the same raw materials as Parkesine: camphor and cellulose. His product, marketed as **celluloid**, was used for film, revolutionizing photography and making the motion picture industry possible, even though celluloid has a tendency to burst into flame.

A Belgian-born American, chemist Leo Hendrik Baekeland, intending his product to be used in the electrical industry, developed the first plastic that could be considered a complete synthetic, using phenol and formaldehyde resin. During the 1920s, the product, marketed as **Bakelite**, became popular for jewelry and household objects such as radios and telephones.

Two scientists working for Westinghouse in the early 1900s, Herbert A. Faber and Daniel J. O'Conor, were also working on developing a material that could be used to insulate electrical wires. Their work built on the work of Baekeland and produced a phenolic laminate resin. Interested in exploiting the decorative possibilities of plastic laminate, the two men left Westinghouse to start their own company, **Formica**, a play on the words *for* (in place of) or *faux* (false) plus *mica* (a type of thin stone used at the time for electrical insulation). The phenolic resin used to make the product could be used only to make dark colors, but Faber and O'Conor soon discovered the design possibilities of a printed top layer. In the 1920s, chemists in several countries were simultaneously working with urea formaldehyde as a substitute for phenolic resin, which was white and translucent, but more expensive. When the companies in Germany, Austria, and Britain exchanged patent rights, development was rapid. When *melamine*, a urea-based resin, was developed as a coating in the 1930s, the result was plastic laminate that had unlimited color and pattern possibilities.

Another goal of industrial scientists was to develop thin flexible sheeting that could be used for film, food wrap, or waterproofing. Swiss textile chemist Jacques Brandenberger first developed a clear film as a protective waterproofing for cloth, using the process developed for **Viscose**, a cellulosic fiber. By 1912, he had perfected the machinery to produce cellophane, used for food packaging. DuPont scientist William Hale Charch found a way to make cellophane moistureproof in 1927. *Saran*, discovered by Dow Chemical scientist Ralph Wiley in 1933 and first used as a spray-on protectant, provided the impervious protection that cellophane lacked.

There was rapid, almost simultaneous development of plastics in Europe and the United States during the first two decades of the twentieth century. Natural resins, rubber, ivory, horn, and tortoiseshell were too expensive or scarce for the increasing demand for both their uses as decorative objects and the burgeoning need for components of manufactured products. With the industrial development of machinery that made extrusion feasible, uses

for plastics rapidly increased. In both World War I and World War II, it became more difficult to import the natural resinous materials from the Pacific Rim countries and, at the same time, there was a high demand for lightweight and durable materials for war-related machinery. The plastics industry provided the necessary materials. After World War II, improvement in chemical technology allowed plastics to replace not just older plastic-type materials but also wood, paper, metal, glass, and leather. New plastics were developed that competed with old plastics. By the end of the 1940s, most of the plastics used today had been invented. By blending components it became possible to tailor the properties of a plastic to fit a specific function. Today, there are thousands of formulas for plastics.

The space program of the mid-twentieth century required the development of strong, lightweight plastic components, which are also essential to the automobile industry and the construction of modern electronics such as computers, televisions, and cell phones. Cheaper methods of producing plastics and an expanding array of potential commercial uses have resulted in the proliferation of plastics, which, if not an improvement over the natural materials they replace, are so inexpensive that it would be difficult to discontinue their use. For instance, the development of the blow mold method of making plastic bottles resulted in the ubiquitous plastic beverage bottle. Concern about the environmental impact of plastic is offset by the improved fuel efficiency of lighter-weight materials used in cars, for instance, or the extreme durability and low cost of most plastic products.

Designers often scorn plastics as cheap imitations of natural materials, but the 1960s and 1970s brought an appreciation for the aesthetics of materials made of plastic: the possibilities for pure, bright colors; hard, shiny surfaces; and the ability to create any form. Furniture designers were especially interested in plastic's aesthetic potential. Furniture designers such as Joe Columbo and Vico Magistretti exploited the sculptural qualities and color opportunities of plastic furniture with chairs and storage pieces made of colorful plastic. Kartell continues to produce plastic furniture by designers, including Philippe Starck. Other designers worked with versions of clear acrylic: Lucite, Perspex, and Plexiglas.

FIGURE 11.4 "Boby" Portable Storage Unit Designed by Joe Columbo for Kartell in 1969.

PRODUCTION: HOW PLASTICS ARE MADE

The raw materials from which plastics are made are carbon-based *monomers,* short molecules that are combined in repeating units to create large molecules or *polymers.* The carbon-based monomers are most commonly by-products of the oil and natural gas industry. Chemists synthesize various monomers in different combinations to achieve desired properties. The chemical mix may include additives such as plasticizers, dyes, and/or flame retardants. Stabilizers and antioxidants may be added to counteract the tendency of polymers to degrade under conditions of heat and light, slowing but not preventing this degradation.

Polymer resin is considered a raw material, but sometimes a resin can be shaped into a finished product, such as polystyrene, or used as a coating, such as epoxy. Polymer resin that will be used to fabricate plastic products is formed into pellets or granules, which can be made into a variety of objects and products by heating, shaping, and cooling. Thermoplastic materials are heat set so they retain their shape. Plastic products may be finished by printing and embossing, such as for vinyl wallcovering; or coating with a wear layer of plastic, such as for vinyl flooring; or impregnating with resin, such as for plastic laminate. However, most plastics have pigment added in the solution phase and the resulting products do not require additional finish.

The methods and forms most often used to shape plastic products used in buildings and interiors are discussed next.

Extrusions are used to make continuous elements such as moldings, sheets, or fibers. Plastic resin pellets or granules are fed through a hopper into a heated barrel or chamber. The pellets are melted into a **solution** and forced through the chamber by a rotating screw and exit through a *die* that creates the desired shape and size. For instance, plastics to be

made into fiber will be extruded through a device that has small holes, resembling a shower head, to create filaments. When the solution is forced through a thin, narrow opening, the result is a polymer ribbon that can be stretched into a thin film or sheet. The extruded plastics are cooled by air or water.

Injection molding is used for plastic parts that have complex shapes. Plastic granules, chips, or pellets are melted in a separate container, and then injected or forced under external pressure into the cavity of a hollow cooled mold that is split when the plastic solidifies.

Rotational molding is used for objects with heavy walls and/or complex shapes. Melted plastic disperses over the inner surface of a rotating mold. The mold rotates, evenly distributing the plastic solution along the walls of the mold.

Blow molding is used to make plastic bottles and other hollow products. Either an injection mold or extrusion is used to push melted plastic into a chilled bottle-shaped mold. Air blows the resin against the walls of the mold.

Spas, bathtubs, sinks, furniture, and light fixtures can be **thermoformed**. This method is good for simple shapes with large radii. Softened sheets of plastic are pressed against the contours of a steel mold. Another piece may be placed over the top. Vacuum forming may be used. When cool, the object retains its shape.

The **casting** process is used for small objects with simple shapes. Powder is heated to liquid solution form and molded with absence of pressure.

Cell casting is used to make uniformly thick, flat acrylic sheets or panels. A mold is made of two sheets of toughened glass connected and sealed with a rubber gasket. The liquid acrylic solution is poured between these two heated sheets of glass. Color can be added to the solution.

The **calendaring** process involves plastic granules that are heated and fed through a series of hot metal rollers until the desired thickness of the sheet of film is achieved. These rollers may *emboss* or press patterns onto the surface of the soft vinyl sheet.

Laminating refers to any process of fusing, under heat and pressure, layers of paper that have been impregnated with phenolic resins and melamine. There are two categories of plastic laminate, high-pressure and low-pressure laminate. *High-pressure laminates* are molded and cured with 1,200 to 2,000 pounds per square inch of pressure. The resulting product is 1/16 inch thick. High-pressure laminates are used for horizontal surfaces such as countertops and table tops. *Low-pressure laminates* are molded and cured at a maximum of 400 pounds per square inch of pressure. Low-pressure laminates are 1/32 inch thick and are used for vertical and low-wear applications.

Foamed plastic, or foaming or expanding, is a process of adding air bubbles within the polymer solution. The bubbles, or the holes left by the bubbles, remain. The result is a cellular structure. *Styrofoam* is an open-cell foamed product. Closed-cell foamed plastic is more solid and is rigid, but still lightweight. Expanded, closed-cell PVC, most often known by the trade name *Sintra,* is used to make signs. It is lightweight, resistant to moisture, and easy to shape.

TYPES OF PLASTICS

Because plastics are completely synthetic, they can be manufactured and modified to emphasize specific desired properties. The many variations of each type of plastic are intended to meet end-use requirements. Even within a chemically consistent type of plastic, additives can be used to produce products that appear very different. For example, PVC with plasticizers added can be made into a flexible sheet material. Without plasticizers, PVC can be made into rigid objects such as plumbing pipe. The most common types of plastics used in buildings and interiors are described next.

Polymethyl Methacrylate (Acrylic) and Polyacrylonitrile (Acrylic fiber)

There are two types of plastic products known as *acrylic*, each with slightly different chemical structure. *Polyacrylonitrile* is the basis for acrylic fiber, discussed in Chapter 12. *Polymethyl methacrylate* is a thermoplastic developed as a substitute for glass. In 1933, acrylic was marketed under the trade name *Plexiglas* by the Rohm and Haas Company. Acrylic has

also been marketed under the trade names *Lucite* and *Perspex*. These products are used by artists and designers to make everything from jewelry to furniture. Acrylic is engineered as an improvement to glass in the following ways:

- Acrylic is clear regardless of thickness, unlike glass, which tends to have a green tint.
- Acrylic is lighter in weight yet stronger than glass.
- Acrylic is a better insulator than glass.
- Acrylic is impact and shatter resistant. When it breaks, the result is large pieces without sharp edges.
- Acrylic will not turn yellow when exposed to ultraviolet light.
- Acrylic does not become brittle or fracture with age.
- Acrylic can be joined with solvents that dissolve the material and fuse the components, resulting in an invisible weld.
- Clear sheets of acrylic can be colored with dyes.
- Although hard and durable, acrylic is softer than glass, so it is susceptible to scratching. Unlike scratched glass, scratches can be buffed out of acrylic.

Because acrylic is not affected by ultraviolet light, it is used for illuminated signs and light fixture lenses. It is also used for skylights, safety glazing, and interior partitions. Acrylic can be cast into sheet material, then easily formed, bent, cut with a saw, or engraved. Acrylic is also the basis for some types of solid surfacing used for countertops. When combined with glass reinforced polyester, acrylic is used as bathtub surrounds and shower stall enclosures.

Melamine

Melamine is a thermosetting plastic combining cyanamide with formaldehyde. The invention of melamine in the 1930s was related to the development of products made from phenol formaldehyde and urea formaldehyde. Melamine formaldehyde was developed for its fire-resistant properties. Because it is clear, colors of melamine products are not limited. Because of its strength and fire resistance, melamine is used as the top or wear layer of plastic laminate. Melamine-saturated decorative paper, laminated to a substrate, is used to construct inexpensive furniture and cabinets or interiors of cabinets. Melamine is also used to make white boards and as an admixture in concrete. Foamed melamine is used for insulation. Other facts regarding melamine are:

- Melamine is hard and glossy.
- Melamine resists staining.
- Melamine is not easily scratched.
- Melamine can withstand higher temperatures than most plastics.
- Melamine does not yellow with age.
- If swallowed, inhaled, or absorbed through the skin, melamine can cause reproductive damage, bladder or kidney stones, or bladder cancer.
- Because melamine is a thermosetting plastic, it cannot be recycled.
- Melamine formaldehyde has a better chemical bond with formaldehyde than urea formaldehyde or phenol formaldehyde, so it is less likely to emit toxins.

Polyamide (Nylon)

In 1938, Wallace Hume Carruthers, working for DuPont, developed *polyamide*, which became the first truly synthetic fiber, known by the tradename *nylon*. DuPont marketed nylon for toothbrush bristles and to replace silk in stockings. However, in World War II, all available nylon was required for parachutes. After the war, nylon was successfully marketed for women's stockings and is now widely used as a fiber for textiles and carpet.

There are two types of nylon. *Nylon 6,6* is a condensation of *adipic acid* and *diaminohexan* monomers and has performance advantages when made into fiber for carpet. *Nylon 6*

is made from *caprolactum* and is more easily recycled. Nylon 6 is more often cast or molded and used for interior products such as hardware, chair casters, and drawer glides. The strength of nylon makes it an *engineering plastic*, suitable as a substitute for metal. Nylon has the following characteristics:

- Nylon combines elasticity with high tensile strength.
- Nylon has a high melting point and is heat resistant.
- Nylon is tough and stiff.
- Nylon has high chemical resistance.
- Nylon is abrasion resistant.
- Nylon has good resistance to ultraviolet light.

Aromatic Polyamide (Arimid)

Arimid is related to nylon. Arimid was developed for its high strength and is also known by the tradename *Kevlar*. Kevlar was developed and patented in 1966 by DuPont scientist Stephanie Kwolek. Kevlar is fire resistant and bullet resistant. It is most commonly made into bullet-resistant fabric, but is also available in panels for installation in walls that require flame resistance and/or bullet resistance.

Polycarbonate (Lexan)

In 1953, *polycarbonate* was developed almost simultaneously by Dr. Daniel Fox, working for General Electric in the United States, and Dr. Hermann Schnell, working for Bayer in Germany. Dr. Fox was searching for a coating for wire, and his discovery of this exceptionally strong product led to the development of *Lexan*. This polycarbonate resin is a thermoplastic that combines bisphenol A and carbonyl dichloride. It is produced in sheet form and as a resin to be molded into a number of lightweight, extremely durable products, including sports helmets, computer and cell phone components, and compact discs. Lexan is used by NASA for space helmets and in buildings for bullet resistance and extremely durable domes and glazing.

Polyethylene Terephthalate (Polyester)

Wallace Caruthers at DuPont was working on the development of the polymer that became known as *polyester* before he turned his focus to nylon. Building on Caruthers' work, English scientists John Rex Whinfield and James Tennant Dickson of Imperial Chemical Industries in Britain developed the first polyethylene terephthalate (PET) polyester in 1941. Used initially for fabrics, the earliest polyester in the United States was DuPont's Dacron. Polyester is used for fibers, resins, and plastics. It can also be used as a plasticizer. Some solid surface countertop material is made from polyester. Polyester has become the primary material for plastic bottles. Plastic bottles made of PET polyester can be recycled, which has resulted in the production of polyester fabrics and carpet fibers made from recycled bottles. Polyester as a fiber is often mixed with other materials. Polyester resin combines with glass fibers to make fiberglass. Alkyd paints are oil modified polyesters.

Polyvinyl Chloride (Vinyl)

In the 1920s, Waldo Semon, a chemist for B. F. Goodrich, was researching synthetic adhesives when he first produced *polyvinyl chloride* (PVC), a combination of *chloride* (salt) and *ethylene* (from natural gas). Semon used the product for shoe heels and golf balls, but by the 1930s, factories had begun using PVC for gaskets and tubing, raincoats, and shower curtains. During World War II, vinyl coating replaced rubber to insulate electrical wiring. Today, PVC is the third most widely produced plastic after polyethylene and polypropylene. Polyvinyl chloride is the plastic that is most used in building and construction, with half of all PVC used for plumbing pipes.

Polyvinyl chloride is a versatile plastic, and as a staple of the construction industry, it is used for everything from siding and roofing on an exterior to flooring material and

wallcovering on an interior. With additives that include plasticizers (usually phthalates), or stabilizers (usually metals such as tin or cadmium), or fillers or lubricants (usually stearates), PVC can be engineered for a variety of end-uses. With the addition of stabilizers that prevent decomposing, PVC can be manufactured to be rigid, such as for plumbing pipes. With the addition of plasticizers, PVC can be flexible and resilient, such as for vinyl wall-covering. It is the addition of phthalates as plasticizers that is the source of most of the environmental concerns with polyvinyl chloride. When PVC was first used by B. F. Goodrich for tires, workers in the factory showed a high incidence of *angiosarcoma*, a type of cancer. This resulted in a change in production methods to a highly regulated closed-loop system that has eliminated the exposure that may have caused the cancer. The following characteristics are found in PVC:

- PVC resists corrosion, light, and chemicals.
- PVC is strong, tough, and durable.
- PVC is resistant to denting.
- PVC is flame resistant.
- PVC is relatively inexpensive because salt is a major component, and it contains less petroleum than other plastics.
- With the addition of plasticizers, PVC is workable, flexible, and resilient.
- PVC is heat sensitive, so stabilizers must be added.

Polystyrene (Styrofoam)

Polystyrene is a hard, impact-resistant thermoplastic. Styrofoam is open-cell polystyrene, made by blowing air into the solution, a process referred to as *foaming*. Styrofoam, used for insulation and carpet backing as well as for hot drink cups, was developed in 1938. Polystyrene was initially hard and brittle. High-impact styrene, developed in the 1950s, had minute particles of rubber (polybutadiene) in the polymer, which made it less clear but not as brittle. High-impact polystyrene is inexpensive and is used for household products and furniture as well as inexpensive trim and moldings. Characteristics include the following:

- Polystyrene is hard and brittle.
- Polystyrene is transparent and takes color well.
- Polystyrene is a good insulator.
- Polystyrene softens in boiling water.
- Polystyrene is flammable.

Polyolefins (Polyethylene, Polypropylene, and Polybutylene)

Although they are different types of thermoplastics, the monomers in *polyethylene* (ethylene), *polypropylene* (propylene), and *polybutylene* (butylene) are all *olefins*. Polyethylene (PE) is the world's most widely used plastic, and it can be manufactured in many variations depending on the density of the polymer and the branching of the molecules. The most common use of polyethylene is plastic bags, although a foamed version is used for upholstery. Polypropylene (PP) is the second most common plastic. In building construction, polypropylene is used as the wear layer in single-ply roofing and in plumbing pipes. It is also used as a component of furniture, such as seats and backs of stacking chairs. Polypropylene fibers are used for residential carpets and rugs, carpet backing, and other carpet fibers. Polybutylene was used for plumbing pipes until it was discovered in the late 1990s that chlorinated water caused them to leak and fail.

Polyurethane

In 1937, Otto Bayer of I. G. Farben in Germany began working with *polyurethane,* initially for fibers and flexible foam. Polyurethane foam is created by blowing agents in the chemical mixture. Rigid polyurethane foam is used for building insulation. More flexible polyurethane

foam is used for foam seating, upholstery padding, and carpet underlayment. Polyurethane fabrics are *elastomeric*, meaning they can be stretched over and over and still return to their original shape; they include the trade names *Spandex* and *Lycra*. Polyurethane resins are used for adhesives, paints, and clear coatings. Hard plastic versions of polyurethane are used to encase electronic equipment. Polyurethane has the following characteristics:

- Polyurethane is combustible; it will ignite if exposed to open flame.
- Polyurethane will discolor over time if exposed to light or ultraviolet radiation.
- Polyurethane foams can be flexible or rigid.
- Polyurethane can be hard or liquid.
- Polyurethane is a thermosetting plastic.

Acetate

Developed in the early 1900s as a cellulosic product, and used for such varied items as hairbrushes and film, *acetate* is combined with other polymers to make fabrics (cellulose acetate) and plumbing pipes (polyvinyl chloride acetate).

Silicone (Neoprene)

Silicone is made from sand or silicon dioxide, and is not carbon based. It is used for gaskets, joint sealants, and elastomeric membrane roofing. Silicone is also used as a water-repellent coating for fabrics. Silicone resists weather, temperature variations, and ultraviolet radiation.

Acrylonitrile-Butadiene-Styrene (ABS)

This plastic, ABS, is a thermoplastic *copolymer*, made by combining the polymers *acrylonitrile*, *butadiene,* and *styrene*. Although more expensive than pure styrene, ABS has strength, impact resistance, and toughness. In building construction, ABS is used for plumbing pipes. In interiors, *acrylonitrile-butadiene-styrene* is used for furniture edging and other components of furniture.

Polyepoxide (Epoxy)

Epoxy is a thermosetting copolymer consisting of an epoxide resin and polyamine hardener. Polymerization occurs by curing. The first experimentation with epoxy resin was in the United States in 1927. In 1936, in the United States, Dr. Pierre Castan and Dr. S. O. Greenlee developed bisphenol A–based epoxy. Epoxy is used in coatings, adhesives, and grouts. It also serves as a base or matrix for composite materials such as fiberglass, resinous poured flooring, and epoxy terrazzo. Epoxy fumes can cause allergic reactions. The presence of bisphenol A in epoxy is also a health concern.

Furan

Furan is a black plastic resin that is used as a grout or stain when strong bonds and chemical and corrosion resistance are needed. Furan is toxic and requires careful handling. It is used in chemical laboratories and industrial locations.

Application: Using Information Regarding Interior Finish Materials

CODE ISSUES

When specifying plastic products to be used on an interior, the designer must first be aware of the typical reaction of different types of plastics when exposed to fire. Thermosetting plastics will usually decompose rather than burn, but they emit toxic gasses when doing so. Thermoplastics generally melt. Individual types of plastics vary in their level of flammability.

Case STUDY *of Plastic Used in an Interior*

Azrock Textile Vinyl Composition Tile by Johnsonite, a Tarkett company, is a vinyl composition tile with nonpolluting limestone used as filler. All the leftovers from production are recycled to make more vinyl composition tile (VCT)—an example of closed-loop recycling. The material is packaged in recyclable cardboard on reusable and biodegradable wooden pallets. The VCT also has a low up-front cost. Azrock Textile pattern VCT has random patterning that gives the look of striated yarns running directionally. No two pieces of tile are alike.

FIGURE 11.5 Textile Vinyl Composition Tile (VCT) Designed as a Pattern in a Waiting Area by Johnsonite, a Tarkett Company.

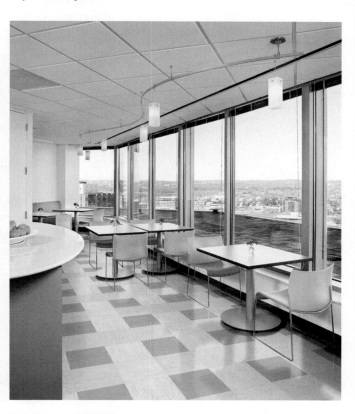

FIGURE 11.6 Textile Vinyl Composition Designed as a Pattern in a Hospital Cafeteria by Johnsonite, a Tarkett Company.

Some plastics burn easily and others resist fire. Plastic products along with other finishes and furnishings in a space may not cause a fire, but can contribute to the spread of fire. However, at least one manufacturer, Koroseal, has developed a vinyl wallcovering that emits an odorless, colorless vapor when the material reaches 300 degrees. This sets off a smoke alarm before a fire starts.

Most interior products made of plastic are used as finish materials applied to a substrate. Exceptions include plastic panels used as divider walls or as window glazing; plastic insulation used within the structure of a wall; and plastics used in the construction of furniture, such as foam padding. Plastic products used as finishes may be applied to walls, floors, and ceilings, as well as used as trim. These products are subjected to appropriate tests for the specified use and rated according to their test performance. For instance, wallcoverings and ceiling finishes are rated Class A, B, or C based on their flame spread and smoke-development scores when tested using the **Steiner Tunnel Test**. Flooring products are rated as Class I or II based on their *critical radiant flux* test score on the **Radiant Panel Test**. Plastic products used to construct furniture or as the components of upholstered pieces are tested as assemblies to meet standards such as California Technical Bulletin 133, which requires testing the finished item.

When selecting and specifying plastic products as finish materials, the designer must be familiar with the following code requirements:

- Building codes address plastics in categories: foamed or cellular, coatings, light-transmitting or light-diffusing panels, plastic veneers, and plastic signage.

- Vinyl wallcovering is thicker than 0.036 inch thick, so it must be treated as a finish that meets code requirements, whereas paint and wallpaper adhered to flame-resistant substrate are not considered potential contributors to fire, so they do not have to meet flame-spread criteria.

- The required rating of the finish applied to the wall or floor depends on the occupancy type and where the product is used in the building. The three location categories are (1) exits, (2) exit access corridors, and (3) other spaces. Depending on the occupancy type, there may be further restrictions.

- Cellular or foamed plastic materials applied as trim cannot constitute more than 10 percent of the area of the wall or ceiling and must meet UL1975, a standard that tests the flame resistance of foamed plastics used for decorative purposes.

- Any trim that constitutes less than 10 percent of the area may have a lower rating, such as Class C Combustible, than the rating required for the wall finish.

- Insulation within the wall must meet the fire-resistance ratings requirements of the assembly of components that make up the wall. Generally, foamed plastics must be separated from the interior of the building with a thermal barrier of ½-inch gypsum board or 1-inch thick masonry or concrete.

- Exposed insulation used as an acoustic panel on the wall or ceiling must have a Class A flame-spread rating based on the Steiner Tunnel Test.

Light-transmitting plastic panels used as ceiling diffusers or in light fixtures—as well as light-transmitting panels used for glazing, skylights, and walls—must meet flame-spread and smoke-development ratings. Panels used for glazing are subject to limitations in size of individual panels, the location in the building, and the number of openings. The class/rating of the material can make a difference.

Vinyl and other floorcoverings made of plastic must also comply with Americans with Disabilities Act Guidelines. They must be stable, firm, and slip resistant. This is especially important at ramps and steps. Highly polished surfaces should be avoided. Studded rubber flooring is often used as a detectable warning, applied at potentially hazardous areas, such as the top of exposed stairways or escalators.

SPECIFYING

The following CSI Masterformat divisions have sections that assist in specifying plastic products:

Division 06: Wood, Plastics and Composites

Plastic laminate-faced architectural cabinets, plastic laminate-faced paneling, and plastic paneling

Division 08: Doors and Windows

Vinyl windows, fiberglass windows, and glazing

Division 09: Finishes

Resilient base and accessories, resilient sheet flooring, and resilient tile flooring

Resinous matrix terrazzo flooring

Vinyl wallcovering

Division 10: Specialties

Signage, including directories, dimensional letter signage, and panel signage

Toilet compartments, shower and dressing compartments

Wall and door protection

Division 11: Equipment

Unit kitchens made of plastic laminate

Division 12: Furnishings

Horizontal and vertical louver blinds and roller shades

Plastic laminate countertops

Simulated stone countertops

Fixed audience seating

Lessening the Environmental Impact of Plastic

Indoor air quality issues that arise from the use of plastics primarily revolve around the use of adhesives made from plastic resins and plasticizers used in vinyl products. Manufacturers of plastic products can apply for certification by **Greenguard**, which certifies indoor air quality; **Greenseal**, which focuses on life cycle assessment; or **Scientific Certification Systems**, an umbrella agency that oversees several certifications, including **Floorscore** certification for resilient flooring and adhesives. According to the *HOK Guidebook to Sustainable Design,* designers can minimize the problems when selecting and specifying plastic products for an interior by following these suggestions:

- Choose substrates such as plywood and particle board or engineered wood products that are constructed with formaldehyde-free adhesives.
- Specify water-based adhesives when possible.
- Specify installation methods that require less adhesive, such as carpet tiles rather than roll goods, since less adhesive is used when only a framework of tiles is adhered.
- Select vinyl tile products rather than sheet vinyl because tiles have fewer plasticizers.
- Allow gasses to dissipate before a building is occupied. One suggestion is to unroll sheet goods in a separate location for a few days before installing, which will allow gasses to dissipate.

In addition, design decisions that minimize the environmental impact of plastics include the following:

- Specify floor tiles rather than sheet goods. This allows replacement of individual tiles in worn areas without replacing the entire installation.
- Specify plastic products that have recycled content. Manufacturers are now offering products within their range that have high percentages of recycled content. For example, DuPont now makes *Corian Terra,* a solid surface material with 40 percent recycled content.
- Specify plastic products that are made from renewable carbon sources. For example, *Biostride,* a polymer made from corn, is used by Armstrong for some resilient flooring.
- Specify products that meet indoor air quality standards set by Greenguard and Floorscore.
- Specify products that do not have bisphenol A in their content. *Acrovyn,* a maker of vinyl wall protectors, uses a non-PVC vinyl with no PBTs, including no bisphenol A. Some Acrovyn products are also completely recyclable.

Plastics Used in an Interior

Floors
Vinyl composition tile
Solid vinyl tile
Luxury vinyl tile
Sheet vinyl
Synthetic rubber flooring
Poured epoxy flooring
Plastic laminate

Walls and Dividers
Vinyl wallcovering
Plastic laminate panels
Solid surface wall panels
Translucent dividers of various plastics
Fiber-reinforced plastic (FRP) wall panels

Ceilings
Vinyl-coated ceiling panels
Plastic ceiling tiles

Kitchen and Bath
Countertops and backsplashes: plastic laminate, solid surface products
Sinks and lavatories
Bathtubs and shower surrounds

Accessories and Trim
Resilient wall base
Resilient carpet edging
Stair treads and nosings
Protective trims: handrails, crash rails, corner guards
Kitchen and bath accessories

Signage
Plastic laminate
Solid surface
Acrylic for internally illuminated signs
Closed-cell polyvinyl chloride, "Sintra"

Hardware
Nylon builders' hardware
Cabinet hardware

Light Fixtures
Housings and grilles

Furniture
Acrylic (Plexiglas, Lucite, Perspex)
Fiberglass
Plastic laminate
Polypropylene

Window Treatments
Vinyl shades
Vinyl blinds

Coatings
Paints and clear finishes
Water protectants (silicone)
Stain protectants (Tedlar, Teflon)
Flame-retardant treatments

Adhesives
Epoxy resins
Polyvinyl acetate adhesives

Grouts
Epoxy

Alternate Uses of Plastics
Fiberglass (polyester resin as matrix for glass fibers)
Epoxy terrazzo (epoxy as matrix for plastic or marble chips)

LIFE CYCLE COSTS

Plastic products are, as a group, less expensive and more durable than similar products made of natural materials. However, the designer should be aware that not all plastics are inexpensive. Many plastic products cost as much or more than natural products, such as nylon hardware or acrylic-based solid surface countertops. A designer can often choose between several types of plastics to construct the same product. The cost may vary according to the emphasis of the manufacturer on design and aesthetics or the cost of the plastic material. Solid vinyl tile is more expensive than vinyl composition tile; nylon is more expensive than hardware made of other plastics; and acrylic-based solid surface countertops are as expensive as granite or marble. Cheap products made of plastic abound, and their use must be considered carefully. As with all products, expected life cycle, maintenance requirements, and durability must be considered along with cost. The long-term aesthetic durability of plastic products must be considered as well.

APPLYING PLASTICS IN AN INTERIOR

FLOORS

Resilient Flooring

Resilient flooring refers to a category of flooring that combines the durability of a hard flooring surface with the ability to recover from indentions caused by foot traffic or compression. This resilience adds to comfort underfoot. Vinyl flooring products were designed to replace nineteenth- and early twentieth-century products made of natural materials such as cork, linoleum, and rubber. Synthetic resilient flooring is engineered to be durable and to allow a wide range of colors, patterns, and textures.

Vinyl resilient flooring includes synthetic rubber floor tiles, solid vinyl floor tiles, sheet vinyl, and vinyl composition tile. Most of these products are made from polyvinyl chloride (PVC) or a combination of PVC and natural materials. The flexibility of resilient flooring is a result of using phthalates as plasticizers, which can leach into soil in landfills. Burning PVC products can release dioxin, which may cause cancer. When initially installed, PVC flooring releases chemical gasses into the air. The same materials used to make resilient flooring are used to make related products such as stair treads and nosings, resilient base, and accessories such as carpet edge strips.

Types of Resilient Flooring

Rubber is a natural product, but it has been modified with the addition of plasticizers to the extent that rubber is almost completely synthetic. Rubber flooring is usually manufactured in tile form, but it also comes in rolls or sheets. Rubber is more expensive than vinyl flooring and is used for installations that require exceptional resilience, such as gymnasium floors, exercise facilities, and dance floors. A style of rubber flooring, first popular under the tradename Pirelli, is *studded rubber*. The raised discs or other shapes add to the slip resistance and industrial aesthetic. Rubber flooring with raised discs may also be used as a

FIGURE 11.7 Studded Rubber Flooring. Claudio Divizia/ Shutterstock

FIGURE 11.8 Vinyl Composition Tile. Photograph courtesy Mannington Commercial

detectable warning surface for people with sight impairment, when located in front of open stairs, escalators, and doorways to hazardous areas. This style of rubber flooring is now manufactured in numerous color variations and variations of raised discs. Other rubber flooring has embossed texture as well as color and pattern within the tile.

Vinyl composition tile, also known as VCT, is composed of vinyl mixed with limestone and color pigments. Vinyl asbestos tile (VAT) was the precursor to VCT. It was introduced at the Chicago "Century of Progress" Exposition in 1933, but was not marketed until after WWII due to wartime material shortages. As the name implies, asbestos, which can cause lung cancer if it breaks into **friable** (easily crumbled) pieces, was included in the composition. Asbestos was eliminated from the product in the early 1980s, but some older installations still may contain asbestos. Mastic used to adhere VAT or VCT to a substrate may also contain asbestos; thus, removal should be done by experts. Vinyl composition tile is made by forming solid sheets of colored vinyl chips mixed with fillers, then cutting the sheets into 12-inch by 12-inch squares. The most common thickness for commercial use is ⅛ inch. Manufacturers are including more recycled content into their vinyl composition. Today, VCT is the least expensive and most brittle of the resilient flooring products. However, it is easy to install and maintain and is available in a wide variety of colors. The standard 12 x 12 tiles are easy to cut and lend themselves to nearly unlimited design and pattern variations.

Solid vinyl tile includes a higher percentage of vinyl than VCT and is more expensive. It may be high or low gloss. Residential vinyl flooring is referred to as *luxury vinyl tile* and is often designed to imitate wood, stone, or ceramic. It may have an embossed surface. Solid vinyl tile for commercial use depends less on imitation for its aesthetic appeal. It often has an appearance more similar to VCT with marbleized or color chip patterns, but with a more translucent and satin appearance.

The availability and marketing of **sheet vinyl** as "no-wax floor" for residential use in the 1960s and 1970s resulted in the near eradication of cork and linoleum. Residential sheet vinyl is constructed in layers. Typically, the bottom or backing layer is fiberglass, topped by a foamed cushion interlayer topped by the vinyl layer and one or more clear wear layers, usually of urethane. The vinyl layer is printed and dyed,

FIGURE 11.9 Solid Vinyl Tile. Karam Miri/ Shutterstock

FIGURE 11.10 Residential Sheet Vinyl Flooring. Tom Gowanlock/Shutterstock

and sometimes embossed, using a rolling cylinder. Sheet vinyl is available in 6-foot and 12-foot widths. Commercial-grade sheet vinyl flooring is used in hospitals where the elimination of tile joints and the use of heat-bonded seams ensure cleanliness. The urethane wear layer may have aluminum oxide added, and anti-microbial treatments are added to the product when intended for use in health-care applications.

Installing Resilient Flooring

Resilient flooring is relatively thin and most of it is very flexible. Thus, the surface to which it is applied, the *substrate,* must be as smooth as possible. A Portland Cement–based leveling compound can be used on concrete to ensure a smooth surface. Wood floors must be sanded, with nails countersunk, loose boards nailed down, and holes filled. Although vinyl tile and VCT perform better when used below grade than natural flooring products such as linoleum, if the flooring is to be installed below grade, the space must be tested for moisture following the manufacturer's instructions. A concrete slab on or below grade should be poured with a vapor barrier below it. Specify appropriate adhesives, using water-based adhesives if possible.

Vinyl tiles are easy to handle and can be installed by a nonprofessional. Tiles are installed using a chalk lines to mark the center of the room and working out from the center to the edges. It is recommended that the floor be laid out and all the perimeter pieces cut before applying adhesive. The tiles are pressed into the adhesive with a 100-pound weight roller.

Sheet vinyl flooring is more difficult to cut and install properly, so professional installation is recommended. Sheet flooring must be rolled out in the space and allowed to relax before installing. Sheet flooring is laid out in the space working from the center of the room outwards. The seams are dry cut before adhesive is applied. Half the flooring is rolled back and adhesive is applied. Rolling with a weight is also used for sheet vinyl. The second half of the floor is adhered and seams are rolled if necessary. Heat-welded seams in sheet vinyl eliminate the potential for dirt to collect in seams, and result in a visually seamless installation. The seams are cut with a gap that is grooved, and then filled with a round solid-color rod of the same material as the flooring. A heat gun melts the rod and fuses the flooring.

Maintaining Resilient Flooring

Vinyl flooring is easily maintained using a damp mop and cleaners recommended by the manufacturer. Generally, VCT is waxed and buffed using special materials and equipment. It can be repeatedly stripped and refinished, and individual tiles can be replaced if damaged.

Hard Flooring
Plastic Laminate Flooring

Plastic laminate, initially a countertop and vertical surfacing material, has also been developed as a flooring material; it can imitate wood and other materials. *Plastic laminate flooring* has four layers: a backing layer, a core of a composite wood product that often has melamine particles added for moisture protection, a photographic paper layer, and a wear layer of melamine and aluminum oxide resin. The layers are all cured under heat and high pressure. Plastic laminate flooring is constructed in a sheet and then cut into individual planks. It is durable and relatively inexpensive, but can de-laminate if exposed to water.

FIGURE 11.11 Construction of Plastic Laminate Flooring.

Wear Layer

Pattern Layer

Substrate Layer

Backing Layer

Installing Laminate Flooring

Plastic laminate flooring sheets are cut into planks with tongue and groove edges that are snapped together and installed as a *floating floor*. As with other flooring products, the substrate must be clean and dry. Concrete must be fully cured. The floor planks must be unpacked and allowed to become acclimated to the space for 48 hours. A vapor barrier is placed on the floor before installation. A ½-inch spacer is used to maintain a gap between the flooring and the wall, allowing for expansion and contraction. This gap will be covered with base trim. The planks are attached to each other by matching tongue to groove and tapping the planks together.

Maintaining Laminate Flooring

Plastic laminate flooring can be maintained by vacuuming with a soft brush attachment. A light spray of cleaner and wiping using a microfiber rag is recommended for removing dirt. Plastic laminate floors should not be cleaned with water, as de-lamination is possible. Unlike wood flooring, plastic laminate flooring cannot be partially replaced if one area is damaged.

Poured Epoxy Flooring/Epoxy Terrazzo

Poured epoxy flooring is used in high-traffic areas, industrial applications that require chemical resistance, and utilitarian areas where extreme durability and cleanliness are desired. Poured epoxy flooring is also waterproof. The same material or variations of the material can be applied on walls for a continuous seamless environment. The epoxy solution can be modified to provide electrostatic discharge and can be made with water-based urethanes to comply with situations that require low emission of volatile organic compounds. A more decorative version of poured epoxy flooring is *epoxy terrazzo*, using epoxy instead of a cementitious product as a matrix with an aggregate of granite, marble, glass, or synthetic resin is added. Epoxy resin is thinner (¼ to ⅜ inch thick) than cementitious terrazzo.

Installing and Maintaining Poured Epoxy Flooring

When installing industrial-type poured epoxy flooring, a liquid epoxy matrix is poured or hand troweled onto the substrate. Synthetic aggregates are broadcast into the matrix while the flooring is still liquid. The flooring has no seams and can be poured with an integral base. For epoxy terrazzo, a two-part epoxy resin and hardener is poured or troweled over a flexible membrane or primer. The aggregate is added to the mix and, after curing, the floor is ground to expose the aggregate and then sealed. Maintenance consists of sweeping, mopping, buffing, and occasionally resealing. Epoxy terrazzo does not wear out.

WALLS

Vinyl Wallcovering

Vinyl wallcovering is made from polyvinyl chloride. The PVC resin gives vinyl wallcovering its durability, abrasion resistance, cleanability, and strength. Plasticizers are added to improve the pliability of the end-product and long-term resistance to cracking. Plasticizers also make processing easier. Vinyl wallcovering is used for its abrasion resistance, especially on outside corners, and its impact resistance, cleanability, and stain resistance; and for the depth and variety of colors and patterns available. Tensile or tear strength is important as well. Vinyl wallcoverings can have additives, referred to as **biocides and fungicides**, which aid in resistance to mold, mildew, and fungus. Wallcoverings with these additives are an advantage when specifying vinyl wallcoverings for hospitals. Other additives include pigments, stabilizers, and stain retardants. Related products that have similar properties include drapery lining, shower curtains, and vinyl fabric.

Residential wallcovering is usually made of paper, but it may have a vinyl or acrylic coating for added durability. One type of vinyl-coated wallcovering is known as **expanded vinyl**. Liquid vinyl is applied to a paper backing and then heated. The heated vinyl creates areas of raised texture on the surface.

FIGURE 11.12 Vinyl Wallcovering.

Making Vinyl Wallcovering

A PVC-based compound is heated and forced through a series of hot metal rollers that flatten the compound into a sheet of vinyl film. Several passes through the rollers are needed to obtain the desired uniform thickness. On the last pass, a fabric backing is bonded to the film under heat and pressure. At this point the sheet of vinyl wallcovering is white. It is then printed with one or more colors of ink. Better-quality products are printed by forcing the ink throughout the material rather than just applying it to the surface. Surface texture is achieved at the same time as printing, using embossing rollers. To finish the product, a topcoat is added, either clear vinyl or *Tedlar,* a proprietary product made by DuPont that provides a protective, stain-resistant coating.

Specifying Vinyl Wallcovering

The designer must select and specify wallcovering based on the level of use. Commercial-grade vinyl wallcovering is classified as Type I, Type II, or Type III. The type of backing has the most impact on the durability of the wallcovering and contributes to the overall weight of the product. Type I, 10.5 to 19 ounces per lineal yard, can be used in nonpublic areas that get light use. Type I wallcoverings generally have a scrim or a nonwoven backing of cellulose and synthetic material, and the typical weight for Type I wallcoverings is 15 ounces per lineal yard. Type II wallcoverings are common for most commercial uses, especially public corridors, lobbies, and spaces that get 24-hour use. Type II vinyl wallcoverings weigh 19.5 to 32 ounces per lineal yard, but most Type II wallcovering is 20 ounces per lineal yard. Backings for Type II wallcovering include a woven backing called *Osnaburg,* or a nonwoven backing. Less common, Type III vinyl wallcovering is for the heaviest use, weighing 33 ounces per lineal yard, with drill fabric backing. Commercial vinyl wallcoverings are usually 54" wide. Commercial vinyl wallcovering is also labeled according to its flame-spread rating, either class A, B, or C, based on the Steiner Tunnel Test.

Installing Vinyl Wallcovering

Because of the width of commercial vinyl wallcovering, it should be installed by a professional installer with an assistant. Walls to which the vinyl will be applied must be clean and dry with no mold, mildew, grease, or stains. Walls should be primed with the manufacturer's recommended primer that includes a mildew inhibitor. The manufacturer's recommended paste is either applied to the back of each sheet of wallcovering with time allowed for soaking in, or if the wallcovering is **dry hung**, the adhesive is applied to the wall. Wallcovering should be installed as it comes off the roll, and pattern matched if necessary. The wallcovering can be **butt-joined**, having no overlapping seams, or the seams can be overlapped and trimmed after installation. Seams must be cleaned of adhesive residue with clean water. When stretched, vinyl wallcovering tends to recover to its original size, so care must be taken in installation to accommodate that tendency.

Maintaining Vinyl Wallcovering

Vinyl wallcoverings are chosen for commercial use because they are durable and easy to maintain. Generally, they can be cleaned with mild soap and warm water, using a bristle brush as necessary to remove soil from the textured surface. Thorough rinsing is necessary to remove residual cleaner that can darken over time. Abrasive cleaners are not recommended because they can damage the surface coating. Ink, paint, or crayon can be removed with rubbing alcohol. With the addition of stain-resistant coatings, vinyl wallcoverings resist ink and soil, and can be scrubbed and/or cleaned with a mild bleach solution.

WALL PANELS

Panels intended to divide space while allowing transmission of light are made from a variety of plastics. Plastic can replace glass in interior partitions and doors and serve as interior

partitions. Some types of **plastic wall panels** are chosen when there is a special need for fire resistance, resistance to vandalism and other damage, or bullet resistance. Wall panels from plastic materials may be used in installations requiring hygienic control and cleanability. Panels may be decorative, with honeycomb structure or with integral color and pattern. Some panels are a sandwich of two layers of clear plastic material with an inner layer of fabric or other material. Other panels have decorative materials embedded in resin.

Decorative Panels

Decorative wall panels made by different manufacturers each have unique characteristics and composition:

- *Knoll's Imago* is made of a type of modified polyester, polyethylene terephthalate glycol (PETG), containing 40 percent post-industrial recycled material. PETG is made from PET soft-drink bottles. Imago is marketed as "frozen fabric" because its aesthetic qualities are derived from the interlayer of fabric chosen by the designer, sandwiched between two sheets of the polyester material.

- *Design Tex* markets a product called *Fusion*, made of co-polyester resin including 40 percent recycled HDPE bottles. The plastic is recyclable, has a Class B flame-spread rating, and can be ordered with a UV inhibitor that allows panels to be used on the exterior of a building. The panels range from $\frac{1}{16}$ inch to 1 inch thick. The aesthetic appeal of this product is derived from embedded materials, objects, or images. The resin can be textured and colored, resulting in a range of custom design possibilities. The product is marketed for its strength, flexibility, and durability as well as aesthetics.

- *3Form* produces a variety of translucent resin panels and products made from different plastics, including *Eco-Resin*, a translucent high-density polyethylene made with 40 percent recycled resins; *100 Percent*, an architectural resin panel made totally from recycled milk bottles; and an exterior grade polycarbonate with 40 percent recycled content. A large variety of patterns, textures, and colors allows the designer creative freedom.

- *Panelite* makes a honeycomb panel with fiberglass and cast resin facings. The designer can choose from many colors and sizes of the honeycomb core. The panels must be framed with C-channels when installed. They are sized to use in ceiling suspension systems as well as wall and door panels.

Functional Panels

Fiberglass reinforced plastic is referred to as *FRP board* and is used for environments that require sanitary conditions, such as commercial kitchens, restrooms, and hospital rooms. This plastic is moistureproof and impact resistant, and can be textured, usually with a pebbled surface, or smooth. Also, FRP board can be attached to a wall with adhesive or mechanical fasteners. Seams are covered with PVC moldings.

 Kevlar provides bullet resistance and can be a hidden layer in wall. **Lexan** panels are used for resistance to damage caused by vandalism.

CEILINGS

Vinyl-coated ceiling panels are used in areas that require moisture resistance and cleanability. Some decorative plastic panels come in sizes to fit in a standard ceiling grid. Ceiling tiles that mimic plaster moldings, tin ceilings, and other types of ceiling tiles can be purchased cheaply to install in a standard ceiling grid system. Some of these tiles are intended for residential use and are designed to be painted by the do-it-yourself homeowner.

FIGURE 11.13 Fusion Wall Panels by DesignTex. Photograph courtesy of DesignTex

COUNTERTOPS

Solid Surface

Solid surface is a term that refers to the products of several manufacturers, each of which has a different chemical composition. Solid surface products have been developed primarily to use as countertops, but also have been used as signage and wall panels, and for tub and shower surrounds.

Solid surfaces are designed to substitute for natural surfacing materials such as granite and marble, but with improved performance characteristics. Solid surfaces are generally composed of a bauxite product, *alumina trihydrate,* and a polymer (either acrylic or polyester or a combination). Additives or fillers may include marble dust, quartz, or glass fiber. Pigments are added to the solution. The finish of solid surface materials ranges from matt to high gloss. Synthetic solid surfaces share the following characteristics:

- Most solid surfaces are homogenous, meaning color is consistent all the way through the surface. Thus, scratches and other damage can be repaired by sanding.
- Solid surfaces are harder than wood, but they can be cut and shaped with woodworking-type tools. This allows a variety of edge profiles and shapes.
- Solid surface products are nonporous and are not affected by water or changes in humidity. Because they are nonporous, solid surface products resist the growth of mold and bacteria.
- Solid surface products that use acrylic in their composition materials are fire resistant. Polyester-based products have a lower fire-resistance rating.
- Solid surface products are stain and chemical resistant.
- Solid surfaces are durable and maintain their aesthetic appearance over time. They can be refinished.
- Seams of solid surfaces can be heat welded or chemically fused. Sink units can be fused to the countertop for a seamless surface.

Specifying Solid Surfaces

The designer must be aware that each brand of solid surfacing has a different composition. *Corian* is a solid surface that uses acrylic as the polymer resin, meeting Class A flame-resistance standards. Acrylic and polyester blends may only be Class B fire rated, and tend to have less depth of color, meaning that they might show white marks when scratched. Other solid surfaces are engineered for specific uses and may have fiberglass or quartz chips in their composition.

Installing Solid Surfaces

Solid surface countertops can be either ½ or ¾ inch thick, with a built-up 1½-inch thick front edge. They are installed on top of base cabinets over supports of wood spaced approximately 24 inches apart. The solid surface material is strong enough to support itself, and because it does expand and contract slightly, installing over a plywood substrate could cause cracking or excessive heat build-up from hot items set on the surface. Joints are invisible because they are created by dissolving the edges of the material with solvents, fusing them, and allowing them to set. This creates an invisible weld. Solid surface panels installed on walls are ¼ inch thick and are installed with adhesives.

Maintaining Solid Surfaces

Solid surfaces are impervious, so they are not harmed by cleaning supplies. Soapy water and ammonia-based cleaner, but not window cleaners, are recommended. An occasional cleaning with diluted bleach is good for disinfecting the counters. It is important to wipe the counter completely dry because water allowed to dry on the surface can eventually build up a dull film. Over time, the countertop may develop a dull appearance and/or minor scratches, which can be repaired or renewed with special abrasive pads. Damaged countertops can be professionally refinished.

FIGURE 11.14 Solid Surfacing Edge
Detail. The material can be cut and shaped into many different edge profiles. Photograph courtesy of Cosentino

PLASTIC LAMINATE

Plastic laminate, developed in the early twentieth century, has continued to be a cost-effective material for countertops, backsplashes, and vertical surfaces such as wall panels and doors. Plastic laminate can also be used for signage. Plastic laminate is also used, with a different layering of materials, for flooring. Plastic laminate is hard and durable, resisting heat and water. It is available in a wide range of patterns and solid colors and in several finishes, including a glossy finish for vertical surfaces only. Satin finishes and textured finishes can be used on horizontal surfaces as well as vertical surfaces.

Plastic laminate surfaces consist of multiple layers of material impregnated with phenolic resins and/or melamine. Most of the layers are made of brown *kraft* paper saturated with phenolic resins, topped with a visible resin-impregnated image sheet and coated with a top

FIGURE 11.15 Plastic Laminate Samples.
Vlue/Shutterstock

layer of melamine. The visible layer is most commonly melamine-impregnated printed paper, but foil, fabric, or wood veneer may be laminated to the paper layers. The layers are fused together under heat and pressure. Texture is added in the pressing process. *High-pressure laminates* are used for exposed surfaces that are heavily used, such as countertops. Plastic laminate is also used to construct furniture. *Low-pressure laminates* are used for vertical and low-wear applications. Plastic laminate must be adhered to a substrate, such as plywood, particle board, or medium-density fiberboard or hardboard. The products used to adhere the laminate to the substrate may give off fumes that can be irritating or toxic. In the shop, a thermosetting adhesive may be used. In the field, a contact adhesive is used because it is less volatile.

Since a characteristic of plastic laminate is a visible black line at the joining of two planes, the detailing of the edges of plastic laminate requires thoughtful design. A *self-edge*, made of plastic laminate, will allow the line to show. Edges can be *post-formed* in the shop or during manufacturing to create a radius edge of laminate. Edges can also be designed using different materials such as a wood edge or a metal edge. Although the process of fabricating plastic laminate can emit toxic gasses, factories have changed the process to eliminate the problem by switching to water-based phenolic resins and are using melamine that uses less toxic material in its composition. Hazardous wastes are burned in closed burners at the factory rather than sent to a landfill. Manufacturers are also reducing the use of metal-based pigments in the printed paper. If the laminate is to be adhered to the substrate at the site, nontoxic contact adhesives should be used. Plastic laminate products can emit gasses after installation, so the fumes must be allowed to dissipate before the space is occupied. Because plastic laminate is a thermosetting plastic, it cannot be recycled, although components of the plastic laminate sandwich may include recycled content.

Maintaining Plastic Laminate

Plastic laminates are durable, but cleaning with abrasive cleaners can scratch the surface, causing the countertop to become dull over time. If this occurs, there are coatings that can be applied to renew the surface. Generally, plastic laminate countertops can be cleaned with household spray cleaners. Stains can be removed by allowing a paste of baking soda to sit on the surface for five minutes before washing off. Gentle solvents such as nail polish remover or denatured alcohol can remove ink and other stains. Some manufacturers suggest bleach to remove stains.

FIGURE 11.16 Plastic Laminate Edge Details: (A) Self-Edge/Beveled, (B) Wood Edge, and (C) Post-Formed Edge.

A. Self Edge/beveled

B. Wood Edge

C. Post Formed Edge

PLUMBING PIPES

Plumbing pipes are made from a variety of plastics. Not all types are suitable for carrying *potable* (drinkable) water, but plumbing pipes made of plastics perform better than the natural alternatives. They are relatively inexpensive, lightweight, easy to install and join, and do not corrode or rust. The inside surfaces of the pipes remain smooth and friction free. The following types of plastic are used to make plumbing pipes:

Acrylonitrile-butadiene-styrene (ABS)
 Supply as well as drain
Polybutylene (PB)
 For cold and hot water plumbing pipes
Polyethlyene (PE)
 For cold water plumbing pipes only
Polyvinyl chloride (PVC)
 Cold water plumbing pipes only and drains
 Half of the PVC produced is used to make plumbing pipes
Chlorinated polyvinyl chloride (CPVC)
 Hot and cold water plumbing pipes

summary

Nearly every product used in an interior can be made of plastic. Plastic products are inexpensive and durable. Not only does plastic mimic natural products but it is often appreciated aesthetically for its characteristically bright colors and functionality and for the ability to form plastic into nearly any shape. There are numerous types of plastics with thousands of variations. Because of the low cost and extreme durability of most plastic products, they can be considered an option for nearly any component of an interior.

On the other hand, plastics have a negative impact on the environment. Plastic products take centuries to degrade, and current recycling options only postpone the inevitable trip to the landfill. In addition, most plastics are made of nonrenewable resources, and some components of plastics can leach into air or water and cause illnesses, including cancer. Manufacturers are working to find alternatives to the components of plastics that are health risks, as well as to develop plastics made of recycled, renewable, and/or biodegradable materials.

A designer must consider both the negative and the positive aspects of plastic when choosing products to finish an interior. Interiors that require durability, combined with low cost and ease of maintenance, may be appropriate applications for plastic products. Products made of plastic may be ideal for applications that have high hygienic requirements or requirements for chemical resistance. The designer must carefully check for flammability ratings and consider the impact of the plastic on indoor air quality. The designer must also consider the options for recycling products made of plastic when the useful life of the product is ended.

To find out more about plastics, the following websites in the plastics industry can be useful:

Association of the Wallcovering and Ceiling Industry: www.awci.org/

Greenguard Environmental Institute: www.greenguard.org/en/index.aspx

How Plastics Work: www.howstuffworks.com/plastic.htmn

The Plastics Distributor and Fabricator Industry Magazine: www.plasticsmag.com

The Plastics Historical Society: www.plastiquarian.com/

Resilient Floor Covering Institute: www.rfci.com/

Solid Surface Alliance: www.solidsurfacealliance.org/

SPI: The Plastics Industry Trade Association: www.plasticsindustry.org

The Vinyl Institute: www.vinylinfo.org

review questions

1. Describe the difference between a thermoset plastic material and a thermoplastic material.

2. Explain why plastics were developed and what benefits they bring to other materials.

3. Analyze the difference between the properties and uses of acrylic, and the properties and uses of nylon.

4. Evaluate how plastics can be a part of an effort toward sustainability.

5. If you were to select a countertop surface for a commercial kitchen, which plastic material would be best for meeting fire codes and health standards?

glossary

Acetate is a plastic that is used as a fiber as well as plumbing pipes.

Acrylic, or *polymethyl methacrylate,* is a clear, hard plastic that includes the tradenames Perspex, Lucite, and Plexiglas. It is primarily used to construct furniture and as a substitute for glass.

Acrylonitrile-butadiene-styrene (ABS) is a plastic that combines three polymers. It is a copolymer used for plumbing pipes and furniture components.

Bakelite was the first marketed plastic that could be considered a complete synthetic, developed by Leo Hendrik Baekeland in the 1920s.

Biocides and fungicides are added to vinyl wallcovering to aid in resisting mold, mildew, and fungus.

Biodegradable plastics are plastics that degrade when exposed to oxygen—a process that takes centuries for nonbiodegradable plastics.

Bio-plastics are plastics made of rapidly renewable sources of carbon as opposed to petroleum.

Blow molding is the method used to make plastic bottles and other plastic products. The plastic solution is forced by air against the walls of the bottle-shaped mold.

Butt joining is a method of applying vinyl wallcovering without overlapping seams.

Calendaring is a method of producing plastic products in sheets, such as vinyl for wallcovering. Heated plastic granules are fed through a series of hot metal rollers. The rollers may have a pattern that can be *embossed* on the surface of the sheet.

Casting is a method of producing small plastic objects with simple shapes. Resin powder is heated to liquid solution and then molded without pressure.

Cell casting is used to make uniformly thick flat acrylic panels. Liquid solution is poured between two heated sheets of glass.

Celluloid is an early plastic made of camphor and cellulose developed by John W. Hyatt in 1869. The development of celluloid was built on earlier similar products, *Xylonite* and *Parkesine*.

Chasing arrows are the symbols commonly used to differentiate types of plastic so they can be appropriately sorted for recycling.

Closed-loop recycling refers to recycling a product into the same product. These products can usually be continuously recycled.

Downcycling is the recycling a product into a different, less valuable or desirable product. Generally, downcycled products cannot be recycled again.

Dry hung refers to a method of applying vinyl wallcovering in which the adhesive is applied to the wall rather than the wallcovering.

Epoxy, or *polyepoxide,* is a resin used for adhesives as well as a matrix for fiberglass and poured epoxy flooring or epoxy terrazzo.

Expanded vinyl wallcovering is a type of textured wallcovering made by coating paper with liquid vinyl and then heating the product.

Extrusion is a method of producing plastic products in which a semi-liquid solution is forced through a *die* that creates the desired shape and size.

Fiber-reinforced plastic (or FRP board) is a moisture-proof and impact-resistant panel used for environments such as restaurants that require sanitary conditions.

Floorscore is a certification of air quality for resilient flooring and adhesives.

Foamed plastic is a process of adding air bubbles to the polymer solution, resulting in a cellular structure. Styrofoam is a foamed plastic.

Formica is the brandname for the first marketed plastic laminate, developed in the early 1900s by Westinghouse scientists Herbert A. Faber and Daniel J. O'Conor.

Friable means easily crumbled. Products made with asbestos may be friable, and thus present a health threat to humans.

Furan is a black plastic resin used for grout in industrial and chemical laboratories.

Greenguard is the agency that certifies indoor air quality.

Greenseal is the agency that evaluates life cycle assessment of supposedly green products.

Injection molding is a method of producing plastic products that have complex shapes by injecting melted resin granules into the cavity of a hollow cooled mold.

Kevlar, or *polyamide arimid,* is a high-strength plastic related to nylon used for bullet resistance.

Laminating refers to any process of fusing sheets of material. Plastic laminate is formed by fusing, under heat and pressure, layers of paper that have been impregnated with melamine and phenolic resins.

High-pressure laminates are used for horizontal surfaces such as countertops and table tops.

Low-pressure laminates are used for vertical and low-wear applications.

Lexan, or *polycarbonate,* is a high-strength plastic used in applications that require vandal resistance and extreme durability.

Melamine is a urea-based resin combining cyanamide with formaldehyde used as wear layer in plastic laminate.

Monomers are short molecules that are combined in repeating units to create larger molecules or polymers.

Nylon, or *polyamide,* is the first truly synthetic fiber. In rigid form, nylon's strength makes it an engineering plastic, used for hardware and other metal substitutes.

Persistent bio-accumulative toxins (PBTs) are harmful components found in plastics, usually as additives, but they may be a structural component of the plastic. Examples include phthalates, bisphenol A, benzene, and styrene. Dioxin is a toxic substance released when plastics are burned.

Plastic is derived from *plastikos,* a Greek term meaning pliant, malleable, or easily changed.

Plasticizers are added to thermoplastics to maintain their flexibility. Some plasticizers are harmful to humans.

Plastic wall panels are most often made of acrylic, but can be made of different plastics. They may be chosen for applications that require extreme durability or cleanliness or as a decorative divider panel, often for their texture and color and/or the addition of materials sandwiched between two clear layers.

Polyester, or *polyethylene terephthalate or PET,* is a plastic used as fiber and paint, and as a resin with glass fibers to make fiberglass.

Polymer is a combination of two or more monomers (or single molecules) to make one large molecule.

Polymer resin is the raw material from which plastic products are made.

Polyolefins include *polyethylene, polypropylene, and polybutylene*. All are forms of *olefin*, a plastic used as fiber as well as upholstery foams, single-ply roofing membranes, and plumbing pipes.

Polystyrene, or *Styrofoam,* is a lightweight, inexpensive plastic. In its foamed form, polystyrene is used as insulation. High-impact polystyrene is used to make furniture and for moldings.

Polyurethane is a plastic that can be foamed for insulation or as foam seats and carpet cushions, or as an elastomeric fiber, or as a resin for clear coatings and paints.

Radiant Panel Test tests flooring products for critical radiant flux.

Resilient flooring combines characteristics of hard surface flooring with the ability to recover from indentations caused by compression; it also provides comfort underfoot.

Rotational molding is a method of producing plastic products with heavy walls and/or complex shapes. Melted plastic is disbursed over the inner surface of the mold as it rotates.

Rubber is a natural product that has been modified with plasticizers to the point that all rubber sold today is almost completely synthetic. Rubber is used in building interiors as resilient flooring.

Scientific Certification Systems is the organization that oversees certifications such as Floorscore.

Sick building syndrome is a term referring to allergic reactions and illnesses of the occupants of a building caused by the off-gassing of volatile organic compounds usually from adhesives, coatings, and plastic products, generally in new construction.

Silicone is made from sand, so it is not carbon-based like other plastics. Among the uses of silicone are gaskets and waterproof coating for fabrics.

Solid surface is a generic term for a variety of countertop materials made of plastics such as acrylic, polyester, or a combination of the two with other additives. They are chosen for their durability, resistance to stains and chemicals, and aesthetic characteristics.

Solution refers to a semi-liquid made of melted resin pellets that are formed to make plastic products.

Steiner Tunnel Test tests products for their smoke developed and flame spread.

Synthetic is a combination of two or more substances to make a product that does not occur in nature.

Thermoforming is a method of producing plastic products that have simple shapes and large radii. Softened sheets of plastic are pressed against a steel mold.

Thermoplastic refers to a type of plastic that will soften when heated and harden again when cooled without damage to the original composition.

Thermosetting plastics are plastics that were once cured or hardened and cannot be softened again.

Vinyl, or *polyvinyl chloride (PVC),* is the third most common plastic, used in building construction for plastic pipes and for interior finishes such as vinyl wallcovering and resilient sheet and tile flooring.

Vinyl composition tile is a type of resilient flooring that is a mix of vinyl, limestone, and colored pigments. Often called VCT, it is more brittle than other resilient flooring products.

Vinyl wallcovering is used in commercial installations for its durability, abrasion resistance, cleanability, and strength. Wallpaper used in residences may be coated with vinyl.

Viscose is a cellulosic fiber, the process of which led to the development of the thin flexible sheeting products *cellophane* and *Saran.*

Vulcanization is a process of adding sulfur to crude rubber to make it more resilient and durable, invented by Charles Goodyear in 1839.

Xenoestrogens, or *endocrine disruptors,* are products that mimic estrogen and cause changes in hormone levels of human beings.

Fibers and Textiles

learning objectives

When you complete this chapter, you should be able to:

1. Use appropriate terms used when discussing fibers and textiles.
2. Identify common uses of textile products in an interior.
3. Summarize the history of textile products use in interiors.
4. Describe how fibers and textile products are produced.
5. Describe how textiles meet code requirements for interior use.
6. Describe the physical characteristics and properties of fibers and textiles for a specific interior use.
7. Analyze the environmental impact of using textile products.
8. Evaluate how well textile products will meet the specific needs of a design project.

Carnegie Xorel Textile Wall Covering
Custom Designed for MAC Cosmetics.
Photograph courtesy of Carnegie Fabrics

Awareness: An Overview

DESCRIPTION AND COMMON USES

Materials used to construct both the shell and the interior of a building are chosen for their strength and durability. Each of the common materials (stone, steel, concrete, brick, tile, and wood) has its own aesthetic appeal, but one characteristic shared by all these materials is hardness. Without textile products in an interior, there would be no softness and little comfort. Textiles, usable products made from fibers, are used in an interior to add characteristic warmth, as well as color and texture that cannot be achieved with other materials.

Fiber is the raw material from which a textile product is made. A fiber is a very fine, hairlike material, defined as being much longer than it is wide. A fiber can be natural or manmade, but in order to make a useful product, the fiber must have the qualities that make it suitable for processing into fabric: length, strength, and flexibility. Most often, a bundle of fibers is twisted together to make **yarn**, which in turn is used to construct a **textile**. The term *textile* has its origins in the Latin word *textilis* as well as the French term *textere,* both meaning "to weave." Thus, the term *textile* originally referred to a type of woven fabric. However, the term has evolved to include fabrics that are constructed using other methods, including knitting, crocheting, felting, tufting, or braiding. The terms *fabric* and *cloth* are often used

interchangeably with the term *textile*. **Fabric** is defined as a flexible, pliable plane, and thus can refer to a range of products, including paper. In the textile industry, the term *fabric* is often used to describe a textile that is intended to be used to construct a final product, such as an article of clothing. **Cloth** is used to refer to textile that is finished for a specific use, such as a table cloth.

Fibers are classified as either manufactured or natural or natural. **Natural fibers** are made from plants, the wool of sheep, or the cocoons of silk worms. Leather, from the skin of animals, does not start as a fiber, but the product, a flexible plane of material, is classified as a fabric.

Manufactured **synthetic fibers** have the same chemical composition as plastics, which are made from from a synthesis of polymer resins. Synthetic manufactured fibers most commonly used in an interior include acrylic, nylon, polyester, and polyolefin. Rayon and Lyocell are tradenames of manufactured fibers derived from *cellulose*, or wood by-products. *Mineral fibers* are manufactured from inorganic raw materials and include asbestos, a known carcinogen that is no longer made; metals, wire as a fiber and screen as a fabric (known as *hardware cloth* in the United States); and lurex, a plastic-coated metal mixed with other fibers. Thin, spun strands of glass are used to create *fiberglass*, which in textile form is sometimes used for drapery.

Textiles may be used as a wallcovering, either applied directly to the wall or wrapped around a substrate that has sound absorbing properties. Fabric-covered panels may also be used as ceiling tiles or applied to a ceiling. Carpets are textile products that are woven or tufted from yarns. Other textile products used in an interior include rugs, window treatments, and fabrics used to upholster furniture or construct pillows and cushions. Products used in an interior made from textiles are often referred to as **soft goods** and include household items such as towels, sheets, and tablecloths. Leather is commonly used for upholstery or desk-pads, but can also be used as floor tiles or applied to a wall. Textiles used in architecture can range from shades, awnings, and canopies to fabric roofs and tensile membrane structures. Textiles used in building construction include a breathable vapor barrier made from felted olefin, known by the trade name Tyvek. High-strength fibers have been developed for technical applications in the aerospace industry, as medical fabrics or as construction fabrics.

CHARACTERISTICS

Textiles are appreciated for their aesthetic properties, adding color, texture, and pattern—as well as softness and warmth—to an interior. The tactile nature of textiles is an important feature, with the term **hand** used to describe the way a textile feels to the touch. All textiles share some level of elasticity, resiliency, and drapability. Although the aesthetic appearance and performance of a textile product can be determined by the structure of the yarn, the method of fabricating the product, the coloring methods, and the type of applied finishes, the most important factor in understanding the character of the final product is the fiber content.

Products made from natural fibers tend to be comfortable, especially to wear. Natural fiber textiles feel good to the touch, take dye well, and are considered beautiful. Each of the natural fibers has unique desirable characteristics, such as the luster of silk, the warmth of wool, and the cool smoothness of linen or cotton. The disadvantage of natural fibers is their relative weakness and high cost. However, some of the negative performance characteristics of natural fibers can be overcome in the fabrication and/or finishing stages.

Each type of natural fiber has unique characteristics derived from the physical properties of the fiber: its cross-sectional and lengthwise shape, overall length and diameter, and surface texture. The shape and texture of manufactured fibers are engineered to mimic those of the natural fibers that have the desired characteristics. Manufactured fibers are also engineered to perform better than natural fibers at less cost. Synthetic manufactured fibers are stronger and generally more abrasion-resistant than natural fibers. However, being plastics, they share the negative characteristics of other plastic products. Manufactured fibers that are cellulosic share some of the characteristics of synthetics and some of the characteristics of natural fibers. The different natural fibers also have unique chemical properties such as

Properties of Natural Fibers

(sustainable properties are noted with green color)

- Natural fibers are **hydrophilic**, or water-loving. Thus, they are easy to dye in a rich range of colors. They tend to be absorbent, holding moisture.
- Natural fibers have an inherent color that may be maintained in the finished product.
- Textiles made from natural fibers tend to be comfortable to the touch, either smooth (silk, linen, and cotton) or warm and rough (wool).
- Textiles made from natural fibers have a desirable **luster**, which refers to sheen rather than shine.
- Natural fibers are generally absorbent. This means that there is little static buildup in textiles made from natural fibers.
- Some natural fibers are **wickable**, meaning that water moves quickly along the fiber and evaporates rapidly.
- Although some natural fibers tend to be strong (silk and linen), they are not as strong as human-made fibers.
- Natural fibers are not as abrasion resistant as human-made fibers.
- Natural fibers are more expensive to produce than most human-made fibers.
- Longer natural fibers (silk and linen) are stronger than shorter natural fibers. They are also smoother.
- Natural fibers tend to be susceptible to damage from moths and microbes.
- Plant-based natural fibers will burn like paper. Wool will resist burning.
- The method of harvesting natural fibers determines their environmental impact. Excessive water use, land use, and distance from source to end-use all have a negative environmental impact.
- Some natural fibers, such as organic cotton, are produced using sustainable processes.
- Products made from natural fibers may be biodegradable.
- Natural fibers come from renewable resources.

Properties of Synthetic Fibers

(sustainable properties are noted with green color)

- Synthetic fibers are **hydrophobic**, meaning water-hating. They are more difficult to dye and clean, they may feel uncomfortable to the touch, and they do not have the breathable characteristics of natural fibers.
- Synthetic fibers are inherently white.
- Synthetic fibers tend to be shiny, but this can be overcome with engineering.
- Synthetics fibers are generally resistant to sunlight, microbes, and moths.
- Synthetic fibers are thermoplastic, and as such will melt when exposed to high heat. However, this means they can be heat set and retain their form.
- Synthetic fibers are abrasion resistant but may have a tendency to pill.
- Because synthetic fibers are made from petroleum by-products, they are **oleophilic**, or oil-loving. Thus, oils tend to stain synthetic textiles.
- Synthetic fibers can be engineered to have high *covering power*, meaning they result in less expensive products.
- Synthetic fibers may be engineered to resist and/or repel soil.
- Synthetic fibers may melt or give off toxic smoke and fumes when exposed to flame. Some synthetic fibers are flame resistant.
- Products made from synthetic fibers such as nylon and polyester can be recycled.
- Synthetic fibers may be produced close to their destination.

resistance to sunlight and pollutant gasses, and heat conductivity. The desirable chemical properties are engineered into manufactured fibers.

ENVIRONMENTAL IMPACT

The environmental impact of textile products is largely determined by the type of fiber. The most sustainable choice is not always clear and each decision may require compromise.

Natural fibers are derived from renewable resources and are biodegradable. However, harvesting, cleaning, and producing usable material from the fibers may require excessive use of water and other resources. The production of natural fibers may involve extensive land use, and they may be harvested a long distance away from their final destination. Landfills do not allow products to degrade, so the advantage of biodegradability may be lost if the product is not disposed of properly. Some fibers, such as organic cotton, are produced using sustainable practices.

Synthetic fibers, being plastics, have an environmental impact similar to other plastic products. Synthetic fibers are processed from nonrenewable petroleum-based by-products. Products made from these synthetic solutions may affect indoor air quality by emitting irritating or toxic gasses. When synthetic fibers are burned, the smoke and fumes can be toxic. On the other hand, many synthetic textiles can be recycled or can be made from recycled plastics. They do not require extensive land use to produce and they can be produced close to their final destination.

Cellulosic manufactured fibers share some characteristics of synthetics and some characteristics of natural fibers. One cellulosic fiber, Rayon is particularly problematic because it is made from trees that are often clear cut from old growth forests, and waste water from processing rayon is often polluted.

The environmental impact of textiles is not fully explained by the environmental impact of the fiber itself. Hazardous chemicals may be used in the manufacturing and finishing process. For example, flame-retardant finishes may give off fumes that affect indoor air quality. The finishing and dying processes use large amounts of water. Chemicals discharged into water from the dying process include dye color, salt, and acids.

GO GREEN Climatex Fabrics

In the 1990s, DesignTex Fabrics commissioned William McDonough to design a sustainable textile. McDonough, an architect and the author of *Cradle to Cradle*, had proposed that products be placed into three categories:

1. *Consumables*, products that when eaten, used, or discarded will turn into soil with no harmful side effects
2. *Durables*, products that can be disassembled and the components recycled or reused
3. *Unsalables*, products considered toxic waste that no one should make and no one wants to buy

McDonough worked with chemist Michael Braungart to design a consumable textile made of wool and ramie, a plant fiber. The Swiss textile mill Rohner was able to produce nontoxic dyes. As a result, the water leaving the mill was cleaner than the water flowing in. The scraps of the textile were felted and used by local strawberry farmers to mulch plants. In fact, the entire textile is pure enough to be eaten. Thus, another of McDonough's design principles was achieved: "Waste = Food."

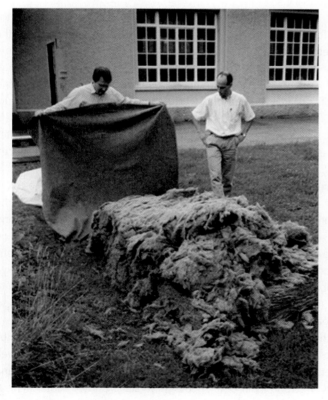

FIGURE 12.1 Climatex Fabric Trimmings Used as Mulch. Photograph courtesy of DesignTex

FIGURE 12.2 "High Fiber-Box Lunch" Climatex Fabric by DesignTex. Photograph courtesy of DesignTex

Understanding: In-Depth Information

HISTORY OF TEXTILES

The nomadic lives of early humans necessitated structures that could be easily dismantled and moved; consequently, almost no physical evidence of their existence remains. Even when the development of agriculture led to more permanent structures of wood, mud brick, or stone, objects and components of structures that were made of textiles were less likely to survive over time. However, information about human habitation in nomadic cultures can be assumed from the design of the dwellings of tribal cultures that had changed little when they were discovered by European explorers. In addition, evidence of early human use of textiles has been found in locations that have dry climate conditions or that provided protection from weathering, such as caves, or by accidental preservation, such as in the peat bogs of northern Europe. Thus, we can assume that people made clothing for warmth and protection from their earliest days, most likely sewing skins of animals together to create wearable garments. These skins would also have been used to enhance the comfort of an interior, adding insulation when applied to walls, such as when skins were hung on the interior walls of igloos.

The earliest method of producing a fabric was **felting**, a process of pounding heated animal hair into a matt of fibers that was used for bedding, whereas the process of **weaving** may have pre-dated the spinning of fiber into yarn. The earliest constructed shelters were most likely the wigwam or tipi form, created by tying tree branches together and covering the framework with a woven enclosure of twigs and branches, an early example of weaving. Plant materials were also woven to make baskets, which served as functional storage in ancient dwellings. Woven basket hats have been found on 25,000-year-old Venus figurines, and imprints of woven nets have been found on 27,000-year-old pieces of hard clay. Plant fibers, used for weaving and dyed in bright colors, have been found in caves in the Republic of Georgia and dated to 36,000 B.C.E.

As early as 5000 B.C.E, Egyptians were making linen cloth from flax, used for clothing and as burial shrouds for Pharaohs. There is also evidence of use of flax in Iraq, the Mediterranean, Belgium, Netherlands, England, Ireland, and by the Aztecs in Mexico. Hemp was used in Southeast Asia and China in 4500 B.C.E. Wool fiber used to create fabric can be traced to the late Stone Age, 3000 B.C.E. Other animals, such as the alpaca, llama, and mohair goat, were used for fibers at least as early as several thousand years ago. Silk production in China dates to 2600 B.C.E. Cotton was harvested and converted to fabric in ancient India, also around 3000 B.C.E, and was also used in Egypt and in the Tigris and Euphrates area. By 71 B.C.E, Romans were using cotton to construct tents. In 800 C.E., Moors introduced the cultivation of cotton to Spain.

Ancient cultures developed the art of dying yarns to create patterns with multiple colors in woven rugs and blankets. Patterns had symbolic meanings unique to each culture. By the fourth century C.E., Egyptians were weaving tapestries, and people in India were printing textiles, and between 600 and 900 C.E., the Chinese were using tie and dye methods on silk. The ancient Persians developed sophisticated techniques for weaving luxurious carpets. Because rugs were an important source of warmth, color, and pattern in ancient dwellings, rug weaving developed globally, especially in what is now the southwest United States and in South America.

Silk from China and cotton from India were imported to Rome and the West along a trade route that became known as the Silk Road. Although China was producing silk by 2,600 B.C.E, the Chinese kept the process secret for centuries. The Islamic countries had developed rich patterns in carpets; Turkey produced carpets as well as felted cloth, towels, and rugs. People of the Mughal Empire in India developed highly valued printed muslins. Thus, the importance of a trade route to China was as much to have access to textiles as to spices.

The Crusades of the Middle Ages exposed Europeans to the rich textiles of the eastern world, and the crusaders returned to Europe and England with silk and cotton. Other wars

and conquests resulted in the movement of textile production from Sicily to Italy to France, which became the center of textile trade. Silk from the Middle East and wool from England were woven into tapestries and brocades in France, Italy, and other parts of Europe. France became the center of tapestry production after Henry IV of France established the royal carpet and tapestry factory at Savonnieres. Between 1650 and 1685, Jean Baptiste-Colbert, finance minister for Louis XIV, established several tapestry workshops, including Gobelins in Paris (1662) and Beauvais Tapestry in the town of Beauvais. Aubusson became a center of flat woven oriental-style rugs, produced for nobility who could not get Savonnieres rugs. The French invented the **Jacquard Loom** which used a punch card to determine the location of different colors of yarn and allowed the pictorial designs of tapestries. Silk weaving was brought to England by French Protestants fleeing persecution in 1685; 3,000 refugees settled near London to weave silk damasks and brocades. England developed two methods of rug weaving still used today: Wilton and Axminster. Complex patterns of weaving were made possible by use of the Jacquard loom, which was perfected in 1801 and became a common attachment to looms in Europe by 1806.

From early times through the Middle Ages, yarns were drawn out and twisted into a continuous thread or yarn using a spindle, whirled by the **spinner**, thus twisting fiber into yarn. The spinning wheel, invented in India, added more twist as it drew out a more uniform yarn. Europe began to use this technology in the Middle Ages. During this time, **tapestries**, heavy fabrics with pictorial images, were used for wall hangings, and later for rugs and furniture upholstery. In addition to being decorative, tapestries that were hung on castle walls served a functional purpose—keeping out drafts. Tapestries were also used in bed hangings, and in Dutch homes tapestry rugs were used to cover tables.

Until the Industrial Revolution, weaving was a craft practiced by individuals using narrow looms or on broad looms; both types of looms required a helper to push the shuttle through. This cottage industry was most generally practiced in individual homes, but occasionally a number of weavers operated under one roof.

During the height of the Industrial Revolution, from 1760 to 1815, Britain became a center for weaving. It was British invention that led to the mechanization of the textile industry. In 1733, John Kay increased the speed of weaving by inventing the *Flying Shuttle*, which

FIGURE 12.3 Medieval Tapestry. John Said / Shutterstock

Jacquard Loom

The Jacquard loom was designed by the French, perfected in 1801, and was a common attachment to looms in Europe by 1806. Jacquard looms allow complex combinations of two or more simple weaves using multiple sets of yarns. Considered a forerunner of the computer, Jacquard weaving originally used a series of cards with holes punched in them to strategically place colored yarns to make a design. Jacquard looms created the construction of machine-woven pictorial tapestries, carrying yarns on the back of the fabric from edge to edge and pulling them into the face when needed for the pattern. Machine-made tapestries will have strips of yarn on the back. Jacquard looms are now controlled by a computer and are used for carpets as well as upholstery and drapery fabrics.

FIGURE 12.4 Image of a Traditional Jacquard Loom Showing the Punch Cards That Control the Pattern.
Alcaude Thibault/Alamy

allowed one person to operate a broad loom. This faster weaving led to a demand for faster spinning, which was met by three inventions. James Hargreaves invented the *Spinning Jenny* in 1764. Richard Arkwright invented the water frame in 1769, which increased the speed of spinning stronger threads for yarns. In 1779, Crompton developed the *spinning mule* yarn spinner, which allowed a single yarn operator to operate 1,000 spindles simultaneously. During the Industrial Revolution, parallel development in the metal industry allowed the construction of factories and equipment. The replacement of water power with steam power freed textile mills from the need to be located near a water source.

England tried to protect its textile industry by outlawing the exporting of machinery, drawings, and specifications, but in 1793, Samuel Slater sold trade secrets to an American, William Cabot Lowell, who used them when he developed the textile mill towns in New England, including Lowell, Massachusetts. Elias Howe's invention of the sewing machine helped mechanize the manufacture of clothing and other products from woven cloth. Erasmus Bigelow invented a power loom to weave carpet in 1839. Until the mid-nineteenth century, natural dyes were used to color textile products.

If textile production was refined using mechanical inventions during the eighteenth and nineteenth centuries, the textile industry of the early twentieth century centered on the development of manufactured fibers and synthetic dyes. The same inventors who experimented with plastic production found ways to create synthetic fibers that mimicked or were an improvement on the performance characteristics of natural fibers at a reduced cost. The focus in the late twentieth century was on maximum strength and high-tech fibers, used

for athletic clothing, aerospace gear, and medical textiles and textiles for industrial purposes. Late twentieth-century developments include *Gore Tex* (1989), a breathable, waterproof, windproof textile, and *microfibers*, very fine **denier** synthetics, developed in 1989. Late twentieth-century techniques of producing textiles include bonding, needleweaving, and the development of composite fabrics.

PRODUCTION: HOW TEXTILE PRODUCTS ARE MADE

Steps in producing a textile product begin with the harvesting or manufacturing of the fiber, which is then converted into yarn or other usable form that is then fabricated and finished.

NATURAL FIBERS

The production of textiles made from natural fibers begins with the *suppliers* who grow and/ or harvest the source of the fibers. Natural fibers are obtained from animals, such as wool from sheep and silk from caterpillars, or plants, such as cotton and flax plants that are grown and harvested for cotton and linen fibers.

Wool Fibers

Sheared from the natural coat of animals, wool is a protein fiber and shares characteristics of fibers from the fleece of other animals, including alpaca, angora rabbit, camel, cashmere goat, and angora goat (for mohair). Less commonly used fibers from the coats of animals include horse hair, llama, vicuna, and qiviut (from the Alaskan musk ox). Fur fibers (beaver, fox, mink, and sable) have similar properties.

The following are steps in the production of wool:

- Shearing or chemical removal of fleece
- Washing the fleece to remove potassium salts and using an acid bath to remove cockleburs and vegetable matter
- Removing lanolin, which is reused
- Carding and spinning to make yarn
- Further production into fabric

FIGURE 12.5 Raw Wool. Mr. Green/Shutterstock

Silk

Silk is a protein fiber derived from the cocoon of the silk worm. **Sericulture** is the term to describe the production of silk. The process is as follows:

- Silk moths lay eggs, which develop into silkworms (caterpillars).
- Silkworms eat mulberry leaves and convert them into *fibroin*.
- The silkworm extrudes two strands of silk filament and *sericin,* a gummy compound that holds strands together.
- Silkworms spin the filaments and sericin in a figure eight fashion to make a cocoon.
- To harvest the cocoon, the silkworm is killed by heat. Otherwise a moth would break out of the cocoon.
- The silk is harvested. Sericin is softened in warm water and silk filaments are unwound in a process called *reeling.*
- Several filaments are combined into multifilament silk yarn in a process called *throwing*. *Noil* is yarn spun from staple-length silk scraps. *Douppioni* is yarn made by spinning together filaments from two or more cocoons.

FIGURE 12.6 Silkworm Cocoons. Suzan Oschmann/Shutterstock

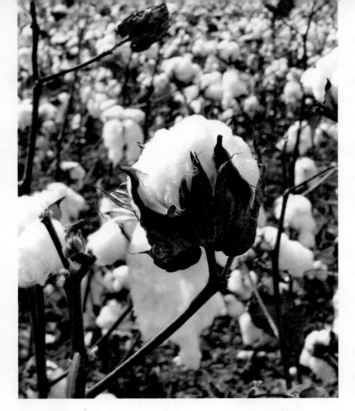

FIGURE 12.7 Cotton Plants. Sherry Yates / Shutterstock

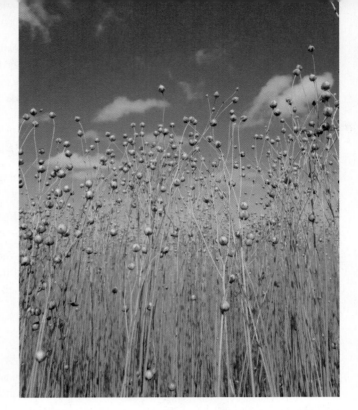

FIGURE 12.8 Flax plants in a Field. Caroline Vancoillie/Shutterstock

Cotton

Cotton is among fibers from the seeds of plants, also including coir (from coconut husks) and kapok. Cotton fibers grow from the seeds on the *boll* or top of the cotton plant. Cotton is harvested by either a picker, a machine that removes the cotton from the boll without damaging the plant, or a stripper that removes the entire boll from the plant. *Ginning* is the process of separating the fibers from the seeds, which are used for oil.

Linen

Linen is a *bast* fiber, made from the outer layers of the stem of the flax plant.

The process of harvesting and producing linen is as follows:

- The entire flax plant is uprooted. The stalks are bundled and dried.
- The fiber is retrieved from the plant using the following processes:
 1. *Rippling* means pulling the tips of the stocks through a course metal comb to remove the seeds, which are processed into oil.
 2. *Retting* means separating the fiber bundles from the woody core of the flax stem.
 3. *Scutching* is scraping away the core material.
 4. *Hackling* is pulling fiber bundles through metal times to align long fibers prior to spinning.

MANUFACTURED FIBERS

All manufactured fibers are the result of industrial processing. *Producers* combine raw materials to manufacture made fibers. These fibers include those made from natural products, such as wood pulp or cellulose. These *cellulosic* manufactured fibers include rayon, acetate, and lyocell.

Most manufactured fibers, however, are *synthetics,* and have the same chemical structure as plastics, which are a synthesis of monomers from petroleum by-products such as natural gas, coal, and oil. Synthetics include acrylic, olefin, polyester, and nylon.

The raw materials, which may be totally synthesized from petroleum by-products or made from cellulose or wood by-products, are converted into a semi-liquid **solution** by either using heat (*melt spinning*, used for cellulosic fibers) or dissolving them in a solvent (*solvent spinning*, used for synthetic fibers).

Because engineering plays a large role in the development of human-made fibers, additives are often incorporated into the solution. The solution is *extruded* or pushed through a **spinneret**, similar in appearance to a shower head, with small holes that have a size and shape that forms a fiber with a desired cross-section. The fiber may be extruded into a chemical or solvent bath, or into a warm or cool air chamber. Filament fibers are drawn or stretched to lengthen and reduce their diameter, creating a fiber that is strong and similar to silk. To imitate natural fibers such as cotton, some filaments are cut to shorter **staple** length. Because synthetic fibers are **thermoplastics**, they can be softened by heat, and will retain their shape when cooled. Thus, synthetic fibers can be heat set to lock in their shape and texture.

YARN

Unravel a woven textile, and the yarn is the component you can see. Whether synthetic or natural, fibers must be combined into yarns to be useful. Yarns, like fibers, are linear and relatively thin. A *yarn* is a strand composed of fibers, filaments, or other materials suitable for construction of fabrics. Two or more fibers can be blended to create a yarn. Natural fibers of different lengths may be blended to create a more uniform yarn.

Monofilament yarns consist of a single fiber and are produced by the fiber manufacturer. Monofilament yarns have a relatively large diameter and are used for thread and to make a lightweight drapery fabric. Extruded tapes are also monofilament yarns.

Filament-length fibers are relatively long and include silk, some linen, and all manufactured fibers. **Throwsters** combine filaments into *multifilament* twisted or untwisted yarns. Multifilament yarns can be textured, crimped, or bulked so that they appear and perform like natural fibers.

Cotton, wool, and linen fibers are shorter, *staple*-length fibers. **Spinners** align, spin, and twist staple fibers into yarns. Some manufactured fibers are cut to staple length and spun to imitate natural fibers. Spinning is based on the traditional techniques of preparing fibers—aligning and twisting fibers using the rotation of the spindle or the spinning wheel. Spinning systems vary according to the fiber, but modern machines can control twist to the ideal tightness using *Z twist* or *S twist* patterns. The direction of twist makes no difference in strength, but the performance characteristics of the fiber can be modified by the number of turns per inch when twisting the yarns. **Carding** aligns cotton fibers, causing

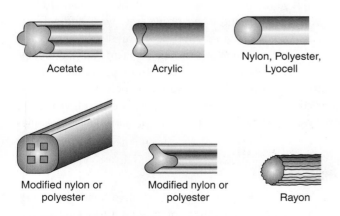

Acetate

Acrylic

Nylon, Polyester, Lyocell

Modified nylon or polyester

Modified nylon or polyester

Rayon

FIGURE 12.9 Manufactured Fiber Cross Sections.

Filaments

Spinneret

FIGURE 12.10 Spinneret.

them to lie parallel prior to spinning. **Combing** is a process of further smoothing the yarn, removing very short fibers, and leaving only the longest fibers, laid parallel. Wool may be *worsted*, a process similar to combing cotton. *Hackling* is a process similar to combing used to straighten and separate flax.

Simple yarns are smooth in appearance and uniform in diameter and can be *single*, *plied* (two or more twisted together), *cord* (two or more plies twisted together), and so on. **Complex yarns** have decorative elements such as variations in the levels of twist, addition of yarns of different fiber content, or three-dimensional decorative features such as *slubs* (intentional small lumps) or specks. These complex decorative yarns may be used for wallcovering fabrics, upholsteries, or draperies. manufactured yarns can be *textured*, reducing the innate slipperiness and pilling tendency of human-made fibers as well as making the fiber, and thus the yarn, more opaque. Methods of texturing include *crimping*, *curling*, *coiling*, *stuffing*, and *knit-de-knit*, a method of knitting yarns, heat seating, and then unraveling. *Bulking* increases air spaces in the yarns, imparting absorbency and improving ventilation. Bulking can be done with air or chemicals or by stretching and releasing the yarn. *Bulked continuous filament nylon*, or *BCF*, is used to add texture and volume to nylon carpet yarns, making the product more like wool.

Not all fibers are thrown or spun into yarns. *Chenille* "yarns" are actually strips cut from a type of woven fabric called *leno*. Polymer tape or extruded filmstrips, metallic yarns made from foil and polyester strips, twisted paper, or natural fibers such as rush, sea grass, or cane are made directly into fabric without spinning into yarn. Metallic yarns are made from silver foil encased in polyester film sheeting slit into yarn-like threads. Felted wool bypasses the yarn stage.

When the yarn is complete, it is wound onto one of the following supporting structures: bobbins, spools, cones, tubes, and cheeses. A skein has no supporting cone.

FABRICATION

Yarns can be woven, knitted, knotted, twisted, braided, or tufted to make fabric. Other products are made directly from fibers. Felting, spunbonding, and needlepunching are nonwoven techniques that can be used to make a textile from natural and manufactured fiber.

Weaving

Weaving is the interlacing of two or more yarns in a right-angle relationship, usually on a loom. The lengthwise yarns threaded on the loom are called **warp**. Warp yarns are generally simple and strong. **Weft** (or woof) yarns are the cross-wise filling yarns. Weft yarns are not required to be as strong as warp yarns, so they can be more decorative. The weaving process can be used to create a large variety of patterns. *Simple weaves* consist of one set of warp yarns and one set of weft yarns. Simple weave patterns include plain or *tabby* weaves and basket weaves, warp and filling rib weaves, twill, herringbone, satin, sateen, and crepe. *Complex weaves* combine several simple weaves and multiple sets of yarns in one fabrication and include jacquard weaving, dobby, and leno weaving. Damask, brocade, double cloth, and tapestry are complex weaves. *Pile weaves* combine a base layer of warp and weft with a pile layer more or less perpendicular to the base. Pile weaves include velvet, velveteen, and corduroy. *Triaxial* weaves combine three sets of yarns at 60-degree angles to one another.

Nonwoven Textiles

A textile product can also be fabricated by methods other than weaving. Knitting, crocheting, and chain stitching are all methods of creating a textile by looping and interconnecting one or more yarns. Knitting can be done by hand or by a machine. Knotting and twisting methods include macramé, lace making, netting,

Warp yarn Weft yarn

FIGURE 12.11 *Basic Weaving.*

FIGURE 12.12 Example of Plain Weave: Twill. Alan Gordine/Shutterstock

FIGURE 12.13 Example of Plain Weave: Canvas. J5M/Shutterstock

FIGURE 12.14 Example of Complex Weave: Brocade. TwilightArtPictures/Fotolia

FIGURE 12.15 Example of Complex Weave: Damask.

FIGURE 12.16 Example of Pile Weave: Velvet. TwilightArtPictures/Fotolia

FIGURE 12.17 Example of Pile Weave: Corduroy. mypokcik/Shutterstock

Fibers and Textiles **221**

FIGURE 12.18 Printed fabric by Jack Lenor Larsen. Jack Lenor Larson's long career as a weaver and fabric designer included the development of printed fabrics for residential and contract use. He incorporated artisan methods of printing in his designs, including batik. The fabric in this illustration is "Primavera," printed on cotton velvet in 1959.

and braiding—techniques that can be used for decorative detail or for artisan textiles. Tufting and fusion bonding are among the nonwoven methods used to produce rugs and carpet.

Fibers that are not made into yarn, whether thin filaments or staple fibers, can be combined using several techniques. Fibers can be held together with heat or adhesive (bonded fibrous bats), chain stitched together with barbed needles (needlepunched), stabilized with heat or chemicals (spunbonded), or mechanically entangled (spunlacing). The resulting fiber products are used for carpet cushions and backings, blankets, mattress pads, backings for textile wallcoverings, and backings for vinyl fabric.

COLORING

Color can be added at any stage in the process of producing a textile. Wool, for instance, may be dyed in the fiber stage. The resulting colors are lustrous and more permanent, but color choices are limited and custom coloring is difficult. Since synthetic fibers are hydrophobic, it is easier to add color to the polymer solution before producing a fiber. **Solution dying** is used only for manufactured fibers; but not all synthetics are solution dyed. Solution-dyed fibers result in products that have high color retention, will not sun fade, and can be cleaned with bleach. The **dyes** are stable and chemical resistant. However, color choices are limited. Solution-dyed colors tend to be muddy and solid colors often have a striped effect. Yarns are often dyed before the textile is constructed. *Yarn-dying* processes are useful because small batches can be dyed and custom coloring is possible. *Piece dying* refers to the process of dying an uncolored textile product. After dying, the fabric is exposed to heat, steam, or chemicals, known as *mordents*, to set the dye.

Colorants are either dyes or pigments, with dyes being water-soluble liquid. If the textile is to be printed, **pigments** in the form of nonsoluble dye paste are used. Dye paste is applied using various methods that allow successive applications of multiple colors. Printing methods include flat-bed screen printing, using one screen per color, rotary drum printing, and roller printing, using one roller per color. Stalwart roller printing, a method used for carpet, results in muted, fuzzy prints.

Carpets are often printed to add a soil-hiding pattern. Rather than a dye paste, a liquid dye may be used. It can be sprinkled randomly over already colored carpet, injected in liquid form so the dye penetrates deep into the pile, or dye foam may be applied.

Some decorative textiles are pigment printed, with the pigment remaining on the surface, giving the textile a slight relief. Acid printing is also known as "burn out," with acid applied to a textile made of two fibers. One fiber is resistant to the acid and is not affected; the other is dissolved by the acid, leaving a pattern of sheer and opaque surfaces.

Resist printing methods, similar to batik, work by applying a material that resists dye to a color to remain, then dying the fabric and removing the resist. Artisan methods of coloring and printing a textile include *block printing*, *batik*, *ikat*, and *tie dye*.

Coloring Carpet

Carpet is a textile that is widely used as an interior finish material. The following dying methods are primarily used for coloring carpet in the solution, fiber, or yarn stage:

- **Solution Dying:** Synthetic fibers may be colored in the solution stage. This is an option for nylon and polyolefin.

- **Stock Dying:** Fibers are dyed in a vat before being made into yarn. Wool as well as synthetic fibers can be stock dyed.

- **Skein Dying:** Yarns are dyed, using a variety of methods. This allows the possibility of custom coloring and designs.
- **Space Dying:** Using a variety of methods, yarns are dyed so that (generally) three colors appear randomly in one yarn. The resulting variegated colored yarns provide the soil hiding and pattern effect of multiple colors using one yarn.

The following methods are used for coloring carpet after it has been constructed:

- **Beck Dying:** Before secondary backing is applied, large rolls of carpet are dyed in a large vat (heated to high temperatures and agitated), resulting in even color. This is used for solid cut pile.
- **Piece Dying:** This method is used for smaller pieces of less dense carpet.
- **Continuous Dying:** Dyes are sprayed onto the surface of greige goods. The color is set by steam.
- **Printing:** Jets of dye are injected into carpet yarns. Computers control the patterns.
- **Differential Dying:** Tufted yarns are engineered to take dye differently. Patterns and colors are planned so that one dye solution will result in different shades of the same color.

FINISHING

An unfinished textile is referred to as **greige goods** or **gray goods**. The textile is not complete until *converters* finish the product by adding color or by adding or applying finishes that modify the appearance or change the performance characteristics.

Basic finishing includes washing, rinsing, and drying, but it may also include removing or repairing defects. The fabric may be bleached if it is to be dyed. If the product is carpet, the secondary backings are applied, and then the yarns are restored to their upright position or sheared and vacuumed.

Treatments to improve or add a desired aesthetic appearance include napping (for flannel), shearing, pressing, brushing, and polishing. Other finishing treatments for aesthetic purposes include:

- *Glazing* chintz by applying resin, shellac, and wax, followed by a buff and polish.
- Creating a sateen fabric by *calendaring*, using polished and heated rollers to flatten the surface of yarn. A moiré pattern, similar to wood grain, can be created by using two calendaring rollers.
- Embellishing surfaces with hand or machine embroidery, needlepoint applique, or quilting.

Treatments applied during the finishing stage that improve the function of textile products may include heat-setting synthetics to maintain dimensional stability, preshrinking and applying durable press finishes to cotton, and aligning warp and weft, using a process called *tentering*. The finishing phase may include applying antimicrobial treatments, optical brighteners, flame retarders, moth repellents, and/or silicone water repellents. Fluorocarbon compounds such as Scotch Guard or Teflon are applied for soil and stain resistance. The shine of synthetics can be controlled with delusterants.

DESIGN

At the converting or finishing stage, textile designers may become involved, working with mills to develop and design end-products. The resulting *yard goods* may be sold to the end-user or to furniture manufacturers for upholstery, or to product manufacturers that use the fabrics to make household products, window treatments, or wallcoverings. The products are distributed through trade showrooms, or sold to customers at retail stores

Physical Properties of Fibers

- The *cross-sectional shape* of the fiber, as seen under a microscope, helps determine the strength of the product as well as luster, hand (how it feels to the touch), soil hiding ability, covering power, and soil shedding.
- The *length of a fiber* determines strength and abrasion resistance. Longer fibers are stronger.
- The *lengthwise shape of the fiber*, whether straight, coiled, twisted, or crimped, affects the luster of the product.
- The *surface texture of the fiber*, whether smooth, rough, or irregular, affects resiliency and hand.
- The *diameter of the fiber* affects covering power and soil reduction.

FIGURE 12.19 Cross Section of Wool Fiber: Oval to Round With Overlapping Scales.

FIGURE 12.20 Cross Section of Silk Fiber: Triangular With Rounded Edges.

FIGURE 12.21 Cross Section of Cotton Fiber: Flat, Oval Lumen With Convolutions.

TYPES OF FIBERS: NATURAL FIBERS

Wool

Wool is used in an interior for upholstery fabric, wallcovering, drapery fabric, and carpets and rugs. Wool's aesthetic properties include its luster and warm touch. Wool fibers have a round cross-section and are short (staple length) with a natural crimp similar to curly hair. The surface of wool fiber is rough with overlapping scales. Wool fibers also have a low abrasion resistance and are not strong, but pills break off easily. Wool is highly elastic and resilient (due to its scaly surface). It is drapable, and naturally stain resistant due to a coating on the surface of the scales. Wool does absorb moisture, but in dry conditions, static can build up. Wool is not resistant to sunlight; white wool will turn yellow.

The scales on wool fiber make it highly insulative. It does not soften when exposed to heat, but will melt just enough to hold its shape. Because of its tendency to absorb moisture, bacteria can breed. Moths will eat wool; wool can also be damaged by strong laundry detergents.

When exposed to flames, wool reacts in several ways:

- Wool curls away from flames.
- When it ignites, wool burns slowly.
- When the source of flame is removed, wool stops burning.
- When burned, wool leaves a brittle, small, black bead.
- Burning wool smells like burning hair or feathers.

Silk

Silk in an interior is used for wallcovering, light-duty upholstery, decorative pillows, and lined drapery. Area rugs are sometimes made from silk. Because of its tendency to rot in sunlight, silk is not appropriate for most window treatments, although a lining can help protect the silk from sunlight. Silk is known for its characteristic shiny luster. Silk fibers are made up of the protein *fibroin*. Silk filaments can be up to two miles long. They have a triangular cross-section and smooth surface.

Silk is strong due to the length of the fibers and the fact that the fiber is composed of ordered polymer chains. However, silk is not particularly abrasion resistant. It is moderately elastic and does not stretch easily, but has enough resilience to recover from slight stretching. If kept clean, silk will resist moths. It is microbe and mildew resistant. Silk is not resistant to chemicals nor is it soil repellent.

When exposed to fire, silk will react in the following ways:

- Silk curls away from flames.
- Silk burns slowly and sputters when in flames.
- Usually silk will self-extinguish when the flame is removed.
- Burned silk leaves a crushable black beadlike residue.

Cotton

Cotton is the most widely used natural fiber, and in an interior, it is used for rugs, wallcovering, upholstery, and many household accessories, including table linens, toweling, and bedding. Cotton is often combined with other fibers such as polyester to take advantage of the properties of both fibers. Cotton has a cool, soft, pleasing hand with a luster that varies from matte to slightly lustrous.

Cotton fibers are staple length, ranging from less than 1 inch to 2½ inches long. The cross-sectional shape of cotton looks like a kidney bean with a hollow core called a **lumen**. Cotton fiber bundles called **fibrils** are tightly knit and twisted at 30-degree spirals, thus deflecting light rays and producing a matte luster. Cotton is fairly strong, with low to moderate elasticity. It is somewhat abrasion resistant. Cotton has poor resiliency and thus will wrinkle. Cotton's drapability depends on the construction of the final textile. The hollow cross-section makes cotton fibers absorbent and *wickable,* meaning that moisture moves quickly along the

fiber surface and thus evaporates quickly. Cotton is flammable, and therefore is often treated with flame-retardant chemicals. Cotton is somewhat resistant to sunlight.

When a flame approaches, cotton will react in the following ways:

- Cotton ignites on contact.
- Cotton burns quickly without melting.
- Cotton continues to burn with an afterglow when flames are removed.
- Cotton leaves a light, feathery ash, light gray to charcoal in color.
- Burning cotton has an odor similar to burning paper.

Linen

Linen is sometimes referred to as *flax fiber* to distinguish it from *linens*, referring to household textiles such as sheets, towels, tablecloths, and napkins, all originally made from linen. Linen is used for upholstery, drapery, and household textiles. Linen toweling is very absorbent, but it is too rough for bath towels. Linen has a matte luster, but is more lustrous than cotton. It is cool to the touch and has a smooth appearance.

FIGURE 12.22 Cross Section of Flax Fiber: Polygonal Lumen.

Linen fibers are long, with highly oriented polymer chains, and an irregular many-sided cross-section with a hollow core. Linen is strong but brittle; it is stiff, does not drape well, and the fibers break easily. Linen's abrasion resistance is low, but not as low as that of wool and silk. Linen has poor resiliency, so it has a tendency to wrinkle. It has high wickability and is quick-drying. Because it is smooth, linen does not attract lint. Linen is comfortable because it does not conduct heat and there is no static buildup. Linen is characterized by two fiber lengths. *Tow fiber* is less than 1 foot long, resulting in dull luster and low abrasion resistance. *Line fiber* is from 1 to 2 feet long and is more durable and smooth. Sunlight does not rot linen, which makes it a good choice for drapery in spite of its stiffness.

Linen is flammable. When approached by flame it reacts in the following ways:

- Linen ignites on contact.
- Linen burns quickly without melting.
- Linen continues to burn when the heat source is taken away.
- Linen leaves a light feathery charcoal-colored ash
- Burning linen smells like burning paper.

Leather

Leather is not a fiber; rather, it is the skin of an animal, usually a cow. Other animals that are used for their skin include pigs, lambs, and reptiles. The skin of the animal is treated with a chemical to make it pliant in a process called *tanning*. The resulting piece of leather, a hide, is a flexible plane, and thus is considered a fabric. Thick hides are split and divided into layers. The top grain is the outer layer and will show marks such as scratches from barbed wire. Full grain leather is thicker. Leather can be natural or dyed.

In an interior, leather is used for upholstery and to make accessories such as desk pads. Being a natural material, leather breathes, making it comfortable as well as durable.

Leather was an early wallcovering, with Moroccan leather used to cover walls in eleventh-century Europe and in seventeenth-century Holland. Today, leather is rarely used as a finish, with the exception of leather floor tiles—a specialty item that should be used in areas that do not receive a lot of foot traffic. Leather can also be applied to walls.

MANUFACTURED CELLULOSIC FIBERS

From the late 1800s to the early 1900s, inventors searched for a substitute for the highly desirable but expensive fiber, silk. Rayon, the result of several years of research, was named in 1920. Acetate and triacetate were produced in 1924, and lyocell was developed in the early 1990s.

Rayon

Rayon can be produced with a luster and sheen similar to silk, but it can also be engineered to resemble cotton by cutting the fibers to staple length and spinning. In an interior, rayon is often blended with other fibers to make fabrics for upholstery and drapery. Rayon may also be used for wallcovering.

Rayon has a negative environmental impact. The wood pulp used as a raw material is often clear cut from mature forests. The process of making rayon uses lots of water that is polluted with acids and chemicals. The reason rayon is desirable is that it is cheap—an advantage that is lost when the methods of production are improved.

Rayon will burn. When approached by flame, rayon will react in the following ways:

- Rayon burns quickly without melting.
- Rayon continues to burn after the source of flame is removed, referred to as *afterglow.*
- Rayon leaves a small amount of light fluffy ash.
- Burning rayon smells like burning paper.

Lyocell

Lyocell is considered a sustainable alternate to rayon. It is made from fast-growing, renewable eucalyptus trees and is solvent spun, which uses fewer hazardous chemicals. The solvents can be recycled. Because lyocell is manufactured from pure cellulose, it has similar characteristics to cotton, including strength, absorbance, and a pleasing touch.

Acetate and Triacetate

Acetate, developed in 1924, and triacetate, developed in 1954, look and feel like silk. They are used in interiors for drapery. However, pollutants and air contaminants result in a phenomenon called *gas fading,* which causes dyes to change colors. To counteract this effect, acetate and triacetate are often solution dyed. In addition, acetate and triacetate fibers are very heat sensitive and will rot as they wear out.

SYNTHETIC FIBERS

Synthetic fibers are stronger than natural fibers, are less expensive to produce, and can be engineered to have the desirable properties of natural fibers. The major synthetic fibers used in an interior are acrylic, olefin, polyester, and nylon. Other synthetics have limited or specialty use and include *aramid*, modacrylic, saran, and spandex. Aramid produces a strong textile that has high temperature and flame resistance. It is used in aircraft upholstery and carpet. *Modacrylic* was developed for flame resistance for similar purposes. Some residential scatter rugs are made from modacrylic. *Saran* is used to make webbing for patio chairs or upholstery for public transportation. Products made from saran are resistant to chemicals, water, mildew, and sunlight. *Spandex* is an elastomeric fiber and is a component of upholstery fabric developed for curved forms.

Nylon

Nylon was the first truly synthesized manufactured fiber, used first for toothbrush bristles in 1938, then for women's hosiery just before World War II. As a fiber, nylon is extensively used in clothing, but in an interior, nylon is primarily used for carpet and upholstery. Nylon has been engineered for use as a carpet fiber because it has more covering power than polyester, and thus is less expensive. When used as an upholstery fabric, nylon is often blended with wool. Nylon's high strength complements wool's otherwise desirable characteristics, and typical blends may be 80 percent wool/20 percent nylon carpet, or 90 percent wool/10 percent nylon upholstery. Because its properties are engineered, nylon can be rough to smooth, shiny to matte. Because it is often solution dyed, the colors are sometimes limited. Because nylon is used for carpet, many modifications have been made to make nylon more suitable for carpet fibers. There are two types of nylon. Type 6 is made from a single monomer, caprolactum.

Type 6,6 is a co-polymer made from adipic acid and hexamethylene diamine. Shape modifications, such as the trilobal shape, help hide soil. Nylon carpet fibers are also modified in the solution stage by adding fluorocarbon compounds that make it soil repellent.

Nylon can be recycled, but of the interior textile products made from nylon, carpet is most often recycled. Carpet made from type 6 nylon is more easily recycled into carpet again than carpet made from type 6,6 nylon. Many carpet manufacturers have developed carpet recycling programs, taking back used carpet to recycle into carpet or into other products.

Nylon fiber has excellent abrasion resistance, but pills cling and won't break off. Nylon is very strong and has good chemical resistance. Static buildup is a problem, however. Because of low moisture regain, electrons build up. The only fibers with lower sunlight resistance than nylon are silk and wool. Thus, sunlight can damage textiles made of nylon. Engineering the fiber can control the elasticity, the stiffness, and resistance to mold and mildew. Heat setting can improve resiliency. The trilobal shape and the micro-rough surface reduce soil adhesion. When nylon is produced for carpet fiber, agents are added to the polymer solution to make it mold and mildew resistant.

Nylon is considered flammable. When flames approach, nylon has these reactions:

- Nylon fuses and shrinks away.
- Nylon burns slowly with melting in the flame.
- After the source is removed, nylon usually self-extinguishes.
- The residue of nylon is a hard, tough, round, gray bead.
- Burning nylon smells like celery.

Acrylic

Acrylic fibers date to 1950. Acrylic is engineered to imitate wool, but with several advantages. Acrylic can be laundered and it resists moths, carpet beetles, and outdoor elements, including sunlight damage. Textiles made from acrylic are used for awnings and to upholster outdoor furniture. Acrylic is blended with nylon and wool to create upholstery fabrics. It is also used for residential carpet, but it is not as strong as nylon. It has a lower melting point than nylon, and so tends to look dirty when the fibers are actually slightly melted.

Acrylic is also used to coat other fabrics so they can be applied directly to the wall as wallcovering. Acrylic adds stability to fabrics used for upholstery. Acrylic foam backing is applied to drapery for insulation. Also, acrylic fibers are produced by synthesizing monomers of natural gas, air, water, and petroleum. The resulting polymer solution includes additives that engineer desired qualities. Acrylic filaments can be either dry or wet spun. The properties of acrylic are similar to those of nylon.

Acrylic is flammable. When flames approach, acrylic will react in the following ways:

- Acrylic fuses and shrinks away.
- Acrylic in flames burns and melts.
- When flames are removed, acrylic continues to burn with melting.
- The residue of acrylic is a brittle, irregular-shaped black bead.
- The odor of burning acrylic is acrid.

Polyester

Nylon is the synthetic fiber that dominates floorcovering because its low specific gravity led it to be engineered for that purpose. Polyester, however, dominates everything else. Polyester was developed in 1953 and is similar to nylon in that it is a co-polymer. Polyester is melt spun; thus, properties can be engineered by controlling the shape of the fiber. Strength, elongation, abrasion resistance, resiliency, and dimensional stability are all engineered by modifying the fiber's cross-sectional shape. The fiber is often blended with cotton and rayon. In an interior, polyester is primarily used for upholstery. Polyester is unique in that it can be easily recycled, and polyester fabric can be made from recycled plastic bottles. The solvents used in the polyester extrusion process can be reused. Polyester can be engineered to imitate various fibers, such

as cotton, linen, and silk. *Trevira* is a tradename for a polyester product that was engineered to imitate the luster of silk, but it is now considered a unique fiber.

The cross-sectional shape of polyester fiber is round and hollow. Polyester microfiber has been engineered with a very fine cross-section. The fiber can be engineered to improve durability. Polyester is not as strong as nylon, but its excellent abrasion resistance is only slightly less than that of nylon. Polyester has excellent resiliency, as well as heat and sunlight resistance, but may allow static buildup.

Polyester is flammable. When flames approach, polyester reacts in the following ways:

- Polyester fuses and shrinks away from flames.
- Polyester burns slowly and melts.
- Polyester is usually self-extinguishing.
- Polyester leaves a hard, tough, round, black bead.
- Buring polyester has a chemical smell.

Polyolefin

Polyolefin, developed in 1961, is also known as olefin. Two plastic solutions can be used to make polyolefin fibers: polyethylene and polypropylene. The polymer chains are held together by crystallinity alone, which means textiles made of polyolefin are difficult to dye. Thus, polyolefin is usually solution dyed. It is used for wallcovering and carpet. Because polyolefin is microbe resistant, it has replaced jute for carpet backing. Polyolefin fibers are melt-spun. The fabric has a smooth, waxy hand, with a medium luster. Textiles made of polyolefin can be recycled.

Polyolefin has high covering power because of its low specific gravity. Thus, polyolefin fibers are inexpensive. The level of elasticity and the drapability of polyolefin can be controlled with engineering. Polyolefin fibers have a round cross-sectional shape. The fibers can be produced with a very fine denier, which improves the drapability of textiles made of Polyolefin.

Polyolefin is strong and has good-to-excellent abrasion resistance. It wicks moisture away from surfaces and is not prone to static buildup. However, several characteristics of polyolefin are problematic. Even though polyolefin is inherently stain repellent, it is highly oleophilic and any oil-based products will stain. Because it is highly sensitive to heat and melts easily, textiles made of polyolefin may appear dirty when the heat of abrasion has actually melted the fibers. Polyolefin does not absorb moisture, is difficult to dye, and has low sunlight resistance.

Application: Using Information Regarding Interior Finish Materials

CODE ISSUES

Textile Products and the ADA

Textile products used on floors have an effect on accessibility—for example, excessive carpet pile height can be a barrier to a person in a wheelchair. Carpet and padding cannot be too thick or too loose. Carpet must have low pile and tight weaves and must be securely fastened at the edges. Also, area rugs in public spaces can cause hazards for people with disabilities. A designer can use an area rug if it is inset, so that the surrounding surface, such as wood, is level with the carpet.

Textile Products and Fire

Textile products react differently to fire, depending on their fiber content. Some natural fibers and some synthetic fibers are highly flammable. Fibers with a high cellulosic content will burst

Case STUDY *of Textiles Used in an Interior*

Plymouth Day Care

Architect: Schaefer Johnson Cox Frey Architecture; Interior Designer: Heather Hatcher

Bolyu carpet tile was chosen for this church preschool for its aesthetic appearance as well as its performance characteristics. The carpet is designed to reduce odors; and because it is solution dyed, chemicals such as bleach can be used when it is necessary to disinfect the carpet or to remove stains. The bright colors in a field of gray add desirable color and continue a design concept that uses colorful squares. Colorful carpet tiles are also used to define spaces, creating the effect of an area rug.

FIGURE 12.23 Colorful Carpet Tiles Create a Reading Rug at Plymouth Preschool. Photograph courtesy Dana Hetrick, Bolyu.

FIGURE 12.24 Carpet Tiles Add Color Accents That Continue a Design Theme Using Colorful Squares. Photograph courtesy of Dana Hetrick, Bolyu

into flame in the presence of a heat source and oxygen. Some synthetics may spontaneously burst into flame in the presence of heat, which is why latex items should not be put into a clothes dryer. Other synthetics smolder, resulting in dense smoke, or they continue to glow and potentially burst into flame again after the heat source is gone. Some synthetic fibers are less likely to burn, but when ignited, they are perhaps more dangerous because they can give off toxic gasses and smoke, or melt and drip onto other flammable materials. Thus, interior textile products must undergo rigorous testing. Textiles used as wallcovering must pass the Steiner Tunnel Test, receiving Class A, B, or C rating. Textiles used as draperies in certain applications, such as hotels, must pass the Vertical Flame Test (NFPA 701). Carpeting must pass the Radiant Panel Test as Class I or II, and must pass the Methenamine Pill Test.

SPECIFYING

All interior surfaces can have textile products applied as finishes. Each surface has different performance and code requirements, and the key to evaluating and specifying appropriate textile products for the interior is to understand the properties of the fiber itself. Labeling is, of course, the primary method of identifying the fiber content of a product. Most, if not all,

Fibers Used in an Interior

Floors
Area rugs
Scatter or throw rugs
Broadloom carpet
Carpet tile
Leather floor tiles

Walls
Fabric wallcovering
Fabric-wrapped panels
Fabric-upholstered walls

Ceilings
Fabric-wrapped ceiling tiles
Acoustical ceiling panels

Household Textiles/Kitchen and Bath
Toweling
Table linens: table cloths, runners, and napkins
Bedcovers: mattress pads, sheets, pillow covers, blankets, comforters, and quilts
Throws
Wall art (artisan techniques)

Accessories and Trim
Trim applied to textile products, such as braid and fringe

Furniture
Upholstery
Cushion covers and pillows

Window Treatments
Curtains
Drapery
Shades
Blinds

Coatings
Acrylic backing on fabrics used for wallcovering
Protective coatings

Composite or Cross-Over Uses
Fiberglass: glass fibers in polymer resin or glass fiber textiles
Hardware cloth (metal screens)

product labels clearly state the percentages of each type of fiber in a product. Visual characteristics are helpful, but if labeling is not present, burn tests or lab tests can help identify the product.

The Association for Contract Textiles (ACT) is a trade organization that voluntarily sets standards for textiles used in contract interior applications. Fabric manufacturers that are part of the association use ACT labels to indicate that the textile complies with standards and the performance ratings of the product. The ACT labels use five symbols to indicate that the textile product has met standards and passed safety and performance tests. It is important to consider the intended end-use of the textile. Different surfaces require compliance with different tests and performance requirements may vary depending on the surface. The following text provides more specific labeling information.

Abrasion

Abrasion or rubbing against the surface can wear out a fabric. This is an important consideration for upholstery fabrics as well as for some applications of wallcoverings. The standard that applies is ASTM D4157, and the test most often used is the Wyzenbeek Test, although a similar test, the Martindale Method, is sometimes used. The Wyzenbeek machine measures a cycle of back and forth rubbing using #10 cotton duck to rub the fabric being tested, a process referred to as "double rubs." The fabric is subjected to double rubs until it breaks or shows noticeable wear. General contract upholstery must survive 15,000 double rubs; heavy-duty upholstery must survive 30,000 double rubs.

Colorfastness to Light

Upholstery, direct glue wallcoverings, wrapped panels and upholstered walls, and drapery are all required to retain their color when exposed to light. The ACT standards require that fabric used for drapery resist light for 60 hours and fabrics used for the remaining categories retain their color for 40 hours. The test method is developed by the American Association of Textile Chemists and Colorists (AATCC) and involves masking a portion of the textile, exposing the unmasked portion to light for the predetermined amount of time, and then measuring the color change.

Flammability (the measurement of a fabric's performance when it is exposed to specific sources of ignition)

Wet and Dry Crocking (transfer of a dye from the surface of a dyed or printed fabric onto another surface by rubbing)

Colorfastness to Light (a material's degree of resistance to the fading effect of light)

Physical Properties (Pilling, Breaking Strength, and Seam Slippage)

General Contract Upholstery Heavy Duty Upholstery
Abrasion (The surface wear of a fabric caused by rubbing and contact with another fabric)

FIGURE 12.25 ACT Label Symbols.

These marks are Registered Certification Marks at the US Patent and Trademark Office and are owned by the Association for Contract Textiles, Inc.

Flammability Standards

Upholstery must meet flammability standards set by California Technical bulletin #117. Direct glue wallcoverings and wrapped panels and upholstered walls must meet the standards set by ASTM E-84-03, which use the Room Corner Test and the Steiner Tunnel Test. Drapery may be required to pass NFPA 701, which uses the Vertical Panel Test.

Physical Properties

Physical properties are also measured by various ASTM standards. Upholstery fabrics must pass ASTM D3511 Brush Pill Test, which measures the formation of pills—those fuzzy balls that form on a surface and sometimes remain attached. Upholstery and fabric-wrapped panels or upholstered walls must pass ASTM D5034 Breaking Strength, which measures the stress required to pull the fabric apart. The tendency of fabrics to pull apart at the seams is tested for upholstery by ASTM D4034 Seam Slippage and ASTM D3597-02-D434 for Drapery.

Wet and Dry Crocking

When a printed or dyed fabric is rubbed against another surface, the dye should not transfer to that surface. Wet or dry crocking tests fabric, both wet and dry. The test used is AATCC 116 – 2001. Upholstery is held to a slightly higher standard than the other applications of fabric, Grade 4 for dry crocking. Fabric for other applications must meet Grade 3 for both wet and dry crocking.

In 2003, ACT formed an environmental committee to develop universal standards for environmental attributes of textiles, including fiber sourcing, safety of materials, water conservation, water quality, air quality, energy use, and recycling.

The following CSI Masterformat divisions have sections that assist in specifying fiber products:

Division 09: Finishes

Division 12: Furnishings

EVALUATING TEXTILES

Aesthetics

Many of the surfaces in an interior that are covered with textiles are also surfaces with which we have physical contact, from sitting on upholstered furniture, to walking barefoot across a bedroom carpet, to using one's hands to open the drapery in the morning. The tactile feel of the textile product is an important aesthetic consideration. How does the fabric feel to the touch? Is it warm, cool, rough, or smooth? Is the textile flexible or stiff?

The appearance of a textile is often judged by the amount of luster, sheen, or shine. In addition to luster and feel, the design of the textile includes color and pattern as well as texture.

Textiles are considered less permanent than other finish materials; consequently, they are more fashion driven. The designer must choose appropriate styling—for example, plain or trimmed with decorative elements, traditional or contemporary. The design must also consider the desired life expectancy of the fashion-driven features of the product.

Durability

Knowledge of the performance characteristics of the fiber content, knowledge of the impact of construction methods, and knowledge about dyes and finishes, as well as evaluating the textile based on label information, will help determine if the product will wear well and retain its appearance over time.

Maintenance

Knowledge of the performance characteristics of the fiber content and reading care labels will help the designer determine the type and amount of maintenance required for a textile product. The designer must determine if the textile can be cleaned, and if so, the cleaning

methods that can be used. The schedule of cleaning required is also a key factor in selecting a textile product.

APPLYING TEXTILES IN AN INTERIOR
FLOORS

Carpet and Rugs

The earliest floorcoverings were made of textiles. Nomadic people could easily pick up and move the animal skins and rugs woven from felted animal fur or plant fibers that were used to cover dirt floors. Discoveries of ancient rugs show a well-developed sophistication of color and pattern. An example is a rug found in a tomb in Siberia, dated to the fifth century B.C.E. This rug was preserved in ice for 2,500 years. The sophisticated pattern and rich color suggest that the techniques had developed over many years. Today, carpets and rugs add sound absorption, insulation, color, and comfort to floors.

Textile floorcoverings include carpet, rugs, and walk-off mats. *Carpet* generally fills a room or large area, installed *wall-to-wall*. Most carpet is produced by tufting; a small percentage is woven; and some carpets are produced by alternate methods such as fusion bonding, knitting, or needlepunching. Carpet may be *broadloom*, woven on a loom or tufted on a machine that is generally 12 feet wide, although it can be made on larger or smaller looms. Some woven carpet is still produced on 27-inch wide looms; the strips are then hand sewn together to create a room-sized installation. *Carpet tile* is produced by tufting or alternate methods such as fusion bonding, and then it is cut to modules, usually 18 inches square, although tiles up to 36 inches square are intended to be used in large spaces such as hotel ballrooms. Carpet tile can be installed to fill a room or to create area rugs. *Rugs* are differentiated from carpets by their smaller size and by the fact that they do not cover an entire floor. Small *scatter rugs* are used in residences for decorative and functional purposes, such as near entrances to wipe feet or to catch and absorb moisture as a bath mat or kitchen sink rug. *Area rugs* are used in both residential and commercial applications to add softness and texture to a room that has hard-surfaced flooring as well as to anchor seating arrangements. Area rugs are generally not attached to the floor and thus can be moved. Area rugs may be manufactured or hand-made in standard sizes. Alternatively, the designer may choose to design an area rug that meets specific requirements by having broadloom carpet cut to the desired size and the edges finished. *Walk-off mats* are designed to be used at the entrance of the building. The texture of the mat collects soil before it can be tracked inside.

Nylon is the primary fiber used for commercial carpets due to its strength, resilience, and low specific gravity, which translates to less cost. Nylon has been engineered to perform as carpet fiber, incorporating soil-hiding features and static resistance. Polyester and acrylic fibers are used for light-duty commercial and residential carpet. Polyolefin is used for commercial as well as residential carpet, but it does not perform as well as nylon. Area rugs and some carpet for residential use can be made of natural plant materials such as sisal and coir. Wool is highly valued for residential carpet and rugs as well as commercial installations that require the combination of wool fiber with woven methods for durability and pattern. Wool, silk, and cotton as well as other fibers are used for area rugs. Walk-off mats can be made of natural fibers such as cocoa fiber or coir, or a synthetic product such as carpet tile made from rough-textured fiber designed to catch dirt before it gets to the room.

Tufted Carpet

Tufting grew out of the concepts associated with hooked rugs and candlewicking, both of which used a hook or needle to push yarn through a woven backing and knot the yarn into place. Machines that produce tufted carpet were developed in the 1930s. The speed at which carpet can be tufted revolutionized the carpet industry. Today, 90 percent of all carpet sold in the United States is tufted. Tufting carpet begins with a woven or nonwoven primary backing. Originally made of jute, backings are now made of synthetic fibers such as polypropylene or polyolefin because of their low cost and resistance to moisture and microbes. The tufting

machine has hundreds of needles across the width of the loom, each of which pushes the yarn through the backing, where it is held at a predetermined height by a hook. The hook may have a knife that cuts the yarn to create cut pile carpet, but otherwise the yarn is left as a loop. A latex coating holds the yarns in place and the entire piece is further reinforced and stabilized by applying a secondary backing. Tufting methods are used for both broadloom carpet and carpet tile. Tufted carpet can be loop or cut pile, or a cut and loop combination. Pile height can vary. Pattern can be created by using variegated colored yarns or the finished carpet can be overprinted using a process that injects dye into the yarn. Due to the developments in computer-aided design, a wide range of patterns are available and custom pattern variations are common.

Fusion Bonded

Fusion bonding is a method of adhering short fibers to a backing using electrostatic methods and adhesive. A secondary backing is applied. Fusion bonding may be used for walk-off mats and rugs. Due to its durability, fusion-bonded carpet tile may be used in areas that receive a lot of traffic.

One version of fusion bonding has been used to manufacture carpet tile. The fibers are sandwiched between two backing layers, which are cut apart to create two separate pieces of fiber-covered material. To make carpet tile, the pieces are then cut into square modules.

Woven Carpet and Rugs

Woven carpet is more expensive than tufted carpet, taking much longer to produce. Woven carpets make up about 2 percent of the carpets sold in the United States. Although some manufacturers produce a competitively priced woven nylon commercial-grade carpet, weaving is usually reserved for more expensive residential carpet made of wool or wool/nylon blends. Woven wool or wool/nylon carpet is also valued by high-end hospitality installations for the durability of the fiber as well as the ability to create large-scale, soil-hiding patterns.

The earliest floorcoverings were woven, and early woven rugs made from cotton or wool had sophisticated patterns and colors. Oriental rugs made in mid-eastern and eastern countries, including Turkey, Pakistan, Tibet, and China, continue a centuries-old tradition of hand-made rugs. True Oriental rugs are handwoven on a vertical loom, with pile yarns knotted into a woven base of cotton or wool, using richly colored wool, silk, or other natural fibers in complex symbolic patterns. The rugs are extremely dense, durable, expensive, and valuable, whether they are new or antique. Other areas of the world have traditional methods and styles of making rugs. *Rya* rugs from Scandinavia and *Flokati* rugs from Greece are types of woven long-pile rugs. Flat woven rugs include cotton *dhurries* from India and Persian prayer rugs, or *Kilims*. Native Americans also produce flat woven wool rugs. Machines can now duplicate the appearance of traditional Oriental rugs or have unique and contemporary designs. England developed and refined *Wilton* and *Axminster* weaving methods in the 1880s. Marshall Field of Chicago founded Karastan in 1928 to make machine-woven, Oriental-style area rugs.

Weaving means the warp and the weft or face and backing of a carpet are created simultaneously. As quality assurance, latex may still be applied to the back of the woven carpet for stability. The three most common methods of weaving carpet are velvet, Wilton, and Axminster.

A **velvet** weave is the simplest method of weaving carpet. Velvet carpet construction is similar to the method of weaving velvet pile fabric. The pile yarns are lifted from the surface of the warp and weft using wires. The warp rows hold the pile fibers in place. The wires are removed after weaving, leaving the looped surface of yarn in place, but they can be used to cut the loops, creating cut pile carpet. The carpet is generally a solid color unless variegated yarns are used.

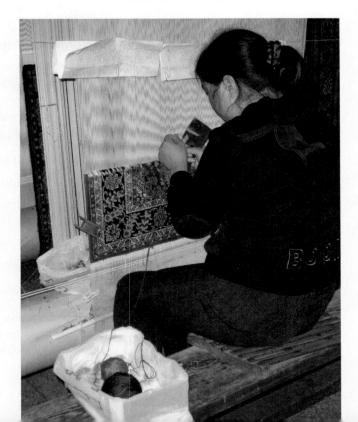

FIGURE 12.26 Hand Weaving a Rug on a Vertical Loom. Thomas Barrat/Shutterstock

Wilton machines have a Jacquard attachment that can be used to create woven patterns with up to six colors. The yarns are carried along the back of the carpet and pulled by the Jacquard attachment to the surface when that color is needed to become part of the pattern. Wilton rugs are dense and strong. *Brussels* is a version of Wilton that has a loop pile construction.

Axminster rugs and carpets allow a broad range of patterns and can imitate Oriental rugs or tapestries. Axminster looms use many spools of yarn that are brought into the rug when they are needed to create the pattern. Axminster can be differentiated from Wilton by rolling the edge. A Wilton can be rolled from either direction; an Axminster can be rolled only from the lengthwise direction. An Axminster rug will have a level cut pile, with a thick surface that resembles a hand-knotted rug. Preparing the loom takes a long time, but the actual weaving is relatively quick.

Other methods of producing carpet include the following:

- **Flocking:** Fibers are sprayed onto a latex backing.
- **Needlepunching:** Needles punch yarn through a base material. This method is used for indoor/outdoor carpet because the backing is porous.
- **Knitting:** Knitted yarns are adhered to a backing.
- **Chenille**: Two looms are used. A chenille blanket is woven on the first loom, and then cut into strips. The strips are then used to weave carpet. Chenille carpet is luxurious and expensive.
- **Hand or Artisan Methods**: Methods include knotting, braiding, and hooking, usually used for decorative rugs.

Carpets are also categorized by the character of the yarns used in their construction:

- *Velvet,* when it does not refer to a weaving process, is a description of plushness. Velvet yarns have a slight twist.
- *Saxony* carpet is made with slightly longer yarns that have a tight twist, but are level.
- *Friezé* uses tightly twisted yarns that curl randomly. Friezé carpet is textured and uneven.
- *Berber* refers to a tight-level loop carpet.
- *Cut and Loop and Multilevel Loop* use loop variations to create patterns controlled by a computer.

Performance Criteria for Carpet

The interior designer will choose carpet based on its intended use. Light-duty uses may be commercial or residential. Most carpet must be medium- or heavy-duty carpet. Stairs require more durable carpet. A simple way to evaluate carpet is to bend it as it would bend on a stair nosing. If you see backing through the yarn, the density is inadequate.

The quality of carpet is determined by the following factors:

- The quality and appropriateness of the fiber
- The thickness (denier) and twist of the yarn
- The length of the yarn (Bulked continuous filament nylon [BCF] provides the strength of a long filament fiber with the aesthetic and hand characteristics of a staple fiber.)
- The ability of color and pattern to hide soil
- The height of the pile, a factor to consider along with the density of the pile

The following measurements are used to evaluate the quality of carpet:

- *Gauge* is the distance between needles. For tufted carpet, ⅛-inch gauge means there are eight needles per inch. Gauges of ⅛-inch or ¹⁄₁₀-inch are considered good quality for commercial installations. The term for a similar measurement for woven carpet is *pitch,* the number of ends of yarn in a 27-inch width.

- *Stitch rate* for tufted carpet refers to the number of stitches per inch in the longitudinal direction as the carpet moves through the tufting machine. The corresponding measurement for woven carpet is rows per inch.
- *Pile density* is measured in ounces per square yard. Pile density measures the average weight of the yarn on the face as well as the portion of the yarn buried in the backing.
- *Face weight* is the weight of the yarns in the carpet exposed on the face of the carpet, also measured in ounces per square yard.
- *Tuft bind* refers to the strength of attachment of yarns to backing.

Carpet Cushion

Carpet will last longer and feel more comfortable if it is installed with a proper underlayment, referred to as *pad* or *cushion.* Options are waffle foam, slab rubber, foam padding, and hair and jute fiber. The type of pad most commonly used is called *rebond* and is made from scraps of high-density foam bonded together. Rebond pad is measured in pounds per cubic foot and thickness. A 6-pound, ⅜ inch thick rebond pad is a typical size. Another option is to use a frothed foam pad, 5⁄16 inch thick. This type of pad is durable and does not emit VOCs.

Carpet Installation Methods: Broadloom

Broadloom carpet may be applied directly to the floor using adhesive. The carpet may or may not be backed with an integral pad. This method of installation, referred to as **direct glue**, is the most common method of installing commercial carpet. Adhered carpet will withstand the effects of rolling carts and foot traffic. Surface preparation is extremely important because imperfections in the floor can be telegraphed through thin carpet.

For high-traffic installations, an installation method called **double glue** is preferred. Using a special pad, carpet is adhered to the pad and the pad is adhered to the floor.

Stretched in or **tackless** installation is the traditional method of installing broadloom carpet. Thin wood strips that have metal teeth embedded in them are nailed or glued to the perimeter of the room. Carpet cushion is laid within the area of the strips. The carpet is stretched into place using a power stretcher or a knee kicker. The carpet is trimmed and tucked behind the strips. The teeth hold the carpet in place. This installation can be problematic if carts or chairs roll over the carpet or if the carpet is very stiff.

Carpet Installation Methods: Carpet Tile

Planning the layout of carpet tiles is similar to designing floor patterns using hard-surfaced flooring. The installation should be planned from the center of the room working out. Carpet tiles allow the option of using color and pattern to create many possible design variations, including a monolithic look that aligns pattern direction or intentionally emphasizing the fact that the floor is modular by turning each tile in a different direction. Usually, the adhesive is applied at the perimeter. In a large installation, additional adhesive is applied in a predetermined grid; however, most tiles are not adhered to the floor but held in place by surrounding tiles. Individual tiles can be removed or replaced.

Carpet Installation Specifications

The designer should request seaming diagrams and review them for efficient layout of the carpet. Seams should be in areas that are less visible and receive less foot traffic.

The contractor should be required to inspect the subfloor for the following conditions:

- Concrete must be cured, clean, and dry. Chemicals used to clean the floor must be removed.
- Wood floors must be smooth and the underlayment must be secure. Check the effect of adhesive on previously painted floors.
- Cracks must be filled. In glue-down installations, imperfections can show through the carpet.
- Check for moisture and install only when the temperature and humidity conditions are appropriate.

Maintaining Carpet

Regular vacuuming is essential because when dirt and grit are allowed to remain on carpet, the fibers will be abraded, and the carpet will wear out faster. Spills should be cleaned immediately. Liquid will remain on the surface for a short time and can be soaked up with a clean cloth. The manufacturer can provide further cleaning instructions, which should be followed.

Environmental Impact of Carpet

The large quantity of used carpet that is sent to landfills each year is a growing problem. This can be addressed in several ways:

- Make carpet last longer. The use of carpet tiles is one way to extend the life of carpet, since individual tiles that are damaged can be replaced without replacing the entire floorcovering.
- Choose manufacturers that take old carpet back.
 - The nylon can be converted back to raw material and used with new plastic to make such products as outdoor furniture, used as an ingredient in concrete, or be recycled to make carpet pads.
 - Nylon can be recycled into nylon that can be made into new carpet. Type 6 nylon can be infinitely recycled.
- Choose carpet made from recycled materials.
 - Nylon carpet can be recycled, and many carpet companies have programs to take back used carpet for recycling.
 - Polyester and some nylon carpet may be made of recycled plastic bottles, but polyester is not durable enough for commercial use.

The adhesives used to apply carpet backing and to install carpet can have a negative environmental impact. Chemicals added to carpet to increase soil resistance and microbe resistance can add to the emission of volatile organic compounds, and they will not dissipate as other VOCs might. Carpets can also act as a "sink" and accumulate VOCs from other sources. Several methods of limiting the potential harmful gasses when installing carpet are:

- Use carpet tile because it requires less adhesive to install. Use perimeter glue methods, which do not require every tile to be adhered.
- If using broadloom, roll out the carpet in a garage or warehouse, allowing fumes to dissipate before installation.
- Dirt and dust can be trapped in carpet, which may be a problem for people with allergies. In some instances, carpet may be the wrong selection. Otherwise, careful and regular cleaning is required.
- Choose a low pile height that avoids some of the VOC accumulation.

WALLS

Applying textiles to walls is as old as hanging tapestry or fur on the wall for color and warmth. Wallcoverings can be made of any planar material, including wood veneer, paper, vinyl, or thin sheets of metal. However, fiber products or textiles are often applied to a wall in order to add texture as well as color or pattern. Depending on the type of textile and the method of installation, fabric wallcoverings may add insulation and acoustical absorption. Textiles on walls may also cover imperfect substrates, such as rough plaster or concrete masonry units. Natural fiber textiles such as silk, linen, and wool are used for their quality and aesthetics. Fabrics can be applied directly to the wall with adhesive, wrapped around a substrate that is then applied to the wall, or applied using upholstery-like attachment techniques.

Direct Glue Wallcoverings

Several types of fiber products are produced to be applied directly to the wall with adhesive. Natural plant fibers are used to make grass cloth, a type of wallcovering that uses grasses woven with thin yarns and adhered to paper backing. Because the grasses have natural variations and are usually applied to the backing horizontally, seams will always show and should be considered a feature of the product. Similar products include string cloth, which uses decorative yarns or strings applied to paper backing. String cloth wallcovering can have less obvious seams because the strings are applied lengthwise to the paper backing. Other decorative yarns may be woven specifically for wallcovering and manufactured using paper backing for wallpaper application.

Natural fibers, such as linen or silk, are often woven into a textile and produced with backings for installation as wallcovering. Synthetics that have similar aesthetic qualities or their own unique qualities are also used. Polyolefin is a fiber that is used to produce a wallcovering that is less expensive than linen, and is cleanable. Other fibers used as wallcovering may be treated with a soil-repellent finish or clear coating. Glass fiber is used to make wall liners that bridge imperfections and can be painted.

Almost any fabric can be applied to the wall if it meets certain conditions. The fabric must be dimensionally stable so that it does not shrink or stretch when exposed to changing levels of humidity, although backing will add stability. Loosely woven fabrics, regardless of fiber content, may not be appropriate. Patterns that require extra attention to matching seams, such as plaids and horizontal stripes, are not recommended. The fabric must meet flame-spread ratings appropriate to its use, and it must be backed with the appropriate backing

FIGURE 12.27 Textile Wallcovering: Carnegie Xorel "Tweed/Strie".
Mike Cohen/Shutterstock

for direct application. Standard backings that can be applied include paper, woven or non-woven fabric such as scrim, acrylic foam, and a light acrylic coating. The interior designer should consult with the manufacturer to determine the best approach, but a light acrylic can add dimensional stability, prevent adhesive from transferring to the surface of the material, and allow the flexibility to adjust the fabric as needed during installation.

Most textile wallcoverings can be vacuumed and spot cleaned. Textile wallcoverings are generally not used in high-traffic areas, so abrasion may not be a problem. However, installations such as hospital and hotel corridors are subject to the abrasion caused by luggage carts and hospital gurneys. Polyolefin wallcovering may be cleanable with bleach and extremely durable and cost effective, but polyolefin's low melting point means that the fibers will appear dirty when they have simply melted under abrasive conditions. The areas that are likely to be abraded can be protected with trim or moldings that withstand abuse.

Wrapped Panels and Upholstered Walls

Panels of acoustical and/or tackable material can be wrapped with fabric and then adhered to the wall using a variety of mechanical attachment methods. Tackable panels may be small and serve as bulletin boards. Panels can have a layer of fiber batting applied to the substrate before the fabric is stretched over the surface and thus add to the sound-absorbent properties of the room. The fabric chosen to wrap tackable panels should have a weave that allows thumbtacks to push through without destroying the fabric. The design and layout of panels should be planned in a similar manner to planning the layout of wood paneling, with elevations drafted to indicate the size and location of panels. Fabric-wrapped acoustical wall panels can also be purchased as units from several manufacturers.

Walls may be *upholstered* with fabric. The fabric is applied to the wall without using adhesives. To cover large wall areas, fabric widths may be sewn together. Textiles used for

upholstered wall installations must be dimensionally stable to avoid sagging under varying conditions of heat and humidity. Methods of applications are:

- Staple the fabric directly to the wall. The stapled edges must be covered with trim such as braid or molding.
- Apply wood furring strips to the wall and fill the space in between the strips with acoustical batting or tackable material. The fabric is stapled to the furring strips and the seams are covered with trim, such as braid, welting, or molding.
- Use a proprietary perimeter attachment system to hold the fabric in place, allowing the raw edges to be tucked into the attachment system, creating neat seams that can be exposed without the need for applied trim to cover joints.

CEILINGS

To increase the acoustical absorption in a room, fabric-wrapped panels can be suspended from the ceiling or applied to the surface of a hard ceiling. These panels can be custom made in a similar fashion to the fabric-wrapped acoustical panels for walls. Manufactured fabric-wrapped panels are available as horizontal installations or as vertically hung baffles. Some manufacturers create custom stretched fabric ceiling designs.

WINDOW TREATMENT

Window treatments are an essential component of controlling daylight and views. They can help reduce undesirable heat gain in the summer and heat loss in the winter. Window treatments can control glare and filter light, and provide a range of privacy options, from semi-privacy to complete privacy provided by shades or opaque "blackout" linings on drapery. Textiles are used to construct almost every type of window treatment, including shades and blinds with fabric-covered vanes, curtains, and drapery.

Curtains and Drapery

Curtains and drapery are characteristically a range of window treatments that attach to or hang from a horizontal supporting rod and are pulled to the side of the window to open. The rod may be decorative, intended to be exposed, or a functional traverse rod that may be hidden by top treatments.

Curtains are lightweight, simple treatments. They can be made from crisp or drapable fabrics. Curtains may be attached to a rod with rings or constructed with a pocket into which the rod slides. They are often unlined and may cover only a portion of a window.

Drapery is more formal and can be designed using a wide range of construction and attachment methods depending on the design criteria for function and style. The most complete approach to window treatment is to provide a fully lined drapery mounted from either an exposed or a hidden rod. Exposed rods may have decorative end caps, or *finials*, and ring attachments. *Traverse rods* allow several layers of drapery to operate separately, and usually have a mechanical pull cord. The drapery may be designed to stack completely outside the frame of the window, so that when open, the window is completely visible. If the drapery fabric is opaque and/or lined, the closed drapery may provide insulation, completely block light, and add privacy. Sheer curtains used in conjunction with lined drapery provide an option for light filtering when the drapery is open. Variations on drapery include numerous styles of pleating the fabric, as well as treatments to cover the top of the drapery such as valances and cornices, or side treatments such as swags and tie-backs.

When choosing a textile for drapery, drapability, sun resistance, and durability must be considered.

- **Drapability:** Some fabrics may be fairly stiff for curtains and some drapery panels; cotton and linen are often used. Generally, however, a soft, drapable fabric is desired. Lightweight wool is drapable, and some synthetics imitate this characteristic.
- **Sun Resistance:** Silk may be drapable, but it will rot in sunlight. If used, silk must be lined. Linen is stiff and tends to wrinkle, but it is sun resistant. Because rayon provides

the drapability of silk with resistance to sunlight, it can be used for drapery, but it may have a yo-yo effect, reacting to changes in humidity. Cotton has good sunlight resistance and is often used for curtains.

- **Durability:** Fabric chosen for curtains and drapery must withstand the wear of regular opening and closing. Abrasion resistance may be required along the leading edge if there is no pull cord for opening and closing. One method is to add a decorative and functional band of more durable fabric along this edge.

Shades and Blinds

Textiles are also used to construct shades, which are adjusted vertically. Simple *roller shades* can be mounted inside the window frame and roll into a small cylinder that allows the glass to be completely exposed. When a foam backing is applied and the shades are mounted to cover the window, a roller shade can provide insulation from heat and cold as well as complete privacy. More decorative shades do not completely clear the window when opened. *Roman shades* are flat when closed and open in a series of wide horizontal pleats. *Balloon shades* use more fabric and open in soft folds. *Austrian shades* are gathered horizontally as well as having generous folds as they open. Sheer fabrics used for shades can filter light and provide semi-privacy, or opaque/lined fabrics provide complete privacy.

Slatted blinds may be adjusted to provide a range of privacy and light-blocking options. Slatted blinds can be horizontal (Venetian or mini-blinds), but these are usually made of metal or plastic. *Vertical slatted blinds* may be manufactured with a decorative textile covering the slats. *Honeycomb shades* are often made of a paper product or a nonwoven textile. The honeycomb has insulative properties, and the color or opacity of the textile can determine the level of privacy.

One type of fabric blind suspends fabric vanes horizontally between two vertical sheets of sheer fabric to create slats that can be adjusted to provide a range of privacy options. *Silhouette shades* by Hunter Douglas are an example of this type of fabric blind. The shades combine the softness and light-filtering characteristic of sheer fabric with the adjustment range of blinds.

summary
Although the materials that are used to create textiles are not as durable as stone or even wood, there is evidence that textiles have been a source of warmth and comfort as well as color and pattern since ancient times, and textiles of today are valued for the same reasons. Textiles are used in an interior as soft goods, for carpeting floors and upholstering furniture and walls. Textile wallcoverings and ceiling treatments add texture, insulation, and acoustical value. Textiles used as window treatments help control daylight and views and provide privacy and protection against heat and cold.

Understanding fiber properties is the key to evaluating textile products. Natural fibers such as cotton, linen, wool, and silk each have desirable characteristics as well as drawbacks. In addition, natural fibers are often expensive. Manufactured and synthetic fibers have been developed to imitate natural fibers while improving on their weaknesses at less cost. Nylon has been engineered to function best as the fiber most used for carpet. Polyester can imitate cotton and other fibers. Synthetic fibers are often combined with their natural counterparts to provide the best of both fibers in one textile.

Textile knowledge is a specialized field; interior design students are often able to take a complete course studying textiles. It is recommended that the designer interested in textiles do further research in specialty areas. To find out more about textiles, the following websites in the textile industry can be useful:

Association for Contract Textiles: www.contracttextiles.org/

American Association of Textile Chemists and Colorists: www.aatcc.org

American Textile History Museum: www.athm.org/

Antique Textile History: www.textileasart.com/

Carpet and Rug Institute: www.carpet-rug.org/

FabricLink: The Textile Dictionary: www.fabriclink.com/dictionaries/textile.cfm

Textile Industry History Website: www.textilehistory.org/

The Textile Museum: www.textilemuseum.org/

questions

1. Explain what warp yarns provide for a textile and the difference between warp and weft yarns.
2. Describe how filament fibers are produced and can be made to mimic silk or cotton.
3. Evaluate the environmental impact of using fibers that were developed to be a substitute for silk.
4. Analyze the following carpets for use in a home with children and dogs: Wool Saxony, Nylon Frieze, and Olefin Berber.
5. Analyze the difference between specifying a piece-dyed carpet and a solution-dyed carpet for use in a 3,000-square-foot office.

glossary

Cloth is a term used in the textile industry to mean a textile that is finished for a specific use such as table cloth.

Denier is a system of measuring yarns or fibers. Finer yarns have smaller numbers. *Microfibers* have a very small denier.

Dye is a soluble liquid and is used to color fibers, yarns, or the final textile product.

Fabric refers to a flexible, pliable plane, and in the textile industry, the term refers to a textile intended to be used to construct a usable product.

Felting is an ancient process of pounding heated animal hair into a mat of fibers. Modern felting uses a variety of techniques to make fabric out of intermeshed fibers.

Fiber is the raw material from which a textile product is made. A *fiber* is a very fine, hair-like material, defined as being much longer than it is wide. *Natural fibers* are made from plants, the wool of sheep, or the cocoons of silk worms. *Manufactured fibers* are made by humans from cellulose. *Synthetic fibers* are manufactured from a synthesis of polymer resins. *Mineral fibers* are manufactured from inorganic raw materials, including asbestos and glass.

Fibrils are the tight bundles of cotton fibers with a 30-degree spiral twist that deflects light rays. They give cotton a matte luster.

Filament refers to a long fiber and includes silk, some linen fibers, and all manufactured fibers.

Gray or greige goods describe an unfinished textile.

Hand refers to the tactile characteristics of a textile, or how it feels to the touch.

Hydrophilic means water-loving. Natural fibers are hydrophilic.

Hydrophobic means water-hating. Synthetic fibers tend to be hydrophobic.

Lumen is the kidney bean-shaped hollow core of the cotton fiber.

Luster is an aesthetic characteristic of a textile, referring to sheen rather than shine.

Monofilament yarns consist of a single fiber and are produced by the fiber manufacturer.

Oleophilic means oil-loving. Since synthetic fibers are made from petroleum, they tend to attract oily stains.

Pigment is a paste used to print a textile product.

Sericulture is the term to describe the production of silk.

Soft goods are household items made from textiles.

Solution refers to the semi-liquid polymer that is extruded to make fiber.

Solution dying refers to adding color to the polymer solution before it is extruded to make a fiber.

Spinneret refers to a device similar in appearance to a shower head. Polymer solution is *extruded* through small holes in the spinneret that have a size and shape that forms a fiber with a desired cross-section.

Spinners align, spin, and twist staple fibers into yarns.

Staple length fibers are short fibers and are generally natural fibers, although synthetic fibers may be cut to staple length to imitate natural fibers.

Textile originally referred to woven fabrics, but the term is now used to describe fabric constructed in a variety of ways.

Thermoplastic fibers can be softened by heat.

Throwsters combine filaments into *multifilament* twisted or untwisted yarns.

Warp yarns are threaded lengthwise on a loom. They are generally simple, strong yarns.

Weaving is the interlacing of two or more yarns in a right angle relationship, usually on a loom.

Weft (or *woof*) yarns are the cross-wise filling yarn in woven textile. Weft yarns are not required to be as strong as warp yarns, so they can be more decorative.

Wickable means moisture moves quickly along a fiber surface and thus evaporates quickly.

Yarn is a bundle of fibers twisted together to make a strand that is suitable for the construction of fabric. Unravel a woven textile, and the yarn is the component you can see. Whether synthetic or natural, fibers must be combined into yarns to be useful.

REFERENCES

PREFACE

Huppatz, D. J. (2012). The first interior? Reconsidering the cave. *Journal of Interior Design, 37* (4), 1–8.

CHAPTER 1

"About ANSI." (Retrieved 1/21/12 from ANSI website) www.ansi.org/about_ansi/overview/overview.aspx?menuid=1

"About ASTM." (Retrieved 1/21/12 from ASTM website) www.astm.org/ABOUT/aboutASTM.html

"About Greenguard." (Retrieved 1/21/12 from Greenguard website) www.greenguard.org/en/index.aspx

"About Greenseal." (Retrieved 1/21/12 from Greenseal website) www.greenseal.org/AboutGreenSeal.aspx

"About ISO." (Retrieved 1/21/12 from ISO website) www.iso.org/iso/about.htm

"About NFPA." (Retrieved 1/21/12 from NFPA website) www.nfpa.org/

"About UL." (Retrieved 1/21/12 from UL website) www.ul.com/global/eng/pages/

Ching, Francis D. K., and Cassandra Adams. *Building Construction Illustrated,* 3rd ed. New York: John Wiley and Sons, 2001.

Council for Interior Design Accreditation. *Professional Standards,* adopted July 2011.

"FloorScore Indoor Air Quality." (Retrieved 1/21/12 from Scientific Certification Systems website) www.scscertified.com/gbc/floorscore.php

Harmon, Sharon Koomen, and Katherine E. Kennon. *Codes Guidebook for Interiors,* 3rd ed. New York: John Wiley and Sons, 2005.

"LEED." (Retrieved 1/23/12 from USGBC website) www.usgbc.org/Default.aspx

"Masterformat." (Retrieved 1/23/12 from Masterspec website) www.masterspec.com/users/ind_resources_mf04.php

Mazria, Edward. "Buildings Are the Problem. Buildings Are the Solution." (Retrieved 1/21/12) http://architecture2030.org/the_problem/buildings_problem_why

McGowan, Maryrose. *Specifying Interiors.* New York: John Wiley and Sons, 1996.

Measures of Sustainability (retrieved 8/10/12 from Canadian Architect website) www.canadianarchitect.com/asf/perspectives_sustainibility/measures_of_sustainablity/measures_of_sustainablity_embodied.htm

Mendler, Sandra, William Odell, and Mary Ann Lazarus. *The HOK Guidebook for Sustainable Design,* 2nd ed. New York: John Wiley and Sons, 2006.

Pile, John. *Interior Design.* New York: Harry N. Abrams, 2003.

Piotrowski, Christine. *Professional Practice for Interior Design, 4th ed.* New York: John Wiley and Sons, 2008.

"What Is NCIDQ?" (Retrieved 8/8/12 from NCIDDQ website) www.ncidq.org

CHAPTER 2

"Anodizing." (Retrieved May 23, 2011) www.anodizing.org/

Bingelli, Corky. *Materials for Interior Environments.* Hoboken, NJ: John Wiley and Sons, 2008.

"Canopies, Clouds and Baffles." (Retrieved May 30, 2011, from Armstrong Ceilings website) www.armstrong.com/commceilingsna/canopies.jsp

Ching, Francis D. K. *Building Construction Illustrated.* Hoboken, NJ: John Wiley and Sons, 2008.

Ching, Francis D. K., and Steven R. Winkel. *Building Codes Illustrated.* Hoboken, NJ: John Wiley and Sons, 2003.

"Choosing Your Finish." (Retrieved May 31, 2011, from Rejuvenation website) www.rejuvenation.com/advice_ideas/options.html

"Electrostatic Painting." (Retrieved May 31, 2011, from Linden Painting website) www.lindenpainting.com/electrostatic_painting.htm

"How Electroplating Works." (Retrieved May 31, 2011, from Finishing dot com, the home page of the finishing industry) www.finishing.com/faqs/howworks.html

Interview with Roger Reed, architectural liaison, Metal Design Systems, May 27, 2011.

McHenry, Robert, ed. *The New Encyclopedia Britannica.* "Macropaedea: Extraction and Processing Industries," The University of Chicago, 1992.

McHenry, Robert, ed. *The New Encyclopedia Britannica.* "Micropaedea: The Iron Age," The University of Chicago, 1992.

McHenry, Robert, ed. *The New Encyclopedia Britannica.* "Micropaedea: Metals," The University of Chicago, 1992.

"Metal Maintenance." (Retrieved May 26, 2011, from Zahner website) www.azahner.com/

"Metals and Finishes." (Retrieved May 30, 2011, from Chown Hardware website) www.chown.com/help/prd/finishes.htm

"Metalworks Products." (Retrieved May 30, 2011, from Armstrong Ceilings website) www.armstrong.com/commceilingsna/article58788.html

"Pewter History." (Retrieved September 8, 2012, from Ramshorn Studio website) www.ramshornstudio.com/pewter.htm

Pile, John. *Interior Design.* New York: Harry N. Abrams, 2003.

"Product Finishes Guide." (Retrieved May 30, 2011, from Hager website) www.hagerco.com/Documents/MarketingLiterature/Product%20Finishes%20Guide%20R3.pdf

Riggs, J. Rosemary. *Materials and Components of Interior Architecture,* 7th ed. Upper Saddle River, NJ. Prentice Hall, 2008.

"Sustainability of Resources." (Retrieved May 23, 2011, from Alcoa website) www.alcoa.com/sustainability/

Tucker, Lisa M. *Sustainable Building Systems and Construction for Designers.* New York: Fairchild Books, 2010.

W. F. Norman home page. (Retrieved May 29, 2011) http://wfnorman.com/

"What Is Metal Fabric?" *Cambridge Architectural.* (Retrieved November 26, 2011) www.cambridgearchitectural.com/FAQMetalFabric.aspx

"What Is Powder Coating?" (Retrieved May 31, 2011, from Finishing dot com; the home page of the Finishing Industry) www.finishing.com/Library/pennisi/powder.html

CHAPTER 3

American Wood Council. http://awc.org/publications/DCA/DCA1/DCA1.pdf

Blakemore, R. G. *History of Interior Design & Furniture: From Ancient Egypt to Nineteenth-Century Europe,* 2nd ed. Hoboken, NJ: John Wiley & Sons, 2006.

Environmental Protection Agency. *Particulate Matter* page found at www.epa.gov/air/particlepollution/health.html

Forest Products Laboratory. *Wood Handbook: Wood as an Engineering Material.* Madison, WI: United States Department of Agriculture Forest Service, 2010.

Forest Stewardship Council. "Types of FSC Certificates." www.fsc.org/types

GreenFloors. "GreenFloors linoleum flooring." www.greenfloors.com/HP_Linoleum_Index.htm

Hardwoods. "Echo wood." www.hardwoods-inc.com/green_eco_friendly.aspx?subnav=4a6-c088e9efa198

Lippke, B., et al. (2011). A natural choice: How wood contributes to sustainability's triple bottom line. *GreenSource* (September–October 2011): 109–112.

Olin, H. B., J. L. Schmidt, and W. H. Lewis (Revised by H. Simmons). (1995). *Construction Principles, Materials and Methods,* 6th ed. New York: Van Nostrand Reinhold.

Powell, J., and L. Svendsen. (2003). *Linoleum.* Salt Lake City: Gibbs Smith, Publishers.

Riggs, J. R. (2008). *Materials and Components of Interior Architecture,* 6th ed. Upper Saddle River, NJ: Pearson Prentice Hall.

Sardar, Z. (2009, March 15). "Palm wood, the new bamboo." (Retrieved from *San Francisco Gate*) www.sfgate.com/

Website: www.madehow.com/Volume-3/Wallpaper.html

Website: www.sustainablematerials.com/bamboo/

Website: www.durapalm.com/about

Website: http://sustainablematerials.com/resources/cork

Weyerhaeuser. "Sustainability and fibria forests." www.lyptus.com/architects-designers/environmental-information

WoodWorks. www.woodworks.org/woodBenefilts/fire-protection.aspx

CHAPTER 4

Bailey, R. "The Colorado Yule Marble Quarry: Our National Treasure." Parachute, CO: Ron Bailey Photography video, 2009.

Blakemore, R. G. (2006). *History of Interior Design & Furniture.* Hoboken, NJ: John Wiley & Sons.

Eble, S., and K. Busch. Stone veneers add impact to high-profile projects. *Interiors & Sources* (January–February 2010): 39–41.

Harwood, B., B. May, and C., Sherman. *Architecture and Interior Design through the 18th Century: An Integrated History.* Upper Saddle River, NJ: Prentice Hall, 2002.

Indiana Limestone Institute of America, Inc. *The Indiana Limestone Handbook*, 22nd ed. www.iliai.com

Ireland, J. (2009). *History of Interior Design.* New York: Fairchild Books.

Kagan, N. (2006). *Concise History of the World: An Illustrated Time Line.* Washington DC: National Geographic Society.

www.naturalstone.iscsurfaces.com (source for photographs)

Kansas State University. "Construction of the K-State Alumni Center" video, 2004.

Marble Institute of America. "From the Quarry to the Kitchen" video, 2004.

Marble Institute of America. www.reedconstructiondata.com

Masonry Advisory Council. 2009–2010 Masonry Cost Guide from www.maconline.org.

North Central Terrazzo Association. (2012). The Essence of Terrazzo. retreived from "http://www.ncterrazzo.com" Heery -HLM/ Design (2007). Medical Center of the Rockies. retreived from "http://www.healthcarebuildingideas.com" Interview with Margie Snow of Gallun Snow Associates, October 2010.

Olin, H. B., J. L. Schmidt, and W. H. Lewis (Revised by H. Simmons). (1995). *Construction Principles, Materials and Methods*, 6th ed. New York: Van Nostrand Reinhold.

Ragone, M. (2010). Designing interiors with the Italian marbles. Internazionale Marmi e Macchine Carrara Spa. At AIA Convention June 10–12, 2010, Miami.

Reed construction data at www.reedconstructiondata.com/smartbuildingindex/terrazzo-flooring/

www.naturalstone.iscsurfaces.com (source for photographs).

CHAPTER 5

Alden, Andrew. "Cement and Concrete." (Retrieved May 17, 2011, from About.com website) http://geology.about.com/od/mineral_resources/a/cement.htm

Bellas, Mary. "The History of Concrete and Cement." (Retrieved May 16, 2011, from About.com website). http://inventors.about.com/library/blconcrete.htm

Bingelli, Corky. *Materials for Interior Environments.* Hoboken, NJ: John Wiley and Sons, 2008.

"Building with ICFs." (Retrieved May 19, 2011, from Insulating Concrete Forms Association website) www.forms.org/index.cfm/buildingicf

Ching, Francis D. K. *Building Construction Illustrated.* Hoboken, NJ: John Wiley and Sons, 2008.

Ching, Francis D. K., and Steven R. Winkel. *Building Codes Illustrated.* Hoboken, NJ: John Wiley and Sons, 2003.

"Classic Rock Faced Block." (Retrieved May 17, 2011) http://classicrockfaceblock.com/

"Concrete Basics." (Retrieved May 18, 2011, from Portland Cement Association website) www.cement.org/basics/concretebasics_concrete basics/asp/

"Concrete Finishing, Concrete Preparation, Curing Concrete." (Retrieved May 18, 2011) www.custom-crete.com/do_it_yourself.htm

"Concrete and LEED." (Retrieved May 16, 2011) www.groupecorbeil.com/en/faxxrail/leed/

"The Ennis House—Frank Lloyd Wright, Los Angeles 1924." (Retrieved May 17, 2011) www.ennishouse.org/htmls/photo_page.htm

"Fly Ash: Its Origins, Applications and the Environment." (Retrieved May 16, 2011) www.gourpecorbeil.com/en/faxxrail/

"Glazed (Prefaced) Units." (Retrieved May 17, 2011, from National Concrete Masonry Association website) www.ncma.org/resources/productuse/products/concrete/Pages/Glazed(Prefaced)Units.aspx

"Historical Timeline of Concrete." (Retrieved May 18, 2011) www.auburn.edu/academic/architecture/bsc/classes/bsc314/timeline/timeline.htm

"History of Concrete." (Retrieved May 17, 2011 from The University of Memphis Department of Civil Engineering website) www.ce.memphis.edu/1101/notes/concrete/2_history.html

Interview with William R. "Rusty" Owings III, AIA, technical services manager for Ash Grove Concrete Group, May, 27, 2011.

"James Hardie: HardieBacker 500 Backerboard." (Retrieved May 17, 2011) www.jameshardie.com/developer/products_backerboard_halfInch.shtml

"Maxxon—Floor Underlayments." (Retrieved May 17, 2011) www.maxxon.com/

"Mayan Architecture." (Retrieved May 16, 2011) http://library.thinkquest.org/10098/mayan.htm

McHenry, Robert, ed. *The New Encyclopedia Britannica.* "Macropaedia: Concrete." The University of Chicago, 1992.

Moore, David. "The Riddle of Ancient Roman Concrete." (Retrieved May 16, 2001) www.romanconcrete.com/docs/spillway/spillway.htm

Pile, John. *Interior Design.* New York: Harry N. Abrams, 2003.

Riggs, J. Rosemary. *Materials and Components of Interior Architecture,* 6th ed. Upper Saddle River, NJ: Prentice Hall, 2003.

"Ward House." (Retrieved May 17, 2011, from American Society of Civil Engineers website) www.ascemetsection.org/content/view/331/864/

CHAPTER 6

Binggeli, C. *Materials for Interior Environments.* Hoboken, NJ: John Wiley & Sons, 2008.

Blakemore, R. G. *History of Interior Design and Furniture.* Hoboken, NJ: John Wiley & Sons, 2006.

Calloway, S., and Cromley, E. (eds.). *The Elements of Style.* New York: Simon & Schuster, 1996.

ENR: Engineering News Record: "McGraw-Hill Construction." Enr.construction.com. January 28, 2009. http://enr.construction.com/business_management/safety_health/2009/0128-ChineseDrywallCorrosion.asp

Gypsum Association. "Gypsum and Sustainability." (Retrieved 2011 from Gypsum Association website) www.gypsumsustainability.org/index.html

Olin, H. B., J. L. Schmidt, and W. H. Lewis (Revised by H. Simmons). (1995). *Construction Principles, Materials and Methods*, 6th ed. New York: Van Nostrand Reinhold.

USG (2003). Sheetrock brand gypsum panels: Installation and finish guide. Chicago: United States Gypsum Company

CHAPTER 7

Brick Industry Association: www.gobrick.com

Harwood, B., May, B., and Sherman, C. *Architecture and Interior Design through the 18th Century: An Integrated History.* Upper Saddle River, NJ: Prentice Hall, 2002.

Interview with Glen-Gery Brick Corporation district sales manager, Rick Holman. May 6, 2010.

Interview with Lois Walkenhorst, architect at Shaw Hofstra & Associates Inc. April 30, 2010.

Sullivan, C. C., and Horwitz-Bennett, B. (August 2008). *The Basics: Building with Brick*, in *Building Design + Construction* www.BDCnetwork.com.

Olin, H. B., J. L. Schmidt, and W. H. Lewis (Revised by H. Simmons). (1995). *Construction Principles, Materials and Methods*, 6th ed. New York: Van Nostrand Reinhold.

www.glengerybrick.com

www.glengerybrick.com/about/manufacturing/index.html

CHAPTER 8

Berendsen, A. (1967). *Tiles: A General History.* New York: Viking Press, 1967.

Boger, L. A. *The Dictionary of World Pottery and Porcelain.* New York: Charles Scribner's Sons, 1971.

Bogo, A. (n.d.) www.ctioa.org/pdf/CeramicTileMissingGreen.pdf

Herz, M. (2012). Mexican folk art: Talavera Poblana. retrieved from "http://www.inside-mexico.com" MasterFormat Specification Divisions retrieved from http://archtoolbox.com "http://www.ceramic-tile.com" "http://www.tileusa.com" "http://www.ctioa.org" "http://www.tileuse.com"

Olin, H. B., J. L. Schmidt, and W. H. Lewis (Revised by H. Simmons). (1995). *Construction Principles, Materials and Methods*, 6th ed. New York: Van Nostrand Reinhold.

Porter, V. *Islamic Tiles.* New York: Interlink Books, 1995.

Riggs, J. R. *Materials and Components of Interior Architecture.* Upper Saddle River, NJ: Prentice Hall, 2004.

Riley, N. (1987). *Tile Art: A History of Decorative Ceramic Tiles.* Secaucus, NJ: Chartwell Books.

CHAPTER 9

About Glass Tile. "Working with Mosaics." (Retrieved September 25, 2010) www.aboutglasstile.com/

Bendheim Glass. (Retrieved September 4, 2010) www.bendheim.com/

Interview with Bill Carter, owner of Carter Glass, Kansas City, Missouri, September 23, 2010.

Ching, Francis D. K. *Building Construction Illustrated.* Hoboken, NJ: John Wiley and Sons, 2008.

Ching, Francis D. K., and Steven R. Winkel. *Building Codes Illustrated.* Hoboken, NJ: John Wiley and Sons, 2003.

Enviroglas. (Retrieved September 25, 2010) www.enviroglasproducts.com

Glass Association of North America. (Retrieved August 21, 2010) www.glasswebsite.com

"Glass Flooring." Jockimo Advanced Architectural Products (Retrieved November 19, 2011) www.jockimo.com/products/glass-flooring/

"Glass Information Bulletin: Glass Floors and Stairs." (Retrieved November 19, 2011, from Glass Association of North America website) www.glasswebsite.com/publications/reference/LD%2006-1107%20-%20Glass%20Floors%20and%20Stairs.pdf

Harmon, Sharon Koomen, and Katherine E. Kennon. *Codes Guidebook for Interiors.* Hoboken, NJ: John Wiley and Sons, 2005.

Interview with Dierk Van Keppel, glass artist and owner of Rock Cottage Glassworks, Merriam, Kansas, September 23, 2010.

Joel Berman Glass Studios. (Retrieved August 21, 2010) www.jbermanglass.com

McHenry, Robert, ed. *The New Encyclopedia Britannica.* "Macropaedia: Decorative Arts and Furnishings." Chicago: The University of Chicago, 1992.

McHenry, Robert, ed. *The New Encyclopedia Britannica.* "Macropaedia: Industrial Glass and Ceramics." Chicago: The University of Chicago, 1992.

Medler, Sandra, William Odell, and Mary Ann Lazarus. *The HOK Guidebook to Sustainable Design.* Hoboken, NJ: John Wiley and Sons, 2006.

"Permissible Loads for Glass Shelves." Nova Display, Inc. (Retrieved November 19, 2011) www.novadisplay.com/

Pile, John. *Interior Design.* New York: Harry N. Abrams, 2003.

Pilkington Profilit Channel Glass. (Retrieved September 25, 2010) www.tgpamerica.com/structural-glass/pilkington-profilit/

Skyline Glass. (Retrieved August 21, 2010) www.skydesign.com

Strategic Materials. (Retrieved September 4, 2010) www.strategicmaterials.com

CHAPTER 10

Baylor, C. *How to Apply a Lacquer Finish.* http://woodworking.about.com

EPA: Renovation, Repair and Painting Program, retrieved from http://www.epa.gov/getleadsafe/ "http://www.pcda.org" "http://www.colormarketing.org" no author (2009). Case Study: Your Council Tree Library is Designed fro Sustainability. Retreived from "http://www.poudrelibraries.org" Interview with Chris Freeland, architect with Aller-Lingle-Masey Architects, October 2011.

no author (2011) Quality, Long-Term Performance Essential for Sustainable Paints, retreived from "http://www.facilitiesnet.com"

Frank, P. *Prebles' Artforms: An Introduction to the Visual Arts,* 10th ed. Boston: Prentice Hall, 2011.

Godsey, L. *Interior Design Materials and Specifications.* New York: Fairchild Books, 2008.

History of Paint, The. www.brendasemanick.com/art/

Ireland, J. (2009). *History of Interior Design.* New York: Fairchild Books, 2009.

Jones, L. M., and P. S. Allen. *Beginnings of Interior Environments*, 10th ed. Upper Saddle River, NJ: Pearson, 2009.

Kopacz, J. *Color in Three-Dimensional Design.* New York: McGraw-Hill, 2004.

Nienstedt, B. Presentation to Interior Design Materials Class. Architectural Account Executive for The Sherwin-Williams Company, October 2009.

Riggs, J. R. *Materials and Components of Interior Architecture*, 7th ed. Upper Saddle River, NJ: Pearson, 2008.

Shearer (2011, April 15). *History of Paint.* (Retrieved April 15, 2001 from Shearer website) www.shearerpainting.com/

Sherwin-Williams. *Paint & Coatings Technology.* CD, March 2009.

Sherwin-Williams. www.sherwin-williams.com/architects-specifiers-designers/facility-solutions/commercial/case-studies/

Simmons, H. L. *Construction: Principles, Materials, and Methods,* 6th ed. New York: Van Nostrand Reinhold, 1995.

Westerkamp, T. A. *Specifying Sustainable Paints Means Determining Life-Cycle Costs.* www.facilitiesnet.com

"About Vinyl." The Vinyl Institute. (Retrieved September 10, 2011) www.vinylinfo.org/
 vinyl-info/about-vinyl/

Bellis, Mary. "The History of Cellophane Films." (Retrieved October 23, 2011 from about.
 com website) http://inventors.about.com/library/inventors/blsaranwrap.htm

Bellis, Mary. "The History of Polyester." (Retrieved October 23, 2011, from about.com
 website) http://inventors.about.com/library/inventors/blpolyester.htm

Bellis, Mary. "Kevlar-Stephanie Kwolek." (Retrieved October 22, 2011, from about.com
 website) http://inventors.about.com/library/inventors/blkevlar.htm

Bellis, Mary. "Saran Wrap." (Retrieved October 23, 2011, from about.com website)
 http://inventors.about.com/library/inventors/blsaranwrap.htm

Ching, Francis D. K. *Building Construction Illustrated*. Hoboken, NJ: John Wiley and Sons,
 2008.

Ching, Francis D. K., and Steven R. Winkel. *Building Codes Illustrated*. Hoboken, NJ: John
 Wiley and Sons, 2003.

"Commercial Wallcovering." (Retrieved September 11, 2011, from Omnova Corporation
 website) www.omnova.com/products/wallCovering/wallcovering.aspx

"Commonly Used Manufacturing Methods of Plastics." (Retrieved October 8, 2011, from
 University of Michigan engineering website) www.engin.umich.edu/labs/EAST/me589/
 gallery/bioplastics_f01/599Website/pmf.htm#_Injection _molding

"Decorative Plastic Laminates." How Products Are Made. (Retrieved September 10, 2011)
 www.enotes.com/how-products-encyclopedia/decorative-plastic-laminate

Dorman, Evelyn S. "Decorative Plastic Laminate." (Retrieved September 11, 2011)
 www.enotes.com/decorative-plastic-laminate-reference/decorative-plastic-laminate

Duggan, Mike. "What Is Solid Surface?" *Journal of the Solid Surface and Stone Industries.*
 (Retrieved November 11, 2011) http://web.archive.org/web/20040222185008/
 http://www.solidsurfacemagazine.com/what_is.htm

"Early Warning Effect." (Retrieved March 15, 2012, from Koroseal website) www.koroseal.
 com/images/translations/image_40_1.pdf

"Epoxy History." (Retrieved October 9, 2011, from Hempel Marine website www.hempel.
 dk/Internet/inecorporatec.nsf/vDOC/085E68EB4DA01C29C1256EBB0034D1C1?
 OpenDocument

Fiberglass Reinforced Plastic Panels. (Retrieved November 10, 2011 from Jensen Bridge
 website)

"Floorscore." (Retrieved November 12, 2011 from Resilient Floor Covering Institute website)
 www.rfci.com/

Formisano, Bob. "Sheet Vinyl Flooring." (Retrieved November 12, 2011, from about.
 com) http://homerepair.about.com/od/interiorhomerepair/ss/Resilient-Bathroom-And-
 Kitchen-Flooring-Vinyl-Cork-Linoleum-Flooring_8.htm

Freudenrich, Craig. "How Plastics Work." (Retrieved September 10, 2011, from How Stuff
 Works website) www.howstuffworks.com/plastic.htmn

Harmon, Sharon Koomen, and Katherine E. Kennon. *Codes Guidebook for Interiors.*
 Hoboken, NJ: John Wiley and Sons, 2005.

"History of Plastics." SPI: The Plastics Industry Trade Association. (Retrieved September 10,
 2011) www.plasticsindustry.org/AboutPlastics/content.cfm?ItemNumber=670&navItem
 Number=1117

"How to Install Laminate Flooring." DIY Network. (Retrieved October 22, 2011, from DIY
 Network website) www.diynetwork.com/how-to/how-to-install-laminate-flooring/
 index.html

"How Is a Terrazzo Floor Installed?" (Retrieved September 11, 2011 from Master Terrazzo
 Technologies website) www.masterterrazzo.com/

"Indoor Air Quality." Greenguard Environmental Institute. (Retrieved October 10, 2011)
 www.greenguard.org/en/index.aspx

"Installation Guidelines, Vinyl Tile." Static Worx. (Retrieved October 9, 2011) www.staticworx. com/flooring-installation/esd_vinyl_tile_install.php

"Laminate Floors." Hoskings Hardwood Floors. (Retrieved October 7, 2011) www.hoskinghardwood.com/Laminate-Floors.aspx?dId=9

Lee, Kim Tobin. "Vinyl Wallcovering." (Reprint of article in *Construction Dimension Magazine,* 1995) Association of the Wallcovering and Ceiling Industry. (Retrieved November 12, 2011) www.awci.org/cd/pdfs/9602_b.pdf

McHenry, Robert, ed. *The New Encyclopedia Britannica.* "Macropaedea: Industries and Chemical Processes." Chicago: University of Chicago Press, 1992.

Medler, Sandra, William Odell, and Mary Ann Lazarus. *The HOK Guidebook to Sustainable Design.* Hoboken, NJ: John Wiley and Sons, 2006.

"People and Polymers." The Plastics Historical Society. (Retrieved September 3, 2011) www.plastiquarian.com/

Pile, John. *Interior Design.* New York: Harry N. Abrams, 2003.

Plunkett, Drew. *Construction and Detailing for Interior Design.* London: Laurence King Publishing, Ltd., 2010.

Riggs, J. Rosemary. *Materials and Components of Interior Architecture,* 7th ed. Upper Saddle River, NJ: Prentice Hall, 2008.

Rustin, Dan. "The Basics: Acrylic Sheet" The Plastics Distributor and Fabricator. (Retrieved November 11, 2011) www.plasticsmag.com/features.asp?fIssue=Jan/Feb-00

"Subtops under Solid Surface Countertops" Woodweb Knowledge Base Article. (Retrieved November 11, 2011) www.woodweb.com/knowledge_base/Subtops_Under_Solid_Surface.html

"Technical Data." Armstrong Flooring. (Retrieved November 12, 2011) www.armstrong. com/commflooringna/flooring-glossary.html

"Vinyl Flooring Construction" Floorfacts Flooring Guide. (Retrieved November 12, 2011) www.floorfacts.com/vinyl-floors/vinyl-floor-construction.asp

"Wallcovering Basics." Omnova Solutions. (Retrieved November 5, 2011) www.omnova. com/products/wallcovering/basics.aspx

"What Are Plastics?" The Plastics Historical Society. (Retrieved September 3, 2011) www.plastiquarian.com/

"What Is Acrylic?" Wise Geek. (Retrieved September 11, 2011) www.wisegeek.com/ what-is-acrylic.htm

"What Is Melamine?" WiseGeek. (Retrieved September 11, 2011) www.wisegeek.com/ what-is-melamine.htm

"What Is Polyester?" WiseGeek. (Retrieved September 11, 2011) www.wisegeek.com/ what-is-polyester.htm

"Why Choose Solid Surface over Granite and Quartz." The Solid Surface Alliance. (Retrieved November 11, 2011) www.solidsurfacealliance.org/

CHAPTER 12

AATCC Test Methods and Evaluation Procedures. (Retrieved March 14, 2012, from American Association of Textile Chemists and Colorists website) www.aatcc.org/ testing/methods/index.htm

ACT Test Method for Abrasion Resistance of Textile Fabrics. (Retrieved March 14, 2012, from Manufacturing Solutions Center website) www.manufacturingsolutionscenter. org/ACT-wyzenbeek-abrasion-tester.html

ACT Voluntary Performance Guidelines. (Retrieved March 14, 2012, from ACT website) www.contracttextiles.org/guidelines

Bellas, Mary. "Industrial Revolution: Timeline of Textile Machinery." (Retrieved February 5, 2012 from about.com website) http://inventors.about.com/library/inventors/ blindustrialrevolutiontextiles.htm

Bellas, Mary. "The Textile Revolution: History of the Textile Industry." (Retrieved February 5, 2012, from about.com website) http://inventors.about.com/od/indrevolution/a/history_textile.htm

Collier, Billie J., and Phyllis G. Tortora. *Understanding Textiles.* 5th ed. Upper Saddle River, NJ: Prentice Hall, 1997.

Dickerson, Katy G. *Textiles and Apparel in the Global Economy.* Upper Saddle River, NJ: Prentice Hall, 1999.

"Environmental Design Stories: Climatex." (Retrieved March 13, 2012, from DesignTex website) www.designtex.com/climatex_Environments.aspx?f=36310

Godfrey, Lisa. *Interior Design Materials and Specifications.* New York: Fairchild Books, 2008.

"History of Carpet." (Retrieved February 5, 2012, from about.com website) http://inventors.about.com/gi/dynamic/offsite.htm?site=http://www.carpetinfo.co.uk/pages/aboutpp/history.htm

"History of Textiles." (Retrieved February 5, 2012, from Textiles as Art website) www.textileasart.com/weaving.htm#top

"How Carpet Is Made." (Retrieved February 21, 2012, from Axminster carpet website) www.axminster-carpets.co.uk/all-about-carpet/how-carpet-is-made/

Interview with Kathy Anderson, manufacturer's representative for DesignTex Fabrics, March 14, 2012.

"Jack Lenor Larsen Exhibition." (Retrieved March 14, 2012, from American Textile History Museum website) www.athm.org/exhibitions/past_exhibitions/jacklarsen.php

Kadolph, Sara J., and Anna L. Langford. *Textiles,* 9th ed. Upper Saddle River, NJ: Prentice Hall, 2002.

Koe, Frank Theodore. *Fabric for the Designed Interior.* New York: Fairchild Publications, 2007.

Larsen, Jack Lenor, and Jane Weeks. *Fabrics for Interiors: A Guide for Architects, Designers, and Consumers.* New York: Van Nostrand Reinhold, 1975.

McDonough, William, and Michael Braungart. *Cradle to Cradle: Remaking the Way We Make Things.* New York: North Point Press, 2002.

McGowan, Maryrose. *Specifying Interiors: A Guide to Construction and FF&E for Commercial Interiors Projects.* New York: John Wiley and Sons, 1996.

Riggs, Rosemary. *Materials and Components of Interior Architecture,* 6th ed. Upper Saddle River, NJ: Pearson Prentice-Hall, 2003.

Textile Dictionary. (Retrieved February 5, 2012, from FabricLink website) www.fabriclink.com/dictionaries/textile.cfm

Textile Industry History. (Retrieved February 5, 2012, from Textile Industry History website) www.textilehistory.org/

Yaeger, Jan, and Lura Teter-Justice. *Textiles for Residential and Commercial Interiors,* 2nd ed. New York: Fairchild Books, 2000.

CHOCOPOLOGIE

For information about permission to reproduce
selections from this book, write to Permissions,
Houghton Mifflin Harcourt Publishing Company,
215 Park Avenue South, New York, New York 10003.

www.hmhco.com

Library of Congress Cataloging-in-
Publication Data

Knipschildt, Fritz.
 Chocopologie / by Fritz Knipschildt with Mary
Goodbody.
 pages cm
ISBN 978-1-118-52352-0 (cloth);
978-0-544-17879-3 (ebk)

1. Chocolate desserts. 2. Cooking (Chocolate)
I. Goodbody, Mary. II. Title.
 TX767.C5K586 2014
 641.6'374—dc23

 2013042029

Book design by Laura Palese

Printed in China

C&C 10 9 8 7 6 5 4 3 2 1

CHOCOPOLOGIE

❧ CONFECTIONS & BAKED TREATS FROM THE ACCLAIMED CHOCOLATIER ❧

FRITZ KNIPSCHILDT
WITH MARY GOODBODY

Photography by Signe Birck

HOUGHTON MIFFLIN HARCOURT
BOSTON · NEW YORK · 2015

CONTENTS

ACKNOWLEDGMENTS

Making chocolates for a living is hard work. It sounds wonderful, and it is, but to produce some of the best truffles, bonbons, and other chocolate treats on the planet requires constant vigilance. Writing this book drew on much of the same discipline and talent—and it was not a solo effort. I have many to thank.

First, I want to thank my small, tight-knit family in Denmark. My mother and father, Inger-lise Hoyer and Tito Knipschildt, as well as my two sisters, Charlotte and Jeanett. They have always believed in me and their support has seen me through so much. Jeanett, who is a brilliant graphic designer, helped me with early designs for Chocopologie and Knipschildt Chocolates packaging and logos, and continues to consult with me today, whenever and wherever I need her. I also want to thank my brother-in-law, Lars H. Joergensen, for branding support.

Thanks to my editor at HMH, Stephanie Fletcher, for seeing the book to publication. I also am grateful to my agent, Doe Coover, and my cowriter, Mary Goodbody, for their always professional and cheerful help.

A big thanks to Signe Birck for her stunning photographs. She caught the essence of the food and my style perfectly. Thanks, too, to the chefs and chocolate team who helped me test recipes and then prepare the food for the camera.

And finally, thank you to my loyal customers who make Chocopologie and Knipschildt Chocolates a reality.

FOREWORD

As the editor of *Chocolatier* magazine for many years, I had the opportunity to taste chocolates and confections from a variety of new companies and artisans just about every day. Despite this, I can still vividly recall the day a box of Knipschildt chocolates arrived on my desk. I couldn't pronounce the name, but when I opened that handsome paper box, my interest was certainly aroused. The glossy chocolates looked and smelled as if they had been made that morning, and each variety sounded fresh and exciting. Caramel Sea Salt? Yes, please. Raspberry Black Pepper? Ooh, why not? These flavors might sound commonplace today, but twelve years ago they were thrillingly original. America was at the dawn of a great artisanal chocolate awakening, and Fritz Knipschildt was right there, conjuring up creative flavor combinations and presenting them uniquely and elegantly.

I've always been struck by Fritz's enthusiasm for chocolate making. He gets quite excited when he's talking about his latest venture (and, with his strong Danish accent, it's not always easy to grasp every word he says. But his passion is unmistakable). He's a true chocolatier who relies on his instincts as a chef to know how far he can push the bounds of creativity to make chocolates with innovative, harmonious flavors.

A few years ago, Fritz competed against Bobby Flay in an episode of the Food Network show *Throwdown* featuring chocolate, and I happened to be one of the judges. Fritz approached the culinary battle with the same seriousness and fervor he brings to his business every day. It was a real pleasure to see him in action: his quick, precise movements and purposeful demeanor working toward his final vision of an elaborate chocolate showpiece. Needless to say, Fritz won the throwdown that day, as well as my lifelong respect and admiration.

The recipes in this book are a reflection of this dedication and passion for chocolate. They are accessible and fun, designed specifically for the home cook, so the process of making them is bound to give you almost as much pleasure as eating the results. Still, if you haven't yet had the experience of tasting a Knipschildt or Chocopologie chocolate, make it a point to seek out a box and decide which flavor you like best. For me, it's still that Caramel Sea Salt.

—Tish Boyle, author, *The Cake Book*

INTRODUCTION

MY STORY

—◦•◦—

IT WASN'T UNTIL I WAS SIXTEEN YEARS OLD AND APPRENTICING in a local restaurant that I tasted good chocolate. I bit into a piece of Valrhona, the famed French brand, and although I didn't know it at the time, my life's course was set.

What I did know was that this morsel was beyond good. The premium chocolate was nothing like the overly sweet and crumbly chocolate bars we snacked on after school or at football games. Dark and fruity with a smooth, almost elusive texture, this chocolate melted in your mouth even as it stood up to your taste buds.

Good chocolate appeals to all the senses and if the brand you are eating or cooking with does not excite your taste, smell, touch, sight, and even hearing, switch brands. Taste and smell are obvious; the chocolate should also feel firm and supple, look glossy and smooth, and emit a pleasing "snap" when you break it or bite into it.

No one was surprised when I decided to devote my career to chocolate. I was trained to cook savory food, not pastries and desserts, but my attraction to chocolate endured. My training allowed me to come up with crazy flavor combinations such as chocolate with strawberries and lemon thyme, chocolate with raspberries and black pepper, chocolate with apricot and basil, and chocolate with apples and rosemary. And I was pairing chocolate with caramel and sea salt at the turn of this century, a combination that remains among my very favorites.

This book offers me another avenue to share what I love. In Danish or in English, books have always inspired me. When I was developing my repertoire, there wasn't a cookbook I wouldn't save up for. I hope *Chocopologie* inspires you to bake (and eat) chocolate desserts and snacks and—most importantly—to have fun!

EARLY DAYS

I spent about two years planning the launch of Knipschildt Chocolates. Although I was broke, I experimented with chocolates, flavorings, and techniques whenever I could, working in my cramped apartment kitchen in Norwalk, Connecticut. It wasn't the greatest part of town, but I had access to varied and high-end ingredients and I poured everything I earned at my chef jobs into my future business.

Because I spent all my money on the finest-quality ingredients for truffles and other bonbons, my personal pantry was pathetic. When I wasn't working, I lived on rice doused with soy sauce and cans of supermarket tuna fish. (Fortunately, I am a trained chef, so I was able to make surprisingly edible tuna cakes—although I never want to taste them again!)

Finally, in 2000, I was ready to debut my chocolates. I rented a somewhat dilapidated commercial kitchen in Norwalk and began production. I spent Sunday afternoons covering craft boxes with exquisite paper I bought from Kate's Paperie in New York's SoHo. I felt, and still feel, that my chocolates deserved to be packed in gorgeous containers.

Boxes decorated, I packed them carefully with the fragile chocolates and then loaded the boxes in the trunk of my rusted 1978 Ford Fairmont. Monday mornings found me making the rounds of all the small shops and markets in upscale Fairfield County, Connecticut.

My first order was for twenty-five boxes from The Good Food Store in tony Darien. Apparently, one of the shop's customers bought a box as a gift for Giorgio DeLuca of Dean and DeLuca, the premier gourmet food store. I arrived home one day to a message from Giorgio on my answering machine (remember answering machines?). I called him back, but I was so excited and nervous that I hung up the minute I heard his voice on his answering machine. I took a walk, breathed deeply, gave myself a pep talk, and tried again, this time leaving a coherent message. He was impressed with the chocolates and wanted to order them for his store. To this day, Dean and DeLuca carries Knipschildt Chocolates at all its locations across the country, and other retailers have followed suit.

MY SCANDINAVIAN ROOTS

Although I wasn't born here, I love living and working in the United States. America is the place for forward thinking and as I am always looking forward in my business, it's a perfect fit. I also appreciate the size of this country and its appetite for chocolate. Americans happily embrace the "new and exciting." Chocolate may not be new, but it's always exciting.

I come from Odense, a small Danish city that lays claim to Hans Christian Andersen, who wrote "The Little Mermaid," "Thumbelina," and "The Ugly Duckling," among other children's favorites. It was a happy place to be a child, but I was eager to grow up, especially once I started working in restaurants. I must have been thirteen or fourteen when I went to work one day to cover for my older sister at her restaurant job. I instantly fell head over heels in love with restaurant life, from the smell of food cooking to the crazy chefs cooking it.

Later, I spent years training in some of the finest restaurants in Europe, primarily in Denmark, France, and Spain. I was in my element, surrounded by great food and dedicated chefs. My enthusiasm for food and gastronomy grew by leaps and bounds during these busy years.

For example, when I apprenticed in Odense at Restaurant Naesbyhoved Skov, I not only eagerly joined every cooking competition I could, but quickly found myself selected by the chefs I worked for to participate, even as a first-year apprentice. I went on to nail-biting national competitions for young chefs. These were fun, instructive, challenging, and, even for a young guy, exhausting.

I also hoarded my days off. Once I had accrued enough, I took time off

to go to France or Spain to work in another restaurant. For free. I couldn't get enough of kitchens and restaurants and food, food, food. I immersed myself completely in this passion for food and cooking and became an accomplished chef along the way. I believe that's the only way to get along in this industry: work crazy hours and never stop. I still work 24/7, and rarely take a day off.

COMING TO AMERICA

After years of training, I decided to take the plunge and boarded a plane for the United States. It was exhilarating, but it was also terribly hard. I wanted to strike out on my own and, like any young man, was ready for adventure. I am not alone; at any given time, any number of European chefs have their eye on New York, Los Angeles, Chicago, Miami, and so on, with a plan to emigrate. I am no different. This does not mean it's easy being so far away from family, friends, and familiar places.

My first trip to the United States was tough. My Danish girlfriend at the time and I arrived here in the mid-1990s and, although in some ways we felt immediately at home, we missed our families. Every day I woke up yearning to go home, but I was stuck, so to speak, because the status of my visa dictated travel even more surely than my sorry bank account. I've met a lot of immigrants since those days and it's always the same story. Our lives are governed by our visas or green cards. And so we work. And work and work—and if we're lucky, as I was, the work sustains us, inspires us, and puts us on the right path. Still, I wasn't able to leave the country when my sister had her first baby and didn't meet my nephew until he was eighteen months old. Because I am so close to my family, this was particularly hard.

The first time I came to the United States, I arrived in New York with four and a half years of intense European training under my belt and landed a job as a private chef in Greenwich, Connecticut. I am grateful that I discovered this small New England state because later, when I launched my own business, I chose Connecticut over New York for its proximity to the city, somewhat slower pace, and more reasonable rents.

As I discovered, working as a private chef is a good way to experiment with your own recipes and to learn about a new country. While there are any number of similarities between Scandinavia and this country, I had to learn to navigate the

gigantic supermarkets and other shops and decipher how ingredients differed—and how they were the same. I also got to cook in a magnificently large kitchen.

When my visa expired I found myself heading east back across the Atlantic. Once I got home, I was struck by how jaded many Europeans were and longed to return to the United States, where people seemed genuinely excited about food and cooking. I spent the next few years traveling, cooking, learning, and, I can't deny it, plotting my return to America.

However, as it turned out, I was in Denmark during the very early days of the Scandinavian culinary renaissance that now is in full bloom, a coincidence for which I am grateful. It's not that Europeans are jaded, I decided. It's just that it has been a while since they have experienced anything really new, so their "default belief" is that everything they eat and produce is the best. On the other hand, Americans have a wondrous propensity for thinking everything is new and fresh (even when this is not necessarily true).

Before I left the States, I had moved on from the private chef gig to a job at a high-end restaurant called Le Château in South Salem, New York, a town in northern Westchester County. The restaurant's owners had agreed to sponsor me should I return, and so with all the paperwork in order, I again boarded a plane and headed for the country that is now my adopted home.

I was happy at Le Château, but I found myself dreaming more and more about chocolate. I followed my stint at the restaurant with two more private chef jobs. For the second job, as a chef for a successful executive, I traveled back and forth between my tiny apartment in Connecticut and my client's townhouse near Gramercy Park in Manhattan. I had the use of an apartment in the townhouse and I freely admit that I sometimes moonlighted there developing the chocolates I wanted eventually to sell. My former boss still sends me Christmas letters and always mentions how pleased he is that my job with him played a small part in getting my business going.

This was when I started laying the groundwork for my chocolate business. I reasoned that since there were only a few super-premium chocolates being made in America, I could fill a void. There are more artisan chocolatiers here now, but a little more than a decade ago, there were only a few. Americans, with their enormous hunger for the new and luxurious, would appreciate my devotion to quality and intriguing flavors. Right?

Happily, my instincts were on the money, but I hadn't a clue how tough it would be to build a business from the ground up. I am sure a lot of entrepreneurs say the same thing, and surely mean it as fervently as I do: I am glad I didn't know what I was up against when I started. Had I, I might never have created Knipschildt Chocolates or Chocopologie.

GROWING

In addition to Knipschildt Chocolates, which appeal to the high-end, luxury market and are among the finest sold in the world, I now produce chocolates bearing the name Chocopologie, which are slightly more mainstream and affordable, although they still reflect my ongoing dedication to quality and perfection.

By 2005, I was ready to move from the dreary commercial kitchen I rented to a space where I could make the chocolates for my growing wholesale business and open a café, as well—all under the same roof.

The retail part of the business was, by nature, rife with day-to-day problems and small fires that had to be extinguished, but it allowed me to test various new products on the public. Without the retail part, I might never have understood that there is a craving for less expensive, more mainstream, and yet impeccably high-quality chocolates—the Chocopologie line—that is just as compelling as the market for very high-end, innovative chocolates—the Knipschildt line. My various chocolates are sold at Dean and DeLuca, Balducci's, and Whole Foods, as well as any number of small shops from coast to coast and in Canada.

Today, I have closed the café but kept my chocolate factory kitchen in the same location, close to home in trendy South Norwalk, an old industrial area with converted, renovated factories and brick sidewalks that years ago the town dubbed SoNo (yes, an homage to SoHo, I am sure). The kitchen is busy all day long, turning out chocolates for both lines. And, by the way, smelling absolutely fantastic.

THE FUTURE

In a joyous full circle, I am now looking homeward to Scandinavia. I am working with a two-hundred-year-old Danish company that sells to restaurants and retail outlets throughout Denmark, Sweden, and Norway. My maternal grandfather, Johannes Augustesen, started a company shortly after World War II

called JA Gros, the first major food distribution company in Denmark. I spent a lot of my childhood with him and from an early age knew he was super-tough—and a fantastic grandparent. I wish he were still around to see my business come home. My father's mother owned a tiny restaurant for a while, directly across the street from the Hans Christian Andersen house. All this adds up to a family that has always been and still is crazy passionate about food, something I admire and appreciate as I move my business through its growing pains and successes.

Had I not gone into the chocolate business, I probably would have opened a high-end restaurant because, after making premium chocolates, I like cooking fine food best. It's my training and my inclination, and even as a chocolatier, I am known for creating savory dishes that incorporate chocolate. Several years ago, I came up with a menu for Hyatt Hotels in Japan that did just that. Soon after, MasterCard asked for a similar savory menu for an event in Mexico City.

There have been other kudos: appearances on television shows with Martha Stewart and Giada De Laurentiis, and participation in Bobby Flay's *Throwdown* and four *Food Network Challenges*. I have been profiled in *O Magazine* and others and have won a number of awards from the Fancy Food Show (a major professional event). And, as a novelty, I make the most expensive truffle in the world, which I call the Madeleine, with a price tag of $250. The ganache is made from Valrhona chocolate infused with vanilla and pure Italian truffle oil. A French Périgord truffle is rolled in the ganache, which is then enrobed with chocolate and dusted with cocoa powder. The price reflects the intense labor and fine ingredients necessary to make these perfect truffles, although it's rare that I actually make more than one or two of them. You can be assured nothing approaching this over-the-top truffle appears in the pages of this book.

As I learn, grow, and thrive, I never lose sight of my subject matter. Chocolate is pure pleasure and always fun. Just thinking of it makes many people smile; eating it transports others to the sublime. For this book, I collected some of my more fun and lighthearted recipes as well as some old favorites that never let you down. I want everyone who reads this book to have a good time, try new things, rest assured that their chocolate creations will turn out, and most of all, enjoy them!

 CHAPTER ONE

COOKIES & BARS

I WON'T LIE. I DID NOT GROW UP EATING COOKIES that I would call "delicious." Because we were apt to buy cookies in a box at the market, those I ate as a child in Denmark weren't very good—just good enough to hold me over until the next meal. Then I came to the United States and discovered the amazing cookie culture here, which is nothing short of remarkable. I now love cookies! Sure, there are plenty of boxed cookies sold in supermarkets, just like the ones from my childhood, but there are also so many spectacular cookies available here that it's a party every day. And of course, the party really takes off when you bake cookies at home. You can be super-creative without too much effort and personalize each sweet, satisfying treat by adding nuts, chocolate chips, rolled oats, dried fruit—even salt and potato chips.

When I arrived here, I was clueless when it came to bar cookies. They are a wonderful dessert in part because they are so portable and you can eat them out of hand. In Europe, we are more inclined to sit down in a coffee house and eat a similar treat with a fork. In America it's more "grab and go," which I think dictates the kind of sweet. And I support this frenetic lifestyle, perhaps more by necessity than preference, but nonetheless I am glad to participate. As a busy chef and business owner, I find that brownies and other bars fit well into my dash-here-dash-there life—something for which I am thankful.

DOUBLE CHOCOLATE CHIP

COOKIES

MOST PEOPLE WHO HAVE TRIED THESE agree that they are pretty special. I add cocoa powder to the dough and use white chocolate chips or chunks. You can substitute dark or milk chocolate.

Makes about 24 cookies

1 cup (2 sticks) unsalted butter, softened

1 cup packed light brown sugar

1 cup granulated sugar

2 large eggs

1 teaspoon pure vanilla extract

2¼ cups all-purpose flour

⅔ cup unsweetened alkalized cocoa powder

½ teaspoon baking soda

½ teaspoon salt

2½ cups white chocolate chips or chunks

Preheat the oven to 350°F. Lightly butter two baking sheets or line them with parchment paper or Silpats.

In the bowl of an electric mixer fitted with the paddle attachment and set on medium-high speed, beat the butter and both sugars until creamy and smooth, 4 to 5 minutes. Add the eggs, one at a time, mixing well after each addition. Add the vanilla and beat just until incorporated.

In a separate mixing bowl, whisk together the flour, cocoa powder, baking soda, and salt.

Reduce the mixer speed to low and add the dry ingredients, a little at a time. Do not overmix, but make sure the dry and wet ingredients are completely blended.

Remove the bowl from the mixer and, using a wooden spoon or rubber spatula, fold in the white chocolate chips or chunks. Cover the bowl with plastic wrap and refrigerate for at least 30 minutes and up to 12 hours or overnight.

With a spoon, scoop mounds of cookie dough onto the baking sheets, leaving about 2 inches between each cookie. Bake until the cookies darken a shade or two and are brown around the edges, 10 to 11 minutes.

Let the cookies rest on the baking sheets for 3 to 4 minutes before transferring them to wire racks to cool completely.

CHOCOLATE-PEANUT BUTTER

COOKIES

I DIDN'T REALLY LIKE PEANUT BUTTER when I first came to the United States. If you don't grow up eating it, it's an acquired taste. I am happy to report I acquired it pretty quickly and now—are you kidding me?—I love it. Anything with peanut butter works for me, especially when it's paired with chocolate. (Try the peanut butter truffles on page 134). Like most of the cookie recipes in this chapter, this one is easy to double. You'll want to.

Makes 22 to 24 cookies

6 tablespoons unsalted butter, softened
½ cup smooth peanut butter
½ cup packed light brown sugar
1 cup confectioners' sugar
1 large egg
½ cup vegetable oil
1½ teaspoons pure vanilla extract
2 cups all-purpose flour
½ teaspoon baking powder
½ teaspoon baking soda
½ teaspoon salt
1¾ cups semisweet mini chocolate chips

Preheat the oven to 350°F. Lightly butter two baking sheets or line them with parchment paper or Silpats.

In the bowl of an electric mixer fitted with the paddle attachment and set on medium-high speed, beat the butter, peanut butter, and both sugars until creamy and smooth, 4 to 5 minutes.

In a separate mixing bowl, whisk together the egg, oil, and vanilla. With the mixer running on medium speed, add the egg mixture to the batter and beat until well mixed.

In another mixing bowl, whisk together the flour, baking powder, baking soda, and salt.

Reduce the mixer speed to low and add the dry ingredients, a little at a time. Do not overmix.

Remove the bowl from the mixer and, using a wooden spoon or rubber spatula, fold in the chocolate chips.

With a spoon or ice cream scooper, drop heaping spoonfuls of dough onto the baking sheets, leaving about 2 inches between each cookie. Bake until golden brown, 10 to 12 minutes.

Let the cookies rest on the baking sheets for 3 to 4 minutes before transferring them to wire racks to cool completely.

ICE CREAM SANDWICHES

✦

I LIKE THE JUXTAPOSITION IN THESE "sort of healthy" cookies—wholesome oatmeal and cherries are paired with decadent ice cream for a super-indulgent dessert that you don't feel too guilty about eating. You can make this with homemade ice cream (see page 186) or store-bought. To be truthful, I would probably just buy the ice cream. There are many good-quality brands in markets that will work well in these sandwiches. Yet there are times when you feel like making ice cream and these sandwiches are a great excuse to do so. What could be better than cookies and ice cream?

Makes 8 sandwiches

1 cup (2 sticks) unsalted butter, softened

1 cup packed light brown sugar

½ cup granulated sugar

2 large eggs

1 teaspoon pure vanilla extract

3 cups uncooked rolled oats

1¾ cups all-purpose flour

1 teaspoon baking soda

1 teaspoon ground cinnamon

½ teaspoon salt

½ cup dried cherries

½ cup coarsely chopped toasted pistachios (see page 210)

About 1 cup Old-Fashioned Vanilla Ice Cream (page 188), Caramel Ice Cream (page 191), or high-quality store-bought vanilla or caramel ice cream

Preheat the oven to 350°F. Lightly butter two baking sheets or line them with parchment paper or Silpats.

In the bowl of an electric mixer fitted with the paddle attachment and set on medium-high speed, beat the butter and both sugars until creamy and smooth, 4 to 5 minutes.

Add the eggs, one at a time, mixing well after each addition. Beat in the vanilla.

In a separate mixing bowl, whisk together the rolled oats, flour, baking soda, cinnamon, and salt.

Reduce the mixer speed to low and add the dry ingredients, a little at a time. Do not overmix.

Remove the bowl from the mixer and, using a wooden spoon or rubber spatula, fold in the cherries and pistachios.

With a spoon, scoop mounds of cookie dough onto the baking sheets, leaving about 2 inches between each cookie. Bake until the cookies are lightly browned around the edges, 10 to 12 minutes.

Let the cookies rest on the baking sheets for 3 to 4 minutes before transferring them to wire racks to cool completely.

Spread about 2 tablespoons of slightly softened ice cream between the flat sides of 2 cookies to form a sandwich. Repeat with the remaining ice cream and cookies. Wrap each sandwich in plastic wrap and freeze in an airtight container for at least 30 minutes to give the ice cream time to firm up. For longer storage, put the wrapped sandwiches in an airtight container and keep in the freezer for up to 2 weeks. Let them sit at room temperature for 5 to 6 minutes before serving.

CHOCOLATE SHORTBREAD

COOKIES

NOT TOO MANY PEOPLE THINK OF chocolate when they think of shortbread, but why not? The cocoa powder gives these buttery cookies gentle chocolate flavor and bold chocolate color. Plan ahead for these, as the dough has to chill in the refrigerator for at least an hour or overnight.

Makes about 24 cookies

¾ cup (1½ sticks) unsalted butter, softened

⅔ cup confectioners' sugar

1 teaspoon pure vanilla extract

1 cup all-purpose flour

½ cup unsweetened alkalized cocoa powder

Pinch of salt

In the bowl of a food processor fitted with the metal blade, pulse the butter, confectioners' sugar, and vanilla until smooth.

Add the flour, cocoa powder, and salt and process by pulsing until the dough begins to come together and form a ball.

Form the dough into a disk, wrap in plastic, and refrigerate for at least 1 hour and up to 8 hours or overnight.

Preheat the oven to 350°F. Sprinkle a work surface with a little flour and cocoa powder. Unwrap the dough and divide the disk in half. Return one half of the dough to the refrigerator while rolling out the other half. Roll the dough out to a thickness of about ½ inch. Cut the dough into 2-inch squares with a small, sharp knife or use a 2-inch cookie cutter to cut out the cookies. If you want larger cookies, use a large cookie cutter. Roll and cut the remaining dough.

Transfer the cookies to ungreased baking sheets, leaving about 1 inch between each cookie. Gather the scraps of dough and roll them out to cut out more cookies. Bake until the cookies are firm to the touch, about 15 minutes. They will not darken.

Let the cookies rest on the baking sheets for about 5 minutes before transferring them to wire racks to cool completely.

BAKING SHEETS

BAKING SHEETS ARE ALSO CALLED COOKIE SHEETS. Most folks have at least one and usually two of these familiar flat metal pans, which have a low rim on one end.

The problem is that many baking sheets are not well made and will, with time, warp, resulting in cookies that don't bake evenly. I suggest you buy high-quality baking sheets that feel heavy when hefted. These will cost a little more and you may have to buy them in a home goods store rather than at the supermarket, but they will last for decades. Avoid any made from dark metal, which attracts heat and can cause burning. Insulated cookie sheets are great; no cookie will burn when you use them. However, they don't work well for crispy cookies, which need a thinner sheet. If you can, own two of each kind: regular and insulated.

CHOCOLATE-COCONUT
MACAROONS

—✦—

ALTHOUGH WE MADE SIMILAR MACAROONS WHEN I was growing up in Denmark, I consider these American in style because they are not made with almond flour, as are French macaroons. I love the aroma of these little cookies as they bake. After they are taken from the oven, I drizzle the cookies with melted chocolate, which gets caught in the cookies' nooks and crannies. Outstanding! One word of warning: If the day is especially humid, the drizzled chocolate may not set as well as it would on a dry day.

Makes 10 to 15 macaroons

2 large egg whites

⅓ cup sugar

2 tablespoons unsweetened cocoa powder

Pinch of salt

1½ cups sweetened shredded coconut

4 ounces bittersweet or semisweet chocolate

Preheat the oven to 350°F. Lightly butter two baking sheets or line them with parchment paper or Silpats.

In a mixing bowl, whisk together the egg whites, sugar, cocoa powder, and salt. Add the coconut and stir until well mixed.

Using a spoon, drop the macaroon batter onto the baking sheets. With dampened fingers, shape the batter into balls or pyramids. Bake until the macaroons are lightly browned, 15 to 20 minutes.

Let the macaroons rest on the baking sheets for 5 to 10 minutes before transferring them to wire racks to cool completely.

Coarsely chop the chocolate and melt it according to the instructions on page 32.

Set the wire racks on a baking sheet to catch the chocolate and drizzle the chocolate over the macaroons in a random pattern. Let the chocolate set at room temperature for at least 1 hour before serving.

MELT CHOCOLATE

IN MANY OF THE RECIPES IN THIS BOOK, such as those for ganache or chocolate sauce, I melt the chocolate simply by pouring hot liquid (generally cream and milk) over coarsely chopped chocolate. The chocolate melts nicely when stirred with the hot liquid and in no time the mixture is smooth and evenly colored. There are times, though, when chocolate needs to be melted alone, without the addition of cream or anything else.

I was trained to melt chocolate over very hot water (not really even simmering) using the double boiler method, in which a smaller pot of chocolate sits on top of a larger pot of water. This age-old method of melting chocolate is effective but does require some care. First, the top pot cannot touch the water in the bottom pot. Second, the water should not get too hot, because you want to avoid steam spiraling up from the water and mixing with the chocolate. This means you must keep the heat low and watch everything carefully. In my opinion, modern technology has made melting chocolate a lot easier and foolproof. When you use the microwave, there's less chance of the chocolate scorching or stiffening (also called "seizing").

To melt chocolate in the microwave, coarsely chop it and transfer it to a microwave-safe container. Microwave on medium power for 1 minute. Stir the chocolate, which will

not be completely melted but will look shiny and moist. Microwave on high power for 20 seconds and stir again. The chocolate should pool into a liquid mass, but if it doesn't, microwave at 20-second intervals until it does. The exact time depends on your microwave (some are more powerful than others), the size of the container, and the amount of chocolate. It's key to remember that when you employ this method, the chocolate will not melt completely until it's stirred.

To melt chocolate in a double boiler, put the chopped chocolate in a clean, dry pot and set it over a pot of hot (barely simmering) water. As the chocolate melts, stir it with a clean, dry wooden spoon. I keep saying "dry" because moisture is the chocolate's enemy during melting. If droplets of water or even steam get into the chocolate, it may stiffen, and once this happens it cannot be retrieved. You will have to start over again with more chocolate, so take great care. And if the heat is too intense, the chocolate can scorch, which spoils its flavor.

All bets are off when you melt chocolate together with butter, cream, or another ingredient. You still have to be careful, but you don't have to be concerned about moisture getting into the chocolate. Such prudence is most important when the chocolate is melted all by itself.

MERINGUES

MERINGUES ARE SO EASY TO MAKE and yet some folks are afraid of them. Beating the egg whites does take some patience, but once you realize the baking process is all about drying out the meringues, it will make more sense and you will find yourself making these over and over. This is why the oven is heated only to 200°F—to dry the meringues for the first two hours. Then they finish drying and crisping at room temperature. As you might imagine, making meringues on a hot, humid summer day is not optimal. Better to wait for cool, dry weather.

Makes about 24 meringues

9 to 10 large egg whites
(about 1¼ cups)

2¼ cups sugar

1 teaspoon cream of tartar

¾ teaspoon almond extract

4 ounces bittersweet or semisweet chocolate, coarsely chopped

⅓ cup slivered almonds, toasted (see Note)

NOTE: *To toast the slivered almonds, spread them in a small, dry skillet and toast over medium-high heat until they darken a shade and are aromatic, about 1 minute. Slide them onto a plate to cool.*

Preheat the oven to 200°F. Line a baking sheet with parchment paper.

In the clean, dry bowl of an electric mixer, whisk together the egg whites, sugar, and cream of tartar by hand. Set the bowl over a saucepan holding about 1 inch of simmering water over medium heat. The bowl should not touch the water in the pan. Whisk until the egg whites are hot to the touch.

Transfer the bowl to the electric mixer, fitted with the whisk attachment and set on medium-high speed. Beat until the meringue is light and fluffy, holds stiff peaks, and is cool to the touch, 8 to 10 minutes. Add the almond extract and beat just until mixed.

Remove the bowl from the mixer and, with a rubber spatula, fold in the chopped chocolate.

Using a spoon, drop the meringue mixture onto the baking sheet, leaving about ½ inch between each meringue. With dampened fingers, shape the meringues into mounds or "kisses." Sprinkle with the almonds and bake until the meringues are crisp and easy to lift off the parchment paper, about 2 hours.

Let the meringues cool completely on wire racks.

MADELEINES

YOU REALLY CAN'T MAKE MADELEINES WITHOUT a madeleine pan because the definition of the cookies relies in part on their shell-like shape. Luckily you can buy madeleine pans very inexpensively at cookware stores. So many recipes for madeleines talk about Marcel Proust's *Remembrance of Things Past*, in which he attributes the unleashing of memories to tasting a madeleine dunked in tea. But I won't do that. I doubt very much if the author was thinking about these chocolate cookies, although I am sure he would have enjoyed them as much as I hope you do.

Makes 12 madeleines

½ cup plus 1 tablespoon all-purpose flour

¼ cup unsweetened alkalized cocoa powder

½ teaspoon baking powder

Pinch of salt

2 large eggs, at room temperature

6 tablespoons packed light brown sugar

2 tablespoons honey

2 tablespoons orange juice

7 tablespoons unsalted butter, melted and cooled

Grated zest of ½ orange

Preheat the oven to 375°F. Lightly butter a 12-mold madeleine pan and then dust it with flour. Tap out the excess flour.

In a mixing bowl, whisk together the flour, cocoa powder, baking powder, and salt.

In the bowl of an electric mixer fitted with the paddle attachment and set on medium speed, beat the eggs, sugar, honey, and orange juice until smooth. Add the dry ingredients and beat just until combined.

Reduce the mixer speed to low and slowly pour the butter into the batter, mixing until incorporated. Remove the bowl from the mixer and fold in the orange zest. Cover the bowl with plastic wrap and refrigerate for at least 1 hour and up to 8 hours or overnight.

Fill a piping bag fitted with a plain tip about halfway with the chilled batter. Return the bowl to the refrigerator until needed. Pipe the batter into the molds, filling each about three-quarters full. Alternatively, spoon the batter into the molds and smooth it slightly. Repeat with the remaining batter until all 12 madeleine molds are filled. Bake until the madeleines are domed and spring back when gently pressed in the middle, about 13 minutes.

Let the madeleines cool in the pan for 3 to 4 minutes before transferring them to wire racks to cool completely. Madeleines are best eaten on the day they are baked.

FUDGY BROWNIES

AS I ALREADY MENTIONED IN THE introduction to this chapter, I didn't know about America's wonderful tradition of brownies and other bar cookies when I was learning to bake and create chocolate desserts in Europe. I am a quick study, though, so it didn't take me long to catch on to the craze for brownies and other bars. I've even come up with a brownie recipe that stands up to the best my adopted country has to offer.

Makes 12 to 16 brownies (or 4 to 9 large brownies, for making the Brownie Sundaes on page 39)

BROWNIES

- 6 ounces bittersweet or semisweet chocolate, coarsely chopped
- ½ cup (1 stick) unsalted butter
- 1½ cups sugar
- 2 large eggs
- ½ teaspoon pure vanilla extract
- 3 cups all-purpose flour
- ½ teaspoon baking powder
- Pinch of salt
- 1½ cups raisins or coarsely chopped walnuts, optional

GANACHE

- 6 ounces bittersweet or semisweet chocolate, coarsely chopped
- ¾ cup heavy cream
- 1 tablespoon honey
- 1 tablespoon unsalted butter

TO MAKE THE BROWNIES: Preheat the oven to 350°F. Butter an 8-inch square baking pan.

In a microwave-safe container or in a pan set over simmering water, melt the chocolate and butter. If microwaving, heat on medium power for 2 minutes, remove from the microwave, and stir. If the chocolate does not liquefy, microwave on medium or medium-high power for another minute or so. If using a pan set over simmering water, stir the mixture often to ensure even melting. Set aside to cool.

In the bowl of an electric mixer fitted with the paddle attachment and set on high speed, beat the sugar with the eggs and vanilla until light and fluffy, 2 to 3 minutes. Remove the bowl from the mixer and fold in the cooled chocolate mixture with a rubber spatula.

In a separate mixing bowl, whisk together the flour, baking powder, and salt. Gently fold the dry ingredients into the batter, mixing just until the flour is fully incorporated. Stir in the raisins or walnuts, if using.

Spread the batter in the brownie pan and bake until a toothpick inserted near the center comes out nearly clean, with just a few crumbs attached, 25 to 30 minutes.

Transfer the pan to a wire rack to cool completely.

TO MAKE THE GANACHE: Put the chocolate in a heatproof bowl.

In a heavy saucepan, bring the cream and honey to a boil over medium-high heat. Once it's bubbling, pour the cream mixture over the chopped chocolate. With a wooden spoon, stir the ganache until the chocolate melts and the mixture is smooth and evenly colored.

Let the ganache cool until warm to the touch, 2 to 3 minutes. Add the butter and stir until the butter melts and is incorporated. Let the ganache cool slightly. It should not be hot when spread on the brownies.

When the brownies are cool, spread with the ganache. Slice into squares and serve.

BROWNIE SUNDAES

ADMITTEDLY, WHEN I TASTED A BROWNIE for the first time I thought it was a delicious chocolate mess, but a mess nonetheless. I have since come to honor them and so when I discovered that Americans like to top brownies with ice cream and chocolate sauce for a concoction called a "brownie sundae," I was right there. What better way to savor a good brownie? Although you might normally cut brownies into 2-inch squares, for this recipe, cut them into larger pieces.

Makes 4 sundaes

CHOCOLATE SAUCE

½ cup heavy cream

⅓ cup semisweet chocolate chips

1½ teaspoons unsalted butter

SUNDAES

4 large (3 to 4 inches square) Fritz's Fudgy Brownies (page 36), without the ganache

4 scoops Old-Fashioned Vanilla Ice Cream (page 188) or high-quality store-bought vanilla ice cream

Sweetened whipped cream (see page 224), for garnish, optional

Chocolate shavings (see page 93), for garnish, optional

4 large fresh strawberries, for garnish, optional

TO MAKE THE CHOCOLATE SAUCE: Heat the cream in a saucepan over medium-high heat until it boils. Reduce the heat to low and add the chocolate chips. Stir gently until the chocolate melts and the sauce is smooth.

Remove the pan from the heat and add the butter. Stir until the butter melts and is fully incorporated. Cover and set aside.

TO MAKE THE SUNDAES: Wrap each brownie in a paper towel and microwave on high until warm, 50 to 60 seconds.

Put each brownie in the center of a dessert plate or shallow bowl and drizzle with the warm sauce. Top each with a scoop of ice cream. If desired, finish each sundae with a dollop of whipped cream and garnish with chocolate shavings or a strawberry.

CHOCOLATE-MARSHMALLOW
S'MORE BARS

I INCORPORATED THE FLAVORS OF TRADITIONAL S'MORES into these bars, beginning with a graham cracker crust and ending with a layer of marshmallows, broiled just until golden brown and a little crusty. Homemade marshmallows make these a little bit better, in my opinion, but if it's easier to use store-bought, go right ahead.

Makes 12 bars

CRUST

20 to 22 whole graham crackers
5 tablespoons unsalted butter, melted
1 large egg white (about 2 ½ tablespoons)
2 tablespoons sugar

FILLING

4 ounces bittersweet or semisweet chocolate, coarsely chopped
½ cup (1 stick) unsalted butter
½ cup sugar
3 large eggs
20 homemade marshmallows (see page 185) or standard-size store-bought marshmallows

Preheat the oven to 350°F. Lightly spray a 9-inch square baking pan with nonstick cooking spray.

TO MAKE THE CRUST: In the bowl of a food processor fitted with the metal blade, process the graham crackers into crumbs. You will have about 1½ cups of crumbs. Add the melted butter, egg white, and sugar and process just until combined.

Transfer the crumbs to the baking pan and press the crust across the bottom and up the sides of the pan. Bake the crust just until firm, about 10 minutes.

TO MAKE THE FILLING: In a saucepan set over medium heat, melt the chocolate and butter, stirring, until smooth and nearly hot (not just warm) to the touch. Remove the pan from the heat and stir in the sugar until dissolved.

Add the eggs, one at a time, whisking until incorporated after each. Pour the filling over the graham cracker crust and spread evenly. Bake until the filling is set, 12 to 15 minutes.

Turn off the oven and turn on the broiler.

Lay the marshmallows over the filling, covering it completely. Broil until the marshmallows are golden brown, 2 to 3 minutes.

Let the bars cool slightly in the pan on a wire rack before cutting into squares (still in the pan); let cool completely before lifting from the pan and serving.

HONEY? IN GANACHE?

TRIAL AND ERROR TAUGHT ME A VALUABLE LESSON about honey: when it's added to ganache, the ganache's "mouthfeel" is amazingly soft and extravagant. I think any honey works, although at first you might want to experiment with mild honey. If you like the result (and you will!), you may want to try with a bolder-tasting, darker honey.

Honey takes on the flavor of the nectar used by the bees to make it. Generally, the lighter the honey's color, the milder the flavor. Lighter, milder honeys include alfalfa, clover, and orange blossom; dark, strong-tasting honeys include tupelo and buckwheat. I like to buy honey when I see it at farmers' markets and local shops and experiment with the various flavors provided by the local flora. Because honey keeps for about a year, I go through all I buy, and if it does crystallize during storage, it's easy to liquefy by setting the jar in a pan of very hot water (not on the stovetop) for 15 to 20 minutes. You can also liquefy it in the microwave in 20- or 30-second intervals.

COCONUT-CHOCOLATE BARS

THESE BARS ARE MORE COCONUT THAN chocolate, but that's okay. If you like the combo of these two flavors, I doubt you will object when you bite into one. I often keep a Coconut-Chocolate Bar tucked into my bag as I travel between clients in the tri-state region (Connecticut, New York, and New Jersey), so I never get too hungry.

Makes 12 bars

CRUST

20 to 22 whole graham crackers

6 tablespoons unsalted butter, melted

2 tablespoons sugar

½ cup chopped walnuts, slivered almonds, or chopped pecans, toasted (see page 210)

½ cup semisweet chocolate chips

TOPPING

2 cups sweetened shredded coconut

1 cup minus 2 tablespoons sweetened condensed milk

2 large egg whites

1 teaspoon pure vanilla extract

Pinch of sea salt

Preheat the oven to 350°F. Lightly spray a 9-inch square baking pan with nonstick cooking spray.

TO MAKE THE CRUST: In the bowl of a food processor fitted with the metal blade, process the graham crackers into crumbs. You will have about 1½ cups of crumbs. Add the melted butter and sugar and process just until combined.

Transfer the crumbs to the baking pan and press the crust across the bottom and up the sides of the pan. Bake the crust just until firm, about 10 minutes.

Remove the crust from the oven and sprinkle the nuts and chocolate chips evenly over it. Set aside.

TO MAKE THE TOPPING: In a mixing bowl, stir together 1½ cups of the coconut, the condensed milk, egg whites, vanilla, and salt. Stir until well blended. Spread the coconut mixture over the crust in an even layer. Sprinkle with the remaining ½ cup coconut.

Bake until the coconut is golden brown, 15 to 20 minutes.

Let the bars cool slightly in the pan on a wire rack before cutting into squares (still in the pan); let cool completely before lifting from the pan and serving.

BACON BLONDIES

I AM NOT IMMUNE TO THE craze for "everything with bacon." The rich saltiness of the cured meat plays happily with the sweet flavors of sugar and chocolate in these blondies, making it nearly impossible to eat only one. For the best, most indulgent treat, buy thick-cut, high-quality bacon—the kind you might find at farmers' markets and butcher shops.

Makes 12 bars

½ cup (1 stick) unsalted butter
4 slices bacon
1¼ cups all-purpose flour
1 teaspoon baking powder
1 cup packed light brown sugar
1 large egg
2 teaspoons pure vanilla extract
1 cup semisweet chocolate chips

Preheat the oven to 350°F. Butter an 8-inch square baking pan and then sprinkle it lightly with flour, tapping out the excess.

In a saucepan, melt the butter over medium-high heat. Stir it constantly and let the butter turn a nutty brown as it cooks. When it starts to foam, smells caramelized, and is golden brown, remove the pan from the heat and set aside to cool for 5 to 10 minutes.

Meanwhile, in a frying pan, cook the bacon until nearly crispy. The bacon should not be brittle and crisp, or flabby and soft, but it should be somewhere in between. Drain the bacon on paper towels. Reserve 2 tablespoons of the bacon fat and discard the rest. Cut or crumble the bacon into small pieces.

In a mixing bowl, whisk together the flour and baking powder.

In the bowl of an electric mixer fitted with the paddle attachment and set on medium speed, beat the browned butter, bacon fat, and sugar until well mixed. Add the egg and vanilla.

Reduce the mixer speed to low and slowly add the flour mixture, beating just until incorporated. Remove the bowl from the mixer and, with a wooden spoon or rubber spatula, fold in the bacon and chocolate chips. Take care not to overmix.

Spread the batter in the prepared pan and bake until the blondies are golden brown and a toothpick inserted near the center comes out with just a few crumbs clinging to it, 22 to 25 minutes.

Transfer the pan to a wire rack and cool to room temperature.

CHAPTER TWO

CAKES

CAKES ARE THE FIRST THING MOST PEOPLE THINK OF when they consider baking. I do, too. When I trained in Europe, I learned to bake classic, traditional cakes, the sort you would expect to find in any bakery or on any restaurant dessert trolley in northern Europe. It was a great education and I have built on it to come up with chocolate cakes with fanciful twists and deep flavors. My chocolate buttermilk cake, which features layers of caramel and peanut butter buttercream, is sort of a Snickers bar in a cake pan, and my banana loaf cake features three kinds of chocolate. Putting a spin on the classics not only lets me have fun but allows me to be inventive.

I know my cakes are a little more European in style than typical American cakes. For example, Americans like thick layers of ultra-sweet frosting slathered on their cakes and between the layers. But I love ganache for its depth of flavor and intrinsic elegance. In Europe, we also like light, subtle génoise, a kind of sponge cake, as opposed to sweeter, denser butter cakes. My cakes often fall between a typical American butter cake and a French génoise.

On both sides of the Atlantic Ocean, cakes are the centerpieces of celebrations from birthdays to weddings and of holidays from Easter to the Fourth of July. On the other hand, if you are like me, you don't wait for a birthday or holiday. If you're feeling super-low at about four in the afternoon, what do you do? Have a slice of cake, of course!

CLASSIC CARROT CAKE

WITH WHITE CHOCOLATE–CREAM CHEESE FROSTING

❧❧❧

CARROT CAKE, WHICH OF COURSE TRACES its roots to America, is bold, brash, and lacking in pretension. It's also downright irresistible, especially when topped with the traditional (and zealously adored) cream cheese frosting. I agree that the sweet, luxurious frosting offsets the moist, earthy cake as nothing else could. But I have made the frosting a little better—at least in my opinion—by adding white chocolate.

Makes one 9-inch cake

CAKE

4 large eggs

1¾ cups granulated sugar

⅓ cup vegetable oil

1¾ cups all-purpose flour

1 tablespoon plus 1½ teaspoons ground cinnamon

1 teaspoon baking soda

½ teaspoon baking powder

½ teaspoon salt

⅛ teaspoon ground allspice

Pinch of ground nutmeg

Pinch of ground cardamom

4 cups peeled, shredded carrots (about 1 pound carrots)

1 cup toasted walnuts (see page 210), coarsely chopped

TO MAKE THE CAKE: Position an oven rack in the center of the oven and preheat the oven to 350°F. Lightly spray two 9-inch round cake pans with nonstick cooking spray (or butter each pan). Scatter some flour in the bottom and up the sides of each pan and then tap out the excess.

In the bowl of an electric mixer fitted with the paddle attachment and set on medium–high speed, mix together the eggs, granulated sugar, and oil.

In a separate mixing bowl, sift together the flour, cinnamon, baking soda, baking powder, salt, allspice, nutmeg, and cardamom. Whisk a few times to ensure even mixing.

Reduce the mixer speed to medium-low and add the dry ingredients, a little at a time. Remove the bowl from the mixer and, with a large rubber spatula, fold in the carrots and walnuts.

Scrape the batter into the prepared pans, dividing it evenly. Smooth the surface of each pan and bake until the cake springs back when lightly touched and a toothpick inserted near the center comes out clean, 35 to 40 minutes.

Let the pans cool on wire racks for about 10 minutes before turning out the cake layers onto the racks to cool completely before frosting.

recipe continues

8 ounces white chocolate, coarsely chopped

1½ teaspoons pure vanilla extract

1 cup (2 sticks) plus 2 tablespoons unsalted butter, softened

1¾ cups sifted confectioners' sugar

24 ounces (three 8-ounce packages) cream cheese, softened

ASSEMBLY

½ to ¾ cup finely chopped toasted walnuts (see page 210), for decoration, optional

TO MAKE THE FROSTING: Melt the white chocolate according to the instructions on page 32. Once melted, remove the chocolate from the heat and stir in the vanilla until smooth.

In the bowl of an electric mixer fitted with the paddle attachment and set on medium-high speed, beat together the butter and confectioners' sugar until smooth and creamy, about 3 minutes. Add the cream cheese and continue beating until smooth.

Reduce the mixer speed to low and add the white chocolate mixture to the frosting. Beat until smooth and blended.

TO ASSEMBLE THE CAKE: Hold each cake layer on the palm of your hand or set it on a cake-decorating turntable. Using a long, serrated knife, slice each layer in half horizontally to make 4 total layers.

Stack the cake layers, spreading ¾ to 1 cup of frosting between each layer. Use the remaining frosting to cover the top and sides of the cake. If desired, decorate the cake by pressing the chopped walnuts onto the sides.

CHOCOLATE BUTTERMILK CAKE

WITH PEANUT BUTTER BUTTERCREAM

I CALL THIS SNICKERS CAKE AND I chose its flavors based on that iconic candy bar. When I have time to ski, I slip a Snickers Bar into my pocket. Not only does it give me a boost on the slopes, but I particularly like it frozen. This cake mimics the candy's flavors: chocolate, caramel, and peanuts.

Makes one 6-inch cake

CAKE

- ½ cup buttermilk
- 1 large egg
- ¾ cup sugar
- ¼ cup vegetable oil
- 1 teaspoon pure vanilla extract
- 1 cup all-purpose flour
- ⅓ cup unsweetened alkalized cocoa powder
- 1 teaspoon baking soda
- ½ teaspoon baking powder
- ¼ teaspoon salt
- ½ cup hot brewed coffee

TO MAKE THE CAKE: Position an oven rack in the center of the oven and preheat the oven to 350°F. Lightly spray one 6-inch round cake pan with nonstick cooking spray and line the bottom of the pan with parchment paper.

In the bowl of an electric mixer fitted with the paddle attachment and set on medium speed, mix together the buttermilk, egg, sugar, oil, and vanilla until blended.

In a separate mixing bowl, sift together the flour, cocoa powder, baking soda, baking powder, and salt.

Reduce the mixer speed to medium–low and add the dry ingredients to the batter, a little at a time, mixing until just incorporated. Pour the coffee into the batter. Using a rubber spatula, scrape down the sides of the bowl. Mix until there are no lumps in the cake batter.

Scrape the batter into the prepared pan, smooth the top, and bake until the cake springs back when gently pressed and a toothpick inserted near the center comes out clean, 45 to 50 minutes.

Let the pan cool on a wire rack for about 10 minutes before turning out the cake onto the rack to cool completely before frosting.

recipe continues

BUTTERCREAM

1 cup sugar

3 large egg whites

Pinch of salt

1 cup (2 sticks) unsalted butter, cut into pieces and softened

¼ cup smooth peanut butter

½ teaspoon pure vanilla extract

ASSEMBLY

20 caramel squares

3 tablespoons heavy cream

¾ cup finely ground chocolate wafer cookie crumbs (12 to 14 wafer cookies)

TO MAKE THE BUTTERCREAM: In the bowl of an electric mixer, whisk together the sugar, egg whites, and salt by hand. Set the bowl over a pan filled with 1 to 2 inches of simmering water and over medium heat. Do not let the bottom of the bowl touch the water. Whisking all the time, heat the egg whites and sugar until hot to the touch.

Transfer the bowl to the mixer, fitted with the whisk attachment and set on high speed, and beat until the meringue starts to thicken and the bottom of the bowl feels cool to lukewarm, 8 to 10 minutes. The meringue will feel about room temperature.

With the mixer on medium-high speed, add the butter, one or two pieces at a time. Do not add the next piece until the previous has been incorporated. Keep beating until the buttercream is smooth and blended.

Add the peanut butter and vanilla and beat until combined.

TO ASSEMBLE THE CAKE: In a saucepan, melt the caramels with the cream over medium heat just until the caramel melts, stirring occasionally until smooth. Alternatively, heat the caramels and cream in the microwave.

Hold the cake on the palm of your hand or set it on a cake-decorating turntable. Using a long, serrated knife, slice the cake into thirds horizontally to make 3 layers.

Stack the cake layers, spreading about ½ cup of the buttercream between each layer and drizzling the caramel over the buttercream, taking care it does not dribble down the sides. When the third cake layer is in place, spread the rest of the buttercream over the top and down the sides of the cake. Press the cookie crumbs onto the sides of the cake.

RED VELVET CAKE

WITH CREAM CHEESE FROSTING

⤝⤞

ALTHOUGH I FIND THIS CAKE DELICIOUS, I am still somewhat surprised that it was a top seller at the café. I had never heard of red velvet cake before I came to the States, although Germans make a similar cake using beet juice. It's an irresistible moist, mild chocolate cake with a dark red hue that fascinated me from the moment I heard about it, and so after some research and experimentation in the kitchen, I came up with my own version. I am proud of this recipe, which requires a little more work than a mix. Like all typical red velvet cakes, this recipe is made with buttermilk, cocoa powder, and a little vinegar to balance the flavors.

Makes one 9-inch cake

CAKE

2½ cups all-purpose flour

3 tablespoons unsweetened cocoa powder

1½ teaspoons baking powder

1 teaspoon baking soda

½ teaspoon salt

½ cup (1 stick) unsalted butter, softened

2 cups granulated sugar

3 large eggs

1 cup buttermilk

3 tablespoons hot water

1 tablespoon white distilled vinegar or apple cider vinegar

2 to 3 teaspoons red food coloring (for deeper color, use 3 teaspoons)

1 teaspoon pure vanilla extract

TO MAKE THE CAKE: Position an oven rack in the center of the oven and preheat the oven to 350°F. Line a 9-inch round cake pan with parchment paper or waxed paper and spray with nonstick cooking spray.

In a mixing bowl, sift together the flour, cocoa powder, baking powder, baking soda, and salt.

In the bowl of an electric mixer fitted with the paddle attachment and set on medium-high speed, cream the butter and granulated sugar until light and fluffy, 4 to 5 minutes. Add the eggs, one at a time, beating well after each addition.

Reduce the mixer speed to low and add the buttermilk, water, vinegar, food coloring, and vanilla. Mix until the batter is blended. With the mixer running, gradually add the dry ingredients to the batter and beat just until combined. Do not overmix.

Scrape the batter into the prepared pan, smooth the surface, and bake until the edges pull away from the sides of the pan and a toothpick inserted near the center comes out clean, 45 to 50 minutes.

Let the cake cool in the pan on a wire rack for about 5 minutes before turning out the cake onto the rack to cool completely before frosting.

recipe continues

FROSTING

¾ cup (1½ sticks) unsalted butter, softened

1½ cups confectioners' sugar

16 ounces (two 8-ounce packages) cream cheese, softened

1 teaspoon pure vanilla extract

TO MAKE THE FROSTING: In the bowl of an electric mixer fitted with the paddle attachment and set on medium speed, beat the butter and confectioners' sugar together until blended. Add the cream cheese and beat until smooth. Add the vanilla and beat just until incorporated.

TO ASSEMBLE THE CAKE: With a long, serrated knife, slice the domed top of the cake layer from the cake so that the top is flat. Reserve the domed top of the cake. Hold the cake in the palm of your hand or set it on a cake-decorating turntable. Using the serrated knife, slice the cake into thirds horizontally to make 3 layers.

Stack the cake layers, spreading about 1 cup of frosting between each layer. Use the remaining frosting to frost the top and sides of the cake.

In the bowl of a food processor fitted with the metal blade, process the reserved top of the cake into crumbs. Press the crumbs onto the sides of the cake and sprinkle them over the top.

BANANA CAKE

THE FIRST CAKE I BAKED IN my life was a banana cake. I don't know how old I was, but I was certainly still in grammar school, and I decided to melt down a few chocolate bars to spread over the cake like frosting. Don't worry, I have perfected the recipe since then. Today I make the batter with two kinds of chocolate and then drizzle melted white chocolate over the cooled cake. I think the flavor marriage of bananas and chocolate is a blessed one, so whenever I have a couple of ripe bananas lying around, I make this simple loaf cake. For the best flavor, wait until the banana skins are covered with dark splotches.

Makes 1 loaf

- 2 ripe bananas
- 2 cups all-purpose flour
- 1 teaspoon ground cinnamon
- 1 teaspoon baking powder
- 1 teaspoon baking soda
- ½ teaspoon salt
- ½ cup (1 stick) unsalted butter, softened
- 1 cup sugar
- 2 large eggs
- 1 tablespoon whole milk
- 3 ounces milk chocolate, coarsely chopped
- 3 ounces bittersweet or semisweet chocolate, coarsely chopped
- ½ cup coarsely chopped toasted walnuts (see page 210)
- 2 ounces white chocolate, coarsely chopped

Position an oven rack in the center of the oven and preheat the oven to 350°F. Lightly spray a 9 by 5-inch loaf pan with nonstick cooking spray (or butter the pan, sprinkle with flour, and then tap out the excess flour).

Using a fork, mash the bananas to a pulp, or do so in a blender or food processor fitted with the metal blade.

In a mixing bowl, sift together the flour, cinnamon, baking powder, baking soda, and salt.

In the bowl of an electric mixer fitted with the paddle attachment and set on medium-high speed, cream the butter and sugar until light and fluffy, 4 to 5 minutes. Add the eggs, one at a time, beating well after each addition. Add the milk and bananas and beat until combined.

Reduce the mixer speed to low and gradually add the dry ingredients, beating just until combined. Do not overmix.

Remove the bowl from the mixer and, using a wooden spoon or rubber spatula, fold in the chopped milk and bittersweet chocolates and the walnuts.

Scrape the batter into the prepared pan, smooth the surface, and bake until the edges pull away from the sides of the pan and a toothpick inserted near the center comes out clean, about 1 hour.

Let the cake cool in the pan on a wire rack for about 5 minutes before turning out the cake onto the rack to cool completely. Once cool, melt the white chocolate according to the instructions on page 32. Drizzle the white chocolate over the cake. Let the chocolate set at room temperature for 1 hour before serving.

POUND CAKE

IF YOU'RE LOOKING FOR A SPECIAL pound cake to dip into Chocolate Fondue (page 152), try this. Amazing! The chocolate and ginger happily meet in this buttery cake where each flavors half of the batter, which is marbled in an ordinary loaf pan. There is no fresh ginger here, but ground ginger is stirred into the batter and candied ginger is sprinkled over the top before baking.

Makes 1 loaf

 3 ounces bittersweet or semisweet
 chocolate, coarsely chopped
 2 cups all-purpose flour
 1 teaspoon baking powder
 ½ teaspoon salt
 1 cup (2 sticks) unsalted butter
1½ cups sugar
 5 large eggs
 ½ teaspoon pure vanilla extract
 1 teaspoon ground ginger
 ¼ cup coarsely chopped candied
 ginger

Position an oven rack in the center of the oven and preheat the oven to 350°F. Butter a 9 by 5-inch loaf pan and then lightly dust it with flour. Tap out the excess flour.

Melt the chocolate in the top of a double boiler set over barely simmering water, stirring until smooth. Take care no water or steam gets into the chocolate. Alternatively, melt the chocolate in the microwave as described on page 32. Let the chocolate cool to lukewarm.

In a mixing bowl, whisk together the flour, baking powder, and salt.

In the bowl of an electric mixer fitted with the paddle attachment and set on medium-high speed, cream the butter and sugar until smooth and fluffy, 3 to 4 minutes. Add the eggs, one at a time, beating well after each addition. Add the vanilla and beat until combined.

Reduce the mixer speed to low and gradually add the flour mixture, beating just until blended.

Divide the batter between the mixer's bowl and another bowl. Add the melted chocolate to half of the batter and, with a rubber spatula, stir until completely incorporated. Stir the ground ginger into the other half of the batter.

Spoon a third of the ginger batter into the pan and smooth the top with a spatula. Spoon half of the chocolate batter over the ginger batter and smooth the top. Repeat with the remaining batters so that you have three layers of ginger alternating with two of chocolate. (The top layer will be ginger.)

With a blunt table knife or metal spatula, gently swirl the batters together to create a marbled effect. Sprinkle the candied ginger over the top of the cake.

Bake until the edges pull away from the sides of the pan and a toothpick inserted near the center comes out clean, about 1 hour.

Let the cake cool in the pan on a wire rack for about 10 minutes. Run a blunt knife between the edges of the cake and the sides of the pan to loosen, then turn out the cake onto the rack to cool completely. Serve at room temperature.

MOLTEN CHOCOLATE CAKES

⚒

I'LL NEVER FORGET THE DAY I tasted my first molten chocolate cake. Nothing beats that experience: you take a spoon, knock it into the cake, and right away chocolate flows from the interior like lava from a volcano. The combination of the baked cake and the liquid center makes all your troubles go away, at least for a few moments.

Makes 6 to 8 cakes

8 ounces bittersweet or semisweet chocolate, coarsely chopped

1 cup (2 sticks) unsalted butter

4 large eggs

4 large egg yolks

¾ cup sugar

¾ cup all-purpose flour

About ½ cup semisweet chocolate chips or chopped bittersweet or semisweet chocolate

Position an oven rack in the center of the oven and preheat the oven to 350°F. Lightly butter six or eight 8-ounce ramekins or custard cups.

In the top of a double boiler set over barely simmering water, melt the chocolate and butter, stirring until smooth. Alternatively, in a microwave-safe container, melt the chocolate and butter on medium power for 2 to 3 minutes. Watch the chocolate carefully, and when it softens, stir it with the butter until smooth. Set the melted chocolate aside to cool slightly.

In the bowl of an electric mixer fitted with the paddle attachment and set on medium-high speed, beat the eggs, egg yolks, and sugar until smooth and thick, 3 to 4 minutes. Add the cooled chocolate mixture and beat until smooth.

Reduce the mixer speed to low and add the flour, a few tablespoons at a time, beating after each addition just until mixed.

Divide the batter among the ramekins, filling each halfway. Gently press 4 to 5 chocolate chips or pieces of chocolate into the batter. Spoon the remaining batter into the ramekins, filling each one to about ¼ inch of the rim. Set the ramekins on a baking sheet.

Carefully transfer the baking sheet to the oven and bake until the cakes are puffed and a little wobbly in the center, 15 to 18 minutes. Serve immediately, while the cakes are still warm.

FLOURLESS CHOCOLATE CAKE

WHILE SOME "FLOURLESS" CHOCOLATE CAKES RELY on a small amount of flour for structure, mine does not. The fats—namely four large egg yolks and a good amount of butter—hold it together once it's baked. I prefer to bake this with chocolate that is *at least 71 percent*, which means 71 percent of the bar is chocolate solids (also called pure chocolate or chocolate liquor), with the rest made up of sugar and fats. The higher the percentage, the more bitter the chocolate and the greater the chocolate wallop. If you prefer a slightly sweeter chocolate, use one that is about 64 percent chocolate solids. The flavor will still be deep, dark, and sensuous—just what you want for a flourless chocolate cake.

Makes one 8-inch cake

¾ cup (1½ sticks) unsalted butter

¾ cup sugar

6 ounces bittersweet or semisweet chocolate, coarsely chopped

4 large eggs, separated

Unsweetened cocoa powder, for dusting

Sweetened whipped cream (see page 224) or vanilla ice cream, for serving

Position an oven rack in the center of the oven and preheat the oven to 350°F. Lightly butter an 8-inch round cake pan. Line the bottom of the pan with parchment paper and then butter the paper.

In a microwave-safe container, microwave the butter, ⅓ cup of the sugar, and the chocolate for 1½ to 2 minutes. Remove from the microwave and stir. The sugar won't be completely melted, but the mixture should be warm to the touch. Transfer to the bowl of an electric mixer fitted with the paddle attachment.

Add the egg yolks to the chocolate-sugar mixture and mix on medium speed until incorporated.

In the clean bowl of the electric mixer, fitted with the whisk attachment and set on medium-high speed, beat the egg whites and the remaining sugar as follows: when the whites are foamy, add about one-third of the remaining sugar; when the whites reach soft peaks, add another one-third of the sugar; when the whites start to stiffen, add the remaining sugar and beat until the meringue forms glossy, nearly stiff peaks. They should bend just a little when the beater is lifted.

recipe continues

With a rubber spatula, fold a third of the meringue into the chocolate mixture. Once incorporated, fold in the rest of the meringue just until incorporated.

Transfer the batter to the prepared pan and smooth the surface. Bake, rotating the pan about halfway through baking, until a toothpick inserted near the center comes out clean, about 30 minutes.

Let the cake cool in the pan on a wire rack for about 8 minutes. Invert the cake pan to remove the cake. Peel the parchment paper off the bottom, turn the cake over, and let it cool completely on the rack.

To serve, dust with cocoa powder and serve whipped cream or ice cream on the side. If not serving immediately, wrap well in plastic wrap and refrigerate for up to 4 days.

COCOA POWDER

NOT ALL COCOA POWDERS ARE CREATED EQUAL. To begin with, there are two kinds, alkalized and non-alkalized, both unsweetened—and in many instances it does not matter which you use. That said, when a recipe specifies one kind or the other, there's a reason and you should use the one called for. Cocoa powder is not expensive and keeps well, and so I suggest you have both kinds on hand at all times.

Non-alkalized cocoa powder is also called natural cocoa powder. It's made by removing the cocoa butter from the cacao bean and then grinding what remains—the chocolate liquor, also called chocolate solids or, my preference, cocoa content—into a powder.

Alkalized cocoa powder is also called Dutch-processed cocoa. It starts out as natural cocoa powder but is treated with an alkali to neutralize the naturally occurring acid in the cocoa, which mellows the flavor and darkens the color.

Non-alkalized cocoa powder tastes bolder and has a lighter color than alkalized, which is dark and comparatively mild.

CHAPTER THREE

CUPCAKES

CUPCAKES HAVE TAKEN ON A LIFE OF THEIR OWN over the last decade. Weren't they the simple treats you baked for a child's birthday party or perhaps a picnic? Weren't they the less glamorous stepsisters of full-size, elegantly decorated layer cakes? All that has changed. These are portable cakes, just a few bites of sweet bliss to savor during a busy day. But they also show up at weddings and dinner parties, and bakeries dedicated only to cupcakes offer many spectacular varieties. Admittedly, bakery cupcakes tend to be larger than those we bake at home, and sometimes more gorgeously decorated, but they are still small enough to eat out of hand.

When I thought about which cupcakes to include in this book, I decided that whatever I chose would be topped with a generous cap of swirled ganache. It's the ultimate chocolate frosting and is perfect on these little gems. Ganache does not have to be purely chocolate, though; it can be flavored with lemon, coconut, coffee, and even dulce de leche, as you will find out on the following pages.

BLACK & WHITE

CUPCAKES

⌖

THERE'S NOTHING FRILLY OR GIMMICKY ABOUT these cupcakes. Just plain yellow cake frosted with deep, dark ganache. And yet, these always satisfy. It's a cake and frosting combo that has legions of fans wherever you look, and when you think about it, there is something appealing about black and white anything: think Oreo cookies or the iconic black and white cookies sold at New York delis.

Makes 12 cupcakes

GANACHE

12 ounces semisweet or bittersweet chocolate, coarsely chopped

1 cup heavy cream

1 tablespoon unsalted butter

CUPCAKES

1½ cups all-purpose flour

2 teaspoons baking powder

¼ teaspoon salt

1 cup sugar

½ cup (1 stick) unsalted butter, softened

2 large eggs

2 teaspoons pure vanilla extract or 1 tablespoon vanilla bean paste (see Note)

½ cup whole milk

TO MAKE THE GANACHE: Put the chocolate in a heatproof bowl.

In a heavy saucepan, bring the cream to a boil over medium-high heat. Once it's bubbling, pour it over the chopped chocolate. With a wooden spoon, stir the ganache until the chocolate melts and the mixture is smooth and evenly colored.

Let the ganache cool until warm to the touch, 2 to 3 minutes. Add the butter and stir until the butter melts and is incorporated. Set the ganache aside at room temperature to cool and thicken while you bake the cupcakes.

TO MAKE THE CUPCAKES: Position a rack in the center of the oven and preheat the oven to 350°F. Line a 12-cup muffin tin with cupcake liners.

Sift the flour, baking powder, and salt into a bowl.

In the bowl of an electric mixer fitted with the paddle attachment and set on medium-high speed, cream the sugar and butter until light and fluffy, about 3 minutes. Add the eggs, one at a time, beating well after each one. Add the vanilla and beat until incorporated.

Reduce the mixer speed to low. Add the flour mixture in two batches, alternating with the milk and beginning and ending with the flour. Do not overmix.

Divide the batter among the cupcake cups and bake for about 20 minutes, rotating the muffin tin halfway through baking to encourage even baking. The cupcakes are done when a toothpick inserted in the center of a cupcake comes out clean and the cake springs back when gently pressed.

Let the cupcakes cool in the tin on a wire rack for about 5 minutes before turning out the cupcakes onto the rack to cool completely.

Fill a piping bag fitted with a plain tip with the cooled ganache and pipe some ganache onto each cupcake. Alternatively, use a rubber spatula or a spoon to spread the ganache on the cupcakes.

NOTE: *Vanilla bean paste is thick and smooth, often flecked with vanilla seeds. It's milder than vanilla extract and adds mellow flavor to cupcakes or other baked goods. Buy it in specialty stores or order it online.*

LEMON-RASPBERRY YOGURT

CUPCAKES

WHEN I BITE INTO ONE OF these cupcakes, I can't help but think of summer. Lemon and raspberry are timeless reminders of warm, sunny days. These cupcakes, made from super-moist lemon cake studded with raspberries and then topped with lemony white chocolate ganache, are perfect served with iced tea on a big old wraparound porch. Even if you nibble on one at your desk or in the car, you will be transported. I promise!

Makes 12 cupcakes

GANACHE

- 3 ounces white chocolate, coarsely chopped, or white chocolate chips (about ½ cup)
- ¼ cup heavy cream
- 3 tablespoons freshly squeezed lemon juice (1 to 1½ lemons)
- 2 tablespoons honey
- 1 teaspoon grated lemon zest
- 1 tablespoon unsalted butter

CUPCAKES

- 1½ cups all-purpose flour
- 2 teaspoons baking powder
- ½ teaspoon baking soda
- 1 cup sugar
- ⅓ cup vegetable oil
- ⅓ cup plain yogurt or plain Greek yogurt
- ¼ cup freshly squeezed lemon juice (1 to 2 lemons)
- 2 large eggs
- 1 tablespoon grated lemon zest
- 1 teaspoon pure vanilla extract
- 1½ cups fresh, whole raspberries

TO MAKE THE GANACHE: Put the chocolate in a heatproof bowl.

In a heavy saucepan, bring the cream, lemon juice, honey, and lemon zest to a boil over medium-high heat. Once it's bubbling, pour the mixture over the chopped chocolate. With a wooden spoon, stir the ganache until the chocolate melts and the mixture is smooth and evenly colored.

Let the ganache cool until warm to the touch, 2 to 3 minutes. Add the butter and stir until the butter melts and is incorporated. Set the ganache aside at room temperature to cool and thicken while you bake the cupcakes.

TO MAKE THE CUPCAKES: Position a rack in the center of the oven and preheat the oven to 350°F. Line a 12-cup muffin tin with cupcake liners.

Sift the flour, baking powder, and baking soda into a bowl.

In the bowl of an electric mixer fitted with the paddle attachment and set on medium-high speed, beat the sugar, oil, yogurt, and lemon juice until well blended, about 1 minute. Add the eggs, one at a time, beating well after each one. Add the lemon zest and vanilla and beat until incorporated.

Remove the bowl from the mixer and add 1 cup of the raspberries. (Reserve the remaining ½ cup berries to decorate the cupcakes.) Using a large rubber spatula, gently fold the berries into the batter.

Divide the batter among the cupcake cups and bake for about 20 minutes, rotating the muffin tin halfway through baking to encourage even baking. The cupcakes are done when a toothpick inserted in the center of a cupcake comes out clean and the cake springs back when gently pressed.

Let the cupcakes cool in the tin on a wire rack for about 5 minutes before turning out the cupcakes onto the rack to cool completely.

Once cool, dip the cupcakes in the ganache to coat the tops. Decorate the cupcakes with the reserved raspberries.

MINI COCONUT-CHOCOLATE
CUPCAKES

WHEN I MAKE MINI CUPCAKES, I pack them with so much flavor that just one quick bite does the trick. You could bake these in a large cupcake pan, of course (just as you can bake standard-size cupcakes in mini pans), but these pack enough of a coconut wallop that they work beautifully as minis.

Makes 48 mini cupcakes

GANACHE

- 7 ounces bittersweet or semisweet chocolate, coarsely chopped
- ⅔ cup heavy cream
- ¼ cup coconut milk (see Note)
- 2 tablespoons honey or light corn syrup
- 1 tablespoon unsalted butter

CUPCAKES

- 1¼ cups all-purpose flour
- 1 teaspoon baking powder
- ¼ teaspoon salt
- 1 cup plus 2 tablespoons sugar
- ½ cup (1 stick) unsalted butter, softened
- 2 large eggs, separated
- 1 teaspoon pure vanilla extract
- ½ cup coconut milk (see Note)
- ⅓ cup plus ¾ cup sweetened shredded coconut, toasted (see Note)

TO MAKE THE GANACHE: Put the chocolate in a heatproof bowl.

In a heavy saucepan, bring the cream, coconut milk, and honey or corn syrup to a boil over medium-high heat. Once it's bubbling, pour the mixture over the chopped chocolate. With a wooden spoon, stir the ganache until the chocolate melts and the mixture is smooth and evenly colored.

Let the ganache cool for about 10 minutes. Add the butter and stir until the butter melts and is incorporated. Set the ganache aside at room temperature to cool and thicken while you bake the cupcakes.

TO MAKE THE CUPCAKES: Position a rack in the center of the oven and preheat the oven to 350°F. Line two 24-cup mini muffin tins with cupcake liners.

Sift the flour, baking powder, and salt into a bowl.

In the bowl of an electric mixer fitted with the paddle attachment and set on medium-high speed, cream 1 cup of the sugar and the butter until light and fluffy, about 3 minutes. Add the egg yolks, one at a time, beating well after each one. Add the vanilla and beat until incorporated.

Reduce the mixer speed to low. Slowly pour the coconut milk into the batter. Add ⅓ cup of the toasted shredded coconut and then the flour mixture. Beat just until combined.

recipe continues

NOTES: *Coconut milk should not be confused with coconut water, which is the thin liquid drained directly from a fresh coconut, or with coconut cream, which is thick and sweet and primarily used in tropical cocktails. Coconut milk is sold frozen or in cans in the supermarket and has a rich, nutty flavor.*

To toast shredded coconut, spread the coconut on a baking sheet and toast in a 350°F oven for 5 to 7 minutes, stirring several times for even browning. Coconut can also be spread in a skillet and toasted over medium heat, stirring, until browned. In both cases, the coconut should be lightly browned.

In the clean, dry bowl of the electric mixer, fitted with the whisk attachment and set on medium-high speed, whip the egg whites with the remaining 2 tablespoons sugar until the meringue forms stiff peaks. Do not overbeat. The whites should stand straight up and not bend when the beater is lifted.

With a large rubber spatula, fold the whites into the batter just until incorporated; do not overmix or the egg whites will deflate. A few flecks of whites in the batter are acceptable.

Spoon a good tablespoon of batter into each cupcake cup. The batter should fill the cups about three-quarters of the way. Bake for about 17 minutes, rotating the muffin tins halfway through baking to encourage even baking. The cupcakes are done when a toothpick inserted in the center of a cupcake comes out clean and the cake springs back when gently pressed.

Let the cupcakes cool in the tin on a wire rack for about 5 minutes before turning out the cupcakes onto the rack to cool completely.

Once cool, spread a generous teaspoon of ganache over each cupcake. Decorate with the remaining ¾ cup toasted shredded coconut.

GO-TO GANACHE

———

GANACHE IS AT THE HEART OF SO MANY CHOCOLATE DESSERTS and other treats, and so it's important to know exactly what it is. That's simple: ganache is the almost magical amalgamation of chocolate and cream—and often also butter, honey, vanilla, or another flavoring—that is at once the chocolatier's workhorse and fairy godmother.

Because it responds to temperature, ganache is almost endlessly versatile. When warm, it's a pourable sauce or a glaze; when cooled to room temperature, it can be spread as a frosting or filling; and when chilled, it is rolled to make truffles and similar bonbons.

It's made by pouring hot cream over chopped chocolate. As I mentioned on page 41, I sometimes add a little honey for a pop of sweetness and to contribute to a smooth, satiny mouthfeel. Butter is also frequently stirred into the warm ganache to boost its lushness. But at the end of the day, it's the chocolate and the cream that make ganache, well, ganache.

As might be expected, the better the chocolate, the better the ganache. Ganaches can be made with milk or white chocolate, but dark chocolate is traditional. The secret is to use the chocolate you like; if you like to eat it, you'll like it in ganache. I like bitter chocolate with 71 percent chocolate solids (or anywhere between 70 and 75 percent). You might prefer slightly sweeter chocolate. Ganaches made with chocolates high in cocoa butter tend to be richer than others. Fresher chocolate and fresher cream produce the freshest-tasting ganache. Sample different chocolates, both high-end brands and more modest ones. Find those you prefer and trust your instincts and your taste buds. You won't go wrong.

CHOCOLATE DULCE DE LECHE

CUPCAKES

AMONG THE MOST INDULGENT CUPCAKES IN the book, these are enriched with sour cream and the ganache frosting includes not just chocolate and heavy cream but also rich, caramely dulce de leche. Although it's easy to make, I usually buy dulce de leche in cans (see the Note on page 80 and the recipe on page 81). I think the canned version is very good. I ought to know: I am one of those people who can eat an entire can with a spoon!

Makes 12 cupcakes

GANACHE

- 2 ounces bittersweet or semisweet chocolate, coarsely chopped
- ½ cup heavy cream
- ½ cup homemade or store-bought dulce de leche (see Note and page 81)
- 1 teaspoon pure vanilla extract
 Pinch of salt

CUPCAKES

- 1 cup all-purpose flour
- ⅓ cup unsweetened alkalized cocoa powder
- 1½ teaspoons baking soda
- 1 teaspoon baking powder
- ¾ teaspoon salt
- 1 cup sugar
- ½ cup (1 stick) unsalted butter, softened
- 2 large eggs
- ⅓ cup sour cream
- 2 teaspoons pure vanilla extract
- ⅓ cup strong brewed coffee, cooled to room temperature

TO MAKE THE GANACHE: Put the chocolate in a heatproof bowl.

In a heavy saucepan, bring the cream to a boil over medium-high heat. Once it's hot, add the dulce de leche and vanilla and cook, stirring, until well blended. Pour the mixture over the chopped chocolate and add the salt. With a wooden spoon, stir the ganache until the chocolate melts and the mixture is smooth and evenly colored. Set the ganache aside at room temperature to cool and thicken while you bake the cupcakes.

TO MAKE THE CUPCAKES: Position a rack in the center of the oven and preheat the oven to 350°F. Line a 12-cup muffin tin with cupcake liners.

Sift the flour, cocoa powder, baking soda, baking powder, and salt into a bowl.

In the bowl of an electric mixer fitted with the paddle attachment and set on medium-high speed, cream the sugar and butter until light and fluffy, about 3 minutes. Add the eggs, one at a time, beating well after each one. Add the sour cream and vanilla and beat until incorporated.

recipe continues

NOTE: *While it's easy to make dulce de leche, you can also buy it canned or in jars in most supermarkets. It's nothing more complicated than slowly cooked sweetened milk that, as it thickens, turns dark and caramelizes. Most recipes begin with sweetened condensed milk, although some include whole milk and sugar. It can be made on top of the stove or in the oven.*

Reduce the mixer speed to medium-low. Add the coffee. Gradually add the flour mixture and beat just until combined.

Divide the batter among the cupcake cups and bake for 20 to 22 minutes, rotating the muffin tin halfway through baking to encourage even baking. The cupcakes are done when a toothpick inserted in the center of a cupcake comes out clean and the cake springs back when gently pressed.

Let the cupcakes cool in the tin on a wire rack for about 5 minutes before turning out the cupcakes onto the rack to cool completely.

Once cool, spread the cooled ganache on top of each cupcake.

DULCE DE LECHE

THIS RECIPE MAKES MORE THAN THE half cup needed for the Chocolate Dulce de Leche Cupcakes on page 78. Refrigerate the leftovers in a glass or rigid plastic container for up to five days. Incorporate it into cake batters and puddings (it's great for bread puddings) or, if you are like me, just eat it off a spoon.

Makes about 1½ cups

1 can (12 ounces) sweetened condensed milk, paper label removed

Put the can of milk in a large pot deep enough to hold the can with a few inches of headroom and then cover it with water.

Bring to a boil over medium–high heat and immediately reduce the heat to a rapid simmer. Simmer the can for about 3 hours, adjusting the heat up or down to maintain a rapid simmer (but not a full boil). Check the water level often and add water as needed to keep the can covered by at least 1 inch (an exposed can could explode).

Using large tongs or heavy oven mitts, lift the can from the water and set aside to cool completely.

Once cool, open the can and spoon out the thickened, caramelized condensed milk, now called dulce de leche.

CHOCOLATE BLOOM

———— ◦•◦ ————

DON'T BE ALARMED IF, when you unwrap your stored chocolate, it appears ruined, covered with powdery white splotches, or feels rough and grainy. Your chocolate has bloomed. Not great news, but certainly no disaster.

The white splotches are caused by storing the chocolate in a warm place so that the fat melts and travels to the surface. The graininess is the result of moisture, which affects the sugar in the chocolate. Both are symptoms of what is called "bloom." But never mind this technical stuff; all you have to know is that all signs of bloom disappear when the chocolate is melted. The flavor is not compromised and you can go on your way to make ganache or chocolate sauce or anything else you desire. The chocolate won't regain its luster unless it's tempered (a technique not used in this book—see page 205), but it will taste fine and behave just as you want it to.

DOUBLE CHOCOLATE

CUPCAKES

WHEN YOU WANT A RICH, SUPER-CHOCOLATY cupcake, this is the one to make. The cake is unadulterated chocolate gratification with just a hint of coffee, and the ganache is as pure as pure can get. Ah, the power of chocolate!

Makes 15 cupcakes

GANACHE

- 1 ounce bittersweet or semisweet chocolate, coarsely chopped
- 1¼ cups heavy cream
- 1 teaspoon pure vanilla extract

CUPCAKES

- 1 cup all-purpose flour
- ⅓ cup unsweetened alkalized cocoa powder
- 1 teaspoon baking soda
- ½ teaspoon baking powder
- Pinch of salt
- ¾ cup sugar
- ½ cup whole milk
- ⅓ cup vegetable oil
- 2 large eggs
- 1 teaspoon pure vanilla extract
- ½ cup hot strong brewed coffee
- ½ cup semisweet chocolate chips or chocolate shavings (see page 93), for decoration

TO MAKE THE GANACHE: Put the chocolate in a heatproof bowl.

In a heavy saucepan, bring the cream to a boil over medium-high heat. Once it's bubbling, pour it over the chopped chocolate. Add the vanilla and, with a wooden spoon, stir the ganache until the chocolate melts and the mixture is smooth and evenly colored. Set the ganache aside at room temperature to cool and thicken while you bake the cupcakes.

TO MAKE THE CUPCAKES: Position a rack in the center of the oven and preheat the oven to 350°F. Line a 12-cup muffin tin and 3 cups of a 6-cup muffin tin with cupcake liners for a total of 15 cupcakes.

Sift the flour, cocoa powder, baking soda, baking powder, and salt into a bowl.

In the bowl of an electric mixer fitted with the paddle attachment and set on medium-high speed, beat the sugar, milk, oil, eggs, and vanilla until smooth.

Reduce the mixer speed to medium-low and gradually add the flour mixture, beating until smooth and evenly blended. Add the coffee and beat until incorporated.

recipe continues

Divide the batter among the cupcake cups and bake for 20 to 24 minutes, rotating the muffin tins halfway through baking to encourage even baking. The cupcakes are done when a toothpick inserted in the center of a cupcake comes out clean and the cake springs back when gently pressed.

Let the cupcakes cool in the tin on a wire rack for about 5 minutes before turning out the cupcakes onto the rack to cool completely.

Using a handheld electric mixer or in the bowl of a standing electric mixer fitted with the paddle attachment and set on medium-high speed, whip the ganache until fluffy. Do not overwhip but stop when the ganache looks airy and light.

Fill a piping bag fitted with a plain tip with the cooled ganache and pipe some ganache onto each cupcake. Alternatively, use a rubber spatula or a spoon to spread the ganache on the cupcakes. Sprinkle each cupcake with chocolate chips or chocolate shavings.

CHOCOLATE CARAMEL ESPRESSO

CUPCAKES

I HAVE A CONFESSION: WHEN I drive around Connecticut and the nearby states of New York and New Jersey, attending various business meetings, I sometimes slip into the drive-through line at McDonald's for a caramel sundae. I know, I know. It's not nearly as good as one I could make at home, but hey, I am not at home! It always satisfies my caramel craving, particularly because I request extra caramel. These cupcakes are more than a few steps up from a fast-food sundae. The matchup of chocolate and caramel is superb, and when you add espresso to the mix, the resulting cupcakes are nothing short of heavenly.

Makes 15 cupcakes

GANACHE

- 10 ounces milk chocolate, coarsely chopped
- 1 cup heavy cream
- 1 tablespoon espresso powder
- 1 teaspoon pure vanilla extract
- ½ teaspoon sea salt
- 2 tablespoons unsalted butter

CUPCAKES

- ¼ cup espresso powder
- ½ cup hot strong brewed coffee
- 1½ cups flour
- 1 teaspoon baking soda
- 1 teaspoon baking powder
- ¾ teaspoon salt
- 1 cup sugar
- ⅓ cup vegetable oil
- ½ cup whole milk
- 2 large eggs
- 1 teaspoon pure vanilla extract
- 1⅓ cups Knipschildt Caramel Sauce (page 192) or store-bought caramel sauce

TO MAKE THE GANACHE: Put the chocolate in a heatproof bowl.

In a heavy saucepan, bring the cream to a boil over medium-high heat. Once it's bubbling, pour it over the chopped chocolate. Add the espresso powder, vanilla, and salt and, with a wooden spoon, stir the ganache until the chocolate melts and the mixture is smooth and evenly colored.

Let the ganache cool until warm to the touch, 2 to 3 minutes. Add the butter and stir until the butter melts and is incorporated. Set the ganache aside at room temperature to cool and thicken while you bake the cupcakes.

TO MAKE THE CUPCAKES: Position a rack in the center of the oven and preheat the oven to 350°F. Line a 12-cup muffin tin and 3 cups of a 6-cup muffin tin with cupcake liners for a total of 15 cupcakes.

In a small bowl or measuring cup, stir the espresso powder into the hot coffee. Set aside.

Sift the flour, baking soda, baking powder, and salt into a bowl.

In the bowl of an electric mixer fitted with the paddle attachment and set on medium-high speed, beat the sugar, oil, milk, eggs, and vanilla until smooth.

Reduce the mixer speed to medium–low and gradually add the flour mixture, beating until smooth and evenly blended. Add the coffee and beat until incorporated.

Divide the batter among the cupcake cups. Spoon about 1½ tablespoons of caramel sauce over each cupcake and, using a butter knife, swirl the caramel through the batter. Bake for 20 to 24 minutes, rotating the muffin tins halfway through baking to encourage even baking. The cupcakes are done when a toothpick inserted in the center of a cupcake comes out clean and the cake springs back when gently pressed.

Let the cupcakes cool in the tin on a wire rack for about 5 minutes before turning out the cupcakes onto the rack to cool completely.

Fill a piping bag fitted with a plain tip with the cooled ganache and pipe some ganache onto each cupcake. Alternatively, use a rubber spatula or a spoon to spread the ganache on the cupcakes.

CHAPTER FOUR

CHEESECAKES

VANILLA BEAN CHEESECAKE WITH CHOCOLATE MOUSSE

BAILEYS CHEESECAKE

OREO COOKIE CHEESECAKE

CHOCOLATE CARAMEL PRETZEL CHEESECAKE

WHITE CHOCOLATE–PUMPKIN CHEESECAKE

AMERICAN CHEESECAKES ROCK. I had never tasted anything quite like them before I came here, but their creamy texture and intense flavors have turned me into a big, big fan. Back in Denmark, we ate one kind of cheesecake, a light confection made with whipped cream, egg yolks, sugar, cream cheese, and lemon zest, all held together with gelatin. It was more of a mousse, really, and while tasty enough, it could never compete with what the Americans came up with. Needless to say, the cheesecakes I make these days are as American as apple pie—or should I say as American as cheesecake?

When I teach classes or talk to people about cheesecakes, many worry about the cheesecake cracking while it cools. They tell me about recipes that instruct you to leave the cheesecake in the oven with the door slightly ajar for hours and hours to allow the cake to cool ever so slowly. I agree that the cakes have to cool before they can be served, but I have good luck removing them from the oven before the center is entirely solid (it still jiggles) and then letting them cool on the countertop. And let's face it: if the top of the cheesecake cracks, who really cares? It won't interfere with the flavor and very often the crack can be hidden with a topping.

VANILLA BEAN CHEESECAKE

WITH CHOCOLATE MOUSSE

THIS TASTES LIKE THE TYPICAL CHEESECAKE you might get at Junior's in Brooklyn or the Carnegie Deli in Manhattan's Midtown. In other words, it's a classic. A vanilla cheesecake like this is generally topped with syrupy cherries, but I slather it with chocolate mousse instead. Even better, in my book!

Makes one 8-inch cheesecake

CHOCOLATE MOUSSE

- 2 cups heavy cream
- 5 ounces semisweet or bittersweet chocolate, coarsely chopped

CHEESECAKE

- About 8 whole graham crackers
- 2½ ounces almonds (about ½ cup), toasted (see page 210) and coarsely chopped
- 3 tablespoons unsalted butter, melted
- 16 ounces (two 8-ounce packages) cream cheese, softened
- ⅔ cup sugar
- 3 large eggs
- ½ cup sour cream
- 1 tablespoon vanilla bean paste or 1 teaspoon pure vanilla extract (see page 71)
- ¼ cup unsweetened cocoa powder, for dusting

TO MAKE THE CHOCOLATE MOUSSE: In a heavy pot, bring the cream to a boil over medium-high heat. Remove the pot from the heat and add the chocolate. Stir until the chocolate melts and the mixture is smooth. Let cool to lukewarm and then cover and refrigerate for at least 6 hours or overnight.

TO MAKE THE CHEESECAKE: Position a rack in the center of the oven and preheat the oven to 350°F.

In the bowl of a food processor fitted with the metal blade, process the graham crackers and nuts into coarse, even crumbs. You should have about 1½ cups crumbs (1 cup graham cracker crumbs and ½ cup ground almonds). Add the melted butter and pulse until the crumbs are moistened.

Press the crust mixture into the bottom of an 8-inch round springform pan. Bake until firm, about 10 minutes. Let the crust cool, and when completely cool, wrap the outside of the pan with aluminum foil. Set aside.

Lower the oven temperature to 325°F.

In the bowl of an electric mixer fitted with the paddle attachment and set on medium-high speed, beat the cream cheese and sugar until smooth, 4 to 5 minutes. Add the eggs, one at a time, mixing well after each addition. Add the sour cream and vanilla paste or extract and beat until smooth.

Pour the batter into the pan over the prebaked crust and set the springform pan in a larger pan. Set both pans in the oven and then pour enough hot tap water into the larger pan to come about 1 inch up the sides of the springform pan (the foil will prevent water from seeping into the cheesecake).

Bake until the filling feels set but still jiggles just a little in the center, 45 minutes to 1 hour.

Run a dull kitchen knife around the edge of the cheesecake to loosen and then cool on a wire rack at room temperature. Once cool, cover and refrigerate, still in the pan, for at least 8 hours or overnight.

In the bowl of an electric mixer fitted with the whisk attachment and set on medium–high speed, whip the chilled chocolate mousse until light and fluffy, 4 to 5 minutes. Do not overmix, or it might turn into butter.

Release and remove the sides of the springform pan. Transfer the cheesecake to a serving plate or platter and spread the mousse on top. Dust the cheesecake with cocoa powder and serve.

BAILEYS

CHEESECAKE

BAILEYS OVER ICE IS ONE OF my favorite "couldn't be easier" desserts—just the thing after a crazy busy day. Because of my fondness for the creamy liqueur, it was a short leap from the drink to a cheesecake flavored with both Baileys and cocoa powder. I top this with sweetened whipped cream and decorate it with chocolate shavings.

One 8-inch cheesecake

CHEESECAKE

- 12 to 13 whole graham crackers
- 3 tablespoons unsweetened cocoa powder
- 5 tablespoons unsalted butter, melted
- ½ cup Baileys Irish Cream
- 1 tablespoon espresso powder
- 24 ounces (three 8-ounce packages) cream cheese, softened
- 1 cup granulated sugar
- 3 large eggs
- 1 large egg yolk
- 1 cup sour cream

TOPPING

- 1 cup heavy cream
- 3 tablespoons confectioners' sugar
- ½ teaspoon pure vanilla extract
- 2 ounces semisweet or bittersweet chocolate shavings (see Note)
- Unsweetened cocoa powder, for dusting

TO MAKE THE CHEESECAKE: Position a rack in the center of the oven and preheat the oven to 350°F.

In the bowl of a food processor fitted with the metal blade, process the graham crackers and cocoa powder into coarse, even crumbs. You should have about 1½ cups crumbs. Add the melted butter and pulse until the crumbs are moistened.

Press the crust mixture into the bottom of an 8-inch round springform pan. Bake until firm, about 10 minutes. Let the crust cool, and when completely cool, wrap the outside of the pan with aluminum foil. Set aside.

Lower the oven temperature to 325°F.

In a small bowl, whisk the Baileys and espresso powder together until the espresso dissolves.

In the bowl of an electric mixer fitted with the paddle attachment and set on medium-high speed, beat the cream cheese and granulated sugar until smooth, 4 to 5 minutes. Add the eggs, one at a time, and then the yolk, mixing well after each addition. Add the sour cream and the Baileys mixture and beat until smooth.

Pour the batter into the pan over the prebaked crust and set the springform pan in a larger pan. Set both pans in the oven and then pour enough hot tap water into the larger pan to come about 1 inch up the sides of the springform pan (the foil will prevent water from seeping into the cheesecake).

Bake until the filling feels set but still jiggles just a little in the center, 1 hour to 1 hour 15 minutes.

Run a dull kitchen knife around the edge of the cheesecake to loosen and then cool on a wire rack at room temperature. Once cool, cover and refrigerate, still in the pan, for at least 8 hours or overnight.

TO MAKE THE TOPPING: In the bowl of an electric mixer fitted with the whisk attachment and set on medium-high speed, whip the cream into soft peaks. Add the confectioners' sugar and vanilla and continue beating until the whipped cream forms stiff peaks.

Release and remove the sides of the springform pan. Transfer the cheesecake to a serving plate or platter. Spread the whipped cream over the top of the cheesecake. Decorate with the chocolate shavings, dust with cocoa powder, and serve.

NOTE: *To shave chocolate, hold a good-sized piece of chocolate between your fingers and, using a vegetable peeler, shave off thin, unevenly shaped pieces. Transfer the chocolate shavings to a piece of waxed paper and set aside. Make sure the shavings stay dry and cool, but do not refrigerate them. It's best to shave the chocolate shortly before using.*

OREO COOKIE

CHEESECAKE

WHO DOESN'T LIKE OREOS? ALTHOUGH I bake a lot of cookies, I never turn down a bag of Oreos. Who does? For this cheesecake, I crush the cookies for the crust and then toss a few more into the batter. A double Oreo whammy.

Makes one 8-inch cheesecake

1 package (18 ounces) Oreo cookies (45 cookies)

4 tablespoons unsalted butter, melted

24 ounces (three 8-ounce packages) cream cheese, softened

1 cup sugar

4 large eggs

1 cup sour cream

1 teaspoon pure vanilla extract

Position a rack in the center of the oven and preheat the oven to 350°F.

In the bowl of a food processor fitted with the metal blade, process 30 cookies into coarse, even crumbs. Add the butter and process until the mixture is well blended and the crumbs are moistened.

Press the crust mixture into the bottom of an 8-inch round springform pan. Bake until firm, about 10 minutes. Let the crust cool, and when completely cool, wrap the outside of the pan with aluminum foil. Set aside.

Lower the oven temperature to 325°F.

Using a large knife or the food processor, chop the remaining 15 cookies into fairly large, uneven chunks.

In the bowl of an electric mixer fitted with the paddle attachment and set on medium-high speed, beat the cream cheese and sugar until smooth, 4 to 5 minutes. Add the eggs, one at a time, mixing well after each addition. Add the sour cream and vanilla and beat until smooth.

Remove the bowl from the mixer and, with a large rubber spatula or wooden spoon, fold in the chopped cookies.

Pour the batter into the pan over the prebaked crust and set the springform pan in a larger pan. Set both pans in the oven and then pour enough hot tap water into the larger pan to come about 1 inch up the sides of the springform pan (the foil will prevent water from seeping into the cheesecake).

Bake until the filling feels set but still jiggles just a little in the center, 1 hour to 1 hour 20 minutes.

Run a dull kitchen knife around the edge of the cheesecake to loosen and then cool on a wire rack at room temperature. Once cool, cover and refrigerate, still in the pan, for at least 8 hours or overnight.

To serve, release the sides of the springform pan and transfer the cheesecake to a serving plate or platter.

SPRINGFORM PANS?

SPRINGFORM PANS ARE DEEP, ROUND CAKE PANS with sides fixed firmly with a clamp on top of a removable bottom. When the clamp is released, the sides "spring" open. Well, not really, but they loosen so they can be easily removed. Cheesecakes are nearly always baked in springforms with 8-, 9-, or 10-inch diameters.

At times, the cakes in springforms are baked in a bain-marie (water bath). Water baths create mild, moist environments for baking relatively fragile preparations such as cheesecakes and custards. As the food cooks, the water insulates it from intense heat so that it cooks gently.

While you can buy special bain-marie pans, they are not necessary. Use a roasting pan or similarly rimmed pan large enough to hold the smaller pan comfortably and deep enough so that the water, once added, will come about halfway up the sides. The bottom and sides of the pan must be well wrapped in aluminum foil to keep water from seeping into the cake batter. The larger pan must also be ample enough that the water does not evaporate too quickly. In any event, check the water level during baking and add more if necessary.

CHOCOLATE CARAMEL PRETZEL

CHEESECAKE

ALL CHEESECAKES ARE ABOUT TEXTURE. Some folks like them a little dry and crumbly, while others prefer them smooth and creamy. I fall into the second category, so that's how I make the cheesecakes in this book. The pleasure of this smooth, creamy cheesecake is only heightened by the crunchiness and the saltiness of the pretzels, which are mixed into the graham cracker crust and also scattered on top of the cheesecake after it has been swathed in caramel. Need I say more? Just thinking about this makes my mouth water!

Makes one 9-inch cheesecake

2 ounces salted pretzels, plus ⅓ cup (½ ounce) coarsely crushed, for topping

4 whole graham crackers

6 tablespoons unsalted butter, melted

¾ cup plus 3 tablespoons sugar

1 extra-large egg white (about 3 tablespoons)

6 ounces semisweet or bittersweet chocolate, coarsely chopped

¼ cup heavy cream

24 ounces (three 8-ounce packages) cream cheese, softened

4 large eggs

¼ cup strong brewed coffee, cooled to room temperature

3 tablespoons unsweetened cocoa powder

1 teaspoon pure vanilla extract

¾ cup Knipschildt Caramel Sauce (page 192) or store-bought caramel sauce

Position a rack in the center of the oven and preheat the oven to 350°F.

In the bowl of a food processor fitted with the metal blade, process 2 ounces of the pretzels and the graham crackers into coarse, even crumbs. You should have about 1½ cups crumbs. Add the butter, 3 tablespoons of the sugar, and the egg white and process until the mixture is well blended and the crumbs are moistened.

Press the crust mixture into the bottom of a 9-inch round springform pan. Bake until firm, about 10 minutes. Let the crust cool, and when completely cool, wrap the outside of the pan with aluminum foil. Set aside.

Lower the oven temperature to 325°F.

In a heavy pot, heat the chocolate and heavy cream over medium heat until the chocolate melts and the cream is hot and bubbling. Stir frequently until smooth. Remove from the heat and set aside.

In the bowl of an electric mixer fitted with the paddle attachment and set on medium-high speed, beat the cream cheese and the remaining ¾ cup sugar until smooth, 4 to 5 minutes. Add the eggs, one at a time, beating well after each addition. Add the coffee, cocoa powder, and vanilla and beat just until combined. Add the chocolate mixture and beat until incorporated.

recipe continues

Pour half the batter into the pan over the prebaked crust and then drizzle ¼ cup of the caramel sauce over the center, staying away from the edges. Pour the remaining batter into the pan and drizzle with another ¼ cup caramel. Run a dull kitchen knife through the batter to create swirls.

Set the springform pan in a larger pan. Set both pans in the oven and then pour enough hot tap water into the larger pan to come about 1 inch up the sides of the springform pan (the foil will prevent water from seeping into the cheesecake).

Bake until the filling feels set but still jiggles just a little in the center, 1 hour to 1 hour 20 minutes.

Run a dull kitchen knife around the edge of the cheesecake to loosen and then cool on a wire rack at room temperature. Once cool, cover and refrigerate for at least 8 hours or overnight.

Just before serving, drizzle the remaining ¼ cup caramel sauce over the top of the cheesecake (you might need to warm the caramel a little first) and sprinkle with the crushed pretzels. Release the sides of the springform pan, transfer the cheesecake to a serving plate or platter, and serve.

WHITE CHOCOLATE–PUMPKIN

CHEESECAKE

—✦—

I OFFER A WHITE CHOCOLATE and Pumpkin Truffle for the fall line of Chocopologie chocolates, which is a best seller while it lasts. It's no surprise that the idea of expanding the flavor profile for a cheesecake made a lot of sense to me, and with the first bite I knew I was right. The crust, made with gingersnaps, is just right against the other flavors. My only advice about this sublime cake is not to wait for autumn to make it.

Makes one 9-inch cheesecake

About 32 gingersnaps

5 tablespoons unsalted butter, melted

5 ounces white chocolate

24 ounces (three 8-ounce packages) cream cheese, softened

1 cup sugar

4 large eggs

1 cup plain pumpkin puree

1 teaspoon pure vanilla extract

1 tablespoon plus 1½ teaspoons ground cinnamon

½ teaspoon ground ginger

¼ teaspoon ground nutmeg (freshly grated if possible)

⅛ teaspoon ground allspice

Position a rack in the center of the oven and preheat the oven to 350°F.

In the bowl of a food processor fitted with the metal blade, process the gingersnaps into coarse, even crumbs. You should have about 1½ cups crumbs. If not, process 5 or 6 more cookies. Add the butter and process until the mixture is well blended and the crumbs are moistened.

Press the crust mixture into the bottom of a 9-inch round springform pan. Bake until firm, about 10 minutes. Let the crust cool, and when completely cool, wrap the outside of the pan with aluminum foil. Set aside.

Lower the oven temperature to 325°F.

Melt the white chocolate according to the instructions on page 32. Remove the pot from the heat and cover the chocolate to keep it warm.

In the bowl of an electric mixer fitted with the paddle attachment and set on medium-high speed, beat the cream cheese and sugar until smooth, 4 to 5 minutes. Add the eggs, one at a time, beating well after each addition. Add the pumpkin puree, vanilla, cinnamon, ginger, nutmeg, and allspice and beat just until incorporated.

Measure about ¼ cup of the pumpkin batter and add it to the warm melted white chocolate. Stir well to mix and then add the white chocolate mixture to the batter in the mixing bowl. Beat gently to mix well.

Pour the batter into the pan over the prebaked crust, scraping the bowl with a rubber spatula. Set the springform pan in a larger pan. Set both pans in the oven and then pour enough hot tap water into the larger pan to come about 1 inch up the sides of the springform pan (the foil will prevent water from seeping into the cheesecake).

Bake until the filling feels set but still jiggles just a little in the center, 1 hour to 1 hour 20 minutes.

Run a dull kitchen knife around the edge of the cheesecake to loosen and then cool on a wire rack at room temperature. Once cool, cover and refrigerate for at least 8 hours or overnight before serving.

CHAPTER FIVE

PIES & TARTS

RASPBERRY CHOCOLATE TART

CHOCOLATE–RED WINE PEAR TART

MILK CHOCOLATE PECAN PIE

RASPBERRY LINZER TART

WHITE CHOCOLATE FRUIT TART

CHOCOLATE PISTACHIO TART WITH FRESH RASPBERRIES

I LOVE PIES AND TARTS. Who doesn't? When I moved to America, I discovered a wide category of pies previously unknown to me: big, bold ones overflowing with sweet, juicy fruit and baked in flaky pie crusts. As delicious as these are—and I am always happy to dig into a slice of apple or cherry pie—I generally rely on my European training and make desserts that are a little more refined, with short crusts and rich, creamy fillings accented with fruit and nuts.

Regardless of the style, pies and tarts are always irresistible. They are amazing constructions of flavors and textures that go from crispy to flaky to tender to creamy and chewy. For me, it's these forever-exciting characteristics that make pies and tarts the marvels they are.

RASPBERRY CHOCOLATE TART

FOR MY MONEY, CHOCOLATE AND RASPBERRY is one of the best-ever combinations, and when the two meet, the less fuss the better. I would be happy with a chocolate bar and a pint of fresh raspberries most of the time, but when I sample a slice of this magnificent tart, my taste buds rejoice. For the ganache filling, whole raspberries are stirred into the chocolate, and once the filling is set, the tart is decorated with more fresh raspberries. The filling is nestled in a pastry crust augmented with a few tablespoons of blanched almonds, which balance the flavors perfectly.

Makes one 10-inch tart

CRUST

1½ cups all-purpose flour

½ cup confectioners' sugar

3 tablespoons ground blanched almonds (from about 2 ounces slivered blanched almonds; see Note)

½ teaspoon baking powder

¼ teaspoon salt

½ cup (1 stick) cold unsalted butter, cut into pieces

1 large egg

FILLING

14 ounces bittersweet or semisweet chocolate, coarsely chopped

1 cup heavy cream

1½ cups fresh raspberries

2 tablespoons honey

3 tablespoons unsalted butter

TO MAKE THE CRUST: In a mixing bowl, stir together the flour, confectioners' sugar, almonds, baking powder, and salt.

Add the butter pieces and cut them into the mixture using a fork, a pastry blender, or your fingers until it resembles a crumbly coarse meal with some pieces the size of peas.

Add the egg and mix until the dough comes together in a mass and comes away from the bowl. Shape the dough into a ball, wrap it in plastic, and refrigerate for at least 30 minutes and up to several hours.

Roll out the chilled dough on a lightly floured surface until it is about ⅛ inch thick and at least 12 inches in diameter. Lift the dough (roll it around the rolling pin, if that makes it easier) and drape it over a 10-inch tart pan with a removable bottom. Gently press the dough into the tart pan. Trim the overhanging dough. Refrigerate for about 30 minutes.

Meanwhile, position a rack in the center of the oven and preheat the oven to 400°F.

Line the tart crust with parchment paper or waxed paper and fill it with pie weights, rice, or dried beans to weight it.

Bake the weighted tart crust for about 15 minutes, lower the oven temperature to 350°F, and continue baking until the crust is light golden brown, 12 to 15 minutes more.

Transfer the tart pan to a wire rack, remove the parchment paper and pie weights, and cool completely.

TO MAKE THE FILLING: Put the chopped chocolate in a heatproof bowl.

In a heavy saucepan, combine the cream, 1 cup of the raspberries, and the honey and bring to a boil over medium-high heat. Once it's bubbling, pour the cream mixture over the chocolate, adding one-third at a time and stirring after each addition. When the filling is as smooth as possible, add the butter, mixing until the filling is well blended.

Pour the filling into the cooled tart crust. Let set at room temperature, 3 to 4 hours. If not serving right away, cover and refrigerate for up to 2 days.

Decorate the tart with the remaining ½ cup raspberries (or use more, if you want), and serve.

NOTE: *To grind almonds, put the blanched, slivered almonds in a small food processor or spice grinder and process until ground but still textured. Two ounces of slivered almonds should yield just about 3 tablespoons ground.*

PEAR TART

THIS TART WOULD NOT BE OUT of place on any table in northern Europe. It's elegantly handsome, with the sliced pears arranged in the chocolate-kissed crust before they are baked. I recommend poaching the pears for hours for the best results, but if you are pressed for time, they are delicious after only ninety minutes of cooking. And here's a tip: if you don't feel like making the tart, poach the pears and then serve them with chocolate sauce for a simple dessert.

Makes one 10-inch tart

POACHED PEARS

- 4 firm, ripe Bosc or Anjou pears
- 2⅓ cups red wine, preferably Cabernet Sauvignon
- 2⅓ cups water
- 1¼ cups sugar
- 1 cinnamon stick
- 1 knob peeled fresh ginger, about 1 inch long
- 3 pink peppercorns
- 3 black peppercorns
- 1 whole clove
- 1 star anise pod

CRUST

- 1¼ cups all-purpose flour
- ¼ cup unsweetened alkalized cocoa powder
- ¼ cup sugar
- ¼ teaspoon salt
- ½ cup (1 stick) cold unsalted butter, cut into pieces
- 1 large egg yolk
- 1 to 2 tablespoons ice water

TO MAKE THE POACHED PEARS: Peel the pears, cut them in half vertically (from stem to blossom end), and remove the seeds and cores. Transfer the pear halves to a large saucepan and add the wine, water, sugar, cinnamon, ginger, peppercorns, clove, and star anise. Bring to a boil over medium-high heat, reduce the heat, and simmer gently until a fork easily pierces the pears, 2 to 3 hours.

Remove the pan from the heat and let the pears cool completely in the poaching liquid. Once cool, cover and refrigerate for at least 6 hours or overnight.

TO MAKE THE CRUST: In the bowl of a food processor fitted with the metal blade, mix together the flour, cocoa powder, sugar, and salt. Add the butter and pulse to mix. Add the egg yolk and water and pulse until the mixture resembles crumbly coarse meal with some pieces the size of peas.

Shape the dough into a ball, wrap in plastic, and refrigerate for at least 30 minutes and up to several hours.

Roll out the chilled dough on a lightly floured surface until it is about ⅛ inch thick and at least 12 inches in diameter. Lift the dough (roll it around the rolling pin, if that makes it easier) and drape it over a 10-inch tart pan with a removable bottom. Gently press the dough into the tart pan. Trim the overhanging dough. Refrigerate for about 30 minutes.

recipe continues

FILLING

- ½ cup (1 stick) unsalted butter, softened
- ½ cup sugar
- 4 ounces almond paste
- 2 large eggs
- 1 teaspoon pure vanilla extract
- ⅓ cup cake flour (see Note)

NOTE: *Cake flour will result in a more tender filling, but is not absolutely necessary for the recipe. It's a low-protein flour that is more finely ground than all-purpose, which can be substituted here, as can pastry flour. Pastry flour has more protein than cake flour and less than all-purpose, and despite what you may have heard, it is not just another name for cake flour.*

If you do much baking, it's a good idea to keep a box of cake flour on hand, but keep track of its expiration date and don't keep it past its time. Cake flour is sold at supermarkets; popular brands are Swans Down and Softasilk. King Arthur makes cake flour, too.

Meanwhile, position a rack in the center of the oven and preheat the oven to 350°F.

TO MAKE THE FILLING: In the bowl of an electric mixer fitted with the paddle attachment and set on medium-high speed, cream the butter and sugar until light and fluffy, 3 to 4 minutes. Add the almond paste and mix until blended.

Add the eggs, one at a time, mixing well after each addition. Mix in the vanilla.

Reduce the mixer speed to medium-low and add the flour, mixing just until blended. Do not overmix.

Lift the pears from the poaching liquid and rinse them with cold water. Pat dry and then slice them very thin, maintaining the pear shape.

Spread the almond filling in the chilled tart crust. It will fill it about halfway. Lay the pear slices on top of the filling, arranging them so that they are about ½ inch from the edge of the tart. The pears can be touching side by side or placed so there is a little space between them.

Bake until the almond filling is golden brown on top and the crust is one shade darker, 35 to 40 minutes.

Let the tart pan cool on a wire rack for about 10 minutes. Unmold the tart. Cool for 15 to 20 minutes more and then serve warm, or cool completely.

HOW TO

STORE CHOCOLATE

—◦◆◦—

THE BEST PLACE TO STORE CHOCOLATE is a dark cupboard or shelf where the temperature stays about 65°F and the humidity is low. If you have not opened the packaging, the chocolate should remain in its original wrapping. If you've already raided the chocolate bar, wrap it tightly in foil and then plastic to protect it. Humidity is no friend to chocolate, so keep it out of the refrigerator and freezer. When it's properly stored, chocolate keeps for months. Dark chocolate (bittersweet and semisweet) will keep for a year or more, and white and milk chocolates for six or seven months. Both white and milk chocolate can easily pick up strong flavors if stored too near foods with robust odors or flavors, such as onions and ground spices. Otherwise, if well wrapped and stored away from heat and humidity, chocolate is far more durable than you might think.

PECAN PIE

THIS PECAN PIE IS THE MOST "American" of any of the pies in this chapter. I line the crust with melted milk chocolate and then pile it high with pecans in sweet syrup. If you like pecan pie, you will love this extra-rich, extra-chocolaty one.

Makes one 9-inch pie

CRUST

1¼ cups all-purpose flour

1 tablespoon granulated sugar

½ teaspoon salt

½ cup (1 stick) cold unsalted butter, cut into pieces

2 to 4 tablespoons ice water

FILLING

10 ounces milk chocolate, coarsely chopped

10 ounces whole pecans (about 2½ cups)

4 large eggs

¾ cup packed light brown sugar

¼ cup light corn syrup

¼ cup molasses

1 teaspoon pure vanilla extract

½ teaspoon salt

3 tablespoons unsalted butter, melted

4 ounces bittersweet or semisweet chocolate, chopped

Sweetened whipped cream (see page 224) or vanilla ice cream, for serving

TO MAKE THE CRUST: In the bowl of a food processor fitted with the metal blade, process the flour, granulated sugar, and salt just to mix. Add the butter and pulse until the mixture resembles a coarse meal, 8 to 10 seconds.

Pour the water into the dough through the feed tube in a slow, steady stream. As soon as the dough comes together in a mass, remove it from the food processor. Shape the dough into a disk, wrap in plastic, and refrigerate for at least 1 hour.

Roll out the chilled dough on a lightly floured surface until it is about ⅛ inch thick and at least 11 inches in diameter. Lift the dough (roll it around the rolling pin, if that makes it easier) and drape it over a 9-inch pie plate. Gently press the dough into the pie plate. Trim the overhanging dough. Using a fork, crimp the edges of the crust.

TO MAKE THE FILLING: Position a rack in the center of the oven and preheat the oven to 350°F.

Melt the milk chocolate according to the instructions on page 32. Cover to keep warm and set aside.

Roughly chop 1½ cups of the pecans and set them aside.

In a large mixing bowl, whisk the eggs until broken up. Add the brown sugar, corn syrup, molasses, vanilla, and salt and whisk until uniformly colored and smooth.

Add the butter, bittersweet chocolate, and chopped pecans and, with a wooden spoon, stir to mix.

Spread the melted chocolate directly over the piecrust and then pour the filling into the crust. Smooth the top of the pie filling and cover the top with the remaining 1 cup pecans. Bake until the filling is set, 50 to 55 minutes.

Transfer the pie plate to a wire rack to cool. Serve slightly warm or at room temperature, with whipped cream or ice cream on the side.

RASPBERRY LINZER TART

I HAVE STUCK WITH MY EUROPEAN training for this tart, which, when you come down to it, is more about the crust than anything—a buttery pastry crust made with flour and, as is traditional, ground hazelnuts. What is not traditional is that I add just a little cocoa because, well, I am all about chocolate. The filling is nothing more than raspberry jam jazzed up with lemon zest. In Austria, where this tart originated, the top is decorated with strips of dough, which I repeat here. When you taste this simple confection you will understand why its popularity has never waned.

Makes one 10-inch tart

CRUST

- ¾ cup whole hazelnuts, toasted (see page 210)
- 1 cup all-purpose flour
- 1½ teaspoons unsweetened cocoa powder
- ½ teaspoon ground cinnamon
- ⅛ teaspoon ground cloves
- ½ cup (1 stick) plus 1 tablespoon unsalted butter, softened
- ½ cup granulated sugar
- 1 large egg

TO MAKE THE CRUST: In the bowl of a food processor fitted with the metal blade, process the nuts until finely ground. Add the flour, cocoa powder, cinnamon, and cloves and pulse until well mixed.

In the bowl of an electric mixer fitted with the paddle attachment and set on medium-high speed, cream the butter and granulated sugar until light and fluffy, 2 to 3 minutes. Add the egg and beat until incorporated, scraping down the sides of the bowl.

Reduce the mixer speed to medium-low. Add the flour mixture and beat until the mixture is well blended and the dough comes together. Form the dough into a disk, wrap in plastic, and refrigerate for at least 1 hour.

Roll out the chilled dough on a lightly floured surface until it is about ¼ inch thick and at least 12 inches in diameter. Lift the dough (roll it around the rolling pin, if that makes it easier) and drape it over a 10-inch tart pan with a removable bottom. Gently press the dough into the tart pan. Trim the overhanging dough and reserve the trimmings, wrapped in plastic wrap. Refrigerate the tart crust and the trimmings for about 30 minutes. Prick the bottom of the tart crust with a fork to prevent rising in the oven, and refrigerate for about 20 minutes more.

recipe continues

1¼ cups good-quality raspberry jam

½ teaspoon grated lemon zest

Confectioners' sugar, for dusting

Sweetened whipped cream (see page 224) or vanilla ice cream, for serving

Meanwhile, position a rack in the center of the oven and preheat the oven to 350°F.

Gather the reserved dough trimmings and roll them out so that they are about ⅛ inch thick. Using a sharp knife, cut the dough into ½-inch-wide strips.

TO MAKE THE FILLING: In a small mixing bowl, stir together the jam and lemon zest.

Spread the jam over the chilled tart crust. Arrange the strips of dough over the jam in a diagonal crisscross pattern. Bake, rotating the pan halfway through baking, until golden brown, 35 to 40 minutes.

Transfer the tart pan to a wire rack to cool completely. Dust with confectioners' sugar and serve with whipped cream or ice cream on the side.

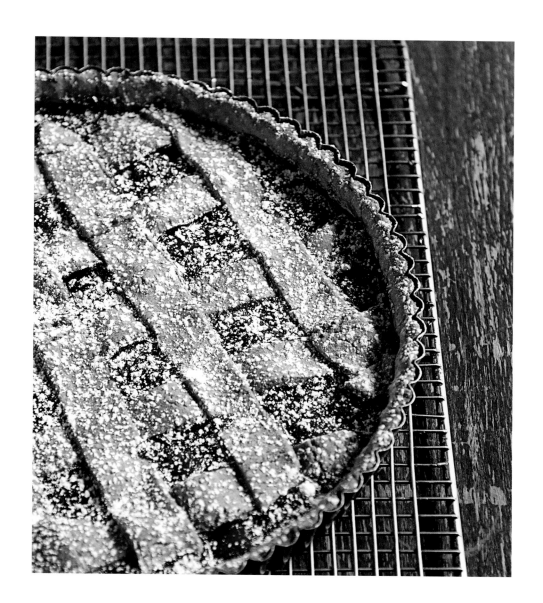

WHITE CHOCOLATE
FRUIT TART

IN EUROPE AND EUROPEAN-STYLE BAKERIES IN the States, tarts similar to this are made with pastry cream, which lies beneath the display of fruit. I don't use pastry cream and instead I use a ganache filling made with white chocolate and heavy cream. Much better than pastry cream, don't you think? It's important to serve this shortly after chilling. It doesn't hold up past the day it's made.

Makes one 10-inch tart

FILLING

8 ounces white chocolate, coarsely chopped

1¼ cups heavy cream

CRUST

½ cup (1 stick) unsalted butter, softened

⅔ cup confectioners' sugar

1 large egg

1¼ cups all-purpose flour

Pinch of salt

ASSEMBLY

2 cups fresh strawberries, hulled and sliced

1½ cups fresh blueberries

1 cup fresh raspberries

2 kiwis, peeled and sliced

⅓ cup apricot jam, optional

TO MAKE THE FILLING: Put the chocolate in a heatproof bowl.

In a heavy saucepan, bring the cream to a boil over medium-high heat. Once it's bubbling, pour it over the chopped chocolate. With a rubber spatula, stir the ganache until the chocolate melts and the mixture is smooth and evenly colored.

Set aside to cool to room temperature. Refrigerate the ganache for 4 to 6 hours.

TO MAKE THE CRUST: In the bowl of an electric mixer fitted with the paddle attachment and set on medium-high speed, cream the butter and confectioners' sugar until light and fluffy, 3 to 4 minutes.

Add the egg and beat to incorporate, scraping down the sides of the bowl.

Reduce the mixer speed to medium-low. Add the flour and salt and beat until they are incorporated and the dough comes together. Form the dough into a disk, wrap in plastic, and refrigerate for about 1 hour.

Meanwhile, position a rack in the center of the oven and preheat the oven to 350°F.

Roll out the chilled dough on a lightly floured surface until it is about ¼ inch thick and at least 12 inches in diameter. Lift the dough (roll it around the rolling pin, if that makes it easier) and drape it over a 10-inch tart pan with a removable bottom. Gently press the dough into the tart pan. Trim the overhanging dough. Refrigerate for about 30 minutes. Prick the bottom of the tart crust with a fork to prevent rising in the oven.

Line the tart crust with parchment paper or waxed paper and fill with pie weights, rice, or dried beans to weight it.

Bake the weighted tart crust for 20 to 25 minutes, rotating the tart pan halfway through baking.

Transfer the tart pan to a wire rack, remove the parchment paper and pie weights, and cool completely.

TO ASSEMBLE THE TART: In the bowl of an electric mixer fitted with the whisk attachment and set on medium speed, whisk the white chocolate mixture just until smooth and fluffy. Do not overmix. Spread over the cooled tart crust. Arrange the fruit on top in a pleasing design.

If desired, heat the apricot jam in a small saucepan. Once hot and liquid, brush over the fruit to glaze. Refrigerate until ready to serve, no longer than 6 to 8 hours.

CHOCOLATE PISTACHIO TART

WITH FRESH RASPBERRIES

━━━━━━━━━━━━━━━━━━━━━━━━━━━ ❈ ━━━━━━━━━━━━━━━━━━━━━━━━━━━

PISTACHIOS ALWAYS MAKE THE LIST OF everyone's favorite nuts. I know they are on mine! They are rich and buttery and used in both sweet and savory dishes. They shine in desserts such as this, where they add their body and flavor to the simple pastry crust, which cradles a classic dark chocolate ganache topped with rows of fresh raspberries.

Makes one 14 by 4-inch tart

CRUST

2¼ ounces shelled whole pistachios, toasted (see page 210)

1¼ cups all-purpose flour

⅔ cup confectioners' sugar

½ teaspoon salt

½ cup (1 stick) plus 1 tablespoon cold unsalted butter, cut into pieces

1 large egg yolk

FILLING

9 ounces bittersweet or semisweet chocolate, coarsely chopped

1¼ cups heavy cream

3 tablespoons honey

3 tablespoons unsalted butter, softened

1½ cups fresh raspberries

TO MAKE THE CRUST: In the bowl of a food processor fitted with the metal blade, process the pistachios until finely ground. Add the flour, confectioners' sugar, and salt and process until well blended.

Add the butter and pulse until the mixture resembles coarse meal. Add the egg yolk and blend just until the dough comes together in a cohesive mass, 5 to 8 seconds.

Gather the dough and form it into a disk. Wrap in plastic and refrigerate for at least 1 hour.

Meanwhile, position a rack in the center of the oven and preheat the oven to 350°F.

Roll out the chilled dough on a lightly floured surface until it is about ¼ inch thick and large enough to fit into a 14 by 4-inch tart pan. This is very thin and the dough is fragile, so work with a light hand. Lift the dough (roll it around the rolling pin, if that makes it easier) and drape it over the pan. Gently press the dough into the tart pan. Trim the overhanging dough.

Line the tart crust with parchment paper or waxed paper and fill it with pie weights, rice, or dried beans to weight it.

Bake the weighted tart crust until the dough looks dry when the parchment paper is lifted, 25 to 30 minutes.

recipe continues

WHO LIKES

MILK CHOCOLATE?

SOME CHOCOLATE PURISTS disdain milk chocolate, despite the reality that it is the world's favorite for eating straight from the wrapper. I don't agree with this snobbishness. Sure, milk chocolate is not as versatile when it comes to baking and candy making, but it's a lovely chocolate to eat out of hand when you are in need of a chocolate fix. Milton Hershey made his fortune by mass-producing milk chocolate bars for the troops during World War I. Of course, Hershey didn't invent milk chocolate; that distinction belongs to Henri Nestlé who, with colleague and friend Daniel Peter, came up with the concept in Switzerland in the 1870s.

Milk chocolate's appeal lies in its mild sweetness. It's made by adding milk solids to dark chocolate along with flavorings such as vanilla and vanillin. It must contain at least 10 percent chocolate solids and 12 percent milk solids, the minimum requirements set by the U.S. Board of Standards. Many manufacturers make milk chocolate with higher percentages of cocoa content, and every time they do, they improve its flavor. Since you're probably going to eat the milk chocolate right from the wrapper, try different brands to discover which you like most. (Tough job, I know!) The milk solids, being proteins, are sensitive to heat, so the chocolate does not behave as consistently as dark chocolate does when cooked. For this reason, you cannot substitute milk chocolate for dark in most recipes. When I use it in the book, it's always as an add-in that is stirred into the batter.

NOTE: *For an extra-special presentation, use a piping bag fitted with a small plain tip to dot the top of each raspberry with melted white chocolate.*

Transfer the tart pan to a wire rack, remove the parchment paper and pie weights, and cool completely.

TO MAKE THE FILLING: Put the chocolate in a heatproof bowl.

In a heavy saucepan, bring the cream and honey to a boil over medium-high heat. Once it's bubbling, pour the cream mixture over the chopped chocolate and stir until the chocolate melts and the mixture is smooth and evenly colored.

Whisk in the butter until incorporated and smooth. Pour the ganache into the cooled tart crust. Set aside at room temperature for at least 4 hours to cool and set. If not serving right away, refrigerate for up to 8 hours or overnight.

Just before serving, arrange the raspberries over the top of the tart.

CHAPTER SIX

TRUFFLES

CLASSIC HAND-ROLLED 71 PERCENT CHOCOLATE TRUFFLES

COCONUT TRUFFLES

KEY LIME TRUFFLES

CREAMSICLE TRUFFLES

MILK CHOCOLATE–PEANUT BUTTER TRUFFLES

ALMOND-CRUSTED WHITE CHOCOLATE–LEMON TRUFFLES

RASPBERRY–MADAGASCAR GREEN PEPPERCORN TRUFFLES

WALNUT-COATED NUTELLA TRUFFLES

COFFEE (OR ESPRESSO!) TRUFFLES

PISTACHIO TRUFFLES

I WAS QUITE YOUNG, JUST BEGINNING MY CULINARY EDUCATION, when the executive chef I worked for gave me a dark chocolate truffle to taste. It was a revelation and unlike anything I had sampled before: from the outside in, I first tasted the dry, mouth-puckering cocoa powder, then the thin chocolate shell that snapped between my teeth, and finally the creamy, soft, simple yet powerful ganache center, the holy grail of the chocolate experience. Then and there, I decided to pursue this magical substance called chocolate and to learn all I could about it. Since that day, I have rolled thousands of truffles and still revel in the glorious tastes and textures.

The recipes in this chapter are for some of my favorite truffles and they also are meant to enlighten. Before you begin, read the tips on pages 124 and 125 for some in-depth instruction. It's really very easy to create truffles that appeal to you in some particular way. Do you like pure chocolate? Lemon and white chocolate? Coconut? Are you a fan of rum and chocolate? Peanut butter and milk chocolate? Perhaps you prefer crushed nuts rather than cocoa powder as a coating. Make the truffles you like, as you like them, following these recipes as general templates. If some of your experiments taste better than others, well, you've learned something. And when you're working with chocolate and sugar and cream, nothing is going to taste too bad!

PERFECT TRUFFLES

WHEN I TEACH TRUFFLE CLASSES, I PASS ON THESE TIPS. The number may seem like overkill for making something that essentially is so easy, but because I am so passionate about these bites of pure, intense chocolate flavor, I want to cover every eventuality. Please read through the tips at least once—chances are you will refer to them time and again once you start making your own truffles. Over the years I have worked with a lot of chocolatiers and I believe you can tell a professional's skill by how well he or she rolls a truffle. You probably aren't going to make these professionally, but you might as well make them as expertly as you can.

1 Use the best chocolate you can find. Truffles are all about chocolate and inferior chocolate will result in inferior truffles. I like chocolate that is between 70 and 75 percent cocoa content, because I prefer bitter chocolate. If you like chocolate that is slightly sweeter, use chocolate with a lower percentage of cocoa content (pure chocolate) instead. For more on the various kinds of chocolate, turn to page 154.

2 If you make truffles with white chocolate, use half the amount of cream needed for truffles made with dark chocolate. For example, 1 pound dark chocolate requires 2 cups heavy cream, while 1 pound white chocolate needs only 1 cup heavy cream.

3 When heating a mixture of cream and sugar, always put the cream in the pan first and then the sugar. This reduces the chance of the sugar burning.

4 Never melt the chocolate before pouring the hot cream over it. The chocolate should simply be coarsely chopped or broken up.

5 Remember that water and chocolate are enemies. This is important to keep in mind when you melt chocolate in a double boiler over barely simmering water, which produces steam. Any moisture in the chocolate can cause it to seize, or stiffen.

6 The key to flavoring chocolate ganache is to infuse the cream with the fruit, herbs, spices, alcohol, coffee, and so on.

7 When you flavor the chocolate with fruit (apples or raspberries, for instance), cook the fruit down with a tablespoon or two of water to a thick jam. Only at this point is it ready to add to the cream.

8 Never add citrus zest to the ganache. Not only does it taste "off," but it will also mold.

9 Dried, ground spices and spice powders can be added to the cream or to the chocolate mixture. Either way works well.

10 Spice seeds and herb leaves need to be strained from the cream. This is easy to do by pouring the cream through a fine-mesh sieve over the chopped chocolate.

11 Pair spices and herbs with fruits that make sense to your taste buds: apple and rosemary, apricot and basil.

12 If flavoring truffles with alcohol, add the liqueur, spirit, or wine to the cream before it comes to a boil. Bring the cream to a boil to cook off the alcohol.

13 When you want to flavor the truffles with coffee, start with really good brewed coffee or espresso and add it to the cream, hot or cold. You can also add espresso powder to the cream while it's heating. Make sure it dissolves completely.

14 Scrape the seeds from vanilla beans and add the seeds (and the pod, if you desire) to the cream as it heats. Strain the cream before pouring it over the chopped chocolate.

15 If the ganache recipe calls for butter, use the right amount—or even a little more. In other words, don't skimp on the butter. It contributes to that glorious mouthfeel desirable in a truffle. I always use unsalted butter with high butterfat content. If the chocolate needs a little salt, don't count on salted butter, over which you have no control, to contribute the salt. Add the salt separately.

16 Never refrigerate warm ganache or the fat might separate and rise to the top. Let it cool to room temperature first.

17 If you plan to refrigerate the ganache for any length of time, divide it into small portions and store them in zipped bags. This makes it more efficient to make the truffles later, a batch at a time.

18 Use latex gloves when rolling truffles. This prevents the ganache from heating up between your palms as it's rolled.

19 Do not roll the truffles longer than necessary to form them, as rolling heats up the ganache. You want the ganache to stay cool so it does not soften.

20 Also wear latex gloves when coating the truffles first in melted chocolate and then in cocoa, chopped nuts, crumbs, coconut, or other ingredients.

21 Always toast nuts before chopping them (see page 210). The heat intensifies their flavor. If you want to flavor the truffles with nuts, do so only as a coating. Do not mix nuts with the ganache; they can cause mold. The exception is Nutella, which can be mixed with the cream and chocolate.

22 In the old days, a truffle wasn't a truffle unless it was rolled in cocoa and thus resembled a freshly dug "real truffle." Nowadays, anything goes. Truffles are rolled in chopped nuts, crumbs, sweetened coconut—just about anything that strikes your fancy.

23 Chocolatiers dip truffles in tempered chocolate, which coats them with a glossy shell. For this book, I am not using any tempered chocolate. Tempering chocolate and keeping it in temper is a complicated process, and while tempered chocolate snaps in a satisfying way and stays shiny and lustrous, I will save the process for another book. That said, I always coat the truffles in melted chocolate before rolling them in cocoa or another coating. The thin layer of chocolate contributes to the flavor and texture of the truffles.

71 PERCENT CHOCOLATE TRUFFLES

EVERYONE HAS A FAVORITE CHOCOLATE FOR their truffles and I prefer 71 percent Ecuadorian dark chocolate, or a similar chocolate with 70 to 75 percent chocolate solids. I find it amazingly powerful and fruity, and its flavors keep developing as you eat it—rather like a good wine. The difference is that the taste of the truffle stays with you for eternity.

Makes about 30 truffles

1 pound 70 to 75 percent bittersweet or semisweet chocolate, coarsely chopped

2 cups heavy cream

½ cup plus 2 tablespoons sugar

4 tablespoons unsalted butter, softened

4 ounces bittersweet or semisweet chocolate, coarsely chopped, for coating

Unsweetened natural (non-alkalized) cocoa powder, for coating

Put the pound of chopped chocolate in a heatproof bowl.

In a heavy saucepan, heat the cream and sugar over medium-high heat until boiling. As soon as the cream mixture boils, slowly pour it over the chopped chocolate, whisking to blend and melt.

Add the butter, 1 tablespoon at a time, whisking until the butter is completely incorporated and emulsified into the ganache. Whisk until smooth and set aside until the ganache cools to warm room temperature (body temperature).

Cover the ganache and refrigerate for 1 to 4 hours.

Remove the ganache from the refrigerator. Pinch off pieces about the size of walnuts and roll them between your palms. They do not have to be perfect rounds but can look a little uneven, like actual truffles. Arrange the truffles on baking sheets and refrigerate for about 20 minutes.

Meanwhile, melt the remaining 4 ounces of chocolate according to the instructions on page 32. Let the chocolate cool slightly.

Spread the cocoa powder on a flat plate or shallow dish.

Wearing latex gloves, dip your fingers in the melted chocolate. Lift a rolled truffle from the baking sheet and dip it in the melted chocolate to coat. Roll the coated truffle in the cocoa powder and set on a clean baking sheet or similar tray. When all the truffles are dipped and rolled, let them set for 5 to 10 minutes before serving.

COCONUT TRUFFLES

※

IN ALL THE RECIPES FOR TRUFFLES using bittersweet chocolate, I suggest chocolate with 71 percent (or thereabouts) cocoa content. If you prefer slightly sweeter truffles, use 64 percent or even lower. The choice is yours. In this truffle, the coconut and other flavors stand up beautifully to the bitter chocolate.

Makes about 30 truffles

- 1 pound 70 to 75 percent bittersweet or semisweet chocolate, coarsely chopped
- 2 cups heavy cream
- ½ cup coconut cream
- ½ cup plus 2 tablespoons sugar
- 1 tablespoon dark rum, optional
- 4 tablespoons unsalted butter, softened
- 4 ounces bittersweet or semisweet chocolate, or white chocolate, coarsely chopped, for coating
- About 1 cup sweetened shredded coconut, for coating

NOTE: *Sweetened shredded coconut, which is easy to find, does a good job of covering the truffles, but to get the snowy coating pictured, use desiccated coconut, which is very fine. You could also grind the shredded coconut in a food processor.*

· GET CREATIVE! ·

For a flavor wallop, add 2 teaspoons curry powder to the cream mixture. Strain the cream through a fine-mesh sieve over the chopped chocolate.

Put the pound of chopped chocolate in a heatproof bowl.

In a heavy saucepan, heat the cream, coconut cream, sugar, and rum, if using, over medium–high heat until boiling. As soon as the cream mixture boils, slowly pour it over the chopped chocolate, whisking to blend and encourage melting.

Add the butter, 1 tablespoon at a time, whisking until the butter is completely incorporated and emulsified into the ganache. Whisk until smooth and set aside until the ganache cools to warm room temperature (body temperature).

Cover the ganache and refrigerate for 1 to 4 hours.

Remove the ganache from the refrigerator. Pinch off pieces about the size of walnuts and roll them between your palms. They do not have to be perfect rounds but can look a little uneven, like actual truffles. Arrange the truffles on baking sheets and refrigerate for about 20 minutes.

Meanwhile, melt the remaining 4 ounces of chocolate according to the instructions on page 32. Let the chocolate cool slightly.

Spread the shredded coconut on a flat plate or shallow dish.

Wearing latex gloves, dip your fingers in the melted chocolate. Lift a rolled truffle from the baking sheet and dip it in the melted chocolate to coat. Roll the coated truffle in the coconut and set on a clean baking sheet or similar tray. When all the truffles are dipped and rolled, let them set for 5 to 10 minutes before serving.

KEY LIME TRUFFLES

KEY LIME PIE WAS A WONDER the first time I tasted it. Similar to European citrus tarts, it nonetheless is iconically American, so when I was coming up with flavors for truffles, I naturally thought of key lime. Like the pie, these truffles are best made with authentic key limes, available only in late winter and early spring. They are particularly tart and add heady astringency to the truffles. You can buy good-quality bottled key lime juice in gourmet stores.

Makes about 25 truffles

1 pound white chocolate, coarsely chopped, plus 4 ounces, coarsely chopped, for coating

1 cup heavy cream

Juice of 6 key limes or 3 other limes (about 5 tablespoons)

½ cup plus 2 tablespoons granulated sugar

4 tablespoons unsalted butter, softened

Doughnut sugar, for coating (see page 133)

· GET CREATIVE! ·

Perk up these tangy truffles by adding some fresh herbs. I suggest adding ½ cup chopped cilantro or basil leaves to the cream mixture and then straining the cream through a fine-mesh sieve over the chocolate. Herbaceous and delicious!

Put the pound of chopped chocolate in a heatproof bowl.

In a heavy saucepan, heat the cream, lime juice, and granulated sugar over medium-high heat until boiling. As soon as the cream mixture boils, slowly pour it through a fine-mesh sieve over the chopped chocolate, whisking to blend and encourage melting.

Add the butter, 1 tablespoon at a time, whisking until the butter is completely incorporated and emulsified into the ganache. Whisk until smooth and set aside until the ganache cools to warm room temperature (body temperature).

Cover the ganache and refrigerate for 1 to 4 hours.

Remove the ganache from the refrigerator. Pinch off pieces about the size of walnuts and roll them between your palms. They do not have to be perfect rounds but can look a little uneven, like actual truffles. Arrange the truffles on baking sheets and refrigerate for about 20 minutes.

Meanwhile, melt the remaining 4 ounces of chocolate according to the instructions on page 32. Let the chocolate cool slightly.

Spread the doughnut sugar on a flat plate or shallow dish.

Wearing latex gloves, dip your fingers in the melted chocolate. Lift a rolled truffle from the baking sheet and dip it in the melted chocolate to coat. Roll the coated truffle in the doughnut sugar and set on a clean baking sheet or similar tray. When all the truffles are dipped and rolled, let them set for 5 to 10 minutes before serving.

SINGLE-ESTATE CHOCOLATES

IN RECENT YEARS, chocolate bars have started to be labeled as "single estate" or "single origin." This means the beans used to make the chocolate were grown on a particular plantation or in a defined region (which very often is an entire equatorial country). Some of these single-estate chocolates are fantastic. I especially like a 71 percent bittersweet from Ecuador; you might prefer another. And yet, single-estate chocolates are not, by definition, superior to other chocolates.

Many factors affect the final taste and feel of the chocolate. As with wine, terroir is critical: the soil, altitude, rainfall, and temperature. (Remember, cacao trees only grow near the equator.) Once the beans are harvested, they are dried, fermented, and roasted. These processes affect the final chocolate, too.

Chocolate makers then work with the beans to make chocolate. They might make chocolate with a bean from a particular plantation or country, or they might mix and match the beans to create blends. Perhaps the easiest way to understand this is to think of coffee sellers. They go to great lengths to procure coffee beans from around the world for their brews. Chocolate manufacturers do the same.

Once the manufacturers buy the beans, they make the chocolate. This involves separating the chocolate solids from the cocoa butter and then processing this pure chocolate while reintroducing the cocoa butter and adding sugar in varying amounts. As this is happening, the chocolate is kneaded in a process called "conching." How long it's conched makes a difference in the final product, too.

Too technical? In the end, it comes down to personal taste. Try the single-estate chocolates you find on the market shelves. They might make you swoon. On the other hand, a blended chocolate made by a fine chocolate company may suit your fancy. Probably, if you are anything like me, you will like more than one kind of chocolate and discover a few reliable favorites. And you will also enjoy exploring new varieties!

CREAMSICLE TRUFFLES

REMEMBER THOSE FRUITY, CREAMY POPSICLES? USUALLY made with orange flavoring (although there are also raspberry creamsicles), they were cool and yummy on hot summer days. That same orangey creaminess translates to a truffle with the ease of ice melting in the July sunshine.

Makes about 25 truffles

1 pound white chocolate, coarsely chopped, plus 4 ounces, coarsely chopped, for coating

½ cup heavy cream

Juice of 2 large or 3 medium-size oranges (about ½ cup)

½ cup plus 2 tablespoons granulated sugar

4 tablespoons unsalted butter, softened

Doughnut sugar, for coating (see Note)

Put the pound of chopped chocolate in a heatproof bowl.

In a heavy saucepan, heat the cream, orange juice, and granulated sugar over medium-high heat until boiling. As soon as the cream mixture boils, slowly pour it through a fine-mesh sieve over the chopped chocolate, whisking to blend and encourage melting.

Add the butter, 1 tablespoon at a time, whisking until the butter is completely incorporated and emulsified into the ganache. Whisk until smooth and set aside until the ganache cools to warm room temperature (body temperature).

Cover the ganache and refrigerate for 1 to 4 hours.

Remove the ganache from the refrigerator. Pinch off pieces about the size of walnuts and roll them between your palms. They do not have to be perfect rounds but can look a little uneven, like actual truffles. Arrange the truffles on baking sheets and refrigerate for about 20 minutes.

Meanwhile, melt the remaining 4 ounces of chocolate according to the instructions on page 32. Let the chocolate cool slightly.

Spread the doughnut sugar on a flat plate or shallow dish.

Wearing latex gloves, dip your fingers in the melted chocolate. Lift a rolled truffle from the baking sheet and dip it in the melted chocolate to coat. Roll the coated truffle in the doughnut sugar and set on a clean baking sheet or similar tray. When all the truffles are dipped and rolled, let them set for 5 to 10 minutes before serving.

NOTE: *Doughnut sugar is also called snow sugar and, unlike the more familiar confectioners' sugar, does not dissolve on baked items. It is a very fine powdered sugar that is commonly used on doughnuts and similar pastries. You may have to order it online or look for it in a specialty store or a shop that caters to bakers. Or ask your local bakery if you can buy some from them, as you don't need much to coat truffles and they might be willing to share a small bag with you. Anything coated with doughnut sugar can be frozen or refrigerated. Truffles are not cooked, of course, but if you want to use the doughnut sugar on baked items, make sure they are not hot when you do.*

· GET CREATIVE! ·

To turn these truffles from sweet, mild bonbons into ones with a surprising jolt, add ½ teaspoon chili powder (I like to use chipotle chili powder) to the cream mixture. Strain the mixture through a fine-mesh sieve over the chopped chocolate. The stronger the chili powder, the more powerful the "wow!" factor.

MILK CHOCOLATE–PEANUT BUTTER

TRUFFLES

IS THERE A BETTER FLAVOR COMBINATION than chocolate and peanut butter? As I have said elsewhere, I didn't know much about peanut butter when I lived in Denmark, but almost as soon as I landed in the USA, I started to experiment with the luscious, buttery spread. Now I can't get enough of it!

Makes about 25 truffles

1 pound milk chocolate, coarsely chopped

1 cup heavy cream

1 cup smooth peanut butter

½ cup plus 2 tablespoons sugar

4 tablespoons unsalted butter, softened

4 ounces bittersweet or semisweet chocolate, coarsely chopped, for coating

About 2 cups crushed salted roasted peanuts, for coating

Put the pound of chopped milk chocolate in a heatproof bowl.

In a heavy saucepan, heat the cream, peanut butter, and sugar over medium-high heat until boiling. As soon as the cream mixture boils, slowly pour it over the chopped chocolate, whisking to blend and encourage melting.

Add the butter, 1 tablespoon at a time, whisking until the butter is completely incorporated and emulsified into the ganache. Whisk until smooth and set aside until the ganache cools to warm room temperature (body temperature).

Cover the ganache and refrigerate for 1 to 4 hours.

Remove the ganache from the refrigerator. Pinch off pieces about the size of walnuts and roll them between your palms. They do not have to be perfect rounds but can look a little uneven, like actual truffles. Arrange the truffles on baking sheets and refrigerate for about 20 minutes.

Meanwhile, melt the 4 ounces of bittersweet or semisweet chocolate according to the instructions on page 32. Let the chocolate cool slightly.

Spread the peanuts on a flat plate or shallow dish.

Wearing latex gloves, dip your fingers in the melted chocolate. Lift a rolled truffle from the baking sheet and dip it in the melted chocolate to coat. Roll the coated truffle in the peanuts and set on a clean baking sheet or similar tray. When all the truffles are dipped and rolled, let them set for 5 to 10 minutes before serving.

DOES ANYONE *REALLY* LIKE

WHITE CHOCOLATE?

TO START WITH, I LIKE WHITE CHOCOLATE—one vote for the pro side of the white chocolate ledger! I don't like to eat it plain, however, as do those who *really, really* like it.

White chocolate on its own is too sweet for my taste, plus I like some actual cocoa content in my eating chocolate. Yet, as a flavoring, white chocolate is a champ. I use it in cheesecakes, cookies, traditional cakes, ganache, and even chocolate milk. And every time it's a winner.

White chocolate is made from cocoa butter. That's *it* when it comes to the cocoa bean. Otherwise, it contains vanilla and vanillin, sugar, and lecithin, a stabilizer. And, according to the people who set the standards, white chocolate only needs to be 20 percent cocoa butter. The cocoa butter is just fat and has none of that beautiful chocolate color; instead, the confection is a lovely ivory color.

WHITE CHOCOLATE–LEMON TRUFFLES

WHITE CHOCOLATE CRIES OUT for lemon and these truffles take the flavor profile to legendary heights with the addition of crushed almonds as a coating. If you like white chocolate, it doesn't get any better than these.

Makes about 30 truffles

1 pound white chocolate, coarsely chopped, plus 4 ounces, coarsely chopped, for coating

1 cup heavy cream

½ cup plus 2 tablespoons sugar

Juice of 2 lemons

1 vanilla bean, split in half lengthwise, or 1 teaspoon pure vanilla extract

4 tablespoons unsalted butter, softened

About 1¼ cups crushed toasted almonds (see page 210), for coating

· GET CREATIVE! ·

Chop up 2 stalks of lemongrass and use them to flavor the truffles in place of the lemon juice. The flavor is a little more herbal but still nice and lemony.

Put the pound of chopped chocolate in a heatproof bowl.

In a heavy saucepan, heat the cream, sugar, lemon juice, and seeds scraped from the vanilla bean or the vanilla extract over medium-high heat until boiling. As soon as the cream mixture boils, strain it slowly through a fine-mesh sieve over the chopped chocolate, whisking to blend and encourage melting.

Add the butter, 1 tablespoon at a time, whisking until the butter is completely incorporated and emulsified into the ganache. Whisk until smooth and set aside until the ganache cools to warm room temperature (body temperature).

Cover the ganache and refrigerate for 1 to 4 hours.

Remove the ganache from the refrigerator. Pinch off pieces about the size of walnuts and roll them between your palms. They do not have to be perfect rounds but can look a little uneven, like actual truffles. Arrange the truffles on baking sheets and refrigerate for about 20 minutes.

Meanwhile, melt the remaining 4 ounces of chocolate according to the instructions on page 32. Let the chocolate cool slightly.

Spread the toasted almonds on a flat plate or shallow dish.

Wearing latex gloves, dip your fingers in the melted chocolate. Lift a rolled truffle from the baking sheet and dip it in the melted chocolate to coat. Roll the coated truffle in the almonds and set on a clean baking sheet or similar tray. When all the truffles are dipped and rolled, let them set for 5 to 10 minutes before serving.

GREEN PEPPERCORN TRUFFLES

PEPPERCORNS ADD BOLD FLAVOR TO THESE fruity truffles, setting them apart from more typical berry-flavored examples. Both are wonderful, but these are a little more edgy, a little more exciting. The green peppercorns are easy to find in small glass jars in specialty stores, and while some of the best come from Madagascar, using Madagascar peppercorns here is not necessary. Chop them while they are still wet. You don't need any of the brine in the chocolate, but you also don't want the peppercorns to be dry. I like to coat the truffles with finely chopped dried strawberries, although you can omit that step if you prefer.

Makes about 25 truffles

1 pound milk chocolate, coarsely chopped

1 cup fresh raspberries

2 tablespoons water

1 cup heavy cream

½ cup plus 2 tablespoons sugar

2 teaspoons chopped green peppercorns packed in brine (chop them while wet; do not pat them dry)

4 tablespoons unsalted butter, softened

4 ounces bittersweet or semisweet chocolate, coarsely chopped, for coating

About 4 ounces dried strawberries, chopped, for coating

Put the pound of chopped milk chocolate in a heatproof bowl.

Combine the raspberries and water in a saucepan and cook over medium-low heat, stirring occasionally, until the berries cook down to a thick jam, 7 to 10 minutes.

Add the cream, sugar, and peppercorns to the raspberry jam and cook over medium–high heat until boiling. As soon as the cream mixture boils, slowly pour it through a fine-mesh sieve over the chopped chocolate, whisking to blend and encourage melting.

Add the butter, 1 tablespoon at a time, whisking until the butter is completely incorporated and emulsified into the ganache. Whisk until smooth and set aside until the ganache cools to warm room temperature (body temperature).

Cover the ganache and refrigerate for 1 to 4 hours.

Remove the ganache from the refrigerator. Pinch off pieces about the size of walnuts and roll them between your palms. They do not have to be perfect rounds but can look a little uneven, like actual truffles. Arrange the truffles on baking sheets and refrigerate for about 20 minutes.

Meanwhile, melt the 4 ounces of bittersweet or semisweet chocolate according to the instructions on page 32. Let the chocolate cool slightly.

In the bowl of a small food processor or in a blender, process the strawberries until finely chopped. Spread the strawberries on a flat plate or shallow dish.

Wearing latex gloves, dip your fingers in the melted chocolate. Lift a rolled truffle from the baking sheet and dip it in the melted chocolate to coat. Roll the coated truffle in the strawberries and set on a clean baking sheet or similar tray. When all the truffles are dipped and rolled, let them set for 5 to 10 minutes before serving.

NUTELLA TRUFFLES

IF YOU'RE MAD ABOUT THE HAZELNUT spread called Nutella, what are you waiting for? It's great smeared on toast or a muffin, but it's equally delicious, yet far more subtle, in a truffle. I coat these with chopped walnuts to carry out the nutty motif.

Makes about 30 truffles

- 1 pound 70 to 75 percent bittersweet or semisweet chocolate, coarsely chopped
- 2 cups heavy cream
- ½ cup plus 2 tablespoons sugar
- 6 tablespoons Nutella
- 4 tablespoons unsalted butter, softened
- 4 ounces bittersweet or semisweet chocolate, coarsely chopped, for coating
- About 2 cups ground toasted walnuts (see page 210), for coating

Put the pound of chopped chocolate in a heatproof bowl.

In a heavy saucepan, heat the cream, sugar, and Nutella over medium-high heat until boiling. As soon as the cream mixture boils, slowly pour it over the chopped chocolate, whisking to blend and encourage melting.

Add the butter, 1 tablespoon at a time, whisking until the butter is completely incorporated and emulsified into the ganache. Whisk until smooth and set aside until the ganache cools to warm room temperature (body temperature).

Cover the ganache and refrigerate for 1 to 4 hours.

Remove the ganache from the refrigerator. Pinch off pieces about the size of walnuts and roll them between your palms. They do not have to be perfect rounds but can look a little uneven, like actual truffles. Arrange the truffles on baking sheets and refrigerate for about 20 minutes.

Meanwhile, melt the remaining 4 ounces of chocolate according to the instructions on page 32. Let the chocolate cool slightly.

Spread the ground walnuts on a flat plate or shallow dish.

Wearing latex gloves, dip your fingers in the melted chocolate. Lift a rolled truffle from the baking sheet and dip it in the melted chocolate to coat. Roll the coated truffle in the walnuts and set on a clean baking sheet or similar tray. When all the truffles are dipped and rolled, let them set for 5 to 10 minutes before serving.

COFFEE (OR ESPRESSO!) TRUFFLES

THE COMBINATION OF CHOCOLATE AND COFFEE is an all-star one. It even has its own name: mocha. These coffee-flavored truffles are exceptional, with neither the chocolate nor the coffee overpowering the other but behaving in perfect balance.

Makes about 30 truffles

1 pound 70 to 75 percent bittersweet or semisweet chocolate, coarsely chopped

2 cups heavy cream

½ cup plus 2 tablespoons sugar

½ cup strong brewed coffee or espresso, hot or cold

2 tablespoons Kahlúa or Tia Maria

1 vanilla bean, split in half lengthwise

4 tablespoons unsalted butter, softened

4 ounces bittersweet or semisweet chocolate, coarsely chopped, for coating

Unsweetened natural (non-alkalized) cocoa powder, for coating

· GET CREATIVE! ·

I sometimes add about ¼ cup honey to the cream mixture. Its sweet intensity works nicely with the bitterness of the coffee.

Put the pound of chopped chocolate in a heatproof bowl.

In a heavy saucepan, heat the cream, sugar, coffee, Kahlúa, and seeds scraped from the vanilla bean over medium-high heat until boiling. As soon as the cream mixture boils, strain it slowly through a fine-mesh sieve over the chopped chocolate, whisking to blend and encourage melting.

Add the butter, 1 tablespoon at a time, whisking until the butter is completely incorporated and emulsified into the ganache. Whisk until smooth and set aside until the ganache cools to warm room temperature (body temperature).

Cover the ganache and refrigerate for 1 to 4 hours.

Remove the ganache from the refrigerator. Pinch off pieces about the size of walnuts and roll them between your palms. They do not have to be perfect rounds but can look a little uneven, like actual truffles. Arrange the truffles on baking sheets and refrigerate for about 20 minutes.

Meanwhile, melt the remaining 4 ounces of chocolate according to the instructions on page 32. Let the chocolate cool slightly.

Spread the cocoa powder on a flat plate or shallow dish.

Wearing latex gloves, dip your fingers in the melted chocolate. Lift a rolled truffle from the baking sheet and dip it in the melted chocolate to coat. Roll the coated truffle in the cocoa powder and set on a clean baking sheet or similar tray. When all the truffles are dipped and rolled, let them set for 5 to 10 minutes before serving.

PISTACHIO TRUFFLES

I USE A PISTACHIO-FLAVORED LIQUEUR CALLED Dumante to give these truffles a very adult, very impressive flavor kick. The crushed toasted pistachios that coat each truffle are the perfect final touch.

Makes about 30 truffles

1 pound 70 to 75 percent bittersweet or semisweet chocolate, coarsely chopped

2 cups heavy cream

½ cup plus 2 tablespoons sugar

2 tablespoons pistachio liqueur, such as Dumante

4 tablespoons unsalted butter, softened

4 ounces bittersweet or semisweet chocolate, coarsely chopped, for coating

About 2 cups crushed toasted pistachios (see page 210), for coating

Put the pound of chopped chocolate in a heatproof bowl.

In a heavy saucepan, heat the cream, sugar, and liqueur over medium-high heat until boiling. As soon as the cream mixture boils, slowly pour it over the chopped chocolate, whisking to blend and encourage melting.

Add the butter, 1 tablespoon at a time, whisking until the butter is completely incorporated and emulsified into the ganache. Whisk until smooth and set aside until the ganache cools to warm room temperature (body temperature).

Cover the ganache and refrigerate for 1 to 4 hours.

Remove the ganache from the refrigerator. Pinch off pieces about the size of walnuts and roll them between your palms. They do not have to be perfect rounds but can look a little uneven, like actual truffles. Arrange the truffles on baking sheets and refrigerate for about 20 minutes.

Meanwhile, melt the remaining 4 ounces of chocolate according to the instructions on page 32. Let the chocolate cool slightly.

Spread the pistachios on a flat plate or shallow dish.

Wearing latex gloves, dip your fingers in the melted chocolate. Lift a rolled truffle from the baking sheet and dip it in the melted chocolate to coat. Roll the coated truffle in the crushed nuts and set on a clean baking sheet or similar tray. When all the truffles are dipped and rolled, let them set for 5 to 10 minutes before serving.

CLASSIC CHOCOLATE DESSERTS

ANYONE WHO TRAINS IN EUROPE in the chocolate and pastry arts is required to learn to make a repertoire of classic confections. I am no exception. And you know what? Every day I thank my lucky stars for my years of intense training as an apprentice in Denmark and throughout the rest of western Europe. You've probably heard that you shouldn't break rules until you understand what they are, and nowhere is this more true than in making desserts and baking. Many of the cakes in Chapter Two are classics; the desserts here are, too.

These timeless favorites never go out of style. Who doesn't love a satiny smooth crème brûlée topped with a crackling crust that shatters like glass the minute you bite into it? Chocolate fondue is not only scandalously delicious, but fun and sexy, too. Crepes suzette may sound like something out of *Mad Men,* but they tasted good then and still do now. This is true of every recipe on the following pages. They have withstood the test of time, which is what makes them classics in the first place.

CREPES SUZETTE

WITH CHOCOLATE ICE CREAM

⟞✦⟝

I LEARNED HOW TO MAKE THESE in a restaurant in Odense, Denmark, and have never forgotten how temptingly delectable they were. Called Restaurant Naesbyhoved Skov, this traditional establishment featured classic Danish recipes and a cooking style that owed a debt to French gastronomy. I spent years there as an apprentice and it was mostly in those kitchens that I learned my craft.

At the restaurant, the suzettes were assembled tableside. Sugar was sprinkled over the pan, where it melted. Next the butter was added and then the already-cooked crepes. The ingredients were flambéed, which of course was dramatic and exciting.

The trick to perfect, light, airy crepes suzette lies with the crepes. Plan ahead when you want to make this, because the crepe batter needs at least a full hour in the refrigerator—and twelve hours is not too long. During this time the flour expands and absorbs the liquid, which results in tender pancakes. The batter also needs to be very smooth. I use a sturdy wire whisk and a strong arm to mix the ingredients together, but you may prefer to use a blender or even a food processor. If there are lumps in the batter, pour it through a fine-mesh sieve to remove them. Velvety smooth, lump-free batter is the name of the game. In addition to the crepes, the warm orange sauce and cold ice cream make this a dessert to die for.

Serves 3 to 6

CREPES

- 4 large eggs
- 4 large egg yolks
- 2 cups whole milk
- 5 tablespoons unsalted butter, melted and cooled
- 3 tablespoons vegetable oil
- 3 tablespoons orange juice
- 1 teaspoon pure vanilla extract
- 2 cups all-purpose flour
- ⅓ cup sugar
- Grated zest of 1 lemon (about 1 tablespoon)

TO MAKE THE CREPES: In a mixing bowl, whisk together the eggs, egg yolks, milk, melted butter, oil, orange juice, and vanilla.

In another mixing bowl, whisk together the flour, sugar, and lemon zest. Add the wet ingredients to the dry ingredients and whisk until smooth. Refrigerate the batter for at least 1 hour to chill thoroughly.

Heat a nonstick 7-inch crepe pan or similar-size frying pan over medium-high heat. When hot, spray it lightly with nonstick cooking spray, or use a little butter to grease the pan. Only use enough oil or butter to film the bottom of the pan. Tilt the pan so that the oil or butter covers the pan.

recipe continues

SAUCE

- ¾ cup (1½ sticks) unsalted butter
- ¼ cup plus 2 tablespoons sugar
- ½ cup orange juice
- ¾ cup orange liqueur, such as Grand Marnier, Cointreau, or triple sec
- 1 tablespoon grated orange zest

SERVING

- 3 to 6 scoops Super Chocolate Ice Cream (page 187) or high-quality store-bought chocolate ice cream

Pour about ¼ to ⅓ cup batter into the pan. Tip the pan to cover it evenly with batter. Cook the crepe until the bottom turns golden brown, 30 to 60 seconds. Turn the crepe using a blunt tool (a kitchen knife or small spatula) and your fingertips and cook until lightly browned on both sides, about 30 seconds more. Remove the crepe and pour more batter into the pan. Continue cooking crepes until all the batter is used, adding more cooking spray or butter as needed. You will need 12 crepes. If you have extra batter, make extra crepes. They freeze very well.

Stack the crepes on top of each other as they cook. If not using right away, wrap the stack in plastic wrap or a kitchen towel to prevent drying. They will keep in the refrigerator for 2 to 3 hours.

When ready to make the sauce, fold the crepes in half and then in half again to create a three-sided shape. Set aside.

TO MAKE THE SAUCE: Heat a large nonstick skillet over medium heat. Melt the butter in the pan until it starts to foam. Add the sugar and stir until the sugar melts. Add the orange juice, bring to a boil, reduce the heat, and cook until slightly reduced, 3 to 5 minutes.

Take the pan from the heat and stir in the liqueur and orange zest.

TO SERVE: Return the pan to medium heat and, working in batches, coat the folded crepes in the sauce, heating them for about 1 minute to absorb some of the liquid.

Put 2 to 4 crepes on each serving plate and top with the chocolate ice cream. Drizzle the remaining sauce over the ice cream and serve.

CRÈME BRÛLÉE

TO MAKE THIS FAVORITE BETTER THAN ever, I line the ramekins with dark chocolate ganache. The creamy, rich custard sings with joy when it mingles with the chocolate. Otherwise, this tastes just like you expect crème brûlée should. You won't find a better recipe anywhere. Read the tips on page 151 to ensure your effort pays off.

Serves 6 to 8

GANACHE

- 8 ounces bittersweet or semisweet chocolate, coarsely chopped
- ½ cup heavy cream
- 1 tablespoon honey

CUSTARD

- 4 cups heavy cream
- 1 tablespoon vanilla bean paste; 1 vanilla bean, split in half lengthwise; or 1 teaspoon pure vanilla extract
- 12 large egg yolks
- ⅔ cup sugar, plus 12 to 16 tablespoons for topping the custards

TO MAKE THE GANACHE: Put the chocolate in a heatproof bowl.

In a heavy saucepan, bring the cream and honey to a boil over medium-high heat. Once it's bubbling, pour the cream mixture over the chopped chocolate. With a wooden spoon, stir the ganache until the chocolate melts and the mixture is smooth and evenly colored.

Pour the ganache into each of 6 or 8 ramekins. The ramekins should be 3 to 4 inches in diameter. If you don't have ramekins, use 6- or 8-ounce custard cups. Tilt the ramekins or use a spoon to coat the bottom of the dishes. Set the ramekins in a roasting pan large enough to hold them and set aside.

TO MAKE THE CUSTARD: Position a rack in the center of the oven and preheat the oven to 300°F.

In a saucepan, bring the cream and vanilla paste to a boil. If using a vanilla bean, scrape the seeds into the cream and add the pod before you bring it to a boil; remove the pod once the cream is taken off the heat.

Take the cream off the heat and add the vanilla extract, if using.

recipe continues

In a mixing bowl, whisk together the egg yolks and the ⅔ cup sugar until pale yellow, 1 to 2 minutes. To temper the custard so that the yolks do not curdle, pour about a cup of the hot cream into the egg mixture, whisking constantly. Add the rest of the cream, stirring constantly.

Pour the custard into the ramekins. Set the roasting pan on an extended oven rack and add enough hot water to come halfway up the sides of the ramekins. Carefully slide the oven rack back into the oven and bake until the custards are softly set and the centers are a little jiggly, 50 to 55 minutes.

Lift the ramekins from the roasting pan and let them cool to room temperature. When cool, refrigerate for at least 3 hours and up to 3 days. The custards will firm up as they cool.

When ready to serve, take the ramekins from the refrigerator and sprinkle each one with an even layer of sugar. Using a blowtorch, caramelize the sugar until amber colored. If you don't have a blowtorch, slide the ramekins under a hot broiler for a minute or so just to caramelize the sugar. Take care not to burn the sugar. Serve immediately.

SPECTACULAR CRÈME BRÛLÉE

1 Leave the custards in the refrigerator until the last minute. It's important that they be as cold as possible when the sugar is heated. The interaction between the cold custard and the hot sugar forms the desired crackling, crisp crust.

2 It's best to use granulated white sugar for the topping, although some people prefer granulated brown sugar. Ordinary brown sugar must be sifted to remove lumps before you can sprinkle it evenly over the custards.

3 If you do not have a little blowtorch—which is easy to find at kitchenware shops and online—use the broiler. An electric broiler should be preheated for about 5 minutes before taking the custards from the fridge so it is very hot. Gas broilers do not need preheating.

4 If you use the broiler, the broiling pan with the custards should be no more than 2 to 3 inches from the heat. Rotate the broiling pan once during broiling to ensure even caramelizing.

5 If you use a butane blowtorch, run it over the tops of the custards, holding it as closely as you can without letting the flame touch the custard.

6 For the best, most authentic, and absolutely heavenly crème brûlée, serve it as soon as the crusts are caramelized.

CHOCOLATE FONDUE

❦

I SAID IN THE INTRODUCTION TO this chapter that fondue was "fun and sexy." It is! When fondue is on the table, there is a lot of sharing and laughter and you can't help but have a good time. If you want to mix it up a little, make the ganache with milk chocolate or white chocolate, although I am partial to the standard dark chocolate ganache with fruit, cake, and brownies. You will need a fondue pot with a candle to keep the fondue warm, and fondue forks for serving.

Serves 6 to 8

GANACHE

- 6 ounces bittersweet or semisweet chocolate, coarsely chopped
- ¾ cup heavy cream
- 1 tablespoon honey
- 1 tablespoon unsalted butter

FONDUE

- 8 Vanilla Marshmallows (page 185) or standard-size store-bought marshmallows
- 8 Chocolate Marshmallows (page 184) or standard-size store-bought marshmallows
- 8 Fritz's Fudgy Brownies (page 36), without the ganache, cut into 1½- to 2-inch chunks
- 8 slices Chocolate-Ginger Swirl Pound Cake (page 60) or your favorite pound cake, cut into 1½- to 2-inch chunks
- 1 banana, sliced
- 8 large fresh strawberries, stemmed and hulled

TO MAKE THE GANACHE: Put the chocolate in a heatproof bowl.

In a heavy saucepan, bring the cream and honey to a boil over medium-high heat. Once it's bubbling, pour the cream mixture over the chopped chocolate. With a wooden spoon, stir the ganache until the chocolate melts and the mixture is smooth and evenly colored.

Let the ganache cool until warm to the touch, 2 to 3 minutes. Add the butter and stir until the butter melts and is incorporated.

TO ASSEMBLE THE FONDUE: Arrange the marshmallows in one bowl or shallow dish, the brownie and cake chunks in another, and the fruit in a third.

Pour the ganache into a fondue pot and set in the base. Set the fondue pot in the center of the table. Light the candle to keep the fondue warm.

Let guests spear cake, fruit, and marshmallows with fondue forks and then dip them in the warm ganache.

POTS DE CRÈME

THESE DESSERTS ARE ALWAYS CHOCOLATE AND have the texture of a pudding. The difference between these and the chocolate pudding on page 169 is that these are baked in little pots, while the pudding is cooked on top of the stove. I love both because I can't get enough of smooth, satiny chocolate desserts. That said, I have been known to scatter these with crushed salty pretzels or even crumbled bacon. Talk about juxtaposing textures and flavors!

Serves 8 to 10

3 cups heavy cream

1 cup whole milk

1 tablespoon vanilla bean paste; 1 vanilla bean, split in half lengthwise; or 1 teaspoon pure vanilla extract

6 ounces bittersweet or semisweet chocolate, coarsely chopped

4 large egg yolks

3 large eggs

½ cup plus 2 tablespoons sugar

Sweetened whipped cream (see page 224), for serving, optional

Fresh strawberries, raspberries, or blackberries, for serving, optional

Position a rack in the center of the oven and preheat the oven to 325°F. Set eight 8- or ten 6-ounce ramekins or custard cups in a roasting pan large enough to hold them comfortably.

In a heavy saucepan, bring the cream, milk, and vanilla paste or bean to a boil over medium-high heat. Reduce the heat, add the chocolate, and whisk until the chocolate melts and the mixture is smooth and evenly colored.

In a separate mixing bowl, whisk together the egg yolks, eggs, and sugar. Slowly pour about 1 cup of the hot cream mixture over the egg mixture, whisking constantly to prevent the eggs from cooking. Slowly pour the rest of the hot cream into the bowl, whisking to mix. If using vanilla extract, add it now.

Strain the custard through a fine-mesh sieve into a bowl to remove any lumps and the vanilla bean, if using.

Divide the custard evenly among the ramekins. Set the roasting pan on an extended oven rack and pour enough hot water into the pan to come halfway up the sides of the ramekins. Cover the roasting pan with aluminum foil and bake until the custards are softly set and the centers are a little jiggly, 50 to 60 minutes.

Lift the ramekins from the roasting pan and set aside to cool to room temperature. Refrigerate for at least 3 hours and up to 3 days. The custards will firm as they cool.

Serve chilled, with sweetened whipped cream and berries, if using.

BITTERSWEET
OR
SEMISWEET?

BY DEFINITION, BOTH BITTERSWEET AND SEMISWEET CHOCOLATES are dark chocolates and must contain at least 35 percent cocoa content, or chocolate solids (whereas milk chocolate must contain only 10 percent, and white chocolate none). Chocolate solids are the bean with the cocoa butter extracted. Chocolate makers then reintroduce the cocoa butter (the fat) into the chocolate in varying amounts. They also add sugar and flavorings (usually vanilla and vanillin).

Obviously, the ratio of these ingredients affects the final flavor and texture of the chocolate. Chocolates that are, perhaps, 50 percent chocolate solids and then 50 percent cocoa butter and sugar will be far sweeter than chocolates with 75 percent chocolate solids and only 25 percent cocoa butter and sugar.

Bittersweet and semisweet chocolates overlap so closely that you can use either in recipes calling for one or the other—but you cannot replace them with unsweetened chocolate (sometimes called baking chocolate or plain chocolate) or milk chocolate.

Just to add to the confusion, bittersweet and semisweet chocolates are usually called just "dark chocolate" by professional bakers and chocolatiers.

MARZIPAN BARS

I GREW UP EATING CONFECTIONS MADE from marzipan and naturally developed a great fondness for the sweet, almond-flavored paste. When I started my chocolate business, I developed bars similar to these, which are European in style and yet appeal to American tastes. It takes a little while to get used to working with marzipan, but once you get the hang of it, you'll want to come up with your own flavor combinations. Try these first, though, and get ready to fall in love.

· *Makes 8 to 10 bars* ·

8 ounces marzipan

1 cup apricot jam

2 teaspoons finely grated fresh ginger

8 ounces bittersweet or semisweet chocolate, coarsely chopped

· GET CREATIVE! ·

FOR MOCHA MARZIPAN BARS, replace the apricot jam and ginger with ½ cup cooled brewed espresso. Replace the bittersweet or semisweet chocolate with milk chocolate. Follow the recipe as written, working the espresso into the marzipan until the mixture is evenly colored.

FOR RASPBERRY MARZIPAN BARS, replace the apricot jam and ginger with 1 cup raspberry jam. Follow the recipe as written.

Put the marzipan in a large bowl and add the jam. Using a wooden spoon, mix the jam with the marzipan and when partially combined, add the ginger. Work the mixture until it is evenly colored and well mixed. You might find it easier to work the marzipan with your hands.

Turn the marzipan mixture out onto a work surface lightly dusted with confectioners' sugar and pat it into a square about 1 inch thick. Using a rolling pin, roll the marzipan into a square about ¾ inch thick.

Dip a sharp knife in very hot water and wipe dry. Cut the marzipan into bars about 3 inches long and ¾ inch wide. Continue to dip and dry the knife between cuts to prevent sticking, as necessary.

Melt the chocolate according to the instructions on page 32.

Holding the bars between your fingers or with a fork, dip the bars, one at a time, into the melted chocolate to coat.

Transfer to a wire rack set over a baking sheet to catch the drips. Let the chocolate set for at least 1 hour at room temperature.

CHOCOLATE BREAD PUDDING

YOU DON'T HAVE TO DO ANY culinary research to know that bread pudding was invented as a way to use up slightly stale bread. Back in the day, recipes called for "day-old bread." Since the bread we buy at the supermarket nowadays keeps for longer than a few days without losing much taste or texture, that term can seem archaic—but not if you buy good-quality bakery bread and let it sit out for a day or so. It will get a little stale, just the right texture to soak up the custardy sauce. I like light and fluffy brioche for this.

Serves 8 to 10

CARAMEL SAUCE

- ⅔ cup heavy cream
- 2 teaspoons vanilla bean paste (see page 71) or ½ vanilla bean, split in half
- 1¼ cups granulated sugar
- ¼ cup water
- 3 tablespoons light corn syrup
- ½ teaspoon freshly squeezed lemon juice
- 2 tablespoons dark rum, optional
- 4 tablespoons cold unsalted butter, cut into pieces
- Pinch of salt

TO MAKE THE CARAMEL SAUCE: In a heavy saucepan, bring the cream and vanilla paste or seeds and pod to a boil over medium-high heat. Immediately reduce the heat to low to keep the cream warm.

In a deep pot, mix together the granulated sugar, water, and corn syrup and bring to a boil over medium-high heat. Cook until the color of amber. Remove the pot from the heat and, slowly and carefully, strain the hot cream mixture through a fine-mesh sieve over the caramel. (Discard the vanilla bean pod, if using.) Use thick oven mitts or pot holders and stand back, as the mixture will bubble and foam. Stir with a long-handled wooden spoon.

When the sauce calms down, stir in the lemon juice and rum, if using. Whisking constantly, add the butter, a piece at a time, until incorporated. Add the salt and stir to combine. Let the sauce cool and use immediately or store in an airtight container for up to 1 month. Reheat before using.

TO MAKE THE BREAD PUDDING: Butter a 13 by 9-inch baking dish and dust with ¼ cup of the granulated sugar.

In a large mixing bowl, whisk together the eggs, egg yolks, the remaining ½ cup granulated sugar, and the brown sugar. Add the milk, cream, and vanilla extract and whisk or stir until well mixed. Stir in the rum, if using.

Fold in the bread cubes, chocolate chips, and bananas, pressing gently on the bread to submerge it in the liquid.

Transfer the bread mixture to the prepared baking dish. Cover and refrigerate for 1 to 1½ hours, pressing on the bread two or three times to make sure it absorbs the liquid.

Meanwhile, position a rack in the center of the oven and preheat the oven to 350°F.

Bake the bread pudding until golden brown and puffy, 45 to 55 minutes.

Let the pudding cool for about 5 minutes and then serve warm with the caramel sauce and vanilla ice cream.

NOTE: *I like rich, eggy brioche for bread pudding and day-old bread is a little drier than fresh and therefore absorbs the liquid more readily. If you don't have day-old bread, slice the brioche and then toast it to dry it out a little.*

BREAD PUDDING

¾ cup granulated sugar

4 large eggs

2 large egg yolks

½ cup packed light brown sugar

2 cups whole milk

2 cups heavy cream

1 teaspoon pure vanilla extract

¼ cup dark rum, optional

 1-pound loaf day-old brioche, cut into ½-inch cubes (see Note)

1½ cups semisweet chocolate chips

2 ripe bananas, cut into small cubes

8 to 10 scoops Old-Fashioned Vanilla Ice Cream (page 188) or high-quality store-bought vanilla ice cream, for serving

BAKED ALASKA

WHENEVER I MAKE BAKED ALASKA, I can't help but think of a similar dessert we made when I was working in Chamonix, France. The region, which includes Mont Blanc, is known for its amazing skiing, and when I was younger, I spent a few winters there. I would cook in the morning and evening and take the afternoons off to go skiing. What a life! It wasn't until I came to the United States that I realized the dessert we called baked Chamonix is called baked Alaska on this side of the Atlantic Ocean. I like it no matter what it's called, and if you haven't tried it, don't decide it's outdated. It's delicious!

Serves 6 to 8

ICE CREAM CAKE

½ cup semisweet chocolate chips

½ cup sugar

6 tablespoons unsalted butter

2 large eggs, separated

1¼ cups all-purpose flour

1½ quarts Super Chocolate Ice Cream (page 187) or high-quality store-bought chocolate ice cream, softened

1 quart Fresh-Brewed Coffee Ice Cream (page 190) or high-quality store-bought coffee ice cream, softened

MERINGUE

5 large egg whites

1 cup sugar

Pinch of cream of tartar

3 tablespoons dark rum

1 teaspoon pure vanilla extract

TO MAKE THE CAKE: Position a rack in the center of the oven and preheat the oven to 350°F. Lightly grease a 9 by 5-inch loaf pan. Line the bottom of the pan with parchment paper or waxed paper.

In the top of a double boiler set over a pan of barely simmering water, or in the microwave, melt the chocolate chips with ¼ cup of the sugar and the butter. Stir the mixture until smooth and blended, but do not worry if the sugar is still a little gritty. Remove from the heat and let the mixture cool for a few minutes.

Add the egg yolks to the warm chocolate mixture and stir well.

In the bowl of an electric mixer fitted with the whisk attachment and set on medium-high speed, beat the egg whites until foamy. With the mixer running, add about a third (a good tablespoon) of the remaining sugar. When the whites reach soft peaks, add another third of the sugar and keep beating until the egg whites reach nearly stiff peaks. Add the rest of the sugar and beat until the egg whites reach stiff peaks.

Fold about a third of the meringue into the chocolate batter. When incorporated, fold in the rest of the whites. Sprinkle the flour over the batter and, using a rubber spatula, gently fold in the flour. Mix well but do not overmix. It is acceptable for a few streaks of whites to remain in the batter. Overmixing will cause the whites to deflate.

recipe continues

Pour the batter into the prepared pan and bake until a toothpick inserted near the center comes out clean, 20 to 25 minutes. The cake will not fill the entire pan.

Let the cake cool in the pan on a wire rack for about 5 minutes before turning out the cake onto the rack to cool completely. Wrap the cake in plastic wrap and freeze for at least 2 hours and up to 24 hours.

Line the same loaf pan with plastic wrap, leaving a generous overlap on each long side of the pan.

Remove and unwrap the cake. Using a serrated knife, split the cake in half horizontally to make two layers. Set the smaller layer in the bottom of the pan.

Spread the softened chocolate ice cream over the cake in the pan to make a 1-inch layer. Top with the softened coffee ice cream. At this point the loaf pan should be nearly full. If the ice cream softens too much, return it to the freezer for a few minutes.

Lay the remaining cake layer on top of the ice cream to fit snugly in the top of the loaf pan. Cover the pan with the plastic wrap overhangs. Freeze the ice cream cake for at least 2 hours.

TO MAKE THE MERINGUE: In the bowl of an electric mixer, whisk together the egg whites, sugar, and cream of tartar by hand. Set the bowl over a pot with about an inch of simmering water and whisk the whites until they are hot to the touch.

Immediately transfer the bowl to the electric mixer, fitted with the whisk attachment and set on medium-high speed. Beat until light, airy, and glossy and still warm to the touch. Add the rum and vanilla and beat just until incorporated.

TO ASSEMBLE: Preheat the oven to 500°F.

Remove and unwrap the ice cream cake. Lift it from the pan, using the plastic wrap, and invert the cake onto a baking sheet or shallow baking pan so that the cake is on the bottom.

Spread the meringue over the top and down the sides of the ice cream, which should be stiff and cold. (If it is not, return the cake to the freezer for 15 to 20 minutes.) Swirl the meringue decoratively on top of the cake.

Bake the cake until the meringue is golden brown, 1 to 2 minutes.

MINI MOLTEN CHOCOLATE CAKES

THESE ARE SIMILAR TO THE LARGER Molten Chocolate Cakes on page 63—just smaller. The creamy whipped ganache for the shot glasses for Chocolate Love on page 162 is made well ahead of serving, but these little darlings have to be baked immediately before they are served so that the centers are rich and warm and flow like lava. You might feel like making these on their own and not as part of Chocolate Love for a simpler chocolate treat.

Serves 8

2½ ounces bittersweet chocolate, coarsely chopped

5 tablespoons unsalted butter

1 extra-large egg

1 extra-large egg yolk

¼ cup granulated sugar

¼ cup all-purpose flour

About 3 tablespoons semisweet chocolate chips or chopped bittersweet or semisweet chocolate

Confectioners' sugar, for dusting

Position a rack in the center of the oven and preheat the oven to 375°F. Lightly butter 8 small ramekins, each with a 3-ounce capacity.

In the top of a double boiler set over a pan of barely simmering water, melt the chocolate and butter, stirring until smooth. Alternatively, in a microwave-safe container, such as a large Pyrex measuring cup, melt the chocolate and butter on medium power for 2 to 3 minutes. Watch the chocolate carefully, and when it softens, stir it with the butter until smooth. Set aside to cool slightly.

In the bowl of an electric mixer fitted with the paddle attachment and set on medium-high speed, beat the egg, egg yolk, and granulated sugar until smooth and thick. Add the cooled chocolate mixture and beat until the batter is smooth.

Reduce the mixer speed to low and add the flour, a few tablespoons at a time, beating after each addition just until mixed.

Divide the batter among the ramekins: Fill each halfway and then gently press 2 or 3 chocolate chips or pieces of chocolate into the batter. Spoon more batter into the ramekins to fill the ramekins to about ¼ inch from the rim. Set the ramekins on a baking sheet.

Carefully transfer the baking sheet to the oven and bake until the cakes are puffed and a little wobbly in the center, 5 to 7 minutes.

Dust some confectioners' sugar over the cakes and serve immediately so that the cakes are still warm.

CHOCOLATE LOVE

THIS IS MORE OF A CHOCOLATE extravaganza than a traditional dessert and, when the café was open, was our best seller. You'll have to bake the mini molten cakes and whip the chocolate mousse–like filling for the shot glasses, but then you can either make your own ice cream or buy it from the market. Ditto for the chocolate cookies, which can be homemade or store-bought. Arrange all the elements on a plate and your guests will think they have died and gone to chocolate heaven.

Serves 8

2 ounces bittersweet or semisweet chocolate, coarsely chopped (I use 71 percent chocolate)

1 cup heavy cream

2 tablespoons honey

About 2 tablespoons chocolate cake or cookie crumbs, made from any leftover chocolate cake or from ground chocolate wafers, or 1 ounce chocolate shavings (see Note, page 93)

8 Mini Molten Chocolate Cakes (page 161)

8 small scoops Super Chocolate Ice Cream (page 187) or high-quality store-bought chocolate ice cream

16 Chocolate Shortbread Cookies (page 281) or your favorite store-bought chocolate cookies

Confectioners' sugar, for dusting

Put the chocolate in a heatproof bowl.

In a saucepan, bring the cream and honey to a boil over medium-high heat. Pour over the chopped chocolate and stir until smooth and melted. Set aside to cool completely. When cool, refrigerate for at least 4 hours or until very cold.

In the bowl of an electric mixer fitted with the whisk attachment and set on medium-high speed, beat the chilled chocolate mixture until light and fluffy but not too stiff.

Spoon the whipped chocolate into a piping bag fitted with a plain tip and pipe into 8 shot glasses. Alternatively, spoon the whipped chocolate into the glasses. Top with the cake or cookie crumbs or chocolate shavings.

Put a shot glass on each of 8 serving plates. Set a mini cake next to the shot glass and put a scoop of ice cream next to the cake. Garnish each plate with 2 cookies. Sift some confectioners' sugar over the plate and serve.

CHAPTER EIGHT

CHOCOPOLO-GEE!

CHOCOLATE TRUFFLE BEIGNETS

AMERICAN CHOCOLATE PUDDING

CHOCOLATE-ALMOND GRANOLA

CARAMELIZED BANANA SPLITS WITH DARK CHOCOLATE SAUCE

CHOCOLATE BARK WITH WALNUTS & PUMPKIN SEEDS

TROPICAL WHITE CHOCOLATE–PEPPERMINT BARK

DOUBLE CHOCOLATE BARK WITH SALTED ALMONDS

CHOCOLATE BARK WITH STRAWBERRIES & CANDIED LEMON

CHOCOLATE MARSHMALLOWS

VANILLA MARSHMALLOWS

SUPER CHOCOLATE ICE CREAM

OLD-FASHIONED VANILLA ICE CREAM

FRESH-BREWED COFFEE ICE CREAM

CARAMEL ICE CREAM

KNIPSCHILDT CARAMEL SAUCE

CHOCOLATE SAUCE

WHILE THE PREVIOUS CHAPTER CELEBRATES a collection of traditional classics, this one is more playful and casual. I gave it a name that picks up on the lighthearted spirit of the recipes: fun and easy and tending to fall into the category of snack, rather than formal dessert.

For example, I include a banana split alongside granola, and in the same chapter as truffle beignets (one of my all-time favorites). I also include the four flavors of ice cream used in recipes throughout the book. Three of these are among the few recipes in this book that *don't* include chocolate. But then again, I do include a recipe for chocolate sauce. Drizzle it over the vanilla, coffee, or caramel ice cream and presto! A chocolate dessert!

CHOCOLATE TRUFFLE
BEIGNETS

THESE TRUFFLE-FILLED TREATS BRING TOGETHER TWO of my favorite things: beignets and chocolate ganache. I roll the beignet dough around the truffles and deep-fry them for indulgent overkill. When you bite into one, it's crispy on the outside and soft and creamy on the inside.

Makes about 12 beignets

GANACHE

1½ pounds 70 to 75 percent bittersweet or semisweet chocolate, coarsely chopped
1 cup heavy cream
¼ cup honey
6 tablespoons unsalted butter

BEIGNET DOUGH

½ cup granulated sugar
½ cup whole milk
1 tablespoon canola oil, plus more for frying
2 large eggs
2½ cups all-purpose flour, plus more for dusting
1½ teaspoons baking powder
¾ teaspoon salt
 Confectioners' sugar, for coating

TO MAKE THE GANACHE: Put the chocolate in a heatproof bowl.

In a heavy saucepan, bring the cream and honey to a boil over medium-high heat. Once it's bubbling, pour the cream mixture over the chopped chocolate. With a wooden spoon, stir the ganache until the chocolate melts and the mixture is smooth and evenly colored. Add the butter and stir until incorporated. Let the ganache cool to room temperature.

Cover the bowl and refrigerate until cold and hard, at least 30 minutes and up to 1½ hours.

When the ganache is cold, remove the bowl from the refrigerator. Pinch off pieces about the size of walnuts and roll them between your palms into balls. Transfer the truffles to a baking sheet and refrigerate again for 15 to 20 minutes to harden.

TO MAKE THE BEIGNET DOUGH: In the bowl of an electric mixer fitted with the paddle attachment and set on medium speed, blend the granulated sugar, milk, and oil until smooth. Add the eggs and mix until incorporated.

In a separate mixing bowl, whisk together the flour, baking powder, and salt.

Reduce the mixer speed to medium-low. Add the dry ingredients, a little at a time, until the dough is smooth and no longer sticky.

Refrigerate the dough until cold, at least 30 minutes.

recipe continues

When the dough is cold, remove it from the refrigerator and turn out onto a lightly floured surface. Take the truffles from the refrigerator.

Pinch off pieces of dough about twice the size of the truffles. Flatten the dough on a lightly floured work surface. Put a truffle in the center of each piece of flattened dough, pull the sides up to cover, and pinch closed. Make sure the truffles are completely covered or they will seep from the beignets when fried. Roll the beignets in a little flour and return to the baking sheet.

Pour about 3 inches of oil into a large, heavy pan and heat over medium-high heat until the oil registers 365°F on a deep-fry thermometer.

Drop 5 or 6 beignets at a time in the hot oil and fry until the beignets are lightly browned on all sides and bob to the surface of the oil, 6 to 10 minutes. Do not crowd the pan, and let the oil regain its heat between batches. (Keep the uncooked beignets in the refrigerator while frying the early batches.)

Drain the fried beignets on paper towels. Spread the confectioners' sugar on a plate and roll the warm beignets in the sugar to coat lightly. Serve warm or at room temperature.

CHOCOLATE PUDDING

I HAVE ALWAYS BEEN DRAWN TO smooth textures, but I confess to total ignorance when it comes to American-style chocolate pudding. The Pots de Crème on page 153, which are baked instead of cooked on the stove, are as close as I get. My American collaborator, Mary, convinced me to include this in the book because, she said, what's a chocolate book without a good old-fashioned chocolate pudding? I agree. This is good! When you make it, it's important not to let the milk boil, which promotes the formation of skin. Laying plastic wrap directly on the pudding as it cools prevents the skin as well.

Serves 4

4 ounces bittersweet or semisweet chocolate, coarsely chopped

1 cup whole milk

1 cup half-and-half

½ cup sugar

2 tablespoons cornstarch

Pinch of salt

3 large egg yolks

2 teaspoons pure vanilla extract

Sweetened whipped cream (see page 224), for garnish

NOTE: *To prevent a skin from forming on top of the pudding, press plastic wrap directly on the surface of the pudding before refrigerating. If you like the skin, cover the ramekins or custard cups with plastic wrap without touching the pudding.*

Put the chocolate in a heatproof bowl.

In a saucepan, combine the milk, half-and-half, sugar, cornstarch, and salt and cook over medium heat, whisking, until hot but not boiling. Remove the pan from the heat.

In a small bowl, beat the egg yolks with a fork just until mixed. Stir about ¼ cup of the hot milk mixture into the eggs. This tempers the eggs so they will not scramble.

Pour the eggs into the milk mixture and cook over medium heat, whisking constantly, until the mixture starts to thicken but is not boiling, 3 to 4 minutes.

Pour the milk mixture over the chocolate and stir with a wooden spoon until the pudding is smooth and all the chocolate is melted. Let the pudding cool for about 5 minutes and then stir in the vanilla.

Pour the pudding into 4 ramekins or custard cups, let the puddings cool to lukewarm, and then cover and refrigerate for at least 3 hours and up to 12 hours or overnight. Serve with whipped cream.

CHOCOLATE-ALMOND
GRANOLA

THERE AREN'T TOO MANY MORNINGS THAT don't begin with granola and yogurt for me. The dual textures—crunchy and soft—are practically made for each other. When chocolate is part of the equation, all the better! Eat this for breakfast or any time during the day. You can change out the almonds and cherries for another kind of nut or dried fruit, but don't omit the cocoa powder or you'll miss out on the intense chocolaty flavor.

Serves 8 to 10

4 cups uncooked rolled oats
1 cup slivered almonds
1 cup dried cherries
½ cup maple syrup
½ cup packed light brown sugar
⅓ cup unsweetened cocoa powder
½ cup coconut oil (see Note)
½ teaspoon pure vanilla extract
¼ teaspoon salt

NOTE: *Coconut oil is a wonderful ingredient for sweet preparations (savory, too, but that's another book). I suggest virgin coconut oil, which has a deeper flavor than processed, or refined, coconut oil. It is solid at room temperature and must be heated to melt. Its flavor is not overwhelming but gentle and reassuring: "I'm here," it says, "but I'm not taking over." Look for coconut oil at natural food stores and supermarkets such as Whole Foods.*

Position a rack in the center of the oven and preheat the oven to 275°F. Line a shallow baking pan (about 15 by 10 inches) with parchment paper or waxed paper.

In a mixing bowl, stir together the oats, almonds, and cherries.

In a saucepan, heat the maple syrup, brown sugar, and cocoa powder over medium-low heat, stirring occasionally, until the sugar dissolves and the mixture is smooth. Remove from the heat and stir in the coconut oil, vanilla, and salt until the coconut oil melts (you might have to put the pan back on the heat for a minute or so to melt the coconut). Pour the maple syrup mixture over the rolled oats and nuts and stir until well mixed.

Spread the granola on the baking pan in a single layer. Bake until the nuts and oats are crispy and golden brown, 50 to 60 minutes. Turn off the oven and let the granola sit in the oven for at least 20 minutes and up to 8 hours.

Store in an airtight container in a cool, dry place for up to a month. For longer storage, tightly wrap small, manageable amounts of the granola in plastic wrap and then put the packets in a freezer bag. The granola will keep for about 4 months.

CARAMELIZED BANANA SPLITS

WITH DARK CHOCOLATE SAUCE

I AM ESPECIALLY FOND OF BANANAS, so when I decided to include a sundae in the book, I went straight for the most opulent: the banana split. Right out of the gate I gild the lily by caramelizing a good amount of sugar on the raw bananas. While the sundae will be extra-special if you make your own ice cream (and I provide recipes for homemade ice cream later in this chapter), there's no reason to skip this extravaganza just because you don't have the time or inclination to make the ice cream. Buy the ice cream instead! I think what I like most about this sundae is the hidden crunch of the caramelized sugar under the heavenly smoothness of the ice cream and chocolate sauce. Does it get any better?

Serves 2

CHOCOLATE SAUCE

¼ cup heavy cream

3 ounces bittersweet or semisweet chocolate, coarsely chopped

½ tablespoon unsalted butter

BANANA SPLITS

2 large bananas, split in half lengthwise from end to end

4 to 6 tablespoons sugar

2 scoops raspberry sorbet

2 scoops Old-Fashioned Vanilla Ice Cream (page 188) or high-quality store-bought vanilla ice cream

2 scoops Super Chocolate Ice Cream (page 187) or high-quality store-bought chocolate ice cream

About ½ cup sweetened whipped cream (see page 224)

2 ounces chocolate shavings (see page 93)

2 large fresh strawberries, halved, for garnish

TO MAKE THE CHOCOLATE SAUCE: Put the cream and chocolate in a microwave-safe container and microwave for 1½ to 2 minutes, stirring after each 30-second interval. When the chocolate is melted and the sauce is hot to the touch, add the butter and whisk until incorporated. (Alternatively, heat the cream and chocolate in a saucepan over medium heat, whisking to prevent the cream from scorching and to help the chocolate melt. Remove from the heat and whisk in the butter until incorporated.)

TO MAKE THE BANANA SPLITS: Preheat the broiler. Lay the banana halves, cut sides up, on a baking sheet and sprinkle with the sugar. Slide them under the broiler until the sugar caramelizes, about 1 minute. Or, if you have a small kitchen torch, run it over the bananas to caramelize the sugar. Transfer the bananas to 2 oval serving dishes, putting 2 halves side by side on each dish.

For each sundae, use an ice cream scoop to set a scoop each of sorbet, vanilla ice cream, and chocolate ice cream along the length of the banana halves. Drizzle generously with chocolate sauce. Dollop whipped cream on top of the sorbet and ice cream scoops and then scatter with chocolate shavings. Garnish with the strawberries.

CHOCOLATE BARK

—◦•◦—

THE NEXT FOUR RECIPES ARE FOR CHOCOLATE BARK. This is one of the easiest and most versatile candies around, and one I make often. It's a perfect way to use up leftover chocolate from another recipe, if you happen to have any, but it's just as legit to go out and buy your favorite chocolate for the purpose of making bark. As I have said several times on these pages, I prefer bittersweet chocolate, generally with cocoa solids ranging from 70 to 75 percent, but if you like a slightly sweeter chocolate, by all means use it.

Chocolate bark can be made with any dried fruit, nuts (I always toast the nuts first), candies, cookie crumbs, or coconut. These add-ins should be about the same temperature as the chocolate, so if they've been refrigerated, let them warm up at room temperature. It's equally important that the ingredients be dry—although it's unlikely they would not be. I prefer dark chocolate for chocolate bark, but there are times when white chocolate works very well, as in two of the four recipes that follow.

I developed these barks with the seasons in mind. The first, which includes walnuts and pumpkin seeds, is clearly meant for fall. It's followed by a white chocolate and peppermint bark that I call "tropical" because of the macadamia nuts, but which is just about perfect for Christmas and other winter holidays. The double chocolate bark made with both dark and white chocolate and with salted almonds is my plain and simple spring offering, and the chocolate bark with candied lemon peel and dried strawberries celebrates summer in all its glory. Although it's not as apparent when you cook with chocolate as it is with lots of fruits and vegetables, it's still a good idea to pay attention to the seasons. It's part of my upbringing, my training as a chef, and my personality. The weather affects my outlook on life, too, so I think it's only natural that I would mark the seasons with chocolate.

Chocolate bark is broken apart when it's time to eat it. You can do this when serving it at a dinner party (you will be the "host of the month" if you do), and it also makes a wonderful handmade gift. I know people who make a lot of bark during the holidays and then pack it in decorative tins to give as gifts. Whether you pack it in tins or in airtight plastic containers for home storage, separate the shards of chocolate with waxed paper.

CHOCOLATE BARK

WITH WALNUTS & PUMPKIN SEEDS

Serves 8 to 10

¼ cup hulled pumpkin seeds

12 ounces bittersweet or semisweet chocolate, coarsely chopped

1 cup coarsely chopped toasted walnuts (see page 210)

½ cup dried cranberries

Spread the pumpkin seeds in a small, dry skillet and toast over medium-high heat, gently shaking the pan, until the seeds are aromatic and darken a shade in color, about 1 minute. Remove from the heat and slide the seeds onto a plate. Set aside to cool.

Line a baking sheet with foil.

Melt the chocolate according to the instructions on page 32. Let the chocolate cool to lukewarm (about 100°F). Stir in about 3 tablespoons of the cooled pumpkin seeds, ¾ cup walnuts, and 6 tablespoons cranberries until thoroughly combined.

Pour the chocolate mixture onto the prepared baking sheet and spread it evenly over the foil with a spatula or palette knife. Work quickly so the chocolate does not harden and become difficult to spread. Spread the remaining pumpkin seeds, walnuts, and cranberries over the bark and gently press them into the chocolate just to adhere.

Refrigerate the bark until the chocolate is cool and is beginning to set, 10 to 15 minutes. Remove the bark from the refrigerator and set the baking sheet on a wire rack. Let the bark set at cool room temperature for 4 to 6 hours. (If the weather is particularly humid, the bark may not set as firmly as on dry days.)

Lift the bark from the foil and break it into uneven pieces, each 2 to 3 inches long. To prevent getting your fingers sticky, hold onto the edge of the chocolate with waxed paper or wear latex gloves.

Serve right away or store the bark for 2 to 3 weeks in an airtight container between layers of waxed paper.

WHITE CHOCOLATE–PEPPERMINT BARK

Serves 8 to 10

1 cup hard peppermint candies or 6 or 7 candy canes

12 ounces white chocolate, coarsely chopped

½ cup chopped toasted macadamia nuts (see page 210)

Line a baking sheet with foil.

Put the candy or candy canes in the bowl of a food processor fitted with the metal blade and process until coarsely ground. There should be a few large shards of peppermint candy and some very fine powder, as well as moderate-size pieces.

Melt the chocolate according to the instructions on page 32. Let the chocolate cool to lukewarm (about 100°F). Stir in about three-quarters each of the peppermint and macadamia nuts until thoroughly combined.

Pour the chocolate mixture onto the prepared baking sheet and spread it evenly over the foil with a spatula or palette knife. Work quickly so the chocolate does not harden and become difficult to spread. Spread the remaining peppermint and nuts over the bark and gently press them into the chocolate just to adhere.

Refrigerate the bark until the chocolate is cool and is beginning to set, 10 to 15 minutes. Remove the bark from the refrigerator and set the baking sheet on a wire rack. Let the bark set at cool room temperature for 4 to 6 hours. (If the weather is particularly humid, the bark may not set as firmly as on dry days.)

Lift the bark from the foil and break it into uneven pieces, each 2 to 3 inches long. To prevent getting your fingers sticky, hold onto the edge of the chocolate with waxed paper or wear latex gloves.

Serve right away or store the bark for 2 to 3 weeks in an airtight container between layers of waxed paper.

DOUBLE CHOCOLATE BARK

WITH SALTED ALMONDS

Serves 8 to 10

8 ounces bittersweet or semisweet chocolate, coarsely chopped

½ cup chopped toasted salted almonds (see page 210)

2 sprigs fresh rosemary, leaves stripped from stems

8 ounces white chocolate, coarsely chopped

Line a baking sheet with foil.

Melt the dark chocolate according to the instructions on page 32. Let the chocolate cool to lukewarm (about 100°F). Stir about one-third of the almonds and one-third of the rosemary leaves into the chocolate until thoroughly combined.

Melt the white chocolate according to the instructions on page 32. Let the chocolate cool to lukewarm (about 100°F). Stir another one-third of the almonds and one-third of the rosemary leaves into the chocolate until thoroughly combined.

Pour the dark chocolate mixture onto the prepared baking sheet and spread it evenly over the foil with a spatula or palette knife. Work quickly so the chocolate does not harden and become difficult to spread. Spread the remaining almonds and rosemary over the bark and gently press them into the chocolate just to adhere.

Refrigerate the dark chocolate bark until the chocolate is cool and is beginning to set, 10 to 15 minutes. Remove the bark from the refrigerator and spread the white chocolate mixture over the dark chocolate. Refrigerate the bark until the white chocolate layer is cool and is beginning to set, 10 to 15 minutes.

Remove the bark from the refrigerator and set the baking sheet on a wire rack. Let the bark set at cool room temperature for 4 to 6 hours. (If the weather is particularly humid, the bark may not set as firmly as on dry days.)

Lift the bark from the foil and break it into uneven pieces, each 2 to 3 inches long. To prevent getting your fingers sticky, hold onto the edge of the chocolate with waxed paper or wear latex gloves.

Serve right away or store the bark for 2 to 3 weeks in an airtight container between layers of waxed paper.

CHOCOLATE BARK

WITH STRAWBERRIES & CANDIED LEMON

Serves 8 to 10

1 lemon

1 cup sugar, plus more for coating the lemon peel

1 cup water

12 ounces bittersweet or semisweet chocolate, coarsely chopped

1½ cups chopped dried strawberries (see Note, page 182)

Rinse the lemon and using a vegetable peeler or a small, sharp knife, remove the colored part of the rind, leaving the bitter white pith behind. Try to peel long, thin strips.

Chop the strips into ½-inch lengths and transfer to a small, heavy saucepan. Add enough water to cover the peel by 2 to 2½ inches and bring to a boil over medium-high heat. Drain and repeat one more time. Set the drained lemon peel strips aside.

Put the sugar in the pan and add the water. Squeeze the lemon juice from the peeled lemon into the pan and bring to a boil over medium-high heat, whisking to help the sugar dissolve. Add the peel and return to a boil. Reduce the heat to medium and simmer until the pieces of peel are tender and almost translucent, about 15 minutes. Let the lemon peel cool in the syrup. When cool, drain and reserve the peel. (Keep the syrup for another use.) You should have about 2 tablespoons of peel.

Spread about ½ cup sugar in a shallow dish. Add the cooled lemon peel and toss to coat with sugar. Let the sugar-coated lemon peel sit for about 2 hours to absorb the sugar. The peel is now ready to use, or it can be stored in an airtight container for about 2 weeks.

Line a baking sheet with foil.

Melt the chocolate according to the instructions on page 32. Let the chocolate cool to lukewarm (about 100°F). Stir until smooth, then pour the chocolate onto the prepared baking sheet and spread it evenly over the foil with a spatula or palette knife. Work quickly so the chocolate does not harden and become difficult to spread.

In a mixing bowl, toss the strawberries and lemon peel together. Scatter the fruit over the chocolate, gently pressing the pieces into the chocolate.

recipe continues

N O T E : *Dried strawberries are available in many supermarkets and specialty stores. They are also available online. Use either air-dried or freeze-dried strawberries for this recipe.*

Refrigerate the bark until the chocolate is cool and is beginning to set, 10 to 15 minutes. Remove the bark from the refrigerator and set the baking sheet on a wire rack. Let the bark set at cool room temperature for 4 to 6 hours. (If the weather is particularly humid, the bark may not set as firmly as on dry days.)

Lift the bark from the foil and break it into uneven pieces, each 2 to 3 inches long. To prevent getting your fingers sticky, hold onto the edge of the chocolate with waxed paper or wear latex gloves.

Serve right away or store the bark for 2 to 3 weeks in an airtight container between layers of waxed paper.

MARSHMALLOWS

I'VE INCLUDED TWO RECIPES FOR HOMEMADE MARSHMALLOWS, one made chocolaty with cocoa and the other flavored with vanilla extract. You can adjust the amount of vanilla upwards by a half teaspoon or so if you prefer more of a vanilla wallop.

In our chocolate kitchen, we make these in a professional-size sheet pan, but for the home cook, I suggest a rimmed baking sheet that measures 13 by 9 inches. You could also use a slightly smaller pan and just discard the excess marshmallow mixture. (Naturally, I would never actually discard it. I would spoon the extra over a large scoop of ice cream and have myself a little sundae!)

Marshmallows get their bouncy texture from gelatin. If you've never worked with it, don't be hesitant. It's really very easy. The secret to working with gelatin is to let it soften in very cold water and then heat it without boiling. I prefer gelatin sheets rather than granules because they soften more evenly in the cold water and I find the final set is better. Keep the water as cold as you can, adding ice cubes to chill it, and be sure to give the sheets a lot of room to soak. Before you drop the sheets of gelatin in the cold water, be sure they are separated. If they clump together during soaking, you will end up with a block of gelatin, which won't melt evenly in the hot pan. When it's time to heat the gelatin, I use the same pan I used to heat the sugar. Because it's still hot but not set over direct heat, the gelatin melts gently.

Once the marshmallow mixture is spread in the pan, it should dry for hours at room temperature for a really good texture. Gelatin keeps working as the mixture sets up, although it stops its magic after 24 hours. In my professional kitchen, we often slide the sheet pans into our large freezers soon after they are made, primarily to get them out of the way in our busy work space. This works fine, although I still prefer drying at room temperature if you have the time and space. For the best results, let the marshmallows set for 20 to 24 hours.

Once the marshmallows are set, cut them into any size or shape that you want. One- or two-inch squares are probably typical, but you may prefer rectangles, circles, or triangles. For this reason I don't give exact yields. Any marshmallows you don't use soon after drying can be stored in the freezer for a couple of weeks.

CHOCOLATE MARSHMALLOWS

15 sheets gelatin

6 large egg whites

3¾ cups sugar

¼ cup plus 1 tablespoon glucose (see Note) or light corn syrup

1 cup minus 1 tablespoon water

½ cup unsweetened natural (non-alkalized) cocoa powder, sifted after measuring

NOTE: *Glucose is nothing more than liquid sugar. It's sold in many supermarkets and specialty stores as well as shops catering to bakers. You can substitute light corn syrup or homemade simple syrup.*

Line a 13 by 9-inch rimmed baking sheet (1½ to 2 inches deep is deep enough) or similar pan with a Silpat. Dust the mat with cornstarch and then with a little cocoa powder. Shake the pan back and forth to mix the two powders and spread them evenly. Set aside.

Separate the gelatin sheets (also called leaves) so that they won't clump together during soaking. Soak the gelatin in ice-cold water until the gelatin softens, 10 to 15 minutes.

Meanwhile, in the bowl of an electric mixer fitted with the whisk attachment and set on medium-high speed, beat the egg whites until soft peaks form. (When the whisk is lifted, the whites should form a peak that droops over.)

In a heavy saucepan, heat the sugar, glucose or corn syrup, and water over medium heat, stirring, until the mixture reaches 290°F on a candy thermometer. Take care, as the sugar will be very hot.

With the mixer running on medium-low speed, pour the hot sugar mixture into the beaten egg whites. Set the empty hot saucepan back on the stove with the heat turned off.

With your hands, gently lift the gelatin sheets from the water and squeeze out the excess water. Put the sheets in the hot saucepan and let them melt into a liquid. Pour the melted gelatin into the meringue.

Add the cocoa powder and, using a rubber spatula, carefully fold the gelatin and cocoa into the meringue, taking care not to deflate it.

Spread the meringue in the prepared pan. Let the pan sit at room temperature for at least 8 hours or overnight. Tip the marshmallows from the pan and flip them over. Let the other side of the marshmallows dry at room temperature for at least 6 hours.

Cut the marshmallows into squares or rectangles. Serve immediately. Store any extras for about 2 weeks in the freezer, wrapped in plastic wrap and then enclosed in a freezer bag.

VANILLA MARSHMALLOWS

Makes one 13 by 9-inch pan of marshmallows

15 sheets gelatin

6 large egg whites

3¾ cups sugar

¼ cup plus 1 tablespoon glucose (see Note, opposite) or light corn syrup

1 cup minus 1 tablespoon water

1 teaspoon pure vanilla extract

Line a 13 by 9-inch rimmed baking sheet (1½ to 2 inches deep is deep enough) or similar pan with a Silpat. Dust the mat with cornstarch. Shake the pan back and forth to spread the powder evenly. Set aside.

Separate the gelatin sheets (also called leaves) so that they won't clump together during soaking. Soak the gelatin in ice-cold water until the gelatin softens, 10 to 15 minutes.

Meanwhile, in the bowl of an electric mixer fitted with the whisk attachment and set on medium-high speed, beat the egg whites until soft peaks form. (When the whisk is lifted, the whites should form a peak that droops over.)

In a heavy saucepan, heat the sugar, glucose or corn syrup, and water over medium heat, stirring, until the mixture reaches 290°F on a candy thermometer. Take care, as the sugar will be very hot.

With the mixer running on medium-low speed, pour the hot sugar mixture into the beaten egg whites. Set the empty hot saucepan back on the stove with the heat turned off.

With your hands, gently lift the gelatin sheets from the water and squeeze out the excess water. Put the sheets in the hot saucepan and let them melt into a liquid. Pour the melted gelatin into the meringue.

Add the vanilla and, using a rubber spatula, carefully fold the gelatin and vanilla into the meringue, taking care not to deflate it.

Spread the meringue in the prepared pan. Let the pan sit at room temperature for at least 8 hours or overnight. Tip the marshmallows from the pan and flip them over. Let the other side of the marshmallows dry at room temperature for at least 6 hours.

Cut the marshmallows into squares or rectangles. Serve immediately. Store any extras for about 2 weeks in the freezer, wrapped in plastic wrap and then enclosed in a freezer bag.

HOMEMADE ICE CREAM

WHEN I STARTED THIS BOOK, I made a decision to use store-bought ice cream for any recipe that required it. Homemade ice cream is amazing, no doubt about it, but there are so many premium store brands available, and so many specialty shops that sell their own versions, that I decided not to bother with my own.

I still believe store-bought ice cream will work well in the recipes in this book, but as I cooked through them, I decided homemade ice cream does have a place here. In fact, it has a place of honor. No one denies it's about as good as it gets. It's a perfect convergence of cream, milk, sugar, and eggs, and when you add to this exquisite balance flavorings such as vanilla, chocolate, caramel, and coffee, you have a dream team. I include these four flavors because they are used in the recipes, but ingredients such as fresh fruit, nuts, fresh ginger, and even green tea enhance ice cream's appeal as well.

Ice cream is a temptation I can rarely resist. Perhaps this is why I decided to avoid it at first, but reason won out and I offer four alluring recipes, one more tempting than the next.

The recipes here are for what some people call French-style ice cream. (I would call it Danish-style, but let's not quibble.) This simply means the ice creams are made from silken egg custards that result in an icy treat that is unparalleled in terms of taste and texture. There are ice creams made without eggs called American- or Philadelphia-style, I am told. Though still good, those are not quite as rich.

CHOCOLATE ICE CREAM

Makes about 1 quart

8 ounces bittersweet or semisweet
 chocolate

4 large egg yolks

½ cup sugar

2 tablespoons unsweetened natural
 (non-alkalized) cocoa powder

 Pinch of salt

1½ cups heavy cream

1½ cups whole milk

2 teaspoons pure vanilla extract

Coarsely chop 6 ounces of the chocolate and put in a heatproof bowl. Chop the remaining 2 ounces into chunks. These chunks will be mixed into the ice cream.

In a mixing bowl, whisk together the egg yolks, sugar, cocoa powder, salt, and ½ cup of the cream.

In a large saucepan, heat the remaining 1 cup cream and the milk over medium heat until just simmering. Do not let the mixture boil or even simmer too rapidly. Remove from the heat and gradually whisk about ½ cup of the hot cream mixture into the egg yolks until smooth to temper the yolks so they don't scramble. Return the egg yolk mixture to the saucepan.

Return the pan to the heat and cook, whisking constantly, over medium-low heat until the custard is thick enough to coat a wooden spoon and running your finger through it on the spoon leaves a visible trail, 4 to 6 minutes. Do not let the custard boil.

Pour the hot custard over the coarsely chopped chocolate and stir until the chocolate melts and the custard is smooth. Strain through a fine-mesh sieve into a metal bowl and stir in the vanilla.

Put the bowl in a larger bowl filled with cold water and ice and stir occasionally until cool. Cover the bowl with plastic wrap, putting it directly on the surface of the custard to prevent a skin from forming, and refrigerate for at least 2 hours and up to 24 hours.

Transfer the custard to an ice cream maker and freeze according to the manufacturer's directions. When the ice cream is almost frozen and approximately the consistency of thick whipped cream, add the reserved chocolate chunks. Churn or stir until mixed.

Spoon the ice cream into a lidded, freezer-safe container and freeze for at least 3 hours or until the ice cream is firm. The ice cream will keep in the freezer for up to 1 week.

VANILLA ICE CREAM

Makes about 1 quart

6 large egg yolks

⅔ cup sugar

Pinch of salt

1½ cups heavy cream

1½ cups whole milk

2 teaspoons pure vanilla extract

In a mixing bowl, whisk together the egg yolks, sugar, salt, and ½ cup of the cream.

In a large saucepan, heat the remaining 1 cup cream and the milk over medium heat until just simmering. Do not let the mixture boil or even simmer too rapidly. Remove from the heat and gradually whisk about ½ cup of the hot cream mixture into the egg yolks until smooth to temper the yolks so they don't scramble. Return the egg yolk mixture to the saucepan with the rest of the hot cream and milk.

Return the pan to the heat and cook, whisking constantly, over medium-low heat until the custard is thick enough to coat a wooden spoon and running your finger through it on the spoon leaves a visible trail, 4 to 6 minutes. Do not let the custard boil.

Strain the custard through a fine-mesh sieve into a metal mixing bowl, add the vanilla, and stir to combine.

Put the bowl in a larger bowl filled with cold water and ice and stir occasionally until cool. Cover the bowl with plastic wrap, putting the wrap directly on the surface of the custard to prevent a skin from forming, and refrigerate for at least 2 hours and up to 24 hours.

Transfer the custard to an ice cream maker and freeze according to the manufacturer's directions.

Spoon the ice cream into a lidded, freezer-safe container and freeze for at least 3 hours or until the ice cream is firm. The ice cream will keep in the freezer for up to 1 week.

PERFECT ICE CREAM

THE TRICK TO MAKING ICE CREAM is to freeze it while air is incorporated into it. This explains its exceptional texture. If the air is not part of the deal, the ice cream freezes into a hard, icy block. So how does this happen? With an ice cream maker.

Today's ice cream makers are relatively inexpensive and so easy to use that it takes only minutes to churn the ice cream. You can buy very fancy ones, but most folks do very well with a machine with inserts that you freeze before using. These machines churn the ice cream in about 20 minutes. After this time, the ice cream needs more time in the freezer to harden, but once the canister is in the freezer, your work is done. The only downside to this kind of ice cream maker is that the canister insert must sit in the freezer for about six hours before it's used, which means you have to plan ahead and can't make ice cream on a whim.

Finally, when you make ice cream at home, think cold, cold, cold. Once the custard is made, it needs to be chilled. I use an ice bath for this and then refrigerate the custard until it's as cold as can be. Only after it reaches this point can it be poured into the (cold) canister and churned in the ice cream maker.

COFFEE ICE CREAM

Makes about 1 quart

4 large egg yolks

½ cup sugar

1 cup strong brewed coffee, cooled to room temperature

Pinch of salt

1½ cups heavy cream

1½ cups whole milk

2 teaspoons pure vanilla extract

In a mixing bowl, whisk together the egg yolks, sugar, coffee, and salt.

In a large saucepan, heat the cream and milk over medium heat until just simmering. Do not let the mixture boil or even simmer too rapidly. Remove from the heat and gradually whisk about ½ cup of the hot cream mixture into the egg yolks until smooth to temper the yolks so they don't scramble. Return the egg yolk mixture to the saucepan with the rest of the hot cream and milk.

Return the pan to the heat and cook, whisking constantly, over medium-low heat until the custard is thick enough to coat a wooden spoon and running your finger through it on the spoon leaves a visible trail, 4 to 6 minutes. Do not let the custard boil.

Strain the custard through a fine-mesh sieve into a metal mixing bowl, add the vanilla, and stir to combine.

Put the bowl in a larger bowl filled with cold water and ice and stir occasionally until cool. Cover the bowl with plastic wrap, putting the wrap directly on the surface of the custard to prevent a skin from forming, and refrigerate for at least 2 hours and up to 24 hours.

Transfer the custard to an ice cream maker and freeze according to the manufacturer's directions.

Spoon the ice cream into a lidded, freezer-safe container and freeze for at least 3 hours or until the ice cream is firm. The ice cream will keep in the freezer for up to 1 week.

CARAMEL ICE CREAM

¾ cup plus 2 tablespoons sugar

2 tablespoons water

1 cup heavy cream

4 large egg yolks

Pinch of salt

1½ cups whole milk

1 tablespoon pure vanilla extract

In a deep saucepan, cook ¾ cup of the sugar and the water over medium-high heat for 1 to 2 minutes, stirring constantly with a wooden spoon until the sugar dissolves. Stop stirring and cook undisturbed until amber, 5 to 6 minutes. Tip or swirl the pan a few times during cooking and watch carefully so that the syrup does not burn. As soon as it turns amber, remove the pan from the heat.

Pour ¾ cup of the cream into the hot caramel. Use thick oven mitts and take care the hot caramel does not splash. (It can cause serious burns.) Stir with a long-handled wooden spoon until smooth and then return the mixture to medium heat and cook until bubbling around the edges, 4 to 5 minutes. Remove from the heat and cover.

In a mixing bowl, whisk together the egg yolks, the remaining 2 tablespoons sugar, the remaining ¼ cup cream, and the salt. When smooth, whisk in the milk.

Pour the milk mixture into the warm caramel and cook over medium heat, stirring constantly with a wooden spoon, until just simmering. Do not let the mixture boil or even simmer too rapidly. Cook until the custard is thick enough to coat a wooden spoon and running your finger through it on the spoon leaves a visible trail, 4 to 6 minutes. Do not let the custard boil.

Strain the custard through a fine-mesh sieve into a metal mixing bowl, add the vanilla, and stir to combine.

Put the bowl in a larger bowl filled with cold water and ice and stir occasionally until cool. Cover the bowl with plastic wrap, putting the wrap directly on the surface of the custard to prevent a skin from forming, and refrigerate for at least 2 hours and up to 24 hours.

Transfer the custard to an ice cream maker and freeze according to the manufacturer's directions.

Spoon the ice cream into a lidded, freezer-safe container and freeze for at least 3 hours or until the ice cream is firm. The ice cream will keep in the freezer for up to 1 week.

KNIPSCHILDT

CARAMEL SAUCE

—=·=—

THE TRICK TO MAKING CARAMEL SAUCE is to let the sugar cook undisturbed for a few minutes until it turns amber colored. Watch it carefully because it can burn quickly at this point—if this happens, you will know instantly because of the acrid smell emanating from the pan. This sauce is one of my favorites with just about anything chocolate; the flavor combination is hard to beat.

Makes about 1 cup

¾ cup sugar

2 tablespoons water

½ teaspoon freshly squeezed
lemon juice

¾ cup heavy cream

In a deep saucepan, cook the sugar, water, and lemon juice over medium-high heat for 1 to 2 minutes, stirring constantly with a wooden spoon until the sugar dissolves. Stop stirring the sugar at this point and let it cook undisturbed until it is amber colored, 5 to 6 minutes. Tip or swirl the pan a few times during cooking and watch carefully so that the syrup does not burn. As soon as it turns amber, remove the pan from the heat.

Pour the cream into the hot caramel. Use thick oven mitts and take care that the hot caramel does not splash. (It can cause serious burns.) Stir with a long-handled wooden spoon until smooth and then return the mixture to medium heat and cook until bubbling around the edges, 4 to 5 minutes. Remove from the heat.

Use immediately or transfer to a heatproof airtight container and refrigerate for up to 4 days.

Reheat gently by setting the uncovered container with the caramel sauce in a pan of gently simmering water. Stir a few times until warm.

CHOCOLATE SAUCE

THIS SAUCE IS A VARIATION ON ganache. Easy to make and easy to keep on hand, it tastes great on ice cream or pound cake—or anything that needs a little molten chocolate.

Makes about 2 cups

¾ cup (1½ sticks) unsalted butter, cut into pieces

2 ounces unsweetened chocolate

1 cup sugar

Pinch of salt

1 cup heavy cream

1 teaspoon pure vanilla extract

In the top of a double boiler set over gently simmering water, melt the butter and chocolate. Stir until smooth. Alternatively, put the butter and chocolate in a microwave-safe container and heat on high for about 1 minute. Stir, return to the microwave for 40 to 50 seconds, and check again. Continue heating in the microwave until melted and smooth. Remove from the heat.

Add the sugar and salt and stir to combine. Transfer the mixture to a saucepan and add the cream. Bring to a boil over medium-high heat, stirring constantly.

Remove from the heat, let the chocolate sauce cool for 2 to 3 minutes, and then stir in the vanilla. Let the sauce cool a little.

Use immediately or transfer to an airtight container and refrigerate for up to 4 days. Reheat gently over low heat.

JUST FOR FUN!

Cookies & Milk

Chocolate Chip Graham Crackers

Chocolate-Caramel Popcorn

Bonfire S'mores

Chocolate-Covered Bacon

Fritz's Rocky Road

Chocopologie Cornflake Clusters

Roasted Walnut Turtles

Creamy Peanut Butter Cups

Coconut-Almond Logs

Chocolate Crisps

Chocolate-Covered Marshmallow Domes

Summertime Grilled Bananas

THE TITLE OF THIS CHAPTER SAYS IT ALL. You'll want to make these easy and somewhat offbeat recipes when you feel like having fun in the kitchen. Chocolate-coated bacon? Seriously? Yes! Try it. Buy an extra box of cornflakes the next time you shop and mix it with melted chocolate. Yum! For something a little more substantial, try the rocky road or the graham crackers. Both you and your kids will be glad you did!

COOKIES & MILK

WHEN I STARTED SEEING COOKIES AND milk on dessert menus, even at high-end New York restaurants, I was baffled. Sure, you might indulge in cookies and milk when you get home at night, but why pay for them in a fancy restaurant? Clearly I was way off; folks love to end a meal with this combo. I take it up a few notches by serving warm ganache on the side. You can spread a little on the cookies or dip the cookie in it, or stir some into the cold milk. Or do all three and then lick the spoon! And make sure the milk is as cold as cold can be.

Serves 6

COOKIES

- ½ cup (1 stick) unsalted butter, softened
- ½ cup packed light brown sugar
- ½ cup granulated sugar
- 1 large egg
- ½ teaspoon pure vanilla extract
- 1½ cups all-purpose flour
- ½ teaspoon baking soda
- ¼ teaspoon salt
- 6 ounces bittersweet or semisweet chocolate, coarsely chopped

TO MAKE THE COOKIES: Preheat the oven to 350°F. Lightly butter two baking sheets or line them with parchment paper or Silpats.

In the bowl of an electric mixer fitted with the paddle attachment and set on medium-high speed, beat the butter and both sugars until creamy and smooth, 4 to 5 minutes. Add the egg and beat until incorporated. Add the vanilla and beat just until combined.

In a separate mixing bowl, whisk together the flour, baking soda, and salt.

Reduce the mixer speed to low and add the dry ingredients to the cookie dough, a little at a time. Do not overmix. With a wooden spoon or rubber spatula, stir in the chopped chocolate by hand.

With a spoon, scoop 9 mounds of cookie dough onto each baking sheet, leaving about 2 inches between each cookie. Bake until the cookies are lightly browned but not too crisp, 10 to 11 minutes.

Let the cookies rest on the baking sheets for 5 minutes before transferring them to wire racks to cool completely.

recipe continues

GANACHE

5 ounces bittersweet or semisweet chocolate, coarsely chopped

⅓ cup heavy cream

2 tablespoons honey

SERVING

About 6 cups whole or 2 percent milk

TO MAKE THE GANACHE: Put the chocolate in a heatproof bowl.

In a heavy saucepan, bring the cream and honey to a boil over medium-high heat. Once it's bubbling, pour the mixture over the chopped chocolate. With a wooden spoon, stir the ganache until the chocolate melts and the mixture is smooth and evenly colored. Set aside to cool just until warm.

TO SERVE: Put 3 cookies on each plate. Spoon about 3 tablespoons of the warm ganache into small serving bowls and set them near the cookies. Serve with 6 glasses of cold milk.

CHOCOLATE CHIP

GRAHAM CRACKERS

HOMEMADE GRAHAM CRACKERS ARE SO MUCH better than store-bought. Eating one is amazing, as you will realize with the first bite. When they are studded with chocolate chips? Even better!

Makes about 40 graham crackers

2 cups whole wheat flour

1¼ cups all-purpose flour

1½ teaspoons baking powder

1 teaspoon baking soda

½ teaspoon sea salt

1 cup (2 sticks) unsalted butter, softened

1 cup packed light brown sugar

½ cup whole milk

1 tablespoon pure vanilla extract

1 cup semisweet chocolate chips, tossed with a little of the flour

In a mixing bowl, whisk together the whole wheat flour, all-purpose flour, baking powder, baking soda, and salt.

In the bowl of an electric mixer fitted with the paddle attachment and set on medium-high speed, cream the butter and brown sugar until light and fluffy, 3 to 4 minutes. Reduce the speed to medium-low and add the milk and vanilla. Beat until smooth.

Reduce the mixer speed to low. Gradually add the dry ingredients, beating just until mixed. Do not overmix. Remove the bowl from the mixer and, using a rubber spatula, fold the chocolate chips into the dough.

Turn the dough onto a lightly floured surface and form it into a flattened disk. Wrap in plastic and refrigerate for at least 1 hour and up to 8 hours.

Position a rack in the center of the oven and preheat the oven to 350°F. Line a baking sheet with parchment paper.

Roll out the dough on a lightly floured surface to the approximate size of the baking sheet. Transfer the dough to the baking sheet and prick it all over with a fork. Cut the dough into 2-inch squares and leave them on the baking sheet. There is no need to separate the squares; they do not spread as they bake.

Bake until lightly browned, 8 to 10 minutes. Let the graham crackers cool on the baking sheet for a few minutes before transferring them to wire racks to cool completely. Once cool, store in an airtight container for up to 1 week.

CHOCOLATE-CARAMEL POPCORN

EVERYONE LIKES CARAMEL POPCORN AND WHEN you add chocolate it just gets better. Don't drizzle the warm chocolate over the popcorn immediately after the popcorn comes out of the oven, but instead let the caramel cool just a little before adorning the popcorn with the chocolate.

Serves 16 to 18

4½ to 5 quarts popped popcorn

2 cups packed light or dark brown sugar

1 cup (2 sticks) unsalted butter

½ cup light corn syrup

1 teaspoon sea salt

1 teaspoon pure vanilla extract

½ teaspoon baking soda

8 ounces bittersweet or semisweet chocolate

Position a rack in the center of the oven and preheat the oven to 250°F.

Put the popcorn in a large mixing bowl. You may have to divide it between two bowls.

In a saucepan, heat the brown sugar, butter, corn syrup, and salt over medium heat, stirring occasionally as the butter and sugar melt. When the sugar has melted, stir constantly until the caramel comes to a boil. Stop stirring and let the caramel cook undisturbed for about 3½ minutes.

Remove the saucepan from the heat and add the vanilla and baking soda. Set aside to cool just a little.

Drizzle the caramel sauce over the popcorn, pouring it in a thin stream. Stir to mix.

Spread the popcorn on one or two ungreased large baking sheets. Bake, stirring two or three times during baking, until the popcorn is crispy and lightly browned, 50 minutes to 1 hour.

Meanwhile, melt the chocolate according to the instructions on page 32. Let it cool to lukewarm (about 100°F).

Remove the baking sheets from the oven. Let the popcorn cool for 5 to 7 minutes (but not completely), and then drizzle the melted chocolate over the popcorn.

Set aside until completely cool, at least 2 hours. Break into pieces for serving.

S'MORES

IT MAY NOT COME AS A surprise that I had never heard of s'mores before I came to the United States, but now that I am here, I am a major fan. The difference between mine and the traditional ones made at campfires across the land is that I make a ganache with chocolate chips rather than using Hershey's chocolate bars. And if you've been super-industrious and made the homemade marshmallows on pages 184 and 185, all the better. Store-bought marshmallows do a good job, too.

Makes 16 s'mores

GANACHE

⅔ cup semisweet chocolate chips

¼ cup heavy cream

1 tablespoon honey

S'MORES

½ cup Knipschildt Caramel Sauce (page 192) or store-bought caramel sauce, warmed

16 graham crackers, broken in half

8 Vanilla Marshmallows (page 185) or standard-size store-bought marshmallows

8 Chocolate Marshmallows (page 184) or standard-size store-bought marshmallows

TO MAKE THE GANACHE: Put the chocolate chips in a heatproof bowl.

In a heavy saucepan, bring the cream and honey to a boil over medium-high heat. Once it's bubbling, pour the mixture over the chocolate chips. With a wooden spoon, stir until smooth and evenly colored. Cover to keep warm.

TO MAKE THE S'MORES: Put the ganache in a bowl and the caramel sauce in another. Set the bowls on the table. Arrange the graham crackers on a serving platter near the sauces.

Light the heat source of a chafing dish. Do not put the actual chafing dish in the stand. The heat source is to heat the marshmallows.

For each s'more, thread a single marshmallow on a long metal skewer. Let people heat their own marshmallows over the heat source. When a marshmallow is browned, dip it in the chocolate or caramel sauce. Lay the hot marshmallow on half of a graham cracker and top with the other half. Press firmly together and remove the skewer. Eat immediately.

WHAT IS

TEMPERING?

—◦·✦·◦—

WHEN CHOCOLATE IS "IN TEMPER," the cocoa butter crystals are stable and it has a shiny, glossy sheen. When it leaves the factory, chocolate is in temper, but it goes out of temper when the chocolate is melted or when it is stored improperly (see How to Melt Chocolate, page 32, and Don't Fear Chocolate Bloom, page 82). Professional chocolatiers and devoted hobbyists know how to temper chocolate so that it regains its shine and seductive texture; they perform a series of precisely monitored raisings and lowerings of temperatures until the cocoa butter crystals stabilize again.

Tempered chocolate not only is lustrous, but breaks with a satisfying "snap." You can feel the same snap when you bite the chocolate, which contributes to its mouthfeel—a term chocolate aficionados bandy about. Chocolate is usually tempered for enrobing truffles and other chocolates and for molding. However, I intentionally do not include any recipes in this book that require tempering to keep it simple.

CHOCOLATE-COVERED BACON

SWEET, SAVORY, SALTY, FATTY, crisp, and tender. Need I say more?

Makes 1 pound

½ pound bittersweet or semisweet chocolate

1 pound bacon (thick cut, if possible)

Sea salt

Melt the chocolate according to the instructions on page 32. Let it cool to lukewarm (about 100°F).

While the chocolate cools, cook the bacon in a large skillet over medium heat until it is as crispy as possible without burning. The idea is to remove as much fat as possible from the bacon. Drain on paper towels.

When the bacon is cool enough to handle, dip the strips of cooked bacon in the chocolate, submerging it to coat both sides of the bacon. Transfer the coated bacon to parchment paper–lined baking sheets. Lightly sprinkle each slice with sea salt.

Let the chocolate set for about 1 hour and then serve.

ROCKY ROAD

WHAT A TREAT THIS IS, MADE with marshmallows, chocolate, and almonds. I eat it straight from the pan or break it up and use it to top ice cream. Don't like almonds? Try walnuts. Just be sure to toast them first, as it really brings out their flavor.

Serves 6 to 8

⅓ cup chopped homemade marshmallows (see page 185) or standard-size store-bought marshmallows

¼ cup toasted sliced almonds (see page 210)

1 pound bittersweet or semisweet chocolate

½ cup packed light or dark brown sugar

4 tablespoons unsalted butter

2 tablespoons light corn syrup

¼ teaspoon sea salt

½ teaspoon pure vanilla extract

Pinch of baking soda

NOTE: *I usually make these as written in the recipe—sort of free-form. But you could also spoon the mixture into rectangular silicone molds to make individual servings as shown opposite. Your choice!*

In a large heatproof mixing bowl, toss together the marshmallows and almonds.

Melt the chocolate according to the instructions on page 32. Let it cool to lukewarm (about 100°F).

In a saucepan, heat the brown sugar, butter, corn syrup, and salt over medium heat, stirring occasionally as the butter and sugar melt. When the sugar has melted, stir constantly until the caramel comes to a boil. Stop stirring and let the caramel cook undisturbed for 2 minutes.

Remove the saucepan from the heat and add the vanilla and baking soda. Stir to mix.

Drizzle the chocolate over the marshmallows and almonds and then pour the caramel over them in a thin stream. As you pour, stir the mixture with a large wooden spoon until all the ingredients are well mixed.

Spread the rocky road mixture in an ungreased rimmed baking sheet, such as a jelly roll pan, that measures approximately 15 by 10 inches or a little larger. The size of the pan will determine the thickness of the rocky road candy.

Set aside for at least 30 minutes at room temperature to cool and set. Break into pieces for serving.

WHY I TOAST NUTS

—◦◦◦◦◦—

THE FLAVOR OF TOASTED NUTS is deeper and more intense than that of untoasted, plus the texture is pleasingly crispy. This is why I nearly always toast almonds, hazelnuts, walnuts, pecans, and other nuts before I use them, and why you should, too. Once you do, you'll be happy you did.

It's very easy to toast (or roast) nuts. For small quantities, spread them in a small, dry skillet and toast them over medium to medium-high heat, shaking the pan to prevent burning. Depending on the amount, it might take only a minute or so to toast the nuts.

For larger amounts of nuts, spread them in a single layer in a shallow, dry roasting pan or baking sheet and bake them at 375°F until fragrant and a shade or two darker. This could take up to 10 minutes, but check the nuts often. Your eyes and your nose will tell you when they are done. Stir the nuts several times to prevent burning. You'll know if the nuts burn because you'll smell them.

Slide the toasted nuts from the pan onto a room-temperature plate or pan so that they can cool without cooking any further on a hot surface.

I usually use the nuts as soon as they are toasted, but you can toast them up to a week before needed. Store them at room temperature in an airtight container.

CORNFLAKE CLUSTERS

IF YOU MAKE THESE WITH WHEATIES rather than cornflakes, they win my vote for a breakfast of champions, although I developed them with cornflakes, which are terrific. These are a novelty, no question about it, but they taste so good you'll probably make them often. Kids love them, of course.

Makes 50 to 75 clusters

1 pound bittersweet or semisweet chocolate

1 large box (12 to 14 ounces) cornflakes

Melt the chocolate according to the instructions on page 32. Let it cool to lukewarm (about 100°F).

Pour the cornflakes into a large bowl. Drizzle the cooled but still liquid chocolate over the cereal. Using your hands or a large wooden spoon (or both), mix the chocolate with the cornflakes, coating the cereal as thoroughly as possible.

Using an ice cream scoop or large spoon, spoon mounds of the mixture onto parchment paper–lined baking sheets. The mounds should be about 2 inches in diameter, although you can make them a little larger or smaller, depending on your preference.

Let the clusters set for about 1 hour. Serve right away or store in an airtight container for up to 3 days.

WALNUT TURTLES

EVERYONE LOVES TURTLES, WHETHER HOMEMADE OR store-bought, and these are as good as they get. I toast the walnuts to accentuate their nuttiness; create a thick, sweet caramel to add smooth texture; and then top the chocolate with a little sea salt to break the sweetness and add depth. The result? Sweet, crunch, and salt. Perfect.

Makes about 12 turtles

2 cups whole walnuts
1½ cups sugar
½ cup corn syrup
½ cup water
6 tablespoons unsalted butter
¼ cup heavy cream
8 ounces bittersweet or semisweet chocolate
Sea salt

Position an oven rack in the center of the oven and preheat the oven to 350°F.

Spread the walnuts on a baking sheet and roast, stirring a few times, until the nuts darken a shade or two and smell roasted and nutty, about 10 minutes. (For more on toasting—or roasting— nuts, see page 210.)

In a saucepan, bring the sugar, corn syrup, and water to a boil over medium-high heat. As soon as the mixture boils, add 4 tablespoons of the butter and the cream. Stir with a long-handled spoon until blended. Cover the caramel to keep it warm and set aside.

In the top of a double boiler set over barely simmering water, melt the chocolate and the remaining 2 tablespoons butter, stirring until blended and smooth.

Lightly spray a baking sheet with nonstick cooking spray or line it with parchment paper. Arrange the nuts, flat side down, in three-nut clusters on the baking sheet, so that the ends point at each other in the center of each cluster. Drizzle about a teaspoon of the warm caramel over each cluster, and then top the caramel with a teaspoonful of melted chocolate. Sprinkle a little sea salt on top of each turtle. Repeat, making as many turtles as you can; you should have about 12 turtles.

Refrigerate until the chocolate is set, at least 20 minutes.

CREAMY

PEANUT BUTTER CUPS

—✺—

AS I MENTIONED ELSEWHERE IN THE book, I did not taste peanut butter until I arrived in the USA, but once I did there was no turning back. I love it! These little cups are especially creamy and dreamy. A little messy to eat in the happiest way, they'll tempt everyone who can't get enough of the astonishing union of chocolate and peanut butter. By the way, you can always make these in mini cupcake pans for twice as many, if smaller, cups.

Makes 12 peanut butter cups

½ cup (1 stick) unsalted butter

2 cups smooth peanut butter

½ cup confectioners' sugar

1 teaspoon ground cinnamon

½ teaspoon almond extract

1 pound bittersweet or semisweet chocolate, coarsely chopped

In the top of a double boiler or in the microwave, melt 4 tablespoons of the butter.

In the bowl of an electric mixer fitted with the paddle attachment and set on medium-high speed, beat the peanut butter, sugar, melted butter, cinnamon, and almond extract until smooth and well blended.

In the top of a double boiler set over barely simmering water, melt the remaining 4 tablespoons butter and the chocolate, stirring until blended and smooth.

Line a 12-cup muffin tin with foil liners. Spoon enough melted chocolate into the cups to fill the liners about halfway. Top with the peanut butter filling and then spoon a little more chocolate over the filling to cover. Refrigerate until the chocolate is set, at least 30 minutes.

COCONUT-ALMOND LOGS

FOR ANYONE WHO GREW UP EATING candy bars, certain flavor combinations are deliciously familiar. Surely coconut and chocolate is one of the most recognizable—and beloved—pairings of all time. I know it's one of my favorites. You can make these logs smaller or larger than I do here, and while you don't have to coat their undersides with chocolate, they are a little more elegant if you do. Fully coated or not, these pack a glorious wallop of coconut.

Makes 24 logs

⅔ cup sweetened shredded coconut (10 ounces Baker's coconut)

1 can (14 ounces) sweetened condensed milk

1 teaspoon almond extract

12 ounces bittersweet or semisweet chocolate, coarsely chopped

½ cup (1 stick) unsalted butter

1 cup whole almonds, toasted (see page 210)

In a mixing bowl, stir together the coconut, condensed milk, and almond extract. Lightly spray a baking sheet with nonstick cooking spray or line it with parchment paper or a Silpat. Spread the coconut mixture on the baking sheet in an even layer, 1 to 1½ inches thick. Refrigerate until the mixture is set, about 10 minutes.

Meanwhile, in the top of a double boiler set over barely simmering water, melt the chocolate and butter, stirring until blended and smooth.

Cut the coconut layer into bars about 2 inches long and 1½ inches wide. Top each one with 2 almonds.

With the bars still on the baking sheet, pour or spoon the melted chocolate over them to cover. Refrigerate until the chocolate is set, about 15 minutes.

Turn the logs over and spoon the chocolate over the bottoms. Refrigerate again until the chocolate hardens.

CHOCOLATE CRISPS

THIS SUPER-CRUNCHY CANDY HITS THE SPOT when you want your chocolate with some ear-crackling CRUNCH! I make these with Rice Krispies, an oldie but goodie, and when I find gluten-free Rice Krispies, I use them for a gluten-free treat.

Makes 16 bars

24 ounces bittersweet or semisweet chocolate, coarsely chopped

½ cup (1 stick) unsalted butter

1 cup heavy cream, heated until hot but not boiling

5 cups Rice Krispies (use the gluten-free variety for gluten-free bars)

In the top of a double boiler set over barely simmering water, melt the chocolate and butter, stirring until blended and smooth.

Pour the chocolate mixture into a large bowl and stir in the hot cream until blended. Add the Rice Krispies and, using a wooden spoon, gently mix until all the cereal is coated with chocolate.

Lightly spray a baking sheet with nonstick cooking spray. Spread the mixture evenly over the baking sheet. Refrigerate until the chocolate hardens, at least 30 minutes.

Dip a sharp knife in very hot water and wipe dry. Cut the crisps into bars about 3½ inches long and 2 inches wide. For the smoothest cuts, continue to dip and dry the knife between cuts, as necessary.

MARSHMALLOW DOMES

※

I LIKE TO MAKE MY OWN marshmallows, but for these candies, using store-bought is just fine, particularly if you're making them with kids. The sugar cookies, marshmallows, and chocolate come together in an absolutely delightful way. If you would prefer to make fewer domes, halve the ganache recipe. Roll and cut only half the cookie dough and freeze the remaining dough for another time—it makes excellent plain sugar cookies.

Makes 40 to 45 domes

COOKIES

⅔ cup sugar

½ cup (1 stick) unsalted butter, softened

1 large egg

¼ teaspoon pure vanilla extract

1⅔ cups all-purpose flour

¾ teaspoon baking powder

¼ teaspoon salt

GANACHE

24 ounces bittersweet or semisweet chocolate, coarsely chopped

½ cup (1 stick) unsalted butter

1 cup heavy cream, heated until hot but not boiling

ASSEMBLY

Vanilla Marshmallows (page 185) or one 10-ounce bag (about 45) standard-size store-bought marshmallows

TO MAKE THE COOKIES: Lightly spray two baking sheets with nonstick cooking spray or line them with parchment paper or Silpats.

In the bowl of an electric mixer fitted with the paddle attachment and set on medium-high speed, beat the sugar and butter until light and fluffy, 3 to 4 minutes. Add the egg and vanilla and beat well.

In a separate mixing bowl, whisk together the flour, baking powder, and salt. Reduce the mixer speed to medium-low and add the dry ingredients in two or three additions. Refrigerate the dough for about 1 hour.

Preheat the oven to 350°F.

On a lightly floured surface, roll the dough out to a thickness of about ¼ inch. Using a 1½-inch cookie cutter or a small glass with a similar diameter, cut out 40 to 45 cookies, re-rolling the dough as necessary.

Transfer the cookies to the prepared baking sheets. Bake until the cookies are lightly browned around the edges, 8 to 10 minutes.

Let the cookies rest on the baking sheets for a few minutes before transferring them to wire racks to cool completely.

TO MAKE THE GANACHE: In the top of a double boiler set over barely simmering water, melt the chocolate and butter, stirring until blended and smooth. Pour the chocolate into a large bowl and stir in the heated cream until blended.

TO ASSEMBLE THE DOMES: Set each cookie, upside down so that the flat side faces up, into in a foil (or paper) cupcake liner.

Use kitchen scissors to cut the marshmallows, whether homemade or store-bought, to fit the cookies: For homemade marshmallows, cut circles from the marshmallow sheet, using the same 1½-inch cookie cutter as a guide. Cut store-bought marshmallows in half horizontally, or as best you can to fit the cookies, cutting additional smaller pieces to help cover the cookie if desired. A thickness of about ½ inch, or slightly thicker if you prefer, is ideal. (The domes will not be perfect.)

Working with 1 cookie at a time, dab a small amount of ganache onto the cookie and then press the cut marshmallow(s), cut side down, on top of the cookie (the ganache acts like "glue"). Repeat with the remaining cookies and marshmallows.

Spoon the ganache over the marshmallows and cookies to cover completely. Refrigerate the domes for at least 30 minutes, or until ready to serve. You can serve them still in the cupcake liners or lift them out before serving.

NOTE: *If you plan to cut and piece together store-bought marshmallows to cover the cookies completely, you might want to buy a second bag. That way, you will have plenty of extra marshmallows on hand. However, if you plan to use just half a marshmallow per cookie without adding extra pieces, one bag will be more than enough.*

GRILLED BANANAS

I MADE THIS UP ONE SUMMER evening when I craved something deep, dark, and delicious—and also had a couple of bananas on the kitchen counter. The flavors are those of s'mores, if s'mores included bananas, and are so good you might come to prefer these. I know I do. Nestle the packets in the hot coals or the embers of a bonfire and have some long tongs on hand to haul them out again after a few minutes. The time depends on the intensity of the heat. And although I think of these as a summer treat, you could easily make them in the fireplace on a cold winter's night.

Serves 2

2 bananas, in their skin

4 to 6 homemade marshmallows (see page 185) or standard-size store-bought marshmallows, cut into ½-inch pieces, or about ½ cup mini marshmallows

2 ounces bittersweet or semisweet chocolate, coarsely chopped

1 whole graham cracker

With a sharp knife, slit the bananas lengthwise so you can open them, but don't cut them into two separate pieces. Holding one of the bananas open, scatter half of the marshmallows in the cavity. Top with half of the chocolate. Repeat with the other banana.

Crumble the graham cracker between your fingers and sprinkle the crumbs on top of the marshmallows and chocolate, dividing them evenly between the bananas.

Wrap each banana tightly in aluminum foil. Put the foil packets directly on the coals or nestle them near the burning wood in a fire pit or fireplace. Let them heat for about 5 minutes or until they feel soft.

Open the packets and eat the chocolaty bananas with a spoon. Discard the skins.

CHOCOLATE DRINKS & BOOZY BEVERAGES

WHETHER YOU PREFER YOUR CHOCOLATE DRINKS hot and soothing, without a drop of liquor, or like them a little more spirited and perhaps even icy cold, I have a recipe that will suit your taste. My dad taught me to like frothy ice cream drinks when I was a kid living in Denmark. He made what I have since learned are called ice cream sodas in the United States, but back then we simply called them milkshakes. I don't have a recipe for an ice cream soda on the following pages, but I do have recipes for two thick, decadent milkshakes, both spiked with liquor, that will put smiles on the faces of dads (and moms) everywhere. But before getting to the alcohol drinks, I offer several variations on hot chocolate.

If you've traveled in Europe and sampled the hot chocolate made there, you will know how much better it is than the watery "cocoa" offered here. My recipes, not surprisingly, are made the European way.

The final five recipes in this chapter are designed for grown-ups. Children need not apply because every one contains vodka, Baileys Irish Cream, rum, whiskey, or Cognac in some amount. As much as I love kid-friendly chocolate drinks, the booze-spiked ones are heavenly departures!

HOT CHOCOLATE

MOST PEOPLE IN THE UNITED STATES have never tasted true European-style hot chocolate, and when they do, it's an epiphany. "What is this?" they want to know, grinning from ear to ear. It's nothing more exotic than hot chocolate made with real milk and real chocolate, and this recipe is the best this side of Paris. But don't take my word for it. Try it and prepare to be blown away! By the way, you don't have to make this much; this recipe is easy to cut in half.

Serves 10 to 12

8 cups whole milk

⅔ cup heavy cream

3 tablespoons sugar

1 pound bittersweet or semisweet chocolate, coarsely chopped

2 teaspoons pure vanilla extract

1¾ cups sweetened whipped cream (see page 224), for garnish, optional

10 to 12 homemade marshmallows (see page 185) or standard-size store-bought marshmallows, for garnish, optional

In a large saucepan, bring the milk, cream, and sugar to a boil over medium–high heat, stirring occasionally to prevent scorching. When the mixture boils, immediately remove from the heat.

Add the chocolate to the hot milk mixture, whisking until the chocolate melts and the hot chocolate is smooth. Whisk in the vanilla.

Pour the hot chocolate into mugs and garnish with dollops of whipped cream or marshmallows, if using. Serve immediately.

NOTE: *While it's highly unlikely, you may end up with leftover hot chocolate. If so, cover and refrigerate for up to 5 days. Reheat gently over medium heat, whisking to give the hot chocolate body and texture. Or, use the leftovers to make either of the martinis on pages 229 and 230.*

SWEETENED WHIPPED CREAM

WHIPPED CREAM IS SO SIMPLE TO MAKE that the importance of knowing exactly how to do so is often overlooked or minimized. Fortunately, it is easy. Just pour the cream into a bowl and whisk it by hand or with an electric mixer. To sweeten it, add sugar to the cream as it whips. The major stumbling block with whipping cream is overwhipping it, which makes it turn to butter. If this happens, you must start over again; there is no salvaging the cream (except as a spread for your morning English muffin). Generally, 1 cup cream yields about 2 cups whipped cream. Here are some tips for making whipped cream:

1 Start with chilled cream and a chilled metal bowl. Even better, refrigerate the hand whisk or the beater(s) from the electric mixer for about an hour.

2 For small amounts of cream—¼ to ½ cup—it's easiest to beat the cream by hand with a wire whisk.

3 For more than ½ cup cream, you will have the best luck using a handheld electric mixer or a standing mixer fitted with the whisk attachment.

4 Add the sugar during beating. Confectioners' sugar blends more smoothly than granulated sugar, although either will sweeten the cream. For 1 cup cream you will need 2 to 3 tablespoons confectioners' sugar, depending on your personal taste.

5 For even fuller flavor, add pure vanilla extract to the cream before you start beating. A cup of cream needs about ½ teaspoon vanilla.

6 Whip the cream until it forms soft peaks. This means the cream will hold peaks when the whisk is lifted, but they will very quickly flop over on their sides. This is the best consistency for dolloping onto desserts and hot chocolate.

7 When you want to pipe the cream into rosettes or other decorative shapes, whip the cream to stiff peaks, which means the peaks don't fall over but stand upright when the whisk is lifted.

8 Serve whipped cream shortly after it's whipped, although it will keep in the refrigerator for 24 hours. Cover it tightly so it does not absorb flavors from other food. If the stored whipped cream is a little watery, beat it briefly before serving.

9 Neither a blender nor a food processor is recommended for whipping cream. A blender is not designed to aerate the cream as it mixes it. And if not watched closely, the cream will turn to butter before your eyes in a food processor.

HOT CHOCOLATE

I MAKE THIS HEADY HOT CHOCOLATE with real mint, and the leaves infuse the milk and cream with their fresh, bright flavor. Although this rich, sweet, indulgent hot chocolate is perfect for cold winter days, its cooling mint flavor will make you think of it fondly in July and August, too—and why not? Make it any time of year when you need a sweet comfort fix. I augment the hot chocolate with a drop or two of peppermint oil. Add it with care because it can quickly overpower. If the fresh mint is flavorful enough, you might not need it at all.

Serves 4 to 6

3½ cups whole milk

½ cup heavy cream

1 tablespoon plus 1½ teaspoons sugar

¾ bunch fresh mint (about ⅓ cup mint leaves)

1 cup plus 3 tablespoons semisweet chocolate chips

1 teaspoon pure vanilla extract

1 to 2 drops peppermint oil, depending on how strong you like it

About ¾ cup sweetened whipped cream (see opposite page), for garnish, optional

4 to 6 sprigs fresh mint, for garnish

In a large saucepan, bring the milk, cream, and sugar to a boil over medium-high heat, stirring occasionally to prevent scorching. When the mixture boils, immediately remove from the heat. Add the mint leaves and let them steep in the hot milk mixture for 5 to 8 minutes.

Pour the milk through a fine-mesh sieve into a bowl, squeezing the leaves to extract as much flavor as possible. Discard the leaves. Return the milk mixture to the saucepan and bring to a boil over medium-high heat. Remove from the heat and add the chocolate chips. Stir until the chocolate is melted and the hot chocolate is smooth. Stir in the vanilla and peppermint oil. Begin with a single drop, taste, and then add more if desired.

Pour the hot chocolate into 4 to 6 mugs and garnish with dollops of whipped cream, if using, and mint sprigs. Serve immediately.

NOTE: *If there are any leftovers, cover and refrigerate for up to 5 days. Reheat gently over medium heat, whisking to give the hot chocolate body and texture.*

WHITE-CHOCOLATE MILK

JUST AS DELICIOUS AS THE EUROPEAN-STYLE Hot Chocolate on page 222, this version exists in that parallel universe where white chocolate reigns supreme. So, if you love white chocolate or have a yen for it, make this and enjoy every creamy sip.

Serves 6 to 8

4½ cups whole milk

1½ cups heavy cream

8 ounces white chocolate, chopped

1½ teaspoons pure vanilla extract

About 1 cup sweetened whipped cream (see page 224), for garnish, optional

Unsweetened cocoa powder, for dusting

NOTE: *If there are any leftovers, cover and refrigerate for up to 5 days. Reheat gently over medium heat, whisking to give the hot chocolate body and texture.*

In a large saucepan, bring the milk and cream to a boil over medium-high heat, stirring occasionally to prevent scorching. When the mixture boils, immediately remove from the heat.

Add the chocolate to the hot milk mixture, whisking until the chocolate melts and the hot chocolate is smooth. Whisk in the vanilla.

Pour the hot chocolate into 6 to 8 mugs and garnish with dollops of whipped cream, if using, and a dusting of cocoa powder. Serve immediately.

CHOCOLATE MILKSHAKE

WITH WHISKEY

I LOVE MILKSHAKES. ALWAYS HAVE. THEY'RE cold and creamy and go down easily, so what's not to love? This and the White Chocolate–Coconut Milkshake with Malibu on page 233 have the added bonus of being flavored with spirits, making them milkshakes for adults. I suspect you'll agree that one of these boozy milkshakes is perfect as an after-dinner sweet or a pick-me-up at the end of a rainy day. If you want, substitute half-and-half or milk for the cream to lighten this up just a little (but not too much!).

Serves 1

½ cup Super Chocolate Ice Cream (page 187) or high-quality store-bought chocolate ice cream

¼ cup heavy cream

2 ounces whiskey

Put the ice cream, heavy cream, and whiskey in a blender. Process until smooth, frothy, and blended. Pour into a milkshake glass or similar tall glass and serve.

CHOCOLATE MARTINI

THIS MARTINI, MADE WITH A FULL complement of vodka and Baileys, can be served as a pre-dinner cocktail or an after-dinner treat.

Serves 1

2 ounces (¼ cup) European-Style Hot Chocolate (page 222), chilled

2 ounces Baileys Irish Cream

2 ounces vodka

4 to 5 ice cubes

Pour the chilled hot chocolate, Baileys, and vodka into a cocktail shaker. Add the ice and shake vigorously. Pour the iced martini through a strainer into a martini glass and serve.

NOTE: *For presentation with style, drizzle melted chocolate into the cool glass. Let set a few minutes before pouring in the martini.*

KNIPSCHILDT MARTINI

THIS MARTINI IS A LITTLE MORE complex than the Chocolate Martini on page 229. First, the rim of the martini glass is coated with sea salt (Hawaiian sea salt has a chocolaty reddish-brown color), and second, caramel sauce is added to the mix. Best of all, I add Malibu, a popular Caribbean rum imbued with the flavor of coconut. I love it when these flavors meet in the cocktail shaker. Except for the rum, the same flavors meet again in my best-selling chocolate, which is called the Hannah.

Serves 1

Hawaiian sea salt or any coarse sea salt

2 ounces (¼ cup) European-Style Hot Chocolate (page 222), chilled

2 ounces Malibu rum

2 ounces vodka

1 tablespoon Knipschildt Caramel Sauce (page 192) or store-bought caramel sauce

4 to 5 ice cubes

Spread the salt on a flat plate. With wet fingers, dampen the rim of the martini glass and then dip the rim in the salt so that the salt adheres to the rim.

Pour the chilled hot chocolate, rum, vodka, and caramel sauce into a cocktail shaker. Add the ice and shake vigorously. Pour the iced martini through a strainer into the martini glass, taking care to pour the cocktail into the center of the glass so as not to wash away the salt. Serve.

MILKSHAKE

THIS IS THE YIN TO THE yang of the Chocolate Milkshake with Whiskey on page 227. Made with vanilla ice cream and white chocolate, and spiked with coconut-flavored rum, it's the drink of choice for white chocolate lovers, or just about anyone else who appreciates a good milkshake.

Serves 1

½ cup Old-Fashioned Vanilla Ice Cream (page 188) or high-quality store-bought vanilla ice cream

¼ cup heavy cream

2 ounces Malibu rum

1 ounce white chocolate, melted, cooled but still liquid (see page 32)

Put the ice cream, heavy cream, rum, and chocolate in a blender. Process until smooth, frothy, and blended. Pour into a milkshake glass or similar tall glass and serve.

LUMUMBA

MY GRANDFATHER MADE THESE FOR ME when I was a teenager. Every now and again, he handed me an Irish coffee mug filled with steaming hot chocolate and spiked with just a little Cognac to elevate it to sophisticated heights (his own drink was always stronger than the one he gave me). I have a soft spot for this hot chocolate drink, mostly, I am sure, because it reminds me of my grandfather. But also because it tastes so good.

Serves 1

3 ounces (¼ cup plus 2 tablespoons) European-Style Hot Chocolate (page 222)

2 ounces Cognac or other brandy
About 1 tablespoon sweetened whipped cream (see page 224)

Pour the hot chocolate into an Irish coffee mug or other glass or mug and stir in the brandy. Garnish with the whipped cream and serve immediately.

INDEX

NOTE: Page references in *italics* indicate recipe photographs.

Chocolate Milkshake with
Whiskey, 227
French-style, about, 186
Fresh-Brewed Coffee, 190
homemade, about, 186
preparing, tips for, 189
Sandwiches, Oatmeal-Cherry
Cookie, 26–27
Super Chocolate, *163*, 187
Vanilla, Old-Fashioned, 188
White Chocolate–Coconut
Milkshake, *232*, 233
Ice cream makers, 189

K

Key Lime Truffles, 130
Knipschildt Caramel Sauce, 192, *193*
Knipschildt Martini, 230, *231*

L

Lemon
Candied, & Strawberries,
Chocolate Bark with,
180, 181–82
-Raspberry Yogurt Cupcakes,
72–73
–White Chocolate Truffles,
Almond-Crusted, 137
Lime, Key, Truffles, 130
Lumumba, 234, *235*

M

Macadamia nuts
Tropical White Chocolate–
Peppermint Bark, *176*, 177
Macaroons, Chocolate-Coconut,
30, *31*
Madeleines, Chocolate-Orange, 35
Marshmallow(s)
Bonfire S'mores, 204
Chocolate, 184
-Chocolate S'more Bars, 40
Domes, Chocolate-Covered,
216–17
Fritz's Rocky Road, 208, *209*

preparing, tips for, 183
Summertime Grilled Bananas,
218, 219
Vanilla, 185
Martinis
Chocolate, *228*, 229
Knipschildt, 230, *231*
Marzipan Bars
Ginger-Apricot, 155
Mocha, 155
Raspberry, 155
Meringues, Chocolate Chip–
Almond, 34
Milk, Cookies &, 198–200, *199*
Milkshakes
Chocolate, with Whiskey, 227
White Chocolate–Coconut,
232, 233
Mini Coconut-Chocolate Cupcakes,
74–76, *75*
Mocha Marzipan Bars, 155
Molten Chocolate Cakes, *62*, 63
Molten Chocolate Cakes, Mini,
161, *163*

N

Nutella Truffles, Walnut-Coated,
140
Nuts. *See also* Almond(s); Walnut(s)
Chocolate Pistachio Tart
with Fresh Raspberries,
12, 118–21, *119*
Coconut-Chocolate Bars,
8, 42, *43*
Milk Chocolate–Peanut Butter
Truffles, 134, *135*
Milk Chocolate Pecan Pie,
110–11
Oatmeal-Cherry Cookie Ice
Cream Sandwiches, 26–27
Pistachio Truffles, *142*, 143
Raspberry Linzer Tart, *112*,
113–14, *115*
toasting, 210
Tropical White Chocolate–
Peppermint Bark, *176*, 177

O

Oats
Chocolate-Almond Granola,
170, 171
Oatmeal-Cherry Cookie Ice
Cream Sandwiches, 26–27
Orange(s)
-Chocolate Madeleines, 35
Creamsicle Truffles, 132–33
Crepes Suzette with Chocolate Ice
Cream, 146–48, *147*
Oreo Cookie Cheesecake, 94–95

P

Peanut Butter
Buttercream, *2*, *52*, 53
-Chocolate Cookies, *24*, 25
Cups, Creamy, 213
–Milk Chocolate Truffles,
134, *135*
Peanuts
Milk Chocolate–Peanut Butter
Truffles, 134, *135*
Pear Tart, Chocolate–Red Wine,
106–8, *107*
Pecan(s)
Coconut-Chocolate Bars, *8*, 42, *43*
Pie, Milk Chocolate, 110–11
Peppercorn, Madagascar Green,
–Raspberry Truffles, 138–39
Peppermint
Hot Chocolate, 225
–White Chocolate Bark, Tropical,
176, 177
Pie, Milk Chocolate Pecan, 110–11
Pistachio(s)
Chocolate Tart with Fresh
Raspberries, *12*, 118–21, *119*
Oatmeal-Cherry Cookie Ice
Cream Sandwiches, 26–27
Truffles, *142*, 143
Popcorn, Chocolate-Caramel,
202, 203
Pots de Crème, 153
Pretzel Chocolate Caramel
Cheesecake, *17*, 97–98, *99*

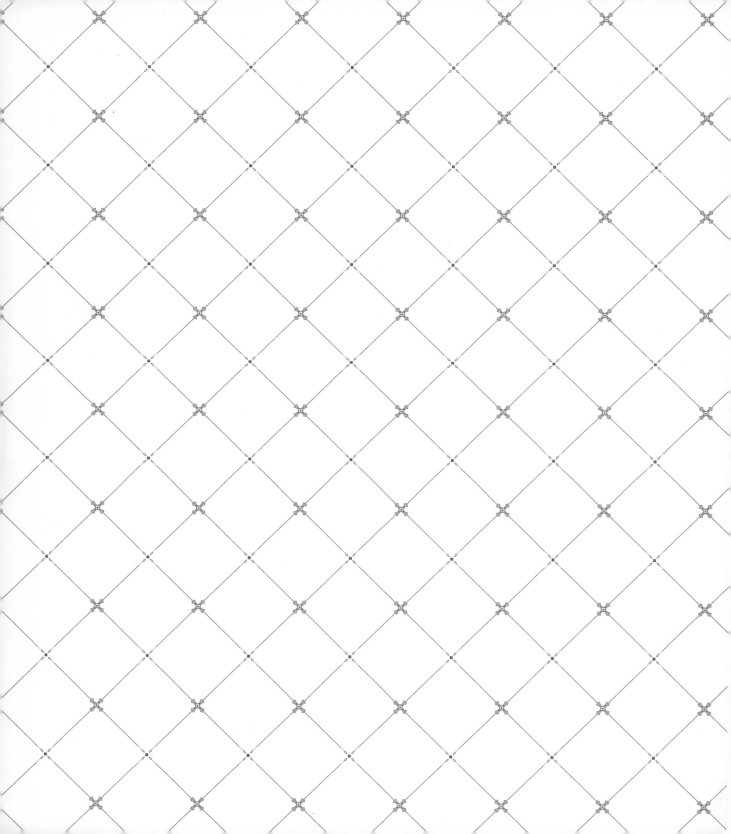